A World of Art encourages students to think critically about the world of art around them. The cover for the new 7th edition is an extension of that critical-thinking message. Students encounter a relatively blank canvas. How are they going to treat this canvas? Will they protect the white page and keep it pristine? Or will they think critically and design a work of art?

Many schools around the country have embraced this impromptu art project and have run student art contests. The winning artwork is selected for the school-specific custom cover. To run your own student art contest for an *A World of Art* custom cover, please contact your Pearson representative. We would also love to see the submissions!

Email scanned covers to Art.Service@Pearson.com.

Example of a custom 6th edition cover.

SEVENTH EDITION

A WORLD OF art

HENRY M. SAYRE

Oregon State University–Cascades Campus

Prentice Hall

Boston Columbus Indianapolis New York San Francisco
Upper Saddle River Amsterdam Cape Town Dubai London
Madrid Milan Munich Paris Montreal Toronto Delhi Mexico City
Sao Paulo Sydney Hong Kong Seoul Singapore Taipei Tokyo

Editorial Director: Craig Campanella
Editor in Chief: Sarah Touborg
Acquisitions Editor: Billy Grieco
Editorial Project Manager: David Nitti
Vice-President, Director of Marketing:
 Brandy Dawson
Executive Marketing Manager: Kate Mitchell
Marketing Assistant: Paige Patunas
Managing Editor: Melissa Feimer
Senior Project Manager: Barbara Marttine Cappuccio
Senior Operations Supervisor: Mary Fischer
Operations Specialist: Diane Peirano

Senior Art Director: Pat Smythe
Interior Design and Cover Design: Riezebos
 Holzbaur Group
Media Director: Brian Hyland
Senior Media Editor: David Alick
Media Project Manager: Rich Barnes
Pearson Imaging Center: Corin Skidds
Full-Service Project Management: PreMediaGlobal
Composition: PreMediaGlobal
Printer/Binder: Courier/Kendallville
Cover Printer: Lehigh Phoenix

Frontispiece: © 2012 Kate Rothko Prizel & Christopher Rothko/Artists Rights Society (ARS),
New York

Credits and acknowledgments borrowed from other sources and reproduced, with permission,
in this textbook appear on the appropriate page within text or on the credit pages in the back
of this book.

Library of Congress Cataloging-in-Publication Data
Sayre, Henry M.
 A world of art / Henry M. Sayre, Oregon State
 University-Cascades Campus. —Seventh Edition.
 pages cm
 Includes bibliographical references and index.
 ISBN 978-0-205-88757-6 (alk. paper)
 1. Art—Textbooks. I. Title.

N7425.S29 2012
700—dc23

2012017292

10 9 8 7 6 5 4

Student Edition
ISBN 10: 0-205-88757-0
ISBN 13: 978-0-205-88757-6

Instructor's Review Copy
ISBN 10: 0-205-90522-6
ISBN 13: 978-0-205-90522-5

Books à la carte
ISBN 10: 0-205-89887-4
ISBN 13: 978-0-205-89887-9

As always, for my boys,
Rob and John, and for Sandy

Brief Contents

Contents

Dear Student

You might be asking yourself, "Why are they making me take this course? What does art have to do with my engineering, or forestry, or business degree?" In fact, many students come to an art appreciation course thinking of it as something akin to a maraschino cherry sitting atop their education sundae—pretty to look at, but of questionable food value, and of little real use.

But as you come to understand art, I hope you will realize that in studying it, you have learned to *think* better. You might be surprised to learn, for instance, that in 2005 the New York City Police Department began taking newly promoted officers, including sergeants, captains, and uniformed executives, to the Frick Collection, an art museum on New York's Upper East Side, in order to improve their observational skills by having them analyze works of art. Similar classes are offered to New York medical students to help them improve their diagnostic abilities when observing patients, teaching them to be sensitive to people's facial expressions and body language. Art appreciation is not forensic science, but it teaches many of the same skills.

Perhaps more than anything else, an art appreciation course can teach you the art of critical thinking—how to ask the right questions about the visual world that surrounds us, and then respond meaningfully to the complexity of that world. This book is, in fact, unique in its emphasis on the critical thinking process—a process of questioning, exploration, trial and error, and discovery that you can generalize to your own experience and your own chosen field of endeavor. Critical thinking is really a matter of putting yourself in a questioning frame of mind.

Our culture is increasingly dominated by images—and I've included a lot of new, very contemporary ones in this new edition. All students today must learn to see and interpret the images that surround them. If you just passively "receive" these images, like some television set, you will never come to understand them. I hope that you'll find this book to be not just a useful, but an indispensable foundation in learning to negotiate your world.

ABOUT THE AUTHOR:

Henry M. Sayre is Distinguished Professor of Art History at Oregon State University–Cascades Campus in Bend, Oregon. He is producer and creator of the 10-part television series *A World of Art: Works in Progress*, which aired on PBS in the fall of 1997; and author of seven books, including *The Humanities; Writing About Art; The Visual Text of William Carlos Williams; The Object of Performance: The American Avant-Garde since 1970;* and an art history book for children, *Cave Paintings to Picasso.*

What's new to this edition?

Henry Sayre's *A World of Art* introduces students to art with an emphasis on critical thinking and visual literacy. This new seventh edition further strengthens these key aspects by examining major themes of art and by adding the new **MyArtsLab**, which provides engaging experiences that personalize, stimulate, and measure learning for each student.

NEW! Artwork throughout the text is tied to thematic modules found within **MyArtsLab**, which encourage students to think critically about art through the themes that have inspired artists throughout the centuries. This thematic content can also be added to your print book as an optional thematic appendix. Ask your local Pearson representative for details.

Fig. 2-6 *Triumphal Entry* (page from a manuscript of the *Shahnamah of Firdawsi*), Persian, Safavid culture, 1562–1583. Opaque watercolor, ink, and gold on paper, 18¹¹/₁₆ × 13 in. Francis Bartlett Donation and Picture Fund. 14.692. Courtesy Museum of Fine Arts, Boston. Reproduced with permission. Photograph © 2012 Museum of Fine Arts, Boston.

Thinking Thematically: See Art and Spiritual Belief on myartslab.com

NEW! Chapter-opening Thinking Ahead questions lead students to focus on and think critically about the chapter's important issues.

THINKING AHEAD

How does subject matter differ from content?

What is representational art?

What constitutes an artwork's form?

What is iconography?

Visual art can be powerfully persuasive, and the purposes of this book is to help you to rec how this is so. Yet it is important for you to stand from the outset that you can neither nize nor understand—let alone communicate visual art affects you without using language. I words, one of the primary purposes of any preciation text is to provide you with a desc vocabulary, a set of terms, phrases, concepts, a proaches that will allow you to think critically

NEW! Thinking Back end-of-chapter reviews follow up on the chapter-opening questions, helping students review, and further engage with, the material they've just read.

THINKING BACK ✓•—Study and review on myartslab.com

How does subject matter differ from content?

An artwork's subject matter is what the image or object literally represents. The content, by contrast, is what the artwork means. How can the subject matter of Shirin Neshat's *Rebellious Silence* be distinguished from its content? How does Lorna Simpson use text and images together to create the content of *She* and *Necklines*?

What constitutes an artwork's form?

Form is the overall structure of an artwork. Form includes such aspects of an artwork as its materials and the organization of its parts into a composition. Wh role does form typically play in nonrepresentational How does form differ from content? How do Kazimi Malevich and Beatriz Milhazes use form in their wo

What is iconography?

NEW! New and updated contemporary art images showcase the latest developments in the contemporary art world.

NEW! New and updated non-Western art images, including coverage of art in Africa, India, China, and Japan, help students see a diversity of cultures throughout the world of art.

NEW! Graphic icons throughout the text direct students to **MyArtsLab** to explore architectural panoramas and simulations, studio technique video demonstrations, primary sources, Closer Looks, and more.

MyArtsLab™

A better teaching and learning experience

This program will provide a better teaching and learning experience for you and your students. Here's how:

The new **MyArtsLab** delivers proven results in helping individual students succeed. Its automatically graded assessments, personalized study plan, and interactive eText provide engaging experiences that personalize, stimulate, and measure learning for each student. And, it comes from a trusted partner with educational expertise and a deep commitment to helping students, instructors, and departments achieve their goals.

- The **Pearson eText** lets students access their textbook anytime, anywhere, and any way they want—including listening to chapter audio read by Henry Sayre, or downloading the text to an iPad®.
- **Personalized study plan** for each student promotes critical-thinking skills. **Assessment** tied to videos, applications, and chapters enables both instructors and students to track progress and get immediate feedback.
- **NEW! Thinking Thematically** modules within MyArtsLab will allow instructors and students to approach the course through the lens of themes. The Thinking Thematically tags found on the page in the eText will link directly to that content, giving students access to thematic content directly at the point of need.
- **NEW!** Henry Sayre's *Writing About Art* 6th edition is now available online in its entirety as an eText within MyArtsLab. This straightforward guide prepares students to describe, interpret, and write about works of art in meaningful and lasting terms.
- **NEW! Discovering Art** is a robust online tutorial for exploring the major elements and principles of art, art media, and art processes. The site offers opportunities to review key terminology, search a large gallery of images, watch videos, and more.
- **NEW! Art21** and **Studio Technique videos** present up-close looks at real-life artists at work, helping students better understand techniques used during different eras.
- **Closer Look tours**—interactive walkthroughs featuring expert audio—offer in-depth looks at key works of art, enabling students to zoom in to see detail they couldn't otherwise see—even in person.
- **360-degree architectural panoramas and simulations** of major monuments help students understand buildings—inside and out.

A fresh, engaging take on assessment

The new **MyArtsLab** Challenge guides students through the ages as they master the study of art appreciation and the humanities. Upon successful completion of each level, students unlock works of art and artifacts to create their own personal galleries to share with their peers.

The **MyArtsLab** Challenge is available for *A World of Art*, Seventh Edition, and *Discovering the Humanities*, Second Edition, both by Henry M. Sayre.

Additional Resources

GIVE YOUR STUDENTS CHOICES.

Pearson arts titles are available in the following formats to give you and your students more choices—and more ways to save.

The **CourseSmart eTextbook** offers the same content as the printed text in a convenient online format—with highlighting, online search, and printing capabilities. **www.coursesmart.com**

The **Books à la Carte edition** offers a convenient, three-hole-punched, loose-leaf version of the traditional text at a discounted price—allowing students to take only what they need to class. Books à la Carte editions are available both with and without access to MyArtsLab.

Build your own Pearson Custom course material. Work with a dedicated Pearson Custom editor to create your ideal textbook and web material—publishing your own original content or mixing and matching Pearson content. *Contact your Pearson representative to get started.*

INSTRUCTOR RESOURCES

NEW! Available on MyArtsLab, the **Teaching *A World of Art* Thematically Instructor's Guide** includes sample syllabi and teaching suggestions from author Henry Sayre.

NEW! The Class Preparation Tool collects the very best class presentation resources in one convenient online destination, so instructors can keep students engaged throughout every class. With art and figures from the text, videos, classroom activities, and much more, it makes lecture preparation simpler and less time-consuming.

NEW! Teaching with MyArtsLab PowerPoints help instructors make their lectures come alive. These slides allow instructors to display the very best interactive features from MyArtsLab in the classroom—quickly and easily.

Instructor's Manual and Test Item File

This is an invaluable professional resource and reference for new and experienced faculty. Each chapter contains the following sections: Chapter Overview, Chapter Objectives, Key Terms, Lecture and Discussion Topics, Resources, and Writing Assignments and Projects. The test bank includes multiple-choice, true/false, short-answer, and essay questions. Available for download from the instructor support section at **www.myartslab.com.**

MyTest

This flexible online test-generating software includes all questions found in the printed Test Item File. Instructors can quickly and easily create customized tests with MyTest. **www.pearsonmytest.com**

Development

Every edition of *A World of Art* has grown over the years in large part due to the instructors and students who share their feedback, ideas, and experiences with the text. This edition is no different and we are grateful to all who participated in shaping its structure and content. Manuscript reviewers for this seventh edition include:

Kathleen Alexander, **San Antonio College**
Laura Amrhein, **University of Arkansas at Little Rock**
Charmagne Andrews, **Alabama State University**
David Bausman, **Laredo Community College**
Benjamin Billingsley, **Cape Fear Community College**
Colleen Bolton, **Mohawk Valley Community College**
Denise Budd, **Bergen Community College**
Ingrid Cartwright, **Western Kentucky University**
Juarez Hawkins, **Chicago State University**

Mary Horst, **Houston Community College - Central Campus**
Noel Hudson, **Santa Fe Community College**
Lynn Metcalf, **Nashville State Community College**
Paul Niell, **University of North Texas**
Cheryl Smart, **Pima Community College**
Brigitta Staley, **Kellogg Community College**
Susan Sutherland, **Blinn College**
Paige Wideman, **Northern Kentucky University**
Cynthia Zyzda, **Colorado Mountain College**

ACKNOWLEDGMENTS

Over the years, a great many people have helped make this book what it is today. The contributions of all the people at Oregon State University who originally supported me in getting this project off the ground—Jeff Hale; three chairs of the Art Department, David Hardesty, Jim Folts, and John Maul; three deans of the College of Liberal Arts, Bill Wilkins, Kay Schaffer, and Larry Rodgers; and three university presidents, John Byrne, Paul Risser, and Ed Ray—cannot be forgotten. To this day, and down through this new edition, I owe them all a special debt of gratitude. Finally, in the first edition of this book, I thanked Berk Chappell for his example as a teacher. He knew more about teaching art appreciation than I ever will, and I miss him dearly.

At Pearson, I am especially grateful to the production team who saw this edition through to completion. For the look of the book, with its elegant cover and interior design, I am indebted to Pat Smythe, senior art director. Ben Ferrini, image lead manager, and Cory Skidds, senior imaging specialist, found the images I required, and worked on image compositing and color accuracy of the artwork—the beauty of so many pages here is testament to their efforts. Barbara Cappuccio, senior production project manager, has been working with me now for any number of editions of any number of books, and I am in constant awe of her ability to keep track of every detail and deal with the minute-to-minute crises that inevitably develop. Finally, I want to thank, once again, Lindsay Bethoney and the staff at PreMedia Global for working so hard to make the book turn out the way I envisioned it.

The marketing and editorial teams at Pearson are beyond compare. On the marketing side, Brandy Dawson, vice president of marketing, and Kate Mitchell, executive marketing manager, help us all to understand just what students want and need. On the editorial side, my thanks to Yolanda de Rooy, president of the Humanities and Social Sciences division, whose overarching vision is responsible for helping to make Pearson such an extraordinarily good publisher to write for; to Sarah Touborg, editor-in-chief, who has supported the ongoing development of this project in every conceivable way; to Billy Grieco, my editor, whose courage to think out of the box is, I think, charting new directions in academic publishing; and to Jessica Parrotta, Billy's editorial assistant, who has the daunting responsibility of keeping track of the two of us. Finally, I want to thank the late Bud Therien, who oversaw the development of most of the earlier editions of this book, and a man of extraordinary fortitude, passion, and vision. He is, in many ways, responsible for the way that art appreciation and art history are taught today in this country. I have had no better friend in the business.

Over the course of the last decade, as technology has increasingly encroached on the book as we know it—with the explosion, that is, of the Internet, digital media, and new forms of publishing, like the iPad and Kindle—I worried that books like *A World of Art* might one day lose their relevance. I envisioned them being supplanted by some as-yet-unforeseen technological wizardry, like a machine in a science fiction novel, that would transport my reader, into a three- or four-dimensional learning space "beyond the book." Well, little did I know that Pearson Education was developing just such a space, one firmly embedded in the book, not beyond it. From my point of view, myartslab.com represents one of the most important

developments in art publishing and education in decades. I am extremely grateful to the team that has put it together and is continually working to improve it.

Finally, as always, I owe my greatest debt to my colleague and wife, Sandy Brooke. She is present everywhere in this project. It is safe to say she made it possible. I can only say it again: without her good counsel and better company, I would not have had the will to get this all done, let alone found the pleasure I have had in doing it.

Henry M. Sayre
Oregon State University–Cascades Campus

Student Toolkit

This short section is designed to introduce the over-arching themes and aims of *A World of Art* as well as provide you with a guide to the basic elements of art that you can easily access whenever you interact with works of art—in these pages, in museums, and anywhere else you encounter them. The topics covered here are developed much more fully in later chapters, but this overview brings all this material together in a convenient, quick-reference format.

WHY STUDY THE WORLD OF ART?

We study art because it is among the highest expressions of culture, embodying its ideals and aspirations, challenging its assumptions and beliefs, and creating new visions and possibilities for it to pursue. That said, "culture" is itself a complex phenomenon, constantly changing and vastly diverse. The "world of art" is composed of objects from many, many cultures—as many cultures as there are and have been. In fact, from culture to culture, and from cultural era to cultural era, the very idea of what "art" even is has changed. It was not until the Renaissance, for instance, that the concept of fine art, as we think of it today, arose in Europe. Until then, the Italian word *arte* meant "guild"—any one of the associations of craftspeople that dominated medieval commerce—and *artista* referred to any student of the liberal arts, particularly grammarians.

But, since the Renaissance, we have tended to see the world of art through the lens of "fine art." We differentiate those one-of-a-kind expressions of individual creativity that we normally associate with fine art—painting, sculpture, and architecture—from craft, works of the applied or practical arts like textiles, glass, ceramics, furniture, metalwork, and jewelry. When we refer to "African art" or "Aboriginal art," we are speaking of objects that, in the cultures in which they were produced, were almost always thought of as applied or practical. They served, that is, ritual or religious purposes that far outweighed whatever purely artistic skill they might evidence. Only in most recent times, as these cultures have responded to the West's ever-more-expansive appetite for the exotic and original, have individual artists in these cultures begun to produce works intended for sale in the Western "fine arts" market.

To whatever degree a given object is more or less "fine art" or "craft," we study it in order to understand more about the culture that produced it. The object gives us insight into what the culture values—religious ritual, aesthetic pleasure, or functional utility, to name just a few possibilities.

THE CRITICAL PROCESS

Studying these objects engages us in a critical process that is analogous, in many ways, to the creative process that artists engage in. One of the major features of this text is a series of spreads called The Creative Process. They are meant to demonstrate that art, like most things, is the result of both hard work and, especially, a process of critical thinking that involves questioning, exploration, trial and error, revision, and discovery.

One of the greatest benefits of studying art is that it teaches you to think critically. Art objects are generally "mute." They cannot explain themselves to you, but that does not mean that their meaning is "hidden" or elusive. They contain information—all kinds of information—that can help you explain and understand them if you approach them through the critical thinking process outlined on the next page.

Seven Steps to
Thinking Critically
about Art

1. Identify the artist's decisions and choices.

Begin by recognizing that, in making works of art, artists inevitably make certain decisions and choices—What color should I make this area? Should my line be wide or narrow? Straight or curved? Will I look up at my subject or down on it? Will I depict it realistically or not? What medium should I use to make this object? And so on. Identify these choices. Then ask yourself why these choices were made. Remember, though most artists work somewhat intuitively, every artist has the opportunity to revise or redo each work, each gesture. You can be sure that what you are seeing in a work of art is an intentional effect.

2. Ask questions. Be curious.

Asking yourself why the artist's choices were made is just the first set of questions to pose. You need to consider the work's title: What does it tell you about the piece? Is there any written material accompanying the work? Is the work informed by the context in which you encounter it—by other works around it, or, in the case of sculpture, for instance, by its location? Is there anything you learn about the artist that is helpful?

3. Describe the object.

By carefully describing the object—both its subject matter and how its subject matter is formally realized—you can discover much about the artist's intentions. Pay careful attention to how one part of the work relates to the others.

4. Question your assumptions.

Question, particularly, any initial dislike you might have for a given work of art. Remember that if you are seeing the work in a book, museum, or gallery, then someone likes it. Ask yourself why. Often you'll talk yourself into liking it too. But also examine the work itself to see if it contains any biases or prejudices. It matters, for instance, in Renaissance church architecture, whether the church was designed for Protestants or Catholics.

5. Avoid an emotional response.

Art objects are supposed to stir up your feelings, but your emotions can sometimes get in the way of clear thinking. Analyze your own emotions. Determine what about the work set them off, and ask yourself if this wasn't the artist's very intention.

6. Don't oversimplify or misrepresent the art object.

Art objects are complex by their nature. To think critically about an art object is to look beyond the obvious. Thinking critically about the work of art always involves walking the line between the work's susceptibility to interpretation and its integrity, or its resistance to arbitrary and capricious readings. Be sure your reading of a work of art is complete enough (that it recognizes the full range of possible meanings the work might possess), and, at the same time, that it doesn't violate or misrepresent the work.

7. Tolerate uncertainty.

Remember that the critical process is an exercise in discovery, that it is designed to uncover possibilities, not necessarily certain truths. Critical thinking is a process of questioning; asking good questions is sometimes more important than arriving at "right" answers. There may, in fact, be no "right" answers.

At the end of each chapter in this book you will find a section called The Critical Process, which poses a series of questions about a work or works of art related to the material in that chapter. These questions are designed both to help you learn to ask similar questions of other works of art and to test your understanding of the chapter materials. Short answers to the questions can be found at the back of the book, but you should try to answer them for yourself before you consult the answers.

Critical thinking is really a matter of putting yourself in a questioning frame of mind. Our culture is increasingly dominated by images, and all students today must learn to see and interpret the visual world around them. As you question what you see, as you actively engage the world of art—and not just passively "receive" its images, like so many television set—you will find that you are at once critical and self-critical. You will see better and understand more— about both the work of art and yourself.

A Quick-Reference Guide
to the Elements of Art

BASIC TERMS

Three basic principles define all works of art, whether two-dimensional (painting, drawing, printmaking, and photography) or three-dimensional (sculpture and architecture):

- Form—the overall structure of the work
- Subject matter—what is literally depicted
- Content—what it means

If the subject matter is recognizable, the work is said to be representational. Representational works that attempt to depict objects as they are in actual, visible reality are called realistic. The less a work resembles real things in the real world, the more abstract it is. Abstract art does not try to duplicate the world, but instead reduces the world to its essential qualities. If the subject matter of the work is not recognizable, the work is said to be nonrepresentational, or nonobjective.

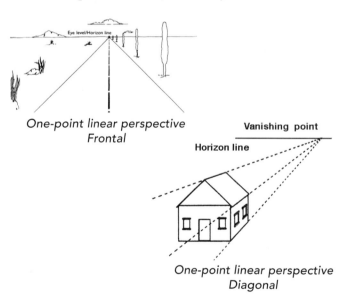

One-point linear perspective Frontal

One-point linear perspective Diagonal

THE FORMAL ELEMENTS

The term form refers to the purely visual aspects of art and architecture. Line, space, levels of light and dark, color, and texture are among the elements that contribute to a work's form.

LINE is the most fundamental formal element. It delineates shape (a flat two-dimensional area) and mass (a solid form that occupies a three-dimensional volume) by means of outline (in which the edge of a form or shape is indicated directly with a more or less continuous mark) or contour (which is the perceived edge of a volume as it curves away from the viewer). Lines can be implied—as in your line of sight. Line also possesses certain emotional, expressive, or intellectual qualities. Some lines are loose and free, gestural and quick. Other lines are precise, controlled, and mathematically and rationally organized.

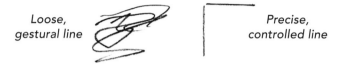

Loose, gestural line

Precise, controlled line

Line is also fundamental to the creation of a sense of deep, three-dimensional space on a two-dimensional surface, the system known as linear perspective. In one-point linear perspective, lines are drawn on the picture plane in such a way as to represent parallel lines receding to a single point on the viewer's horizon, called the vanishing point. When the vanishing point is directly across from the viewer's vantage point, the recession is frontal. When the vanishing point is to one side or the other, the recession is diagonal.

In two-point linear perspective, more than one vanishing point occurs, as, for instance, when you look at the corner of a building.

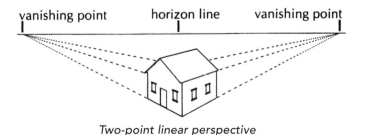

Two-point linear perspective

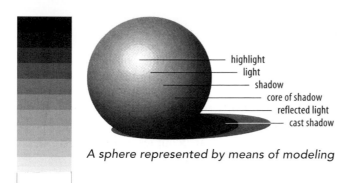

highlight
light
shadow
core of shadow
reflected light
cast shadow

A sphere represented by means of modeling

Gray scale

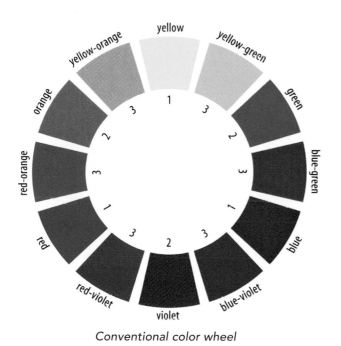

Conventional color wheel

LIGHT AND DARK are also employed by artists to create the illusion of deep space on a two-dimensional surface. In atmospheric perspective—also called aerial perspective—objects further away from the viewer appear less distinct as the contrast between light and dark is increasingly reduced by the effects of atmosphere. Artists depict the gradual transition from light to dark around a curved surface by means of modeling. Value is the relative degree of lightness or darkness in the range from white to black created by the amount of light reflected from an object's surface (the gray scale).

COLOR has several characteristics. Hue is the color itself. Colors also possess value. When we add white to a hue, thus lightening it, we have a tint of that color. When we add black to a hue, thus darkening it, we have a shade of that color. The purer or brighter a hue, the greater its intensity. Different colors are the result of different wavelengths of light. The visible spectrum—that you see, for instance, in a rainbow—runs from red to orange to yellow (the so-called warm hues) to green, blue, and violet (the so-called cool hues). The spectrum can be rearranged in a conventional color wheel. The three primary colors—red, yellow, and blue (designated by the number 1 on the color wheel)—are those that cannot be made by any mixture of the other colors. Each of the secondary colors—orange, green, and violet (designated by the number 2)—is a mixture of the two primaries it lies between. The intermediate colors (designated by the number 3) are mixtures of a primary and a neighboring secondary. Analogous color schemes are those composed of hues that neighbor each other on the color wheel. Complementary color schemes are composed of hues that lie opposite each other on the color wheel. When the entire range of hues is used, the color scheme is said to be polychromatic.

TEXTURE is the tactile quality of a surface. It takes two forms: the actual surface quality—as marble is smooth, for instance—and a visual quality that is a representational illusion—as a marble nude sculpture is not soft like skin.

VISITING MUSEUMS

Museums can be intimidating places, but you should remember that the museum is, in fact, dedicated to your visit. Its mission is to help you understand and appreciate its collections and exhibits.

One of the primary functions of museums is to provide a context for works of art—that is, works are grouped together in such a way that they inform one another. They might be grouped by artist (all the sculptures of Rodin might be in a single room); by school or group (the French Cubists in one room, for instance, and the Italian Futurists in the next); by national and historical period (nineteenth-century British landscape); or by some critical theory or theme. Curators—the people who organize museum collections and exhibits—also guarantee the continued movement of people through their galleries by limiting the number of important or "star" works in any given room. The attention of the viewer is drawn to such works by positioning and lighting.

A good way to begin your visit to a museum is to quickly walk through the exhibit or exhibits that particularly interest you in order to gain an overall impression. Then return to the beginning and take your time. A set of worksheets that poses questions for you to consider as you look at the works in a museum can be found in the appendix to this book. Remember, this is your chance to look at the work close at hand, and, especially in large paintings, you will see details that are never visible in reproduction—everything from brushwork to the text of newsprint incorporated in a collage. Take the time to walk around sculptures and experience their full three-dimensional effects. You will quickly learn that there is no substitute for seeing works in person.

A Do-And-Don't Guide
to Visiting Museums

DO PLAN AHEAD. Most museums have Web sites that can be very helpful in planning your visit. The Metropolitan Museum of Art in New York, for instance, and the Louvre in Paris are so large that their collections cannot be seen in a single visit. You should determine in advance what you want to see.

DO HELP YOURSELF to a museum guide once you are at the museum. It will help you find your way around the exhibits.

DO TAKE ADVANTAGE of any information about the collections—brochures and the like—that the museum provides. Portable audio tours can be especially informative, as can museum staff and volunteers—called docents—who often conduct tours.

DO LOOK AT THE WORK BEFORE YOU READ ABOUT IT. Give yourself a chance to experience the work in a direct, unmediated way.

DO READ THE LABELS that museums provide for the artworks they display after you've looked at the work for a while. Almost all labels give the name of the artist (if known), the name and date of the work, its materials and technique (oil on canvas, for instance), and some information about how the museum acquired the work. Sometimes additional information is provided in a wall text, which might analyze the work's formal qualities, or provide some anecdotal or historical background.

DON'T TAKE PHOTOGRAPHS, unless cameras are explicitly allowed in the museum. The light created by flashbulbs can be especially damaging to paintings.

DON'T TOUCH THE ARTWORK. The more texture a work possesses, the more tempting it will be, but the oils in your skin can be extremely damaging, even to stone and metal.

DO TURN OFF YOUR CELL PHONE out of courtesy to others.

DON'T TALK LOUDLY, and be aware that others may be looking at the same piece you are. Try to avoid blocking their line of sight.

DO ENJOY YOURSELF, don't be afraid to laugh (art can be funny), and if you get tired, take a break.

A WORLD OF

art

1 | Part 1: The Visual World
A World of Art

Fig. 1-1 Cai Guo-Qiang, *Footprints of History: Fireworks Project for the Opening Ceremony of the 2008 Beijing Olympic Games.*
© Cai Studio

THINKING AHEAD

What do all artists share?

What are the roles of the artist?

What is active seeing?

On August 8, 2008—the eighth day of the eighth month of the eighth year of the twenty-first century—the 29th Olympic Games opened in Beijing, China. The time was 08:08:08 pm. Eight is a lucky number in Chinese culture because it sounds like the word for wealth and prosperity. The New York-based, Chinese-born artist Cai Guo-Qiang had been chosen by the Chinese government two years earlier to serve as Director of Visual and Special Effects for the opening and closing ceremonies of the games. Cai's opening gambit was a trail of 29 firework "footprints of history" (**Fig. 1-1**), representing each of the 29 Olympiads and fired in succession for 63 seconds across the 9.3 miles of sky between

Tiananmen Square in the center of the city and the Bird's Nest, the Olympic Stadium, designed by the Swiss firm of Herzog & de Meuron (**Fig. 1-2**). Itself a marvel, the stadium consists of a red concrete bowl seating some 91,000 people surrounded by an outer steel frame that structurally resembles the twigs of a bird's nest. One of China's first truly environmentally conscious buildings, it is heated and cooled by a geothermal heating system under the stadium floor, a rainwater collection system on the roof purifies water and recycles it for use in the venue, and a translucent roof provides essential sunlight for the grass below.

Born in 1957, Cai had left China in 1986 to study in Japan, where he began to explore the properties of gunpowder as a tool for making drawings, drawings that developed, eventually, into large-scale explosion events. He had staged one of the most dramatic of these in 1993, when, with a band of volunteers, both Japanese and Chinese, he returned to China to lay 10 kilometers (about 6 miles) of fuse and gunpowder clusters, one every 3 meters, in the Gobi Desert, beginning at the place where the Great Wall ends; at twilight, he detonated an explosion that slithered in a red line on the horizon to form an ephemeral extension of the Great Wall. Entitled *Project to Extend the Great Wall of China by 10,000 Meters: Project for Extraterrestrials No.10*, he understood full well that it was best viewed from high above the earth. From the ground, the event was awe-inspiring. One could only imagine what it might have looked like from on high. Where the Great Wall had originally been built to separate people, Cai's extension brought them together. Where gunpowder was originally a force of destruction, now it was a thing of beauty. These were the same goals that Cai wished to achieve in his pyrotechnic display at the 29th Olympiad.

But *Footprints of History* met with almost immediate controversy. Although the pyrotechnic display actually occurred as Cai planned, it was not broadcast live. Television viewers saw instead a 55-second digital film, created from dress-rehearsal footage of the footprint fireworks exploding that was then sequenced into place using computer graphics. Given climatic conditions in Beijing, where smog often reduces visibility to a few hundred feet, Cai believed the video was necessary. In fact, he considered the video

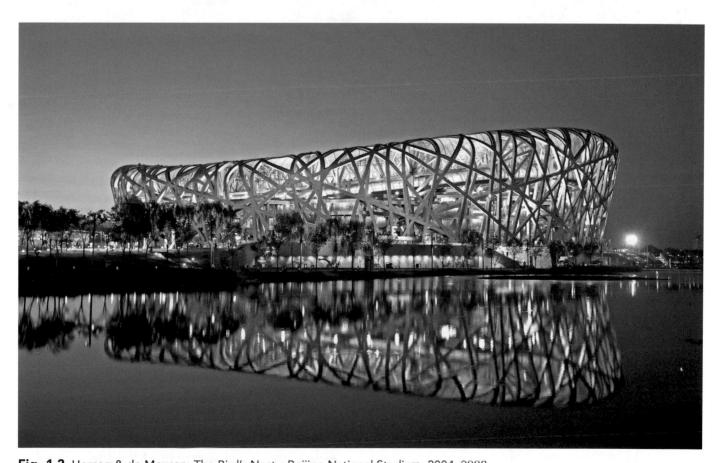

Fig. 1-2 Herzog & de Meuron, The Bird's Nest—Beijing National Stadium, 2004–2008.
Corbis.

Fig. 1-3 Zhang Hongtu, *Bird's Nest, in the Style of Cubism* 2008.
Oil on canvas, 36 × 48 in.
© Zhong Hongtu Studio

a second work of art. "From my own perspective as an artist," Cai explained,

there are two separate realms in which this artwork exists, as two very different mediums have been utilized. First, there is the artwork that exists in the material realm: the ephemeral sculpture. This was viewed by people attending the ceremonies inside the stadium and standing outside on the streets of Beijing. This artwork was documented from various vantage points on video, which has been broadcast by many international media outlets. Second, there is a creative digital rendering of the artwork in the medium of video. It is a single version of the event viewed by a large broadcast audience. Such a conceptual work can exist simultaneously in these two separate realms. And perhaps to also take Footprints of History *into this second realm was necessary because in many of my explosion events, such as* Project to Extend the Great Wall of China by 10,000 Meters, *the very best vantage point is not the human one.*

Cai has posted five videos made by audience members of the "ephemeral" event on his website, www.caiguoqiang.com, under Projects for 2008

(a short, 1-minute 7-second video of the *Project to Extend the Great Wall of China by 10,000 Meters* is available for viewing on the same site under Projects for 1993). To some people, Cai's televised video seemed a form of subterfuge. Others wondered whether fireworks even qualified as art.

In the end, Cai's pyrotechnics were stunning, and widely admired. Whatever trouble the broadcast of a back-up reel on television caused him was dwarfed by that endured by fellow Chinese artist Zhang Hongtu. When Zhang's painting *Bird's Nest, in the Style of Cubism* (**Fig. 1-3**) arrived in China for an exhibition at the German embassy, it was seized by Chinese officials. They were holding it, they said, pending "clarification of its meaning." Modeled closely on Cubist works such as Georges Braque's *Soda* (**Fig. 1-4**), with its fragmented objects (which appear to be a wineglass, a pipe, a sheet of music, and the word SODA, perhaps a label on a bottle), all set on an abstract Parisian café tabletop, Zhang's painting includes Chinese characters for the French supermarket chain Carrefour, which has stores all over China and whose purported support of the Dalai Lama (the Buddhist head of the Tibetan government in exile) resulted in protests across China

Fig. 1-4 Georges Braque (1882–1963), *Soda*, Paris, spring 1912.
Oil on canvas, 14¼ in. (36.2 cm) diameter. Acquired through the Lillie P. Bliss Bequest.
The Museum of Modern Art, New York, NY, U.S.A.

in the spring of 2008 as the government was struggling to complete final preparations for the Olympic games. The number "8" is repeated 23 times, a direct allusion to what Zhang called China's "stupid" numerological superstitions. At the bottom right is the letter J beside four horizontal lines, a reference to June 4, the date of the Tiananmen Square massacre in Beijing in 1989. Finally, the motto for the 2008 Olympics appears in Chinese characters: "One World, One Dream." If nothing else, these words clearly mean different things to Zhang Hongtu and Chinese government officials.

As it turned out, officially, the painting's muted palette was deemed inappropriate for the celebratory nature of the Olympic games, and the government demanded that the painting be removed from China. But more than the painting's Cubist idiom, the government was provoked by the inclusion of the word "Tibet" just above "Human Right[s]," both of which directly refer to China's 50-year occupation of that country (or province, from the Chinese government's point of view). Reactions to both *Footprints of History* and *Bird's Nest, in the Style of Cubism* differed depending on the point of view of their various audiences, but both raised the same questions. What is the purpose of this work of art (and what is the purpose of art in general)? What does it mean? What is my reaction to the work and why do I feel this way? How do the formal qualities of the work—such as its color, its organization, its size and scale—affect my reaction? What do I value in works of art? These are some of the questions that this book is designed to help you address. Appreciating art is never just a question of accepting visual stimuli, but also involves intelligently contemplating why and how works of art come to be made and have meaning. By helping you understand the artist's creative process, we hope to engage your own critical ability, the process by which you create your own ideas, as well.

The World as Artists See It

If the work of Cai Guo-Qiang and Zhang Hongtu demonstrates how people understand and value the same work of art in different ways, similarly, different artists, responding to their world in different times and places, might see the world in apparently divergent terms. They do, however, share the fundamental desire to *create*. All people are creative, but not all people possess the energy, ingenuity, and courage of conviction that are required to make art. In order to produce a work of art, the artist must be able to respond to the unexpected, the chance occurrences or results that are part of the creative process. In other words, the artist must be something of an explorer and inventor. The artist must always be open to new ways of seeing. The landscape painter John Constable spoke of this openness as "the art of seeing nature." This art of seeing leads to imagining, which leads in turn to making. Creativity is the sum of this process, from seeing to imagining to making. In the process of making a work of art, the artist also engages in a self-critical process—questioning assumptions, revising and rethinking choices and decisions, exploring new directions and possibilities. In other words, the artist is also a *critical thinker*, and the creative process is, at least in part, an exercise in critical thinking.

Exploring the creative process is the focus of this book. We hope you take from this book the knowledge that the kind of creative and critical thinking engaged in by artists is fundamental to every discipline. This same path leads to discovery in science, breakthroughs in engineering, and new research in the social sciences. We can all learn from studying the creative process itself.

ROLES OF THE ARTIST

Most artists think of themselves as assuming one of four fundamental roles—or some combination of the four—as they approach their work: 1) they help us to see the world in new and innovative ways; 2) they create a visual record of their time and place; 3) they make functional objects and structures more pleasurable by imbuing them with beauty and meaning; and 4) they give form to immaterial ideas and feelings.

1) Artists help us to see the world in new or innovative ways.

This is one of the primary roles that Cai Guo-Qiang assumes in creating works like *Project to Extend the Great Wall of China by 10,000 Meters*. In fact, almost all of his work is designed to transform our experience of the world, jar us out of our complacency, and create new ways for us to see and think about the world around us.

The work of Japanese artist Yayoi Kusama has much the same effect. Kusama is widely known for her fascination with polka-dots. In the late 1950s, she began to produce paintings that she called "Infinity Nets," huge canvases painted all over in tiny circles. The paintings were a means of coming to grips with an obsessive hallucinatory vision that she first experienced as a child:

> One day I was looking at the red flower patterns of the tablecloth on a table, and when I looked up I saw the same pattern covering the ceiling, the windows and the walls, and finally all over the room, my body and the universe. I felt as if I had begun to self-obliterate, to revolve in the infinity of endless time and the absoluteness of space, and be reduced to nothingness.

Over a career that has spanned the last 50 years, she has covered people, rooms, buildings, and landscapes with her polka-dot patterns, and she has created

Fig. 1-5 Yayoi Kusama, *You Who Are Getting Obliterated in the Dancing Swarm of Fireflies*, 2005. Mixed media. The Phoenix Museum of Art. Museum purchase with funds provided by Jan and Howard Hendler (2005.146). Photo by Ken Howie. Courtesy Yayoi Kusama Studio, Inc.

installations—room-sized environments—that quite literally reflect her sense of "the infinity of endless time." *You Who Are Getting Obliterated in the Dancing Swarm of Fireflies* (**Fig. 1-5**) is an example. Created for the new 2005 addition to the Phoenix Museum of Art—where it has quickly become the most popular work of art in the collection—it consists of a room, the ceiling, floor, and walls of which are covered with mirrors that reflect the flickering glow of tiny dots of LED lights suspended in the space on small strings. Passing through, the viewer feels literally awash in a space so vast that all sense of self—or at least self-importance—is obliterated. Kusama makes us aware of just how small we are in the grand scheme of things.

2) Artists make a visual record of the people, places, and events of their time and place.

Sometimes artists are not so much interested in seeing things anew as they are in simply recording, accurately, what it is that they see. The sculpture of *Pat* (**Fig. 1-6**) almost looks as if it were alive, and certainly anyone meeting the real "Pat" would recognize her from this sculpture. In fact, Pat is one of many plaster casts made from life by John Ahearn and Rigoberto Torres, residents of the South Bronx in New York City. In 1980, Ahearn moved to the South Bronx and began to work in collaboration with local resident Torres. Torres had learned the art of plaster casting from his uncle, who had cast plaster statues for churches and cemeteries. Together Ahearn and Torres set out to capture the spirit of a community that was financially impoverished but that possessed real, if unrecognized, dignity. "The key to my work is life—lifecasting," says Ahearn. "The people I cast know that they are as responsible for my work as I am, even more so. The people make my sculptures." The photographer Nan Goldin responded to the same community by capturing it on film. Her portrait of her friend Cookie Mueller (**Fig. 1-7**), who later died of AIDS in 1989, was taken at Tin Pan Alley, a Times Square bar, in the era before Times Square was gentrified, where Ahearn and Torres decorated the walls with their plaster casts. "There was never another bar like that in New York," Goldin recalls, "such a mix of the streets, the sex trade, artists, bands like the Clash on tour, and hip Japanese tourists." Artists have always understood that in the myriad

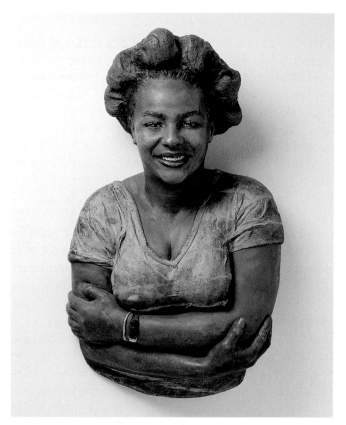

Fig. 1-6 John Ahearn and Rigoberto Torres, *Pat*, 1982. Painted cast plaster, 28½ × 16½ × 11 in. Courtesy Alexander and Bonin, New York. Collection Norma and William Roth, Winterhaven, Florida.
Photo courtesy of Sotheby's.

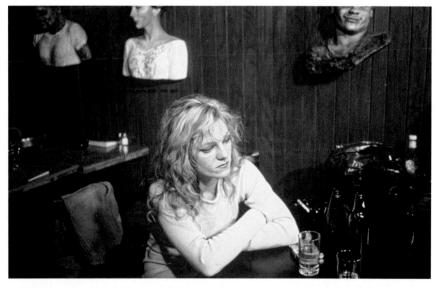

Fig. 1-7 Nan Goldin, *Cookie at Tin Pan Alley, New York City 1983*, from the multimedia installation, *The Ballad of Sexual Dependency*.
Cibachrome print, 30 × 40 in. Courtesy of Nan Goldin and Matthew Marks Gallery, New York.
© 2006 Nan Goldin, courtesy of Matthew Marks Gallery, New York.

expressions and attitudes visible in the faces of the people who make up their world, something like the spirit of their age might be discovered, and Goldin's project in her constantly evolving slide show and subsequent photographic sequence *The Ballad of Sexual Dependency*, from which this photograph is extracted, was, she says, "to preserve the sense of peoples' lives, to endow them with the strength and beauty I see in them."

Portraiture is, in fact, one of the longest-standing traditions in art. Until the invention of photography, the portrait—whether drawn, painted, or sculpted—was the only way to preserve the physical likeness of a human being. In the sixteenth century, portraiture became especially valued by the Muslim Mughal leaders of India. When the Mughal ruler Akbar took the throne in 1556 at the age of just 14 years, he established a school of painting taught by masters from Tabriz, Persia, and open to both Hindu and Islamic artists. He also urged his artists to study the Western paintings and prints that Portuguese traders began to bring into the country in the 1570s. By the end of Akbar's reign, a state studio of more than 1,000 artists had created a library of over 24,000 illuminated manuscripts.

Akbar ruled over a court of thousands of bureaucrats, courtiers, servants, wives, and concubines. Fully aware that the population was by and large Hindu, Akbar practiced an official policy of religious toleration. He believed that a synthesis of the world's faiths would surpass the teachings of any one of them. Thus he invited Christians, Jews, Hindus, Buddhists, and others to his court to debate with Muslim scholars. Despite taxing the peasantry heavily to support the luxurious lifestyle that he enjoyed, he also instituted a number of reforms, particularly banning the practice of immolating surviving wives on the funeral pyres of their husbands.

Under the rule of Akbar's son, Jahangir, portraiture found even greater favor in India. The painting *Jahangir in Darbar* is exemplary (**Fig. 1-8**). It shows Jahangir, whose name means "World Seizer," seated between the two pillars at the top of the painting, holding an audience, or *darbar*, at court. His son, the future emperor Shah Jahan, stands just behind him. The figures in the street are a medley of portraits, composed in all likelihood from albums of portraits kept by court artists. Among them is a Jesuit priest from Europe dressed in his black robes. The stiff formality of the figures, depicted in profile facing left and right toward a central axis, makes a sharp contrast to the variety of faces with different racial and ethnic features that fills the scene. But the painting does, nevertheless, fully document the variety and tolerance of the Mughal court.

No one would mistake Claude Monet's representation of the Gare Saint-Lazare (**Fig. 1-9**) for a portrait. And yet his depiction of the Paris train station that by 1868 was handling over 13 million commuter passengers a year captures, as fully as *Jahangir in Darbar*, the spirit of its age. Beginning in 1852, Paris had undergone a complete transformation. Long, straight, wide boulevards had been extended across the city. Working-class citizens, who had previously lived in the labyrinth of ancient streets that the boulevards replaced, were removed to the suburbs, along with the industry they supported. Shops, cafés, and the world's first department stores lined the broad sidewalks of the new promenades. New parks, squares, and gardens

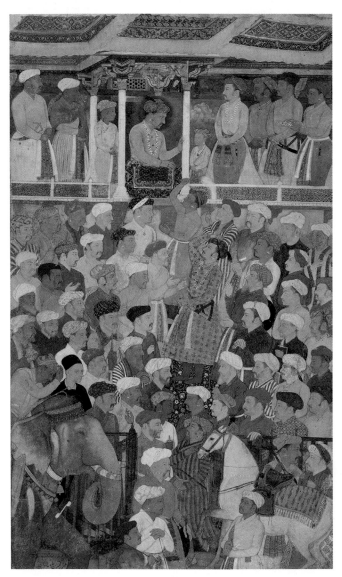

Fig. 1-8 Attributed to Manohar, *Jahangir in Darbar*, Mughal period, India, about 1620.

Opaque watercolor and gold on paper, 13³/₄ × 7⁷/₈ in. Museum of Fine Arts, Boston. Francis Bartlett Donation of 1912 and Picture Fund 14.654.

Photograph © 2012 Museum of Fine Arts, Boston.

were built, and the avenues were lined with over 100,000 newly planted trees. In order to allow traffic to flow seamlessly around the train station, a massive new bridge, the Pont de l'Europe, was built over the tracks. By the time Monet painted the Gare Saint-Lazare in 1877, these changes had been effected. His painting captures the transformation of not only Paris, but modernity itself. Here is a portrait of the new modern world, for better or worse—both the promise of the railroad, of modern speed and industry, and the atmosphere of steam and smoke created in its wake. All around this scene—and Monet painted it seven times in 1877—are the new open avenues of airy light, but here, Monet seems to suggest, just below ground level, lies the heart of the new modern city. In describing the world, the artist is free to celebrate and praise it, or critique and ridicule it, or, as is the case here, acknowledge its ambiguities.

Fig. 1-9 Claude Monet, *Le Pont de l'Europe, Gare Saint-Lazare*, 1877. Oil on canvas, 25¼ × 31⅞ in. Musée Marmottan, Paris, France. Giraudon / Art Resource, New York.

3) Artists make functional objects and structures (buildings) more pleasurable and elevate them or imbue them with meaning.

It is, perhaps, somewhat surprising to recognize that the sculpture of a cocoa pod by African artist Kane Kwei (**Fig. 1-10**) is actually a coffin. Trained as a carpenter, Kwei first made a decorative coffin for a dying uncle, who asked him to produce one in the shape of a boat. In Ghana, coffins possess a ritual significance, celebrating a successful life, and Kwei's coffins delighted the community. Soon he was making fish and whale coffins for fishermen, hens with chicks for

women with large families, Mercedes-Benz coffins for the wealthy, and cash crops for farmers, such as the 8 1/2-foot cocoa bean coffin illustrated here. In 1974, an enterprising San Francisco art dealer brought examples of Kwei's work to the United States, and today the artist's large workshop makes coffins for both funerals and the art market. Today, Kwei's workshop is headed by his grandson, Anang Cedi, and a video of Cedi's work can be viewed on myartslab.

Perhaps the object upon which cultures lavish their attention most is clothing. Clothing serves

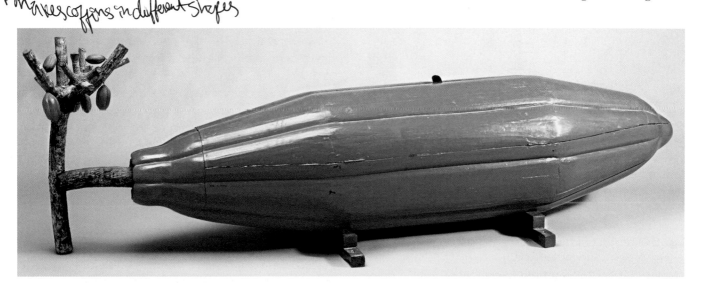

Fig. 1-10 Kane Kwei (Teshi tribe, Ghana, Africa), *Coffin Orange, in the Shape of a Cocoa Pod*, c. 1970. Polychrome wood, 34 × 105½ × 24 in. The Fine Arts Museums of San Francisco. Gift of Vivian Burns, Inc., 74.8.

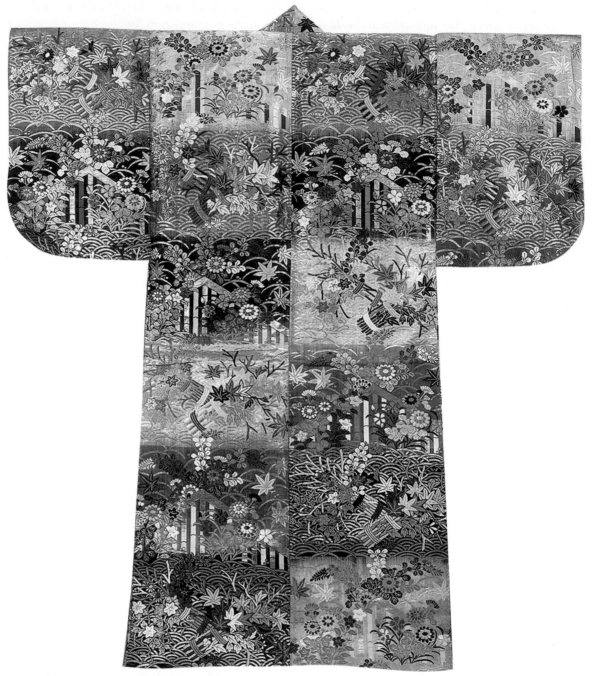

Fig. 1-11 Karaori kimono, Middle Edo Period, Japan, c. 1700. Brocaded silk, length 60 in. Tokyo National Museum, Japan.

many more purposes than just protecting us from the elements: It announces the wearer's taste, self-image, and, perhaps above all, social status. The Karaori kimono illustrated here (**Fig. 1-11**) was worn by a male performer who played the part of a woman in Japanese Noh theater. In its sheer beauty, it announced the dignity and status of the actor's character. Made of silk, brocaded with silver and gold, each panel in the robe depicts autumn grasses, flowers, and leaves. Thus, the kimono is more an aesthetic object than a functional one—that is, it is conceived to stimulate a sense of beauty in the viewer.

Almost all of us apply, or would like to apply, this aesthetic sense to the places in which we live. We decorate our walls with pictures, choose apartments for their visual appeal, ask architects to design our homes, plant flowers in our gardens, and seek out well-maintained and pleasant neighborhoods. We want city planners and government officials to work with us to make our living spaces more appealing.

Public space is particularly susceptible to aesthetic treatments. One of the newest standards of aesthetic beauty in public space is its compatibility with the environment. A building's beauty is measured, in the minds of many, by its self-sufficiency (that is, its lack of reliance on nonsustainable energy sources such as coal), its use of sustainable building materials (the elimination of steel, for instance, since it is a product of iron ore, a nonrenewable resource), and its suitability to the climate and culture in which it is built (a glass tower, however attractive in its own right, would seem out of place rising out of a tropical rainforest). These are the principles of what has come to be known as "green architecture."

The Jean-Marie Tjibaou Cultural Center in Nouméa, New Caledonia, an island in the South Pacific, illustrates these principles (**Fig. 1-12**). The architect is Renzo Piano, an Italian, but the principles guiding his design are anything but Western. The Center is named after a leader of the island's indigenous people, the Kanak, and it is dedicated to preserving and transmitting Kanak culture. Piano studied Kanak culture thoroughly, and his design blends Kanak tradition with green architectural principles. The buildings are constructed of wood and bamboo, easily renewable resources of the region. Each of the Center's 10 pavilions represents a typical Kanak dwelling (in a finished dwelling the vertical staves would rise to meet at the top, and the horizontal elements would weave in and out between the staves, as in basketry). Piano left the dwelling forms unfinished, as if under construction, but to a purpose—they serve as wind scoops, catching breezes off the nearby ocean and directing them down to cool the inner rooms, the roofs of which face south at an angle that allows them to be lit largely by direct daylight. As in a Kanak village, the pavilions are linked with a covered walkway. Piano describes the project as "an expression of the harmonious relationship with the environment that is typical of the local culture. They are curved structures resembling huts, built out of wooden joists and ribs; they are containers of an archaic appearance, whose interiors are equipped with all the possibilities offered by modern technology."

For many people, the main purpose of art is to satisfy our aesthetic sense, our desire to see and experience the beautiful. Many of Pablo Picasso's representations of women in the late 1920s and early

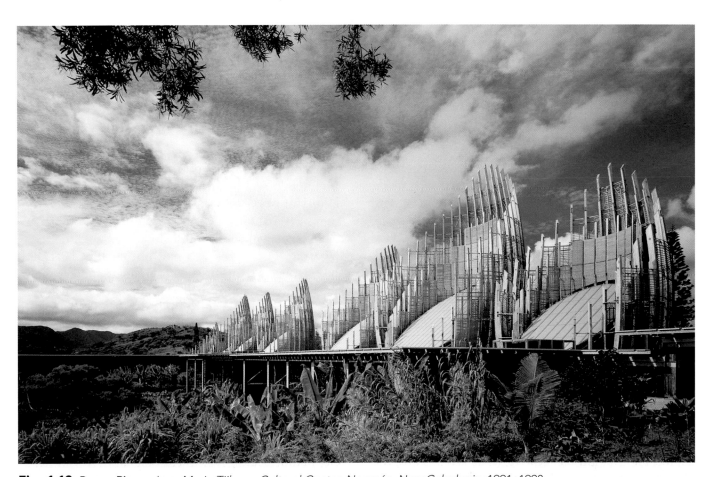

Fig. 1-12 Renzo Piano, *Jean-Marie Tjibaou Cultural Center, Nouméa, New Caledonia, 1991–1998.*

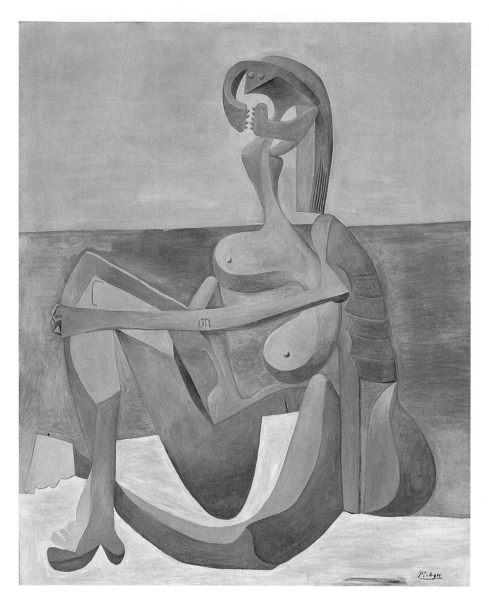

Fig. 1-13 Pablo Picasso, *Seated Bather (La Baigneuse)*, Paris, early 1930.
Oil on canvas, 64¼ × 51 in. (163.2 × 129.5 cm). Mrs. Simon Guggenheim Fund. (82.1950). The Museum of Modern Art, New York, NY, U.S.A.

1930s are almost demonic in character. Most biographers believe images such as his *Seated Bather by the Sea* (**Fig. 1-13**) to be portraits of his wife, the Russian ballerina Olga Koklova, whom he married in 1918. By the late 1920s, their marriage was in shambles, and Picasso portrays her here as a skeletal horror, her back and buttocks almost crustacean in appearance, her horizontal mouth looking like some archaic mandible. Her pose is ironic, inspired by classical representations of the nude, and the sea behind her is as empty as the Mediterranean sky is gray. Picasso means nothing in this painting to be pleasing, except our recognition of his extraordinary ability to invent expressive images of tension. Through his entire career, since his portrayal of a brothel in his 1907 *Les Demoiselles d'Avignon* (see *The Creative Process*, pp. 12–13), he represented his relation to women as a sort of battlefield between attraction and repulsion. There can be no doubt which side has won the battle in this painting.

From a certain point of view, the experience of such dynamic tension is itself pleasing, and it is the ability of works of art to create and sustain such moments that many people value most about them. That is, many people find such moments aesthetically pleasing. The work of art may not itself be beautiful, but it triggers a higher level of thought and awareness in the viewer, and the viewer experiences this intellectual and imaginative stimulus—this higher order of thought—as a form of beauty in its own right.

4) Artists give form to the immaterial—hidden or universal truths, spiritual forces, personal feelings.

Picasso's treatment of women in both *Seated Bather* and *Les Demoiselles d'Avignon* gives form to his own, often tormented, feelings about the opposite sex. In *Les Demoiselles d'Avignon*, the power of these feelings was heightened by his incorporation of African masks into the composition.

When Westerners first encountered African masks in the ethnographic museums of Europe in the late nineteenth and early twentieth centuries, they saw them in a context far removed from their original settings and purposes. In the West, we are used to approaching everyday objects made in African, Oceanic, Native American, or Asian cultures in museums as "works of art." But in their cultures of origin, such objects might serve to define family and community relationships, establishing social order and structure. Or they might document momentous events in the history of a people. They might serve a simple utilitarian function, such as a pot to carry water or a spoon to eat with. Or they might be sacred instruments that provide insight into hidden or spiritual forces believed to guide the universe.

A fascinating example of the latter is a type of magical figure that arose in the Kongo in the late nineteenth century (**Fig. 1-14**). Known as *minkisi* ("sacred medicine"), for the Kongo tribes such figures embodied their own resistance to the imposition of foreign ideas as European states colonized the continent. Throughout Central Africa, all significant human powers are believed to result from communication with the dead. Certain individuals can communicate with the spirits in their roles as healers, diviners, and defenders of the living. They are believed to harness the powers of the spirit world through *minkisi* (singular *nkisi*). Among the most formidable of *minkisi* is the type known as *minkonde* (singular *nkonde*), which are said to pursue witches, thieves, adulterers, and wrongdoers by night. The communicator activates a *nkonde* by driving nails, blades, and other pieces of iron into it so that it will deliver similar injuries to those worthy of punishment.

Minkonde figures stand upright, as if ready to spring forward. In many figures, one arm is raised and holds a knife or spear (often missing, as here), suggesting that the figure is ready to attack. Other *minkonde* stand upright in a stance of alertness, like a wrestler challenging an opponent (an example of this sort of *nkonde* can be viewed in the *Closer Look* section of myartslab). The hole in the stomach of the figure illustrated here contained magical "medicines," known as *bilongo*, sometimes blood or plants, but often kaolin, a white clay believed to be closely linked to the world of the dead, and red ocher, linked symbolically to blood. Such horrific figures—designed to evoke awe in the spectator—were seen by European missionaries as direct evidence of African idolatry and witchcraft, and the missionaries destroyed many of them. More accurately, the *minkonde* represented a form of **animism**, a foundation of many religions, referring to the belief in the existence of souls and the conviction that nonhuman things can also be endowed with a soul. However,

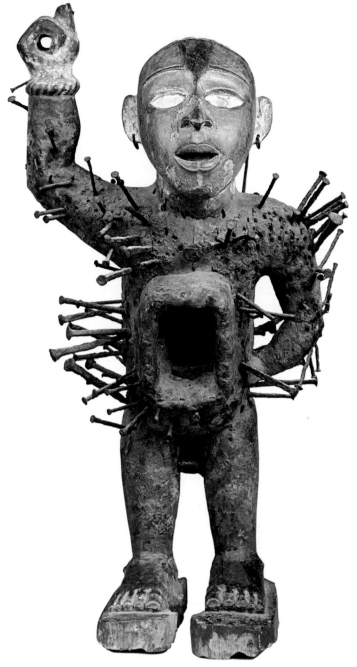

Fig. 1-14 Female Figure (nksi), Kongo people (Muserongo), Zaire, late nineteenth century.
Wood, iron nails, glass, resin, height 20¼" × 11" × 8". The University of Iowa Museum of Art, Iowa City, IA. The Stanley Collection, X1986.573.

View the Closer Look on *nkonde* figures on myartslab.com

European military commanders saw them as evidence of an aggressive native opposition to colonial control.

Despite their suppression during the colonial era, such figures are still made today and continue to be used by the peoples of the Kongo and among Caribbean peoples of African descent. In fact, Cuban

THE CREATIVE PROCESS

No one could look at Picasso's large painting of 1906–07, *Les Demoiselles d'Avignon* (**Fig. 1-17**), and call it aesthetically *beautiful*, but it is, for many people, one of his most aesthetically *interesting* works. Nearly 8 feet square, it would come to be considered one of the first major paintings of the modern era—and one of the least beautiful. The title, chosen not by Picasso but by a close friend, literally means "the young ladies of Avignon," but its somewhat tongue-in-cheek reference is specifically to the prostitutes of Avignon Street, the red-light district of Barcelona, Spain, Picasso's hometown. We know a great deal about Picasso's process as he worked on the canvas from late 1906 into the early summer months of 1907, not only because many of his working sketches survive but also because the canvas itself has been submitted to extensive examination, including X-ray analysis. This reveals early versions of certain passages, particularly the figure at the left and the two figures on the right, which lie under the final layers of paint.

An early sketch (**Fig. 1-15**) reveals that the painting was originally conceived to include seven figures—five prostitutes, a sailor seated in their midst, and, entering from the left, a medical student carrying a book. Picasso probably had in mind some anecdotal or narrative idea contrasting the dangers and joys of both work and pleasure, but he soon abandoned the male figures. By doing so, he involved the viewer much more fully in the scene. No longer does the curtain open up at the left to allow the medical student to enter. Now the curtain is opened by one of the prostitutes as if she were admitting us, the audience, into the bordello. We are implicated in the scene.

And an extraordinary scene it is. Picasso seems to have willingly abdicated any traditional aesthetic sense of beauty. There is nothing enticing or alluring here. Of all the nudes, the two central ones are the most traditional, but their bodies are composed of a series of long lozenge shapes, hard angles, and only a few traditional curves. It is unclear whether the second nude from the left is standing or sitting, or possibly even lying down. (In the early drawing, she is clearly seated.) Picasso seems to have made her position in space intentionally ambiguous.

We know, through X-rays, that all five nudes originally looked like the central two. We also know that sometime after he began painting *Les Demoiselles*, Picasso visited the Trocadero, now the Museum of Man, in Paris, and saw its collection of African sculpture, particularly African masks. He was strongly affected by the experience. The masks seemed to him imbued with power that allowed him, for the first time, to see art, he said, as "a form of magic designed to be a mediator between the strange, hostile world and us, a way of seizing power by giving form to our terrors as well as our desires." As a result, he quickly transformed the faces of three of the five

Fig. 1-15 Pablo Picasso, *Medical Student, Sailor, and Five Nudes in a Bordello* (study for *Les Demoiselles d'Avignon*), Paris, early 1907.
Charcoal and pastel, 18½ × 25 in. Kunstmuseum Basel, Kupferstichkabinett.
Photo: Kunstmuseum Basel, Martin P. Buhler.

prostitutes in his painting into African masks. The masks freed him from representing exactly what his subjects looked like and allowed him to represent his idea of them instead.

That idea is clearly ambivalent. Picasso probably saw in these masks something both frightening and liberating. They freed him from a slavish concern for accurate representation, and they allowed him to create a much more emotionally charged scene than he would have otherwise been able to accomplish. Rather than offering us a single point of view, he offers us many, both literally and figuratively. The painting is about the ambiguity of experience.

Nowhere is this clearer than in the squatting figure in the lower right-hand corner of the painting. She seems twisted around on herself in the final version, her back to us, but her head is impossibly turned to face us, her chin resting on her grotesque, clawlike hand. We see her, in other words, from both front and back. (Notice, incidentally, that even the nudes in the sketch possess something of this "double" point of view: Their noses are in profile though they face the viewer.) But this crouching figure is even more complex. An early drawing (**Fig. 1-16**) reveals that her face was originally conceived as a headless torso. What would become her hand was originally her arm. What would become her eyes were her breasts. And her mouth began as her bellybutton. Here we are witness to the extraordinary freedom of invention that defines all of Picasso's art, as well as to a remarkable demonstration of the creative process itself.

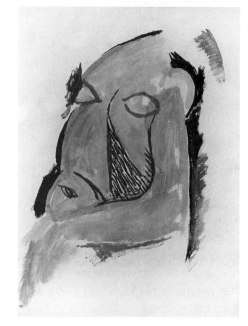

Fig. 1-16
Pablo Picasso, *Study for Les Demoiselles d'Avignon. Head of the Squatting Demoiselle*, 1907. Inv.: MP 539. Gouache and Indian ink on paper, $24^3/_4 \times 18^7/_8$ in. Musée Picasso, Paris.
Reunion des Musées Nationaux / Art Resource, NY. © 2012 Estate of Pablo Picasso / Artists Rights Society (ARS), New York.

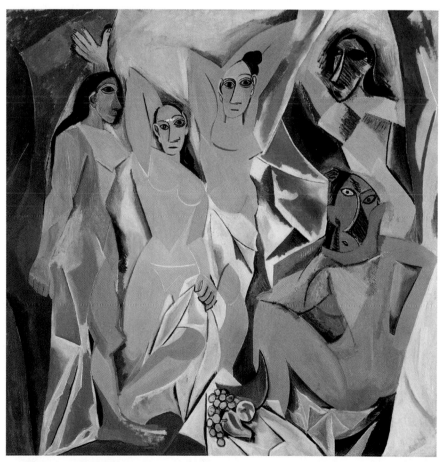

Fig. 1-17 Pablo Picasso, *Les Demoiselles d'Avignon*, 1907.
Oil on canvas. 8′ × 7′8″ (2.44 × 2.34 m) Acquired through the Lillie P. Bliss Bequest. The Museum of Modern Art, New York, NY, U.S.A.

View the Closer Look for *Les Demoiselles d'Avignon* on myartslab.com

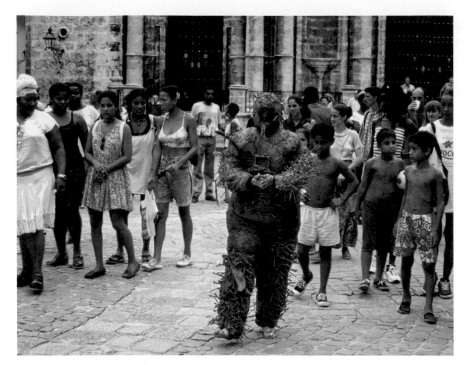

Fig. 1-18 Tania Bruguera, *Displacement*, embodying a Nkisi Nkonde icon,1998–99.

Cuban earth, glue, wood, nails / textile. Dimensions variable. Still from film of the original performance in Havana, Cuba, 1988–89, exhibited at the Neuberger Museum of Art, Purchase, NY, January–April, 2010.

Courtesy of Studio Bruguera

performance artist Tania Bruguera dressed up as a *nkisi nkonde* in August 1998 (**Fig. 1-18**), standing still in the lobby of the Wilfredo Lam Center of Contemporary Art in Havana until she began to wander the city as if in search of those who had broken the promises made to the icon in return for its help, asserting the power of the icon even as she revealed the vulnerabilities of her audience. The performance was reenacted at the Neuberger Museum of Art in Purchase, New York, in 2010.

In the West, the desire to give form to spiritual belief is especially apparent in the traditions of Christian religious art. For example, the idea of daring to represent the Christian God has, throughout the history of the Western world, aroused controversy. In seventeenth-century Holland, images of God were banned from Protestant churches. As one contemporary Protestant theologian put it, "The image of God is His Word"— that is, the Bible—and "statues in human form, being an earthen image of visible, earthborn man [are] far away from the truth." In fact, one of the reasons that Jesus, for Christians the son of God, is so often represented in Western art is that representing the son, a real person, is far easier than representing the father, a spiritual unknown who can only be imagined.

Nevertheless, one of the most successful depictions of the Christian God in Western culture was painted by Jan Van Eyck nearly 600 years ago as part of an

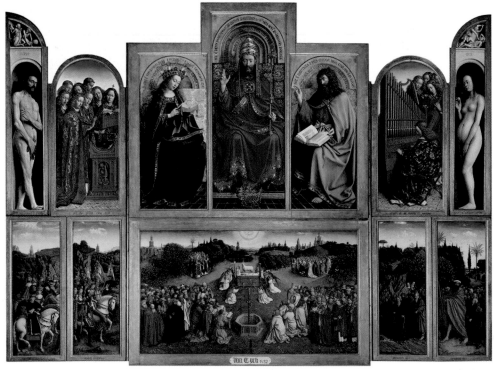

Fig. 1-19 Jan and Hubert van Eyck, *The Ghent Altarpiece*, c. 1432.

11 ft. 5 in. × 15 ft. 1 in. Church of St. Bavo, Ghent, Belgium.

Scala / Art Resource, NY.

View the Closer Look for the *Ghent Altarpiece* on myartslab.com

altarpiece for the city of Ghent in Flanders (**Figs. 1-19** and **1-20**). Van Eyck's God is almost frail, surprisingly young, apparently merciful and kind, and certainly richly adorned. Indeed, in the richness of his vestments, Van Eyck's God apparently values worldly things. Van Eyck's painting seems to celebrate a materialism that is the proper right of benevolent kings. Behind God's head, across the top of the throne, are Latin words that, translated into English, read: "This is God, all powerful in his divine majesty; of all the best, by the gentleness of his goodness; the most liberal giver, because of his infinite generosity." God's mercy and love are indicated by the pelicans embroidered on the tapestry behind him, which in Christian tradition symbolize self-sacrificing love, for pelicans were believed to wound themselves in order to feed their young with their own blood if other food was unavailable. In the context of the entire altarpiece, where God is flanked by Mary and John the Baptist, choirs of angels, and, at the outer edges, Adam and Eve, God rules over an earthly assembly of worshippers, his divine beneficence protecting all.

The World as We Perceive It

Many of us assume, almost without question, that we can trust our eyes to give us accurate information about the world. Seeing, as we say, is believing. Our word "idea" derives, in fact, from the Greek word *idein*, meaning "to see," and it is no accident that when we say "I see" we often mean "I understand."

THE PROCESS OF SEEING

But the act of seeing is not a simple matter of our vision making a direct recording of reality. Seeing is both a physical and psychological process. Physically, visual processing can be divided into three steps:

reception → extraction → inference

In the first step, reception, external stimuli enter the nervous system through our eyes—we "see the light." Next, the retina, which is a collection of nerve cells at the back of the eye, extracts the basic information it needs and sends this information to the visual cortex, the part of the brain that processes visual stimuli. There are approximately 100 million sensors in the retina, but only 5 million channels to the visual cortex. In other words, the retina does a lot of "editing," and so does the visual cortex. There, special mechanisms capable of extracting specific information about such features as color, motion, orientation, and size "create" what is finally seen. What you see is the inference your visual cortex extracts from the information your retina sends it.

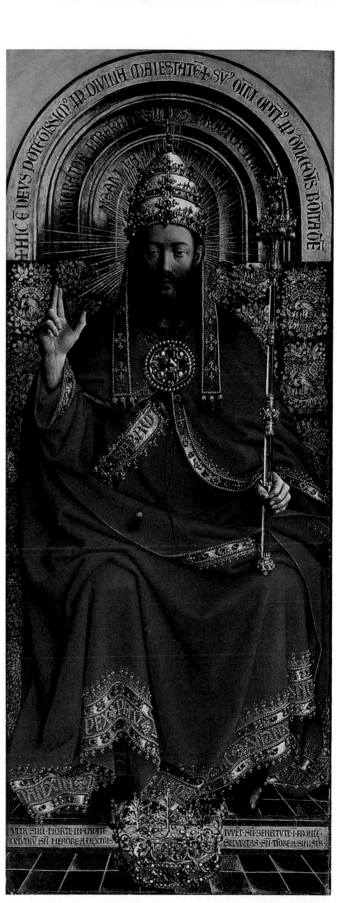

Fig. 1-20 Jan van Eyck, *God*. Panel from *The Ghent Altarpiece*, c. 1432.
Church of St. Bavo, Ghent, Belgium.
Scala / Art Resource, NY.

Seeing, in other words, is an inherently creative process. The visual system makes conclusions about the world. It represents the world for you by editing out information, deciding what is important and what is not. Consider, for example, what sort of visual information you have stored about the American flag. You know its colors—red, white, and blue—and that it has 50 stars and 13 stripes. You know, roughly, its shape—rectangular. But do you know its proportions? Do you even know, without looking, what color stripe is at the flag's top, or what color is at the bottom? How many short stripes are there, and how many long ones? How many horizontal rows of stars are there? How many long rows? How many short ones? The point is that not only do we each perceive the same things differently, remembering different details, but also we do not usually see things as thoroughly or accurately as we might suppose. As the philosopher Nelson Goodman explains, "The eye functions not as an instrument self-powered and alone, but as a dutiful member of a complex and capricious organism. Not only how but what it sees is regulated by need and prejudice. It selects, rejects, organizes, discriminates, associates, classifies, analyzes, constructs. It does not so much mirror as take and make." In other words, the eye mirrors each individual's complex perceptions of the world.

ACTIVE SEEING

Everything you see is filtered through a long history of fears, prejudices, desires, emotions, customs, and beliefs. Through art, we can begin to understand those filters and learn to look more closely at the visual world. Jasper Johns's *Three Flags* (**Fig. 1-21**) presents an opportunity to look closely at a familiar image. According to Johns, when he created this work, the flag was something "seen but not looked at, not examined." *Three Flags* was painted at a time when the nation was obsessed with patriotism, spawned by Senator Joseph McCarthy's anti-communist hearings in 1954, by President Eisenhower's affirmation of all things American, and by the Soviet Union's challenge of American supremacy through the space race. Many of the painting's first audiences saw the fact that the flag becomes less grand and physically smaller the closer it gets to the viewer as a challenge to their idea of America. While contemporary viewers may not have experienced that

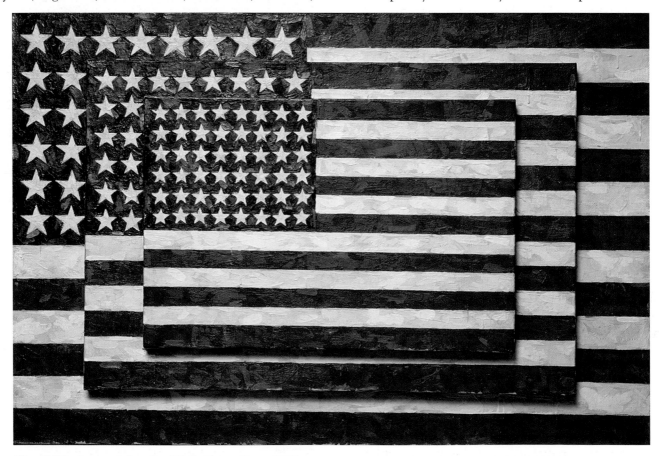

Fig. 1-21 Jasper Johns (b. 1930), *Three Flags*, 1958.
Encaustic on canvas, $30^{7}/_{8} \times 45^{1}/_{2} \times 5$ in. (78.4 × 115.6 × 12.7 cm) 50th Anniversary Gift of the Gilman Foundation, Inc., The Lauder Foundation, A. Alfred Taubman, Laura-Lee Whittier Woods, and purchase 80.32. Collection of Whitney Museum of American Art, New York.

Cold War era, the work still asks us to consider what the flag represents.

Faith Ringgold's *God Bless America* (**Fig. 1-22**) has as its historical context the Civil Rights Movement. In it, the American flag has been turned into a prison cell. Painted during a time when white prejudice against African Americans was enforced by the legal system, the star of the flag becomes a sheriff's badge, and its red and white stripes are transformed into the black bars of the jail. The white woman portrayed in the painting is the very image of contradiction, at once a patriot, pledging allegiance to the flag, and a racist, denying blacks the right to vote. She is a prisoner of her own bigotry.

The World as We Understand It: Thinking Thematically

Painted the year after Martin Luther King's "I Have a Dream Speech," delivered on the steps of the Lincoln Memorial in Washington, D. C., Ringgold's painting is a product of her times. But in its desire to address the politics of the moment, it represents one of the traditional themes that, over the centuries, art has addressed.

There are many others. This book will focus on six major themes:

- Art, Politics, and Community
- Art and Spiritual Belief
- Art and the Passage of Time
- Art and Beauty
- Art, Gender, and Identity
- Art, Science, and the Environment

It would be possible to describe virtually every work of art in this book in terms of these themes. They represent universal concerns, concerns that all creative people, in all cultures and at all times, have sought to explore and understand. If different cultures and different eras have inevitably addressed them differently, the quest to understand the world and our place in it is common to us all.

Throughout this book, you will find, in the captions to nearly 150 images, a "tag" line referring you to the Thinking Thematically section of myartslab.com. There you will find an introduction to the theme, outlining its general significance, followed by images of the works in *A World of Art* that address the theme, each with its own discussion of the ways in which it specifically relates to the given theme. This approach not only allows us to broaden our discussion of the works in question, but it has the distinct advantage of approaching the themes of art in a way that allows

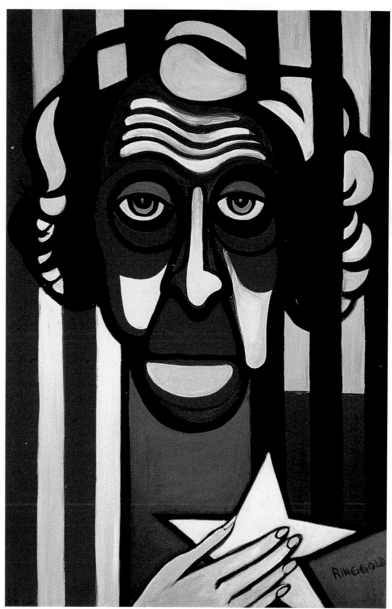

Fig. 1-22 Faith Ringgold, *God Bless America*, 1963. Oil on canvas, 31 × 19 in.
© Faith Ringgold © 1963

you to view the work in relation to other works of art, from throughout the book, that address similar concerns. Furthermore, it provides you with the opportunity to think critically about how various cultures and eras have addressed the same questions and issues.

For instance, if you turn to the Thinking Thematically section of myartslab.com, under the Art, Politics, and Community heading, you will find a reproduction of Eugène Delacroix's *Liberty Leading the People* (see Fig. 20-17) painted in 1830 in France. It depicts the events of the July Revolution of 1830. At the apex of a mound of bodies lying in the streets of Paris stands Liberty (the same Liberty whom the French would later give the United States as the Statue of Liberty). In her hand,

she hoists the French flag. The discussion of the image addresses not only the politics of the July Revolution, but the meaning of that flag to the French people in 1830.

Another reproduction illustrates one of the most controversial works of art that has ever addressed the politics that surround the American flag. It was first displayed on February 20, 1989 in an installation at the Art Institute of Chicago consisting of works of art by 66 students who were members of minority groups. Dread Scott's *What Is the Proper Way to Display a US Flag?* (**Fig. 1-23**) consisted of a 34 × 57-inch American flag draped on the floor beneath photographs of flag-draped coffins and South Koreans burning the flag. Beneath the photos was a ledger in which viewers were asked to record their opinions. The problem was not only that the flag was on the floor, but that it was difficult to write in the ledger without stepping on it. Thus the flag became a barrier to the freedom of expression it was meant to defend. Viewers had to choose which they revered more—the flag or freedom of speech.

Angry veterans wearing combat fatigues protested the exhibit soon after it opened, waving American flags, singing the national anthem, and carrying signs saying, "The American flag is not a doormat." Said one: "When I walked in there and saw those muddy footprints on the flag, I was disgusted. It would be different if it was his rendering of the flag. But it was a real flag. And it belongs to the American people." Scott responded that he had purchased the flag at a store for $3.95. It had been made in Taiwan.

The subsequent battle over the installation would finally be resolved in the Supreme Court of the United States. You will have the opportunity to consider, in the Arts, Politics, and Community section of myartslab. com, the relationship between the flags in both Scott's work and Delacroix's. What do they tell us about national pride? And about the nature of revolution and civil rights? These are just two of the questions that thinking thematically can generate.

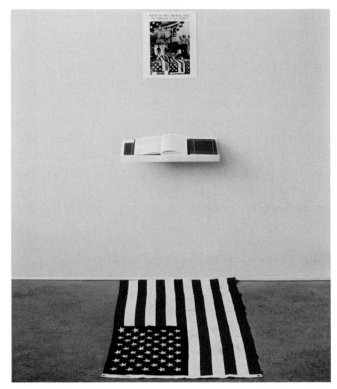

Fig. 1-23 Dread Scott, *What Is the Proper Way to Display a US Flag?*, 1988.
Gelatin silver print of installation, U.S. flag, book, pen, shelf, audience, 80 × 128 × 60 in.

Thinking Thematically: See Art, Politics, and Community on myartslab.com

THINKING BACK

✓—Study and review on myartslab.com

What do all artists share?

Artists all share the fundamental desire to create, but different artists respond to their world in divergent terms. The artist must be something of an explorer or inventor. What distinguishes artists from other people? What must an artist be able to do to produce a work of art?

What are the roles of the artist?

Most artists think of themselves as assuming one of four fundamental roles—or some combination of the four—as they approach their work. Artists may help us to see the world in new and innovative ways, create visual records of specific times and places, imbue objects with beauty and meaning, and give form to feelings and ideas. What roles do artists John

Ahearn and Rigoberto Torres play in their work *Pat*? What distinguishes Kane Kwei's decorative coffins? How does Pablo Picasso give form to the immaterial in his painting *Les Demoiselles d'Avignon*?

What is active seeing?

The act of seeing is not a simple matter of making a direct recording of reality. Everything we see is filtered through a long history of fears, prejudices, emotions, customs, and beliefs. Through art, we can begin to understand those filters and learn to look more closely at the visual world. In his painting *Three Flags*, how does Jasper Johns present an opportunity to look closely at a familiar image? How might the historical context of Faith Ringgold's *God Bless America* influence how we see the work?

THE CRITICAL PROCESS
Thinking about Making and Seeing

In this chapter, we have discovered that the world of art is as vast and various as it is not only because different artists in different cultures see and respond to the world in different ways, but also because each of us sees and responds to a given work of art in a different way. Artists are engaged in a *creative process*. We respond to their work through a process of *critical thinking*. At the end of each chapter of *A World of Art* is a section like this one titled *The Critical Process* in which, through a series of questions, you are invited to think for yourself about the issues raised in the chapter. In each case, additional insights are provided at the end of the text, in the section titled *The Critical Process: Thinking Some More about the Chapter Questions*. After you have thought about the questions raised, turn to the back and see if you are headed in the right direction.

Here, Andy Warhol's *Race Riot* (**Fig. 1-24**) depicts events of May 1963 in Birmingham, Alabama, when police commissioner Bull Connor employed attack dogs and fire hoses to disperse civil rights demonstrators led by Reverend Martin Luther King, Jr. The traditional roles of the artist—to help us see the world in new or innovative ways; to make a visual record of the people, places, and events of their time and place; to make functional objects and structures more pleasurable and elevate them

or imbue them with meaning; and to give form to immaterial, hidden or universal truths, spiritual forces, or personal feelings—are all part of a more general creative impulse that leads, ultimately, to the work of art. Which of these is, in your opinion, the most important for Warhol in creating this work? Did any of the other traditional roles play a part in the process? What do you think Warhol feels about the events (note that the print followed soon after the events themselves)? How does his use of color contribute to his composition? Can you think why there are two red panels, and only one white and one blue? Emotionally, what is the impact of the red panels? In other words, what is the work's psychological impact? What reactions other than your own can you imagine the work generating? These are just few of the questions raised by Warhol's work, questions designed to help you initiate the critical process for yourself.

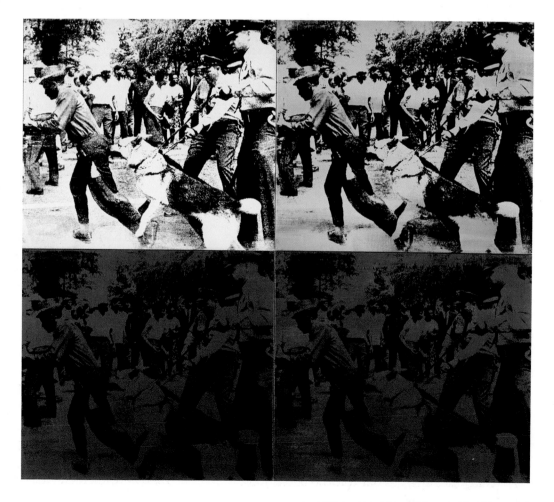

Fig. 1-24 Andy Warhol, *Race Riot*, 1963.

Acrylic and silkscreen on canvas, four panels, each 20 × 33 in.

© 2007 Andy Warhol Foundation for the Visual Arts / Artists Rights Society (ARS), New York.

2 | **Developing Visual Literacy**

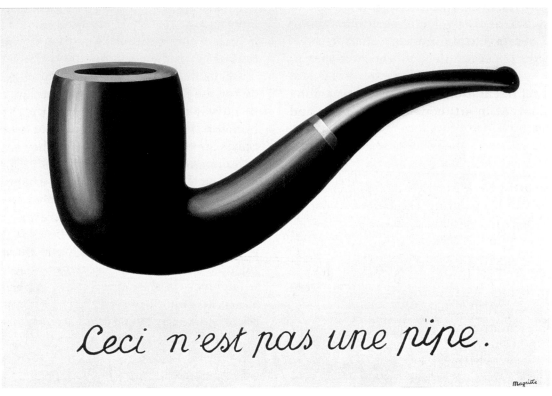

Fig. 2-1 René Magritte (1898-1967), *La Trahison des images (Ceci n'est pas une pipe) (The Treason of Images)*, 1929.
Oil on canvas, 21½ × 28½ in. (60 × 81 cm) Location: Los Angeles County Museum of Art, Los Angeles, CA.
Banque d'Images, ADAGP / Art Resource, NY. © 2012 C. Herscovici, London//Artists Rights Society (ARS), NY

THINKING AHEAD

How does subject matter differ from content?

What is representational art?

What constitutes an artwork's form?

What is iconography?

((•●[**Listen** to the chapter audio on myartslab.com

Visual art can be powerfully persuasive, and one of the purposes of this book is to help you to recognize how this is so. Yet it is important for you to understand from the outset that you can neither recognize nor understand—let alone communicate—how visual art affects you without using language. In other words, one of the primary purposes of any art appreciation text is to provide you with a descriptive vocabulary, a set of terms, phrases, concepts, and approaches that will allow you to think critically about visual images. It is not sufficient to say, "I like this or that painting." You need to be able to recognize why

you like it, how it communicates to you. This ability is given the name *visual literacy.*

The fact is, most of us take the visual world for granted. We assume that we understand what we see. Those of us born and raised in the television era are often accused of being nonverbal, passive receivers, like TV monitors themselves. If television, the Internet, movies, and magazines have made us virtually dependent upon visual information, we have not necessarily become visually literate in the process. This chapter will introduce you to some essential concepts in visual literacy—the relationships among words, images, and objects in the real world; the idea of representation; the distinctions among form and content in art; conventions in art; and iconography.

Words and Images

The Belgian artist René Magritte offered a lesson in visual literacy in his painting *The Treason of Images* (**Fig. 2-1**). Magritte reproduced an image of a pipe similar to that found in tobacco store signs and ads of his time. The caption under the pipe translates into English as "This is not a pipe," which at first seems contradictory. We tend to look at the image of a pipe as if it were really a pipe, but of course it isn't. It is the representation of a pipe. In a short excerpt from the 1960 film by Luc de Heusch, *Magritte, or The Object Lesson,* which can be viewed on myartslab, Magritte himself discusses the arbitrary relation between words and things. Both images and words can refer to things that we see, but they are not the things themselves. Magritte's painting invites us to think critically about the representations that bombard us in daily life.

The work of photographer Lorna Simpson consistently challenges the relations between words and images (see *The Creative Process,* pp. 22–23). Consider her photographs of a black female sitting in a chair, entitled *She* (**Fig. 2-2**). She is dressed in a brown suit, as if at an interview. Without the title and the italic script label at the top—"female"—the sitter's gender would be in doubt. If the work were called, say, *Interviewee,* the sitter's head cut off at the chin, there would be no way to know the gender of the sitter. In fact, Simpson has said that black women in the United States are treated by society as if they are faceless—without identity, personality, or individuality. Here, *She* challenges gender stereotypes, seemingly usurping man's place. It is as if, in the old phrase, *She* is wearing the pants in the family. And even if the words do somewhat diminish the ambiguity of the piece, it remains as open to interpretation as the sitter's hand gestures, which are expressive even if we don't know what, precisely, they express. The **subject matter** of the work—what the image literally depicts—barely hints at the complexity of its **content**—what the image means.

⊙ **Watch** the video on René Magritte on myartslab.com

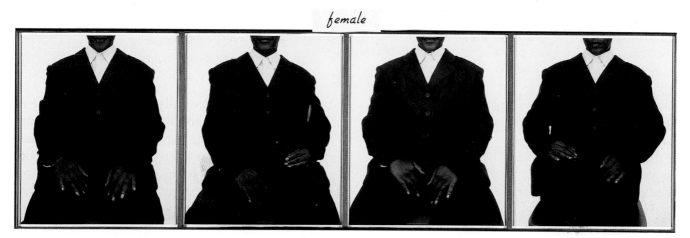

Fig. 2-2 Lorna Simpson, *She,* 1992.

Photographs, four dye-diffusion transfers (Polaroids) and plaque, 29 × 85¼ in. Reproduced with permission. Ellen Kelleran Gardner Fund, 1992.204a-e. Museum of Fine Arts, Boston.

Photograph © 2012 Museum of Fine Arts, Boston.

THE CREATIVE PROCESS

As a photographer, Lorna Simpson is preoccupied with the question of representation and its limitations. All of her works, of which the multi-panel *Necklines* (**Fig. 2-3**) is a good example, deal with the ways in which words and images function together to make meaning. Simpson presents us with three different photographs of the same woman's neck and the neckline of her dress. Below these images are two panels with four words on each, each word in turn playing on the idea of the neck itself. The sensuality of the photographs is affirmed by words such as "neck-ing" and "neck-ed" (that is, "naked"), while the phrases "neck & neck" and "break-neck" introduce the idea of speed or running. The question is, what do these two sets of terms have to do with one another? Necklaces and neckties go around the neck. So do nooses at hangings. In fact, "necktie parties" conduct hangings, hangings break necks, and a person runs from a "necktie party" precisely because, instead of wearing a necklace, in being hanged one becomes "neckless."

If this set of verbal associations runs contrary to the sensuality and seeming passivity of Simpson's photographs, it does not run contrary to the social reality faced, throughout American history, by black people in general. The anonymity of Simpson's model serves not only to universalize the situation that her words begin to explore, but also depersonalizes the subject in a way that suggests how such situations become possible. Simpson seeks to articulate this tension—the violence that always lies beneath the surface of the black person's world—by bringing words and images together.

A group of large-scale black-and-white serigraphs, or silkscreen prints, on felt takes up different subject matter but remains committed to investigating the relationship between words and images. Created for the opening of the Sean Kelly Gallery in New York City in October 1995, all of the works but one are multi-panel

photographs of landscapes (the one exception is a view of two almost identical hotel rooms). They employ a unique process. Simpson first photographed the scenes. Then she arranged with Jean Noblet, one of the premier serigraph printers in the world, to print them, blown up into several large panels, on felt, a material never before used in the silkscreen printing process. The felt absorbed vast quantities of ink, and each panel had to be printed several times to achieve the correct density of black. Furthermore, each panel had to match the others in the image. It seems miraculous that in less than two weeks, the entire suite of seven images, consisting of more than 50 panels, was printed, just in time for the show.

Each of the images is accompanied by a wall text that, when read, transforms the image. On one side of *The Park* (**Fig. 2-4**), for instance, the viewer reads:

Just unpacked a new shiny silver telescope. And we are up high enough for a really good view of all the buildings and the park. The living room window seems to be the best spot for it. On the sidewalk below a man watches figures from across the path.

On the other side of the image, a second wall text reads:

It is early evening, the lone sociologist walks through the park, to observe private acts in the men's public bathrooms. . . . He decides to adopt the role of voyeur and look out in order to go unnoticed and noticed at the same time. His research takes several years. . . .

These texts effectively involve Simpson's audience in a complex network of voyeurism. The photographer's position is the same as that of the person who has purchased the telescope, and our viewpoint is the same

necktie
neck & neck
neck - ed
neckless

necking
neckline
necklace
breakneck

Fig. 2-3 Lorna Simpson, *Necklines*, 1989.
Three silver prints, two plastic plaques, 68½ × 70 in.
© Lorna Simpson. Courtesy of the artist and Salon94

Fig. 2-4 Lorna Simpson, *The Park*, 1995.
Edition of 3, serigraph on 6 felt panels with felt text panel (not shown), 67 × 67½ in. overall.
© Lorna Simpson. Courtesy of the artist and Salon94

as theirs. Equipped with a telescope (or the telescopic lens of a camera) apparently purchased for viewing the very kind of scene described in the second text, the "we" of the first text wants to zoom in to see what's going on below.

There is, in fact, a kind of telescopic feel to the work. The image itself is more than 5½ feet square and can be readily taken in from across the room. But to understand it, we need to come in close to read the texts. Close up, the image is too large to see as a whole, and the crisp contrasts of the print as seen

from across the room are lost in the soft texture of the felt. The felt even seems to absorb light rather than reflect it as most photographic prints do, blurring our vision in the process. As an audience, we zoom in and out, viewing the scene as a whole, and then coming in to read the texts. As we move from the general to the particular, from the panoramic view to the close-up text, the innocuous scene becomes charged with meaning. The reality beneath surface appearances is once again Simpson's theme—the photographer challenging the camera's view.

In a series of photographs focused on the role of women in her native Iran and entitled *Women of Allah*, Shirin Neshat combines words and images in startling ways. In *Rebellious Silence* (**Fig. 2-5**), Neshat portrays herself as a Muslim woman, dressed in a black *chador*, the traditional covering that extends from head to toe revealing only hands and face. A rifle divides her face, upon which Neshat has inscribed in ink a Farsi poem by the devout Iranian woman poet Tahereh Saffarzadeh. Saffarzadeh's verses express the deep belief of many Iranian women in Islam. Only within the context of Islam, they believe, are women truly equal to men, and they claim that the *chador*, by concealing a woman's sexuality, prevents her from becoming a sexual object. The *chador*, in this sense, is liberating. It also expresses women's solidarity with men in the rejection of Western culture, symbolized by Western dress. But to a Western audience, the values embodied in the poem are indecipherable, a fact that Neshat fully understands. Thus, because we cannot understand the image, it is open to stereotyping, misreading, misunderstanding—the very conditions of the division between Islam and the West, imaged in the division of Neshat's body and face by the gun.

Fig. 2-5 Shirin Neshat, *Rebellious Silence*, from the series *Women of Allah*, 1994.

Gelatin silver print and ink, 11 × 14 in.

Photo: Cynthia Preston. © Shirin Neshat, courtesy the artist and Gladstone Gallery, New York and Brussels

Thinking Thematically: See **Art, Politics, and Community** on myartslab.com

Fig. 2-6 *Triumphal Entry* (page from a manuscript of the *Shahnamah of Firdawsi*), Persian, Safavid culture, 1562–1583.
Opaque watercolor, ink, and gold on paper, 18 11/16 × 13 in. Francis Bartlett Donation and Picture Fund. 14.692. Courtesy Museum of Fine Arts, Boston. Reproduced with permission.
Photograph © 2012 Museum of Fine Arts, Boston.

Thinking Thematically: See **Art and Spiritual Belief** on myartslab.com

In Islamic culture, in fact, words take precedence over images, and calligraphy—that is, the fine art of handwriting—is the chief form of Islamic art. The Muslim calligrapher does not so much express himself as act as a medium through which Allah (God) can express himself in the most beautiful manner possible. Thus, all properly pious writing, especially poetry, is sacred. This is the case with the page from the poet Firdawsi's *Shahnamah* (**Fig. 2-6**).

Sacred texts are almost always decorated with designs that aim to be visually compelling but not representational. Until recent times, in the Muslim world, every book, indeed almost every sustained statement, began with the phrase *bismillah al-rahman al-rahim*, which can be translated "In the name of Allah, the Beneficent, Ever-Merciful," the same phrase that opens the Qur'an. On this folio page from the *Shahnamah*, the *bismillah* is in the top right-hand corner (Arabic texts read from right to left). To write the *bismillah* in as beautiful a form as possible is believed to bring the scribe forgiveness for his sins.

The Islamic emphasis on calligraphic art derives, to a large degree, from the fact that at the heart of Islamic culture lies the word, in the form of the recitations that make up the Qur'an, the messages the faithful believe that God delivered to the prophet Muhammad through the agency of the angel Gabriel. The word could be trusted in a way that images could not. In the hadith, the collections of sayings and anecdotes about Muhammad's life, Muhammad is quoted as having warned, "An angel will not enter a house where there is a dog or a painting." Thus, images are notably absent in almost all Islamic religious architecture. And because Muhammad also claimed that "those who make pictures will be punished on the Day of Judgment by being told: make alive what you have created," the representation of "living things," human beings especially, is frowned upon.

Such thinking would lead the Muslim owner of a Persian miniature representing a prince feasting in the countryside to erase the heads of all those depicted (**Fig. 2-7**). No one could mistake these headless figures for "living things."

The distrust of images is not unique to Islam; at various periods in history Christians have also debated whether it was sinful to depict God and his creatures in paintings and sculpture. In the summer of 1566, for instance, Protestant **iconoclasts** (literally "image breakers," those who wished to destroy images in religious settings) threatened to destroy van Eyck's *Ghent Altarpiece* (see Fig. 1-19), but just three days before all Ghent's churches were sacked, the altarpiece was dismantled and hidden in the tower by local authorities. In Nuremberg, Germany, a large sculpture of Mary and Gabriel hanging over the high altar of the Church of San Lorenz was spared destruction, but only after the town council voted to cover it with a cloth that was not permanently removed until the nineteenth century. The rationale for this wave of destruction, which swept across northern Europe, was a strict reading of the Ten Commandments: "Thou shalt not make any graven image, or any likeness of any thing that is in heaven above, or that is in the earth beneath, or that is in the water under the earth: Thou shalt not bow down thyself to them nor serve them" (Exodus 20:4–5). But whatever the religious justification, it should be equally clear that the distrust of visual imagery is, at least in part, a result of the visual's power. If the worship of "graven images"—that is, idols—is forbidden in the Bible, the assumption is that such images are powerfully attractive, even dangerously seductive.

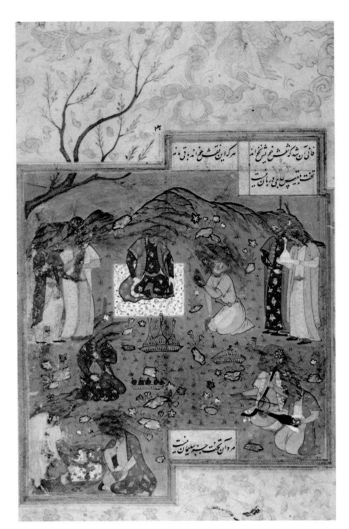

Fig. 2-7 Page from a copy of Nezami's *Khamseh* (the "*Quintet*") illustrating a princely country feast, Persian, Safavid culture, 1574–75.
Illuminated manuscript, 9¾ × 6 in. India Office, London.

Describing the World

In the last section, we explored the topic of visual literacy by considering the relationship between words and images. Words and images are two different systems of describing the world. Words refer to the world in the abstract. Images represent the world, or reproduce its appearance. Traditionally, one of the primary goals of the visual arts has been to capture and portray the way the natural world looks. But, as we all know, some works of art look more like the natural world than others, and some artists are less interested than others in representing the world as it actually appears. As a result, a vocabulary has developed that describes how closely, or not, the image resembles visual reality itself. This basic set of terms is where we need to begin in order to talk or write intelligently about works of art.

REPRESENTATIONAL, ABSTRACT, AND NONREPRESENTATIONAL ART

Generally, we refer to works of art as either **representational**, **abstract**, or **nonrepresentational** (or **nonobjective**). A representational work of art portrays natural objects in recognizable form. The more the representation resembles what the eye sees, the more it is said to be an example of **realism**. When a painting is so realistic that it appears to be a photograph, it is said to be **photorealistic** (see *The Creative Process*, pp. 22–23). The less a work resembles real things in the real world, the more it is said to be an example of abstraction. When a work does not refer to the natural or objective world at all, it is said to be nonrepresentational or nonobjective.

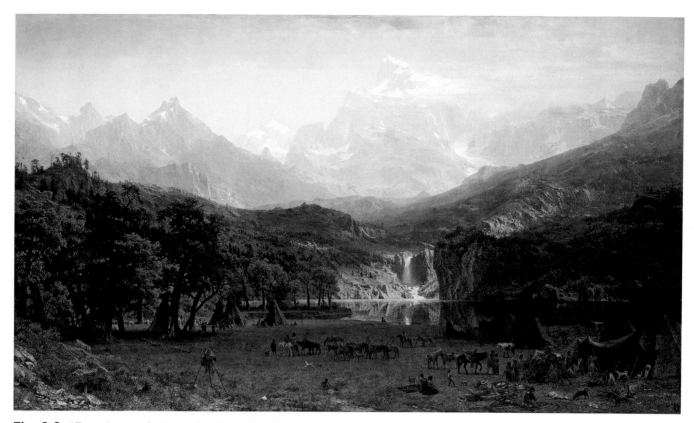

Fig. 2-8 Albert Bierstadt (1830–1902), *The Rocky Mountains, Lander's Peak*, 1863.
Oil on canvas, 73¹/₂ × 120³/₄ in. (186.7 × 306.7 cm). Signed and dated lower right. A. Bierstadt/1863. The Metropolitan Museum of Art, Rogers Fund, 1907 (07.123).

Thinking Thematically: See **Art, Science, and the Environment** on myartslab.com

Albert Bierstadt's painting *The Rocky Mountains* (**Fig. 2-8**) is representational and, from all appearances, highly realistic. Painted in 1863, it was one of the most popular paintings of its time, seeming to capture, for the American imagination, the vastness and majesty of the then still largely unexplored West. Writing about the painting in his 1867 *Book of the Artists*, the critic H. T. Tuckerman described it in glowing terms: "Representing the sublime range which guards the remote West, its subject is eminently national; and the spirit in which it is executed is at once patient and comprehensive—patient in the careful reproduction of the tints and traits which make up and identify its local character, and comprehensive in the breadth, elevation, and grandeur of the composition." In its breadth and grandeur, the painting seemed to Tuckerman an image of the nation itself. If it was **sublime**—that is, if it captured an immensity so large that it could hardly be comprehended by the imagination—the same was true of the United States as a whole. *The Rocky Mountains* was a truly democratic painting, vast enough to accommodate the aspirations of the nation.

But even if it was truly democratic, it was not true to life. Despite Tuckerman's assertion that Bierstadt has captured the "tints and traits" of the scene, no landscape quite like this exists in the American West. Rather, Bierstadt has painted the Alps, widely considered in the nineteenth century to be the most sublime mountains in the world, and the painting's central peak is, in fact, a barely disguised version of the Matterhorn, a peak in the Swiss Alps that he often painted. In fact, Bierstadt's painting is *naturalistic* rather than *realistic*. **Naturalism** is a brand of representation in which the artist retains apparently realistic elements—in Bierstadt's case, accurate representations of Western flora and fauna, as well as Native American dress and costume—but presents the visual world from a distinctly personal or subjective point of view. The Rockies, for Bierstadt, are at least as sublime as the Alps. He wants us to share in his feeling.

Throughout the last three decades of the last century, George Green painted in a distinct style that came to be known as Abstract Illusionism. It was characterized by images of abstract sculptural forms that seemed to float free of the painting's surface in highly illusionistic three-dimensional space. In the last few years of the 1990s, he began to make these paintings on birch, using the wood's natural grain to heighten the illusion. It was as if one were looking at a photorealistic painting of an abstract wooden sculpture.

Over the last decade, this process has evolved into a series of canvases of which . . . *marooned in dreaming: a path of song and mind* (**Fig. 2-12**) is exemplary. Like his earlier Abstract Illusionist works of the late 1990s, these paintings begin with a single sheet of raw birch (**Fig. 2-9**). Green then paints a highly illusionistic frame and mat onto the birch (**Fig. 2-10**). The frame is an example of what we call **trompe l'oeil**, French for "fool or deceive the eye." As opposed to photorealism, in which the painting is so realistic it appears to be a photograph, trompe-l'oeil effects result in a painting that looks as if it is an actual thing—in this case, an actual frame and mat. If one looks carefully at the lighter wood grain of the birch board at both the left and right edges, it becomes obvious that the shadowing created by the beveled edges and concave surfaces of the moulding are painted onto the flat surface of the wood. But Green's frames are so visually convincing that on more than one occasion collectors have asked him if he would mind if they changed the frame. (They can't, of course—the frame is an integral part of the painting.)

Figs. 2-9, 2-10, and 2-11 George Green, . . . *marooned in dreaming: a path of song and mind,* in progress, 2011. Top: Raw birch ground before painting. Middle: Second stage, painted frame and mat. Bottom: Third stage, painted frame and seascape. Courtesy of the artist.

Fig. 2-12 George Green, . . . *marooned in dreaming: a path of song and mind*, 2011. Acrylic on birch, 48 × 80 in.
Courtesy of the artist.

The third stage of Green's process is to paint a photorealistic seascape into the frame and mat (**Fig. 2-11**). While these seascapes are based on actual photographs taken by the artist, they are, upon further consideration, anything but photographic. In . . . *marooned in dreaming: a path of song and mind*, the clouds are too purple, the sea too garishly green. The aura of the sun behind the clouds lends the scene a quasi-spiritual dimension. And the lightning looks more like airborne jellyfish than an actual atmospheric electrostatic discharge (that said, photographs of actual lightning storms are every bit as unbelievable as these). For all its ostensible realism, in other words, the painting evokes a sort of otherworldliness. Writing about Green's work, the photorealist painter Don Eddy puts it this way: "The totality has the quality of an altered state that I find deeply reminiscent of movies that are heavily dependent on CGI [Computer Generated Imagery]."

Finally, Green overlays the entire composition with a filigree of scrolls and arabesques intertwined with planes of color, globes of wood, and even snapshots of landscapes—all painted on the surface. They are meant to evoke the unrepresentable—the "look" of music, or the flight of the mind. It is as if these elements have been painted on a sheet of glass set atop the painting and frame beneath. They create, at any rate, another surface, closer to the viewer than landscape and frame, and in their total abstraction, they insist on the artificiality of the entire composition. As Green's title suggests, the artist is alone with his own mind, and that mind works between several worlds—the world of actual objects, the imaginative dreamscapes of fantasy, and the unrepresentable sounds of song and music. These are, he suggests, the very layers of imagination.

Fig. 2-13 Wolf Kahn, *Afterglow I*, 1974.

Oil on canvas, 42 × 66 in. Whitney Museum of American Art, NY.
Courtesy of the artist.

While still a recognizable image of a landscape, Wolf Kahn's *Afterglow I* (**Fig. 2-13**) is far more abstract than Bierstadt's *Rocky Mountains*. The painting consists of four bands of color. In the near foreground is the edge of a field, behind it a band of trees in dark shadow, and behind the trees a blue cloud and an orange-hued sunset sky. For Kahn, the less realistic detail, the better the painting. "When a work becomes too descriptive," Kahn told an interviewer in 1995, "too much involved with what's actually out there, then there's nothing else going on in the painting, and it dies on you." In fact, his paintings could be said to be more about light than the actual landscape.

Although Australian Aboriginal artist Clifford Possum Tjapaltjarri's *Man's Love Story* (**Fig. 2-14**) is, in fact, a landscape, it is not recognizably one and it is fully abstract. The organizing logic of most Aboriginal art is the so-called Dreaming, a system of belief unlike that of most other religions in the world. The Dreaming is not literally dreaming as we think of it. For the Aborigine, the Dreaming is the presence, or mark, of an Ancestral Being in the world. Images of these Beings—representations of the myths about them, maps of their travels, depictions of the places and landscapes they inhabited—make up the great bulk of Aboriginal art. To the Aboriginal people, the entire landscape is thought of as a series of marks made upon the earth by the Dreaming. Thus, the landscape itself is a record of the Ancestral Being's passing, and geography is full of meaning and history. Painting is understood as a concise vocabulary of abstract marks conceived to reveal the ancestor's being, both present and past, in the Australian landscape.

Ceremonial paintings on rocks, on the ground, and on people's bodies were made for centuries by the Aboriginal peoples of Central Australia's Western Desert region. Acrylic paintings, similar in form and content to these traditional works, began to be produced in the region in 1971. In that year, a young art teacher named Geoff Bardon arrived in Papunya, a settlement on the edge of the Western Desert organized by the government to provide health care, education, and housing for the Aboriginal peoples. Several of the older Aboriginal men became interested in Bardon's classes, and he encouraged them to paint in acrylic, using traditional motifs. At first they painted on small composition boards, but between 1977 and 1979, Tjapaltjarri moved from these small works to largescale canvases—*Man's Love Story* is nearly 7 by 8½ feet—which he painted on the floor, using a stick with a round, flat end that is dipped into paint.

Each design still carries with it its traditional ceremonial power and is actual proof of the identity of those involved in making it. *Man's Love Story* tells the story of two ancestors: one who came to Papunya in search of honey ants whose presence was suggested by a white sugary substance called *lurrka*, deposited by the ants on leaves fallen from mulga trees; the other who, longing for the love of a woman that kinship rules barred him from marrying, came to a waterhole nearby, where he sat to spin hair into a string, a traditional way for a man to attract a woman. Both the ant's nest, on the left, and the water hole, on the right, are depicted as concentric target-like circles. The ancestors are represented by U-shaped forms—the white one on the left, bisected by his "journey line," or the

Fig. 2-14 Clifford Possum Tjapaltjarri, *Man's Love Story*, 1978.
Synthetic polymer paint on canvas,
6'11¾" × 8'4¼" (2.15 × 2.57 m). Art Gallery
of South Australia, Adelaide.
Visual Arts Board of the Australia Council Contemporary
Art Purchase Grant, 1980. Aboriginal Artists Agency.

View the Closer Look on *Man's Love Story* on myartslab.com

path of his trek into the region, is the honey ant hunter, and the brown one, facing north, the lover. White mulga leaves are scattered just above the hunter, and his digging stick is to his right. The form rising out of the water hole in front of the lover is the spindle upon which he was spinning his hair string. When his lover approached him, he let the string blow away (represented by the cascade of brown dots below him). Four women—the U-shaped figures at each corner of the central area—have come to guard the lovers at night. The two horizontal lines above and below the central area are believed to represent desert mirages. The paths of other ancestral figures are indicated by the wavy line across the top and the white footprints that form an arc around the bottom left corner of the painting.

Unlike most other forms of Aboriginal art, acrylic paintings are permanent and are not destroyed after serving the ceremonial purposes for which they were produced. In this sense, the paintings have tended to turn dynamic religious practice into static representations, and, even worse, into commodities. Conflicts have arisen over the potential revelation of secret ritual information contained in the paintings, and the star status bestowed upon certain painters, particularly younger ones, has had destructive effects on traditional hierarchies within the community. On the other hand, these paintings have tended to revitalize and strengthen traditions that were, as late as the 1960s, thought doomed to extinction.

MEANING IN NONREPRESENATIONAL ART

Nonobjective or nonrepresentational works of art do not refer to the natural or objective world at all. Kazimir Malevich's *Black Square* (**Fig. 2-15**) is concerned primarily with questions of form. When we speak of a work's form, we mean everything from the materials used to make it, to the way it employs the various formal elements (discussed in Part 2), to the ways in which those elements are organized into a

Fig. 2-15 Kazimir Malevich, *Black Square*. ca. 1923-30.
Oil on plaster, 14½ × 14½ in. Musee National d'Art Moderne, Centre Georges Pompidou, Paris, France. Inv.: AM 1978-631.
CNAC/MNAM/Dist. Réunion des Musées Nationaux / Art Resource, NY.

composition. **Form** is the overall structure of a work of art. Somewhat misleadingly, it is generally opposed to **content**, which is what the work of art expresses or means. Obviously, the content of nonobjective art is its form, but all forms, Malevich well knew, suggest meaning. Malevich's painting is really about

the relation between the black square and the white ground behind it. By 1912, Malevich was engaged, he wrote, in a "desperate attempt to free art from the ballast of objectivity." To this end, he says, "I took refuge in the square." He called his new art Suprematism, defining it as "the supremacy of . . . feeling in . . . art." He opposed feeling, that is, to objectivity, or the disinterested representation of reality.

Black Square was first exhibited in December 1915 at an exhibition in Petrograd entitled "0.10: The Last Futurist Exhibition of Paintings." The exhibition's name refers to the idea that each of the 10 artists participating in the show were seeking to articulate the "zero degree"—that is, the irreducible core—of painting. What, in other words, most minimally makes a painting? In this particular piece, Malevich reveals that in relation, these apparently static forms—two squares, a black one set on a white one—are energized in a dynamic tension. At the "0.10" exhibition, *Black Square* was placed high in the corner of the room in the

Fig. 2-16 Beatriz Milhazes, *Carambola*, 2008.
Acrylic on canvas, $54^7/_8 \times 50^5/_8$ in. Courtesy James Cohan Gallery, New York.
Photo: Jason Mandella.

place usually reserved in traditional Russian houses for religious icons. The work is, in part, parodic, replacing images designed to invoke deep religious feeling with what Malevich referred to as "an altogether new and direct form of representation of the world of feeling." As he wrote in his treatise, *The Non-Objective World*, "The square = feeling, the white field = the void beyond this feeling." What "feeling" this might be remains unstated—that is, totally abstract.

The work of contemporary Brazilian artist Beatriz Milhazes is likewise founded upon formal relationships. *Carambola* (**Fig. 2-16**), like all of her work, is based on the square, and, not coincidentally, she counts Malevich among those whose work has most influenced her own. She begins each work with a square, and then, she says, "I build things on top of it. The squares may disappear, but they are still a reference for me to think about composition." In fact, she thinks of the circles that dominate paintings like *Carambola* as containing squares. In essence, she pulls together into a geometrical composition the shapes and forms of Brazilian culture—ornate church facades, the ruffled blouses of Brazilian Mardi Gras costumes, the design of the serpentine walkway that stretches along her native Rio de Janeiro's beachfront, the exotic plants in the botanical garden neighboring her studio in Rio (where, in fact, the carambola tree, from which this painting takes its name, grows). Her color, too, captures the dizzying kaleidoscope of Brazilian Carnival. "I am interested in conflict," she says, "and the moment you add one more color, you start the conflict, which is endless. So there is a constant movement to your eyes, to your self, to your body, and I like it."

MEANING AND CULTURE

Our understanding of Milhazes's work is highly dependent on understanding its cultural context. Consider another set of examples: an ancient sculpture of the Greek god Apollo and a carved mask from the Sang tribe of Gabon in West Africa (**Figs. 2-17** and **2-18**). In the late 1960s, art historian Kenneth Clark compared the two images through an ethnocentric lens and concluded that the image of the messenger god Apollo demonstrated the superiority of classical Greek civilization. Clark understood the conventions of Greek sculpture and recognized the meaning of the idealized

Fig. 2-17 Apollo Belvedere (detail), Roman copoy after a fourth-century BCE Greek original.
Height of entire sculpture 7 ft. 4 in. Vatican Museums, Rome.
© Alinari / Art Resource, NY.

Fig. 2-18 African, Gabon; Fang: Reliquary Guardian Head (mask), Fang people, 19th century. Wood, egg, and dust (coating). O.1948.SC.236. The Samuel Courtauld Trust, The Courtauld Gallery, London.

Thinking Thematically: See Art and Spiritual Belief on myartslab.com

sculptural form: "To the Hellenistic imagination it is a world of light and confidence, in which the gods are like ourselves, only more beautiful, and descend to earth in order to teach men reason and the laws of harmony." His interpretation of the African mask, however, reveals his ignorance of the conventions of the West African nation that created it: "To the Negro imagination it is a world of fear and darkness, ready to inflict horrible punishment for the smallest infringement of a taboo." However, the features of the African mask are exaggerated at least in part to separate it from the "real." Clark's ethnocentric reading of it neglects its ritual, celebratory social function in African society. Worn in ceremonies, masks are seen as vehicles through which the spirit world is made available to humankind.

ICONOGRAPHY

Cultural conventions are often carried forward from one generation to the next by means of **iconography**,

a system of visual images the meaning of which is widely understood by a given culture or cultural group. These visual images are **symbols**—that is, they represent something more than their literal meaning. The subject matter of iconographic images is not obvious to any viewer unfamiliar with the symbolic system in use. Furthermore, every culture has its specific iconographic practices, its own system of images that are understood by the culture at large to mean specific things. Christian audiences, for instance, can easily read incidents from the story of Christ, such as those represented in the lower six panels of the center window in the west front of Chartres Cathedral in France (**Fig. 2-19**). This window was made about 1150 and is one of the oldest and finest surviving stained-glass windows in the world. The story can be read like a cartoon strip, beginning at the bottom left and moving right and up, from the Annunciation (the angel Gabriel announcing to Mary that she will bear the Christ Child) through the Nativity, the Annunciation to

Fig. 2-19 Lower six panels of the center lancet window in the west front of Chartres Cathedral, showing the Nativity, Annunciation to the Shepherds, and the Adoration of the Magi, c. 1150. Chartres Cathedral, France.

the Shepherds, and the Adoration of the Magi. The window is usually considered the work of the same artist who was commissioned by the Abbot Suger to make the windows of the relic chapels at Saint-Denis, which portray many of the same incidents. "The pictures in the windows are there," the Abbot explains in his writings, "for the sole purpose of showing simple people, who cannot read the Holy Scriptures, what they must believe." But he understood as well the expressive power of this beautiful glass. It transforms, he said, "that which is material into that which is immaterial." Suger understood that whatever story the pictures in the window tell, whatever iconographic significance they contain, and whatever words they generate, it is, above all, their art that lends them power.

Similarly, most of us in the West probably recognize a Buddha when we see one, but most of us do not know that the position of the Buddha's hands carries iconographic significance. Buddhism, which originated in India in the fourth century BCE, is traditionally associated with the worldly existence of Sakyamuni, or Gautama, the Sage of the Sakya clan, who lived and taught around the mid-fifth century BCE. In his 35th year, Sakyamuni experienced enlightenment under a tree at Gaya (near modern Patna), and he became Buddha or the Enlightened One.

Buddhism spread to China in the first and second centuries CE. Long before it reached Japan by way of Korea in the middle of the fifth century CE, it had developed a more or less consistent iconography, especially related to the representation of Buddha himself. The symbolic hand gestures, or *mudras*, refer both to general states of mind and to specific events in the life of Buddha. The mudra best known to Westerners, the hands folded in the seated Buddha's lap, symbolizes meditation. The small bronze sculpture of Buddha illustrated here (**Fig. 2.20**) was created for private worship. The gesture of the raised right hand symbolizes Buddha's fearlessness—a mudra known as *abaya* ("without fear")—and the lowered left the granting of protection. The Buddha of Infinite Light, whom the Japanese call Amida, was believed to rule the Pure Land, or the Paradise in the West, into which the faithful might find themselves reborn, thus gaining release from the endless cycle of birth, rebirth, and suffering.

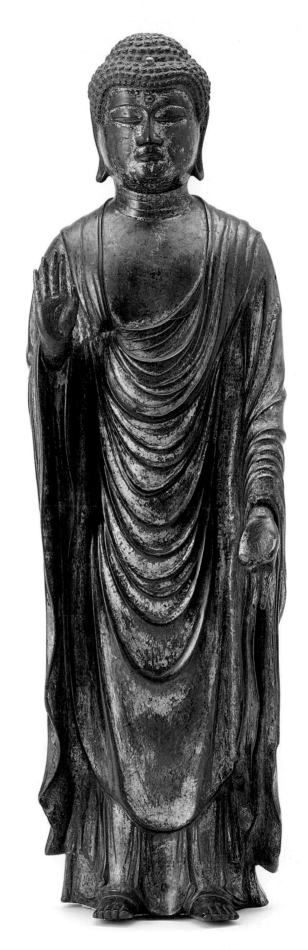

Fig. 2-20 Amitabha Budda (Amida), the Buddha of Infinite Light, Kamakura period, Japan, 13th century. Freer Gallery of Art, Smithsonian Institution, Washington, D.C.: Purchase, F1971.4a-b

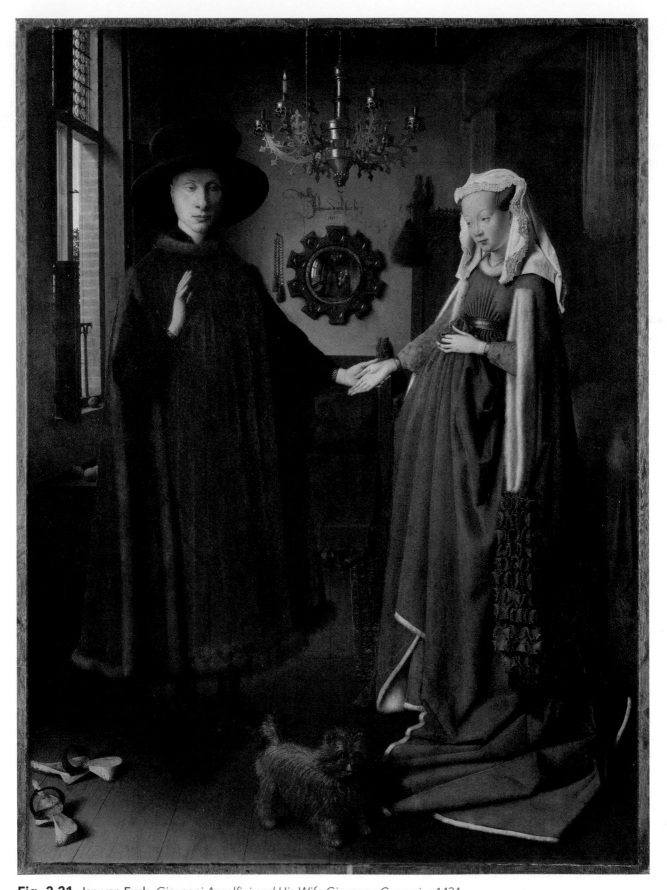

Fig. 2-21 Jan van Eyck, *Giovanni Arnolfini and His Wife Giovanna Cenami*, c.1434.
Oil on oak panel, 32¼ × 23½ in. National Gallery, London.

Thinking Thematically: See **Art and Beauty** on myartslab.com

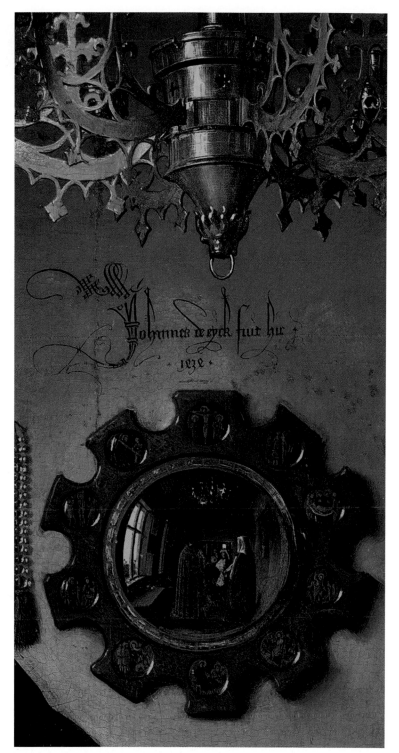

Fig. 2-22 Jan van Eyck, *Giovanni Arnolfini and His Wife Giovanna Cenami* (detail), c.1434.
Oil on oak panel, 32¼ × 23½ in. National Gallery, London.

Even within a culture, the meaning of an image may change or be lost over time. When Jan van Eyck painted his portrait of *Giovanni Arnolfini and His Wife Giovanna Cenami* in 1434 (**Fig. 2-21**), its repertoire of visual images was well understood, but today, much of its meaning is lost on the average viewer. For example, the bride's green dress, a traditional color for weddings, was meant to suggest her natural fertility. She is not pregnant—her swelling stomach was a convention of female beauty at the time, and her dress is structured in a way to accentuate it. The groom's removal of his shoes is a reference to God's commandment to Moses to take off his shoes when standing on holy ground. A single candle burns in the chandelier above the couple, symbolizing the presence of Christ at the scene. And the dog, as most of us recognize even today, is associated with faithfulness and, in this context, particularly, with marital fidelity.

But what would Islamic culture make of the dog in the van Eyck painting, as in the Muslim world dogs are traditionally viewed as filthy and degraded? From the Muslim point of view, the painting verges on nonsense. Even to us, viewing van Eyck's work more than 500 years after it was painted, certain elements remain confusing. An argument has recently been made, for instance, that van Eyck is not representing a marriage so much as a betrothal, or engagement. We have assumed for generations that the couple stands in a bridal chamber where, after the ceremony, they will consummate their marriage. It turns out, however, that in the fifteenth century it was commonplace for Flemish homes to be decorated with hung beds with canopies. Called "furniture of estate," they were important status symbols commonly displayed in the principal room of the house as a sign of the owner's prestige and influence. It was also widely understood in van Eyck's time that a touching of the hands, the woman laying her hand in the palm of a man, was the sign, especially in front of witnesses, of a mutual agreement to wed.

The painter himself stands in witness to the event. On the back wall, above the mirror, are the words

View the Closer Look on *Giovanni Arnolfini and His Wife* on myartslab.com

Jan de Eyck fuit hic, 1434—"Jan van Eyck was here, 1434" (**Fig. 2-22**). We see the backs of Arnolfini and his wife reflected in the mirror, and beyond them, standing more or less in the same place as we do as viewers, two other figures, one a man in a red turban who is probably the artist himself.

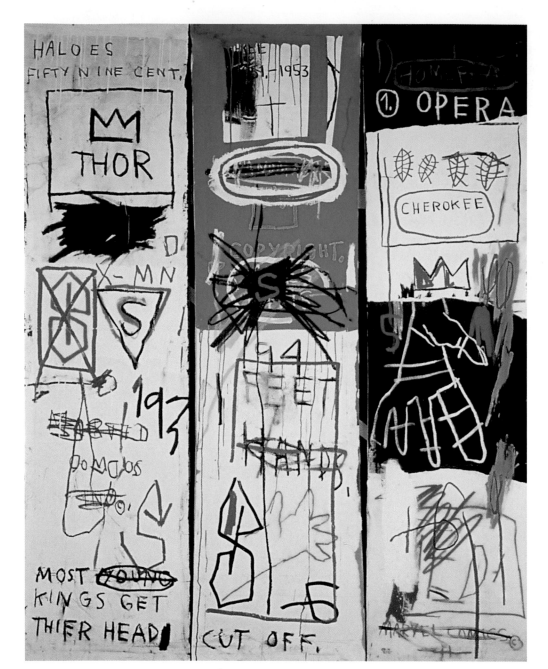

Fig. 2-23 Jean-Michel Basquiat, *Charles the First*, 1982.

Acrylic and oil oilstick on canvas, three panels. Triptych. 6'6" × 5'2¼" (1.98 × 1.58 m). overall.

© The Estate of Jean-Michel Basquiat/ © 2009 Artists Rights Society (ARS), New York.

Thinking Thematically: See **Art and the Passage of Time** on myartslab.com

In his painting *Charles the First* (**Fig. 2-23**), Jean-Michel Basquiat employs iconographic systems both of his own and others' making. The painting is an homage to the great jazz saxophonist Charlie Parker, who died in 1955, one of a number of black cultural heroes celebrated by the graffiti-inspired Basquiat. Son of a middle-class Brooklyn family (his father was a Haitian-born accountant, his mother a black Puerto Rican), Basquiat left school in 1977 at age 17, living on the streets of New York for several years during which time he developed the "tag"—or graffiti pen-name—SAMO, a combination of "Sambo" and "same ol' shit." SAMO was most closely associated with a three-pointed crown (as self-anointed "king" of the graffiti artists) and the word "TAR," evoking

racism (as in "tar baby"), violence ("tar and feathers," which he would entitle a painting in 1982), and, through the anagram, the "art" world as well. A number of his paintings exhibited in the 1981 New York/New Wave exhibit at an alternative art gallery across the 59th Street Bridge from Manhattan attracted the attention of several art dealers and his career exploded. (The impact of the art market on his career will be discussed in a section on the art market in the next chapter.)

Central to his personal iconography is the crown, which is a symbol not only of his personal success, but of the other African-American "heroes" that are the subject of many of his works—jazz artists, such as Parker and Dizzy Gillespie, and "famous Negro

View the Closer Look on *Charles the First* on myartslab.com

athletes," as he calls them, such as boxer Sugar Ray Leonard and baseball's Hank Aaron. Heroism is, in fact, a major theme in Basquiat's work, and the large "S," which appears three times in the first panel of *Charles the First* and twice in the second, is a symbol for the superhero Superman, as well as for SAMO.

Directly above the triangular Superman logo in the first panel are the letters "X-MN," which refer to the X-Men comic book series, published by Marvel Comics, whose name appears crossed out at the bottom of the third panel. Marvel describes the X-Men as follows: "Born with strange powers, the mutants known as the X-Men use their awesome abilities to protect a world that hates and fears them." Basquiat clearly means to draw an analogy between the X-Men and his African-American heroes. And, in fact, Basquiat refers to another Marvel Comics hero, the Norse god Thor, whose name appears below the crown in the top left of Basquiat's painting.

The "X" has a special significance in Basquiat's iconography. In the *Symbol Source-book: An Authoritative Guide to International Graphic Symbols*, a book by American industrial designer Henry Dreyfuss first published in 1972, Basquiat discovered a section on "Hobo Signs," marks left, graffiti-like, by hobos to inform their brethren about the lay of the local land. In this graphic language, an "X" means "O.K. All right."

The "X" is thus ambiguous, a symbol of both negation (crossed-out) and affirmation (all right). This is, of course, the condition in which all of Basquiat's African-American heroes find themselves. Charlie Parker is also Charles the First, a reference to the King Charles I of England, beheaded by Protestants in the English Civil War in 1649—hence the phrase across the bottom of panels one and two, "Most kings get thier [sic] head cut off." Basquiat's reference to Parker's rendering of "Cherokee," in the third panel, evokes not only the beauty of the love song itself, but also the Cherokee Indian Nation's "Trail of Tears," the forced removal of the tribe from Georgia to Oklahoma in 1838 that resulted in the deaths of some 4,000 of their people. Above "Cherokee" are four feathers, a reference at once to Indians, Parker himself, whose nickname was "Bird," and, in the context of Basquiat's work as a whole, the violent practice of tar and feathering. Finally, Basquiat's sense that the price of heroism is high indeed is embedded in two other of his iconographic signs: The "S," especially when lined or crossed out, also suggests dollars, $, and the copyright © sign, which is ubiquitous in his paintings, suggests not just ownership, but the exercise of property rights and control in American society, an exercise and control that Basquiat sees as the root cause of the institution of slavery (to say nothing of the removal of the Cherokee nation to Oklahoma).

In sum, Basquiat's paintings are literally packed with a private, highly ambiguous iconography. But their subject is clear enough. When asked by Henry Geldzahler, curator of contemporary art at the Metropolitan Museum of Art in New York City, just what his subject matter was, Basquiat replied: "Royalty, heroism, and the streets."

THINKING BACK

✓—Study and review on myartslab.com

How does subject matter differ from content?

An artwork's subject matter is what the image or object literally represents. The content, by contrast, is what the artwork means. How can the subject matter of Shirin Neshat's *Rebellious Silence* be distinguished from its content? How does Lorna Simpson use text and images together to create the content of *She* and *Necklines*?

What is representational art?

Representational artworks portray recognizable forms. The more the representation resembles what the eye sees, the more it is said to be an example of realism. What does Albert Bierstadt represent in his painting *The Rocky Mountains, Lander's Peak*? What distinguishes naturalism from other types of realism? How does representational art differ from abstract art?

What constitutes an artwork's form?

Form is the overall structure of an artwork. Form includes such aspects of an artwork as its materials and the organization of its parts into a composition. What role does form typically play in nonrepresentational art? How does form differ from content? How do Kazimir Malevich and Beatriz Milhazes use form in their works?

What is iconography?

Iconography is a system of images whose meaning is understood by a certain cultural group. The images used in iconography represent concepts or beliefs beyond literal subject matter. Cultural conventions are often carried from one generation to the next through iconography. How might the meaning of an image change over time? What is personal iconography? How is iconography used in the lower six panels of the center lancet window of Chartres Cathedral?

THE CRITICAL PROCESS
Thinking about Visual Conventions

Very rarely can we find the same event documented from the point of view of two different cultures, but two images, one by John Taylor, a journalist hired by *Leslie's Illustrated Gazette* (**Fig. 2-24**), and the other by the Native American artist Howling Wolf (**Fig. 2-25**), son of the Cheyenne chief Eagle Head, both depict the October 1867 signing of a peace treaty between the Cheyenne, Arapaho, Kiowa, and Comanche peoples and the United States government at Medicine Lodge Creek, a tributary of the Arkansas River, in Kansas. Taylor's illustration is based on sketches done at the scene, and it appeared soon after the events. Howling Wolf's work, actually one of several depicting the events, was done nearly a decade later, after he was taken east and imprisoned at Fort Marion in St. Augustine, Florida, together with his father and

70 other "ringleaders" of the continuing Native American insurrection in the Southern Plains. While in prison, Howling Wolf made many drawings such as this one, called "ledger" drawings because they were executed on blank accountants' ledgers.

Even before he was imprisoned, Howling Wolf had actively pursued ledger drawing. As Native Americans were introduced to crayons, ink, and pencils, the ledger drawings supplanted traditional buffalo hide art, but in both the hide paintings and the later ledger drawings, artists depicted the brave accomplishments of their owners. The conventions used by these Native American artists differ greatly from those employed by their Anglo-American counterparts. Which, in your opinion, is the more representational? Which is the more abstract?

Fig. 2-24 John Taylor, *Treaty Signing at Medicine Creek Lodge*, 1867. Drawing for *Leslie's Illustrated Gazette*, September–December 1867, as seen in Douglas C. Jones, *The Treaty of Medicine Lodge*, page xx, Oklahoma University Press, 1966.

Fig. 2-25 Howling Wolf, *Treaty Signing at Medicine Creek Lodge*, 1875–1878.
Ladger drawing, pencil, crayon, and ink on paper, 8 × 11 in.
Courtesy of the New York State Library, Manuscripts and Special Collections, Albany, New York.

Both works possess the same overt content—that is, the peace treaty signing—but how do they differ in form? Both Taylor and Howling Wolf depict the landscape, but how do they differ? Can you determine why Howling Wolf might want to depict the confluence of Medicine Creek and the Arkansas in his drawing? It is as if Howling Wolf portrays the events from above, so that simultaneously we can see tipis, warriors, and women in formal attire, and the grove in which the United States soldiers meet with the Indians. Taylor's view is limited to the grove itself. Does this difference in the way the two artists depict space suggest any greater cultural differences? Taylor's work directs our eyes to the center of the image, while Howling Wolf's does not. Does this suggest anything to you?

Perhaps the greatest difference between the two depictions of the event is the way in which the Native Americans are themselves portrayed. In Howling Wolf's drawing, each figure is identifiable—that is, the tribal affiliations and even the specific identity of each individual are revealed through the iconography of the decorations of his or her dress and tipi. How, in comparison, are the Native Americans portrayed in Taylor's work? In what ways is Taylor's work ethnocentric?

One of the most interesting details in Howling Wolf's version of the events is the inclusion of a large number of women. Almost all of the figures in Howling Wolf's drawing are, in fact, women. They sit with their backs to the viewer, their attention focused on the signing ceremony before them. Their braided hair is decorated with customary red paint in the part. This convention is of special interest. When the Plains warrior committed himself to a woman, he ceremonially painted her hair to convey his affection for and commitment to her. Notice the absence of any women in Taylor's depiction, as opposed to their prominence in Howling Wolf's. What does this suggest to you about the role of women in the two societies?

View the Closer Look on *Treaty at Medicine Creek Lodge* on myartslab.com

3 | Seeing the Value in Art

Fig. 3-1 Sylvie Fleury, *Serie ELA 75/K (Plumpity . . . Plump)*, 2000.
Gold-plated shopping cart, plexiglas handle with vinyl text, rotating pedestal (mirror, aluminum, motor). No. 5 shopping cart.
$32^3/4 \times 37^3/4 \times 21^5/8$ in. (83 × 96 × 55 cm) Pedestal $12^1/4 \times 39^3/8$ in.
(31 × 100 cm) Diameter.
Courtesy of the artist and Galerie Eva Presenhuber, Zürich.

THINKING AHEAD

How does the public tend to receive innovative artwork?

What was the purpose of the Arts in Public Places Program?

What constitutes the activist direction in public art?

((•—**Listen** to the chapter audio on myartslab.com

At the end of Chapter 2, we briefly mentioned the explosive career of Jean-Michel Basquiat after a number of his graffiti-like paintings were exhibited in the 1981 *New York/New Wave* exhibit at P. S. 1 Contemporary Art Center, an alternative art gallery across the 59th Street Bridge from Manhattan. Henry Geldzahler, then Cultural Commissioner for New York City, saw his paintings at P. S. 1 Contemporary Art Center and "just flipped out." Alanna Heiss, founder of P. S. 1, recalls "standing in front of Jean-Michel's work with a director of Philip Morris. We were paralyzed. It was so obvious that he was enormously talented."

By 1982, Basquiat was earning an average of about $4,000 a week by painting. Two years later, at age 24, he became the first black artist to grace the cover of *The New York Times Magazine*. At the time of his death, four months before his 28th birthday, the victim, according to the medical examiner's report, of "acute mixed drug intoxication (opiates–cocaine)," his paintings were selling for about $30,000 each (normally a dealer keeps 50 to 60 percent of the sale price). Soon after his death, the auction house Christie's sold a 1981 canvas for $110,000. Now, 20 years since his death, the current auction record for a Basquiat is $14.6 million for *Untitled*, a painting featuring a figure with large hands. It sold at Sotheby's in 2007. As an obituary ironically entitled "Banking on Basquiat", put it, "There's no artist like a dead artist, some dealers are fond of saying."

Fig. 3-2 Installation view of Giorgio Armani exhibition at the Solomon R. Guggenheim Museum, New York, October, 20, 2000–January, 17, 2001.

If these numbers seem staggering, it is not uncommon for works of art to increase dramatically in value, even in an artist's own lifetime. It is worth remembering that the monetary value of works of art is closely tied to the business of art, and, from a business point of view, artworks are commodities to be bought and sold like any others, ideally for profit. Sylvie Fleury's *Serie ELA 75/K (Plumpity . . . Plump)* (**Fig. 3-1**) is a wry commentary on this fact. Here the artwork is literally a shopping cart, placed on a revolving pedestal and plated in 24K gold. Art, Fleury's work implies, is literally shopping.

And very high-end shopping at that. The art market depends on the participation of wealthy clients through their investment, ownership, and patronage. It is no accident, then, that the major financial centers of the world also support the most prestigious art galleries, auction houses, and museums of modern and contemporary art. Art galleries bring artists and collectors together. They usually sign exclusive contracts with artists whose works they believe they can sell. Collectors may purchase work as an investment but, because the value of a given work depends largely upon the artist's reputation, and artists' reputations are finicky at best, the practice is very risky. As a result, what motivates most collectors is the pleasure of

owning art and the prestige it confers upon them (the latter is especially important to corporate collectors).

It is at auction that the monetary value of works of art is most clearly established. But auction houses are, after all, publicly owned corporations legally obligated to maximize their profits, and prices at auction are often inflated. The business of art informs the practices of museums as well, which market their exhibitions as "events" in every way comparable to a rock concert or major motion picture. In fact, in order to finance their work, museums have increasingly relied on corporate sponsorship. Consider, for instance, the Guggenheim Museum's 2000–01 exhibition dedicated to the fashion design of Giorgio Armani (**Fig. 3-2**), whose company, not coincidentally, had entered into a $15 million sponsorship agreement with the museum. It is no accident, either, that the exhibition took place over the Christmas shopping season.

But the value of art is not all about money. Art has intrinsic value as well, and that value is often the subject of intense debate. The fate of the work of two artists, Robert Mapplethorpe and Chris Offili, offers two clear examples of just what is at stake in what have sometimes been called the "culture wars" surrounding artistic expression.

In the summer of 1989, the work of photographer Robert Mapplethorpe was scheduled to be exhibited at the Corcoran Gallery of Art in

Washington, D.C. Mapplethorpe had died just a few months earlier of AIDS. He was known largely for his photographs of male nudes, and, in a group of works known as the "X Portfolio," for his depictions of sadomasochistic and homoerotic acts. These last, and, in particular, a photograph of a little girl sitting on a bench revealing her genitals, had raised the ire of Senator Jesse Helms of North Carolina, who threatened to terminate funding for the National Endowment for the Arts, which had partially funded the exhibition at the Corcoran. Not wanting to jeopardize continued funding of the Endowment, the Corcoran canceled the show. It was moved to a smaller Washington gallery, Project for the Arts, where nearly 50,000 people visited it in 25 days. After leaving Washington, the exhibition ran without incident in both Hartford, Connecticut, and Berkeley, California, but when it opened at Cincinnati, Ohio's Contemporary Arts Center, police seized many of the photographs as "criminally obscene" and arrested Dennis Barrie, the Center's director, on charges of pandering and the use of a minor in pornography. The Arts Center, the Robert Mapplethorpe Foundation, and the Mapplethorpe estate together countered the police action by filing suit to determine whether the photographs were obscene under Ohio state law. "We want a decision on whether the work as a whole has serious artistic value," they stated.

In Cincinnati, the judge in the trial of Barrie and the Arts Center ruled that the jury should not consider Mapplethorpe's work "as a whole"; rather, he declared, "the Court finds that each photograph has a separate identity; each photograph has a visual and unique image permanently recorded." Nevertheless, the jury acquitted both Barrie and the Arts Center. They found that each of the images possessed serious artistic value. A good deal of the testimony focused on the formal qualities of Mapplethorpe's work—for example, the way that in his portrait of *Ajitto* (**Fig. 3-3**) the human body assumes the geometrical precision of a pentagon. But one of the most compelling witnesses was Robert Sobieszek, senior curator of the International Museum of Photography in Rochester, New York. Mapplethorpe, said Sobieszek, "wanted to document what was beautiful and what was torturous—in his

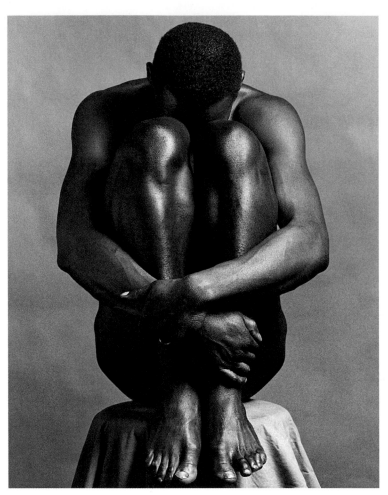

Fig. 3-3 Robert Mapplethorpe, *Ajitto*, 1981.
Gelatin silver print, 30 × 40 in.
© 1981 The Estate of Robert Mapplethorpe.

Thinking Thematically: See Art and Beauty on myartslab.com

personal experience. If something is truly obscene or pornographic, then it's not art." But in addressing the terms of his own life, he said, Mapplethorpe was "not unlike van Gogh painting himself with his ear cut off."

Thus the jury found that, considered in the context of art as a whole, in the context of art's concern with form, and in the context of the history of art and its tradition of confronting those parts of our lives that give us pain as well as pleasure, Mapplethorpe's work seemed to them to possess "serious artistic value." The Mapplethorpe story makes clear that "value," like beauty, as discussed in the last chapter, is a relative term. What some people value, others do not and cannot.

A decade later, this state of affairs was reaffirmed by the controversy surrounding the

exhibition *Sensation: Young British Artists from the Saatchi Collection*, which appeared at the Brooklyn Museum of Art October 2, 1999 through January 9, 2000. At the center of the storm was a painting called *The Holy Virgin Mary* (**Fig. 3-4**) by Chris Ofili, a British-born artist who was raised a Catholic by parents born in Lagos, Nigeria. The work's background gleams with glitter and dabs of yellow resin, a shimmering mosaic evoking medieval icons that contrast with the soft, petal-like texture of the Virgin's blue-gray robes. What appears to be black-and-white beadwork turns out to be pushpins. Small cutouts decorate the space—bare bottoms from porn magazines meant to evoke putti, the baby angels popular in Renaissance art. But most controversial of all is the incorporation of elephant dung, acquired from the London Zoo, into the work. Two balls of resin-covered dung, with pins stuck in them spelling out the words "Virgin" and "Mary," support the painting, and another ball of dung defines one of the Virgin's breasts.

Cardinal John O'Connor called the show an attack on religion itself. The Catholic League for Religious and Civil Rights said people should picket the museum. New York mayor Rudolph W. Giuliani threatened to cut off the museum's city subsidy and remove its board if the exhibition was not canceled, calling Ofili's work, along with the work of several other artists, "sick stuff." (Taken to court, the mayor was forced to back down.) Finally, Dennis Heiner, a 72-year-old Christian who was incensed by Ofili's painting, eluded guards and smeared white paint across the work. For Ofili, the discomfort his work generates is part of the point: His paintings, he says, "are very delicate abstractions, and I wanted to bring their beauty and decorativeness together with the ugliness of shit and make them exist in a twilight zone—you know they're there together, but

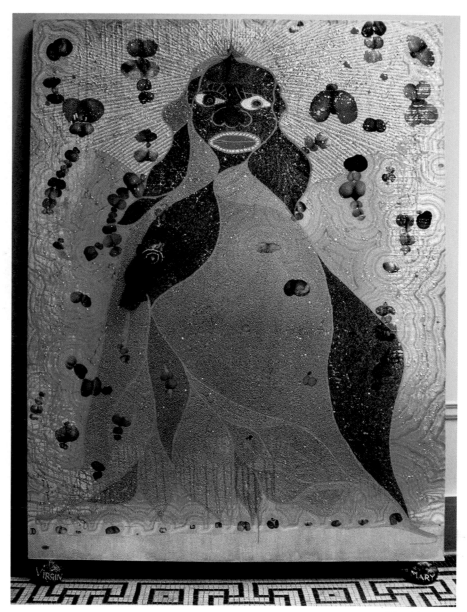

Fig. 3-4 Chris Ofili, *The Holy Virgin Mary*, 1996.
Paper collage, oil paint, glitter, polyester, resin, map pins, and elephant dung on linen, 8 × 6 ft. The Saatchi Gallery, London.
Photo: Diane Bondareff / AP World Wide Photos.

Thinking Thematically: See **Art and Spiritual Belief** on myartslab.com

you can't really ever feel comfortable about it." Ofili exists in this same twilight zone, caught between his African heritage and his Catholic upbringing.

The Ofili and Mapplethorpe examples demonstrate the many complex factors that go into a judgment of art's value. In the rest of this chapter, we will explore the public nature of art in order to reach some conclusions about how our culture comes to value it above and beyond its monetary worth.

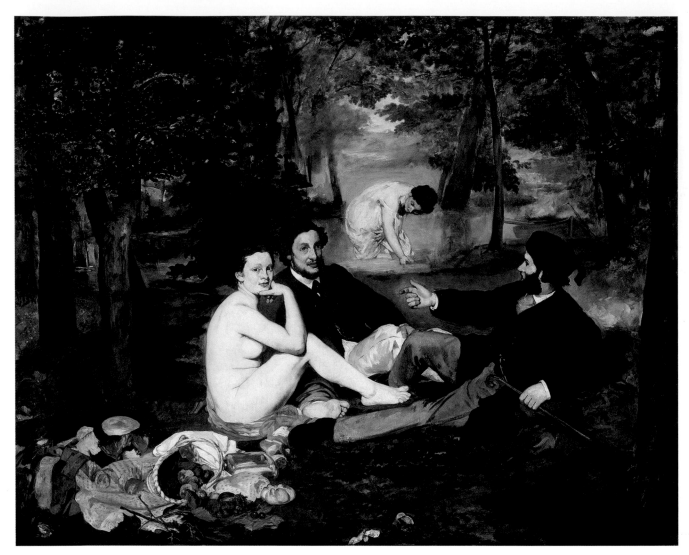

Fig. 3-5 Edouard Manet, *Luncheon on the Grass* (*Le Déjeuner sur l'herbe*), 1863. Oil on canvas, 7 ft. × 8 ft. 10 in. (2.13 × 2.6 m). Musée d'Orsay, Paris.

Réunion des Musées Nationaux / Art Resource, NY.

Thinking Thematically: See Art, Politics, and Community on myartslab.com

Art and Its Reception

The artist's relation to the public, it should be clear, depends on the public's understanding of what the artist is trying to say. But the history of the public's reception of art abounds with instances of the public's misunderstanding. In 1863, for example, Edouard Manet submitted his painting *Luncheon on the Grass*, more commonly known by its French name, *Déjeuner sur l'herbe* (**Fig. 3-5**), to the conservative jury that picked paintings for the annual Salon exhibition in Paris. It was rejected along with many other paintings considered "modern." (A detailed discussion of what specifically offended the jury is included in the Closer Look discussion in myartslab.) The resulting outcry forced Napoleon III to create a Salon des Refusés, an exhibition of works refused by the Salon proper, to let

the public judge for itself the individual merits of the rejected works. Even at the Salon des Refusés, however, Manet's painting created a scandal. Some years later, in his novel *The Masterpiece*, Manet's friend Emile Zola wrote a barely fictionalized account of the painting's reception:

> *It was one long-drawn-out explosion of laughter, rising in intensity to hysteria. . . . A group of young men on the opposite side of the room were writhing as if their ribs were being tickled. One woman had collapsed on to a bench, her knees pressed tightly together, gasping, struggling to regain her breath. . . . The ones who did not laugh lost their tempers. . . . It was an outrage and should be stopped, according to elderly gentlemen who brandished their walking sticks in indignation. One very serious individual,*

🔍 **View** the Closer Look on *Luncheon on the Grass* on myartslab.com

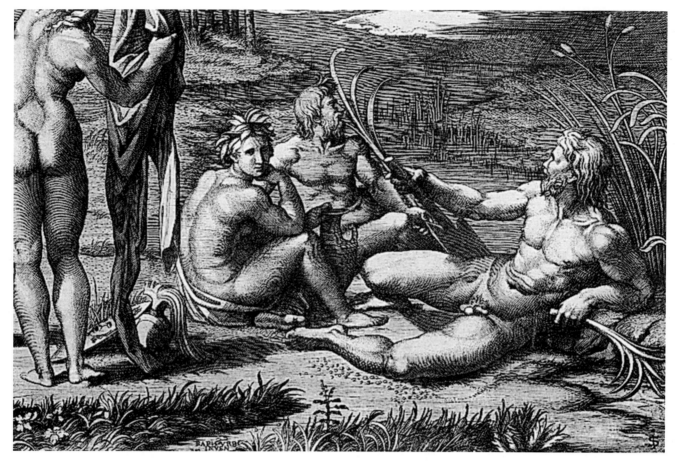

Fig. 3-6 Marcantonio Raimondi, *The Judgment of Paris* (detail), c. 1510–1520.
Oil engraving, after Raphael. Clipped impression, Plate line 11 ⅝ × 17 ¼ in. (29.5 × 43.8 cm).
Overall: 11⁷/₁₆ × 17³/₁₆ in. (29.1 × 43.7 cm). The Metropolitan Museum of Art, New York, NY, U.S.A. Rogers Fund,
1919 (19.74.1).

*as he stalked away in anger, was heard announcing
to his wife that he had no use for bad jokes. . . .
It was beginning to look like a riot . . . and as the
heat grew more intense faces grew more and more
purple.*

Though it was not widely recognized at the time, Manet had, in this painting, by no means abandoned tradition completely to depict everyday life in all its sordid detail. *Déjeuner sur l'herbe* was based on a composition by Raphael that Manet knew through an engraving, *The Judgment of Paris*, copied from the original by one of Raphael's students, Marcantonio Raimondi (**Fig. 3-6**). The pose of the three main figures in Manet's painting directly copies the pose of the three figures in the lower right corner of the engraving. However, if Manet's sources were classical, his treatment was anything but. In fact, what most irritated both critics and the public was the apparently "slipshod" nature of Manet's painting technique. He painted in

broad, visible strokes. The body of the seated nude in *Déjeuner* was flat. The painting's sense of space was distorted, and the bather in the background and the stream she stands in both seemed about to spill forward into the picnic.

Manet's rejection of traditional painting techniques was intentional. He was drawing attention to his very modernity, to the fact that he was breaking with the past. His manipulation of his traditional sources supported the same intentions. In the words of his contemporary, Karl Marx, Manet was looking "with open eyes upon his conditions of life and true social relations." Raphael had depicted the classical judgment of Paris, the mythological contest in which Paris chose Venus as the most beautiful of the goddesses, a choice that led to the Trojan War. In his depiction of a decadent picnic in the Bois de Bologne, Manet passed judgment upon a different Paris, the modern city in which he lived. His world had changed. It was less heroic, its ideals less grand.

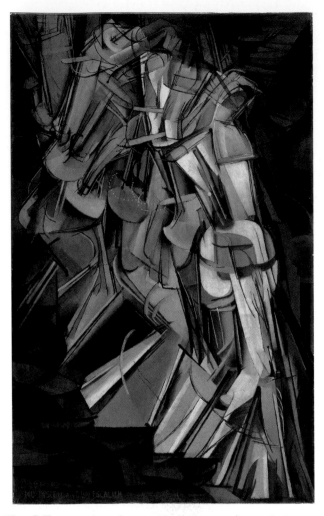

Fig. 3-7 Marcel Duchamp, *Nude Descending a Staircase, No. 2*, 1912.

Oil on canvas, 58 × 35 in. Philadelphia Museum of Art: The Louise and Walter Arensberg Collection.

The public tends to receive innovative artwork with reservation because it usually has little context, historical or otherwise, in which to view it. It is not easy to appreciate, let alone value, what is not understood. When Marcel Duchamp exhibited his *Nude Descending a Staircase* (**Fig. 3-7**) at the Armory Show in New York City in 1913, it was a scandalous success, parodied and ridiculed in the newspapers. Former President Teddy Roosevelt told the papers, to their delight, that the painting reminded him of a Navajo blanket. Others called it "an explosion in a shingle factory," or "a staircase descending a nude." The American Art News held a contest to find the "nude" in the painting. The winning entry declared, "It isn't a lady but only a man."

The Armory Show was most Americans' first exposure to modern art, and more than 70,000 people saw it during its New York run. By the time it closed, after also traveling to Boston and Chicago, nearly 300,000 people had seen it. If not many understood the *Nude* then, today it is easier for us to see what Duchamp was representing. He had read, we know, a book called *Movement*, published in Paris in 1894, a treatise on human and animal locomotion written by Etienne-Jules Marey, a French physiologist who had long been fascinated with the possibility of breaking down the flow of movement into isolated data that could be analyzed. Marey began to photograph models dressed in black suits with white points and stripes, which allowed him to study, in images created out of a rapid succession of photographs, the flow of their motion. These images, called "chronophotographs,"

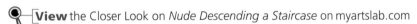

🔍 **View** the Closer Look on *Nude Descending a Staircase* on myartslab.com

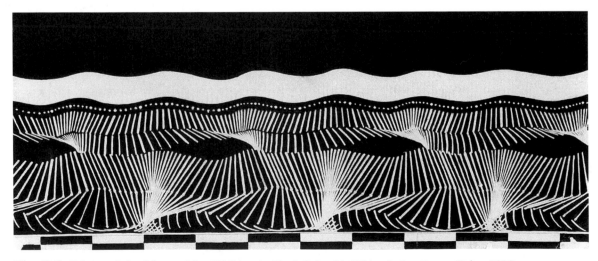

Fig. 3-8 Etienne-Jules Marey, *Man Walking in Black Suit with White Stripe Down Sides*, 1883.

Collection Musée Marey, Beaune, France.

Photograph by Jean-Claude Couval.

Thinking Thematically: See Art, Science, and the Environment on myartslab.com

Fig. 3-9 Maya Lin, *Vietnam Memorial*, Washington, D.C., 1982.
Polished black granite, length 492 ft.

literally "photographs of time" (**Fig. 3-8**), are startlingly like Duchamp's painting. "In one of Marey's books," Duchamp later explained, "I saw an illustration of how he indicated [movement] . . . with a system of dots delimiting the different movements. . . . That's what gave me the idea for the execution of [the] *Nude*."

Marey and Duchamp had embarked, we can now see, on the same path, a path that led to the invention of the motion picture. On December 28, 1895, at the Grand Café on the Boulevard des Capucines in Paris, the Lumière brothers, who knew Marey and his work well, projected motion pictures of a baby being fed its dinner, a gardener being doused by a hose, and a train racing directly at the viewers, causing them to jump from their seats. Duchamp's vision had already been confirmed, but the public had not yet learned to see it.

A more recent example of the same phenomenon, of a public first rejecting and then coming to understand and accept a work of art, is Maya Lin's *Vietnam Memorial* in Washington, D.C. (**Fig. 3-9**). Lin's work was selected from a group of more than 1,400 entries in a national competition. At the time her proposal was selected, Lin was 22 years old, a recent graduate of Yale University, where she had majored in architecture.

Many people at first viewed the monument as an insult to the memory of the very soldiers whom it was supposed to honor. Rather than rise in majesty and dignity above the Washington Mall, like the Washington Monument or the Jefferson Memorial, it descends below earth level in a giant V, more than 200 feet long on each side. It represents nothing in particular, unlike the monument to the planting of the flag on the hill at Iwo Jima, which stands in Arlington National Cemetery, directly across the river. If Lin's memorial commemorates the war dead, it does so only abstractly.

And yet this anti-monumental monument has become the most visited site in Washington. In part, people recognize that it symbolizes the history of the Vietnam War itself, which began barely perceptibly, like the gentle slope that leads down into the V, then deepened and deepened into crisis, to end in the riveting drama of the American withdrawal from Saigon. Though technically over, the war raged on for years in the nation's psyche, while at the same time a slow and at times almost imperceptible healing process began. To walk up the gentle slope out of the V symbolizes for many this process of healing. The names of the 58,000 men and women who died in Vietnam are chiseled into the wall in the order in which they were killed. You find the name of a loved one or a friend by looking it up in a register. As you descend into the space to find that name, or simply to stare in humility at all the names, the polished black granite reflects your own image back at you, as if to say that your life is what these names fought for.

Like Manet's *Déjeuner* and Duchamp's *Nude*, Lin's piece was misunderstood by the public. But unlike either, it was designed for public space. As we have seen, the public as a whole is a fickle audience, and the fate of art in public places can teach us much about how and why we, as a culture, value art.

Art, Politics, and Public Space

A certain segment of the public has always sought out art in galleries and museums. But as a general rule (except for statues of local heroes mounted on horseback in the public square—of interest mainly to pigeons), the public could ignore art if it wished. In 1967, when Congress first funded the National Endowment for the Arts (NEA), that changed. An Arts in Public Places Program was initiated, quickly followed by state and local programs nationwide that usually required 1 percent of the cost of new public buildings to be dedicated to purchasing art to enhance their public spaces. Where artists had before assumed an interested, self-selected audience, now everyone was potentially their audience. And, like it or not, artists were thrust into activist roles—their job, as the NEA defined it, to educate the general public about the value of art.

The Endowment's plan was to expose the nation's communities to "advanced" art, and the Arts in Public Places Program was conceived as a mass-audience art appreciation course. Time and again, throughout its history, it commissioned pieces that the public initially resisted but learned to love. Alexander Calder's *La Grand Vitesse* (**Fig. 3-10**) in Grand Rapids, Michigan, was the first piece commissioned by the Program. The selection committee was a group of four well-known outsiders, including New York painter Adolph Gottlieb and Gordon Smith, director of the Albright-Knox Art Gallery in Buffalo, New York, and three local representatives, giving the edge to the outside experts, who were, it was assumed, more knowledgeable about art matters than their local counterparts. In the case of *La Grand Vitesse*, the public initially reacted negatively to the long organic curves of Calder's praying mantis–like forms but soon adopted the sculpture as a civic symbol and a source of civic pride. The NEA and its artists were succeeding in teaching the public to value art for art's sake.

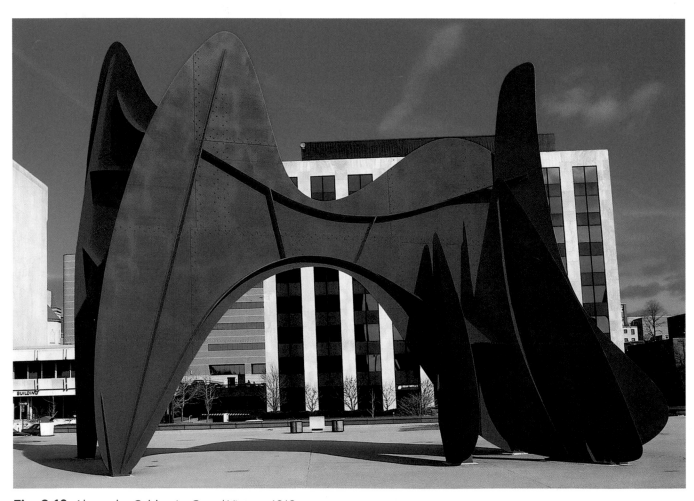

Fig. 3-10 Alexander Calder, *La Grand Vitesse*, 1969.
Painted steel plate, 43 × 55 ft. Calder Plaza, Vandenberg Center, Grand Rapids, Michigan.

PUBLIC SCULPTURE

To value art for art's sake is to value it as an aesthetic object, to value the beauty of its forms rather than its functional practicality or its impact on social life. The NEA assumed, however, that teaching people to appreciate art would enhance the social life of the nation. Public art, the Endowment believed, would make everyone's lives better by making the places in which we live more beautiful, or at least more interesting. The public sculpture considered in this section tests this hypothesis.

Richard Serra's controversial *Tilted Arc* (**Fig. 3-11**) was received far less enthusiastically than Calder's *Grand Vitesse*. When it was originally installed in 1981 on Federal Plaza in Lower Manhattan, there was only a minor flurry of negative reaction. However, beginning in March 1985, William Diamond, newly appointed Regional Administrator of the General Services Administration, which had originally commissioned the piece, began an active campaign to have it removed. At the time, nearly everyone believed that the vast majority of people working in the Federal Plaza complex despised the work. In fact, of the approximately 12,000 employees in the complex, only 3,791 signed the petition to have it removed, while nearly as many—3,763—signed a petition to save it. Yet the public perception was that the piece was "a scar on the plaza" and "an arrogant, nose-thumbing gesture," in the words of one observer. Selections from the testimony at a hearing to have the sculpture removed, including Serra's own defense of the piece, are included in an excerpt from the video *The Trial of the Tilted Arc*, on myartslab.com. Finally, during the night of March 15, 1989, against the artist's vehement protests and after he had filed a lawsuit to block its removal, the sculpture was dismantled and its parts stored in a Brooklyn warehouse. It has subsequently been destroyed.

From Serra's point of view, *Tilted Arc* was destroyed when it was removed from Federal Plaza. He had created it specifically for the site, and once removed, it lost its reason for being. In Serra's words: "Site-specific works primarily engender a dialogue with their surroundings. . . . It is necessary to work in opposition to the constraints of the context, so that the work cannot be read as an affirmation of questionable ideologies and political power." Serra intended his work to be confrontational. It was political. That is, he felt that Americans were divided from their government, and the arc divided

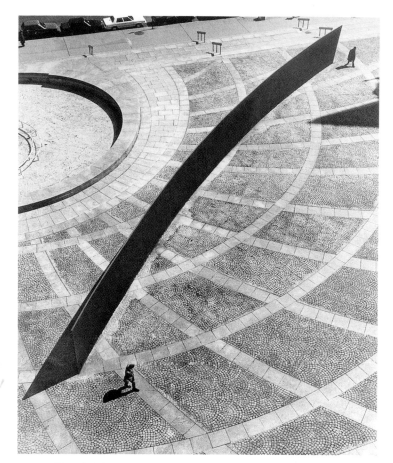

Fig. 3-11 Richard Serra, *Tilted Arc*, 1981.
Cor-Ten steel, 12 ft. × 120 ft. × 2½ in. Installed, Federal Plaza, New York City. Destroyed by the U.S. government March 15, 1989.
© 2012 Richard Serra / Artists Rights Society (ARS), New York.

◉—⌐**Watch** a video about the *Tilted Arc* trial onmyartslab.com

the plaza in the same way. Its tilt was ominous—it seemed ready to topple over at any instant. Serra succeeded in questioning political power probably more dramatically than he ever intended, but he lost the resulting battle. He made his intentions known and understood, and the work was judged as fulfilling those intentions. But those in power judged his intentions negatively, which is hardly surprising, considering that Serra was challenging their very position and authority.

One of the reasons that the public has had difficulty, at least initially, accepting so many of the public art projects that have been funded by both the NEA and percent-for-art programs is that they have not found them to be aesthetically pleasing. The negative reactions to Serra's arc are typical. If art must be beautiful, then Serra's work was evidently not a work of art, at least not in the eyes of

the likes of William Diamond. And yet, as the public learned what the piece meant, many came to value the work, not for its beauty but for its insight, for what it revealed about the place they were in. Serra's work teaches us a further lesson about the value of art. Once public art becomes activist, promoting a specific political or social agenda, there are bound to be segments of the public that disagree with its point of view.

A classic example is Michelangelo's *David* (**Fig. 3-12**). Today, it is one of the world's most famous sculptures, considered a masterpiece of Renaissance art. But it did not meet with universal approval when it was first displayed in Florence, Italy, in 1504. The sculpture was commissioned three years earlier, when Michelangelo was 26 years old, by the Opera del Duomo ("Works of the Cathedral"), a group founded in the thirteenth century to look after the Florence cathedral and to maintain works of art. It was to be a public piece, originally designed for the Duomo itself, but eventually determined to be better suited for outdoor display in the Piazza della Signoria, the plaza where public political meetings took place on a raised platform called the *arringhiera* (from which the English word "harangue" derives). Its political context, in other words, was clear. It represented David's triumph over the tyrant Goliath and was meant to symbolize Republican Florence—the city's freedom from foreign and papal domination, and from the rule of the Medici family as well.

The *David* was, as everyone in the city knew, a sculptural triumph in its own right. It was carved from a giant 16-foot-high block of marble that had been quarried 40 years earlier. Not only was the block riddled with cracks, forcing Michelangelo to bring all his skills to bear, but earlier sculptors, including Leonardo da Vinci, had been offered the problem stone and refused.

When the *David* was finished, in 1504, the process of moving it to the *arringhiera* began at eight in the evening. It took 40 men four days to move it the 600 yards to the Piazza della Signoria. It required another 20 days to raise it onto the *arringhiera*.

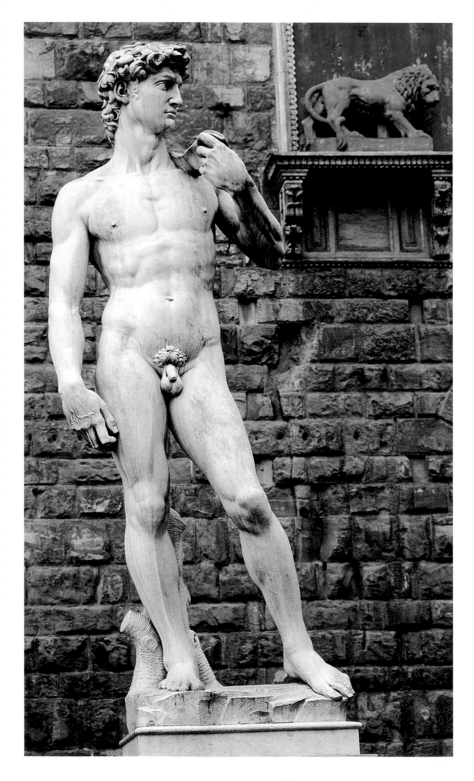

Fig. 3-12 Michelangelo, *David*, 1501–1504.
Copy of the original as it stands in the Piazza dellaSignoria, Florence. Original in the Galleria dell'Accademia, Florence. Marble, height 13 ft. 5 in.
© Bill Ross / Corbis.

The entire time, its politics hounded it. Each night, stones were hurled at it by supporters of the Medici, and guards had to be hired to keep watch over it. Inevitably, a second group of citizens objected to its nudity, and before its installation a skirt of copper leaves was prepared to spare the general public any possible offense. Today, the skirt is long gone. By the time the Medici returned to power in 1512, the *David* was a revered public shrine, and it remained in place until 1873, when it was replaced by a copy (as reproduced here in order to give the reader a sense of its original context) and moved for protection from a far greater enemy than the Medici—the natural elements themselves. Michelangelo's *David* suggests another lesson about the value of art. Today, we no longer value the sculpture for its politics but rather for its sheer aesthetic beauty and accomplishment. It teaches us how important aesthetic issues remain, even in the public arena.

THE "OTHER" PUBLIC ART

Public art has been associated particularly with sculptural works. Whatever social issues or civic pride they may symbolize, there are kinds of public art that are designed to have direct impact on our lives. For example, in their 1994 piece *The Cruci-fiction Project* (**Fig. 3-13**), performance artists Guillermo Gómez-Peña and Roberto Sifuentes crucified themselves for three hours on 16-foot-high crosses at Rodeo Beach, in front of San Francisco's Golden Gate Bridge (for discussion of two other pieces by Gómez-Peña, see *The Creative Process*, pp. 54-55). "The piece was designed for the media," Gómez-Peña explains, "as a symbolic protest against the xenophobic immigration politics of California's governor Pete Wilson." The artists identified themselves as modern-day versions of Dimas and Gestas, the two small-time thieves who were crucified along with Jesus Christ, and they dressed as Mexican stereotypes: "I was an 'undocumented bandido,' crucified by the INS [Immigration and Naturalization Service]," Gómez-Peña recalls, "and Roberto was a generic 'gang-member,' crucified by the LAPD [Los Angeles Police Department]." Gómez-Peña describes what happened at the performance:

> Our audience of over 300 people each received a handout, asking them to "free us from our martyrdom as a gesture of political commitment." However, we had miscalculated their response. Paralyzed by

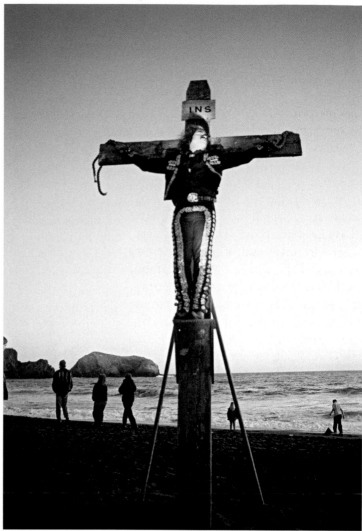

Fig. 3-13 Guillermo Gómez-Peña and Roberto Sifuentes, *The Cruci-fiction Project*, 1994.
Site-specific performance, Marin headlands, California.
Photo: Victor Zaballa. Courtesy Headlands Center for the Arts.

> the melancholia of the image, it took them over three hours to figure out how to get us down. By then, my right shoulder had become dislocated and Roberto had passed out. We were carried to a nearby bonfire and nurtured back to reality, while some people in the crowd rebuked those who were trying to help us, saying, "Let them die!"

> Photographs of the event were quickly picked up by the media, and the piece became international news. The image appeared in, among other publications, Der Spiegel (Germany), Cambio 16 (Spain), Reforma and La Jornada (Mexico), and various U.S. newspapers. The photos have since reappeared in major news media and art publications as the debates on immigration and arts funding continue to be the focus of the political right.

THE CREATIVE PROCESS

In his work, Mexican artist and activist Guillermo Gómez-Peña has chosen to address what he considers to be the major political question facing North America—relations between the United States and Mexico. For him, the entire problem is embodied in the idea of the "border." As the border runs from the Gulf of Mexico up the Rio Grande, it has a certain geographical reality, but as it extends west from Texas, across the bottom of New Mexico, Arizona, and California, its arbitrary nature becomes more and more apparent until, when it reaches the Pacific Ocean between San Diego and Tijuana, it begins to seem patently absurd. Gómez-Peña's work dramatizes how the geographical pseudo-"reality" of the border allows us, in the United States, to keep out what we do not want

to see. The "border" is a metaphor for the division between ourselves and our neighbors, just as the difference in our national languages, English and Spanish, bars us from understanding one another. Gómez-Peña's work is an ongoing series of what he calls "border crossings," purposeful transgressions of this barrier.

Gómez-Peña asks his audience in the United States to examine its own sense of cultural superiority. He laces all his performances with Spanish in order to underscore to his largely English-speaking audience members that he, the Mexican, is bilingual, and they are not. In one of his most famous pieces, *Two Undiscovered Amerindians* (**Fig. 3-14**), a collaboration with Coco Fusco, he and Fusco dressed as recently discovered, wholly uncivilized "natives" of the fictitious

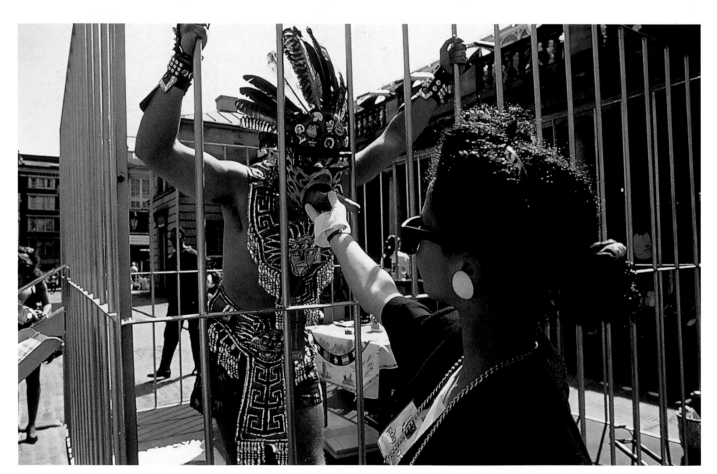

Fig. 3-14 Guillermo Gómez-Peña and Coco Fusco, *Two Undiscovered Amerindians Visit London*, May 1992.
Site-specific performance, London, England.
Photograph by Peter Barker.

island of Guatinaui in the middle of the Gulf of Mexico. At places such as the Walker Art Center in Minneapolis, Columbus Plaza in Madrid, Spain, and in London, England, they performed, in their own words, "authentic and traditional tasks, such as writing on a laptop computer, watching television, sewing voodoo dolls, and doing exercise." Audience members could pay for "authentic" dances or for Polaroid snapshots. To the artists' astonishment, nearly half of the audience members assumed that they were real, and huge numbers of people didn't find the idea of supposed natives locked in a cage as part of an "art" or "anthropological" exhibit objectionable or even unusual. The project pointed out just how barbaric the assumptions of Western culture can be.

Another ongoing performance and installation work is titled *The Temple of Confessions*

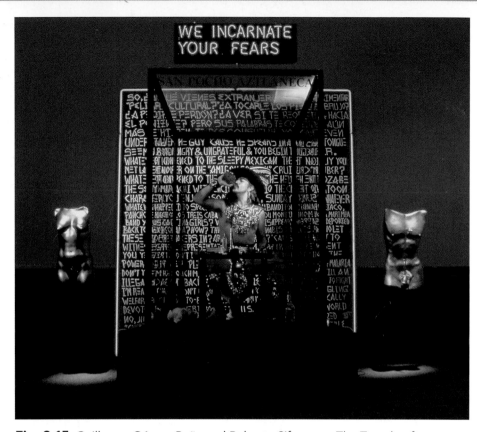

Fig. 3-15 Guillermo Gómez-Peña and Roberto Sifuentes, *The Temple of Confessions*, 1994.
Site-specific performance, Detroit Institute of the Arts, 1994.
Photograph by Dirk Bakker.

(**Fig. 3-15**). Gómez-Peña and Roberto Sifuentes exhibit themselves, for five to seven hours a day, inside Plexiglas booths. Sifuentes's arms and face are painted with tattoos, his bloody T-shirt is riddled with bullet holes. He shares his booth with 50 cockroaches, a four-foot iguana, and what appear to be real weapons and drug paraphernalia. In his own booth, Gómez-Peña sits on a toilet (or wheelchair), dressed as what he calls a "curio shop shaman." Hundreds of souvenirs hang from his chest and waist. He shares his box with live crickets, stuffed animals, tribal musical instruments, and a giant ghetto blaster. A violet neon light frames the entire altar, and a highly "techno" soundtrack plays constantly.

In front of each booth, there is a church kneeler with a microphone to allow audience members to confess their "intercultural fears and desires." At least a

third of all visitors eventually do so. Gómez-Peña describes the effect: "Emotions begin to pour forth from both sides. Some people cry, and in doing so, they make me cry. Some express their sexual desire for me. Others spell their hatred, their contempt, and their fear. . . . The range goes from confessions of extreme violence and racism toward Mexicans and other people of color, to expressions of incommensurable tenderness and solidarity with us. Some confessions are filled with guilt, or with fear of invasion, violence, rape, and disease. Others are fantasies about wanting to be Mexican or Indian, or vice versa: Mexicans and Latinos suffused in self-hatred wanting to be Anglo, Spanish, or 'blond.'" At night, after each performance, Sifuentes and Gómez-Peña listen to tapes of all the confessions of the day. The most revealing ones are edited and incorporated into the installation soundtrack.

Fig. 3-16 Krzysztof Wodiczko, *Homeless Vehicle*, 1988.
Preliminary drawing showing vehicle in washing, sleeping, and resting position (day).
Courtesy of the artist and Gallery Lelong, New York.

Fig. 3-17 Krzysztof Wodiczko, *Homeless Vehicle* in New York City, 1988–1989.
Color photograph.
Courtesy of the artist and Gallery Lelong, New York.

The Cruci-fiction Project was designed to draw public attention to immigration issues in California. The work of artist Krzysztof Wodiczko embodies this activist direction in art. His *Homeless Vehicle* (**Figs. 3-16** and **3-17**), is a shopping cart representing the very opposite of Sylvie Fleury's (see Fig. 3-1), which opened this chapter. Wodiczko, who had fled Poland in 1984 and had lived in the United States for only four years, was appalled during the winter of 1987–88 that an estimated 70,000 people were homeless in New York City alone. While he felt that "the fact that people are compelled to live on the streets is unacceptable," he also proposed to do something about it. Given the failure of the city's shelter system, he asked himself, "What can we do for individuals struggling for self-sufficiency on the streets today?" His solution was a vehicle for the homeless. As ingenious as the vehicle itself is, providing a level of safety and some creature comforts on the streets, Wodiczko's project is also motivated by more traditional issues. He draws attention to what the viewer has failed, or refused, to see, and thus attempts "to create a bridge of empathy between homeless individuals and observers." As he says in the video *Peace*, "We must sustain a certain kind of adversarial life in which we are struggling with our problems in public."

👁—**Watch** a video of Krzysztof Wodiczko on myartslab.com

THINKING BACK

✔—**Study** and review on myartslab.com

How does the public tend to receive innovative art?

The public tends to receive innovative artwork with reservation because it usually has little context by which to understand and appreciate it. It is difficult to value that which is not understood. Why did a significant segment of the public have difficulty appreciating Edouard Manet's *Luncheon on the Grass* (*Le Déjeuner sur l'herbe*)? How did the public respond to Maya Ying Lin's *Vietnam Memorial*?

What was the purpose of the Arts in Public Places program?

The National Endowment for the Arts (NEA) created an Arts in Public Places Program that usually required 1 percent of the cost of new public buildings to be dedicated to art for their public spaces. This broadened the audience of art and brought artists into the role of educating the general public about the value of art. How did the public typically receive works commissioned by the Arts in Public Places Program? How was Richard Serra's *Tilted Arc* received when it was installed on Federal Plaza in Manhattan?

What constitutes the activist direction in public art?

Public artworks often directly impact our daily lives. Many artists use the public context for activist goals, addressing social and political issues. What issues do Guillermo Gómez-Peña and Roberto Sifuentes address in their work The *Cruci-fiction Project*? How does Krzysztof Wodiczko use sculpture to convey an activist concern with homelessness?

THE CRITICAL PROCESS

Thinking about the Value of Art

In December 1977, outside the Los Angeles City Hall, Suzanne Lacy and Leslie Labowitz staged a collaborative performance piece entitled *In Mourning and in Rage* to protest violence against women in America's cities (**Fig. 3-18**). To ensure media coverage, the performance was timed to coincide with a Los Angeles city council meeting. Ten women stepped from a hearse wearing veils draped over structures that, headdress-like, made each figure seven feet tall. Representing the 10 victims of the Hillside Strangler, a serial killer then on the loose in Los Angeles, each of the figures, in turn, addressed the media. They linked the so-called Strangler's crimes to a national climate of violence against women and the sensationalized media coverage that supports it. As Lacy and Labowitz have explained: "The art is in making it compelling; the politics is in making it clear. . . . *In Mourning and in Rage* took this culture's trivialized images of mourners as old, powerless women and transformed them into commanding seven-foot-tall figures angrily demanding an end to violence against women." To maximize the educational and emotional impact of the event, the performance itself was followed up by a number of talk show

Fig. 3-18 Suzanne Lacy and Leslie Labowitz, *In Mourning and in Rage*, 1978.
Holly Near singing "Fight Back" on the steps of L.A. City Hall.
Photo by Maria Karras. Courtesy Suzanne Lacy.

appearances and activities organized in conjunction with a local rape hot line.

Since then, Lacy has continued to pursue this kind of art. One of the most visually spectacular of her works is *Whisper, the Waves, the Wind* (**Fig. 3-19**), a performance tableau in which 154 women over the age of 65 proceeded through an audience of 1,000 and down steep stairs to two beach coves situated back-to-back in La Jolla, California, to sit around white cloth-covered tables and talk about their lives, their relationships, their hopes, and their fears. In the middle of the performance, the audience was invited onto the beach to listen close at hand. The piece was motivated by several salient facts: By the year 2020, one of every five people in the United States will be over 65; this population will be predominantly female and single; and today women account for nearly 75 percent of the aged poor. For Lacy, the performance reinforced the strong spiritual and physical beauty of older women. Lacy says, "They reminded me of the place where the ocean meets shoreline. Their bodies were growing older, wrinkled. But what I saw was the rock in them; solid, with the presence of the years washing over them." The monetary value of this piece is unquantifiable, but what other values does it possess? Judging from the photograph of the performance, what aesthetic qualities of the work reinforce Lacy's comment on its symbolic nature?

Fig. 3-19 Suzanne Lacy, *Whisper, the Waves, the Wind*, 1984.
Site photograph of a performance in the Whisper Projects.
Courtesy Suzanne Lacy.

Thinking Thematically: See Art and the Passage of Time on myartslab.com

4 | Line

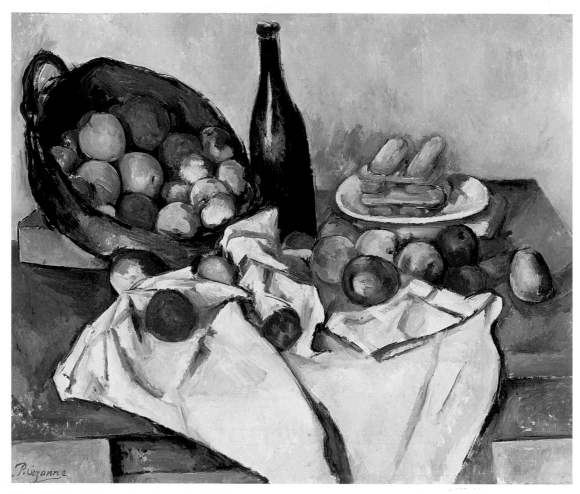

Fig. 4-1 Paul Cézanne, *The Basket of Apples*, c. 1895.
Oil on canvas, 21⁷/₁₆ × 31¹/₂ in. The Art Institute of Chicago. Helen Birch Bartlett Memorial Collection.
1926.252.
© The Art Institute of Chicago.

THINKING AHEAD

What is a contour line?

What are some of the functions and qualities of line?

How do arrangements that stress horizontal and vertical lines tend to differ from those defined by expressive lines?

((•●[Listen to the chapter audio on myartslab.com

Paul Cézanne's *The Basket of Apples* (**Fig. 4-1**) is a still life, but it is also a complex arrangement of visual elements: lines and shapes, light and color, space, and, despite the fact that it is a "still" life, time. Upon first encountering the painting, most people sense immediately that it is full of what appear to be visual "mistakes." The edges of the table, both front and back, do not line up. The wine bottle is tilted sideways, and the apples appear to be spilling forward, out of the basket, onto the white

A LINE MADE BY WALKING

ENGLAND 1967

Fig. 4-2 Richard Long, *A Line Made by Walking*, 1967.
Photograph and pencil on board, 14¹/₂ × 12³/₄ in. Tate, London, purchased 1976 P07149.
© Tate London 2012

Thinking Thematically: See Art, Science, and the Environment on myartslab.com

napkin, which in turn seems to project forward, out of the picture plane. Indeed, looking at this work, one feels compelled to reach out and catch that first apple as it rolls down the napkin's central fold and falls into our space.

However, Cézanne has not made any mistakes at all. Each decision is part of a strategy designed to give back life to the "still life"—which in French is called *nature morte*—"dead nature." He wants to animate the picture plane, to make its space dynamic rather than static, to engage the imagination of the viewer. He has taken the visual elements of line, space, and texture, and has deliberately manipulated them as part of his composition, the way he has chosen to organize the canvas. As we begin to appreciate how the visual elements routinely function—the topic of this and the next four chapters—we will better appreciate how Cézanne manipulates them to achieve the wide variety of effects in this still life.

Varieties of Line

One of the most fundamental elements of art is **line**. To draw a line, you move the point of your pencil across paper. To follow a line, your eye moves as well. Lines seem to possess direction—they can rise or fall, head off to the left or to the right, disappear in the distance. Lines can divide one thing from another, or they can connect things. They can be thick or thin, long or short, smooth or agitated. Lines also reflect movement in nature. The patterns of animal and human movement across the landscape are traced in paths and roadways. Richard Long's *A Line Made by Walking* (**Fig. 4-2**) is literally a path made by walking back and forth across a field in the west of England until the grass was matted down. Long photographed the line, and then departed. The grass soon returned to its natural state, and the field seemed once again untouched. Long's work—both the action of walking and the photographic documentation of his

walking—underscores just how easily mankind can impact the environment, as well as the fragility and restorative power of nature itself.

The flow of water from mountaintop to sea follows the lines etched in the landscape by streams and rivers. An example is a line of hazel leaves that Andy Goldsworthy, a British artist who experiments with the movement of line in art and nature through sculptural works that are constructed entirely out of natural materials, stitched together with grass stalks, shaped into a spiral, and placed in a pool in a small stream in southern Scotland (**Fig. 4-3**). The path of a similar work is recorded in the documentary *Rivers and Tides* (2001). In the film, we see the current take hold of the outer end of the spiral and pull it downstream. As it unfurls in the pool, a long line of hazel leaves undulates downstream on the current. Eventually, parts of the green line are caught on rocks and debris. The leaves break apart, caught in this swirl or that, until the piece's journey is over. Like Long's *Line Made by Walking*, Goldsworthy's changeable and impermanent lines are a metaphor for human life, both the paths of our personal lives and the "time line" of human history.

Lines, in fact, sometimes play a major role in human history, delineating city limits, county lines, and state and national borders. In 2004, Belgium-born artist Francis Alÿs, who has lived in Mexico City since the mid-1980s, walked through Jerusalem dripping a line of green paint from a can along the armistice border established by the United Nations after the 1948 Arab–Israeli war and known as "the Green Line" (**Fig. 4-4**). The Green Line, which was created by Israeli general Moshe Dayan, essentially divided Jerusalem in half—Israel getting the western side, Arabs the east. In the 1967 war, Israel captured all of Jerusalem, in essence causing the boundary to disappear. But recent

Fig. 4-3 Andy Goldsworthy, *Hazel Leaves (each stitched to next with grass stalks/gently pulled by the river/out of a rock pool/floating downstream/low water)*, Scaur Water, Dumfriesshire, June 5, 1991.
© Andy Goldsworthy, courtesy Galerie Lelong, New York.

Thinking Thematically: See Art, Science, and the Environment on myartslab.com

peace negotiations between the Palestinians and Israelis have underscored the continuing relevance of the Green Line's role in cultural self-determination. Subtitled *Sometimes doing something poetic can become political and sometimes doing something political can become poetic*, *The Green Line* questions the boundaries not only between Israel and Palestine, but the more conceptual line between the poetic imagination and actual politics. Alÿs's website, www.francisalys.com, features 19 public-domain videos. Although the video of *The Green Line* is not among them, a video of a work which anticipates it is available—*The Leak*, a 1995 action in São Paolo, Brazil, in which he walked from a gallery, around the city, and back into the gallery trailing a dribbled line from an open can of blue paint.

Fig. 4-4 Francis Alÿs (in collaboration with Julien Devaux), *The Green Line (Sometimes doing something poetic can become political and sometimes doing something political can become poetic)*, Jerusalem, 2004. Video documentation of an action. Image: Julien Devaux.

Video projection, 2 hard drives, touch screen, 5 mdf tables, 10 lamps, framed map, works on paper, photocollages, 1 painting, 1 wood gun sculpture.
Courtesy David Zwirner Gallery, New York.

OUTLINE AND CONTOUR LINE

An important feature of line is that it indicates the edge of a two-dimensional (flat) shape or a three-dimensional form. A shape can be indicated by means of an **outline**, as in Jaune Quick-to-See Smith's *House* (**Fig. 4-5**), and a three-dimensional form can be indicated by **contour lines**, as in Henri Gaudier-Brzeska's *Female Nude Back View* (**Fig. 4-6**).

In Smith's painting, a black outline in the shape of an Indian tipi establishes her subject for the viewer. By stenciling the word "House" on the image, she reminds us of the difference between her mental image of a house as a Native American artist and our own. Pasted into the painting are a number of purposefully ironic messages: "Remember How Much Easier a Home Came Together When You Didn't Have to Choose Carpet"; "All Sunrooms Are Not Created Equal"; "Some Children Lead a Very Sheltered Life"; "Room for Two"; and, perhaps most tellingly, "'Tis a Gift to Be Simple." Smith's simple outline drawing, in other words, underscores with some real nostalgia the

Fig. 4-6 Henri Gaudier-Brzeska (1891–1915), *Female Nude, Back View*, c. 1912.
Drawing, pen and blue ink on off-white wove paper, 14⅝ × 10 in. (37.1 × 25.4 cm) Princeton University Art Museum. Bequest of Dan Fellows Platt, Class of 1895. × 1948-137
Photo: Bruce M. White.

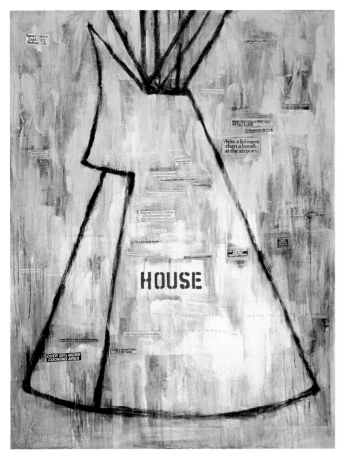

Fig. 4-5 Jaune Quick-to-See Smith, *House*, 1995. 80″ × 60″. Acrylic and mixed media on canvas, 6 ft. 8 in. × 5 ft.
Courtesy of Jaune Quick-to-See Smith.

✳ ▔**Explore** a Discovering Art tutorial about the uses of line on myartslab.com

simplicity of a traditional Native American lifestyle still enjoyed by many families on Smith's reservation when, in the summer, they erect tipis behind their houses or cabins for cool summer sleeping.

The contour lines in Gaudier-Brzeska's drawing create the illusion of a body occupying space. Lines at the outside of the form define the limits of our vision—what we can see of the form from our point of view. Lines within the figure suggest the inner curve of elbow, calf, and buttocks. It is as if each line surrounds and establishes a volume.

IMPLIED LINE

If we point our finger at something, we visually "follow" the line between our fingertip and the object in question. Although Alberto Giacometti's sculpture *Man Pointing* (**Fig. 4-7**) points at nothing specific, his gesture does activate the space around it. Like some traffic officer in the middle of an intersection, he seems to command the viewer's space, even as the almost immaterial thinness of his figure suggests his fragility. For Giacometti, this skeletal figure represents the human condition itself, isolated and alone, and yet, somehow, still managing and willing to communicate with the world around it. One of the most powerful kinds of **implied line** is a function of line of sight, the direction the figures in a given composition are looking. In his *Assumption and Consecration of the Virgin* (**Fig. 4-8**), Titian ties together the three separate horizontal areas of the piece—God the Father above, the Virgin Mary in the middle, and the Apostles below—by implied lines that create simple, interlocking, symmetrical triangles (**Fig. 4-9**) that serve to unify the worlds of the divine and the mortal.

Implied line can also serve to create a sense of directional movement and force, as in *Calvary*, a painting by African artist Chéri Samba (**Fig. 4-10**). Samba began his career before he was 20, working as a signboard painter and newspaper cartoonist in Kinshasa, the capital of Zaire. With their bold shapes and captions (in French and Langala, Zaire's official language), they are, in essence, large-scale political cartoons. *Calvary* places the artist in the position of Christ, not on the cross but splayed out on the ground, a martyr. He is identified as "le peintre," the painter, on the back of his shirt. He lies prostrate before "the house of painting," so identified over the doorway. He is being beaten by three soldiers, identified on the back of one as agents of the Popular Church of Zaire. The caption at the top left reads: "The Calvary of a painter in a country where the rights of man are practically nonexistent." Here implied lines arc over the artist—the imminence of the downward thrust of the soldiers' whips—and the political power of the image rests in the visual anticipation of terror that these implied lines convey.

Qualities of Line

Line delineates shape and form by means of outline and contour line. Implied lines create a sense of enclosure and connection as well as movement and direction. But line also possesses certain intellectual, emotional, and expressive qualities.

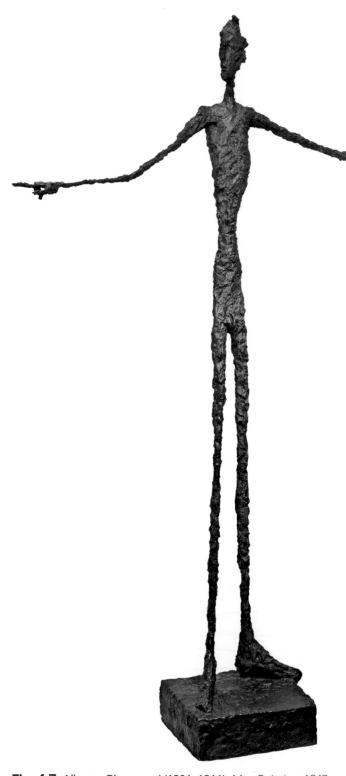

Fig. 4-7 Alberto Giacometti (1901–1966), *Man Pointing*, 1947. Bronze, 70$^1/2$ × 40$^3/4$ × 16$^3/8$ in. at base, 12 × 13 1/4". Museum of Modern Art, New York, NY, U.S.A. Mrs. John D. Rockefeller 3rd. (678.1954)
© 2008 Artists Rights Society (ARS), New York / ADAGP, Paris.

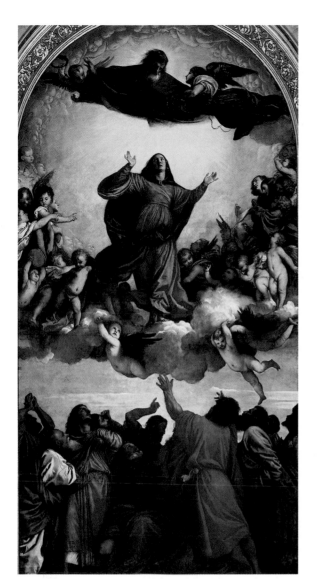

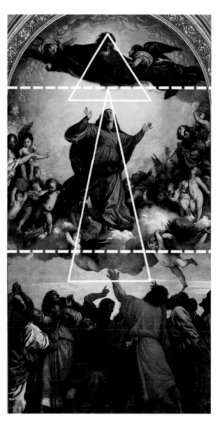

Fig. 4-8 Titian, *Assumption and Consecration of the Virgin*, c. 1516–18.
Oil on wood, 22½ × 11⅘ ft. Santa Maria Gloriosa dei Frari, Venice.
Scala / Art Resource, NY.

Fig. 4-9 Line analysis of Titian, *Assumption and Consecration of the Virgin*, c. 1516–18.
Oil on wood, 22½ × 11⅘ ft. Santa Maria Gloriosa dei Frari, Venice.
Scala / Art Resource, NY.

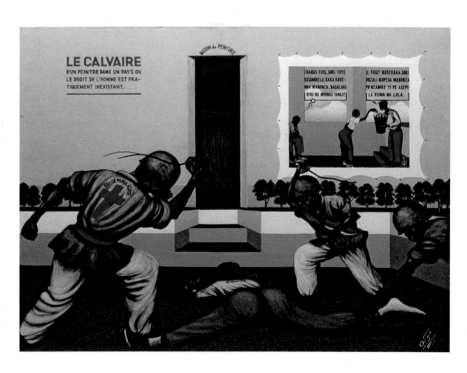

Fig. 4-10 Chéri Samba, *Calvary* (Le Calvaire), 1992.
Acrylic on canvas, 35 × 45⅝ in.
Photo courtesy Annina Nosei Gallery, New York/
© Cheri Samba. Courtesy CAAC.

Thinking Thematically: See **Art, Politics, and Community** on myartslab.com

Fig. 4-11 Pat Steir, *Drawing Lesson, Part I, Line #1*, 1978. Drypoint with aquatint, from a portfolio of 7 etchings, each 16 × 16 in., edition of 25.
Published by Crown Point Press, San Francisco.

In a series of seven works entitled *Drawing Lesson, Part I, Line #1*, Pat Steir has created what she calls "a dictionary of marks," derived from the ways in which artists whom she admires employ line. Each pair of works represents a particular intellectual, emotional, or expressive quality of line. One pair, of which **Fig. 4-11** is an example, refers to the work of Rembrandt, particularly to the kinds of effects Rembrandt achieved in works like *The Three Crosses* (**Fig. 4-12**). The center square of Steir's piece is a sort of "blow-up" of Rembrandt's basic line; the outside frame shows the wide variety of effects achieved by Rembrandt as he draws this line with greater or lesser density. Rembrandt's lines seem to envelop the scene, shrouding it in a darkness that moves in upon the crucified Christ like a curtain closing upon a play or a storm descending upon a landscape. Rembrandt's line—and Steir's too—becomes more charged emotionally as it becomes denser and darker.

A second pair of Steir's "drawing lessons" is even more emotionally charged. In the center

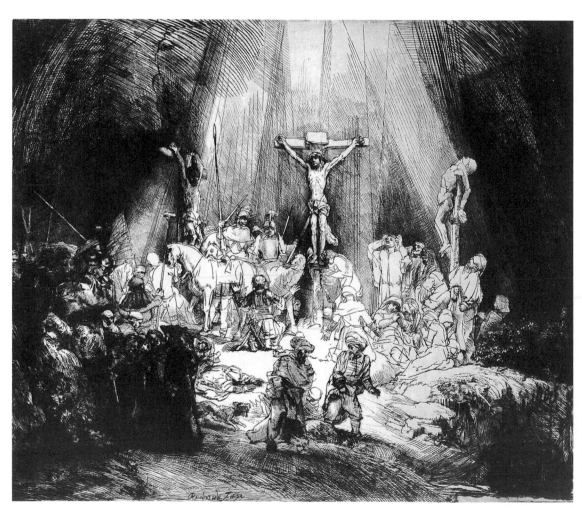

Fig. 4-12
Rembrandt van Rijn, *The Three Crosses*, 1653.
Etching,
15¼ × 17¾ in.

Thinking Thematically: See Art and the Passage of Time on myartslab.com

Fig. 4-13 Pat Steir, *Drawing Lesson, Part I, Line #5*, 1978.
Sugar lift aquatint with soft ground etching from a portfolio of 7 etchings, each 16 × 16 in., edition of 25.
Published by Crown Point Press, San Francisco.

of **Fig. 4-13** is a dripping line, one of the basic "signatures" of contemporary abstract painting. It indicates the presence of the artist's brush in front of the canvas. Surrounding it is a series of gestures evocative of Vincent van Gogh. Of the swirling turmoil of line that makes up *The Starry Night* (**Fig. 4-14**), van Gogh would write to his brother Theo, "Is it not emotion, the sincerity of one's feeling for nature, that draws us?" Steir has willingly submitted herself to van Gogh's emotion and style. "Getting into his mark," she says, "is like getting onto a merry-go-round, you can't stop. . . . It's like endless movement."

EXPRESSIVE QUALITIES OF LINE

Van Gogh's paintings are, for many, some of the most personally expressive in the history of art. His use of line is loose and free, so much so that it seems almost out of control. It remains, nevertheless, consistent enough that it is recognizably van Gogh's. It has become, in this sense, *autographic*. Like a signature, it identifies the artist himself, his deeply anguished and creative genius (see *The Creative Process*, p. 66).

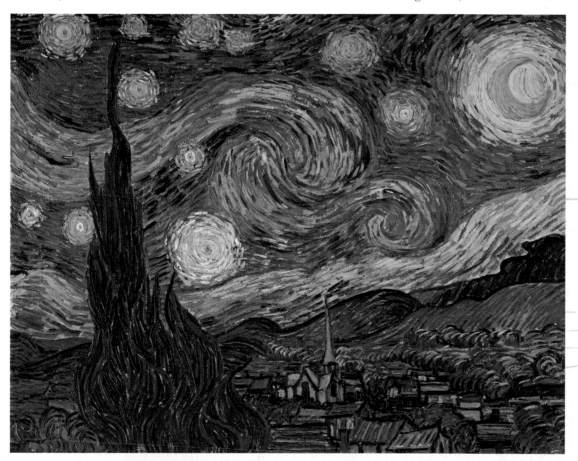

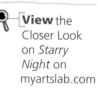

View the Closer Look on *Starry Night* on myartslab.com

Fig. 4-14 Vincent van Gogh (1853–1890), *The Starry Night*, 1889.
Oil on canvas, 29 × 36¹/₄ in. The Museum of Modern Art, New York, NY, U.S.A. Acquired through the Lillie P. Bliss Bequest. (472.1941).
Digital Image © The Museum of Modern Art / Licensed by Scala / Art Resource, New York.

Thinking Thematically: See Art, Gender, and Identity on myartslab.com

We know more about the genesis and development of *The Sower* than about any of Vincent van Gogh's other paintings, and we can follow the work's progress in some detail. There are four different descriptions of it in his letters, the first on June 17, 1888, in a letter to Austrian painter John Russell (**Fig. 4-15**) that includes a preliminary sketch of his idea. "Am working at a Sower," van Gogh writes in the letter, "the great field all violet the sky & sun very yellow. It is a hard subject to treat."

The difficulties he was facing in the painting were numerous, having particularly to do with a color problem. At sunset, he wrote in a letter to the painter Emile Bernard on the very next day, June 18, Van Gogh was faced with a moment when the "excessive" contrast between the yellow sun and the violet shadows on the field would necessarily "irritate" the beholder's eye. He had to be true to that contrast and yet find a way to soften it. For approximately eight days he worked on the painting. First, he tried making the sower's trousers white in an effort to create a place in the painting that would "allow the eye to rest and distract it." That strategy apparently failing, he tried modifying the yellow and violet areas of the painting. On June 26, he wrote to his brother Theo: "Yesterday and today I worked on the sower, which is completely recast. The sky is yellow and green, the ground violet and orange." This plan succeeded (**Fig. 4-16**). Each area of the painting now contained color that connected it to the opposite area, green to violet and orange to yellow.

The sower was, for van Gogh, the symbol of his own "longing for the infinite," as he wrote to Bernard, and having finished the painting, he remained, in August, still obsessed with the image. "The idea of the Sower continues to haunt me all the time," he wrote to Theo. In fact, he had begun to think of the finished painting as a study that was itself a preliminary work leading to a drawing (**Fig. 4-17**). "Now the harvest, the Garden, the Sower . . . are sketches after painted studies. I think all these ideas are good," he wrote to Theo on August 8, "but the painted studies lack clearness of touch. That is [the] reason why I felt it necessary to draw them."

Fig. 4-15 Vincent van Gogh, Letter to John Peter Russell, June 17, 1888.
Ink on laid paper, 8 × 10¼ in. Solomon R. Guggenheim Museum, New York. Thannhauser Collection, Gift, Justin K. Thannhauser, 1978. 78.2514.18.

In the drawing, sun, wheat, and the sower himself are enlarged, made more monumental. The house and tree on the left have been eliminated, causing us to focus more on the sower himself, whose stride is now wider and who seems more intent on his task. But it is the clarity of van Gogh's line that is especially astonishing. Here we have a sort of anthology of line types: short and long, curved and straight, wide and narrow. Lines of each type seem to group themselves into bundles of 5 or 10, and each bundle seems to possess its own direction and flow, creating a sense of the tilled field's uneven but regular furrows. It is as if, wanting to represent his longing for the infinite, as it is contained at the moment of the genesis of life, sowing the field, van Gogh himself returns to the most fundamental element in art—line itself.

Thinking Thematically: See Art and the Passage of Time on myartslab.com

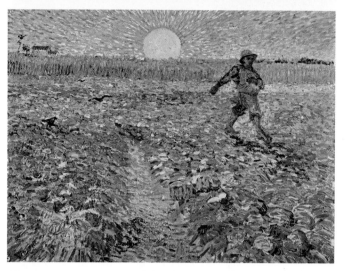

Fig. 4-16 Vincent van Gogh, *The Sower,* 1888. Oil on canvas, 25¼ × 31¾ in. Signed, lower left: Vincent. Collection Kröller-Müller Museum, Otterlo, The Netherlands.

Fig. 4-17 Vincent van Gogh (1853–1890), *The Sower,* 1888. Drawing. Pencil, reed pen, and brown and black ink on wove paper, 9⅝ × 12½ in. Amsterdam, Van Gogh Museum (Vincent van Gogh Foundation).

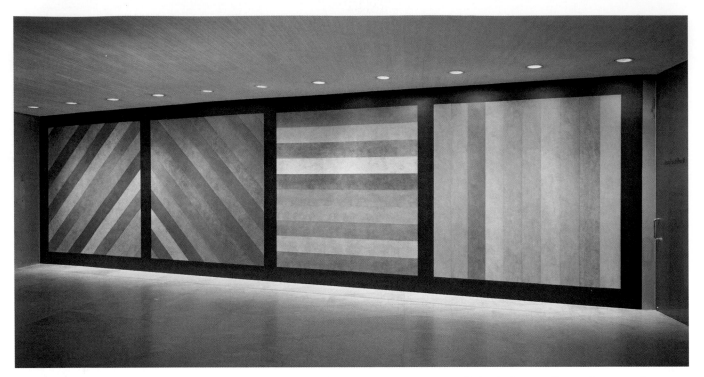

Fig. 4-18 Sol LeWitt (artist), American (1928–2007), *Wall Drawing No. 681 C, A wall divided vertically into four equal squares separated and bordered by black bands. Within each square, bands in one of four directions, each with color ink washes superimposed*, 1993.
Colored ink washes, image (size of installed drawing): 120 × 444 in. (304.8 × 1127.8 cm) The National Gallery of Art, Washington, D.C. Dorothy and Herbert Vogel Collection, 1993.41.1.

During the 15 months just before *Starry Night* was painted, while he was living in the southern French town of Arles, van Gogh produced a truly amazing quantity of work: 200 paintings, more than 100 drawings and watercolors, and roughly 200 letters, mostly written to his brother Theo. Many of these letters help us understand the expressive energies released in this creative outburst. In *Starry Night*, life and death—the town and the heavens—collide, and they are connected by both the church spire and the swaying cypress, a tree traditionally used to mark graves in southern France and Italy. "My paintings are almost a cry of anguish," van Gogh wrote. On July 27, 1890, a little over a year after *The Starry Night* was painted, the artist shot himself in the chest. He died two days later at the age of 37.

Sol LeWitt employs a line that is equally autographic, recognizably his own, but one that reveals to us a personality very different from van Gogh's. LeWitt's line is precise, controlled, mathematically rigorous, logical, and rationally organized, where van Gogh's line is imprecise, emotionally charged, and almost chaotic. One seems a product of the mind, the other of the heart. And while van Gogh's line is produced by his own hand, LeWitt's often is not.

Fig. 4-19 Installation of *Wall Drawing No. 681 C*, August 25, 1993.
National Gallery of Art, Washington, D.C.
Photograph © Board of Trustees, National Gallery of Art, Washington, D.C.

LeWitt's works are usually generated by museum staff according to LeWitt's instructions. Illustrated here is *Wall Drawing No. 681 C* (**Fig. 4-18**), along with two photographs of the staff at the National Gallery of Art installing the work in 1993 (**Fig. 4-19**). If a museum "owns" a LeWitt, it does not own the actual wall drawing but only the instructions on how to make it. Since LeWitt often writes his instructions so that the staff executing the drawing must make its own decisions about the placement and arrangement of the lines, the work has a unique appearance each time that a museum or gallery produces it.

LeWitt's drawings usually echo the geometry of the room's architecture, lending the work a sense of mathematical precision and regularity. But it is probably the **grid**, the pattern of vertical and horizontal lines crossing one another to make squares, that most characteristically dominates compositions of this variety. The grid's geometric regularity lends a sense of order and unity to any composition. Jasper Johns's *Numbers in Color* (**Fig. 4-20**) is a case in point. Johns's brushwork—what we call his gesture—is fluid and loose, yet the grid here seems to contain and control it, to exercise some sort of rational authority over it. The numbers themselves repeat regularly, and like the alphabet, which arbitrarily organizes random elements into a coherent system, they impose a sense of logic where none necessarily exists.

Often artists use both loose and controlled line in the same work. The work of London-born painter Matthew Ritchie is a prime example. Ritchie's project is ambitious and vast. He seeks to represent the entire universe and the structures of knowledge and belief through which we seek to understand it. His work begins with drawings that he scans into a computer. In that environment, he can resize and

Fig. 4-20 Jasper Johns, *Numbers in Color*, 1958–59. Encaustic and newspaper on canvas, 67 × 49 1/2 in. Albright-Knox Art Gallery, Buffalo, New York. Gift of Seymour H. Knox, Jr., 1959. Art.
© Jasper Johns / Licensed by VAGA, New York, NY.

reshape them, make them three-dimensional, take them apart, combine them with other drawings, and otherwise transform them. The drawing is above all linear and charged with a personal symbolism, as he explains:

I use the symbol of the straight line a lot in my drawings and paintings. It usually represents a kind of wound, or a direction. The curved line

is like a linking gesture that joins things. But the straight line is usually more like an arrow, or rein, or a kind of rupture. It reminds me of St. Sebastian [the third century BCE Christian martyr who was tied to a tree, shot with arrows, and left for dead]. Whenever you see an arrow or spear in a painting, it's always much more damaging than it is constructive, whereas the looping sort of curved line is much more generous and inclusive. Often, in my drawings and paintings, you'll see figures being pierced by multiple fates that are sort of embodied in the lines. It's like the lines in your destiny. Who would want a straight-line destiny? It'd be rotten, right?

From the bottom of *No Sign of the World* (**Fig. 4-21**), violet straight lines shoot up into a field of what appear to be broken sticks and branches. Above the horizon line, across the sky, looping lines of this same violet color appear to gather these fragments into circular fields of energy. After 9/11, in fact, Ritchie began to make paintings, in his words, "about figures being reassembled and rebuilt inside the people that had survived." It is as if we are at the dawn of creation, at the scene of some original "big bang."

A painting on the same theme, the creation of the universe, but employing an entirely different character of line, is Hung Liu's *Relic 12* (**Fig. 4-22**). A Chinese-born painter working today in the United States, Hung Liu's work consistently addresses woman's place in both pre- and post-revolutionary China (see *The Creative Process*, pp. 72–73). Here she represents a Chinese courtesan surrounded by symbols from classical Chinese painting, including the circle, or *pi*, the ancient Chinese symbol for the universe, and the butterfly, symbol of change, joy, and love. In front of her, in the red square in the middle of the painting, are Chinese characters representing "female" and "Nu-Wa."

Fig. 4-21 Matthew Ritchie, *No Sign of the World*, 2004.
Oil and marker on canvas, 99 × 154 in. (251.46 × 391.16 cm). ARG # RM2004–001.
Courtesy of Andrea Rosen Gallery, New York.

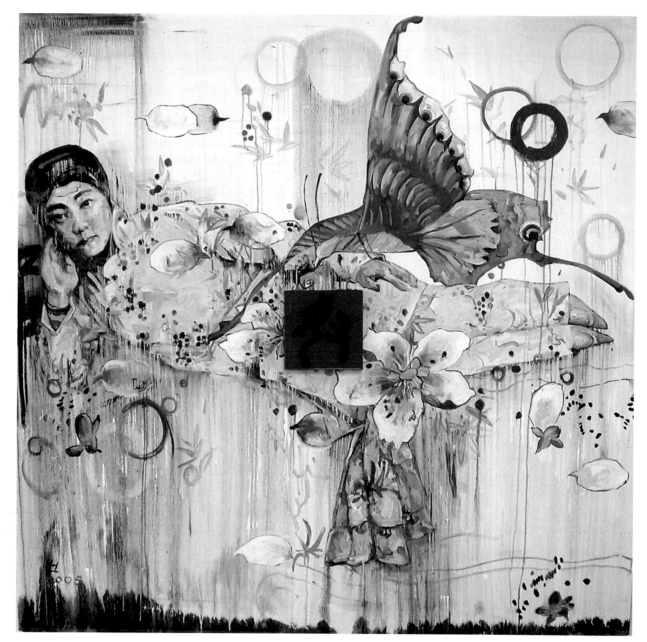

Fig. 4-22 Hung Liu, *Relic 12*, 2005.
Oil on canvas and lacquered wood, 66 × 66 in.
Courtesy of Nancy Hoffman Gallery, New York.

Nu-Wa is the Chinese creation goddess. It was she who created the first humans from the yellow earth, after Heaven and Earth had separated. Since molding each figure individually was too tedious a process, she dipped a rope into mud and then swung it about her, covering the earth around her with lumps of mud. The early handmade figurines became the wealthy and the noble; those that arose from the splashes of mud were the poor and the common. Nu-Wa is worshipped as the intermediary between men and women, as the goddess who grants children, and as the inventor of marriage. Here the soft curves of her figure, and of the butterfly, circles, flowers, and leaves, seem to conspire with the vertical drips of paint that fall softly to the bottom of the canvas like life-giving rain. As opposed to Ritchie's work, in which straight and curved lines contrast with one another, here they seem to work together to create an image of the wholeness and unity of creation.

THE CREATIVE PROCESS

Born in Changchun, China, in 1948, the year that Chairman Mao forced the Nationalist Chinese off the mainland to Taiwan, painter Hung Liu lived in China until 1984. Beginning in 1966, during Mao's Cultural Revolution, she worked for four years as a peasant in the fields. Successfully "re-educated" by the working class, she returned to Beijing where she studied, and later taught, painting of a strict Russian Social Realist style—propaganda portraits of Mao's new society that employed a precise and hard-edged line. But this way of drawing and painting constricted Hung Liu's artistic sensibility. In 1980, she applied for a passport to study painting in the United States, and in 1984 her request was granted. An extraordinarily independent spirit, raised and educated in a society that values social conformity above individual identity, Liu depends as a painter on the interplay between the line she was trained to paint and a new, freer line more closely aligned to Western abstraction but tied to ancient Chinese traditions as well.

During the Cultural Revolution, Liu had begun photographing peasant families, not for herself, but as gifts for the villagers. She has painted from photographs ever since, particularly archival photographs that she has discovered on research trips back to China in both 1991 and 1993. "I am not copying photographs," she explains. "I release information from them. There's a tiny bit of information there—the photograph was taken in a very short moment, maybe 1/100 or 1/150 of a second—and I look for clues. The clues give me an excuse to do things." In other words, for Liu, to paint from a photograph is to liberate something locked inside it. For example, the disfigured feet of the woman in *Virgin/Vessel* (**Fig. 4-23**) are the result of traditional Chinese foot-binding. Unable to walk, even upper-class women were forced into prostitution after Mao's Revolution confiscated their material possessions and left them without servants to transport them. In the painting, the woman's body has become a sexual vessel, like the one in front of her. She is completely isolated and vulnerable.

Three Fujins (**Fig. 4-24**) is also a depiction of women bound by the system in which they live. The Fujins were concubines in the royal court at the end of the nineteenth century. Projecting in front of each of them is an actual birdcage, purchased by Liu in San Francisco's Chinatown, symbolizing the women's spiritual captivity. But even the excessively unified formality of their pose—its perfect balance, its repetitious rhythms—belies their submission to the rule of tyrannical social forces. These women have given up themselves—and made themselves up—in order to fit into their proscribed roles.

Fig. 4-23 Hung Liu, *Virgin/Vessel,* 1990.
Oil on canvas, broom, 72 × 48 in. Collection of Bernice and Harold Steinbaum.
© Hung Liu. Courtesy Bernice Steinbaum Gallery, Miami, FL.

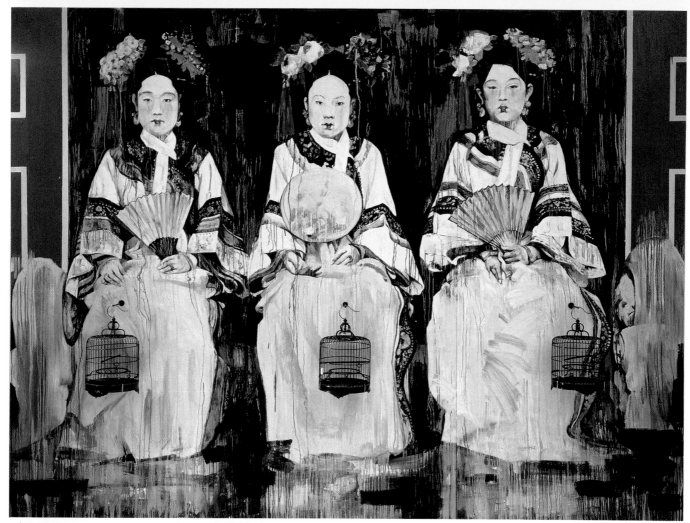

Fig. 4-24 Hung Liu, *Three Fujins*, 1995.
Oil on canvas, bird cages, 96 × 126 × 12 in. Private collection, Washington, D.C.
Photo: Ben Blackwell. Courtesy of Bernice Steinbaum Gallery, Miami, FL.

Liu sees the composition of the image as symbolizing "relationships of power, and I want to dissolve them in my paintings."

Speaking of *Three Fujins*, Liu explains how that dissolution takes place, specifically in terms of her use of line: "Contrast is very important. If you don't have contrast, everything just cancels each other thing out. So I draw, very carefully, and then I let the paint drip—two kinds of contrasting line." One is controlled, the line representing power, and the other is free, liberated. "Linseed oil is very thick," Liu goes on,

"it drips very slowly, sometimes overnight. You don't know when you leave what's going to be there in the morning. You hope for the best. You plant your seed. You work hard. But for the harvest, you have to wait." The drip, she says, gives her "a sense of liberation, of freedom from what I've been painting. I could never have done this work in China. But the real Chinese tradition—landscape painters, calligraphers—are pretty crazy. My drip is closer to the real Chinese tradition than my training. It's part of me, the deeply rooted traditional Chinese ways."

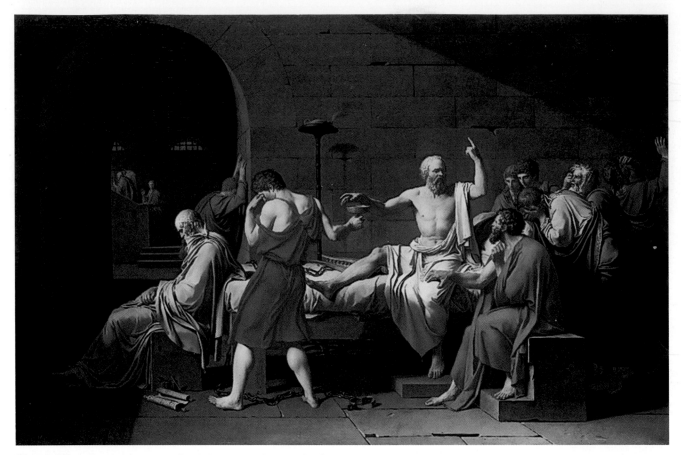

Fig. 4-25 Jacques-Louis David (1748–1825), *The Death of Socrates*, 1787.
Oil on canvas, 51 × 77 ¼ in. (129.5 × 196.2 cm) Signed and dated (lower left) L.D./MDCCLXXXVII; (on bench, at right). L. David. The Metropolitan Museum of Art, New York, NY, U.S.A., Catherine Lorillard Wolfe Collection, Wolfe Fund, 1931 (31.45).

Thinking Thematically: See Art, Politics, and Community on myartslab.com

LINE ORIENTATION

Most viewers react instinctively to the expressive qualities of line, and these expressive qualities are closely associated with their orientation in the composition. Linear arrangements that emphasize the horizontal and vertical possess a certain architectural stability, that of mathematical, rational control. The deliberate, precise arrangement of Jacques-Louis David's *Death of Socrates* (**Fig. 4-25**) is especially apparent in his charcoal study for the painting (**Fig. 4-26**). David portrays Socrates, the father of philosophy, about to drink deadly hemlock after the Greek state convicted him of corrupting his students, the youth of Athens, by his teaching. In the preliminary drawing, David has submitted the figure of Socrates to a mathematical grid of parallels and perpendiculars that survives into the final painting. The body of the philosopher is turned toward the viewer. This frontal pose is at an angle of 90 degrees to the profile poses of most of

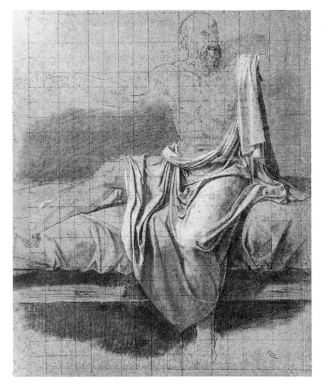

Fig. 4-26 Jacques-Louis David, *Study for the Death of Socrates*, 1787.
Charcoal heightened in white on gray-brown paper, 20 ½ × 17 in. Musée Bonnat, Bayonne, France.
Art Resource, New York.

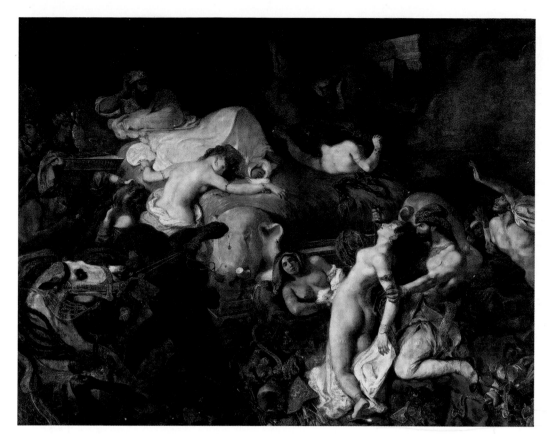

Fig. 4-27 Eugène Delacroix, *The Death of Sardanapalus*, 1827.
Oil on canvas, 12 ft. 1 ½ in. × 16 ft. 2 ⅞ in. (3.69 × 4.95 m). Musée du Louvre, Paris.

Fig. 4-28 Eugène Delacroix, *Study for The Death of Sardanapalus*, 1827–28.
Pen, watercolor, and pencil, 10 ¼ × 12 ½ in. Cabinet des Dessins, Musée du Louvre, Paris. Cliché des Musées Nationaux, Paris.

the other figures in the composition—at a right angle, that is, that corresponds in three dimensions to the two-dimensional grid structure of the composition. Right angles in fact dominate the painting. Socrates, for instance, points upward with his left hand in a gesture that is at a right angle to his shoulders. Notice especially the gridwork of stone blocks that form the wall behind the figures in the final painting. The human body and the drama of Socrates's suicide are submitted by David to a highly rational order, as if to insist on the rationality of Socrates's actions.

The structure and control evident in David's line is underscored by comparing it to Eugène Delacroix's much more emotional and romantic *Study for The Death of Sardanapalus* (**Fig. 4-27**). (The term romantic, often used to describe nineteenth-century art such as Delacroix's, does not refer just to the expression of love, but also to the expression of all feelings and passions.) The finished painting (**Fig. 4-28**) shows Sardanapalus, the last king of the second Assyrian dynasty at the end of the ninth century BCE, who was besieged in his city by an

enemy army. He ordered all his horses, dogs, servants, and wives slain before him, and all his belongings destroyed, so that none of his pleasures would survive him when his kingdom was overthrown. The drawing is a study for the lower corner of the bed, with its elephant-head bedpost, and, below it, on the floor, a pile of jewelry and musical instruments. The figure of the nude leaning back against the bed in the finished work, perhaps already dead, can be seen at the right edge of the study. Delacroix's line is quick, imprecise, and fluid. A flurry of curves and swirls, organized in a diagonal recession from the lower right to the upper left, dominates the study. And this same dynamic quality—a sense of movement and agitation, not, as in David's *Death of Socrates*, stability and calm—is retained in the composition of the final painting. It seems almost chaotic in its accumulation of detail, and its diagonal orientation seems almost dizzyingly unstable. Delacroix's line, finally, is as compositionally disorienting as his subject is emotionally disturbing.

THINKING BACK

✓—[**Study** and review on myartslab.com

What is a contour line?

Line is used to indicate the edge of a two-dimensional (flat) shape or a three-dimensional form. A contour line is the perceived line that marks the border of an object in space. How do contour lines differ from implied lines? What purpose do contour lines serve in Henri Gaudier-Brzeska's *Female Nude Back View*?

What are some of the functions and qualities of line?

Line delineates shape and form by means of outline and contour line. Implied lines create a sense of enclosure and connection as well as movement and direction. Line can also possess intellectual, emotional, and expressive qualities. How does Pat Steir use line in her *Drawing Lesson* series? What does it mean for line to be autographic? What qualities are implied by a grid?

How do arrangements that stress horizontal and vertical lines tend to differ from those defined by expressive lines?

Linear arrangements that emphasize the horizontal and vertical tend to possess an architectural stability. These works tend to be defined by mathematical, rational control and a sense of calm. They differ from those works that stress expressive line, which by contrast, inspires the viewer's instinctive reactions. How does Jacques-Louis David's use of line differ from Eugène Delacroix's? What does the term *romantic* mean when discussing nineteenth-century art?

THE CRITICAL PROCESS
Thinking about Line

Line is, in summation, an extremely versatile element. Thick or thin, short or long, straight or curved, line can outline shapes and forms, indicate the contour of a volume, and imply direction and movement. Lines of sight can connect widely separated parts of a composition and direct the viewer's eye across it. Depending on how it is oriented, line can seem extremely intellectual and rational or highly emotional. It is, above all, the artist's most basic tool.

It should come as no surprise, then, that the biases of our culture are, naturally, reflected in the uses artists make of line. Especially in the depiction of human anatomy, certain cultural assumptions have come to be associated with line. Conventionally, vertical and horizontal geometries have been closely identified with the male form—as in David's *Death of Socrates*. More loose and gestural lines seem less clear, less "logical," more emotional and intuitive, and traditionally have been identified with the female form. In other words, conventional representations of the male

and female nude carry with them recognizably sexist implications—man as strong and rational, woman as weak and given to emotional outbursts.

These conventions have been challenged by many contemporary artists. Compare, for instance, a Greek bronze (**Fig. 4-29**), identified by some as Zeus, king of the Greek gods, and by others as Poseidon, Greek god of the sea, and Robert Mapplethorpe's photograph of Lisa Lyon (**Fig. 4-30**), winner of the First World Women's Bodybuilding Championship in Los Angeles in 1979. The Greek bronze has been submitted to very nearly the same mathematical grid as David's Socrates. The pose that Lyon assumes seems to imitate that of the Greek bronze. In what ways does the orientation of line, in the Mapplethorpe photograph, suggest a feminist critique of Western cultural traditions? How does Lyon subvert our expectations of these traditions, and how does the use of line contribute to our understanding of her intentions?

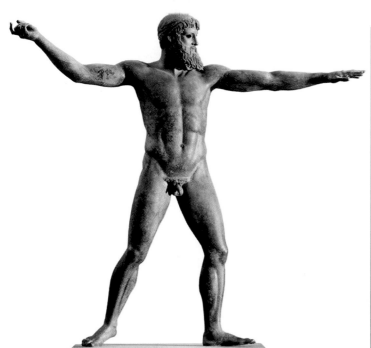

Fig. 4-29 *Zeus*, or *Poseidon*, c. 460 BCE.
Bronze, height 82 in. National Archaeological Museum, Athens.
Erich Lessing / Art Resource, NY.

Thinking Thematically: See Art and Spiritual Belief on myartslab.com

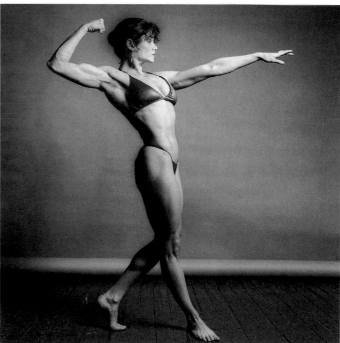

Fig. 4-30 Robert Mapplethorpe, *Lisa Lyon*, 1982.
© 1982 The Estate of Robert Mapplethorpe / Art & Commerce.

5 | Space

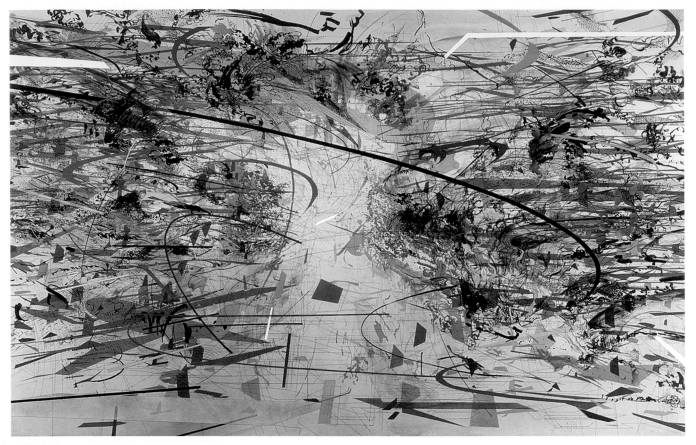

Fig. 5-1 Julie Mehretu, *Dispersion*, 2002.
Ink and acrylic on canvas, 90 × 144 in. Collection of Nicolas and Jeanne Greenberg Rohatyn, New York.
Courtesy of the artist and The Project Gallery-New York and Los Angeles

Thinking Thematically: See **Art, Politics, and Community** on myartslab.com

THINKING AHEAD

How does a shape differ from a mass?

What are negative spaces?

How can three-dimensional space be represented on a flat surface using perspective?

How does oblique projection differ from axonometric projection?

Why have modern artists challenged the means of representing three dimensions on two-dimensional surfaces?

((•─ **Listen** to the chapter audio on myartslab.com

We live in a physical world whose properties are familiar, and, together with line, space is one of the most familiar. It is all around us, all the time. We talk about "outer" space (the space outside our world) and "inner" space (the space inside our own minds). We cherish our own "space." We give "space" to people or things that scare us. But in the twenty-first century, space has become an increasingly contested issue. Since Einstein, we have come to recognize that the space in which we live is fluid. Not only does it take place in time, but we are able to move in and across it with far greater ease than ever before.

The work of Ethiopian-born Julie Mehretu consciously reflects this new condition. She moved

to the United States when she was six, grew up in Michigan, and has worked in Senegal, Berlin, and New York. Her work investigates what she calls "the multifaceted layers of place, space, and time that impact the formation of personal and communal identity." She accomplishes this by mapping public spaces at very large scale. She might, for instance, project an elevated view of a city onto a canvas, and then trace the lines of its streets disappearing into the distance, or she might begin by drawing the architectural plans of a building, or the layout of an international airport. Across this space swirl lines of movement, quasi-geometrical planes of color, and a multitude of marks derived from sources as varied as weather maps, graffiti, Chinese calligraphy, cartoons, and anime—the signage, that is, of contemporary life. (In myartslab, you can see an Art21 "Exclusive" video of Mehretu working on the painting *Middle Grey* [2007–2009], one of a group of seven paintings exhibited at the Solomon R. Guggenheim Museum in New York in 2010.) In *Dispersion* (**Fig. 5-1**), she takes up the theme of diaspora—the scattering of peoples that began with the dispersion of the Jews in the sixth century BCE, but which in more modern times affected, particularly, African peoples transported to the Western hemisphere by the slave trade, and in more modern times yet, by the worldwide movement of people, like Mehretu herself, from one culture to another. A giant cleft or rift divides the painting down its middle like an ocean lying between what might be called "populations" of dense black marks. At the lower left, the fuselage of an airplane evokes a world on the move. Travel, in fact, accounts for nearly 10 percent of world trade and global employment, as nearly 700 million people travel internationally each year, and half a million hotel rooms are built each year to house them. *Dispersion* suggests the sheer complexity of creating and negotiating communal space in the contemporary world. And it suggests an even newer kind of space—the space of mass media, the Internet, the computer screen, "virtual reality," and cyberspace—as well as the migration of the human mind across it. This new kind of space results, as we shall see, in new arenas for artistic exploration. But first, we need to define some elementary concepts of shape, mass, and perspective.

Shape and Two-Dimensional Space

A **shape is flat.** In mathematical terms, a shape is a two-dimensional area; that is, its boundaries can be measured in terms of height and width. A form, or **mass**, on the other hand, is a solid that occupies a three-dimensional volume. It must be measured in terms of height, width, and depth. Though mass also implies density and weight, in the simplest terms, the difference between shape and mass is the difference between a square and a cube, or a circle and a sphere.

Donald Sultan's *Lemons, May 16, 1984* (**Fig. 5-2**) is an image of three lemons overlapping in space, but it consists of a flat yellow shape on a black ground over 8 feet square. To create the image, Sultan covered vinyl composite tile with tar. Then he drew the outline of the lemons, scraped out the area inside the outline, filled it with plaster, and painted the plaster area yellow. The shape of the three lemons is created not only by the outline Sultan drew but also by the contrasting colors and textures—black and yellow, tar and plaster.

Sultan's image contains two shapes: the square black background, and the yellow figure. Indeed, the instant we place any shape on a ground, another

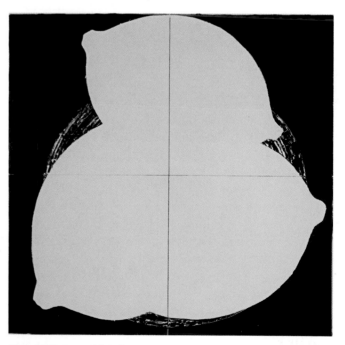

Fig. 5-2 Donald Sultan, *Lemons, May 16, 1984*, 1984. Latex, tar on vinyl tile over wood, H. 97 × W. 97½ in. Virginia Museum of Fine Arts, Richmond. Gift of the Sydney and Frances Lewis Foundation.
Photograph: Katherine Wetzel, © Virginia Museum of Fine Arts

Watch the video on Julie Mehretu on myartslab.com

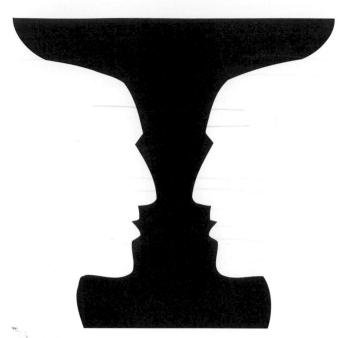

Fig. 5-3 Rubin vase.

shape is created. The ground is known as a negative shape, while the figure that commands our attention is known as a positive shape. Consider, however, the more dynamic figure-ground relationship in **Figure 5-3**. At first glance, the figure appears to be a black vase resting on a white ground. But the image also contains the figure of two heads resting on a black ground. Such figure-ground reversals help us recognize how important both positive and negative shapes are to our perception of an image.

Three-Dimensional Space

A photograph cannot quite reproduce the experience of seeing Martin Puryear's *Self* (**Fig. 5-4**), a sculptural mass that stands nearly six feet high. Made of wood, it looms out of the floor like a giant basalt outcropping, and it seems to satisfy the other implied meanings of mass—that is, it seems to possess weight and density as well as volume. "It looks as though it might have been created by erosion," Puryear has said, "like a rock worn by sand and weather until the angles are all gone. . . . It's meant to be a visual notion of the self, rather than any particular self—the self as a secret entity, as a secret, hidden place." And, in fact, it does not possess the mass it visually announces. It is actually very lightweight, built of thin layers of wood over a hollow core. This hidden, almost secret fragility is the "self" of Puryear's title. Barbara Hepworth's sculpture *Two Figures* (**Fig. 5-5**) invites the viewer to look at it up close. It consists of two standing vertical masses that occupy three-dimensional space in a

manner similar to standing human forms. (See, for example, the sculpture's similarity to the standing forms of *King Menkaure and His Queen*, Fig. 13-9.) Into each of these figures Hepworth has carved **negative spaces**, so called because they are empty spaces that acquire a sense of volume and form by means of the outline or frame that surrounds them. Hepworth has painted these negative spaces white. Especially in the left-hand figure, the negative spaces suggest anatomical features: The top round indentation suggests a head, the middle hollow a breast, and the bottom hole a belly, with the elmwood wrapping around the figure like a cloak.

The negative space formed by the bowl of the ceremonial spoon of the Dan people native to Liberia and the Ivory Coast (**Fig. 5-6**) likewise suggests anatomy. Nearly a foot in length and called the "belly pregnant with rice," the bowl represents the generosity of the most hospitable woman of the clan, who is known as the *wunkirle*. The *wunkirle* carries this spoon at festivals, where she dances and sings. As *wunkirles* from other clans arrive, the festivals become

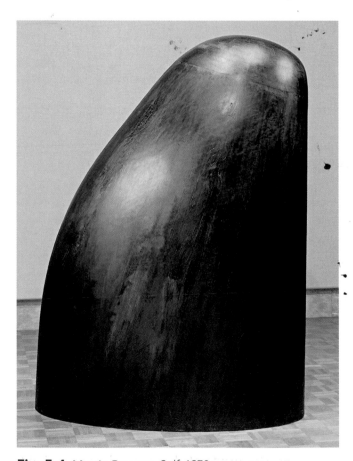

Fig. 5-4 Martin Puryear, *Self,* 1978.
Polychromed red cedar and mahogany, 69 × 48 × 25 in.
Joslyn Art Museum, Omaha, Nebraska.

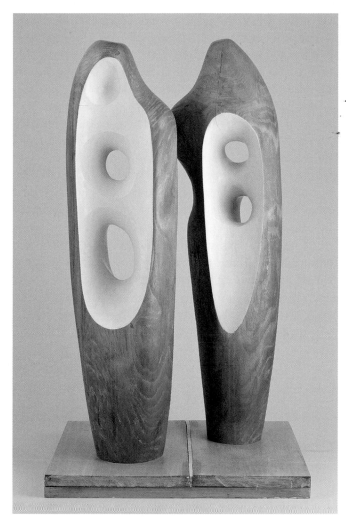

Fig. 5-5 Barbara Hepworth, *Two Figures*, 1947–48.
Painted elmwood and white paint, 40 × 23 × 23 in. Collection
Frederick R. Weisman Art Museum at the University of
Minnesota, Minneapolis.
The John Rood Sculpture Collection. 1962.12.

competitions, each woman striving to give away more
than the others. Finally, the most generous *wunkirle*
of all is proclaimed, and the men sing in her honor.
The spoon represents the power of the imagination
to transform an everyday object into a symbolically
charged container of social good.

The world that we live in (our homes, our streets,
our cities) has been carved out of three-dimensional
space, that is, the space of the natural world, which
itself possesses height, width, and depth. A building
surrounds empty space in such a way as to frame it or
outline it. Walls shape the space they contain, and
rooms acquire a sense of volume and form. The great
cathedrals of the late medieval era were designed es-
pecially to elicit from the viewer a sense of awe at
the sheer magnitude of the space they contained.
Extremely high naves carried the viewer's gaze up-
ward in a gravity-defying flight of vision. At Reims

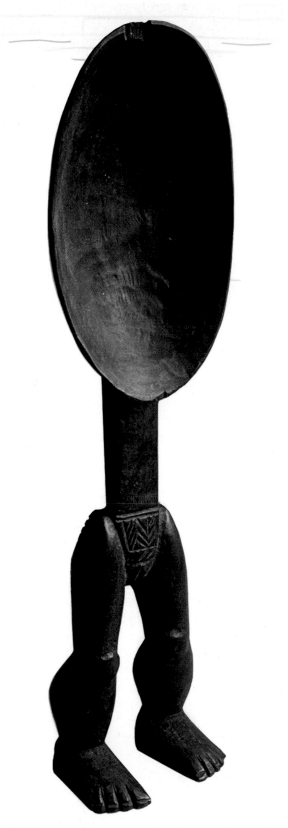

Fig. 5-6 Feast-making spoon (Wunkirmian), Liberia/Ivory
Coast, Dan, twentieth century.
Wood and iron, height 24¼ in. The Seattle Art Museum.
Gift of Katherine C. White and the Boeing Company,
81.17.204.
© abm - archives barbier-mueller-studio Ferrazzini-Bouchet, Geneve

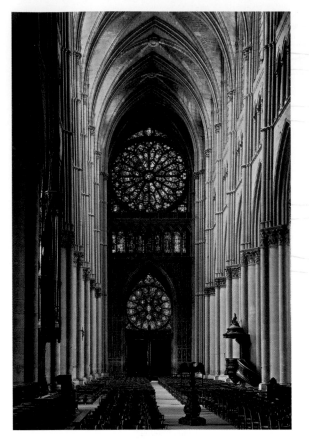

Fig. 5-7 Nave, Reims Cathedral, begun 1211; nave c. 1220. View to the west.
Courtesy Getty Research Institute

🔍**View** the panorama of Reims Cathedral on myartslab.com

Cathedral (**Fig. 5-7**), the nave is 125 feet high. If you visit the panorama of the site in myartslab, you can experience for yourself something of the magnitude of the space, which is heightened in the panorama by the quality of golden light that fills the space. In fact, light can contribute significantly to our sense of space. Think of the space in a room as a kind of negative space created by the architecture. Danish artist Olafur Eliasson seems to fill this space with color in his 1995 installation *Suney* (**Fig. 5-8**). Actually, he has bisected a gallery with a yellow Mylar sheet. The side of the gallery in which the viewer stands seems bathed in natural light, while the opposite side seems filled with yellow light. There are separate entrances at each end of the space and, if viewers change sides, their experience of the two spaces is reversed.

Representing Three-Dimensional Space

Many artists, such as Beverly Buchanan (See *The Creative Process*, pp. 84–85), work in both two- and three-dimensional forms. But in order to create a sense of depth, of three dimensions, on a flat canvas or paper the artist must rely on some form of *illusion*.

There are many ways to create the illusion of deep space—and most are used simultaneously—as in Steve

Fig. 5-8 Olafur Eliasson, *Suney*, 1995.
Installation view at the Kunstlerhas Stuttgart, Germany, 1995.
Courtesy the artist. Photo: Marcus Keibel

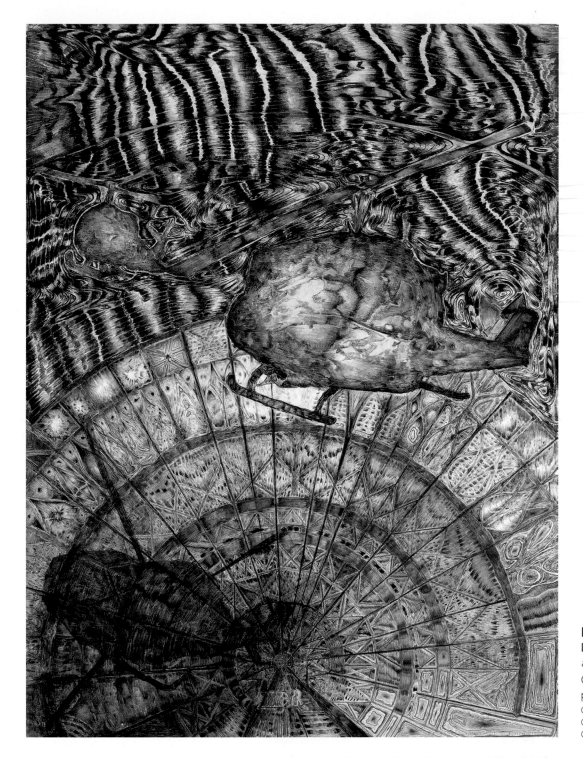

Fig. 5-9 Steve DiBenedetto, *Deliverance*, 2004.

Colored pencil on paper, 30⅛ × 22½ in.

Courtesy of David Nolan Gallery, New York. Private Collection, New York.

Thinking Thematically: See **Art, Science, and the Environment** on myartslab.com

DiBenedetto's *Deliverance* (**Fig. 5-9**). For example, we recognize that objects close to us appear larger than objects farther away, so that the juxtaposition of a large and a small helicopter suggests deep space between them. Overlapping images also create the illusion that one object is in front of the other in space: the helicopters appear to be closer to us than the elaborately decorated red launching or landing pad below. And because we are looking down on the scene, a sense of deep space is further suggested. The use of line also adds to the illusion, as the tightly packed, finer lines of the round pad pull the eye inward. The presence of a shadow supplies yet another visual clue that the figures possess dimensionality, and we will look closely at how the effect of light creates believable space in the next chapter. Even though the image is highly abstract and decorative, we are still able to read it as representing objects in three-dimensional space.

Beginning in the early 1980s, Beverly Buchanan started photographing the makeshift shacks that dot the Southern landscape near her home in Athens, Georgia. It is an enterprise that she has carried on ever since (**Fig. 5-10**). "At some point," she says, "I had to realize that for me the structure was related to the people who built it. I would look at shacks and the ones that attracted me always had something a little different or odd about them. This evolved into my having to deal with [the fact that] I'm making portraits of a family or person."

Buchanan soon began to make both drawings and sculptural models of the shacks. Each of her three-dimensional models tells a story. This legend, for instance, accompanies the sculpture of *Richard's Home* (**Fig. 5-11**):

Some of Richard's friends had already moved north, to freedom, when he got on the bus to New York. Richard had been "free" for fifteen years and homeless now for seven. . . . After eight years as a foreman, he was "let go." He never imagined it would be so hard and cruel to look for something else. Selling his blood barely fed him. At night, dreams took him back to a childhood of good food, hard work, and his Grandmother's yard of flowers and pinestraw and wood. Late one night, his cardboard house collapsed during a heavy rain. Looking down at a soggy heap, he heard a voice, like thunder, roar this message through his brains, RICHARD GO HOME!

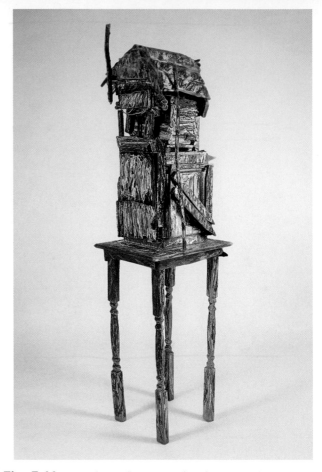

Fig. 5-11 Beverly Buchanan, *Richard's Home*, 1993. Wood, oil crayon, and mixed media, 78 × 16 × 21 in. Photo by Adam Reich. Collection: Barbara and Eric Dobkin. Courtesy Steinbaum Krauss Gallery, Miami, Florida

Buchanan's sculpture does not represent the collapsed cardboard house in the North, but Richard's new home in the South. It is not just a ramshackle symbol of poverty. Rather, in its improvisational design, in its builder's determination to use whatever materials are available, to make something of nothing, as it were, the shack is a testament to the energy and spirit of its creator. More than just testifying to Richard's

Fig. 5-10 Beverly Buchanan, *Ms. Mary Lou Furcron's House, deserted*, 1989. Ektacolor print, 16 × 20 in. Courtesy Steinbaum Krauss Gallery, NYC.

Fig. 5-12 Beverly Buchanan, *Monroe County House with Yellow Datura*, 1994.
Oil pastel on paper, 60 × 79 in.
Photo by Adam Reich. Collection of Bernice and Harold Steinbaum. Courtesy of Bernice Steinbaum Gallery, Miami, Florida

will to survive, his shack underscores his creative and aesthetic genius.

Buchanan's pastel oilstick paintings, such as *Monroe County House with Yellow Datura* (**Fig. 5-12**), are embodiments of this same energy and spirit. She eschews traditional perspective (see the following pages) in order to capture the improvisational construction of the three-dimensional shacks, which, after all, challenge the geometrical regularity of standard construction in their own right. The giant yellow datura flowers, which seem to fall out of the sky, collapse the normal distinction between the near and the far (also addressed later in this chapter). Her use of expressive line and color is almost abstract, especially in the fields of color that surround the house. These distinctive

scribble-like marks are based on the handwriting of Walter Buchanan, her great-uncle and the man who raised her. Late in his life he suffered a series of strokes, and before he died he started writing letters to family members that he considered very important. "Some of the words were legible," Buchanan explains, "and some were in this kind of script that I later tried to imitate. . . . What I thought about in his scribbling was an interior image. It took me a long time to absorb that. . . . And I can also see the relation of his markings to sea grasses, the tall grasses, the marsh grasses that I paint." The seemingly untutored rawness of her marks mirrors the haphazard construction of the shacks. And both equally depict the human drive to create real or imaginative spaces of our own.

LINEAR PERSPECTIVE

The overlapping images in DiBenedetto's work evoke certain principles of perspective, one of the most convincing means of representing three-dimensional space on a two-dimensional surface. Perspective is a system, known to the Greeks and Romans but not mathematically codified until the Renaissance, that, in the simplest terms, allows the picture plane to function as a window through which a specific scene is presented to the viewer. In one-point linear perspective (Fig. 5-13), lines are drawn on the picture plane in such a way as to represent parallel lines receding to a single point on the viewer's horizon, called the vanishing point. As the two examples in Figure 5-13 make clear, when the vanishing point is directly across from the vantage point where the viewer is positioned, the recession is said to be **frontal**. If the vanishing point is to one side or the other, the recession is said to be **diagonal**.

To judge the effectiveness of linear perspective as a system capable of creating the illusion of real space on a two-dimensional surface, we need only look at an example of a work painted before linear perspective was fully understood and then compare it to works in which the system is successfully employed. Commissioned in 1308, Duccio's *Maestà* ("Majesty") *Altarpiece* is an enormous composition—its central panel alone is 7 feet high and 13½ feet wide. Many smaller scenes depicting the life of the Virgin and the Life and Passion of Christ appear on both the front and back of the work. In one of these smaller panels, depicting the *Annunciation of the Death of the Virgin* (**Fig. 5-14**), in which the

Fig. 5-13 One-point linear perspective. Left: frontal recession, street level. Right: diagonal recession, elevated position.

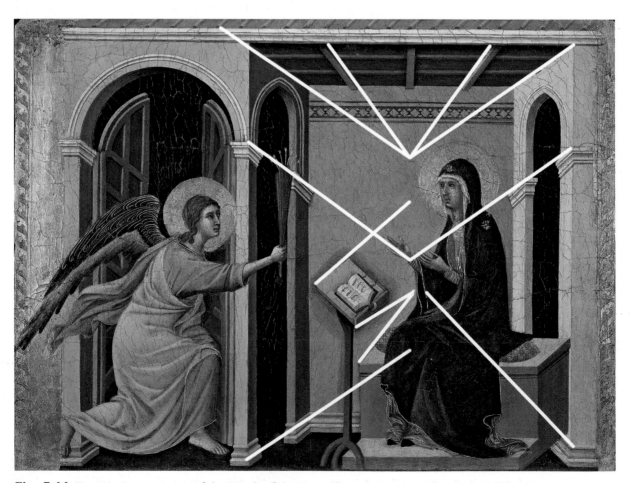

Fig. 5-14 Duccio, *Annunciation of the Death of the Virgin*, from the *Maestà Altarpiece*, 1308–11 (perspective analysis).
Tempera on panel, 16⅜ × 21¼ in. Museo dell'Opera del Duomo, Siena.

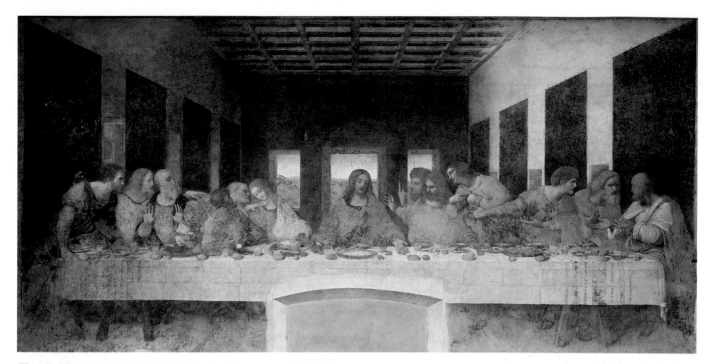

Fig. 5-15 Leonardo da Vinci, *The Last Supper,* c. 1495–98.
Mural (oil and tempera on plaster), 15 ft. 1⅛ in. × 28 ft. 10½ in. Refectory, Monastery of Santa Maria delle Grazie, Milan.
Index Ricerca Iconografica. Photo: Ghigo Roli.

angel Gabriel warns the Virgin of her impending death, Duccio is evidently attempting to grasp the principles of perspective intuitively. At the top, the walls and ceiling beams all converge at a single vanishing point above the Virgin's head. But the moldings at the base of the arches in the doorways recede to a vanishing point at her hands, while the base of the reading stand, the left side of the bench, and the baseboard at the right converge on a point beneath her hands. Other lines converge on no vanishing point at all. Duccio has attempted to create a realistic space in which to place his figures, but he does not quite succeed. This is especially evident in his treatment of the reading stand and bench. In true perspective, the top and bottom of the reading stand would not be parallel, as they are here, but would converge to a single vanishing point. Similarly, the right side of the bench is splayed out awkwardly to the right and seems to crawl up and into the wall.

By way of contrast, the space of Leonardo da Vinci's famous depiction of *The Last Supper* (**Fig. 5-15**) is completely convincing. Leonardo employs a fully frontal one-point perspective system, as the perspective analysis shows (**Fig. 5-16**). This system focuses our attention on Christ, since the perspective lines appear almost as rays of light radiating from Christ's head. During the mural's restoration, a small nail hole was discovered in Christ's temple, just to the left of his right

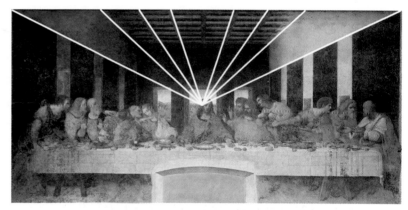

Fig. 5-16 Perspective analysis of Leonardo da Vinci, *The Last Supper,* c. 1495–98.
Mural (oil and tempera on plaster), 15 ft. 1⅛ in. × 28 ft. 10½ in. Refectory, Monastery of Santa Maria delle Grazie, Milan.
Index Ricerca Iconografica. Photo: Ghigo Roli.

👁 **Watch** the video on *The Last Supper* on myartslab.com

eye. Leonardo evidently drew strings out from this nail to create the perspectival space, a theory described in the myartslab video on the restoration of the painting. *The Last Supper* itself is a wall painting created in the refectory (dining hall) of the Monastery of Santa Maria delle Grazie in Milan, Italy. Because the painting's architecture appears to be continuous with the actual architecture of the refectory, it seems as if the world outside the space of the painting is organized around Christ as well. Everything in the architecture of the

painting and the refectory draws our attention to him. His gaze controls the world.

When there are two vanishing points in a composition—that is, when an artist uses **two-point linear perspective** (**Fig. 5-17**)—a more dynamic composition often results. The building in the left half of Gustave Caillebotte's *Place de l'Europe on a Rainy Day* (**Fig. 5-18**) is realized by means of two-point linear perspective, but Caillebotte uses perspective to create a much more complex composition. A series of multiple vanishing points organize a complex array of parallel lines emanating from the intersection of the five Paris streets depicted (**Fig. 5-19**). Moving across and

Fig. 5-17 Two-point linear perspective.

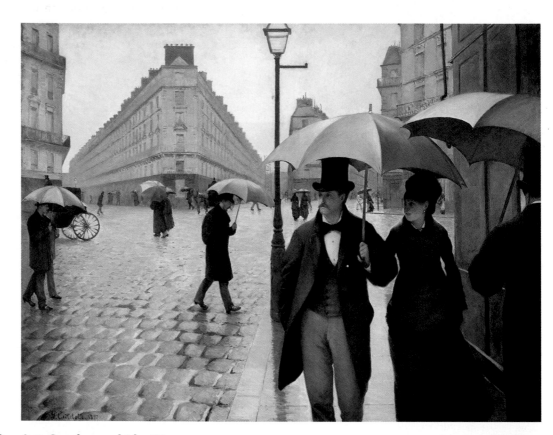

Fig. 5-18 Gustave Caillebotte, *Place de l'Europe on a Rainy Day*, 1876–77.

Oil on canvas, 83¹/₂ × 108³/₄ in. The Art Institute of Chicago. Charles H. and Mary F. S. Worcester Collection, 1964.336.

Thinking Thematically: See Art, Gender, and Identity on myartslab.com

through these perspective lines are the implied lines of the pedestrian's movements across the street and square and down the sidewalk in both directions, as well as the line of sight created by the glance of the two figures walking toward the viewer. Caillebotte imposes order on this scene by dividing the canvas into four equal rectangles formed by the vertical and the horizon line.

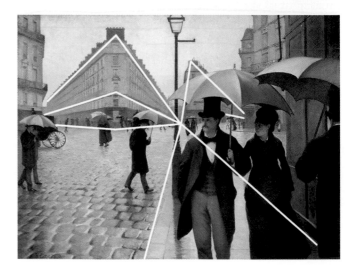

Fig. 5-19 Perspective analysis of Gustave Caillebotte, *Place de l'Europe on a Rainy Day*, 1876–77.

Oil on canvas, 83¹/₂ × 108³/₄ in. The Art Institute of Chicago. Charles H. and Mary F. S. Worcester Collection, 1964.336.

SOME OTHER MEANS OF REPRESENTING SPACE

Systems other than linear perspective have been developed as ways of projecting space. A type of projection commonly found in Japanese art is **oblique projection**.

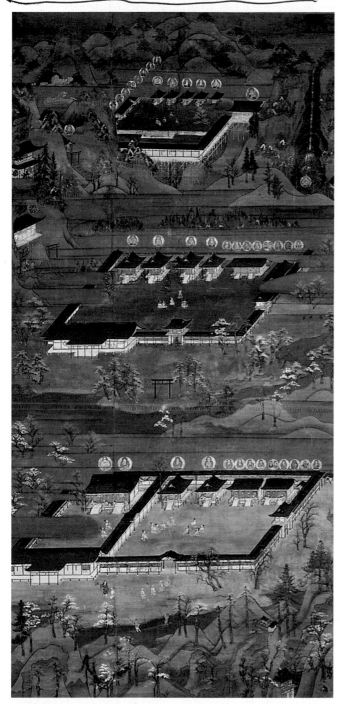

Fig. 5-20 *The Three Sacred Shrines at Kumano: Kumano Mandala,* Japan, Kamakura period (1185–1333), c. 1300. Hanging scroll, ink and color on silk, 52¼ × 24¼ in. (217.2 × 80.0 cm) The Cleveland Museum of Art. John L. Severance Fund, 1953.16.

© The Cleveland Museum of Art. John L. Severance Fund, 1953.16

Thinking Thematically: See Art and Spiritual Belief on myartslab.com

The sides of the buildings are parallel, with one face parallel to the picture plane as well. The same scale is used for height and width, while depth is reduced. This hanging scroll (**Fig. 5-20**) depicts, in oblique perspective, the three sacred Shinto-Buddhist shrines of Kumano, south of Osaka, Japan. The shrines are actually about 80 miles apart: the one at the bottom of the scroll high in the mountains of the Kii Peninsula in a cypress forest, the middle one on the eastern coast of the peninsula, and the top one near a famous waterfall that can be seen to its right. In addition to oblique projection, the artist employs two other devices to give a sense of spatial depth. As is common in traditional perspective, each shrine appears smaller the farther away it is. But spatial depth is also indicated here by position—the farther away the shrine, the higher it is in the composition.

A related means of projecting space is **axonometric projection** (**Fig. 5-21**), commonly employed by architects and engineers. It has the advantage of translating space in such a way that the changes of scale inevitable in linear perspective—in the way that a thing in the distance appears smaller than a thing close at hand—are eliminated. In axonometric projections, all lines remain parallel rather than receding to a common vanishing point, and all sides of the object are at an angle to the picture plane.

Fig. 5-21 Theo van Doesburg (1883–1931) and Cornelius van Eesteren (1897–1988), *Contra-Construction Project Axonometric,* Project for a private house, 1923. Gouache on lithograph, 22½ × 22½ in. (57.2 × 57.2 cm) The Museum of Modern Art, New York, NY, U.S.A. Gift of Edgar J. Kaufmann, Jr. Fund. 1947. (149.1947).

Digital Image © The Museum of Modern Art/Licensed by SCALA / Art Resource, NY.

Fig. 5-22 Photographer unknown, *Man with Big Shoes*, c. 1890.
Courtesy of the Library of Congress

DISTORTIONS OF SPACE AND FORESHORTENING

The space created by means of linear perspective is closely related to the space created by photography, the medium we accept as representing "real" space with the highest degree of accuracy. The picture drawn in perspective and the photograph both employ a monocular, that is, one-eyed, point of view that defines the picture plane as the base of a pyramid, the apex of which is the single lens or eye. Our actual vision, however, is binocular. We see with both eyes. If you hold your finger up before your eyes and look at it first with one eye closed and then with the other, you will readily see that the point of view of each eye is different. Under most conditions, the human organism has the capacity to synthesize these differing points of view into a unitary image.

Fig. 5-23 Albrecht Dürer, *Draftsman Drawing a Reclining Nude*, c. 1527.
Woodcut, second edition, 3 × 8¹/₂ in. One of 138 woodcuts and diagrams in *Underweysung der Messung, mit dem Zirkel und richtscheyt* (*Teaching of Measurement with Compass and Ruler*).
Photograph © 2012 Museum of Fine Arts, Boston.

In the nineteenth century, the stereoscope was invented precisely to imitate binocular vision. Two pictures of the same subject, taken from slightly different points of view, were viewed through the stereoscope, one by each eye. The effect of a single picture was produced, with the appearance of depth or relief, a result of the divergence of the point of view. Usually, the difference between the two points of view is barely discernible, especially if we are looking at relatively distant objects. But if we look at objects that are nearby, as in the stereoscopic view of the *Man with Big Shoes* in **Figure 5-22**, the difference is readily apparent.

Artists working in other media can make up for such distortions in ways that photographers cannot. If the artist portrayed in Dürer's woodcut (**Fig. 5-23**) were to draw exactly what he sees before his eyes, he would end up drawing a figure with knees and lower legs that are too large in relation to her breasts and head. The effect would not be unlike that achieved by the enormous feet that reach toward the viewer in *Man with Big Shoes*. These are effects that Andrea Mantegna would work steadfastly to avoid in his depiction of *The Dead Christ* (**Fig. 5-24**). Such a representation would make comic or ridiculous a scene of high seriousness and consequence. It would be indecorous. Thus, Mantegna has employed **foreshortening** in order to represent Christ's body. In foreshortening, the dimensions of the closer extremities are adjusted in order to make up for the distortion created by the point of view.

Fig. 5-24 Andrea Mantegna, *The Dead Christ*, c. 1501. Tempera on canvas, 26 × 30 in. Brera Gallery, Milan.

THE NEAR AND THE FAR

Foreshortening is a means of countering the laws of perspective, laws which seem perfectly consistent and rational when the viewer's vantage point is sufficiently removed from the foreground, but which, when the foreground is up close, seem to produce weird and disquieting imagery. When Japanese prints entered European markets after the opening of Japan in 1853–54, new possibilities for representing perspectival space presented themselves. Many Japanese prints combined close-up views of things near at hand, such as flowers, trees, or banners, with views of distant landscapes. Rather than worrying about presenting the space as a continuous and consistent recession from the near at hand to the far away, Japanese artists simply elided what might be called the "in between." Thus, in Utagawa Hiroshige's *Moon Pine, Ueno* (**Fig. 5-25**), from his *One Hundred Famous Views of Edo* (Edo was renamed Tokyo in 1868), a giant gap lies between the foreground pine and the city in the distance. The habit in Edo was to give names to trees of great age or particular form, and this pine, renowned for the looping round form of its lower branch, was dubbed "moon pine." Looking at the tree from different angles, one could supposedly see the different phases of the moon as well. The site is a park in the Ueno district of Tokyo, overlooking Shinobazu pond. In the middle of the lake is an island upon which stands the Benten (Benzaiten) Shrine, dedicated to the goddess of the fine arts, music, and learning. In the print, the shrine is the red building just above the branch at the lower right. Here, where the branch crosses the island, the gulf between the near and far seems to collapse, and a certain unity of meaning emerges, as the extraordinary beauty of the natural world (the nearby

Fig. 5-25 Utagawa Hiroshige (Ando), *Moon Pine, Ueno*, No. 89 from *One Hundred Famous Views of Edo*, 7th month of 1856.
Woodblock print, 14³/₁₆ × 9¹/₄ in. The Brooklyn Museum. Gift of Anna Ferris. 30.1478.89.

pine) merges with the best aspects of human productivity (embodied in the distant shrine).

This flattening of space proved to be especially attractive to European modernist painters in the late nineteenth and early twentieth centuries, who, as we will see in the following pages, found the rules of perspective to be limiting and imaginatively

Fig. 5-26 Janine Antoni, *Touch*, 2002.
Color video, sound (projection), 9:36 min. loop. Edition number 3 of five. The Art Institute of Chicago. Gift of Donna and Howard Stone, 2007.43.

cumbersome. But the surprising effects that can be achieved in collapsing the apparent distance between the near and the far have continued to fascinate artists down to the present day. In her video *Touch* (**Fig. 5-26**), Janine Antoni appears to walk along the horizon, an illusion created by her walking on a tightrope stretched between two backhoes on the beach directly in front of her childhood home on Grand Bahama Island. She had learned to tightrope walk, practicing about an hour a day, as an exercise in bodily control and meditation. As she practiced, she realized, she says, that "it wasn't that I was getting more balanced, but that I was getting more comfortable with being out of balance." This she took as a basic lesson in life. In touch, this sense of teetering balance is heightened by the fact that she appears to be walking on a horizon line that we know can never be reached, as it continually moves away from us as

we approach it. We know, in other words, that we are in an impossible place, and yet it is a place that we have long contemplated and desired as a culture, the sense of possibility that always seems to lie "just over the horizon." When, in the course of the full-length video, both Antoni and the rope disappear, we are left, as viewers, contemplating this illusory line and just what it means. And we come to understand that the horizon represents what is always in front of us. "It's a very hopeful image," Antoni says, "it's about the future, about the imagination."

Modern Experiments and New Dimensions

One of the most important functions of the means of representing three dimensions on a two-dimensional surface is to make the world more intelligible. Linear

perspective provides a way for artists to focus and organize the visual field. Axonometric projections help the architect and engineer to visualize the spaces they create. Foreshortening makes the potentially grotesque view of objects seen from below or above seem more natural, less disorienting.

Modern artists have consistently challenged the utility of these means in capturing the complex conditions of contemporary culture. Very often it is precisely the disorienting and the chaotic that defines the modern for them, and perspective, for instance, seems to impose something of a false order on the world. Even photographers, the truth of whose means was largely unquestioned in the early decades of the twentieth century, sought to picture the world from points of view that challenged the ease of a viewer's recognition. One of the most startling of these points of view was the overhead shot. Used to seeing people on the street at eye level, viewers found the sudden appearance of people's bodies from above, compacted into spaces the breadth of their shoulders, disconcerting

and strange. A good example is *Mystery of the Street*, by German photographer Otto Umbehr, known as Umbo (**Fig. 5-27**). Umbo actually photographed the scene from the other side, but recognizing the power of the shadows, seemingly standing erect on the flat street and sidewalk, he inverted the image. As a result, the shadows seem more animate, more human and real, than the figures themselves.

Similar effects were achieved by photographers by means of other odd points of view, extreme close-ups, and radical cropping. In his *Abstraction, Porch Shadows* (**Fig. 5-28**), Paul Strand employs all three techniques. The image is an unmanipulated photograph (that is, one not altered during the development process) of the shadows of a porch railing cast across a porch and onto a white patio table turned on its side. The camera lens is pointed down and across the porch. The close-up of approximately 9 square feet of porch is cropped so that no single object in the picture is wholly visible. Strand draws the viewer's attention not so much to the scene itself as to the patterns of light and dark

Fig. 5-27 Umbo (Otto Umbehr), *Weird Street* (Unheimliche Straße), 1928.
Gelatin silver print, 11⁷/₁₆ × 9¹/₄ in. Metropolitan Museum of Art, New York. Ford Motor Company Collection, Gift of Ford Motor Company and John C. Waddell, 1987 (1987.1100.49).
© Galerie Rudolf Kicken, Cologne and Phyllis Umbehr, Frankfurt/M.

Fig. 5-28 Paul Strand, *Abstraction, Porch Shadows*, 1916.
Silver platinum print, 12¹⁵/₁₆ × 9¹/₈ in. Musée d'Orsay, Paris. Réunion des Musées Nationaux / Art Resource, NY. Inv. Pho1981-35-10.
© Aperture Foundation

Fig. 5-29 Henri Matisse, *Harmony in Red (The Red Room)*, 1908–09. Oil on canvas, 70 7/8 × 86 5/8 in. The Hermitage, St. Petersburg. 9426.

that create a visual rhythm across the surface. The picture is more abstraction, as its title suggests, than realistic rendering; it is a picture of shapes, not things.

In painting, modern artists intentionally began to violate the rules of perspective to draw the attention of the viewer to elements of the composition other than its verisimilitude, or the apparent "truth" of its representation of reality. In other words, the artist seeks to draw attention to the act of imagination that created the painting, not its overt subject matter. In his large painting *Harmony in Red* (**Fig. 5-29**), Henri Matisse has almost completely eliminated any sense of three-dimensionality by uniting the different spaces of the painting in one large field of uniform color and design. The wallpaper and the tablecloth are made of the same fabric. Shapes are repeated throughout: The

spindles of the chairs and the tops of the decanters echo one another, as do the maid's hair and the white foliage of the large tree outside the window. The tree's trunk repeats the arabesque design on the tablecloth directly below it. Even the window can be read in two ways: It could, in fact, be a window opening to the world outside, or it could be the corner of a painting, a framed canvas lying flat against the wall. In traditional perspective, the picture frame functions as a window. Here the window has been transformed into a frame.

What one notices most of all in Cézanne's *Mme. Cézanne in a Red Armchair* (**Fig. 5-30**) is its very lack of spatial depth. Although the arm of the chair seems to project forward on the right, on the left the painting is almost totally flat. The blue flower pattern on the wallpaper seems to float above

the spiraled end of the arm, as does the tassel that hangs below it, drawing the wall far forward into the composition. The line that establishes the bottom of the baseboard on the left seems to ripple on through Mme. Cézanne's dress. Most of all, the assertive vertical stripes of that dress, which appear to rise straight up from her feet parallel to the picture plane, deny Mme. Cézanne her lap. It is almost as if a second, striped vertical plane lies between her and the viewer. By this means Cézanne announces that it is not so much the accurate representation of the figure that interests him as it is the design of the canvas and the activity of painting itself, the play of its pattern and color.

With the maturity of the computer age, a new space for art has opened up, one beyond the boundaries

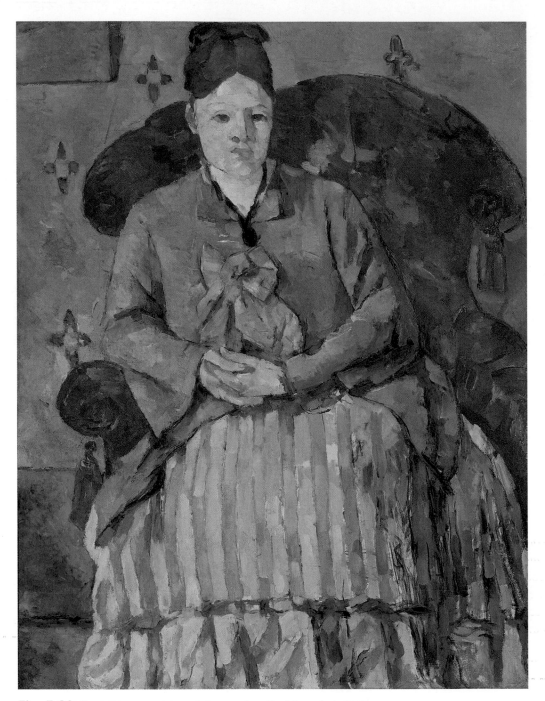

Fig. 5-30 Paul Cézanne, *Mme. Cézanne in a Red Armchair*, 1877.
Oil on canvas, 28½ × 22 in. Museum of Fine Arts, Boston. Bequest of Robert Treat Paine II, 44.77.6.
Photograph © 2012 Museum of Fine Arts, Boston.

Thinking Thematically: See **Art and Beauty** on myartslab.com

Fig. 5-31 Terry Winters, *Color and Information*, 1998.

Oil and alkyd resin on canvas, 9 × 12 ft. (108″ × 144″)

© Terry Winters, courtesy Matthew Marks Gallery, New York.

Thinking Thematically: See **Art, Science, and the Environment** on myartslab.com

of the frame and, moreover, beyond the traditional boundaries of time and matter. It is the space of information, which in Terry Winters's *Color and Information* (**Fig. 5-31**) seems to engulf us. The painting is enormous, 9 by 12 feet. It is organized around a central pole that rises just to the left of center. A web of circuitry-like squares circle around this pole, seeming to implode into the center or explode out of it—there is no way to tell. Writing in *Art in America* in 2005, critic Carol Diehl describes her reaction to paintings such as this one:

> At any given moment, some or all of the following impressions may suggest themselves and then quickly fade, to be replaced by others: maps, blueprints, urban aerial photographs, steel girders, spiderwebs, X-rays, molecular structures, microscopic slides of protozoa, the warp and woof of gauzy fabric, tangles or balls of yarn, fishing nets, the interlace of wintry tree branches, magnified crystals, computer readouts or diagrams of the neurological circuits of the brain, perhaps on information overload. That we can never figure out whether what we're looking at depicts something organic or man-made only adds to the enigma.

In fact, the title of this painting refers only to Winters's process, not its enigmatic content. The work began with a series of black-and-white woodcuts generated from small pen-and-ink drawings scanned

into a computer so that the blocks could be cut by a laser. Winters wanted to see what would happen if he transformed this digital information into a painting, confounding or amplifying the stark black-and-white contrast of the source images by adding color and vastly magnifying their size. In front of the resulting work, we are suspended between order and chaos, image and abstraction, information and information overload.

Standing in front of Winters's painting is something akin to being immersed in the technological circuitry of contemporary life. But few artists have more thoroughly succeeded in integrating the viewer into digital space than Chinese artist Feng Mengbo. In 1993, having graduated in 1991 from the Printmaking Department of Central Academy of Fine Arts, Beijing, he created a series of 42 paintings entitled *Game Over: Long March*. They amounted to screenshots of an imaginary video game, and, as one walked by them, one could imagine oneself in a side-scrolling game of the classic Super Mario Bros. variety. When Mengbo finally acquired a computer in 2003, he began transforming his project into an actual video game based on the 8,000-mile, 370-day retreat of the Chinese Communist Party's Red Army, under the command of Mao Zedong, in 1934–35. The audience's avatar in Mengbo's work is a small Red Army soldier who, seated on a crushed Coca-Cola can, encounters a variety of ghosts, demons,

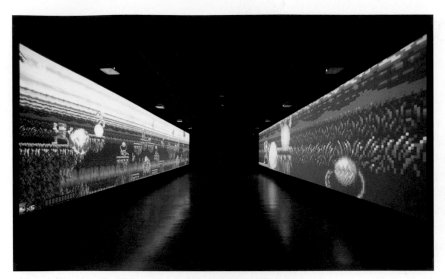

Fig. 5-32 Feng Mengbo, *Long March: Restart*, 2010.
Video game installation, each screen approx. 20 × 80 ft.
Museum of Modern Art, New York. Given anonymously.
Photograph by Matthew Septimus. © MoMA PS1. Courtesy of the artist and
Chambers Fine Art.

and deities, in an effort to rescue Princess Toadstool. Now entitled *Long March: Restart* (**Fig. 5-32**), the work is a giant digital space consisting of two walls each 80 feet long. The viewer is invited to take control of the Red Army avatar who moves through five screens following the Great Wall into 14 progressively more difficult levels of play. "You go inside the video game. You don't passively sit and play it," says Mengbo. The speed at which the avatar moves causes the viewer to move at a frenetic pace down the gallery, then to spin around and move back up the opposite wall. Disembodied, fighting long odds, at the brink of disaster, one realizes that Mengbo's *Long March* is a metaphor for the long march that is contemporary life itself.

THINKING BACK

✔ Study and review on myartslab.com

How does a shape differ from mass?

A shape is a two-dimensional area, the boundaries of which can be measured in height and width. A form, or mass, by contrast, is a solid that occupies a three-dimensional volume. How does Donald Sultan work with shapes in *Lemons, May 16, 1984*? What are negative shapes and positive shapes? What is figure–ground reversal?

What are negative spaces?

Negative spaces are empty spaces that acquire a sense of volume and form by means of the outline or frame that surrounds them. Negative spaces can be used to suggest forms. How does the sculptor of the Feast-making spoon use negative space to suggest form? How does Barbara Hepworth treat negative spaces in her sculpture *Two Figures*?

How can three-dimensional space be represented on a flat surface using perspective?

By means of illusion, a sense of depth, or three dimensions, can be achieved on a flat surface. There are many ways to create such an illusion, and an artist will often use more than one such technique for creating depth in a single work. Perspective is a system that allows the picture plane to function as a window through which a specific scene is presented to the viewer. What is a vanishing point? How is two-point linear perspective used? How does

Gustave Caillebotte create an illusion of real space in his painting *Place de l'Europe on a Rainy Day*?

How does oblique projection differ from axonometric projection?

In both oblique and axonometric projection, the sides of an object are represented as parallel. In oblique projection, one face is parallel to the picture plane as well, while in axonometric projection, all sides of an object are at an angle to the picture plane. How do these forms of projection differ from linear perspective? How do Theo van Doesburg and Cornelius van Eesteren represent space in *Color Construction*? What role does position play in oblique projection?

Why have modern artists challenged the means of representing three dimensions on two-dimensional surfaces?

Modern artists have consistently challenged the utility of perspective and other techniques used to create the illusion of three dimensions on two-dimensional surfaces. Often it is precisely the disorienting and chaotic that defines the modern to many artists, and systems such as perspective seem, to them, to present a false sense of order. How have photographers challenged the viewer's recognition of the world? In *Harmony in Red (The Red Room)*, how does Henri Matisse nearly eliminate any illusion of three-dimensionality? How can the illusion of digital space be created?

THE CRITICAL PROCESS

Thinking about Space

The history of modern art has often been summarized as the growing refusal of painters to represent three-dimensional space and the resulting emphasis placed on the two-dimensional space of the picture plane. While modern art diminished the importance of representing "real" space in order to draw attention to other types of reality, continuing developments in video and computer technologies have made it increasingly possible to represent the effects of these technologies on human experience in an era of ever-increasing mobility, both real and virtual.

Video artist and filmmaker Doug Aitken continuously explores this condition in his work. "On some level," he says, "all my work is related to what I see as certain new tendencies in the culture Accelerated nomadism, self-contained, decentralized communication—these things are at the core of the space we're living in, a terrain that is radically different from the past." In his video installation *the moment* (**Fig. 5-33**), for instance, 11 screens suspended from the ceiling in a giant S-curve in a large room show people waking up in various hotel rooms or other more-or-less anonymous environments and then moving out into the nearly deserted cityscapes of their daily lives. As projection begins, a voice whispers, "I want to be every place." Characters in the screens migrate from one screen to another at an increasingly frantic pace, until the 6-minute 30-second video ends, and they return to the state of rest at which they began, only to begin their "moment" again as the loop recycles.

Confronted with 11 screens in a deep, dark space, viewers find themselves wandering through a similarly disorienting landscape, wanting to see, more or less impossibly, what is on every screen at once. As a result, our sense of space opens to redefinition, and Aitken's work suggests that this new perception of space is perhaps as fundamental as that which occurred in the fifteenth century when the laws of linear perspective were finally codified. How would you speak of this space? In what ways is it two-dimensional? In what ways is it three-dimensional? How is space "represented"? How is time incorporated into our sense of space? What are the implications of our seeming to move in and through an array of two-dimensional images? What would you call such new spaces? Electronic space? Four-dimensional space? What possibilities do you see for such spaces?

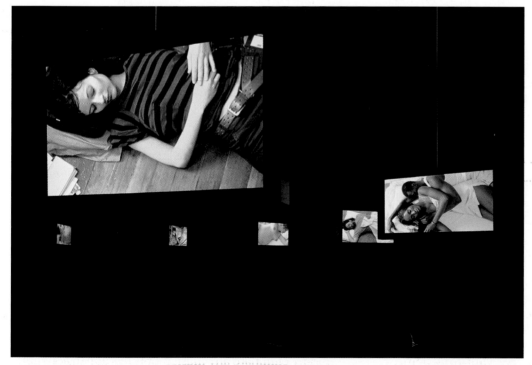

Fig. 5-33 Doug Aitken, American (born 1968) *the moment*, 2005.

Eleven-channel digital video, sound (projected on plasma screens with mirrors); 6:30 min. loop. Edition number 1 of 4. The Art Institute of Chicago. Gift of Donna and Howard Stone, 2007.34.

Courtesy Doug Aitken and 303 Gallery, New York.

Thinking Thematically: See Art and the Passage of Time on myartslab.com

6 | Light and Color

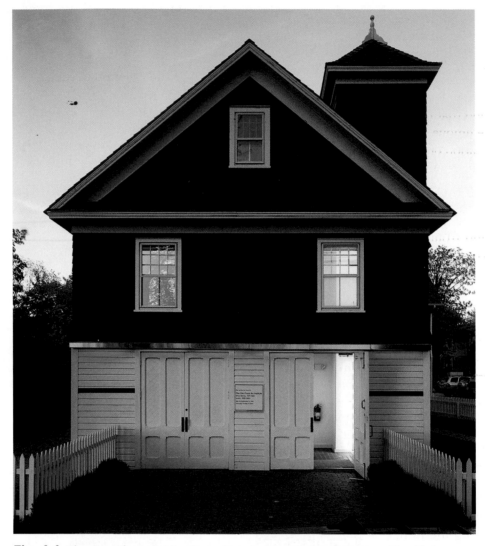

Fig. 6-1 The Dan Flavin Art Institute, Exterior view, Bridgehampton, New York, 1963–83. Long-term installation.
Courtesy Dia Art Foundation. Photo: Florian Holzherr.

THINKING AHEAD

What are the "rules" of atmospheric, or aerial, perspective?

What contributions did Sir Isaac Newton make to our understanding of color?

What is a complementary color scheme?

How does local color differ from perceptual color?

((•─[Listen to the chapter audio on myartslab.com

The manipulation of perspective systems is by no means the only way that space is created in art. Light is at least as important to the rendering of space. For instance, light creates shadow, and thus helps to define the contour of a figure or mass. Color, too, is essential in defining shape and mass. It allows us, for instance, to see a red object against a green one, and thus establish their relation in space.

Light

Since natural light helps us to define spatial relationships, it stands to reason that artists are interested in manipulating it. By doing so, they can control our experience of their work. Architects, particularly, must concern themselves with light. Interior spaces demand lighting, either natural or artificial, and our experience of a given space can be deeply affected by the quality of its light.

In 1963, artist Dan Flavin began working exclusively with fluorescent fixtures and tubes to manipulate the viewer's experience of interior space. Flavin was the first artist to work with fluorescent light, and he quickly came to understand that the light and color specific to the medium were unique. One of the results of his research was the creation of the Dan Flavin Art Institute in Bridgehampton, New York, which opened to the public in 1983 (**Fig. 6-1**). The building itself was originally a firehouse, built in 1908, and from 1924 until the mid-1970s it was used as a church. In creating this space, Flavin thought of the fluorescent sculptures that he distributed through the interiors as working together with the architecture to form a single, unified work of art, consisting of the building and its lighting.

Green, for instance, is the most luminous fluorescent light, so much so that, especially when emitted from multiple tubes, it fatigues the eye and quickly appears to be white, an effect the viewer immediately experiences upon entering the front door of the building. He also discovered that as blue mixes with pink light, it forms a purple band, and green with pink mixed together form yellow. These colors are all apparent in one of the most complex pieces installed at Flavin's Art Institute, *untitled*

Fig. 6-2 Dan Flavin, *Untitled (in honor of Harold Joachim) 3"* 1977.
Pink, yellow, blue, and green
fluorescent light, 8 ft. (244 cm)
square across a corner.
Courtesy Dia Art Foundation. Photo: Billy Jim.

(in honor of Harold Joachim) 3 (**Fig. 6-2**). Situated as it is in the corner of the room, the piece is fully integrated into the architecture, the light on the wall as much a part of it as the grid of tubes that stretches across the corner space.

ATMOSPHERIC PERSPECTIVE

For Leonardo da Vinci, representing the effects of light was at least as important as linear perspective in creating believable space. The effect of the atmosphere on the appearance of elements in a landscape is one of the chief preoccupations of his notebooks, and it is fair to say that Leonardo is responsible for formulating the "rules" of what we call **atmospheric** or **aerial perspective**. Briefly, these rules state that the quality of the atmosphere (the haze and relative

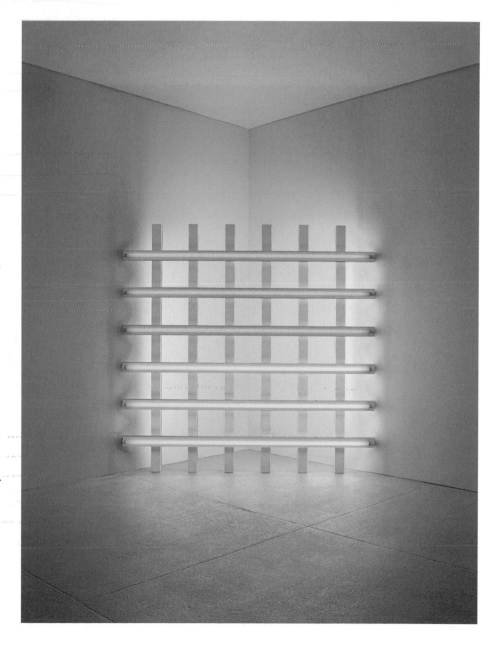

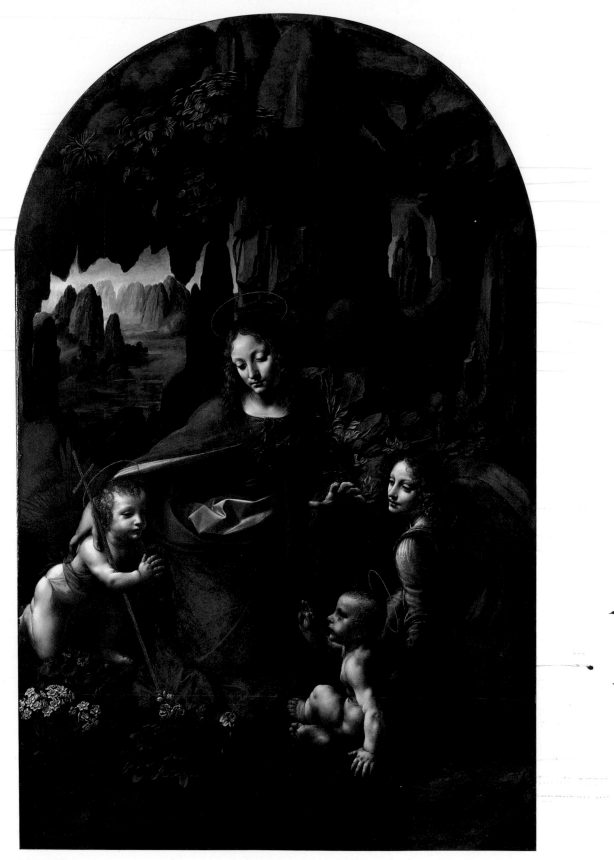

Fig. 6-3 Leonardo da Vinci, *Madonna of the Rocks*, c. 1495–1508.
Oil on panel, 75 × 47 in. The National Gallery, London.

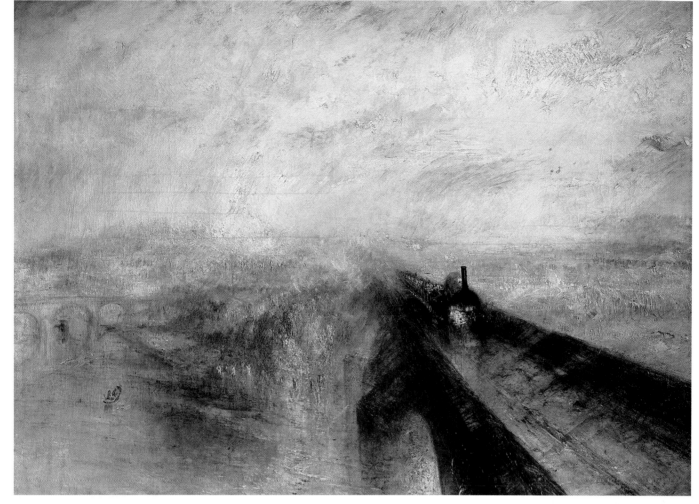

Fig. 6-4 J. M. W. Turner, *Rain, Steam, and Speed—The Great Western Railway*, 1844. Oil on canvas, 33³/₄ × 48 in. Clore Collection, Tate Gallery, London.

Thinking Thematically: See **Art, Science, and the Environment** on myartslab.com

humidity) between large objects, such as mountains, and us changes their appearance. Objects farther away from us appear less distinct, often bluer in color, and the contrast between light and dark is reduced.

Clarity, precision, and contrast between light and dark dominate the foreground elements in Leonardo's *Madonna of the Rocks* (**Fig. 6-3**). The Madonna's hand extends over the head of the infant Jesus in an instance of almost perfect perspectival foreshortening. Yet perspective has little to do with the way in which we perceive the distant mountains over the Madonna's right shoulder. We assume that the rocks in the far distance are the same brown as those nearer to us, yet the atmosphere has changed them, making them appear blue. We know that of these three distant rock formations, the one nearest to us is on the right, and the one farthest away is on the left. Since they are approximately the same size, if they were painted with the same clarity and the same amount of contrast

between light and dark we would be unable to place them spatially. We would see them as a horizontal wall of rock, parallel to the picture plane, rather than as a series of mountains, receding diagonally into space.

By the nineteenth century, aerial perspective had come to dominate the thinking of landscape painters. A painting like *Rain, Steam, and Speed—The Great Western Railway* (**Fig. 6-4**) certainly employs linear perspective: The diagonal lines of two bridges converge on a vanishing point on the horizon. We stare over the River Thames across the Maidenhead Bridge, which was completed for the railway's new Bristol and Exeter line in 1844, the year Turner painted the scene. But the space of this painting does not depend upon linear perspective. Rather, light and atmosphere dominate it, creating a sense of space that in fact overwhelms the painting's linear elements in luminous and intense light. Turner's light is at once so opaque that it conceals everything behind it and so deep that it seems

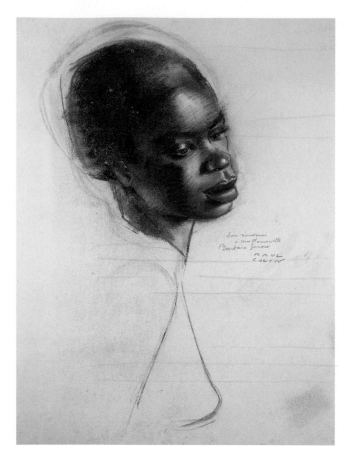

Fig. 6-5 Paul Colin (French, 1892–1985), *Figure of a Woman*, c. 1930.

Black and white crayon on light beige paper, 24 × 18½ in. Lent by Frederick and Lucy S. Herman Foundation to the University of Virginia Art Museum.

© 2012 Artists Rights Society (ARS), New York /ADAGP, Paris.

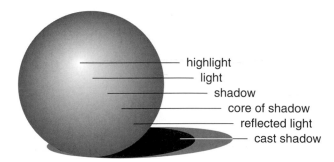

Fig. 6-6 A sphere represented by means of modeling.

to stretch beyond the limits of vision. Describing the power of a Rembrandt painting in a lecture delivered in 1811, Turner praised such ambiguity: "Over [the scene] he has thrown that veil of matchless color, that lucid interval of Morning dawn and dewy light on which the Eye dwells . . . [and he] thinks it a sacrilege to pierce the mystic shell of color in search of form." With linear perspective one might adequately describe physical reality—a building, for instance—but through light one could reveal a greater spiritual reality.

CHIAROSCURO

One of the chief tools employed by artists of the Renaissance to render the effects of light is **chiaroscuro**. In Italian, the word *chiaro* means "light," and the word *oscuro* means "dark." Thus, the word refers to the balance of light and shade in a picture, especially its skillful use by the artist in representing the gradual transition around a curved surface from light to dark. The use of chiaroscuro to represent light falling across a curved or rounded surface is called **modeling**.

In his *Figure of a Woman* (**Fig. 6-5**), French artist Paul Colin has employed the techniques of chiaroscuro to model his figure. Drawing on light beige paper, he has indicated shadow by means of black crayon and has created the impression of light with white crayon. Colin made his fame as a poster designer for La Revue Nègre, a troupe of 20 musicians and dancers from Harlem who took the Parisian art world by storm in 1925. It was led by the dancer Josephine Baker, who introduced a new dance, the Charleston, to Parisian audiences, popularized American jazz in Europe, and, most famously, often performed almost completely in the nude. This drawing almost surely derives from Colin's association with Baker and her circle

The basic types of shading and light employed in chiaroscuro can be observed in **Fig. 6-6**. **Highlights**, which directly reflect the light source, are indicated by white, and the various degrees of shadow are noted by darker and darker areas of black. There are three basic areas of shadow: the **shadow** proper, which transitions into the **core of the shadow**, the darkest area on the object itself, and the **cast shadow**, the darkest area of all. Finally, areas of reflected light, cast indirectly on the table on which the sphere rests, lighten the underside of shadowed surfaces.

In her *Judith and Maidservant with the Head of Holofernes* (**Fig. 6-7**), Artemisia Gentileschi takes the technique of chiaroscuro to a new level. One of the most important painters of seventeenth-century Europe, Gentileschi utilizes a technique that came to be known as **tenebrism** from the Italian *tenebroso*,

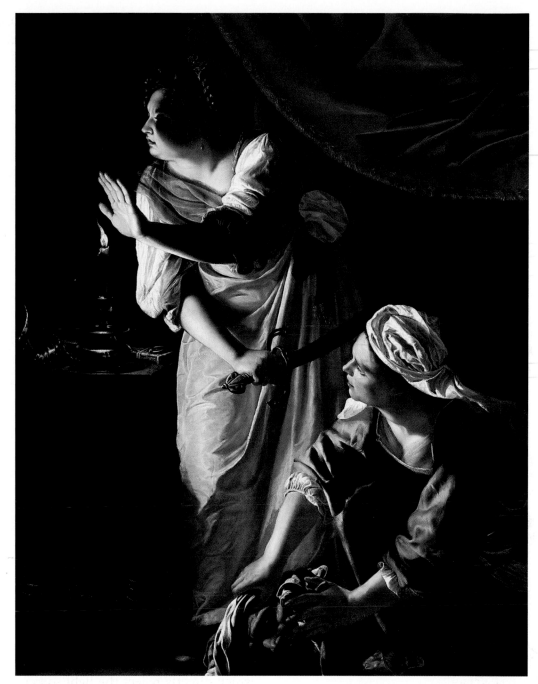

Fig. 6-7 Artemisia Gentileschi, *Judith and Maidservant with the Head of Holofernes,* c. 1625.
Oil on canvas, 72½ × 55¾ in. Detroit Institute of Arts. Gift of Mr. Leslie H. Green, 52.253.
Thinking Thematically: See **Art, Gender, and Identity** on myartslab.com

meaning murky. As opposed to chiaroscuro, a tenebrist style is not necessarily connected to modeling at all. Tenebrism makes use of large areas of dark contrasting sharply with smaller brightly illuminated areas. Competing against the very deep shadows in Gentileschi's painting are dramatic spots of light. Based on the tale in the book of Judith in the Bible, in which the noble Judith seduces the invading general Holofernes and then kills him, thereby saving her people from destruction, the painting is larger than

life-size. Its figures are heroic, illuminated in a strong artificial spotlight, and modeled in both their physical features and the folds of their clothing with a skill that lends them astonishing spatial reality and dimension. Not only does Judith's outstretched hand cast a shadow across her face, suggesting a more powerful, revealing source of light off canvas to the left, but it also invokes our silence. Like the light itself, danger lurks just offstage. If Judith is to escape, even we must remain still.

HATCHING AND CROSS-HATCHING

Other techniques used to model figures include hatching and cross-hatching. Employed especially in ink drawing and printmaking, where the artist's tools do not readily lend themselves to creating shaded areas, hatching and cross-hatching are linear methods of modeling. **Hatching** is an area of closely spaced parallel lines, or hatches. The closer the spacing of the lines, the darker the area appears. An example of hatching can be seen in *The Coiffure* (**Fig. 6-8**), a drawing by Mary Cassatt, an artist deeply interested in the play of light and dark (see *The Creative Process*, pp. 108–109). Here parallel lines, of greater or lesser density, define the relative deepness of the shadow in the room. Interestingly, the woman's reflection in the mirror is rendered as untouched white reserve.

Hatching can also be seen in Michelangelo's *Head of a Satyr* (**Fig. 6-9**), at the top and back of the satyr's head and at the base of his neck. But in Michelangelo's drawing, it is through **cross-hatching** that the greatest sense of volume and form in space is achieved. In cross-hatching, one set of hatches is crossed at an angle by a second, and sometimes a third, set. As in

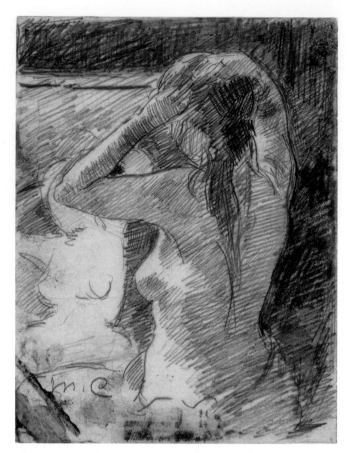

Fig. 6-8 Mary Cassatt, *The Coiffure*, c. 1891.
Graphite with traces of green and brown watercolor, approx. $5^{7}/_{8} \times 4^{3}/_{8}$ in. The National Gallery of Art, Washington, D.C. Rosenwald Collection, 1954.12.6.
Photograph © Board of Trustees, National Gallery of Art, Washington, D.C.

hatching, the denser the lines, the darker the area appears. The hollows of the satyr's face are tightly cross-hatched. In contrast, the most prominent aspects of the satyr's face, the highlights at the top of his nose and on his cheekbone, are almost completely free of line. Michelangelo employs line to create a sense of volume not unlike that achieved in the sphere modeled in Figure 6-6.

CONTRAST: LIGHT AND DARK

Generally speaking, the greater the contrast between light and dark, as in Artemisia Gentileschi's *Judith and Maidservant with the Head of Holofernes* (see Fig. 6-7), the greater the dramatic impact of the image, an effect exploited particularly by filmmakers, video artists, and photographers working with black-and-white film. A still from Shirin Neshat's black-and-white video *Fervor* is especially evocative (**Fig. 6-10**). Not only are the women and men worshipping at the mosque separated by the screen that cuts down

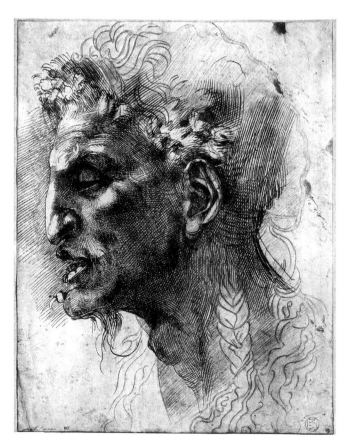

Fig. 6-9 Michelangelo, *Head of a Satyr*, c. 1620–30.
Pen and ink over chalk, $10^{5}/_{8} \times 7^{7}/_{8}$ in. Musée du Louvre, Paris.
Giraudon / Art Resource, New York.

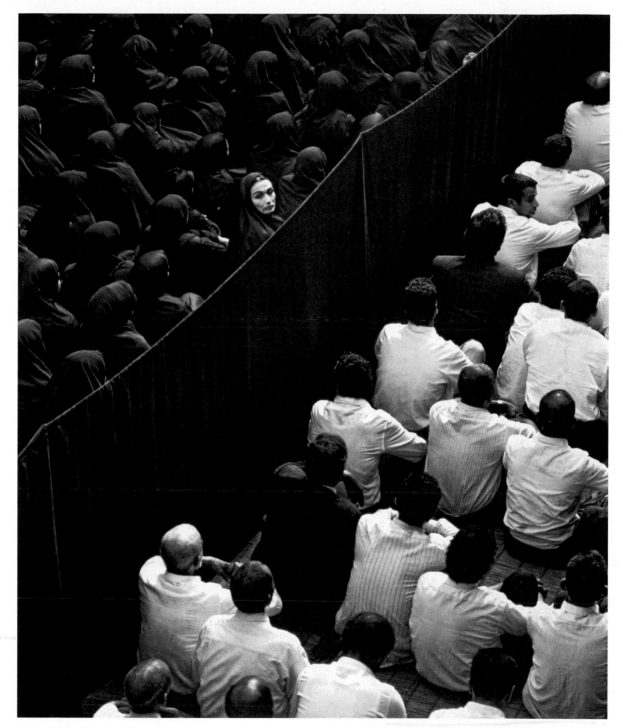

Fig. 6-10 Shirin Neshat, *Fervor*, 2000.
Gelatin silver print, 66 × 47 in.
Courtesy of the artist and Gladstone Gallery, New York and Brussels.

Thinking Thematically: See **Art, Gender, and Identity** on myartslab.com

the center of the space, but they are also separated black from white, chador from collared shirt. The power of this image of the separation of female and male worlds (which is, after all, fundamental to Muslim worship) is nothing, however, compared to the contrast between the wall of black chadors and the single white face of the woman who turns toward

the camera. Set off from the other women around her, she engages our view with a kind of fierce, almost defiant determination. In the video, it is clear that she is turning to meet the gaze of a man whom she has accidentally met in the street. He is standing on a podium reading the story of Zuleikha and Yusuf, which appears in both the Qur'an and the Bible (where it appears as

THE CREATIVE PROCESS

Painted in 1879, the year she first exhibited with the Impressionists, Mary Cassatt's *In the Loge (At the Français, a Sketch)* (**Fig. 6-12**) is a study in the contrast between light and dark, as becomes evident when we compare the final work to a tiny sketch, a study perhaps made at the scene itself (**Fig. 6-11**). In the sketch, Cassatt divides the work diagonally into two broad zones, the top left bathed in light, the lower right dominated by the woman's black dress. As the drawing makes clear, this diagonal design is softened by Cassatt's decision to fit the woman's figure into the architectural curve of the loge itself, so that the line running along the railing, then up the woman's arm, continues around the line created by her hat and its strap in a giant compositional arch. Thus, the woman's face falls into the zone of light, highlighted by her single diamond earring, and cradled, as it were, in black.

In the final painting, the strict division between light and dark has been somewhat modified, particularly by the revelation of the woman's neck between the hat's strap and her collar, creating two strong light-and-dark diagonals. A sort of angularity is thus introduced into the painting, emphasizing the horizontal quality of the woman's profile and gaze as she stares out at the other loges through her binoculars, at an angle precisely 90 degrees from our point of view.

Across the way, a gentleman, evidently in the company of another woman, leans forward out of his box to stare through his own binoculars in the direction of the woman in black. He is in the zone of light, and the dramatic division between light and dark defines itself as a division between male and female spaces. But Cassatt's woman, in a bold painterly statement, enters the male world. Both her face and her hand holding the binoculars enter the space of light. Giving up the female role as the passive recipient of his gaze, she becomes as active a spectator as the male across the way.

Fig. 6-11 Mary Cassatt, Study for the painting *In the Loge*, 1878.
Graphite, 4 × 6 in. Museum of Fine Arts, Boston. Gift of Dr. Hans Schaeffer, 55.28.
Photograph © 2012 Museum of Fine Arts, Boston.

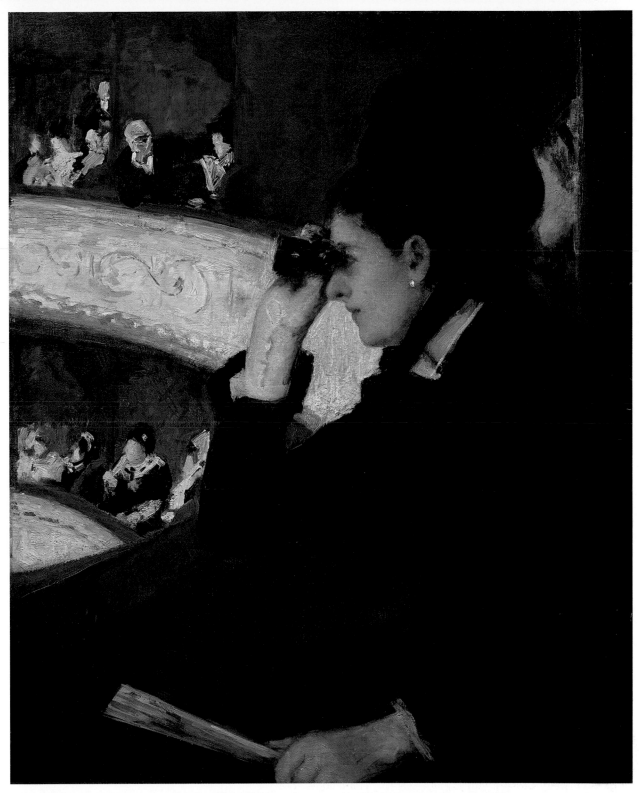

Fig. 6-12 Mary Cassatt (American, 1844–1926), *In the Loge (At the Francais, a Sketch)*, 1878.
Oil on canvas, 32 × 26 in. Museum of Fine Arts, Boston. The Hayden Collection, 10.35.
Photo © 2012 Museum of Fine Arts, Boston.

the story of Joseph and the wife of Potiphar). It is a story of seduction and temptation in which love for the beauty of the physical world is finally understood to be comparable to love for the beauty of God. The drama of Neshat's image depends fully upon the contrast between black and white, which underscores the tension-ridden contrast between phsyical and spiritual love, as well as the independence of the female gaze from the conformity of the religious practice of those who surround her.

Even when an image is almost totally devoid of human drama, the contrast between light and dark can imbue it with symbolic power. Consider the work of Hiroshi Sugimoto. Born in Tokyo in 1948, Sugimoto moved to New York in 1974, where he has continued to work. In the early 1990s he began to photograph movie screens as films were being projected on them (**Fig. 6-13**). "As soon as the movie started," he explains, "I fixed the shutter [of a large format camera] at a wide-open aperture, and two hours later when the movie finished, I clicked the shutter closed." The result is an image that contrasts time and space, the lighted screen an image of time's passing, the darkened theater the space in which time transpires. In essence, Sugimoto's photograph is a symbolic embodiment of the space-time continuum.

Sugimoto's ongoing series of seascapes are studies in the meeting point of light and dark, water and air, at the horizon (**Fig. 6-14**). Each photograph is the result of an extended stay on Sugimoto's part at the location itself. "I find that spot," he says, "that I want to stay and I stay there maybe, sometimes, one week, sometimes a couple of weeks, two, three weeks, and then I just stay there and just feel like I'm part of this nature and landscape. . . . I start feeling this is the creation of the universe and I am witnessing it." Light and dark here become almost biblical, as if we are witness in Sugimoto's photograph to the opening lines of the Book of Genesis.

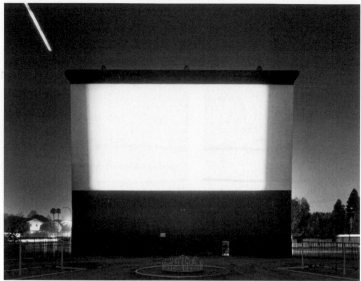

Fig. 6-13 Hiroshi Sugimoto, *Studio Drive-in, Culver City,* 1993.
Silver gelatin photograph, dimensions variable by edition.
© Hiroshi Sugimoto, courtesy The Pace Gallery.

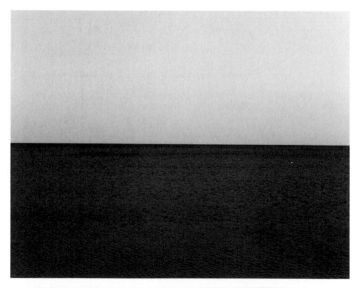

Fig. 6-14 Hiroshi Sugimoto, *Seascape: Baltic Sea, near Rügen,* 1996.
Silver gelatin photograph, dimensions variable by edition.
© Hiroshi Sugimoto, courtesy The Pace Gallery.

VALUE

The gradual shift from light to dark that characterizes both chiaroscuro and atmospheric perspective is illustrated by the gray scale (**Fig. 6-15**). The relative level of lightness or darkness of an area or object is traditionally called its relative value. That is, a given area or object can be said to be darker or lighter in value. Colors, too, change value in similar gradients. Imagine, for example, substituting the lightest blue near the bottom of this scale and the darkest cobalt near its top (**Fig. 6-16**). The mountains in the back of Leonardo's *Madonna of the Rocks* (see Fig. 6-3) are depicted in a blue of lighter and lighter value the farther they are away from us.

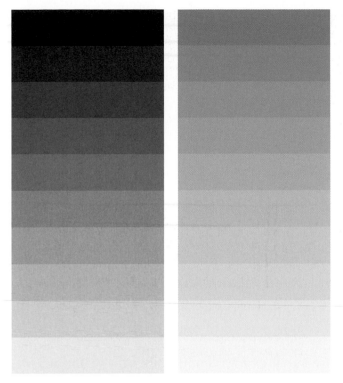

Likewise, light pink is a lighter value of red, and dark maroon a darker value. In terms of color, whenever white is added to the basic hue, or color, we are dealing with a **tint** of that color. Whenever black is added to the hue, we are dealing with a shade of that color. Thus, pink is a tint, and maroon a shade, of red. Pat Steir's two large paintings, *Pink Chrysanthemum* (**Fig. 6-17**) and *Night Chrysanthemum* (**Fig. 6-18**), are composed of three panels, each of which depicts the same flower in the same light viewed increasingly close up, left to right. Not only does each panel become more and more abstract as our point of view focuses in on the flower, so that in the last panel we are looking at almost pure gestural line and brushwork, but also the feeling of each panel shifts, depending on its relative value. The light painting becomes increasingly energetic and alive. The dark one likewise becomes increasingly less somber but at the same time menacing.

Fig. 6-15 The gray scale. **Fig. 6-16** Blue in a range of values.

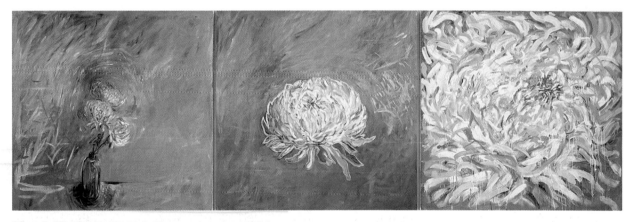

Fig. 6-17 Pat Steir, *Pink Chrysanthemum*, 1984.
Oil on canvas, 3 panels, 60 × 60 inches each.
Courtesy of the artist and Cheim & Read, New York.

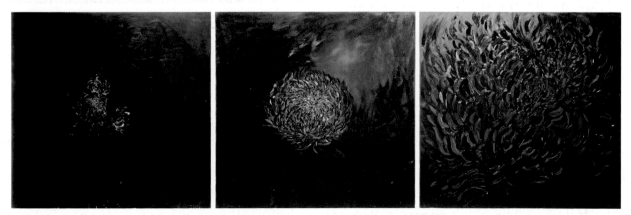

Fig. 6-18 Pat Steir, *Night Chrysanthemum*, 1984.
Oil on canvas, 3 panels, 60 × 60 inches each.
Courtesy of the artist and Cheim & Read, New York.

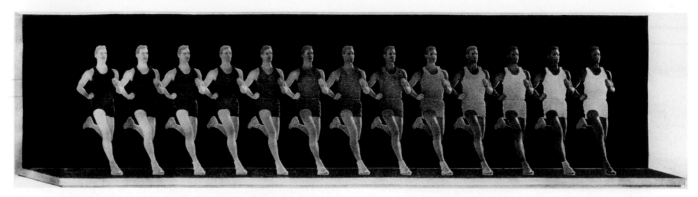

Fig. 6-19 Nikolai Buglaj, *"Race"ing Sideways*, 1991.
Graphite and ink, 30 in. high × 40 in. wide.
Courtesy of the artist.

Thus, even if Hiroshi Sugimoto's seascapes are almost passive in the feelings they evoke (see Fig. 6-14), the first lines of the Book of Genesis are not nearly so neutral. They openly associate the dark with the bad and the light with the good:

In the beginning God created the heaven and the earth. And the earth was without form, and void; and darkness was upon the face of the deep. And the Spirit of God moved upon the face of the waters. And God said, Let there be light: and there was light. And God saw the light, that it was good: and God divided the light from the darkness.

In the history of art, this association of light or white with good, and darkness or black with evil, was first fully developed in the late-eighteenth- and early-nineteenth-century color theory of the German poet and dramatist Johannes Wolfgang von Goethe. For Goethe, colors were not just phenomena to be explained by scientific laws. They also had moral and religious significance, existing halfway between the goodness of pure light and the damnation of pure blackness. In heaven there is only pure light, but the fact that we can experience color—which, according to the laws of optics, depends upon light mixing with darkness—promises us at least the hope of salvation.

Since Biblical times, Western culture has tended to associate blackness with negative qualities and whiteness with positive ones, and it is understandable that people might take offense at this association. In *"Race"ing Sideways* (**Fig. 6-19**), Nikolai Buglaj has drawn 13 racers, conceived as mannequins in an installation, tied for the lead in a race no one seems intent on winning. From left to right, their skin color changes from white to black,

even as their clothing changes from black to white, a double version of the traditional "value" scale. But what "values" are at stake here? The runners are moving forward uniformly, all equally "making progress." But this equality is an illusion. Left to right, our "values" change. They reveal themselves to be governed by questions of race (skin color) and class (clothing color, i.e., "white collar," "blue collar"). And we understand that Buglaj's drawing is a stinging indictment of the lack of progress Americans have made in race and class relations in this country. For Buglaj, perceptual illusion replicates cultural illusion.

If for Goethe blackness is not merely the absence of color but also the absence of good, for African Americans, blackness is just the opposite. In poet Ted Wilson's words:

*Mighty drums echoing the voices
of Spirits. . . .
these sounds are rhythmatic
The rhythm of vitality,
The rhythm of exuberance
and the rhythms of Life
These are the sounds of blackness
Blackness—the presence of all color.*

Ben Jones's *Black Face and Arm Unit* (**Fig. 6-20**) is in many ways the visual equivalent of Wilson's poem. Cast life-size from actual hands and arms, the 12-part piece literally embodies an essential blackness. Adorning this essence is a series of bands, decorations, and scarifications, reminiscent of the facial decorations evident in some of the most ancient African sculpture. The use of line and color here creates a sense of rhythm and exuberance as it celebrates African cultural identity.

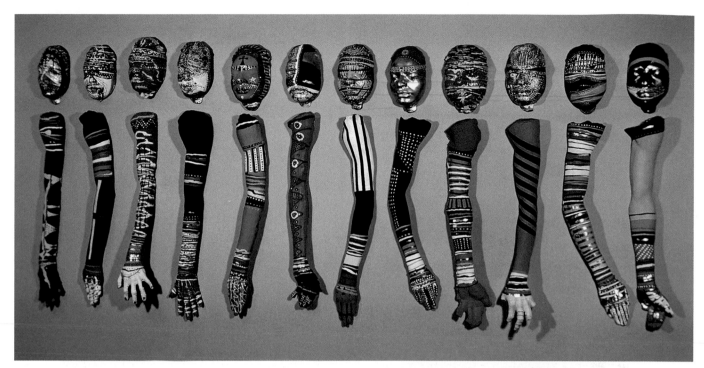

Fig. 6-20 Ben Jones, *Black Face and Arm Unit*, 1971.
Acrylic on plaster, life-size plaster casts.
Courtesy of the artist.

A Nigerian funeral cloth (**Fig. 6-21**) commissioned by a collector in the late 1970s similarly illustrates the limits of white Western assumptions about the meanings of light and dark, black and white. The cloth is the featured element of a shrine, called a *nwomo*, constructed of bamboo poles to commemorate the death of a member of Ebie-owo, a Nigerian warriors' association. A deceased elder, wearing a woolen hat, is depicted in the center of this cloth. His eldest daughter, at the left, pours liquor into his glass. The woman on the right wears the hairdo of a mourning widow. She is cooking two dried fish for the funeral feast.

But the dominant colors of the cloth—red, black, and white—are what is most interesting. While in the West we associate black with funerals and mourning, here it signifies life and the ancestral spirits. White, on the other hand, signifies death. Though red is the color of blood, it is meant to inspire the warrior's valorous deeds.

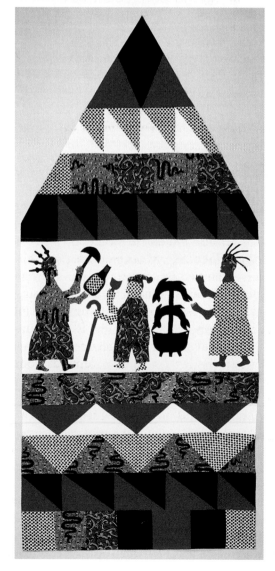

Fig. 6-21 **Okun Akpan Abuje,** Nigerian funerary shrine cloth, commissioned in the late 1970s. Cotton, dye 135³/₄ × 60¹/₄ in.
National Museum of African Art/Smithsonian Institution Museum Purchase 84-6-9.
Photo: Frank Khoury.

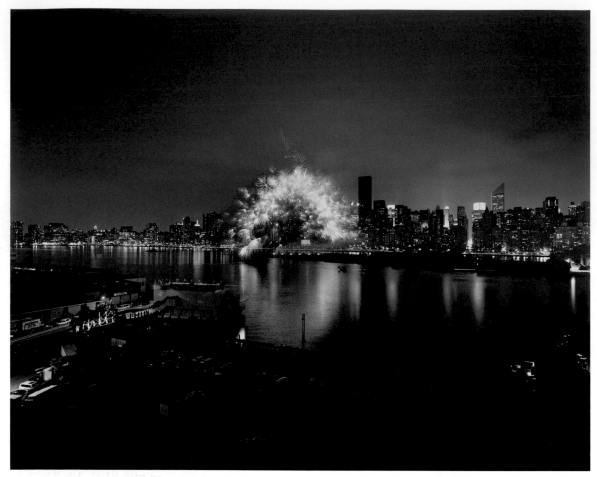

Fig. 6-22 Cai Guo-Qiang, *Transient Rainbow*, 2002.
1,000 3-inch multicolor peony fireworks fitted with computer chips, 300 × 600 feet, duration 15 seconds. Commissioned by Museum of Modern Art, New York.
Photo: Hiro Ihara, courtesy Cai Studio.

Color

When New York City's Museum of Modern Art closed for an extensive redesign and moved to temporary quarters across the river in Queens, it commissioned artist Cai Guo-Qiang, who would later serve as Director of Visual and Special Effects at the 29th Olympiad in Beijing (see Fig. 1-1), to celebrate the move with one of his famous explosion events. His proposal resulted in *Transient Rainbow* (**Fig. 6-22**), a massive fireworks display that extended across the East River, connecting Manhattan and Queens, on the evening of June 29, 2002. For the artist, the rainbow is a sign of hope, renewal, and promise. In Chinese mythology, the rainbow is associated with the goddess Nu-Wa (see Fig. 4-22), who sealed the broken sky after a fight among the gods with stones of seven different colors—the colors of the rainbow. Coming after 9/11, the choice of the rainbow image was similarly designed to heal, at least symbolically, the wounded city. Reflected in the water, the arch created by Cai Guo-Qiang's rainbow creates the circular *pi*, the ancient Chinese symbol for the universe. Nevertheless, since it is by its very nature fleeting and transitory, this work reminds viewers of the fragility and transience of the moment and, by extension, life itself.

BASIC COLOR VOCABULARY

As Sir Isaac Newton first discovered in the 1660s, color is a direct function of light. Sunlight passed through a prism, Newton found, breaks into bands of different colors, in what is known as the **spectrum** (**Fig. 6-23**). By reorganizing the visible spectrum into a circle, as Newton himself was the first to do, we have what is recognized as the conventional **color wheel** (**Fig. 6-24**).

The three **primary colors** in this system are red, yellow, and blue (designated by the number 1 on the color wheel). Each of the **secondary colors**—orange,

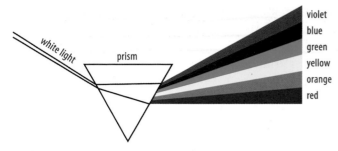

Fig. 6-23 Colors separated by a prism.

✴ **Explore** a Discovering Art tutorial about color in light on myartslab.com

green, and violet (designated by the number 2)—is a mixture of the two primaries that it lies between. Thus, as many children learn in elementary school, green is made by mixing yellow and blue. The **intermediate colors** (designated by the number 3) are mixtures of a primary and a neighboring secondary. If we mix the primary yellow with the secondary orange, for instance, the result is yellow-orange. Theoretically, if we mixed all the colors together, we would end up with black, the absence of color (**Fig. 6-25**)—hence, this color system, which is that of all pigments, is called a **subtractive process**.

Colored light mixes in a very different way. The primary colors of light are red-orange, green, and blue-violet. The secondaries are yellow, magenta, and cyan. When we mix light, we are involved in an **additive process** (**Fig. 6-26**). Our most common exposure to this process occurs when we watch television or look at a computer monitor. This is especially apparent on a large-screen monitor, where yellow, if viewed close up, can be seen to result from the overlapping of many red and green dots. In the additive color process, as more and more colors are combined, more and more light

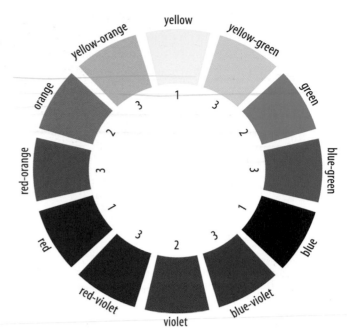

Fig. 6-24 Conventional color wheel.

is added to the mixture, and the colors that result are brighter than either source taken alone. As Newton discovered, when the total spectrum of refracted light is recombined, white light results.

Color is described first by reference to its **hue** as found on the color wheel. There are 12 hues in the color wheel illustrated in Figure 6-24. A color is also described by its relative value, as well as by its **intensity or saturation**. Intensity is a function of a color's relative brightness or dullness. One lowers the intensity of a hue by adding to it either gray or the hue opposite it on the color wheel (in the case of red, we would add green). Intensity may also be reduced by adding **medium**—a liquid that makes paint easier to manipulate—to the hue.

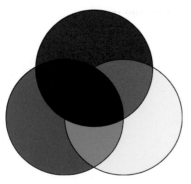

Fig. 6-25 Color mixtures of reflected pigment—subtractive process.

Fig. 6-26 Color mixtures of refracted light—additive process.

✴ **Explore** a Discovering Art tutorial about color in pigment on myartslab.com

There is perhaps no better evidence of the psychological impact that a change in intensity can make than to look at the newly restored frescoes of the Sistine Chapel at the Vatican in Rome, painted by Michelangelo between 1508 and 1512 (**Figs. 6-27** and **6-28**). Restorers have discovered that the dull, somber hues always associated with Michelangelo were not the result of his **palette**, that is, the range of colors he preferred to use, but rather of centuries of accumulated dust, smoke, grease, and varnishes made of animal glue that were painted over the ceiling by earlier restorers. The colors are in fact much more saturated and intense than anyone had previously supposed. Some experts find them so intense that they seem, beside the golden tones of the unrestored surface, almost garish. As a result, there has been some debate about the merits of the cleaning. But, in the words of one observer: "It's not a controversy. It's culture shock."

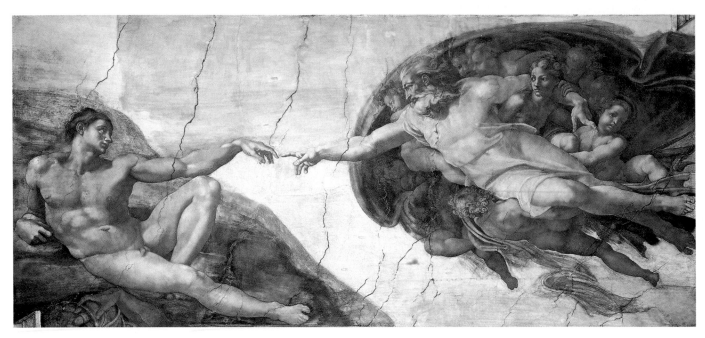

Fig. 6-27 Michelangelo, *The Creation of Adam* (unrestored), ceiling of the Sistine Chapel, 1508–12. Fresco. The Vatican, Rome.

Fig. 6-28 Michelangelo, *The Creation of Adam* (restored), ceiling of the Sistine Chapel, 1508–12. Fresco. The Vatican, Rome.

Thinking Thematically: See Art and Beauty on myartslab.com

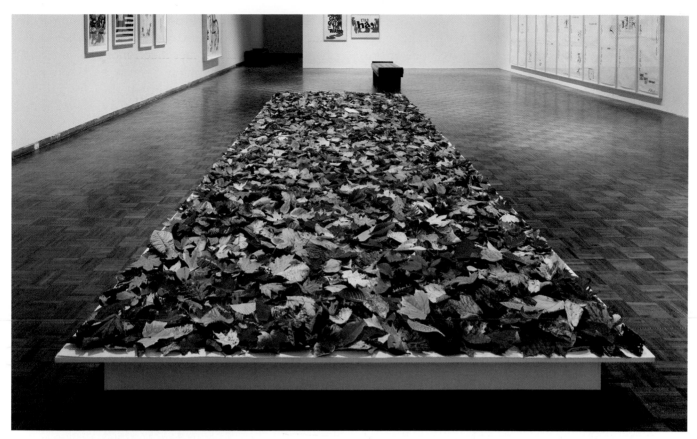

Fig. 6-29 Jane Hammond, *Fallen*, 2004–2011.
Archival digital inkjet prints on archival paper with acrylic, gouache, matte medium, Jade glue, fiberglass strands, and Sumi ink on a pedestal of high-density foam, cotton, muslin, cotton thread, foam core, and handmade cotton rag paper, 11 × 154 × 89 in. Whitney Museum of American Art, New York. 2007.6.
© Jane Hammond. Courtesy Galerie Lelong, New York. Photo: Peter Muscato

COLOR SCHEMES

Colors can be employed by artists in different ways to achieve a wide variety of effects. **Analogous color schemes are those composed of hues that neighbor each other on the color wheel.** Such color schemes are often organized on the basis of color **temperature**. Most of us respond to the range from yellow through orange and red as warm, and to the opposite side of the color wheel, from green through violet, as cool. Jane Hammond's *Fallen* (**Fig. 6-29**) is a decidedly warm work of art—just like a sunny fall day. The color scheme consists of yellows, oranges, and reds in varying degrees of intensity and value, punctuated with an occasional touch of green. Even what appears to be brown in this composition is a result of mixing this spectrum of warm colors. Each leaf is in fact a digitally scanned and printed reproduction of an actual leaf that is then painted and dipped into a finish to make it look real. They are subsequently sewn onto the platform on which they are displayed.

But the visual warmth of Hammond's construction is double-edged. Beginning in 2004, Hammond inscribed each of these leaves with the name of a soldier killed in the Iraq war—1,511 names to begin with. As the war wore on, she continued to add new leaves to the pile. As a special exhibition of the work came to a close at New York's FLAG Art Foundation on December 31, 2011, and as President Obama officially ended the war, the last leaf was added. The piece was acquired by the Whitney Museum of American Art in 2006, and when it was exhibited at the museum in October 2007, it contained 3,786 leaves. When it opened at FLAG Art in September 2011, it contained 4,455 leaves.

If *Fallen* is a testament to the tragedy of the war in Iraq, it is also a means of healing, serving much the same purpose as Maya Lin's Vietnam Memorial (see Fig. 3-9). Hammond tells the story of a soldier's mother who overheard a conversation about the piece while visiting New York, sought it out at Hammond's gallery, and found her son's name on a leaf—a remarkable coincidence since only about one in six names is visible. The mother was able to find solace in the sheer warmth and beauty of Hammond's field of the fallen.

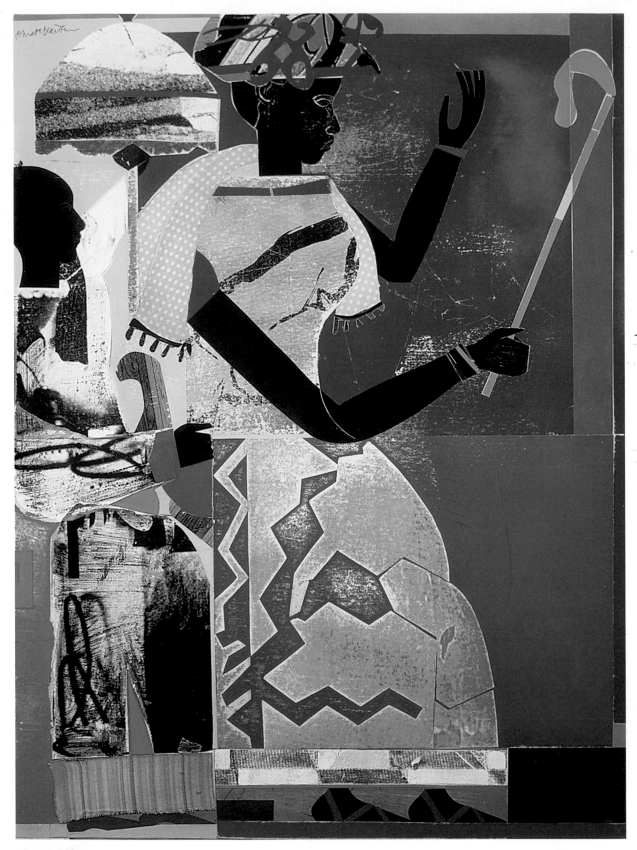

Fig. 6-30 Romare Bearden, *She-ba*, 1970.
Collage on paper cloth and synthetic polymer paint on composition board, 48 × 35⁷/₈ in. Wadsworth Atheneum, Hartford.
The Ella Gallup Sumner and Mary Catlin Sumner Collection Fund. Art.

Thinking Thematically: See **Art and the Passage of Time** on myartslab.com

Just as warm and cool temperatures literally create contrasting physical sensations, when both warm and cool hues occur together in the same work of art they tend to evoke a sense of contrast and tension. Romare Bearden's *She-ba* (**Fig. 6-30**) is dominated by cool blues and greens, but surrounding and accenting these great blocks of color are contrasting areas of red, yellow, and orange. "Sometimes, in order to heighten the character of a painting," Bearden wrote in 1969, just a year before this painting was completed, "I introduce what appears to be a dissonant color where the reds, browns, and yellows disrupt the placidity of the blues and greens." Monarch of a kingdom that, 3,000 years ago, spanned modern-day Ethiopia and Yemen, Bearden's queen, imparts a regal serenity to all that surrounds her. It is as if, in her every gesture, she cools the atmosphere, like rain in a time of drought, or shade at an oasis in the desert.

Compositions that employ hues that lie opposite each other on the color wheel, as opposed to next to each other, are called **complementary color schemes**. When two complements appear in the same composition, especially if they are pure hues, each will appear more intense. If placed next to each other, without mixing, complements seem brighter than if they appear alone. This effect, known as **simultaneous contrast**, is due to the physiology of the eye. The cells in the retina that respond to color can only register one complementary color at a time. As the cells respond to one color and then the other, the colors appear to be more intense and highly charged.

The Brazilian feather mask, known as a *Cara Grande* (**Fig. 6-31**), illustrates how complementary colors can intensify each other. The mask is worn during the annual Banana Fiesta in the Amazon Basin; it is almost 3 feet tall. It is made of wood and is covered with pitch to which feathers are attached. The colored feathers are not dyed, but instead are the natural plumage of tropical birds, and their brilliance is heightened by the simultaneous contrast between yellow-orange and blue-violet, which is especially apparent at the outer edge of the mask.

Color interactions can also cause the retina to produce a spot of color where none exists. This is

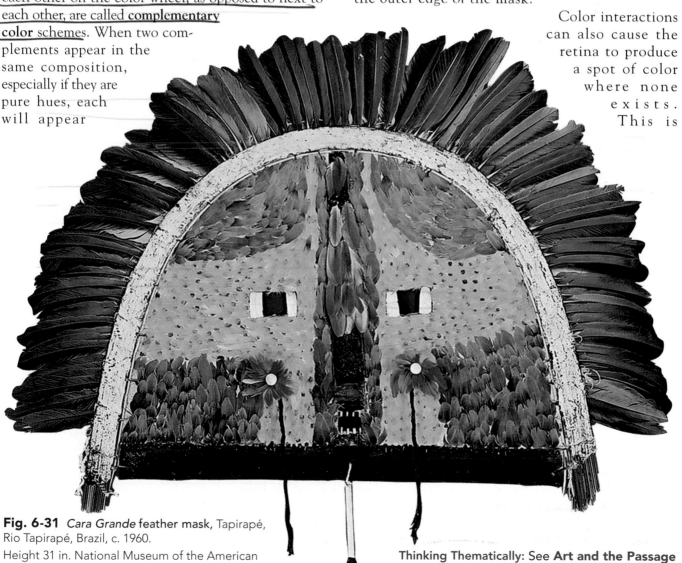

Fig. 6-31 *Cara Grande* feather mask, Tapirapé, Rio Tapirapé, Brazil, c. 1960.
Height 31 in. National Museum of the American Indian/Smithsonian Institution.

Courtesy, National Museum of the American Indian, Smithsonian Institution, S03834. Photo by Carmelo Guadagno, 23/3299.

Thinking Thematically: See **Art and the Passage of Time** on myartslab.com

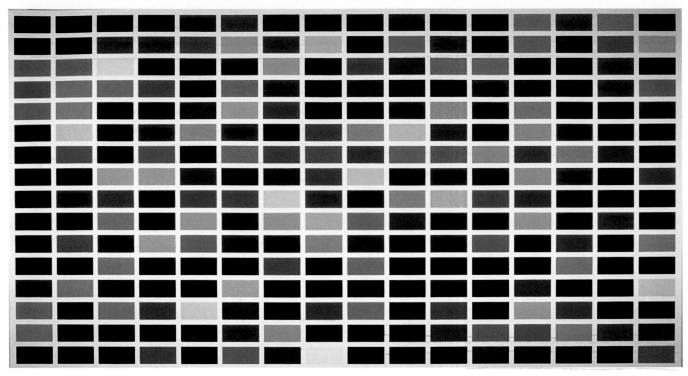

Fig. 6-32 Gerhard Richter, *256 Farben (256 Colors)*, 1974–84.
Enamel on canvas, 7 ft. 3 in. × 14 ft. 5 in. Castello di Rivoli Museo d'Arte Contemporanea, Turin, Italy. Long-term loan—
private collection.
© Gerhard Richter.

readily demonstrated in Gerhard Richter's *256 Farben (256 Colors)* (**Fig. 6-32**). The painting belongs to a series of color charts painted by the artist from the mid-1960s on. The arrangement of the colors on the squares was done by a random process to obtain a diffuse, undifferentiated overall effect, intentionally stripping color of its emotional value. But, to Richter's delight, the paintings were hardly static. Where the vertical and horizontal white lines intersect, a grayish "pop" appears. If the viewer looks at any given "pop" directly, it disappears, suggesting that it exists to the eye only at the edge of vision, as a sort of blur or aura that surrounds color.

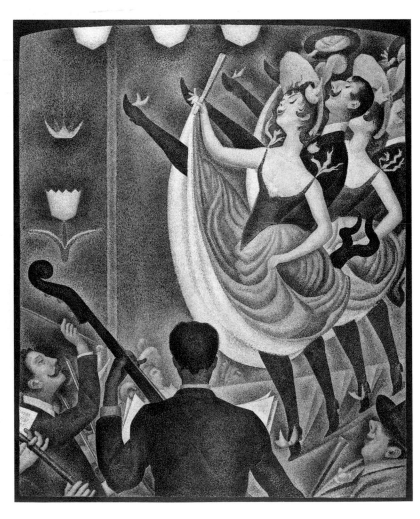

Fig. 6-33 Georges Seurat, *Le Chahut* (*The Can-Can*), 1889–90.
Oil on canvas, 66 1/8 × 55 1/2 in. Collection State Museum Kröller-Müller, Otterlo, The Netherlands.
Thinking Thematically: See Art, Politics, and Community
on myartslab.com

Fig. 6-34 Georges Seurat, *Le Chahut* (*The Can-Can*), detail, 1889–90.
Oil on canvas, 66¹/₈ × 55¹/₂ in. Collection Kröller-Müller Museum, Otterlo, The Netherlands.

In his *Le Chahut* (*The Can-Can*) (**Fig. 6-33**), Georges Seurat tried to *harmonize* his complementary colors rather than create a sense of tension with them. With what almost amounted to fanaticism, Seurat painted this canvas with thousands of tiny dots, or points, of pure color in a process that came to be known as *pointillism*. Instead of mixing color on the palette or canvas, he believed that the eye of the perceiver would be able to mix colors optically. Seurat strongly believed that if he placed complements side by side—particularly orange and blue in the shadowed areas of the painting, as in the detail of the area just below the closest dancer's raised leg (**Fig. 6-34**)—the intensity of the color would be dramatically enhanced. Seurat believed that the intensity of his color mixtures would likewise increase the emotional intensity

of the work, and thus, in *Le Chahut*, the combination of blue and orange, meant to suggest the light from the gas lamps on the wall and ceiling, together with the rising lines of the dancers' skirts and legs, would contribute to a sense of joyousness and festivity in the painting. But to his dismay, most viewers found paintings such as *Le Chahut* "lusterless" and "murky." This is because there is a rather limited zone in which the viewer does in fact optically mix the pointillist dots. For most viewers, Seurat's paintings work from about 6 feet away—closer, the painting breaks down into abstract dots; farther away, the colors muddy, turning almost brown. Although Seurat's experiment was not a complete success, the contemporary artist Chuck Close has perfected the technique, as is evidenced in *The Creative Process*, pp. 122–123.

THE CREATIVE PROCESS

Chuck Close's 1981 oil painting *Stanley* (**Fig. 6-36**) might best be described as "layered" pointillism (see Fig. 6-33). Like all of his paintings, the piece is based on a photograph. Close's working method is to overlay the original photograph with a grid. Then he draws a grid with the same number of squares on a canvas. Close is not so much interested in representing the person whose portrait he is painting as he is in reproducing, as accurately as possible, the completely abstract design that occurs in each square of the photo's grid. In essence, Close's large paintings—*Stanley* is nearly 8 feet high and 6 feet wide—are made up of thousands of little square paintings, as the detail (**Fig. 6-35**) makes clear. Each of these "micropaintings" is composed as a small target, an arrangement of two, three, or four concentric circles. Viewed up close, it is hard to see anything but the design of each square of the grid. But as the viewer moves farther away, the design of the individual squares of the composition dissolves, and the sitter's features emerge with greater and greater clarity.

In an interview conducted by art critic Lisa Lyons for an essay that appears in the book *Chuck Close*, published by Rizzoli International in 1987, Close describes his working method in *Stanley* at some length, comparing his technique to, of all things, the game of golf:

Golf is the only sport in which you move from the general to the specific. In the beginning when you take your first shot, you can't even see the pin. And in a matter of three or four strokes, you're supposed to be in the cup, a very small, specific

Fig. 6-35 Chuck Close, *Stanley* (large version), 1980–81, detail.

Oil on canvas, 108 × 84 in. The Solomon R. Guggenheim Museum, New York. Purchased with funds contributed by Mr. and Mrs. Barrie M. Damson, 1981, 81.2839. Photograph by: David Heald. Courtesy The Pace Gallery. (FN 2839).

Fig. 6-36 Chuck Close, *Stanley* (large version), 1980–81.

Oil on canvas, 108 × 84 in. The Solomon R. Guggenheim Museum, New York. Purchased with funds contributed by Mr. and Mrs. Barrie M. Damson, 1981, 81.2839.

Photograph by David Heald. Courtesy The Pace Gallery. (FN 2839).

place a very long ways away. I thought of the gridded canvas as a golf course, and each square of the grid as a par-four hole. Then just to complicate things and make the game more interesting, I teed off in the opposite direction of the pin. For example, I knew that the color of the skin was going to be in the orange family, so I started out by putting down a thin wash of blue, green, or purple—something very different from what the final color would be. The second color then had to go miles to alter the first one. So for this big correcting stroke, I chose a hue that moved me into the generic color family I should have been aiming for. Now I had moved into orange, but it was too yellow, so in the middle of that stroke, I put down a gob of red to move into a reddish orange. Then I was at the equivalent of being "on the green" and hopefully quite close to the cup. But the color was still much too bright. So the final stroke was a little dot of blue, the complementary color, which optically mixed with the orange and lowered its intensity, dropping it down to an orangish brown. I was in the cup.

[It was possible] to have a birdie—to come in a stroke early. It was even possible to have an eagle—to come in two [strokes] under par. Of course, it was also equally possible to have a bogie or a double bogie [one or two strokes over par], and even get mired in some aesthetic sandtrap, just making strokes and getting nowhere at all.

Close's "game" with color is exacting and demanding, requiring a knowledge of the optical effects of color mixing that is virtually unparalleled in the history of art. He is able to achieve, in his work, two seemingly contradictory goals at once. On the one hand, his work is fully representational. On the other, it is fully abstract, even nonobjective, in its purely formal interest in color. Close has it both ways.

The generation of modern painters who followed Seurat took experiments with color relationships to a new level. Among them were the artists Robert and Sonia Delaunay, who explored what their poet friend, Guillaume Apollinaire, called "the beautiful fruit of light," the colors of the modern world. In the work of both artists, these colors assumed the shape of disks. Robert called these *simultaneous disks* (**Fig. 6-37**), and they were based on his own notions about the simultaneous contrast of colors. He sought to balance complements in giant color wheels. Sonia was less scientific in her approach to the design. Electric streetlights, which were still a relatively new phenomenon, transfixed her: "The halos of the new electric lights made colors and shades turn and vibrate, as if as yet unidentified objects fell out of the sky around us." In *Electric Prism* (**Fig. 6-38**) she captured the dynamic movement of color and flowing lines that represented for her the flux and flow, the energy and dynamism, of modernity itself.

Artists working with either analogous or complementary color schemes choose to limit the range of their color selection. In his painting *Filàs for Sale* (**Fig. 6-39**), Charles Searles has rejected such a **closed** or **restricted palette** in favor of an **open palette**, in which he employs the entire range of hues in a wide variety of keys and intensities. Such a painting is **polychromatic**. The painting depicts a Nigerian marketplace and was inspired by a trip Searles took to Nigeria, Ghana, and Morocco in 1972. "What really hit me," Searles says, "is that the art is in the people. The way the people carried themselves, dressed, decorated their houses became the art to me, like a living art." A pile of *filàs*, or brightly patterned skullcaps, occupies the left foreground of this painting. The confusion and turmoil of the crowded marketplace is mirrored in the swirl of the variously colored textile patterns. Each pattern has its own color scheme—yellow arcs against a set of violet dots, for instance, in the swatch of cloth just above the pile of hats—but all combine to create an almost disorienting sense of movement and activity.

When artists limit their palette to a single color, a **monochromatic** painting results. In the 1960s, Brice Marden created a series of apparently gray

Fig. 6-37 Robert Delaunay, *Premier Disque*, 1912. Oil on canvas, 53 in. diameter. Christie's Images Ltd. 1999. © Christie's Images Ltd - ARTOTHEK 1999.

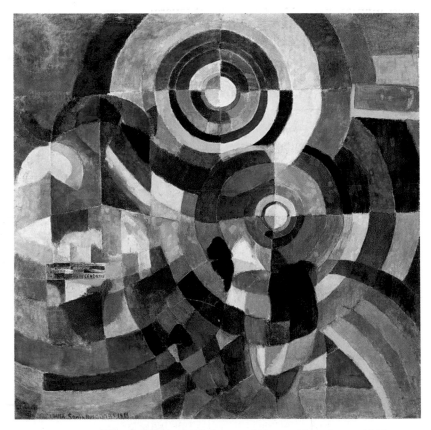

Fig. 6-38 Sonia Delaunay, *Prismes Electriques*, 1914. Oil on canvas, 98³/₈ × 98³/₈ in. Musée National d'Art Moderne, Paris. Collection du Centre Georges Pompidou. © L & M Services B.V. the Hague 20120207.

monochomatic works, including *The Dylan Painting* (**Fig. 6-40**), so named, Marden says, because "I had told [Bob] Dylan that I wanted to make a painting for him, put it out in the world to help his career, but by the time I got this painting finished, he was very, very famous." To make the painting, Marden combined oil and color (in this case, a sort of eggplant purple and gray) with a mixture of turpentine and beeswax, and then applied the mixture to the canvas. Along a slight strip at the bottom edge short drips of paint mark the history of this painting process. Then, Marden went over all but the bottom strip with a spatula to eliminate all brushstrokes. It is impossible to define the color of the resulting surface, which appears to change with each change of light. The effect of the surface is, in fact, impossible to see in reproduction. From a distance, the painting is decidedly neutral. But up close, the apparent gray becomes a richly colorful surface, full of texture created by the spatula, that catches all manner of light, and the effect is like looking into an atmosphere of almost infinite space. Marden is one of several painters of the era who, in rejecting polychromatic color and expressive line, became known as Minimalists. But the richness of Marden's surfaces are, arguably, anthing but minimal.

Fig. 6-39 Charles Searles, *Filàs for Sale* (*Nigerian Impressions* Series), 1972.
Acrylic on canvas, 72 × 52 in. Lent by the Museum of the National Center of Afro-American Artists, Boston.

Fig. 6-40 Brice Marden, *The Dylan Painting*, 1966/1986.
Oil and beeswax on canvas, $60^{3}/_{8} \times 120^{1}/_{2}$ in. San Francisco Museum of Modern Art, Helen Crocker Russell Fund purchase and gift of Mrs. Helen Portugal.
© 2012 Brice Marden / Artists Rights Society (ARS), New York.

COLOR IN REPRESENTATIONAL ART

There are four different ways of using color in representational art. The artist can employ local color, represent perceptual color, create an optical mix like Seurat, or simply use color arbitrarily for formal or expressive purposes. **Local color** is the color of objects viewed close up in even lighting conditions. Local color is the color we "know" an object to be, in the way that we know a banana is yellow or a fire truck is red.

Yet while we think of an object as having a certain color, we are also aware that its color can change depending on the light. As we know from the example of atmospheric perspective, we actually see a distant pine-covered hill as blue, not green. That blue is a **perceptual color**, as opposed to the local color of the green trees. The Impressionist painters were especially concerned with rendering such perceptual colors. Monet painted his landscapes outdoors, in front of his subject—*en plein air* is the technical term, the French words for "in the open air"—so as to be true to the optical colors of the scene before him. He did not paint a grainstack yellow simply because he knew hay to be yellow. He painted it in the colors that natural light rendered it to his eyes. Thus, this *Grainstack* (**Fig. 6-41**) is dominated by reds, with afterimages of green flashing throughout.

The Impressionists' attempt to render the effects of light by representing perceptual reality is different from Seurat's attempt to reproduce light's effects by means of optical color mixing. Monet mixes color on the canvas. Seurat expects color to mix in your own eye. He puts two hues next to each other, creating a third, new hue in the beholder's eye. As we have noted, Seurat's experiment was not a complete success.

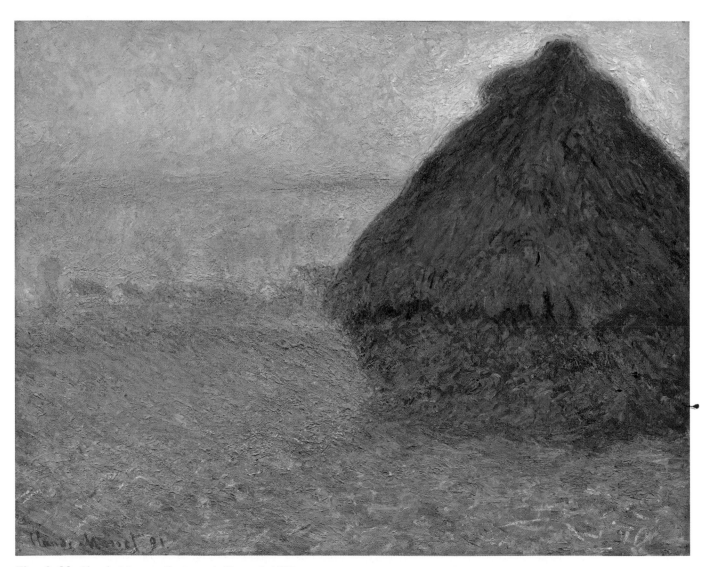

Fig. 6-41 Claude Monet, *Grainstack (Sunset),* 1891.
Oil on canvas, 28⁷/₈ × 36¹/₂ in. Museum of Fine Arts, Boston. Juliana Cheney Edwards Collection, 25.112.
Photo © 2012 Museum of Fine Arts, Boston.

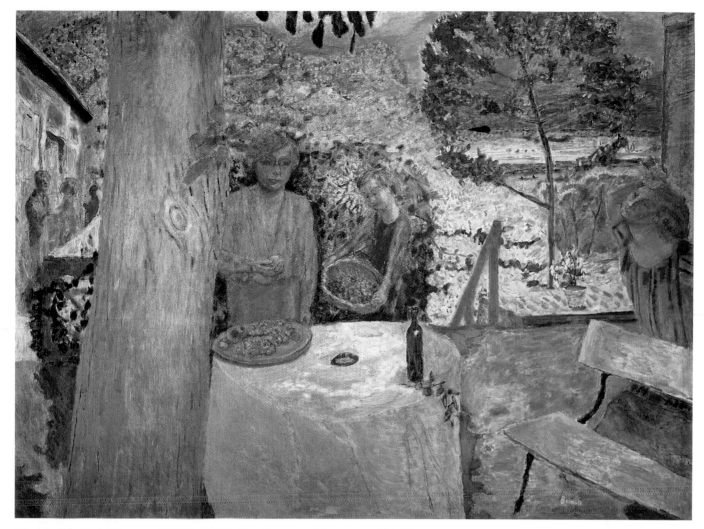

Fig. 6-42 Pierre Bonnard (1867–1947), *The Terrace at Vernon*, c. 1920–39.
Oil on canvas, 57¹¹/₁₆ × 76½ in. The Metropolitan Museum of Art, New York. Gift of Mrs. Frank Jay Gould, 1968 (68.1).
Image copyright © The Metropolitan Museum of Art. Image source: Art Resource, NY. © 2012 Artists Rights Society (ARS), New York/ADAGP, Paris.

Artists sometimes choose to paint things in colors that are not "true" to either optical or local colors. Bonnard's painting *The Terrace at Vernon* (Fig. 6-42) is an example of the expressive use of arbitrary color. No tree is really violet, and yet this large foreground tree is. The woman at the left holds an apple, but the apple is as orange as her dress. Next to her, a young woman carrying a basket seems almost to disappear into the background, painted, as she is, in almost the same hues as the landscape (or is it a hedge?) behind her. At the right, another young woman in orange reaches above her head, melding into the ground around her. Everything in the composition is sacrificed to Bonnard's interest in the play between warm and cool colors, chiefly orange and violet or blue-violet, which he uses to flatten the composition, so that the fore-, middle-, and backgrounds

all seem to coexist in the same space. "The main subject," Bonnard would explain, "is the surface which has its color, its laws, over and above those of the objects." He sacrifices both the local and optical color of things to the arbitrary—but not unplanned or random—color scheme of the composition.

SYMBOLIC USE OF COLOR

To different people in different situations and in different contexts, color symbolizes different things. There is no one meaning for any given color, though in a particular cultural environment, there may be a shared understanding of it. So, for instance, when we see a stoplight, we assume that everyone understands that red means "stop" and green means "go." In China, however, this distinction does not exist.

In Western culture, in the context of war, red might mean "death" or "blood" or "anger." In the context of Valentine's Day, it means "love." Most Americans, when confronted by the complementary pair of red and green, think first of all of Christmas.

In his painting *The Night Café* (**Fig. 6-43**), van Gogh employs red and green to his own expressive ends. In a letter to his brother Theo, written September 8, 1888, he described how the complements work to create a sense of visual tension and emotional imbalance:

In my picture of the Night Café I have tried to express the idea that the café is a place where one can ruin oneself, run mad, or commit a crime. I have tried to express the terrible passions of humanity by means of red and green. . . . Everywhere there is a clash and contrast of the most alien reds and greens. . . . So I have tried to express, as it were, the powers of darkness in a low wine-shop, and all this in an atmosphere like a devil's furnace of pale sulphur. . . . It is color not locally true from the point of view of the stereoscopic realist, but color to suggest the emotion of an ardent temperament.

While there is a sense of opposition in Wassily Kandinsky's *Black Lines* (**Fig. 6-44**) as well, the atmosphere of the painting is nowhere near so ominous. The work is virtually nonobjective, though a hint of landscape can be seen in the upper left, where three mountain-like forms rise in front of and above what appears to be a horizon line defined by a lake or an ocean at sunset. The round shapes that dominate the painting seem to burst into flowers. Emerging like

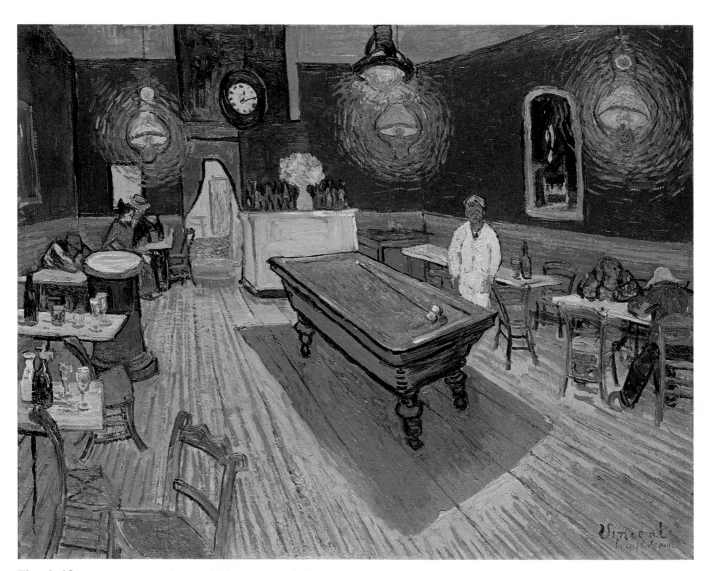

Fig. 6-43 Vincent van Gogh (Dutch, 1853–1890), *The Night Café (Le Café de nuit)*, 1888.
Oil on canvas, 28¹/₂ × 36¹/₄ in. 1961.183.4. Yale University Art Gallery, New Haven, Conneticut, U.S.A.
Yale University Art Gallery/Art Resource, NY

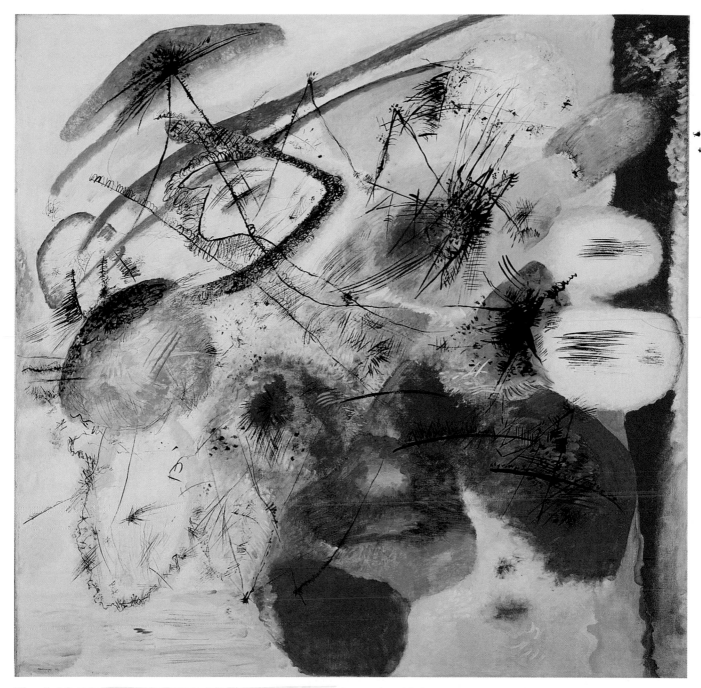

Fig. 6-44 Wassily Kandinsky, *Black Lines (Schwarze Linien)*, December 1913.
Oil on canvas, 51 × 51⁵/₈ in. Solomon R. Guggenheim Museum, New York. Gift, Solomon R. Guggenheim, 1937, 37.241.
Photograph by: David Heald, © The Solomon R. Guggenheim Foundation, New York. © 2012 Artists Rights Society (ARS), New York/ADAGP, Paris

pods from the red-orange border at the painting's right, they suffuse the atmosphere with color, as if to overwhelm and dominate the nervous black lines that give the painting its title.

Color had specific symbolic meaning for Kandinsky. "Blue," he says, "is the heavenly color." Its opposite is yellow, "the color of the earth." Green is a mixture of the two; as a result, it is "passive and static, and can be compared to the so-called 'bourgeoisie'— self-satisfied, fat, and healthy." Red, on the other hand, "stimulates and excites the heart." The complementary pair of red and green juxtaposes the passive and the active. "In the open air," he writes, "the harmony of red and green is very charming," recalling for him not the "powers of darkness" that van Gogh witnessed in the pair, but rather the simplicity and pastoral harmony of an idealized peasant life.

Read a document from Wassily Kandinsky on myartslab.com

What are the "rules" of atmospheric, or aerial, perspective?

The "rules" of atmospheric, or aerial, perspective state that an object's appearance changes depending on how much atmosphere lies between it and the person viewing it. Objects that lie further away from the viewer appear less distinct, are generally bluer in color, and have decreased contrast between lights and darks. How does atmospheric perspective differ from linear perspective? How does J.M.W. Turner use atmospheric perspective in his painting *Rain, Steam, and Speed—The Great Western Railway?*

What contributions did Sir Isaac Newton make to our understanding of color?

Sir Isaac Newton first discovered that color is a direct function of light. He found that sunlight breaks into bands of different colors, known as the spectrum. Newton reorganized the visible spectrum into a circle known as the color wheel. What are the primary colors, secondary colors, and intermediate colors? What is a subtractive process of color mixing? What is a color's saturation?

What is a complementary color scheme?

Colors can be employed to achieve a wide variety of effects. Compositions that employ colors that lie opposite each other on the color wheel are said to have complementary color schemes. How does a complementary color scheme differ from an analogous color scheme? What is color temperature? What is simultaneous contrast?

How does local color differ from perceptual color?

Local color is the color of objects viewed up close, under even lighting conditions. Perceptual color can change depending on the light and surrounding atmosphere. What was Claude Monet's approach to color? What is plein-air painting?

THE CRITICAL PROCESS

Thinking about Light and Color

Don Gray's series of paintings, *Nine Stones* (**Fig. 6-45**) was inspired when, getting out of his car in a small gravel parking lot at a nature preserve in the Grande Ronde Valley in northeastern Oregon, his attention was drawn to the basalt boulders evenly spaced around the edge of the space. Although entirely ordinary—and, in terms of the geology of the Columbia River Plateau, abundant to the point of composing almost the entire upper mantle of the region—Gray was suddenly struck by their presence. In fact, he realized, this stone, the product of one of the largest ever "flood" lava flows, in which magma flows out of vents in the earth's crust rather than erupting, occurring some 17 to 15 million years ago, connected the present moment to the remote past at a scale that was virtually unimaginable. He began to think of the stones as part of a larger "living organism," in the manner that the indigenous peoples of the region think of the entire earth as a living organism. "It occurred to me," he says, "that the only reason we think of a rock as inanimate is because its lifespan is unimaginably longer than our own. I sensed the life in these stones as metaphors of the

Fig. 6-45 Don Gray, *Nine Stones*, 2009.
Oil on 9 panels, 23 × 23 in. each; installed length approx. 25 ft.
© 2009 Don Gray.

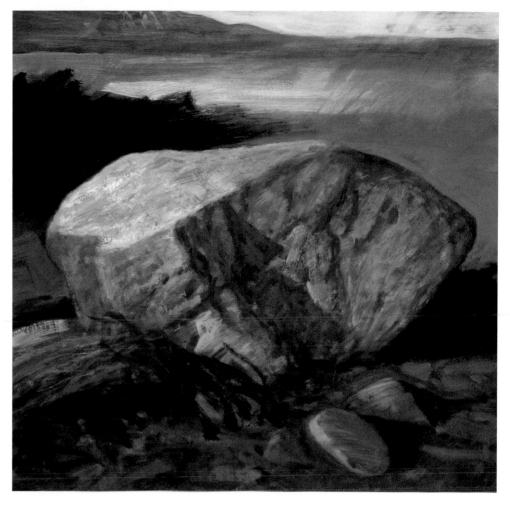

living earth." Gray decided to paint a "portrait" of each stone. Although the stones are of a more or less uniform color, the coloration of each "portrait" is markedly different. How is this a function light? How does the changing light, from morning to night and from season to season, create a distinct sense of the passage of time in this series? How does this contrast with the age of the rocks themselves? In several of the pieces, including *Stone #2* (**Fig. 6-46**), Gray employs a complementary color scheme, and moving from image to image, other complementary pairs emerge. Although none of his hues is quite pure, a certain sense of simultaneous contrast is achieved. Likewise, the color temperatures of the pantings vary dramatically. How do simultaneous contrast and temperature variation serve to "animate" Gray's stones, giving them a sense of being part of the "living earth"?

In French, the words for both the time and the weather are *le temps*. What does Gray's series share with Monet's *Grainstack* paintings (see Fig. 6-41); but see also the discussion of Monet's *Grainstacks* in the "Time and Motion" section of the next chapter, p. 141)? Several of these paintings combine cloud and sky imagery with the rocks—and even when there is no such imagery, the light in the paintings suggests it. For Gray, the elemental relation between sky and stone—or light and rock—suggests the more profound relation between heaven and earth. How does this analogy relate to Johann Wolfgang von Goethe's theory of color?

7 | Other Formal Elements

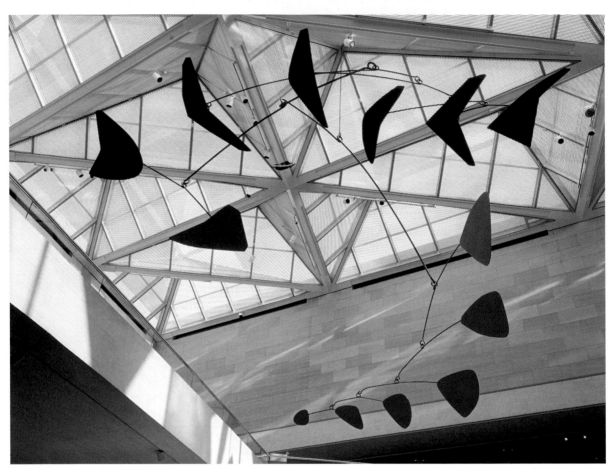

Fig. 7-1 Alexander Calder, *Untitled*, 1977.
Aluminum and steel, overall: 29 ft. 11³/₈ in. × 75 ft. 11⁵/₈ in.; gross weight: 920 lb. National Gallery of Art, Washington, D.C. Gift of the Collectors Committee. 1977.76.1.

THINKING AHEAD

How does visual texture differ from actual texture?

What is pattern?

How are the plastic arts temporal as well as spatial?

Which of the arts are most concerned with time and motion?

To this point, we have discussed some of the most important of the formal elements—line, space, light, and color—but several other elements employed by artists can contribute significantly to an effective work of art. **Texture** refers to the surface quality of a work. **Pattern** is a repetitive motif or design. And **time** and **motion** can be introduced into a work of art in a variety of ways. A work can suggest the passing of time by telling a story, for instance, in a sequence of

((•–**Listen** to the chapter audio on myartslab.com

✳–**Explore** a Discovering Art tutorial about texture and pattern on myartslab.com

panels or actions. It can create the illusion of movement, optically, before the eye. Or the work can actually move, as Alexander Calder's mobiles do (**Fig. 7-1**), or as video and film do. Calder's mobile is an example of **kinetic art**: art that moves or at least seems to move. Composed of 13 panels and 12 arms that spin around their points of balance, mobiles like the one in the East Building of the National Gallery of Art in Washington, D.C. are designed to create a sense of virtual volume as they turn on the air currents in the room in the manner of a dancer moving through the space of a stage.

Texture

Texture is the word we use to describe a work of art's ability to call forth certain tactile sensations. It may seem rough or smooth, as coarse as sandpaper or as fine as powder. If it seems slimy, like a slug, it may repel us. If it seems as soft as fur, it may make us want to touch it. In fact, most of us are compelled to touch what we see. It is one of the ways we come to understand our world. That's why signs in museums and galleries saying "Please Do Not Touch" are so necessary: If, for example, every visitor to the Vatican in Rome had touched the marble body of Christ in Michelangelo's *Pietà* (**Fig. 7-2**), the rounded, sculptural forms would have been reduced to utter flatness long ago.

View the Closer Look on the *Pietà* on myartslab.com

ACTUAL TEXTURE

Marble is one of the most tactile of all artistic mediums. Confronted with Michelangelo's almost uncanny ability to transform marble into lifelike form, we are virtually compelled to reach out and confirm that Christ's dead body is made of hard, cold stone and not the real, yielding flesh that the grieving Mary seems to hold in her arms. Even the wound on his side, which Mary almost touches with her own hand, seems real. The drapery seems soft, falling in gentle folds. The visual experience of this work defies what we know is materially true. Beyond its emotional content, part of the power of this work derives from the stone's extraordinary texture, from Michelangelo's ability to make stone come to life.

Another actual texture that we often encounter in art is paint applied in a thick, heavy manner. Each brushstroke is not only evident but also seems to have a "body" of its own. This textural effect is called **impasto**. Throughout his career, Robert Ryman has painted almost exclusively in a wide variety of white pigments. His subject matter is actually the brushstroke itself, and its relation to the ground or canvas

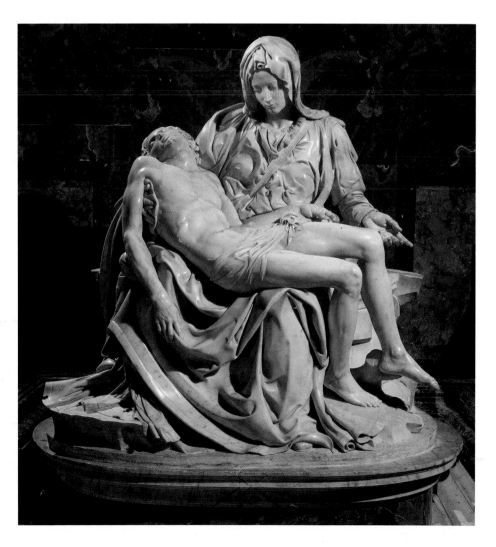
Fig. 7-2 Michelangelo, *Pietà*, 1501. Marble, height 6 ft. 8½ in. Vatican, Rome.

Thinking Thematically: See **Art and Beauty** on myartslab.com

Fig. 7-3 Robert Ryman, *Long*, 2002.
Oil on linen, 12 × 12 in.
Photography by Bill Jacobson. Courtesy the artist and The Pace Gallery, New York.

on which he layers it. In *Long* (**Fig. 7-3**), thickly impastoed strokes of white are piled deeply above a series of more thinly painted green marks. These last create a certain sense of shadow beneath the textured surface of the work, lending it an almost sculptural materiality.

In Manuel Neri's bronze sculpture from the *Mujer Pegada Series* (**Fig. 7-4**), the actual texture of the bronze is both smooth, where it implies the texture of skin on the figure's thigh, for instance, and rough, where it indicates the "unfinished" quality of the work. It is as if Neri can only begin to

capture the whole woman who is his subject as she emerges half-realized from the sheet of bronze. Our sense of the transitory nature of the image, its fleeting quality, is underscored by the enamel paint that Neri has applied in broad, loosely gestural strokes to the bronze. This paint adds yet another texture to the piece, the texture of the brushstroke. This brushstroke helps, in turn, to emphasize the work's two-dimensional quality. It is as if Neri's three-dimensional sculpture is attempting to escape the two-dimensional space of the wall, to escape, that is, the space of painting.

Fig. 7-4 Manuel Neri, *Mujer Pegada Series No. 2*, 1985–86. Bronze with oil-based enamel, 70 × 56 × 11 in.
Photograph by M. Lee Fatheree. Courtesy Charles Cowles Gallery, New York.

Thinking Thematically: See Art and the Passage of Time on myartslab.com

Fig. 7-5 Max Ernst, *The Horde*, 1927.
Oil on canvas, 44⁷/₈ × 57¹/₂ in. Collection, Stedelijk Museum, Amsterdam.
© 2012 Artists Rights Society (ARS), New York/ADAGP, Paris

VISUAL TEXTURE

Visual texture appears to be actual but is not. Like the representation of three-dimensional space on a two-dimensional surface, a visual texture is an illusion. If we were to touch the painting *Horde* (**Fig. 7-5**), it would feel primarily smooth, despite the fact that it seems to possess all sorts of actual surface texture, bumps and hollows of fungus-like growth.

The painting is by Max Ernst, the inventor of a technique called **frottage**, from the French word *frotter*, "to rub." By putting a sheet of paper (painted brown for *Horde*) over textured materials (in this case an unravelled spool of string) and then rubbing across the paper (sometimes with a pencil, but in *Horde* with an orange crayon), he was able to create a wide variety of textural effects. As he himself described his method: "I began to experiment indifferently and to question . . . all sorts of materials to be found in my visual field: leaves and their veins, the ragged edges of a bit of linen, the brush strokes of a 'modern' painting, the unwound thread of a spool, etc. There my eyes discovered human heads, animals, a battle that ended with a kiss . . . rocks, the sea and the rain, earthquakes, the sphinx in her stable, the little tables around the earth. . . ." In *Horde*, the lines produced by rubbing the orange crayon over the string created contour lines of the barbaric creatures. The area above the figures was painted over with blue paint to silhouette the figures against the sky.

William Garnett's stunning aerial view of strip farms stretching across an eroding landscape (**Fig. 7-6**) is a study in visual texture. The plowed strips of earth contrast dramatically with the strips that have been left fallow. And the predictable, geometric textures of

the farmed landscape also contrast with the irregular veins and valleys of the unfarmed and eroded landscape in the photograph's upper left. Garnett was, in fact, an avid pilot, deeply interested in American land-use practices even as he was deeply moved by the beauty of the country as seen from the air. Over the course of his career he logged over 10,000 hours of flight time, photographing the landscape out the window as he traveled over every state and many parts of the world.

The evocation of visual textures is, in fact, one of the primary tools of the photographer. When light falls across actual textures, especially raking light, meaning light that illuminates the surface from an oblique angle, the resulting patterns of light and shadow emphasize the texture of the surface. In this way, the Garnett photograph reveals the most subtle details of the land surface. But remember, the photograph itself is smooth and flat, and its textures are therefore visual. The textures of its subject, revealed by the light, are actual ones.

Pattern

The textures of the landscape in Garnett's photograph reveal themselves as a pattern of light and dark stripes. Any formal element that repeats itself in a composition—line, shape, mass, color, or texture—creates a recognizable pattern.

In its systematic and repetitive use of the same motif or design, pattern is an especially important decorative tool. Throughout history, decorative patterns have been applied to utilitarian objects in order to make them more pleasing to the eye. Early manuscripts, for instance, such as the page reproduced here from the eighth-century *Lindisfarne*

Fig. 7-6 William A. Garnett, *Erosion and Strip Farms*, 1951.
Gelatin-silver print, 15⁹/₁₆ × 19¹/₂ in. (39.5 × 49.5 cm) Purchase0 The Museum of Modern Art, New York, NY, U.S.A.

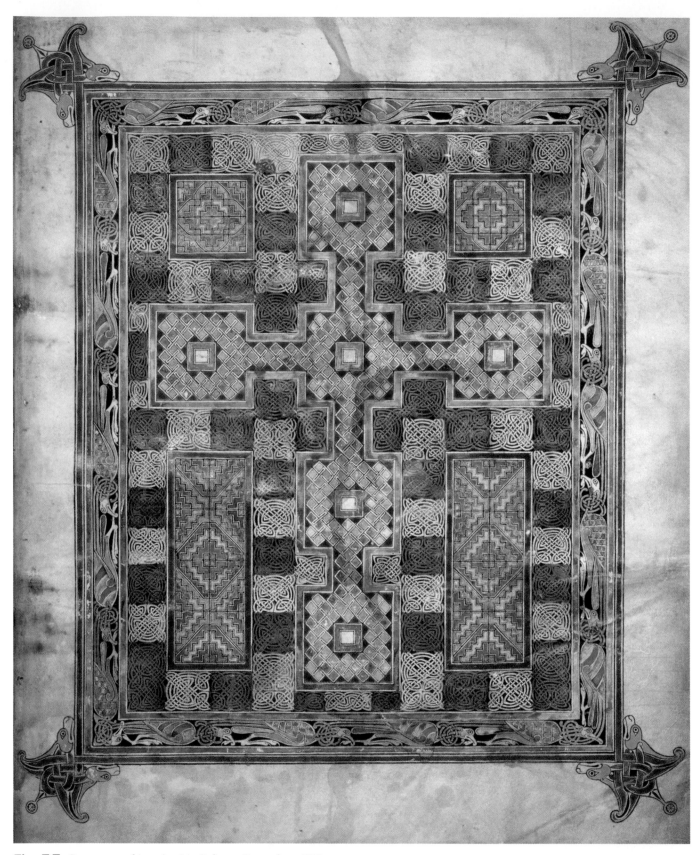

Fig. 7-7 Cross page from the *Lindisfarne Gospels*, c. 700.
Ink and tempera on vellum, 13¹/₂ × 9¹/₄ in.

Gospels (**Fig. 7-7**), were illuminated—elaborately decorated with drawings, paintings, and large capital letters—to beautify the sacred text. This page represents the ways in which Christian imagery—the cross—and earlier pre-Christian pagan motifs came together in the early Christian era in the British Isles. The simple design of the traditional Celtic cross, found across Ireland, is almost lost in the checkerboard pattern and the interlace of fighting beasts with spiraling tails, extended necks, and clawing legs that borders the page. These beasts are examples of the pagan *animal style*, which consists of intricate, ribbon-like traceries of line that suggest wild and fantastic beasts. The animal style was used not only in England but also in Scandinavia, Germany, and France.

Patterned textiles are closely identified with social prestige and wealth among the Ewe and Asante societies of Ghana. Known as *kente* cloths, these fabrics are designed to be worn at special occasions and ceremonies in the manner of a toga draped around the body (**Fig. 7-8**). The cloths are woven in narrow vertical strips and then sewn together—a man's *kente* prestige cloth is usually made up of 24 such strips. A subtly repetitive pattern results. Before the seventeenth century, *kente* were made of white cotton with designs woven on them in indigo-dyed thread, but after the introduction of richly dyed silks by European traders, the color palette of the *kente* was greatly expanded.

Because decorative pattern is associated with the beautifying of utilitarian objects in the crafts—the *kente* prestige cloth is an example—with folk art, and with "women's work" such as quilt-making, it had not been held in the highest esteem among artists. But since the early 1980s, as the value of "women's work"

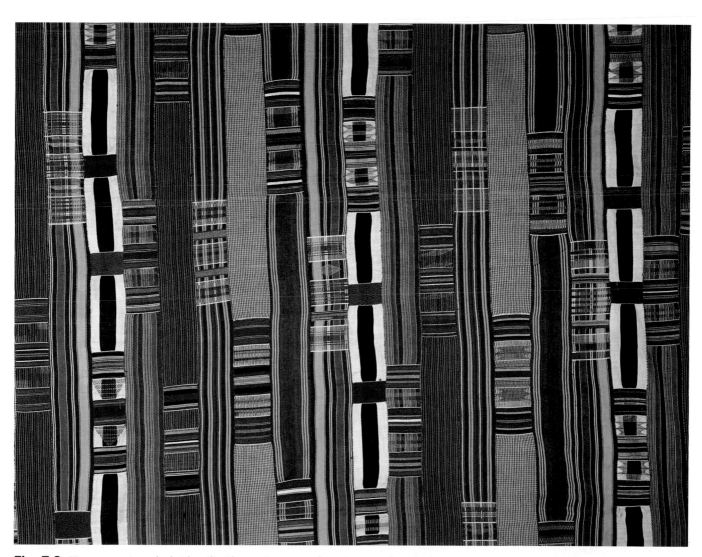

Fig. 7-8 *Kente* prestige cloth (detail), Ghana; Ewe peoples, nineteenth century. Cotton, silk; warp (vertical threads) 6 ft. 2 in., weft (horizontal threads) 9 ft. 1⁷/₈ in. The British Museum, London (Af1934,0307.165).

Thinking Thematically: See Art, Gender, and Identity on myartslab.com

has been rethought, and as the traditional "folk" arts of other cultures have come to be appreciated by the Western art world, decorative pattern's importance in art has been reassessed by many.

Of all the artists working with pattern and decoration, Miriam Schapiro has perhaps done the most to legitimate pattern's important place in the arts. Schapiro creates what she calls "femmages," a bilingual pun, contracting the French words *femme* and *hommage*, "homage to woman," and the English words *female* and *image*. "I wanted to explore and express," Schapiro explains, "a part of my life which I had always dismissed—my homemaking, my nesting." In her monumental multimedia work *Barcelona Fan* (**Fig. 7-9**), Schapiro has chosen an explicitly feminine image, the fan that fashionable women, in earlier days, used to cool themselves. Partially painted and partially sewn out of fabric, it intentionally brings to mind the kinds of domestic handiwork traditionally assigned to women as well as the life of leisure of the aristocratic lady.

Time and Motion

Pattern's repetitive quality creates a sense of linear and directional movement. Anyone who has ever stared at a wallpaper pattern, trying to determine where and how it begins to repeat itself, knows how the eye will follow a pattern. Nevertheless, one of the most traditional distinctions made between the

plastic arts—painting and sculpture—and the written arts, such as music and literature, is that the former are *spatial* and the latter *temporal* media. That is, we experience a painting or sculpture all at once; the work of art is before us in its totality at all times. But we experience music and literature over time, in a linear way; a temporal work possesses a clear beginning, middle, and end.

While there is a certain truth to this distinction, time plays a greater role in the plastic arts than such a formulation might suggest. Even in the case where the depiction of a given event implies that we are witness to a photographic "frozen moment," an instant of time taken from a larger sequence of events, the single image may be understood as part of a larger *narrative* sequence: a story.

Consider, for instance, Bernini's sculpture of David (**Fig. 7-10**). As opposed to Michelangelo's David (see Fig. 3-12) who rests, fully self-contained, at some indeterminate time before going into battle, Bernini's figure is caught in the midst of action, coiled and ready to launch his stone at the giant Goliath. In a sense, Bernini's sculpture is "incomplete." The figure of Goliath is implied, as is the imminent flight of David's stone across the implicit landscape that lies between the two of them. As viewers, we find ourselves in the middle of this same scene, in a space that is much larger than the sculpture itself. We intuitively back away from David's sling. We follow his eyes toward the absent giant. We are engaged in David's energy, and in his story.

Fig. 7-9 Miriam Schapiro, *Barcelona Fan*, 1979.
Fabric and acrylic on canvas. 72 × 144 in. The Metropolitan Museum of Art, New York, NY, U.S.A. Gift of Steven M. Jacobson and Howard Kalka, 1993.1993.408.

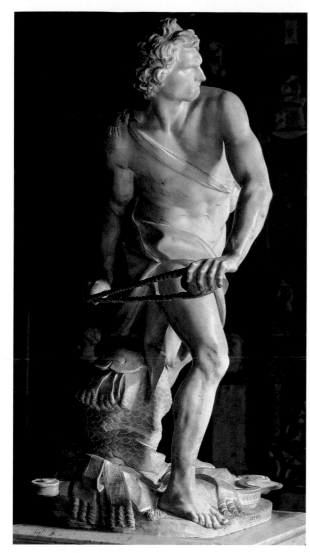

Fig. 7-10 Gianlorenzo Bernini, *David*, 1623.
Marble, life-size. Galleria Borghese, Rome.
Galleria Borghese, Rome/Canali PhotoBank, Milan/SuperStock.

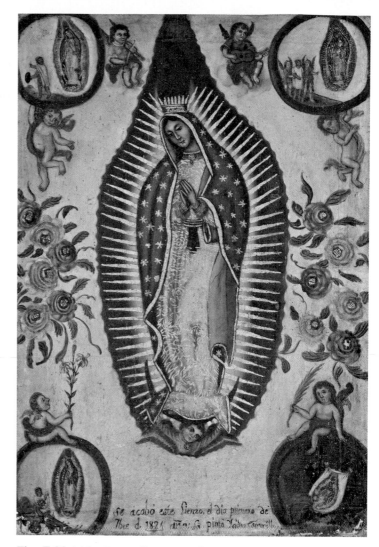

Fig. 7-11 Isidro Escamilla, *Virgin of Guadalupe*, 1824.
Oil on canvas, 22⅞ × 15 in. Brooklyn Museum, Henry
L. Batterman Fund, 45.128.189.

Thinking Thematically: See Art, Politics, and Community
on myartslab.com

A work of art can also, in and of itself, invite us to experience it in a linear or temporal way. Isidro Escamilla's *Virgin of Guadalupe* (**Fig. 7-11**) narrates one of the most famous events in Mexican history. The story goes that in December 1531, on a hill north of Mexico City called Tepeyac, once site of a temple to an Aztec mother goddess, a Christian Mexican Indian named Juan Diego beheld a beautiful dark-skinned woman (in the top left corner of the painting). Speaking in Nahuatl, the native Aztec language, she told Juan Diego to tell the bishop to build a church in her honor at the site, but the bishop doubted Juan Diego's story. So the Virgin caused roses to bloom on the hill out of season and told Juan Diego to pick them and take them to the bishop (represented in the bottom left corner of the painting). When Juan Diego opened his cloak to deliver the roses, an image of the dark-skinned Virgin appeared on the fabric (represented

at the bottom right). Soon, miracles were associated with her, and pilgrimages to Tepeyac became increasingly popular. In 1746, the Church declared the Virgin patron saint of New Spain, and in the top right corner of the painting, other saints pay her homage. By the time Escamilla painted this version of the story, the Virgin of Guadalupe had become the very symbol of Mexican identity.

Likewise, we naturally "read" Pat Steir's *Chrysanthemum* paintings (see Figs. 6-17 and 6-18) from left to right, in linear progression. While each of Monet's *Grainstack* paintings (see Fig. 6-38) can be appreciated as a wholly unified totality, each can also be seen as part of a larger whole, a time sequence. Viewed in a series, they are not so much "frozen moments" removed from time as they are about time itself and the ways in which our sense of place changes over time.

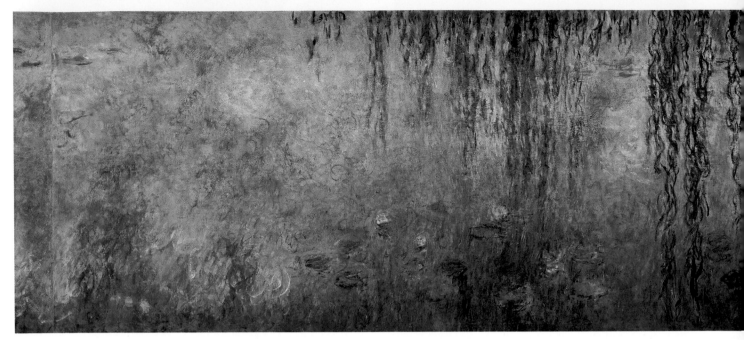

Fig. 7-12 Claude Monet (1840–1926), *Water Lilies, Morning: Willows* (right side), 1916–26.
Triptych, each panel 80 × 170 in. Musée de l'Orangerie, Paris, France.
Giraudon/RMN Reunion des Musees Nationaux/Art Resource, NY.

View a Closer Look for the *Water Lilies* on myartslab.com

To appreciate large-scale works of art, it may be necessary to move around and view them from all sides, or to see them from a number of vantage points—to view them over time. Monet's famous paintings of his lily pond at Giverny, which were installed in the Orangerie in Paris in 1927, are also designed to compel the viewer to move (**Fig. 7-12**). They encircle the room, and to be in the midst of this work is to find oneself suddenly in the middle of a world that has been curiously turned inside out: The work is painted from the shoreline, but the viewer seems to be surrounded by water, as if the room were an island in the middle of the pond itself. The paintings cannot be seen all at once. There is always a part of the work behind you. There is no focal point, no sense of unified perspective. In fact, the series of paintings seems to organize itself around and through the viewer's own acts of perception and movement.

According to Georges Clemenceau, the French statesman who was Monet's close friend and who arranged for the giant paintings to hang in the Orangerie, the paintings could be understood not just as a simple representation of the natural world, but also as a representation of a complex scientific fact, the phenomenon of "Brownian motion." First described by the Scottish scientist Robert Brown in 1827, Brownian motion is a result of the physical movement of minute particles of solid matter suspended in fluid.

Any sufficiently small particle of matter suspended in water will be buffeted by the molecules of the liquid and driven at random throughout it. Standing in the midst of Monet's panorama, the viewer's eye is likewise driven randomly through the space of the paintings. The viewer is encircled by them, and there is no place for the eye to rest, an effect that Jackson Pollock would achieve later in the century in the monumental "drip" paintings he executed on the floor of his studio (see *The Creative Process*, pp. 144–145).

Some artworks are created precisely to give us the illusion of movement. In **optical painting**, or "Op Art," as it is more popularly known, the physical characteristics of certain formal elements—particularly line and color—are subtly manipulated to stimulate the nervous system into thinking it perceives movement. Bridget Riley's *Drift 2* (**Fig. 7-13**) is a large canvas that seems to wave and roll before our eyes even though it is stretched taut across its support. One of Riley's earliest paintings was an attempt to find a visual equivalent to heat. She had been crossing a wide plain in Italy: "The heat off the plain was quite incredible—it shattered the topographical structure of it and set up violent color vibrations. . . . The important thing was to bring about an equivalent shimmering sensation on the canvas." In *Drift 2*, we encounter not heat, but wave action, as though we were, visually, out at sea.

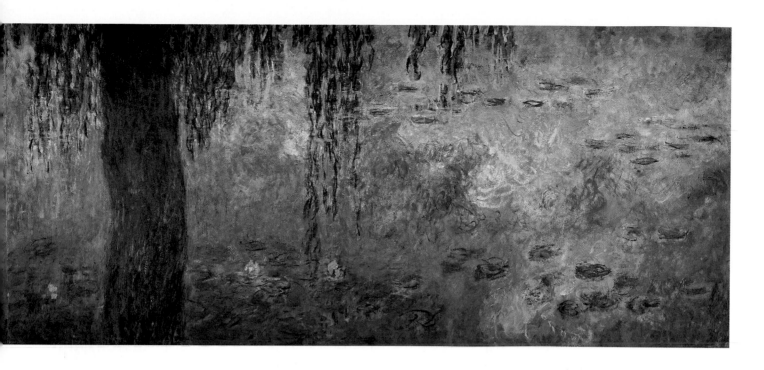

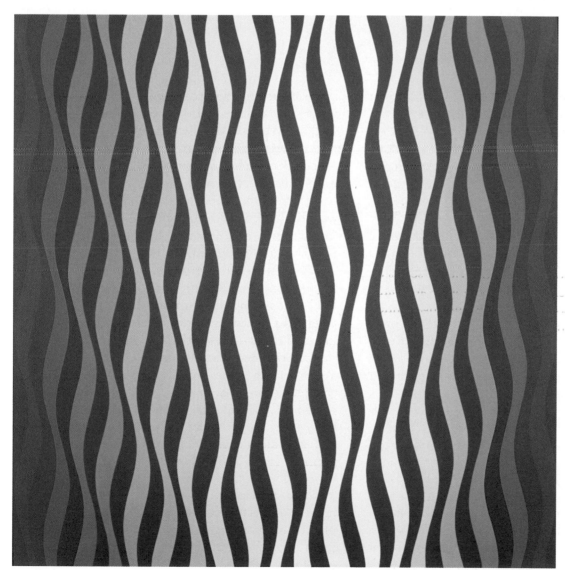

THE CREATIVE PROCESS

While not as large as Monet's paintings at the Orangerie, Jackson Pollock's works are still large enough to engulf the viewer. The eye travels in what one critic has called "galactic" space, following first one line, then another, unable to locate itself or to complete its visual circuit through the web of paint. Work such as this has been labeled "Action Painting," not only because it prompts the viewer to become actively engaged with it, but also because the lines that trace themselves out across

Fig. 7-14 Hans Namuth, Jackson Pollock painting *Autumn Rhythm*, 1950.
Gelatin silver print, Center for Creative Photography, Tucson.
Photograph by Hans Namuth.

the sweep of the painting seem to chart the path of Pollock's own motions as he stood over it. The drips and sweeps of paint record his action as a painter and document it, a fact captured by Hans Namuth in October of 1950 in a famous series of photographs (**Fig. 7-14**) of Pollock at work on the painting *Autumn Rhythm*, and then in two films, one shot in black and white and the other in color. An excerpt from the black-and-white film can be viewed on myartslab.com. It shows Pollock first creating a linear network of black lines by dripping paint with a small brush over an entire canvas, and then overlaying that web of lines with white paint dripped from a much larger brush. The second, color film was shot from below through a sheet of glass on which Pollock was painting, vividly capturing the motion embodied in Pollock's work. The resulting work, *No. 29, 1950* (**Fig. 7-15**), was completed over the course of five autumn weekends, with Namuth filming the entire event. After a false start on the painting, which Pollock wiped out in front of the camera, he created a collage web of paint, containing pebbles, shells, sand, sections of wire mesh, marbles, and pieces of colored plastic.

Namuth's photographs and films teach us much about Pollock's working method. Pollock longed to be completely involved in the process of painting. He wanted to become wholly absorbed in the work. As he had written in a short article called "My Painting," published in 1947, "When I am in my painting, I'm not aware of what I'm doing . . . the painting has a life of its own. I try to let it come through. It is only when I lose contact with the painting that the result is a mess. Otherwise there is pure harmony, an easy give and take, and the painting comes out well."

In Namuth's photographs and films, we witness Pollock's absorption in the work. We see the immediacy of his gesture as he flings paint, moving around the work, the paint tracing his path. He worked on the floor, in fact, in order to heighten his sense of being in the work. "I usually paint on the

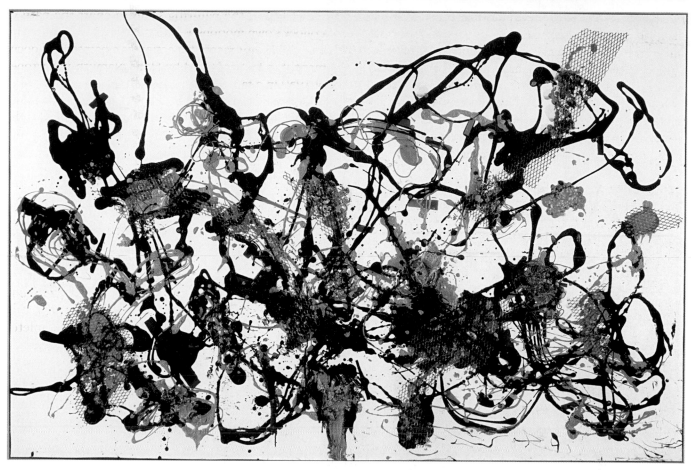

Fig. 7-15 Jackson Pollock (American, 1912–1956), *No. 29, 1950*, 1950.
Oil, expanded steel, string, glass, and pebbles on glass, 48 × 72 in. National Gallery of Canada, Ottawa. Purchased 1968.
© 2012 The Pollock-Krasner Foundation/Artists Rights Society (ARS), New York

View the Closer Look for *Autumn Rhythm* on myartslab.com

floor," he says in Namuth's film. "I feel more at home, more at ease in a big area, having a canvas on the floor, I feel nearer, more a part of a painting. This way I can walk around it, work from all four sides and be in the painting." We also see in Namuth's images something of the speed with which Pollock worked. According to Namuth, when Pollock was painting, "his movements, slow at first, gradually became faster and more dancelike." In fact, the traceries of line on the canvas are like choreographies, complex charts of a dancer's movement. In Pollock's words, the paintings are

energy and motion
made visible—
memories arrested in space.

Namuth was disturbed by the lack of sharpness and the blurred character in some of his photographs, and he did not show them to Pollock. "It was not until years later," Namuth admitted, "that I understood how exciting these photographs really were." At the time, though, his inability to capture all of Pollock's movement led him to the idea of making a film. "Pollock's method of painting suggested a moving picture," he would recall, "the dance around the canvas, the continuous movement, the drama."

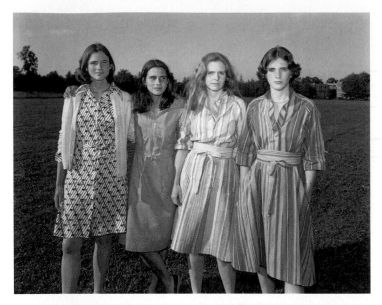

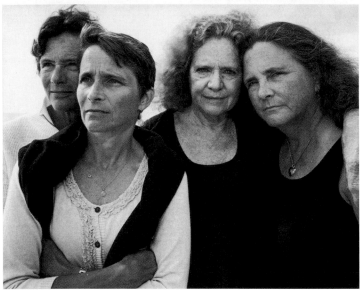

Fig. 7-16 (top) **Nicholas Nixon,** *The Brown Sisters,* 1976.

Gelatin silver print, 7¹¹/₁₆ × 9⁵/₈ in. Museum of Modern Art, New York. Purchase. 687.1976.

© Nicholas Nixon, courtesy Fraenkel Gallery, San Francisco and Pace/MacGill Gallery, New York. Digital Image © The Museum of Modern Art/Licensed by SCALA / Art Resource, NY.

Fig. 7-17 (bottom) **Nicholas Nixon,** *The Brown Sisters, Truro, Massachusetts,* 2011.

Gelatin silver print, 17¹⁵/₁₆ × 22⁵/₈ in. Museum of Modern Art, New York. Gift of the artist. 884.2011.

© Nicholas Nixon, courtesy Fraenkel Gallery, San Francisco and Pace/MacGill Gallery, New York. Digital Image © The Museum of Modern Art/Licensed by SCALA / Art Resource, NY.

commitment of the women to sustain the project, and now, as they age, the prospect of their—or the photographer's—eventual demise. The series is not only a testament to time's relentless force, but to the power of family, and love, to endure and sustain us all, as if in spite of time itself. The power of the image to endure may, Nixon's work suggests, in fact lie at the heart of every family's commitment to documenting in photography its very history, even as the family is transformed and irrevocably changed by that history.

The ways in which time and motion can transform the image itself is one of the principal subjects of Grace Ndiritu, a British-born video and performance artist of Kenyan descent. Ndiritu makes what she calls "hand-crafted videos," solo performances in front of a camera fixed on a tripod. *Still Life: White Textiles* (**Fig. 7-18**) is one part of the larger four-screen video work *Still Life.* (An excerpt from the *White Textiles* segment, as well as excerpts from a number of her other works, can be screened at axisweb.org, a British non-profit corporation that describes itself as "the online resource for contemporary art." Search Ndiritu's name under the "artists and curators" heading.) Ndiritu's title, *Still Life,* is entirely ironic, for seated between two sheets of African batik printed fabric, she caresses her thighs, moves her hands beneath the fabric, pulls it, stretches it—in short, she *animates* the cloth. At once hidden and exposed, Ndiritu creates an image that is at once chaste and sexually charged.

Still Life was inspired by a 2005 exhibition of paintings by Henri Matisse at the Royal Academy in London, "Matisse: The Fabric of Dreams, His Art and His Textiles." Seeing the show, she said,

reaffirmed the similarity of our working process . . . we share the ritual of assembling textiles and setting up the studio with fabrics as a background to galvanize our artistic practice. Matisse understands and

Of all the arts, those that employ cameras are probably most naturally concerned with questions of time and motion. Time and motion are the very conditions of these media. Consider Nicholas Nixon's ongoing series of photographs depicting his wife, Bebe Brown Nixon and her three sisters, the Brown sisters (**Figs. 7-16** and **7-17**). Each year, beginning in 1975, when the four women ranged in age from 15 to 25, Nixon has made a single black-and-white photograph of the four, always photographing them in the same order from left to right: Heather, Mimi, Bebe, and Laurie. Although he shoots any number of exposures, he has printed only one photograph each year. By 2011, he had created a series of 37 photographs that reveal not only the gradual aging process of the sisters, but, he suggests, the ever-changing dynamics of the relationships among them. Yet two of the most fascinating aspects of the series are the

appreciates the beauty and simplicity of working with textiles. The hallucinogenic properties of overlapping patterns, shift and swell in his paintings, override perspective and divorce shape from color.

The effects of which Ndiritu speaks are clearly visible in Matisse's *Harmony in Red (The Red Room)* (Fig. 5-25), where the textile pattern of the tablecloth is mirrored in the wallpaper, flattening perspective and disorienting the viewer's sense of space. After visiting North Africa in 1911, Matisse often painted female models clothed in African textiles in settings decorated with other textile patterns. But in Ndiritu's work, time and motion transform the textile from decorative pattern into live action. By implication, the female body in Ndiritu's "video painting," as she calls it, is transformed from a passive object of contemplation—as it was in so many of Matisse's paintings—into an almost aggressive agent of seduction. The power of the work lies in the fact that, hidden and exposed as Ndiritu is, that seduction is at once invited and denied.

Video artists Teresa Hubbard and Alexander Birchler think of their videos as "long photographs" to which they have added sound, thus extending the space of the image beyond the frame. In *Detached Building* (**Figs. 7-19** and **7-20**), the camera dollies in one seamless movement around the inside of a tin shed converted into a workshop and rehearsal space, moving to the sound of chirping crickets over a cluttered workbench, a guitar, a chair, a sofa, a drum set, and a power drill, then passing without interruption through the shed's wall into the neglected garden behind it. A young woman enters the garden, picks up stones, and throws them at a nearby house. A window can be heard breaking, and a dog begins to bark. The camera passes back into the interior of the shed, where three young men are now sitting around the room, while a fourth plays a continuous riff on a bass guitar. The camera sweeps around the room again and then passes back outside. The young woman has disappeared. Only the chirping of crickets and the muted sound of the bass guitar can be heard. The camera passes back through the wall, sweeps around the room again, and moves back outside to a view of the guitar player within. The video plays on a continuous 5-minute, 38-second loop, and so, at this point, the

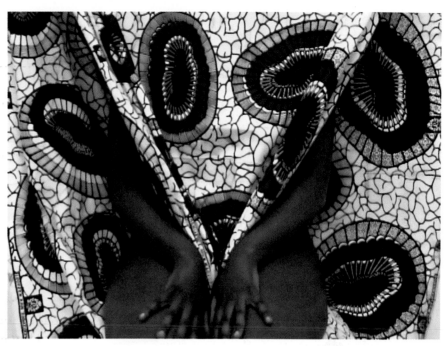

Fig. 7-18 Grace Ndiritu, *Still Life: White Textiles*, 2005/2007.
Still from a silent video, duration 4 min. 57 sec.
© LUX, London.

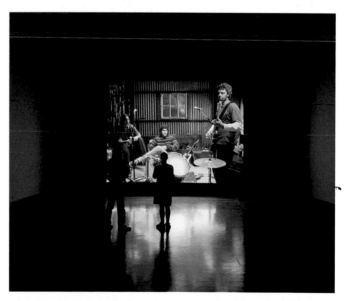

Fig. 7-19 Teresa Hubbard and Alexander Birchler, *Detached Building*, 2001.
High-definition video with sound transferred to DVD, 5 min. 38 sec. loop.
Installation photo by Stefan Rohner. Courtesy of the artists and Tanya Bonakdar Gallery, New York and Burger Collection, Zurich.

camera returns to the empty workshop, and the entire sequence repeats itself. What, the viewer wonders, is the connection between the two scenarios, the men inside, the woman outside? No plot evidently connects them, only a series of oppositions: interior and exterior, light and dark, male and female, the group and the individual. The movement of the camera across the boundary of the wall suggests a disruption not only of space but of time. In looped video works such as this one, viewers can enter the installation at any point, leave at any point, and construct any narrative they want out of what they see.

Fig. 7-20 Teresa Hubbard and Alexander Birchler, *Detached Building*, 2001. High-definition video with sound transferred to DVD, 5 min. 38 sec. loop.
Stills courtesy of the artists and Tanya Bonakdar Gallery, New York.

THINKING BACK

✓●—[Study and review on myartslab.com

How does visual texture differ from actual texture?

Actual texture refers to the real surface quality of an artwork. Visual texture, by contrast, is an illusion, not unlike the representation of three-dimensional space on a two-dimensional surface. What is impasto? How does Manuel Neri use texture in *Mujer Pegada Series No. 2*? What is the technique of *frottage*?

What is pattern?

Pattern is a repetitive motif or design in an artwork. Any formal element (such as line, shape, mass, color, or texture) can form a pattern, when repeated in a recognizable manner. Why has pattern been used in art throughout history? What is the animal style? What are "femmages"?

How are the plastic arts temporal as well as spatial?

Traditionally, the plastic arts (such as painting and sculpture) have been regarded as *spatial*, while music and literature have been classified as *temporal*. However, it is important to recognize the temporal aspect of the plastic arts as well. An image or object may often be part of a larger story, which is, by definition, sequential. Why might Gianlorenzo Bernini's *David* be called "incomplete"? How do Claude Monet's paintings of water lilies relate to the phenomenon of Brownian motion?

Which of the arts are most concerned with time and motion?

Of all the arts, those that employ cameras are probably most naturally concerned with questions of time and motion. The very conditions of photography and film are, in fact, time and motion. How does time structure Nicholas Nixon's ongoing series *The Brown Sisters*? What does Grace Ndiritu do in her "hand-crafted videos"?

THE CRITICAL PROCESS
Thinking about the Formal Elements

Fig. 7-21 Bill Viola, *Room for St. John of the Cross*, 1983.
Video/sound installation. Collection: Museum of Contemporary Art, Los Angeles.
Photo: Kira Perov / SQUIDDS & NUNNS.

Thinking Thematically: See Art and Spiritual Belief on myartslab.com

Bill Viola's video installation *Room for St. John of the Cross* (**Figs. 7-21** and **7-22**) creates a structure of opposition similar to Hubbard and Birchler's *Detached Building*. The work consists of a small television monitor in a cubicle that shows a color image of a snow-covered mountain. Barely audible is a voice reading poetry. The videotape consists of a single "shot." The camera never moves. The only visible movement is wind blowing through the trees and bushes.

This cubicle is like the cell of the Spanish mystic and poet St. John of the Cross, who was imprisoned in 1577 for nine months in a windowless cell too small to allow him to stand upright. In this cell, he wrote most of the poems for which he is known, poems in which he often imaginatively flies out of captivity, over the city walls and across the mountains. The image on the small monitor is the landscape of which St. John dreams. On the large screen, behind the cubicle, Viola has projected a black-and-white video image of snow-covered mountains, shot with an unstable handheld camera. These mountains move in wild, breathless flights, image after image flying by in an uneven, rapid rhythm, like the imagination escaping imprisonment as it rides on the sound of the loud roaring wind that fills the room, making the voice reading in the cubicle even harder to hear. The meditative stillness of the small cubicle is countered by the fury of the larger space.

As we ourselves move in this installation—and we must move in order to view the piece—we experience many of the formal elements of art all at once. How do you think the architecture of the cell contrasts with the image on the large screen? What conflicting senses of space does Viola employ? How is the play between light and dark, black-and-white and color imagery, exploited? How does time affect your experience of the piece? These are the raw materials of art, the formal elements, playing upon one another in real time. Viola has set them in motion together in a single composition.

Fig. 7-22 Bill Viola, *Room for St. John of the Cross*, 1983. Video/sound installation. Collection: Museum of Contemporary Art, Los Angeles.
Photo: Kira Perov / SQUIDDS & NUNNS.

8 | The Principles of Design

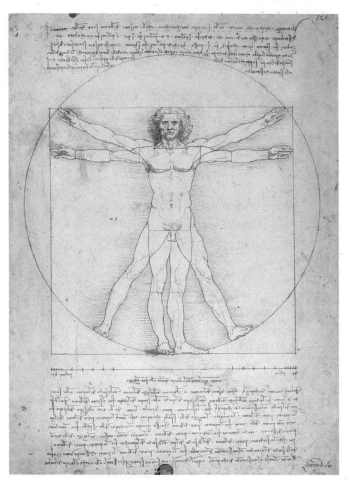

Fig. 8-1 Leonardo da Vinci, *Study of Human Proportion: The Vitruvian Man*, c. 1492.
Pen and ink drawing, 13^1/$_2$ × 9^5/$_8$ in. Galleria dell'Accademia, Venice.

Thinking Thematically: See **Art and Beauty** on myartslab.com

THINKING AHEAD

What is visual weight, and how does it differ from actual weight?

What is a focal point?

How does scale differ from proportion?

How do artists use repetition and rhythm?

((•─ **Listen** to the chapter audio on myartslab.com

The word *design* is both a verb and a noun. To design something, the process is to organize the formal elements that we have studied in the last four chapters—line, space, light and color, texture, pattern, time and motion—into a unified whole, a composition or design. Design is also a field of study and work within the arts, encompassing graphic, fashion, interior, industrial, and product design. The design field is the subject of Chapter 16; here we will focus on design principles that can apply to all works of art.

The principles of design are usually discussed in terms of the qualities of balance, emphasis, proportion and scale, rhythm and repetition, and unity and variety. For the sake of clarity, we must discuss these qualities one by one, but artists unite them. For example, Leonardo's famous *Study of Human Proportion: The Vitruvian Man* (**Fig. 8-1**) embodies them all. The figure is perfectly balanced and symmetrical. The very center of the composition is the figure's navel, a focal point that represents the source of life itself, the fetus's connection by the umbilical cord to its mother's womb. Each of the figure's limbs appears twice, once to fit in the square, symbol of the finite, earthly world, and once to fit in the circle, symbol of the heavenly world, the infinite and the universal. Thus, the various aspects of existence—mind and matter, the material and the transcendental—are unified by the design into a coherent whole.

By way of contrast, architect Frank Gehry's Rasin Building, in Prague, Czech Republic (**Fig. 8-2**), seems anything but unified. Built on the site of a Renaissance structure destroyed in World War II, the building's teetering sense of collapse evokes the postwar cityscape of twisted I-beams, blown-out facades with rooms standing open to the sky, and sunken foundations, all standing next to a building totally unaffected by the bombing. But that said, the building is also a playful, almost whimsical celebration, among other things, of the marvels of modern engineering—a building made to look as if it is at the brink of catastrophe, even as it is completely structurally sound. So light-hearted is the building that it was called the "Dancing House," or, more specifically, "Ginger and Fred," after the American film stars Ginger Rogers and Fred Astaire. The more solid tower on the corner seems to be leading the transparent tower—Ginger—by the waist, as the two spin around the corner.

The building was the idea of Czech architect; Vlado Milunić, and he enlisted American architect Frank Gehry to collaborate on the project. To many eyes in Prague, a city renowned for its classical architecture, it seemed an absolutely alien American element dropped into the city. But Milunić conceived of the building as addressing modern Prague even as it engaged the city's past. He wanted the building to consist of two parts: "Like a society that forgot its totalitarian past—a static part—but was moving into a world full of changes. That was the main idea. Two different parts in dialogue, in tension, like plus and minus, like Yang and Yin, like man and woman." It was Gehry who nicknamed it "Ginger and Fred."

Despite the building's startling sense of tension, the architects used many of the traditional principles of design—most notably rhythm and repetition; balance; scale and proportion; and unity and variety—all of which we will consider in more detail later in the chapter. If one side seems about to fall, the other holds it up, in a perfect state of balance. The windows of the more solid tower, connected by sweeping curvilinear lines, move up and down on the façade in an almost musical rhythm. But it was most important to the architects to establish a simultaneous sense of connection and discontinuity between the two towers; they were not meant to blend into a harmonious, unified whole. Rather, it was variety—and change—that most interested them.

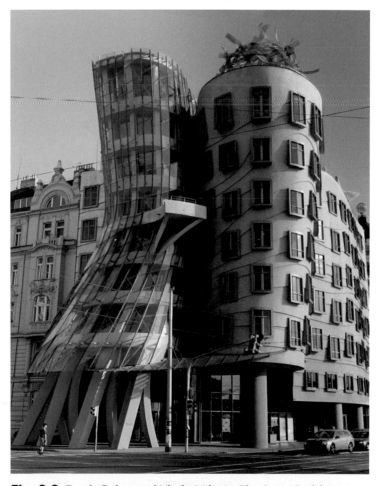

Fig. 8-2 Frank Gehry and Vlado Milunić. The Rasin Building, also known as the Dancing House or "Ginger and Fred," Prague, Czech Republic. 1992–96.

Leonardo's study is a remarkable example of the "rules" of proportion, yet the inventiveness and originality of Milunić and Gehry's work teaches us, from the outset, that the "rules" guiding the creative process are, perhaps, made to be broken. In fact, the very idea of creativity implies a certain willingness on the part of artists to go beyond the norm, to extend the rules, and to discover new ways to express themselves. As we have seen, artists can easily create visual interest by purposefully breaking with conventions such as the traditional rules of perspective; likewise, any artist can stimulate our interest by purposefully manipulating the principles of design.

In the remainder of this chapter, we discuss the way artists combine the formal elements with design principles to create inventive, original work. Once we have seen how the formal elements and their design come together, we will be ready to survey the various materials, or *media*, that artists employ to make their art.

Balance

As a design principle, **balance** refers to the even distribution of weight in a composition. In sculpture and architecture, **actual weight**, or the physical weight of materials in pounds, comes into play, but all art deals with **visual weight**, the apparent "heaviness" or "lightness" of the shapes and forms arranged in the composition. Artists achieve visual balance in compositions by one of three means—symmetrical balance, asymmetrical balance, or radial balance. They may also deliberately create a work that appears to lack balance, knowing that instability is threatening and makes the viewer uncomfortable.

SYMMETRICAL BALANCE

If you were to draw a line down the middle of your body, each side of it would be, more or less, a mirror reflection of the other. When children make "angels" in the snow, they are creating, almost instinctively, **symmetrical** representations of themselves that recall

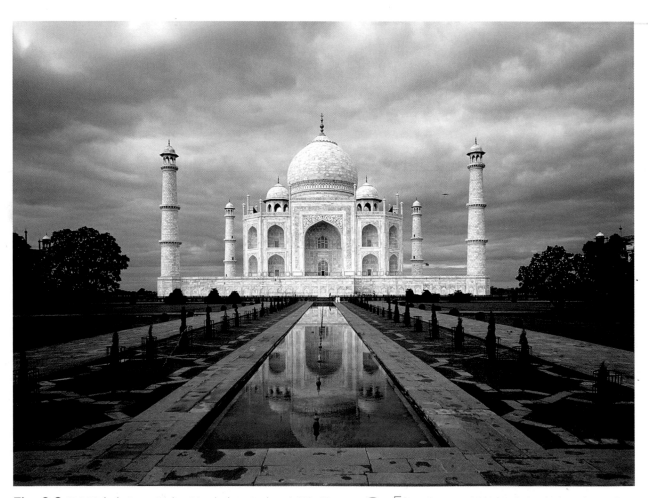

Fig. 8-3 Taj Mahal, Agra, India, Mughal period, c. 1632–48.

◉─▶**Watch** an architectural simulation about the Taj Mahal on myartslab.com

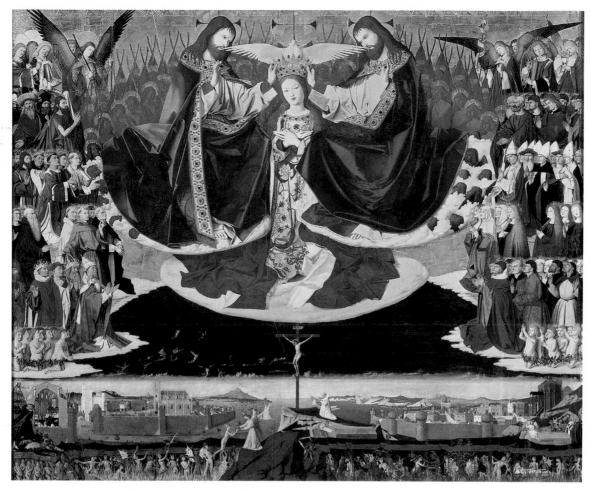

Fig. 8-4 Enguerrand Quarton, *Coronation of the Virgin*, 1453–54.
Panel painting, 72 × 86⅝ in. Musée de l'Hospice, Villeneuve-lès-Avignon.
Giraudon/Art Resource, NY.

Leonardo's *Study of Human Proportion*. When each side is exactly the same, we have **absolute symmetry**. But even when it is not, as is true of most human bodies, where there are minor discrepancies between one side and the other, the overall effect is still one of symmetry, and specifically what we call **bilateral symmetry**. The two sides seem to line up.

One of the most symmetrically balanced—and arguably one of the most beautiful—buildings in the world of architecture is the Taj Mahal, built on the banks of the Jumna River at Agra in northern India (**Fig. 8-3**). Built as a mausoleum for the favorite wife of Shah Jahan (pictured beside his father, Shah Jahangir, in Fig. 1-8), who died giving birth to their fourteenth child, it is basically a square, although each corner is cut off in order to create a subtle octagon. Each facade is identical, featuring a central arched portal flanked by two stories of smaller arched openings. These voids in the facade contribute to a sense of weightlessness in the building, which rises to a central onion dome. The facades are inlaid with elaborate decorations of

semi-precious stones—carnelian, agate, coral, turquoise, garnet, lapis, and jasper—but they are so delicate and lacelike that they emphasize the whiteness of the whole rather than calling attention to themselves. The sense of overall symmetry is further enhanced by the surrounding gardens and reflecting pools.

One of the dominant images of symmetry in Western art is the crucifix, which is, in itself, a construction of absolute symmetry. In Enguerrand Quarton's remarkable *Coronation of the Virgin* (**Fig. 8-4**), the crucifix at the lower center of the composition is a comparatively small detail in the overall composition. Nevertheless, its cruciform shape dominates the whole, and all the formal elements in the work are organized around it. Thus, God the Father and Jesus, the Son, flank Mary in almost perfect symmetry, identical in their major features (though the robes of each fall a little differently). On earth below, the two centers of the Christian faith flank the cross, Rome on the left and Jerusalem on the right. And at the very bottom of the painting, below ground level, Purgatory, on the left,

out of which an angel assists a newly redeemed soul, balances Hell on the right. Each element balances another, depicting a unified theological universe.

ASYMMETRICAL BALANCE

Balance can be achieved even when the two sides of a composition lack symmetry, if they seem to possess the same visual weight. A composition of this nature is said to be **asymmetrically balanced**. You probably remember from childhood what happened when an older and larger child got on the other end of the seesaw. Up you shot, like a catapult. In order to right the balance, the larger child had to move toward the fulcrum of the seesaw, giving your smaller self more leverage and allowing the plank to balance. The illustrations (**Fig. 8-5**) show, in visual terms, some of the ways this balance can be attained (in a work of art, the center axis of the work is equivalent to the fulcrum):

(*a*) *A large area closer to the fulcrum is balanced by a smaller area farther away.* We instinctively see something large as heavier than something small.

(*b*) *Two small areas balance one large area.* We see the combined weight of the two small areas as equivalent to the larger mass.

(*c*) *A dark area closer to the fulcrum is balanced by a light area of the same size farther away.* We instinctively see light-colored areas as light in weight, and dark-colored areas as dense and heavy.

(*d*) *A large light area is balanced by a small dark one.* Because it appears to weigh less, the light area can be far larger than the dark one that balances it.

(*e*) *A textured area closer to the fulcrum is balanced by a smooth, even area farther away.* Visually, textured surfaces appear heavier than smooth ones because texture lends the shape an appearance of added density—it seems "thicker" or more substantial.

These are only a few of the possible ways in which works might appear balanced. There are, however, no "laws" or "rules" about how to go about visually balancing a work of art. Artists generally trust their own eyes. When a work looks balanced, it *is* balanced.

Johannes Vermeer's *Woman Holding a Balance* (**Fig. 8-6**) is an asymmetrically balanced composition whose subject is the balance between the material and spiritual worlds. The center axis of the composition runs through the fulcrum of the scales that the woman is holding. Areas of light and dark on each side balance the design. The woman is evidently in the process of weighing her jewelry, which is scattered on the table before her. Behind her is a painting depicting the Last Judgment, when Christ weighs the worth of all souls for entry into heaven. The viewer is invited to think about the connection between the images in the two sides of the painting and how they relate to the woman's life.

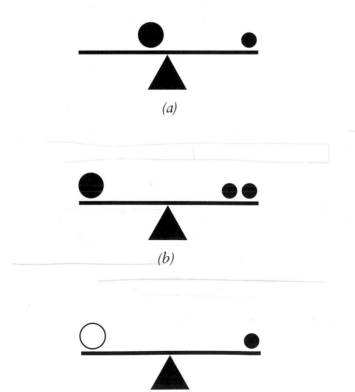

(a)

(b)

(d)

(c)

(e)

Fig. 8-5 Some different varieties of asymmetrical balance.

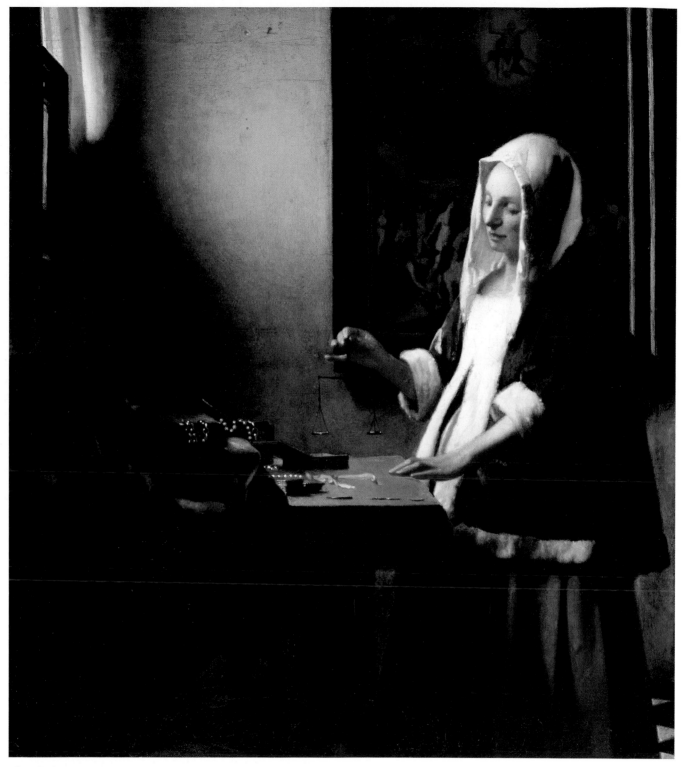

Fig. 8-6 Johannes Vermeer, *Woman Holding a Balance*, c. 1664.
Oil on canvas, 16³/₄ × 15 in., framed: 24³/₄ × 23 × 3 in. Widener Collection, National Gallery of Art, Washington, D.C.

Thinking Thematically: See **Art and Spiritual Belief** on myartslab.com

View the Closer Look for *Woman Holding a Balance* on myartslab.com

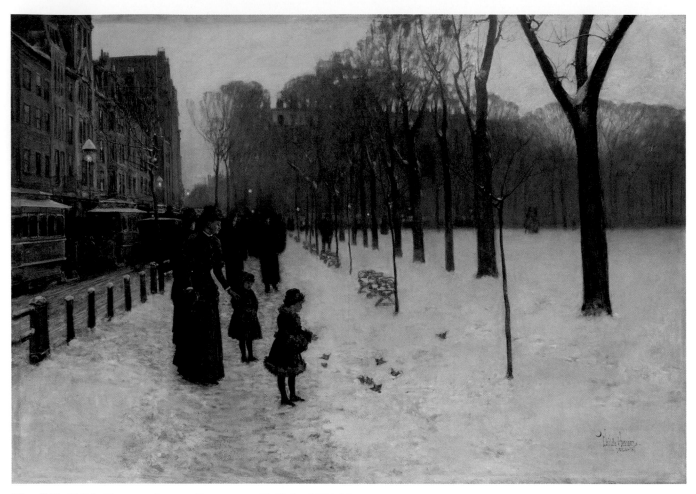

Fig. 8-7 Childe Hassam, *Boston Common at Twilight*, 1885–86.
Oil on canvas, 42 × 60 in. Museum of Fine Arts, Boston. Gift of Miss Maud E. Appleton, 1931. 31.952.
Photo © 2004 Museum of Fine Arts, Boston. All rights reserved.

Childe Hassam's *Boston Common at Twilight* (**Fig. 8-7**) is a good example of asymmetrical balance functioning in yet another way. The central axis around which this painting is balanced is not in the middle, but to the left. The setting is a snowy sidewalk on Tremont Street at dusk, as the gaslights are coming on. A fashionably dressed woman and her daughters are feeding birds at the edge of the Boston Common. The left side of this painting is much heavier than the right. The dark bulk of the buildings along Tremont Street, along with the horse-drawn carriages and streetcars and the darkly clad crowd walking down the sidewalk, contrast with the expanse of white snow that stretches to the right, an empty space broken only by the dark trunks of the trees rising to the sky. The tension between the serenity of the Common and the bustle of the street, between light and dark—even as night comes on and daylight fades—reinforces our sense of asymmetrical balance. If we were to imagine a fulcrum beneath the painting that would balance the composition, it would in effect divide the street from the Common, dark from light, exactly, as it turns out, below the vanishing point established by the buildings, the street, and the lines of the trees extending down the park. Instinctively, we place ourselves at this fulcrum.

As Hassam's painting suggests, formal balance (or lack of it) can contribute to a work of art's emotional or psychological impact. Ida Applebroog's *Emetic Fields* (**Fig. 8-8**) is one of a number of works from a series of paintings called *Nostrums*. A nostrum is medicine (in this case an emetic, designed to induce vomiting) recommended by its preparer but usually without scientific proof of effectiveness. It is also the Latin word for "ours." These works represent, in other words, the trust we mistakenly place

in those who purport to cure us. *Emetic Fields* is by and large symmetrical in its composition, consisting of a central grouping of four panels dominated by the color orange, flanked by a pair of two-panel images dominated by the color green. These outer panels are representations of a surgeon and Queen Elizabeth. Applebroog explains:

> I love Queen Elizabeth. . . . Here's this woman called "Queen"—she gives that little wave—and she has no power whatsoever. In Emetic Fields, there is the figure of Queen Elizabeth and there is the figure of a surgeon. And that all goes back to my own sense of how power works. Queen Elizabeth, to me, is the epitome of how power works. Not too well. . . .
>
> And it's the idea of how power works—male over female, parents over children, governments over people, doctors over patients—that operates continuously [in my work].

The symmetry of the painting suggests, in other words, a certain "balance of power" exercised by the two figures who purport to cure our physical and social ills—the surgeon and the Queen. These two, in turn, dominate the figures in the painting's central panels. In the largest of these, a woman stands above a pile of rotten fruit, her shoes attached to platforms, effectively impeding her ability to move. Hanging from the tree above her is other fruit, some of which contains images of other people, presumably about to rot on the branch themselves. Surrounding her are other images—a couple embracing, a lineup of girls apparently dressed for gym class, a man swinging an ax, a mother and child, a male figure carrying another who seems wounded, and a figure bending down to pick up a stone, as if, David-like, he is about to bring down the Goliath surgeon whose space he crosses into at the bottom left. Finally, the psychological imbalance suggested in the relation of the outer panels to the inner is underscored by the words that are repeated down the panel in front of Queen Elizabeth: "You are the patient. I am the real person."

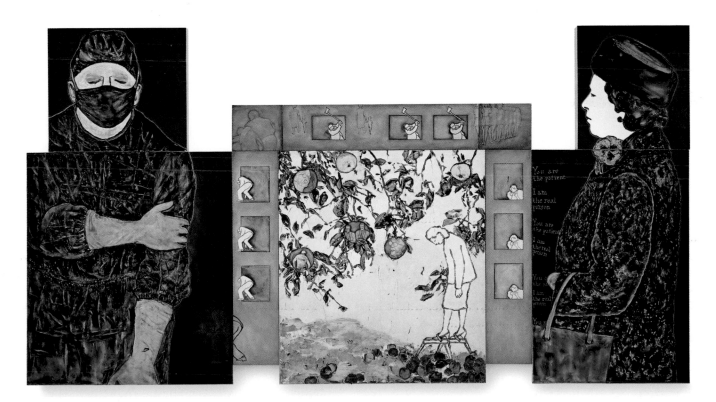

Fig. 8-8 Ida Applebroog b. 1929, *Emetic Fields*, 1989.
Oil on canvas, 8 panels, Overall: 110^{7}/$_{16}$ × 204^{5}/$_{8}$ in. (280.5 × 519.8 cm) Whitney Museum of American Art, New York/gift of Jean Lignel 99.100a-h.
Courtesy Ronald Feldman Fine Arts, New York.

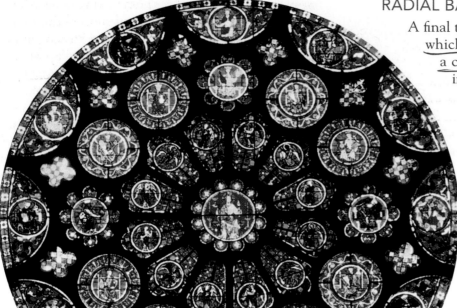

RADIAL BALANCE

A final type of balance is **radial balance**, in which everything *radiates* outward from a central point. The large, dominating, and round stained-glass window above the south portal of Chartres Cathedral in France (**Fig. 8-9**) is a perfect example. Called a *rose window* because of its dominant color and its flowerlike structure, it represents the Last Judgment. At its center is Jesus, surrounded by the symbols of Matthew, Mark, Luke, and John, the writers of the Gospels, and by angels and seraphim. The Apostles, depicted in pairs, surround these, and on the outer ring are scenes from the Book of Revelation. In other words, the entire New Testament of the Bible emanates from Jesus in the center.

Perhaps because radial balance is so familiar in nature—from the petals of a flower to the rays of the sun—it commonly possesses, as at Chartres, spiritual and religious significance. This was particularly true of Native American cultures. The image of a star in the center of the Mescalero Apache basket (**Fig. 8-10**) suggests that the basket was intended to hold the bounty of the universe—especially food. Because natural grasses and fibers are so susceptible to decay, early examples of Native American fiber arts are rare, but thousands of baskets from the nineteenth and early twentieth centuries survive. By the dawn of the twentieth century, basket collecting had become a literal craze among white collectors, even spawning a quarterly journal called *The Basket: A Journal of the Basket Fraternity or Lovers of Indian Baskets and Other Good Things*. In fact, the poplarity of basketry, pottery, and other arts among Anglo collectors has contributed significantly to the survival of Native American arts, and, to a certain extent, the traditions embodied in their art. The economic benefits resulting from commercial sales of artwork have stimulated the Native Americans' own desire to preserve the cultural integrity and traditions of their peoples.

Fig. 8-9 Rose window, south transept, Chartres Cathedral, c. 1215.
Chartres, France.

🔍 **View** the Closer Look on Chartres Cathedral's stained glass on myartslab.com

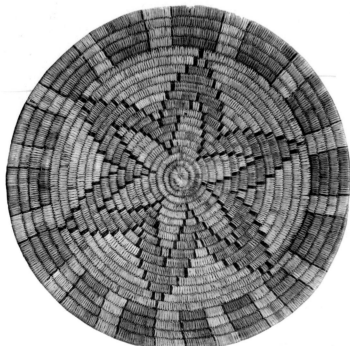

Fig. 8-10 Mescalero Apache coiled basket, early twentieth century.
Arizona State Museum, University of Arizona, Tucson.
Photo: Jannelle Weakly. (26496-x-2)

Emphasis and Focal Point

Artists employ emphasis in order to draw the viewer's attention to one area of the work. We refer to this area as the **focal point** of the composition. The focal point of a radially balanced composition is obvious. The center of the rose window in the south transept of Chartres Cathedral (see Fig. 8-9) is its focal point and, fittingly, an enthroned Christ occupies that spot. The focal point of Quarton's *Coronation of the Virgin* (see Fig. 8-4) is Mary, who is also, not coincidentally, the object of everyone's attention.

One important way that emphasis can be established is by creating strong contrasts of light and color. *Still Life with Lobster* (**Fig. 8-11**) uses a complementary color scheme to focus our attention. The work was painted in the court of the French king Louis XVI by Anna Vallayer-Coster, a female member of the Académie Royale, the official organization of French painters (though it is important to note that after Vallayer-Coster was elected to the Académie in 1770, membership by women was limited to four, perhaps because the male-dominated Académie felt threatened by women's success). By painting everything else in the composition a shade of green, Vallayer-Coster focuses our attention on the delicious red lobster in the foreground. Lush in its brushwork, and with a sense of luminosity that we can almost feel, the painting celebrates Vallayer-Coster's skill as a painter, her ability to control both color and light. In essence—and the double meaning is intentional—the painting is an exercise in "good taste."

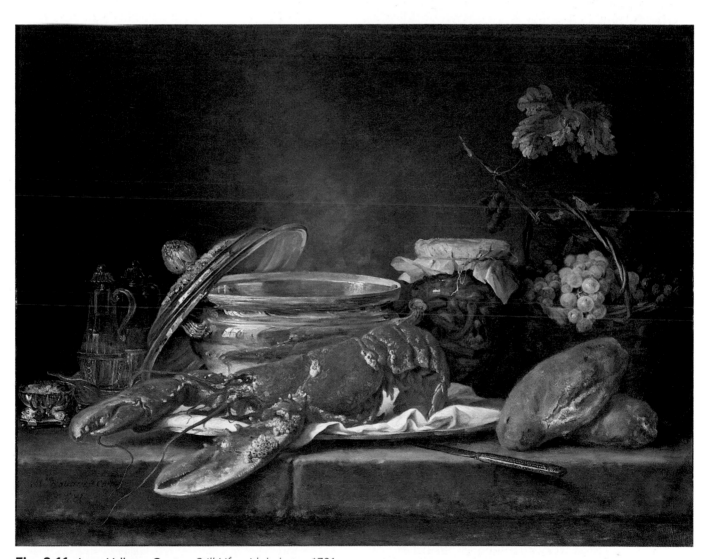

Fig. 8-11 Anna Vallayer-Coster, *Still Life with Lobster*, 1781.
Oil on canvas, 27³/₄ × 35¹/₄ in. Toledo Museum of Art, Toledo, Ohio. Purchased with funds from the Libbey Endowment, Gift of Edward Drummond Libbey.

Thinking Thematically: See Art, Gender, and Identity on myartslab.com

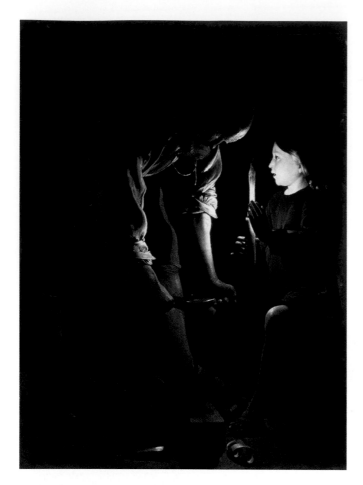

Fig. 8-12 Georges de La Tour, *Joseph the Carpenter*, c. 1645. Oil on canvas. 18¹/₂ × 25¹/₂ in. Musée du Louvre, Paris.
Gerard Blott/Réunion des Musées Nationaux / Art Resource, NY.

Light can function like a stage spotlight, as in Artemisia Gentileschi's *Judith and Maidservant with the Head of Holofernes* (see Fig. 6-7), directing our gaze to a key place within the frame. The light in Georges de La Tour's *Joseph the Carpenter* (**Fig. 8-12**) draws our attention away from the painting's titular subject, Joseph, the father of Jesus, and to the brightly lit visage of Christ himself. The candlelight here is comparable to the Divine Light, casting an ethereal glow across the young boy's face.

Similarly, Anselm Kiefer's *Parsifal I* (**Fig. 8-13**) draws our attention to the brightly lit crib set under the window of the artist's attic studio in a rural schoolhouse in Odenwald, a forested region of Southern Germany. First in a series of four paintings that illustrate Richard Wagner's last opera and its source in a thirteenth-century romance by Wolfram von Eschenbach, the painting represents the young hero Parsifal's innocent and sheltered childhood. Although his mother tried to protect him from knowledge of chivalric warfare, Parsifal would grow up to

become a knight. His ultimate task was to recover, from the magician Klingsor, the so-called Spear of Destiny—the very spear, legend had it, that a Roman centurion had thrust into the side of Christ on the cross—so that peace could be restored to the kingdom of the Grail. This is one of the earliest paintings in which Kiefer reflects upon and critiques the myths and chauvinism that eventually propelled the German Third Reich into power, in this case Hitler's own obsession with owning the Spear of Destiny, housed in the Hapsburg Treasure House in Vienna. When Hitler was 21 years old, a Treasure House guide had told him that whoever possessed the spear would hold the destiny of the world in his hands. Hitler would eventually invade Vienna and take possession of the relic. The painting thus embodies the ambivalence felt by Kiefer and his generation toward the excessive arrogance of German nationalism and its impact on

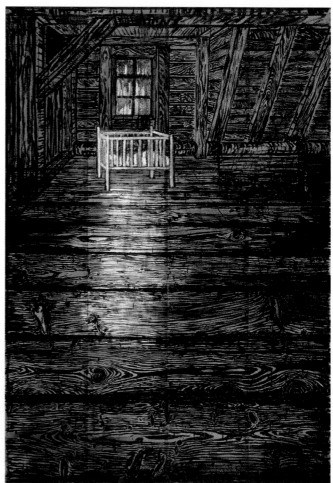

Fig. 8-13 Anselm Kiefer, *Parsifal I*, 1973. Oil on paper. 127⁷/₈ × 86¹/₂ in. Tate Gallery, London, Great Britain. Purchased 1982. T0340.
Courtesy of the arts and Gagosian Gallery.

Thinking Thematically: See Art, Politics, and Community on myartslab.com

history. Its focal point, reflecting across the floor as if across time, is a moment of innocence, the longing for a German past before war took a terrible toll on German consciousness.

Finally, it is possible, as the earlier example of *Pollock's No. 29* (see Fig. 7-15) indicates, to make a work of art that is afocal—that is, not merely a work in which no single point of the composition demands our attention any more or less than any other, but also one in which the eye can find no place to rest.

Diego Velázquez's *Las Meninas* is such a work (see *The Creative Process*, pp. 162–163). So is Larry Poons's *Orange Crush* (**Fig. 8-14**). The painting becomes afocal because the viewer's eye is continually distracted from its point of vision. If you stare for a while at the dots in the painting and then transfer your attention quickly to the more solid orange area that surrounds them, dots of an even more intense orange will appear. Your vision seems to want to float aimlessly through the space of this painting, focusing on nothing at all.

Fig. 8-14 Larry Poons, *Orange Crush*, 1963.
Acrylic on canvas, 80 × 80 in. Albright–Knox Art Gallery, Buffalo, NY. Gift of Seymour H. Knox, Jr., 1964. Art.
© Larry Poons/Licensed by VAGA, New York, NY.

In his masterpiece *Las Meninas* (*The Maids of Honor*) (**Fig. 8-17**), Diego Velázquez creates competing points of emphasis. The scene is the Spanish court of King Philip IV. The most obvious focal point of the composition is the young princess, the *infanta* Margarita, who is emphasized by her position in the center of the painting, by the light that shines brilliantly on her alone, and by the implied lines created by the gazes of the two maids of honor who bracket her. But the figures outside this central group, that of the dwarf on the right, who is also a maid of honor, and the painter on the left (a self-portrait of Velázquez), gaze away from the *infanta*. In fact, they seem to be looking at us, and so too is the *infanta* herself. The focal point of their attention, in other words, lies outside the picture plane. In fact, they are looking at a spot that appears to be occupied by the couple reflected in the mirror at the opposite end of the room, over the *infanta's* shoulder (**Fig. 8-18**)—a couple that turns out to be King Philip IV and Queen Mariana, recognizable from the two portrait busts painted by Velázquez at about the same time as *Las Meninas* (**Figs. 8-15** and **8-16**). It seems likely that they are the subject of the enormous canvas on the left that Velázquez depicts himself as painting, since they are in the position that would be occupied normally by persons sitting for a portrait. The *infanta* Margarita and her maids of honor have come, it would seem, to watch the royal couple have their portrait painted by the great Velázquez. And Velázquez has turned the tables on everyone—the focal point of *Las Meninas* is not the focal point of what he is painting.

Or perhaps the king and queen have entered the room to see their daughter, the *infanta*, being painted by Velázquez, who is viewing the entire room, including himself, in a mirror. Or perhaps the image on the far wall is not a mirror at all, but a painting, a double portrait. It has, in fact, been suggested that both of the single portraits illustrated here are studies for just such

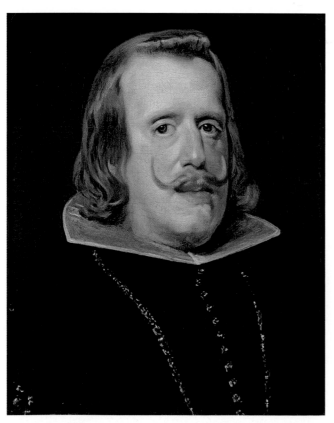

Fig. 8-15 Diego Velázquez, *Philip IV, King of Spain*, 1652–53. Oil on canvas, 17¹/₂ × 14³/₄ in. Kunsthistorisches Museum, Vienna.

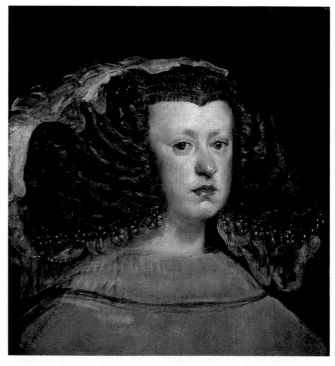

Fig. 8-16 Diego Rodriguez de Silva y Velazquez (Spanish, 1599-1660), *Portrait of Queen Mariana*, c. 1656.
Oil on canvas, 18³/₈ × 17¹/₈ in. (46.5 × 43.5 cm) Meadows Museum, SMU. Algur H. Meadows Collection. MM78.01.

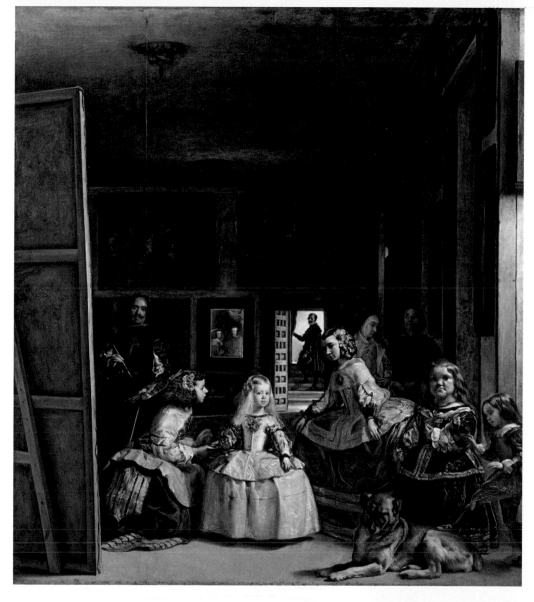

View the Closer Look on *Las Meninas* on myartslab.com

Fig. 8-17 Diego Velázquez, *Las Meninas* (*The Maids of Honor*), 1656.
Oil on canvas, 10 ft. 1/2 in. × 9 ft. 1/2 in. Museo Nacional del Prado, Madrid.

Fig. 8-18 Diego Velázquez, *Las Meninas* (*The Maids of Honor*), 1656, detail.
Museo Nacional del Prado, Madrid.

a double portrait (which, if it ever existed, is now lost). Or perhaps the mirror reflects not the king and queen but their double portrait, which Velázquez is painting and which the *infanta* has come to admire.

Whatever the case, Velázquez's painting depicts an actual work in progress. We do not know, we can never know, what work he is in the midst of making—a portrait of the king and queen, or *Las Meninas*, or some other work—but it is the working process he describes. And fundamental to that process, it would appear, is his interaction with the royal family itself, who are not merely his patrons, but the very measure of the nobility of his art.

Scale and Proportion

Scale is the word we use to describe the dimensions of an art object in relation to the original object that it depicts or in relation to the objects around it. Thus, we speak of a miniature as a "small-scale" portrait, or of a big mural as a "large-scale" work. Scale is an issue that is important when you read a textbook such as this. You must always remember that the reproductions you look at do not usually give you much sense of the actual size of the work. The scale is by no means consistent throughout. That is, a relatively small painting might be reproduced on a full page, and a very large painting on a half page. In order to make the artwork fit on the book page we must—however unintentionally—manipulate its scale.

In both Do-Ho Suh's *Public Figures* (**Fig. 8-19**) and Claes Oldenburg and Coosje van Bruggen's *Spoonbridge and Cherry* (**Fig. 8-20**), the artists have intentionally manipulated the scale of the object depicted. In Do-Ho Suh's case, the scale of the people carrying the sculptural pediment has been diminished in relation to the pediment itself, which is purposefully lacking the expected statue of a public hero standing on top of it. "Let's say if there's one statue at the plaza of a hero, who helped or protected our country," Do-Ho Suh explains, "there are hundreds of thousands of individuals who helped him and worked with him, and there's no recognition for them. So in my sculpture, *Public Figures*, I had around six hundred small figures, twelve inches high, six different shapes, both male and female, of different ethnicities"—the "little people" behind the heroic gesture. Oldenburg and van Bruggen's *Spoonbridge and Cherry*, in contrast, is gigantic in scale. It is an intentional exaggeration that parodies the idea of garden sculpture even as it wryly comments on art as the "maraschino cherry" of culture, the useless and artificial topping on the cultural sundae.

Proportion refers to the relationship between the parts of an object and the whole, or to the relationship between an object and its surroundings. In Do-Ho Suh's *Public Figures*, the relationship between the parts of the work—between figures and the pedestal—works against our expectations of proportion in a monument. In Oldenburg and van Bruggen's *Spoonbridge and Cherry*, it is the unusual relationship between the object and its surroundings that gives the work its element of delight.

Artists also manipulate scale by the way they depict the relative size of objects. As we know from our study of perspective, one of the most important ways to represent recessional space is to depict a thing closer to us as larger than a thing the same size farther away. This change in scale helps us to measure visually the space in the scene before us. When a mountain fills a small percentage of the space of a painting, we know that it lies somewhere in the distance. We judge its actual size relative to other elements in the painting and our sense of the average real mountain's size.

Fig. 8-19 Do-Ho Suh, *Public Figures*, October 1998–May 1999.
Installation at the Metrotech Center Commons, Brooklyn, NY. Fiberglass/resin, steel pipes, pipe fittings, 120" × 84" × 108" (304.8 × 213.4 × 274.3 cm)
Courtesy of the artist and Lehmann Maupin Gallery, New York.

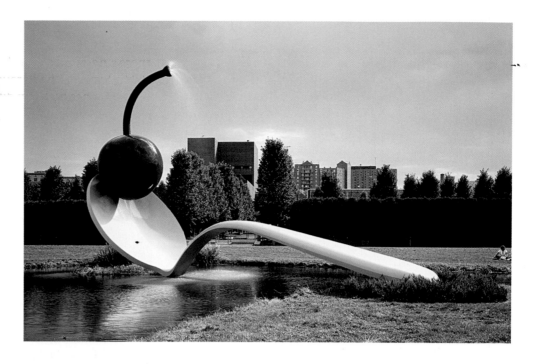

Fig. 8-20 Claes Oldenburg and Coosje van Bruggen, *Spoonbridge and Cherry*, 1895–1988.
Aluminum, Stainless Stell, paint 354" × 618" × 162". Collection Walker Art Center, Minneapolis. Gift of Frederick R. Weisman in honor of his parents, William and Mary Weisman, 1988.
© Claes Oldenburg and Coosje van Bruggen.

Because everybody in Japan knows just how large Mount Fuji is, many of Hokusai's various views of the mountain take advantage of this knowledge and, by manipulating scale, play with the viewer's expectations. His most famous view of the mountain (**Fig. 8-21**) is a case in point. In the foreground, two boats descend into a trough beneath a great crashing wave that hangs over the scene like a giant, menacing claw. In the distance, Fuji rises above the horizon, framed in a vortex of wave and foam. Hokusai has echoed its shape in the foremost wave of the composition. While the wave is visually larger than the distant mountain, our sense of scale causes us to diminish its importance. The wave will imminently collapse, yet Fuji will remain. For the Japanese, Fuji symbolizes not only the everlasting, but Japan itself, and the print juxtaposes the perils of the moment with the enduring life of the nation.

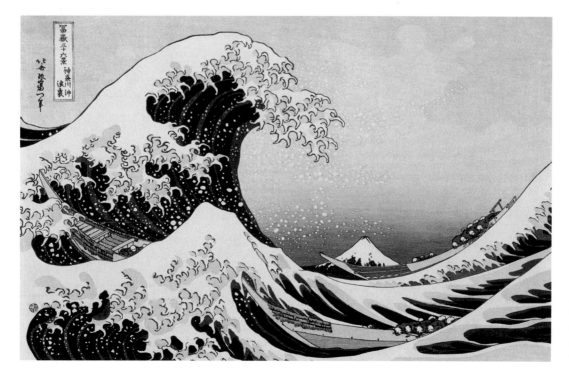

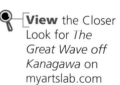

View the Closer Look for *The Great Wave off Kanagawa* on myartslab.com

Fig. 8-21 Hokusai, *The Great Wave off Kanagawa*, from the series *Thirty-Six Views of Mount Fuji*, 1823–29. Color woodcut, 10 × 15 in.

In the work of political activist artists like Felix Gonzalez-Torres, shifts in scale are designed to draw attention to the magnitude of global socio political crises. In 1991, as part of an exhibition at the Museum of Modern Art in New York, Gonzalez-Torres installed 24 billboards across New York City with an image of an empty, unmade bed (**Fig. 8-22**). The image evoked feelings of emptiness, loss, loneliness, and, ultimately, death. Its enormous scale was designed, above all, to suggest the enormity of the AIDS epidemic, not only the number of people affected by it, but also the personal and private cost that it had inflicted on both the city's gay community and its heterosexual population. By bringing to light and making large what was otherwise hidden, as muralist Judith F. Baca does in her work (see *The Creative Process*, pp. 162–163), Gonzalez-Torres meant to heighten New York's awareness of the problem that he himself faced. He would die of AIDS in 1996, at the age of 38.

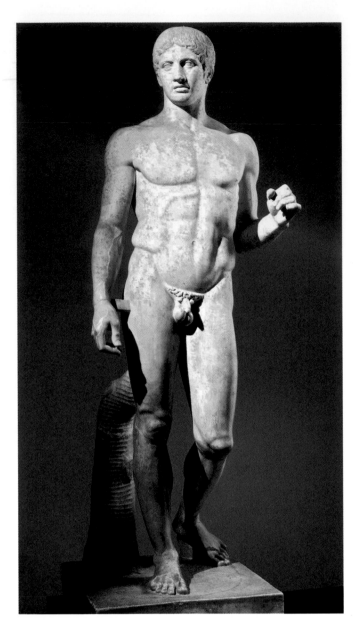

Fig. 8-23 Polyclitus, *Doryphoros*, 450 BCE. Marble, Roman copy after lost bronze original, height 84 in. National Archaeological Museum, Naples.

Alfredo Dagli Orti / The Art Archive at Art Resource, NY.

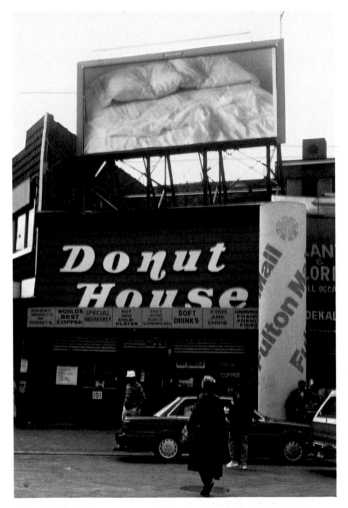

Fig. 8-22 Felix Gonzalez-Torres, *Untitled*, 1991. Billboard, overall dimensions vary with installation. The Museum of Modern Art, New York, NY, U.S.A.

© The Felix Gonzalez-Torres Foundation. Courtesy of Andrea Rosen Gallery, New York.

When the proportions of a figure seem normal, on the other hand, the representation is more likely to seem harmonious and balanced. The classical Greeks, in fact, believed that beauty itself was a function of proper proportion. In terms of the human body, these perfect proportions were determined by the sculptor Polyclitus, who not only described them in a now-lost text called the **canon** (from the Greek *kanon*, or "rule") but who also executed a sculpture to embody them. This is the *Doryphoros*, or "spear bearer," the original of which is also lost, although numerous copies survive (**Fig. 8-23**). The perfection of this figure is

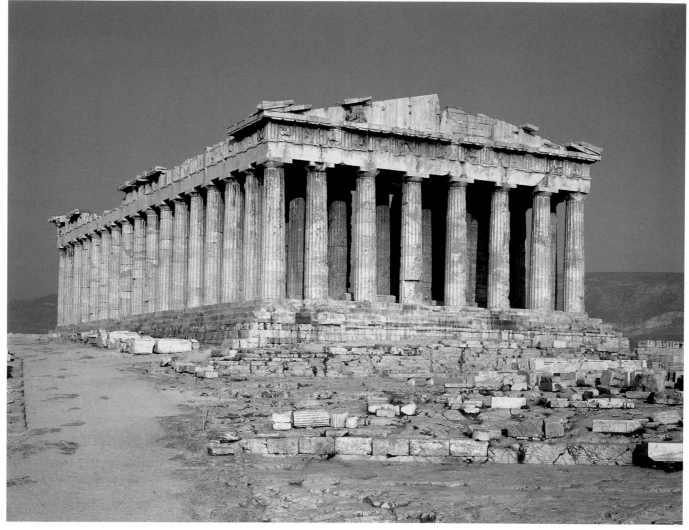

Fig. 8-24 Parthenon, 447–438 BCE.
Pentelic marble, 111 × 237 ft. at base. Athens, Greece. D.A. Harissiadis, Athens.
Studio Kontos/Photostock.

✳ Explore the architectural panorama of the Parthenon on myartslab.com

based on the fact that each part of the body is a common fraction of the figure's total height. According to the canon, the height of the head ought to be one-eighth and the breadth of the shoulders one-fourth of the total height of the body.

This sense of mathematical harmony was utilized by the Greeks in their architecture as well. The proportions of the facade of the Parthenon, constructed in the fifth century BCE on the top of the Acropolis in Athens (**Fig. 8-24**), are based on a ratio that can be expressed in the algebraic formula $x = 2y + 1$. The temple's columns, for instance, reflect this formula: there are 8 columns on the short ends and 17 on the sides, because $17 = (2 \times 8) + 1$. The ratio of the length

of the top step of the temple's platform, the *stylobate*, to its width is 9:4, because $9 = (2 \times 4) + 1$. That the Parthenon should be constructed with such mathematical harmony is hardly accidental. It is a temple to Athena, not only the protectress of Athens but also the goddess of wisdom, and such mathematical precision represents to the ancient Greeks not merely beauty, but also the ultimate wisdom of the universe. Furthermore, this monument to perfection sits atop the Athenian acropolis, literally "the top of the city." The commanding presence of the buiding is especially apparent if you look at the southwest view in the architectural panorama in myartslab, where the port of Piraeus can be seen 7½ miles away.

In 1933, Mexican artist David Alfaro Siqueiros painted a mural, *America Tropical*, on Olvera Street, the historic center of Chicano and Mexican culture in Los Angeles. It was quickly painted over by city fathers, who objected to its portrayal of the plight of Mexicans and Chicanos in California. Currently under restoration with funds provided by the Getty Foundation, the mural depicts a *mestizo* (a person of mixed European and Native American ancestry) shooting at an American eagle and a crucified Chicano, one of the inspirations for Guillermo Gómez-Peña's *Cruci-fiction Project* (see Fig. 3-13). Siqueiros's mural, and the work of the other great Mexican muralists of the twentieth century, Diego Rivera and Clemente Orozco—Los Tres Grandes, as they are known—has also inspired activist artist Judy Baca, who has dedicated her career to "giving voice" to the marginalized communities of California.

In 1996, at the University of Southern California in Los Angeles, Baca was commissioned to create a mural (**Fig. 8-26**) for the student center, designed to embody the Chicano presence on campus and to symbolize the long struggle of USC's Chicano community to gain acknowledgment at the university. The project illustrates her working method. She begins with a group effort, gathering interested students together to research the historical events that took place around the site. This "excavation of the land," as she calls it, is the foundation for the collaborative venture to follow. Layers of information and historical data in the form of photographs, newspaper clippings, and old letters are gathered by students. Like layers of paint, the information is blended to become the imagery of the art—an imagery that will express, Baca hopes, the truth of the place where the work will be housed. She then creates a drawing (**Fig. 8-25**) based on the students' research, and the drawing is transferred to the wall.

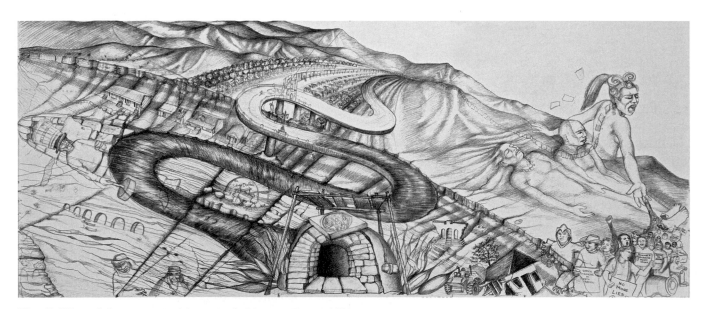

Fig. 8-25 Judith F. Baca, *La Memoria de Nuestra Tierra*, 1996.
Preliminary drawing. Acrylic on canvas, 9 × 23 ft. USC Student Topping Center.
Courtesy of SPARC (sparcmurals.org).

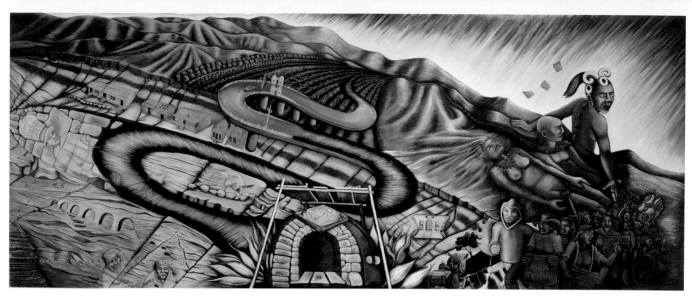

Fig. 8-26 Judith F. Baca, *La Memoria de Nuestra Tierra*, 1996.
Acrylic on canvas, 9 × 23 ft. USC Student Topping Center.
© 1997 Judith F. Baca. Courtesy of SPARC (sparcmurals.org).

The USC mural was conceived as a history of the Chicano community in Los Angeles, from the earliest houses in Sonora town to the destruction of the large community at Chavez Ravine—the line of blue houses under the freeway—to make way for Dodger Stadium. At the bottom center of the painting is a kiva, the traditional ceremonial center of native American culture in the Southwest, from which flows the river of life, itself transformed into a freeway before it leads out into the fields beyond. At the right, an Aztec goddess rises in protest from the land, and from her hand flows a river of blood, which is itself transformed into a cadre of Chicano civil rights activists. Like the mural by Siqueiros, it originally included a lynching, visible under the white S-curve of the freeway in the drawing. This tiny 3/4-inch image, a reference to the lynching of Mexican-American workers in California before and during the Mexican-American Civil Rights Movement, was deemed "absolutely unacceptable" by the president of the university, causing work on the project to come to a stop. It was subsequently removed from the final mural, a compromise that allowed Baca to complete the rest of the project as she had originally planned.

Scale is everywhere an issue in Baca's mural. The mural is, in the first place, a "large-scale" work, dominating the room it occupies. In the process of its creation, the piece changes scale as well, from drawing to wall, from the intimate view to the public space. Most interesting of all is the controversy surrounding the hanging man. The image was itself very small, but it became emotionally large in scale—absolutely unacceptable, Baca agreed, but not as an image—as a fact.

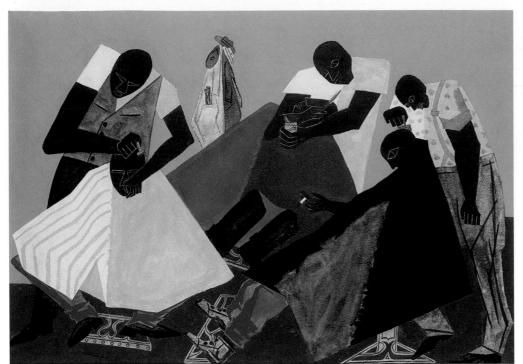

Fig. 8-27 Jacob Lawrence, *Barber Shop*, 1946. Gouache on paper, 21 1/8 × 29 3/8 in. The Toledo Museum of Art, Toledo, Ohio. Purchased with funds from the Libbey Endowment, Gift of Edward Drummond Libbey.

Repetition and Rhythm

Repetition often implies monotony. If we see the same thing over and over again, it tends to get boring. Nevertheless, when the same or like elements—shapes, colors, or a regular pattern of any kind—are repeated over and over again in a composition, a certain visual **rhythm** will result. In Jacob Lawrence's *Barber Shop* (**Fig. 8-27**), this rhythm is established through the repetition of both shapes and colors. One pattern is based on the diamond-shaped figures sitting in the barber chairs, each of which is covered with a different-colored apron: one lavender and white, one red, and one black and green. The color and pattern of the left-hand patron's apron is echoed in the shirts of the two barbers on the right, while the pattern of the right-hand patron's apron is repeated in the vest of the barber on the left. Hands, shoulders, feet—all work into the triangulated format of the design. "The painting," Lawrence explained in 1979, "is one of the many works . . . executed out of my experience . . . my everyday visual encounters." It is meant to capture the rhythm of life in Harlem, where Lawrence grew up in the 1930s. "It was inevitable," he says, "that the barber shop with its daily gathering of Harlemites, its clippers, mirror, razors, the overall pattern and the many conversations that took place there . . . was to become the subject of many of my paintings. Even now, in my imagination, whenever I relive my early years in the Harlem community, the barber shop, in both form and content . . . is one of the scenes that I still see and remember."

As we all know from listening to music, and as Lawrence's painting demonstrates, repetition is not necessarily boring. *The Gates of Hell* (**Fig. 8-28**), by Auguste Rodin, was conceived in 1880 as the entry for the Museum of Decorative Arts in Paris, which was never built. The work is based on the *Inferno* section of Dante's *Divine Comedy* and is filled with nearly 200 figures who swirl in hellfire, reaching out as if continually striving to escape the surface of the door. Rodin's famous *Thinker* sits atop the door panels, looking down as if in contemplation of man's fate, and to each side of the door, in its original conception, stand Adam and Eve. At the very top of the door is a group of three figures, the *Three Shades*, guardians of the dark inferno beneath.

What is startling is that the *Three Shades* are not different, but, in fact, all the same (**Fig. 8-29**). Rodin cast his Shade three times and arranged the three casts in the format of a semicircle. (As with *The Thinker* and many other figures on the *Gates*, he also exhibited them as a separate, independent sculpture.) Though each figure is identical, thus arranged, and viewed from different sides, each appears to be a unique figure. Furthermore, in the *Gates*, the posture of the figure of Adam, in front and to the left, echoes that of the *Shades* above. This formal repetition, and the downward pull that unites all four figures, implies that Adam is not merely the father of us all, but also, in his sin, the very man who has brought us to the Gates of Hell.

In Laylah Ali's most famous and longest-running series of paintings, depicting the brown-skinned

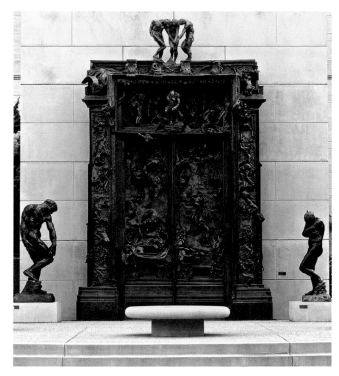

Fig. 8-28 Auguste Rodin, *Gates of Hell with Adam and Eve*, 1880–1917.
Bronze, 251 × 158 × 33 in. Stanford University Museum of Art.
Photograph by Frank Wing.

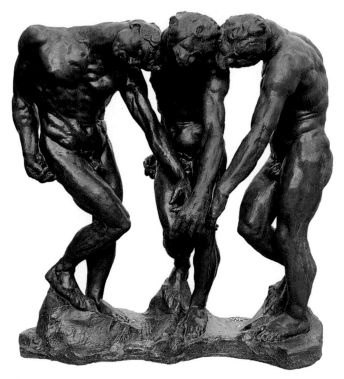

Fig. 8-29 Auguste Rodin (France, 1840–1917), *The Three Shades*, 1881–86.
Bronze, Coubertin Foundry. Posthumous cast authorized by Musée Rodin, 1980, 75½ × 75½ × 42 in. (195.5 × 195.5 × 108.8 cm) Iris & B. Gerald Cantor Center for Visual Arts at Stanford University. Gift of the B. Gerald Cantor Collections.

and gender-neutral Greenheads (**Fig. 8-30**), repetition plays a crucial role. Her figures are the archetypal "Other," a sort of amalgam of extraterrestrial Martians with their green heads and the dark-skinned denizens of the Third World. In the image reproduced here, three almost identical but masked Greenheads are being hung in front of an unmasked fourth victim. The hanged Greenheads hold in their hands the amputated leg and arm, as well as the belt

(for Ali, belts connote power) of the figure awaiting his or her fate. As Ali says, "The repetition is what I think is so striking. It's not like one thing happens and you say, 'Wow! That was just so terrible,' and it will never happen again. You know it will happen again." The horror of her images, in other words, resides exactly in their repetition.

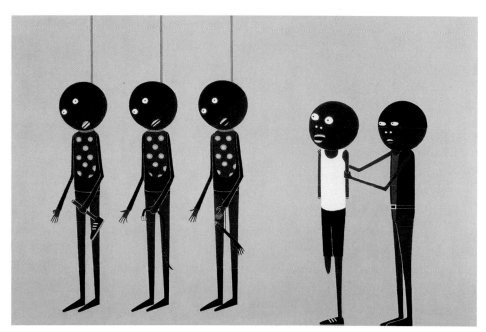

Fig. 8-30 Laylah Ali, *Untitled*, 2000.
Gouache on paper, 13 × 19 in.
Courtesy Laylah Ali and 303 Gallery, New York.

Unity and Variety

Repetition and rhythm are employed by artists in order to unify the different elements of their works. In *Barber Shop* (see Fig. 8-27), Jacob Lawrence gives the painting a sense of coherence by repeating shapes and color patterns. Each of the principles of design that we have discussed leads to this idea of organization, the sense that we are looking at a unified whole—balanced, focused, and so on. Even Lawrence's figures, with their strange, clumsy hands, their oversimplified features, and their oddly extended legs and feet, are uniform throughout. Such consistency lends the picture its feeling of being complete.

It is as if, in *Barber Shop*, Lawrence is painting the idea of community itself, bringing together the diversity of the Harlem streets through the unifying patterns of his art. In fact, if everything were the same, in art as in life, there would be no need for us to discuss the concept of "unity." But things are not the same. The visual world is made up of different lines, forms, colors, textures—the various visual elements themselves—and they must be made to work together. Still, Rodin's *Three Shades* atop the *Gates of Hell* (see Fig. 8-28) teaches us an important lesson. Even when each element of a composition is identical, it is variety—in this case, the fact that our point of view changes

with each of the Shades—that sustains our interest. In general, unity and variety must coexist in a work of art. The artist must strike a balance between the two.

James Lavadour's *The Seven Valleys and the Five Valleys* (**Fig. 8-31**) is a stylistically unified composition of 12 landscape views, but each of the views is quite different from the others. Lavadour's paintings constantly negotiate the boundaries between realism and abstraction—between the landscape of his Native American heritage and his training as a contemporary artist. Close up, they seem to dissolve into a scraped, dripped, and brushed abstract surface, but seen from a distance, they become expansive landscape views, capturing the light and weather of the Pacific Northwest plateau country where Lavadour lives. Viewing a painting such as this is like viewing a series of Monet grain stacks, all rolled into one.

In the twentieth century, artists have increasingly embraced and exploited tensions such as those found in Lavadour's work. Rather than seeking a means to unify the composition, they have sought to expose not just variety, but opposition and contradiction. A photograph by Louise Lawler, *Pollock and Tureen* (**Fig. 8-32**) not only brings two radically contradictory objects into a state of opposition but demonstrates how, by placing them side by side, they influence the ways in which we understand

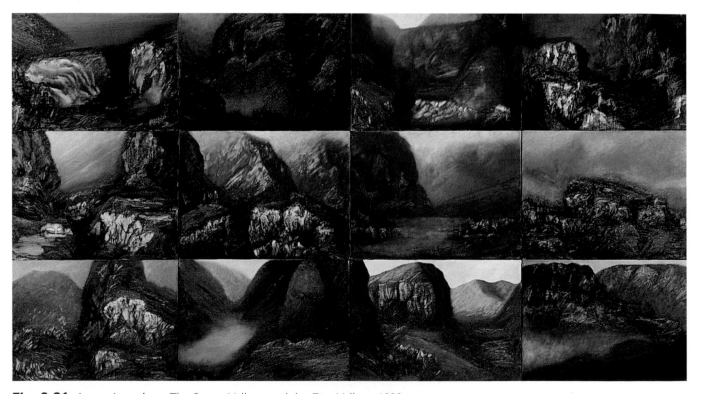

Fig. 8-31 James Lavadour, *The Seven Valleys and the Five Valleys*, 1988.
Oil on canvas, 54 × 96 in. Collection of Ida Cole.
Courtesy of the artist and PDX, Portland, OR.

them. Thus, the Pollock painting in this photograph is transformed into a decorative or ornamental object, much like the tureen centered on the table in front of it. Lawler not only underscores the fact that the painting is, like the tureen, a marketable object, but also suggests that the expressive qualities of Pollock's original work have been emptied, or at least nearly so, when looked at in this context.

It is this sense of disjunction, the sense that the parts can never form a unified whole, that we have come to identify with what is commonly called postmodernism. The discontinuity between the two parts of Frank Gehry's Rasin building in Prague, Czech Republic (see Fig. 8-2), discussed at the beginning of this chapter, is an example of this postmodern sensibility, a sensibility defined particularly well by another architect, Robert Venturi, in his important 1972 book, *Learning from Las Vegas*, written with Denise Scott Brown and Steven Izenour. For Venturi, the collision of styles, signs, and symbols that marks the American "strip," especially the Las Vegas strip (**Fig. 8-33**), could be seen in light of a new sort of unity. "Disorder," Venturi writes, "[is] an order we cannot see . . . The commercial strip within the urban sprawl . . . [is an order that] *includes*; it includes at all levels, from the mixture of seemingly incongruous land uses to the mixture of seemingly

Fig. 8-32 Louise Lawler, *Pollock and Tureen*, 1984. Cibachrome, 28 × 39 in.
Courtesy of the Artist and Metro Pictures.

incongruous advertising media plus a system of neo-organic . . . restaurant motifs in Walnut Formica." The strip declares that anything can be put next to anything else. While traditional art has tended to exclude things that it deems unartful, postmodern art lets everything in. In this sense, it is democratic. It could even be said to achieve a unity larger than the comparatively elitist art of high culture could ever imagine.

Fig. 8-33 *Las Vegas*, Nevada, c. 1985.
Steve Vidler/SuperStock

Elizabeth Murray's shaped canvas *Just in Time* (**Fig. 8-34**) is, at first glance, a two-panel abstract construction of rhythmic curves, oddly and not quite evenly cut in half. But on second glance, it announces its postmodernity. For the construction is also an ordinary teacup, with a pink cloud of steam rising above its rim. In a move that calls to mind Claes Oldenburg and Coosje van Bruggen's *Spoonbridge and Cherry* (see Fig. 8-20), the scale of this cup—it is nearly 9 feet high—monumentalizes the banal, domestic subject matter. Animal forms seem to arise out of the design—a rabbit on the left, an animated, Disney-like, laughing teacup in profile on the right. The title recalls pop lyrics—"Just in time, I found you just in time." Yet it remains an abstract painting, interesting as painting and as design. It is even, for Murray, deeply serious. She defines the significance of the break down the middle of the painting by citing a stanza from W. H. Auden's poem, "As I walked out one evening":

> *The glacier knocks in the cupboard,*
> *The desert sighs in the bed,*
> *And the crack in the tea-cup opens*
> *A lane to the land of the dead.*

Who knows what meanings are rising up out of this crack in the cup, this structural gap? Murray's painting is at once an ordinary teacup and an image rich in possible meanings, stylistically coherent and physically fragmented. The endless play of unity and variety is what it's about.

Fig. 8-34 Elizabeth Murray, *Just in Time*, 1981.
Oil on canvas in two sections, 106 × 97 in. The Philadelphia Museum of Art. Purchased: The Edward and Althea Budd Fund, the Adele Haas Turner and Beatrice Pastorius Fund, and funds contributed by Marion Stroud and Lorine E. Vogt. 1981–1994-1a,b.

THINKING BACK

✓ **Study** and review on myartslab.com

What is visual weight, and how does it differ from actual weight?

All art deals with visual weight, the apparent "heaviness" or "lightness" of the shapes and forms arranged in the composition. Actual weight, by contrast, refers to the physical weight in pounds of an artwork's materials. What is asymmetrical balance? How is visual weight balanced in the Taj Mahal? What is radial balance?

What is a focal point?

Artists employ *emphasis* in order to draw the viewer's attention to one area of a work. This area is the focal point of the composition. What is the focal point of a radially balanced artwork? How does Anna Vallayer-Coster create emphasis in *Still Life with Lobster*?

How does scale differ from proportion?

Scale refers to the dimensions of an art object in relation to the original object that it represents or in relation to the objects around it. Proportion, by contrast, refers to the relationship between the parts of an object and the whole, or between the object and its surroundings. How do Claes Oldenburg and Coosje van Bruggen manipulate scale in their sculpture *Spoonbridge and Cherry*? What is the canon?

How do artists use repetition and rhythm?

When the same or similar elements are repeated over and over again in a composition, a visual rhythm is established. Artists often use this rhythm in order to unify different elements of a work. How does Laylah Ali depict the Greenheads? How does repetition structure meaning in Jacob Lawrence's *Barber Shop*?

THE CRITICAL PROCESS
Thinking about the Principles of Design

By way of concluding this part of the book, let's consider how the various elements and principles inform a particular work, Monet's *The Railroad Bridge, Argenteuil* (**Fig. 8-35**). Line comes into play here in any number of ways. How would you describe Monet's use of line? Is it classical or expressive? Two strong diagonals—the near bank and the bridge itself—cross the picture. What architectural element depicted in the picture echoes this structure? Now note the two opposing directional lines in the painting—the train's and the boat's. In fact, the boat is apparently tacking against a strong wind that blows from right to left, as the smoke coming from the train's engine indicates. Where else in the painting is this sense of opposition apparent? Consider the relationships of light to dark in the composition and the complementary color scheme of orange and blue that is especially used in the reflections and in the smoke above. Can you detect opposing and contradictory senses of symmetry and asymmetry? What about opposing focal points?

What appears at first to be a simple landscape view upon analysis reveals itself to be a much more complicated painting. In the same way, what at first appears to be a cloud becomes, rather disturbingly, a cloud of smoke. Out of the dense growth of the near bank, a train emerges. Monet seems intent on describing what larger issues here? We know that when Monet painted it, the railroad bridge at Argenteuil was a new bridge. How does this painting capture the dawn of a new world, a world of opposition and contradiction? Can you make a case that almost every formal element and principle of design at work in the painting supports this reading?

Fig. 8-35 Claude Monet, *The Railroad Bridge, Argenteuil*, 1874.
Oil on canvas, 21⁴/₅ × 29²/₅ in. The John G. Johnson Collection, The Philadelphia Museum of Art. J#1050.

9 Drawing

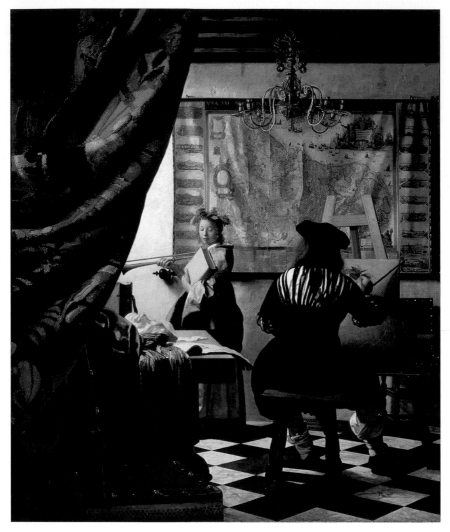

Fig. 9-1 Jan Vermeer, *The Allegory of Painting (The Painter and His Model as Clio)*, 1665–66.
Oil on canvas, 48 × 40 in. Kunsthistorisches Museum, Vienna, Austria. Cat. 395, Inv. 9128.
Erich Lessing/Art Resource, NY.
Thinking Thematically: See Art, Science, and the Environment on myartslab.com

THINKING AHEAD

What is a medium?

What is the technique known as metalpoint?

What are the characteristics of wet media?

How can drawing be an innovative medium?

((•—|Listen to the chapter audio on myartslab.com

In Jan Vermeer's *The Allegory of Painting* (**Fig. 9-1**), a stunning variety of media are depicted. The artist, his back to us, is shown painting his model's crown, but the careful observer can detect, in the lower half of the canvas, below his elbow, the white chalk lines of his preliminary drawing. A tapestry has been pulled back at the left, and a beautifully crafted chandelier hangs from the ceiling. A map on the back wall illustrates the art of cartography. The model herself is posed above a sculpted mask, which

lies on the table below her gaze. As the muse of history, she holds a book in one hand, representing writing and literature, and a trumpet, representing music, in the other hand.

Each of the materials in Vermeer's work—painting, drawing, sculpture, tapestry, even the book and the trumpet—represents what we call a **medium**. The history of the various media used to create art is, in essence, the history of the various technologies that artists have employed. These **technologies** have helped artists both to achieve their desired effects more readily and to discover new modes of creation and expression. A technology, literally, is the "word" or "discourse" (from the Greek *logos*) about a "techne" (from the Greek word for art, which in turn comes from the Greek verb *tekein*, "to make, prepare, or fabricate"). A medium is, in this sense, a techne, a means of making art.

In Part 3 we will study all of the various media, but we turn our attention first to drawing, perhaps the most basic medium of all. Drawing has many purposes, but chief among them is preliminary study. Through drawing, artists can experiment with different approaches to their compositions. They illustrate, for themselves, what they are going to do. And, in fact, illustration is another important purpose of drawing. Before the advent of the camera, illustration was the primary way that we recorded history, and today it provides visual interpretations of written texts, particularly in children's books. Finally, because it is so direct, recording the path of the artist's hand directly on paper, artists also find drawing to be a ready-made means of self-expression. It is as if, in the act of drawing, the soul or spirit of the artist finds its way to paper.

From Preparatory Sketch to Work of Art

When Captain Cook first sailed along the eastern coast of Australia in 1770, he encountered an Australian Aboriginal culture that possessed what we now know to be the longest continuously practiced artistic tradition anywhere in the world. In Arnhem Land, in Northern Australia, a great many rock formations and caves are decorated with rock art dating from the earliest periods of human history (40,000–6000 BCE) to works created within living memory (**Fig. 9-2**). The earliest of these are stick-like figures that represent ancestral spirits, or *mimis*, some of which are visible behind the kangaroo in the photograph below. According to Arnhem legend, *mimis* made the earliest rock art drawings and taught the art to present-day Aborigines, who, in painting such figures themselves, release the power of the *mimis*. Aboriginal artists do not believe that they create or invent their subjects; rather, the *mimis* give them their designs, which they then transmit for others to see. The act of drawing creates a direct link between the present and the past.

The kangaroo in this drawing is rendered in what has become known as the *X-ray style*, where the skeletal structure, heart, and stomach of an animal are

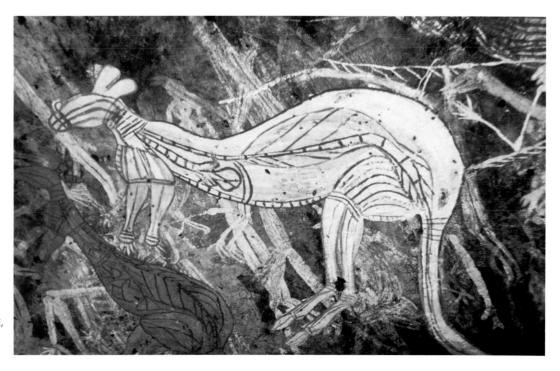

Fig. 9-2 Mimis and kangaroo, rock art, Oenpelli, Arnhem Land, Australia. Older paintings before 7000 BCE, kangaroo probably post-contact.

drawn over its silhouetted form as if the viewer is able to see the life force of the animal through its skin. Aboriginal artists still work in this style. In fact, of all the colors used in Aboriginal rock art, white is the most subject to chemical deterioration. This, together with the fact that many layers of art lie beneath it, suggests that the X-ray–style kangaroo was drawn on the wall relatively recently.

The example of Aboriginal rock art suggests that drawing is fundamental to human experience. In the case of Aboriginal artists, it seems to possess religious, or at least spiritual, significance. But it is also an activity fundamental to the advancement of human knowledge. Artists and scientists have traditionally used drawing as a means of conveying information—from studying human anatomy, to recording the variety of botanical species, to mapping the physical world. In nineteenth-century Europe, drawing was considered a necessary skill, and was thus a fundamental part of European education.

Today, we think of drawing as an everyday activity that anyone, both artists and ordinary people, might take up at any time. You doodle on a pad; you throw away the marked-up sheet and start again with a fresh one. We think of artists as making dozens of sketches before deciding on the composition of a major work. But people have not always been able or willing to casually toss out marked-up paper and begin again. Before the late fifteenth century, paper was costly. Look closely at an early Renaissance drawing probably from the workshop of Pollaiuolo (**Fig. 9-3**). The young man is sketching on a wooden tablet that he would sand clean after each drawing. The artist who drew him at work, however, worked in pen and ink on rare, expensive paper. This work thus represents a transition point in Western art—the point at which artists began to draw on paper before they committed their ideas to canvas or plaster.

Paper was not manufactured in the Western world until the thirteenth century in Italy. It was traditionally made out of fiber derived from scraps of cloth—generally hemp, cotton, and linen—and it was less costly than papyrus and parchment, both of which served as the principal writing materials in the West until the arrival of paper. *Papyrus* (from which our word *paper* derives, although they are very different), was the invention of the ancient Egyptians (sometime around 4000 BCE) and was made by pounding and pasting together strips of the papyrus plant, which grew in abundance in the marshes of the Nile River. *Parchment*, popularized by the ancient Romans after the second century BCE, but used around the Mediterranean for many centuries before that, was made from animal

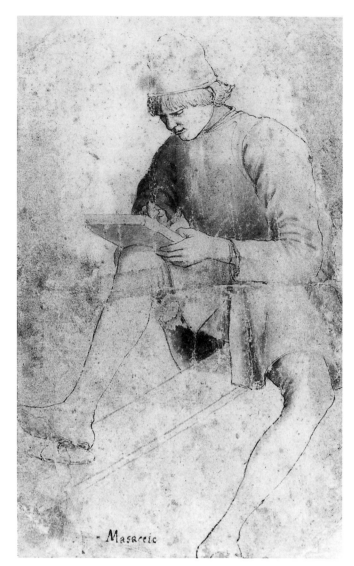

Fig. 9-3 Workshop of Pollaiuolo (?), *Youth Drawing*, late 15th century.
Pen and ink with wash on paper, 7⅝ × 4½ in.
© The Trustees of the British Museum / Art Resource, NY.

skins that had been scraped, soaked and dried, and was thus more widely available than papyrus, since animals are obviously found outside of the Nile River basin, but also more expensive, since valuable animals had to be killed to make it. Paper was cheaper than both.

Paper arrived in the West through trade with the Muslim world, which in turn had learned of the process from China. Tradition has it that it was invented in 105 CE by Cai Lun, a eunuch who served in the imperial Han court, but archaeologists have found fragments of paper in China that date to before 200 BCE. Papermaking was introduced into the Arabic world sometime in the eighth century CE, where it supported a thriving book trade, centered in Baghdad. It was not until the invention of the printing press by Johannes Gutenberg in fifteenth-century Germany, which itself

spurred widespread interest in books, especially the Bible, that papermaking began to thrive in the West. Then publishers, which soon proliferated across the continent, vied for the rag supply. At one point in the early Renaissance, the city of Venice banned the export of rags for fear that its own paper industry might be threatened.

Because it required cloth rags in large quantities, paper remained an expensive, relatively luxurious commodity (the technology for making paper from wood pulp was not discovered until the middle of the nineteenth century), and because, until the late fifteenth century, drawing was generally considered a student medium, as the Pollaiuolo drawing of a student suggests, it was not often done on paper. Copying a master's work was the means by which a student learned the higher art of painting. Thus, in 1493, the Italian religious zealot Savonarola outlined the ideal relationship between student and master: "What does the pupil look for in the master? I'll tell you. The master draws from his mind an image which his hands trace on paper and it carries the imprint of his idea. The pupil studies the drawing, and tries to imitate it. Little by little, in this way, he appropriates the style of his master. That is how all natural things, and all creatures, have derived from the divine intellect." Savonarola thus describes drawing as both the banal, everyday business of beginners and as equal in its creativity to God's handiwork in nature. For Savonarola, the master's idea is comparable to "divine intellect." The master is to the student as God is to humanity. Drawing is, furthermore, autographic: It bears the master's imprint, his style.

By the end of the fifteenth century, then, drawing had come into its own. It was seen as embodying, perhaps more clearly than even the finished work, the artist's personality and creative genius. As one watched an artist's ideas develop through a series of preparatory sketches, it became possible to speak knowingly about the creative process itself. By the time Giorgio Vasari wrote his famous *Lives of the Painters* in 1550, the tendency was to see in drawing the foundation of Renaissance painting itself. Vasari had one of the largest collections of fifteenth-century—or so-called *quattrocento*—drawings ever assembled, and he wrote as if these drawings were a dictionary of the styles of the artists who had come before him.

In the *Lives* Vasari recalls how, in 1501, crowds rushed to see Leonardo's *Madonna and Child with St. Anne and Infant St. John the Baptist*, a **cartoon** (from the Italian *cartone*, meaning "paper") or drawing done to scale for a painting or a fresco. "The work not only won the astonished admiration of all the artists," Vasari reported, "but when finished for two days it attracted to the room where it was exhibited a crowd of men and women, young and old, who flocked there, as if they were attending a great festival, to gaze in amazement at the marvels he had created." Though this cartoon apparently does not survive, we can get some notion of it from the later cartoon illustrated here (**Fig. 9-4**). Vasari's account, at any rate, is the earliest recorded example we have of the public actually admiring a drawing.

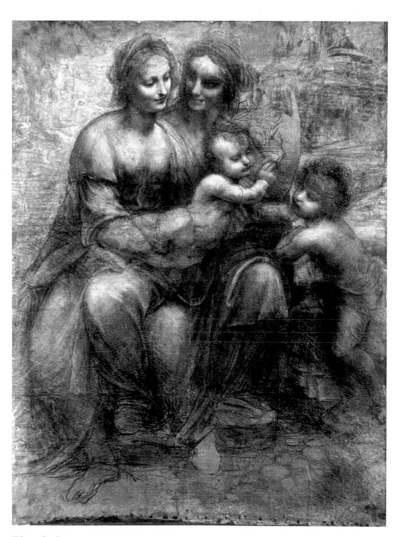

Fig. 9-4 Leonardo da Vinci, *Madonna and Child with St. Anne and Infant St. John the Baptist*, c. 1505–07.
Charcoal (and wash?) heightened with white chalk on paper, mounted on canvas, 55³/₄ × 41¹/₄ in. National Gallery, London. Purchased with a special grant and contributions from The Art Fund, The Pilgrim Trust, and through a public appeal organised by The Art Fund, 1962. NG6337.

Leonardo's drawings illustrate why drawing merits serious consideration as an art form in its own right and why they would so influence younger artists such as Raphael, who based so many of his paintings on quickly realized preparatory sketches (see *The Creative Process*, pp. 182–183). In Leonardo's *Study for a Sleeve* (**Fig. 9-5**), witness the extraordinary fluidity and spontaneity of the master's line. In contrast to the stillness of the resting arm (the hand, which is comparatively crude, was probably added later), the drapery is depicted as if it were a whirlpool or vortex. The directness of the medium, the ability of the artist's hand to move quickly over paper, allows Leonardo to bring out this turbulence. Through the intensity of his line, Leonardo imparts a degree of emotional complexity to the sitter, which is revealed in the part as well as in the whole. But the drawing also reveals the movements of the artist's own mind. It is as if the still sitter were at odds with the turbulence of the artist's imagination, an imagination that will not hold still whatever its object of contemplation. The fact is that in drawings like this one we learn something important not only about Leonardo's technique but also about what drove his imagination. More than any other reason, this was why, in the sixteenth century, drawings began to be preserved by artists and, simultaneously, collected by connoisseurs, experts on, and appreciators of fine art.

Drawing Materials

Just as the different fine arts media produce different kinds of images, different drawing materials produce different effects as well. Drawing materials are generally divided into two categories—dry media and liquid media. The dry media, which include metalpoint, chalk, charcoal, graphite, and pastel, consist of coloring agents, or **pigments**, that are sometimes ground or mixed with substances that hold the pigment together, called **binders**. Binders, however, are not necessary if the natural pigment—for instance, charcoal made from vine wood heated in a hot kiln until only the carbon charcoal remains—can be applied directly to the surface of the work. In liquid media, pigments are suspended in liquid binders like ink. Liquid flows much more easily than dry chalk on a paper surface.

Fig. 9-5 Leonardo da Vinci, *Study for a Sleeve*, c. 1510–13.
Pen, lampblack, and chalk, $3^1/_8 \times 6^3/_4$ in. The Royal Collection.
The Royal Collection © 2012, Her Majesty Queen Elizabeth II.

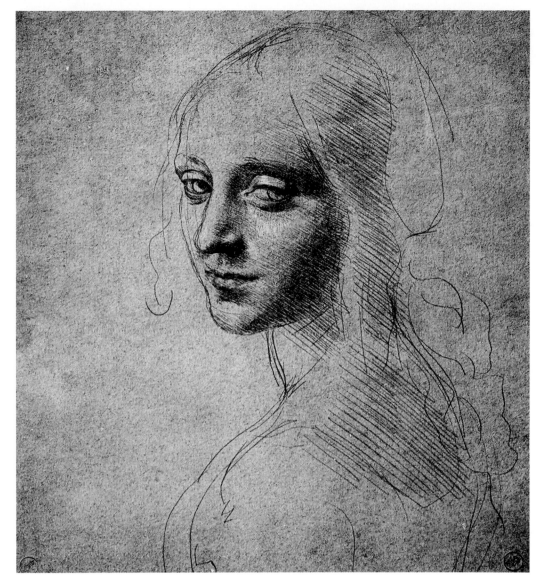

Fig. 9-6 Leonardo da Vinci, *Study of a woman's head or of the angel of the Vergine delle Rocce*, 1473.
Silverpoint with white highlights on prepared paper, 7¹⁄₈ × 6¹⁄₄ in. Biblioteca Reale, Turin, Italy.
Alinari/Art Resource, NY.

DRY MEDIA

Metalpoint

One of the most common tools used in drawing in late-fifteenth- and early-sixteenth-century Italy was **metalpoint**. A stylus (point) made of gold, silver, or some other metal is applied to a sheet of paper prepared with a mixture of powdered bones (or lead white) and gumwater. (When the stylus was silver, as it often was, the medium was called silverpoint.) Sometimes, pigments other than white were added to this preparation in order to color the paper. When the metalpoint is applied to this ground, a chemical reaction results, and line is produced.

A metalpoint line, which is pale gray, is very delicate and cannot be widened by increasing pressure upon the point. To make a thicker line, the artist must switch to a thicker point. Often, the same stylus has a fine point on one end and a blunt one on the other. Since a line cannot be erased without resurfacing the paper, drawing with metalpoint requires extreme patience and skill. Leonardo's metalpoint drawing of a woman's head **(Fig. 9-6)** shows this skill. Shadow is rendered here by means of careful hatching. At the same time, a sense of movement and energy is evoked not only by the directional force of these parallels, but also by the freedom of Leonardo's line, the looseness of the gesture, even in this most demanding of formats.

THE CREATIVE PROCESS

In a series of studies for *The Alba Madonna* (**Fig. 9-9**), the great Renaissance draftsman Raphael demonstrates many of the ways that artists use drawings to plan a final work. It is as if Raphael, in these sketches, had been instructed by Leonardo himself. We do know, in fact, that when Raphael arrived in Florence in 1504, he was stunned by the freedom of movement and invention that he discovered in Leonardo's drawings. "Sketch subjects quickly," Leonardo admonished his students. "Rough out the arrangement of the limbs of your figures and first attend to the movements appropriate to the mental state of the creatures that make up your picture rather than to the beauty and perfection of their parts."

In the studies illustrated here, Raphael worked on both sides of a single sheet of paper (**Figs. 9-7** and **9-8**). On one side he has drawn a male model from life and posed him as the Madonna. In the sweeping cross-hatching below the figure in the sketch, one can already sense the circular format of the final painting, as these lines rise and turn up the arm and shoulder and around to the model's head. Inside this curve is another, rising from the knee bent under the model up across his chest to his neck and face. Even the folds of the drapery under his extended arm echo this curvilinear structure.

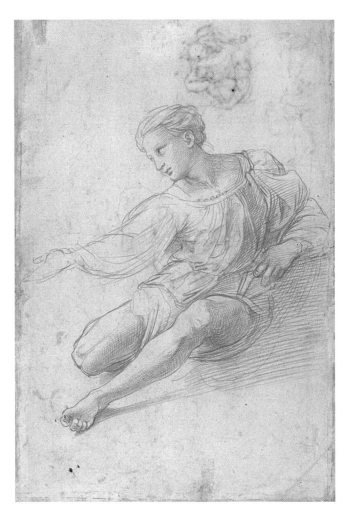 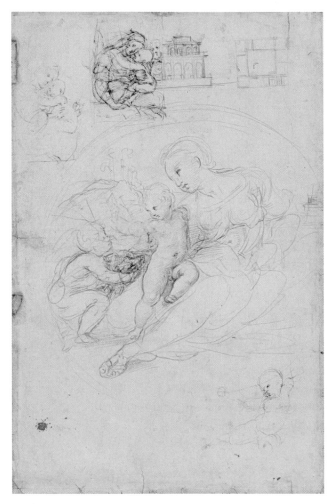

Figs. 9-7 and **9-8** Raphael, Studies for *The Alba Madonna* (recto and verso), c. 1511. Left: red chalk; right: red chalk and pen and ink, both 16⅝ × 10¾ in. Musée des Beaux Arts, Lille, France.

On the other side of the paper, all the figures present in the final composition are included. The major difference between this and the final painting is that the infant St. John offers up a bowl of fruit in the drawing and Christ does not yet carry a cross in his hand. But the circular format of the final painting is fully realized in this drawing. A hastily drawn circular frame encircles the group (outside this frame, above it, are first ideas for yet another Madonna and Child, and below it, in the bottom-right corner, an early version of the Christ figure for this one). The speed and fluency of this drawing's execution is readily apparent, and if the complex facial expressions of the final painting are not yet indicated here, the emotional tenor of the body language is. The postures are both tense and relaxed. Christ seems to move away from St. John even as he turns toward him. Mary reaches out, possibly to comfort the young saint, but equally possibly to hold him at bay. Raphael has done precisely as Leonardo directed, attending to the precise movements and gestures that will indicate the mental states of his subjects in the final painting.

Fig. 9-9 Raphael, *The Alba Madonna*, c. 1510. Oil on panel transferred to canvas, diameter 37¼ in.; framed: 54 × 53½ in. National Gallery of Art, Washington, D.C. Andrew W. Mellon Collection.

Thinking Thematically: See **Art and Beauty** on myartslab.com

Watch a video on figure and gesture drawing on myartslab.com

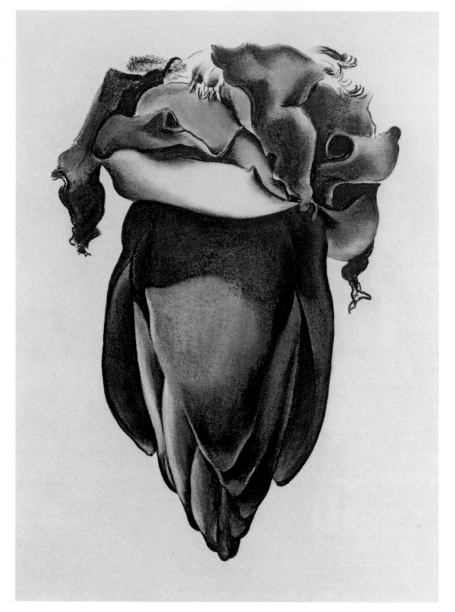

Fig. 9-10 Georgia O'Keeffe, *Banana Flower*, 1933.
Charcoal and black chalk on paper, 21³/4 × 14³/4 in. The Museum of Modern Art, New York, NY, U.S.A. Given anonymously (by exchange).

Chalk and Charcoal

Metalpoint is a mode of drawing that is chiefly concerned with **delineation**—that is, with a descriptive representation of the thing, seen through an outline or contour drawing. Effects of light and shadow are essentially "added" to the finished drawing by means of hatching or heightening. With the softer media of chalk and charcoal, however, it is much easier to give a sense of the *volumetric*—that is, of three-dimensional form—through modulations of light and dark. By the middle of the sixteenth century, artists like Raphael were using natural chalks, derived from red ocher hematite, white soapstone, and black carbonaceous shale, which were fitted into holders and shaved to a point (see Figs. 9-7 and 9-8). With these chalks, it became possible to realize gradual transitions from light to dark, either by adjusting the pressure of one's hand or by merging individual strokes by gently rubbing over a given area with a finger, cloth, or eraser. Charcoal sticks are made from burnt wood, and the best are made from hardwood, especially vines. They can be either hard or soft, sharpened to so precise a point that they draw like a pencil, or held on their sides and dragged in large bold gestures across the surface of the paper.

In her charcoal drawing of a banana flower (**Fig. 9-10**), Georgia O'Keeffe achieves a sense of volume and space comparable to that realized by means of chalk. Though she is noted for her stunning oil paintings of flowers, this is a rare example in her work of a colorless flower composition. O'Keeffe's interest here is in creating three-dimensional space with a minimum of means, and the result is a study in light and dark in many ways comparable to a black-and-white photograph.

Because of its tendency to smudge easily, charcoal was not widely used during the Renaissance except in **sinopie**, tracings of the outlines of compositions drawn on the wall before the painting of frescoes. Such sinopie have come to light only recently, as the plaster supports for frescoes have been removed for conservation purposes. Drawing with both charcoal and chalk requires a paper with *tooth*—a rough surface to which the media can adhere. Today, charcoal drawings can be kept from smudging by spraying synthetic resin fixatives over the finished work.

In the hands of modern artists, charcoal has become one of the more popular drawing media, in large part because of its expressive directness and immediacy. In her *Self-Portrait, Drawing* (**Fig. 9-11**), Käthe Kollwitz has revealed the extraordinary expressive capabilities of charcoal as a medium. Much of the figure was realized by dragging the stick up and down in sharp angular gestures along her arm from her chest to her hand. It is as if this line, which mediates between

the two much more carefully rendered areas of hand and face, embodies the dynamics of her work. This area of raw drawing literally connects her mind to her hand, her intellectual and spiritual capacity to her technical facility. It embodies the power of the imagination. She seems to hold the very piece of charcoal that has made this mark sideways between her fingers. She has rubbed so hard, and with such fury, that it has almost disappeared.

Thinking Thematically: See **Art, Gender, and Identity** on myartslab.com

Graphite

Graphite, a soft form of carbon similar to coal, was discovered in 1564 in Borrowdale, England. As good black chalk became more and more difficult to obtain, the lead **pencil**—graphite enclosed in a cylinder of soft wood—increasingly became one of the most common of all drawing tools. It became even more popular during the Napoleonic Wars early in the nineteenth century. Then, because supplies of English graphite were cut off from the continent, the Frenchman Nicholas-Jacques Conté invented, at the request of Napoleon himself, a substitute for imported pencils that became known as the **Conté crayon** (not to be confused with the so-called Conté crayons marketed today, which are made with chalk). Conté substituted clay for some of the graphite. This technology was quickly adapted to the making of pencils generally. Thus, the relative hardness of the pencil could be controlled—the less graphite, the harder the pencil—and a greater range of lights (hard pencils) and darks (soft pencils, employing more graphite) became available.

Georges Seurat's Conté crayon study (**Fig. 9-12**) indicates the powerful range of tonal effects afforded by the new medium. As Seurat presses harder, in the lower areas of the composition depicting the shadows of the orchestra pit, the coarsely textured paper is filled by the crayon. Above, pressing less firmly, Seurat creates a sense of light dancing on the surface of the stage. Where he has not drawn on the surface at all—across the stage and on the singer's dress—the glare of the white paper is almost as intense as light itself.

Fig. 9-12 Georges Seurat, *Café Concert*, c. 1887–88. Conté crayon 12 × 9¹/₄ in. Museum of Art, Rhode Island School of Design, Providence. Gift of Mrs. Murray S. Danforth.
Photo: Erik Gould.

Vija Celmins's *Untitled (Ocean)* (**Fig. 9-13**) is an example of a highly developed photorealist graphite drawing. A little larger than a sheet of legal paper, the drawing is an extraordinarily detailed rendering of ocean waves as seen from the Venice Pier in Venice, California. "I had a realization," Celmins recalled in 2002,

> that the surface of the ocean was somehow like the surface of the paper and that I could combine the images and have the image and the drawing unfold together. I really didn't fudge around or erase or smear. The graphite went on quite clear. I usually started actually at the right hand corner and moved straight up, like a kind of record of a double consciousness. A consciousness of the surface of the paper and also the surface of the image. It's about a kind of double reality of seeing what's there in a most ordinary way, a flat piece of paper and then seeing the double reality of an image that implies a different kind of space which is laid on top of the other image, but which really isn't there. . . . I like to think of it like a ghost of an ocean. There is a feeling of timelessness that's implied in an image of an ocean that really has no boundaries.

This is one of a long series of drawings based on small $3\frac{1}{2} \times 5$-inch photographs, and the sense of infinite space that her drawings evoke is in no small part a function of the arbitrary frame of the camera lens which always suggests the continuance of space beyond its edges. Celmins used a pencil of differing hardness for each drawing in the series, exploring the range of possibilities offered by the medium. In the process, she learned a great deal about the expressive potential of the medium. "I began to see," she says, "that graphite itself had a certain life to it."

Fig. 9-13 Vija Celmins (b. 1939), *Untitled (Ocean)*, 1970.
Graphite on acrylic ground on paper, 14 $\frac{1}{8} \times$ 18 $\frac{7}{8}$ in. The Museum of Modern Art, New York, NY, U.S.A. Mrs. Florene M. Schoenborn Fund.
Courtesy of Vija Celmins and McKee Gallery.

Pastel

Pastel is essentially a chalk medium with colored pigment and a nongreasy binder added to it. Pastels come in sticks the dimension of an index finger and are labeled soft, medium, and hard, depending on how much binder is incorporated into the medium—the more binder, the harder the stick. Since the pigment is, in effect, diluted by increased quantities of binder, the harder the stick, the less intense its color. This is why we tend to associate the word "pastel" with pale, light colors. Although the harder sticks are much easier to use than the softer ones, some of the more interesting effects of the medium can only be achieved with the more intense colors of the softer sticks. The lack of binder in pastels makes them extremely fragile. Before the final drawing is fixed, the marks created by the chalky powder can literally fall off the paper, despite the fact that, since the middle of the eighteenth century, special ribbed and textured papers have been made that help hold the medium to the surface.

Of all artists who have ever used pastel, perhaps Edgar Degas was the most proficient and inventive. He was probably attracted to the medium because it was more direct than painting, and its unfinished quality seemed particularly well suited to his artistic goal of capturing the reality of the contemporary scene, especially in a series of pastel drawings of women at their bath (**Fig. 9-14**). Degas' use of his medium is unconventional, incorporating into the "finished" work both improvised gesture and a loose, sketchlike drawing. Degas invented a new way to use pastel, building up the pigments in successive layers. Normally, this would not have been possible because the powdery chalks of the medium would not hold to the surface. But Degas worked with a fixative, the formula for which has been lost, that allowed him to build up

layers of pastel without affecting the intensity of their color. Laid on the surface in hatches, these successive layers create an optical mixture of color that shimmers before the eyes in a virtually abstract design.

The American painter Mary Cassatt met Degas in Paris in 1877, and he became her artistic mentor. Known for her pictures of mothers and children, Cassatt learned to use the pastel medium in even bolder terms than Degas. In this drawing, *Young Mother, Daughter, and Son* (**Fig. 9-15**), one of Cassatt's last works, the gestures of her pastel line again and again exceed the boundaries of the forms that contain them, and loosely drawn, arbitrary blue strokes extend across almost every element of the composition.

The owner of this work, Mrs. H. O. Havemeyer, Cassatt's oldest and best friend, saw in works such as this one an almost virtuoso display of "strong line, great freedom of technique and a supreme mastery of color." When Mrs. Havemeyer organized a benefit exhibition of Cassatt's and Degas's works in New York in 1915, its proceeds to be donated to the cause of women's suffrage, she included works such as this one because Cassatt's freedom of line was, to her, the very symbol of the strength of women and their equality to men. Seen beside the works by Degas, it would be evident that the pupil had equaled, and in many ways surpassed, the achievement of Degas himself.

Oilstick

Oilsticks are oil paint manufactured with enough wax for the paint to be molded into stick form. They allow the painter to draw directly onto a surface without brushes, palettes, paint tubes, or solvents. They are related to the pastel oilsticks used by artists such as Beverly Buchanan (see Fig. 5-12). But unlike with pastel oilsticks, which are too soft to permit long and continuous strokes across the surface, the density of oilsticks allows the artist more gestural freedom and a sense of direct engagement with the act of drawing itself. Sandy Brooke's oilstick drawing, *Fate and Luck: Eclipse* (**Fig. 9-16**), is one of a series of paintings and drawings on the theme. As Brooke says, "Things we cannot explain are often written off as Fate, and when things go well, we might feel we just got Lucky. Much of life is a complete mystery, It's the same in painting." Here, the helicopters are simultaneously symbols of rescue and agents of war. The eclipse of the title, imaged in a horizontal band about one-quarter the way up the painting, is, in some cultures, an omen of good things to come, in others just the opposite. The forces of nature—the dragonfly, the hummingbirds, the sea, and the eclipse—collide here with the forces of civilization. With oilstick—often smeared and

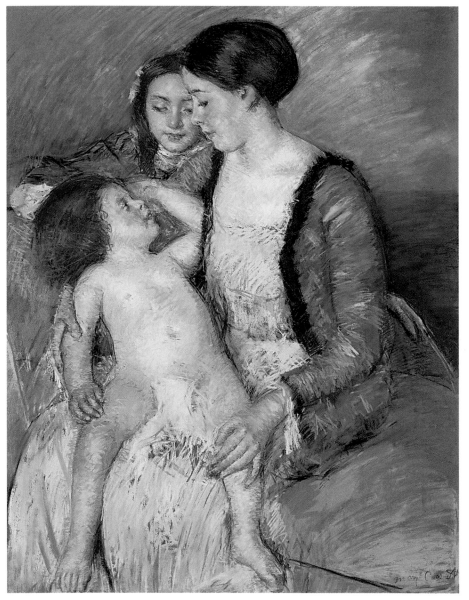

Fig. 9-15 Mary Cassatt, *Young Mother, Daughter, and Son*, 1913. Pastel on paper, 43¼ × 33¼ in.
Memorial Art Gallery of the University of Rochester. Marion Stratton Gould Fund.

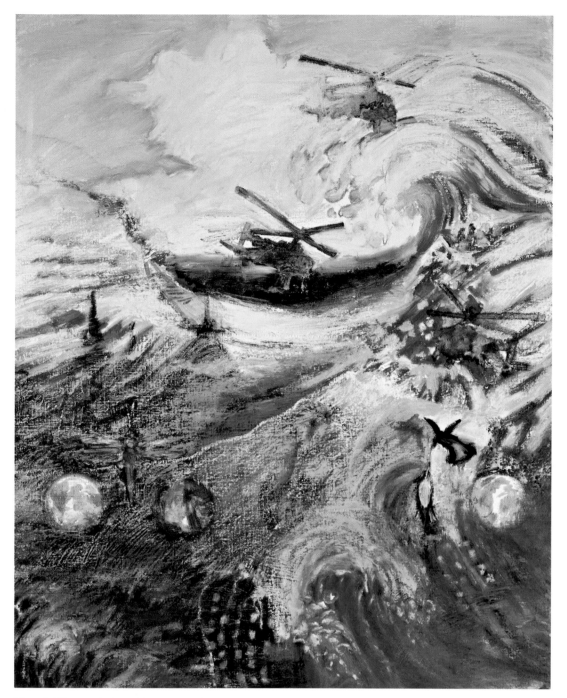

Fig. 9-16 Sandy Brooke, *Fate and Luck: Eclipse*, 2011.
Oilstick on linen, 30 × 24 in.
Courtesy of the artist. © 2011 Sandy Brooke. Photo: Gary Alvis.

👁 **Watch** a video of oil painting on myartslab.com

diluted—Brooke is able to create particularly transparent effects. "For me," Brooke says, "the act of looking at the surface of this work is comparable to looking into water. Images behind and above the viewer are reflected off the semi-transparent surface beneath which other forms appear and disappear, fragment and coalesce, depending on the degree of surface turbulence. As we look into the painting, the possibility arises that what we see there, in the flow of the current, in the shadow of the storm, is a reflection of ourselves, and a reflection of history itself, the disasters and triumphs of our age."

LIQUID MEDIA

Pen and Ink

During the Renaissance, as paper became more and more widely available, most drawings were made with iron-gall ink, which was made from a mixture of iron salts and an acid obtained from the nutgall, a swelling on an oak tree caused by disease. The characteristic brown color of most Renaissance pen-and-ink drawings results from the fact that this ink, though black at application, browns with age.

The quill pen used by most Renaissance artists, which was most often made from a goose or swan feather, allows for far greater variation in line and texture than is possible with a metalpoint stylus or even with a pencil. As we can see in this drawing by Elisabetta Sirani (**Fig. 9-17**), one of the leading artists in Bologna during the seventeenth century, the line can be thickened or thinned, depending on the artist's manipulation of the flexible quill and the absorbency of the paper (the more absorbent the paper, the more

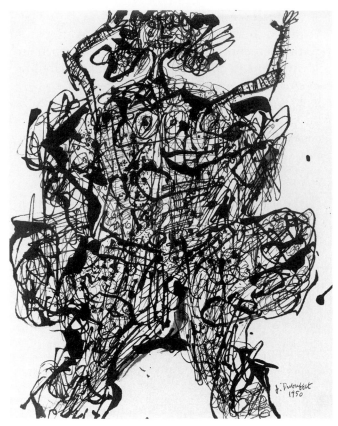

Fig. 9-18 Jean Dubuffet, *Corps de Dame*, June–December 1950.

Pen, reed pen, and ink, 10⅝ × 8⅜ in. The Museum of Modern Art, New York, NY, U.S.A. The Joan and Lester Avnet Collection. (54.1978).

© 2012 Artists Rights Society (ARS), New York/ADAGP, Paris.

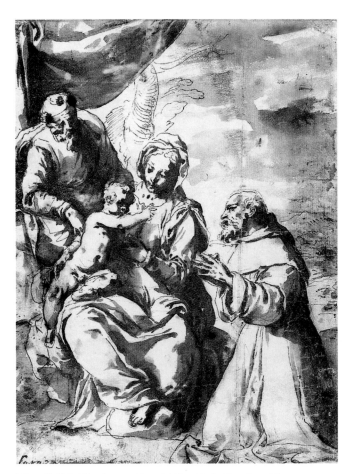

Fig. 9-17 Elisabetta Sirani, *The Holy Family with a Kneeling Monastic Saint*, c. 1660.

Pen and brown ink, black chalk, on paper, 10⅜ × 7⅜ in. Private collection.

freely the ink will flow through its fibers). Diluted to a greater or lesser degree, ink also provides her with a more fluid and expressive means to render light and shadow than the elaborate and tedious hatching that was necessary when using stylus or chalk. Drawing with pen and ink is fast and expressive. Sirani, in fact, displayed such speed and facility in her compositions that, in a story that most women will find familiar, she was forced to work in public in order to demonstrate that her work was her own and not done by a man.

In this example from Jean Dubuffet's series of drawings *Corps de Dame* (**Fig. 9-18**) ("corps" means both a group of women and the body of a woman), the whorl of line, which ranges from the finest hairline to strokes nearly a half-inch thick, defines a female form, her two small arms raised as if to ward off the violent gestures of the artist's pen itself. Though many see Dubuffet's work as misogynistic—the product of someone who hates women—it can also be read as an attack on academic figure drawing, the pursuit of formal perfection and beauty that has been used traditionally to justify drawing from the nude. Dubuffet does

not so much render form as flatten it, and in a gesture that insists on the modern artist's liberation from traditional techniques and values, his use of pen and ink threatens to transform drawing into scribbling, conscious draftsmanship into automatism, that is, unconscious and random automatic marking. In this, his work is very close to surrealist experiments designed to make contact with the unconscious mind.

Wash and Brush

When ink is diluted with water and applied by brush in broad, flat areas, the result is called a wash. Tiepolo's *Adoration of the Magi* (**Fig. 9-19**) is essentially three layers deep. Over a preliminary graphite sketch is a pen-and-ink drawing, and over both, Tiepolo has laid a brown wash. The wash serves two purposes here: It helps to define volume and form by adding shadow, but

Fig. 9-19 Giovanni Battista Tiepolo, *The Adoration of the Magi*, c. 1740s.
Pen and brown wash over graphite sketch, 11³/₅ × 8¹/₅ in. Iris & B. Gerald Cantor Center for Visual Arts at Stanford University. Mortimer C. Leventritt Fund.1950.392.

it also creates a visual pattern of alternating light and dark elements that helps to make the drawing much more dynamic than it would otherwise be. As we move from right to left across the scene, deeper and deeper into its space, this alternating pattern leads us to a central moment of light, which seems to flood from the upper right, falling on the infant Jesus himself.

Many artists prefer to draw with a brush. It not only affords them a sense of immediacy and spontaneity, but the soft brush tip also allows artists to control the width of their lines. Drawing with a brush is a technique with a long tradition in the East, perhaps because the brush is used there as a writing instrument. Chinese calligraphy requires that each line in a written character begin very thinly, then broaden in the middle and taper again to a point. Thus, in the same gesture, a line can move from broad and sweeping to fragile and narrow, and back again. Such ribbons of line are extremely expressive. In his depiction of the Tang poet Li Bo (**Fig. 9-20**), Liang Kai juxtaposes the quick strokes of diluted ink that form the robe with the fine, detailed brushwork of his face. This opposition contrasts the fleeting materiality of the poet's body—as insubstantial as his chant, which drifts away on the wind—with the enduring permanence of his poetry.

INNOVATIVE DRAWING MEDIA

Drawing is by its nature an exploratory medium. It invites experimentation. Taking up a sheet of heavy prepainted paper of the brightest colors, Henri Matisse was often inspired, beginning in the early 1940s, to cut out a shape in the paper with a pair of wide-open scissors, using them like a knife to carve through the paper. He considered working with scissors a kind of drawing. "Scissors," he says, "can acquire more feeling for line than pencil or charcoal." Sketching with the scissors, Matisse discovered what he considered to be the essence of a form. Beginning in 1951, confined to a wheelchair and unable to stand to paint, and until his death in 1954, Matisse turned almost exclusively to cut-outs. He cut very large swathes of color freehand, and then had them pinned loosely to the white studio walls. Studying them from his wheelchair, he later rearranged them, recut and recombined them, until their composition satisfied him. In their color, they were like painting. In their cutting, they were a kind of drawing. And in the process of subtracting paper from the original sheets of color, they were like sculpting from a large block of wood or marble. Finally, the shapes were glued to large white paper backgrounds for shipping and display. In this *Venus* (**Fig. 9-21**), the figure of the goddess is revealed in the negative space of the

Fig. 9-20 Liang Kai, *The Poet Li Bo Walking and Chanting a Poem*, Southern Song Dynasty, c. 1200.
Hanging scroll, ink on paper, 31³/₄ × 11⁷/₈ in. Tokyo National Museum, Japan.

Fig. 9-21 Henri Matisse, *Venus*, 1952.
Paper collage on canvas, 39^7/$_8$ × 30^1/$_8$ in. National Gallery of Art, Washington, D.C. Ailsa Mellon Bruce Fund.

Fig. 9-22 Whitfield Lovell, *Whispers from the Walls*, 1999.
Mixed-media installation, varying dimensions. Courtesy DC Moore Gallery, New York.
Photo: Steve Dennie.

Thinking Thematically:
See **Art and the Passage of Time** on myartslab.com

composition. It is as if the goddess of love—and hence love itself—were immaterial. In the blue positive space to the right we discover the profile of a man's head, as if love springs, fleetingly, from his very breath.

In his installation *Whispers from the Walls* (**Fig. 9-22**), a full-scale recreation of what a 1920s North Texas one-room house lived in by an African-American family working the fields might have looked like, Whitfield Lovell has used charcoal drawing in a particularly evocative way. On the shack's plank walls—salvaged from abandoned buildings around Denton, Texas, where the piece was first installed at the University of North Texas— he has drawn life-size figures based on actual photographs of the Texas African Americans, especially those who lived in the thriving Denton African-American community in the 1920s. The very fragility of the medium lends the drawings an almost ghost like presence, an eerie sense of the past rising through and in the collection of period artifacts—blankets, a rag carpet, a trunk, a gas lamp, pots and pans, the hat on the bed—that he has assembled in the room. The room smells of must. "Rising River Blues" seems to play on an old phonograph. The sound of softly speaking voices can be overheard, as if emanating from the drawings themselves.

Lovell says that the inspiration for drawing on walls came from a 1993 visit to an Italian villa that had been owned by a slave trader: "Somehow the experience of being in the villa and knowing its history was so haunting that I could not work the way I was accustomed to working. . . . I wanted to leave some dignified images of black people in that space." *Whispers from the Walls* is, in this sense, Lovell's attempt to restore to contemporary America—and Denton, Texas in particular—that dignity.

One of the great drawing innovators of the day is South African artist William Kentridge, who employs his drawings to create his own animated films. These films are built up from single drawings in charcoal and pastel on paper that are successively altered through erasure, additions, and re-drawings that are photographed at each stage of evolution. Instead of being constructed, as in normal animation, out of hundreds of separate drawings, Kentridge's films are made of hundreds of photographs of drawings in process. Drawing over a week's time might add up to around 40 seconds of animation.

The process of erasure, and the smudged layering that results, is for Kentridge a kind of metaphor for memory, and it is memory that concerns Kentridge, especially the memory of apartheid in South Africa and by extension the memory of the forces that mark the history of modernity as a whole. The films chronicle the rise and fall of a white Johannesburg-businessman, Soho Eckstein. Always dressed in a pin-striped suit, Soho buys land and then mines it, extracting the resources and riches of the land and creating an empire based upon his own exploitation of miners and landscape. He is

emotionally the very embodiment of the industrial infrastructure he has helped to create—dark, somber, virtually dehumanized. Over time, as the films have followed his career, he has come to understand the high price that he and his country have paid for his actions.

Reproduced here are four drawings from the seventh film in the Soho Eckstein cycle, *WEIGHING . . . and WANTING* (**Fig. 9-23**). The first is an image of Soho's brain as he passes through a magnetic resonance imaging (MRI) apparatus. It reveals a line of workers heading into the mines. Next, we see the ore in the mine itself imaged in his skull. The scanned brain is then transformed into a rock, which Soho comes across on his evening walk and embraces. Inside it, he can hear his own memories, as if fossilized within the stone.

Drawing has always held an important place in popular culture, particularly in the world of the comic book and that version of the comic-book genre generally intended for more mature audiences, the graphic novel. Among the most popular of the latter have been Frank Miller's *Batman: The Dark Knight Returns* (1986) and Art Spiegelman's *Maus: A Survivor's Tale* (1986), a tale recounting his own parents' experience as Polish Jews during World War II, in which Jews are portrayed as mice, Germans as cats, and Americans as dogs. The latter made a lasting impression on Iranian artist Marjane Satrapi, who created her own graphic novel, *Persepolis*, while living in exile in Paris in 2001. Named after the capital of ancient Persia, in what is now modern-day Iran, *Persepolis* tells the story of Satrapi's own childhood as she grew up in Iran. Born in 1969, she was 10 years old when the king of Iran, Shah Mohammed Reza Pahlavi, was forced to flee the country as Islamic fundamentalists under the spiritual leadership of Ayatollah Khomeini took over. The page

Fig. 9-23 William Kentridge, four drawings from *WEIGHING . . . and WANTING*, 1997–09.
Charcoal, pastel on paper, from left to right, top: 24⅝ × 30¾ in., 24⅝ × 30¾ in.; bottom: 47¼ × 63 in., and 47¼ × 63 in.
Thinking Thematically: See **Art, Politics, and Community** on myartslab.com

Fig. 9-24 Marjane Satrapi, page from the "Kim Wilde" chapter of *Persepolis*, 2001.

Ink on paper, 16⁶/₁₆ × 11¹¹/₁₆ in.

© Marjane Satrapi/L'Assocation, photograph Westimage.

from the novel illustrated here takes place in 1983 (**Fig. 9-24**). Unsympathetic to the revolution, and in some measure proud of their 13-year-old daughter's defiance of its dismissal of all things Western as morally corrupt, her parents have smuggled into the country a denim jacket, a pair of Nike tennis shoes, a Michael Jackson button, and posters of the heavy metal band Iron Maiden and pop star Kim Wilde, whose new-wave hit "Kids in America" had reached the top of the rock charts in 1981. Here, Satrapi dresses up in her new gear in preparation for heading out into the streets to buy bootleg tapes of Kim Wilde and the English band Camel. "For an Iranian mother," Satrapi writes at the bottom of the page, "my mother is very permissive. On my part, I only know two or three other girls who have the right to go out alone at the age of thirteen." Satrapi's drawing style subtly but effectively supports this narrative. In revolutionary Iran, all is black and white. From the point of view of the guardians of the revolution, there is no moral middle ground, only right and wrong, as plain and simple as Satrapi's drawing itself. It should come as no surprise, finally, that in 2007 Satrapi turned *Persepolis* into an animated feature film, which was nominated for an Academy Award for Best Animated Feature in 2008. As a form, the graphic novel lends itself to precisely the kind of animation that distinguishes Satrapi's art.

THINKING BACK

What is a medium?

A material used to create art is a medium (plural: media). Painting, drawing, sculpture, and tapestry are all examples of media. Various technologies have helped artists to achieve their desired effects and discover new modes of creation and expression. How does Jan Vermeer represent different media in his work *The Allegory of Painting* (*The Painter and His Model as Clio*)? What are some of the purposes of drawing?

What is the technique known as metalpoint?

Metalpoint was one of the most common drawing techniques in late-fifteenth- and early-sixteenth-century Italy. In this technique, a stylus (point) made of metal is applied to a sheet of prepared paper. When the point touches the prepared ground, a chemical reaction results, producing marks on the paper. What is delineation?

What are the characteristics of wet media?

Wet media consist of a pigment, which is the coloring agent, and a binder, which holds the pigment together. In wet media, such as ink, the pigment is held in a liquid binder. How was ink typically made during the Renaissance? What is a wash? What qualities does a brush afford in drawing?

How can drawing be an innovative medium?

Drawing is, by nature, an exploratory medium, inviting experimentation. Many modern and contemporary artists have pushed traditional boundaries of drawing, using new techniques and materials, working at a large scale, and integrating drawing with film. How did Henri Matisse work in an innovative manner to make Venus? How did William Kentridge create *WEIGHING . . . and WANTING*?

THE CRITICAL PROCESS
Thinking about Drawing

As we have seen, drawing is one of the most basic and one of the most direct of all media. Initially, drawing was not considered an art in its own right, but only a tool for teaching and preliminary study. By the late Renaissance, it was generally acknowledged that drawing possessed a vitality and immediacy that revealed significant details about the artist's personality and style.

Frank Auerbach's *Head of Catherine Lampert VI* (**Fig. 9-25**) began with a series of drawings that were rubbed and wiped out—perhaps over a period of a couple of years, given the drawing's dates. In the process, he created a light-gray charcoal ground. With

an eraser, he carved into this ground, establishing the light planes of the face, and then built up her features with a much darker, loosely gestural line.

A year or two before this drawing was made, Auerbach met Lampert when she was curating the 1978 exhibition of his work at the Hayward Gallery in London. She has since curated numerous exhibitions by the artist, and has been sitting for his portraits for over 30 years, visiting his Camden studio always for two hours at a time, usually in the evening. Drawings such as this one are studies for the numerous painted portraits of his sitters, and are always made from life in preparation for, and often during, the process of making a painting.

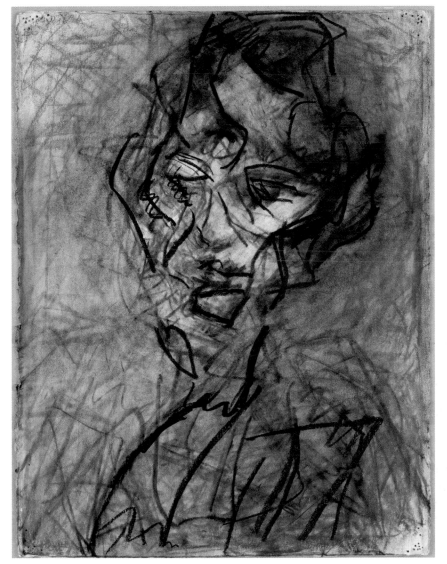

In her introduction to the exhibition catalogue of Auerbach's exhibition at the Venice Biennale in 1986, Lampert described Auerbach's process: "[He] moves noisily around the room . . . continuously active, drawing in the air, talking to himself, hardly pausing, much less contemplating in the usual sense of the word." The drawings and paintings, she says, represent an effort "to celebrate life through the energy specific to all individuals through their changing moods and to fuse those energies with his own furious energy during the painting's execution." How is that energy reflected in Auerbach's line? Does anything about the drawing suggest repose? How would you compare it to Delacroix's study for *The Death of Sardanapalus* (see **Fig. 4-28**)? How does Auerbach achieve a sense of three-dimensional depth in this drawing? If his purpose is to capture something of the sitter's personality, what does this drawing suggest about her temperament?

Fig. 9-25 Frank Auerbach, *Head of Catherine Lampert VI*, 1979–1980.
Charcoal and chalk on paper, 30³/₈ × 23 in. The Museum of Modern Art, New York, NY, U.S.A. Purchase. (436.1981).
Digital image © 2001 The Museum of Modern Art, New York. Scala/Art Resource, NY.

10 | Printmaking

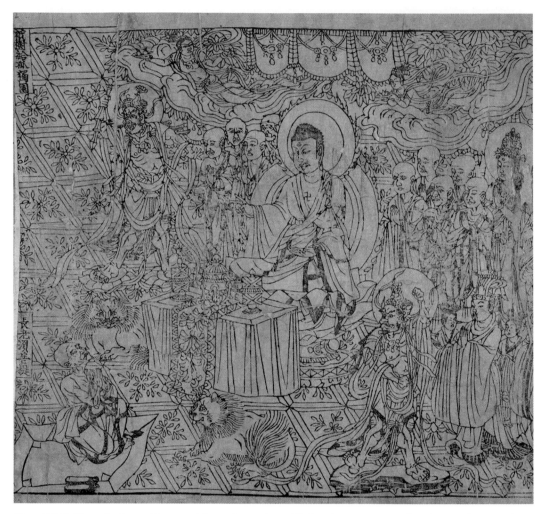

Fig. 10-1 Frontispiece, *Diamond Sutra* from Cave 17, Dunhuang, printed in the ninth year of the Xiantong Era of the Tang Dynasty, 868 CE.
Ink on paper, woodblock handscroll, British Library Or.8210/ P.2.

Thinking Thematically: See Art and Spiritual Belief on myartslab.com

THINKING AHEAD

What defines a print?

What are relief processes in printmaking?

What are intaglio processes in printmaking?

How are lithographs made?

((•─ **Listen** to the chapter audio on myartslab.com

The medium of printmaking appears to have originated in China in the ninth century CE with the publication of the world's earliest known printed book, the *Diamond Sutra*, one of Buddhism's more important texts. The beginning of the 18-foot-long handscroll is illustrated by a print showing Buddha preaching to his followers (**Fig. 10-1**). Although only a single copy of the scroll survives (in the British Library), the image was apparently intended for wide-scale distribution. An inscription at the end of the scroll reads: "Reverently [caused to be] made

for universal free distribution by Wang Jie on behalf of his two parents on the 13th of the 4th moon of the 9th year of Xiantong [11 May 868 CE]." This postscript reveals one of the most important characteristics of the print (as opposed to painting or sculpture)—that is, its vital role in the mass distribution of ideas, especially the popularization of the iconographic and stylistic traditions, the conventions of a shared visual culture.

The art of printmaking in Europe seems to have spread, like paper itself, westward from China. Of course, the basic principles of printmaking had existed for centuries before the publication of the *Diamond Sutra*. In the ancient world, from China to Greece, signature seals—small engraved carvings pressed into wax to confirm receipt or ownership—were widely used to confirm receipt, authorship, or ownership of a letter or document. Before the widespread use of paper, pictorial designs were being printed onto fabric across the European continent. As paper became more and more widely used in the fifteenth century, producers inscribed signature watermark designs on their paper by attaching bent wire to the molds used in production. Among the earliest paper prints to receive widespread distribution across Europe, among even the illiterate, were playing cards, the designs of which have changed little since late medieval times.

But printmaking developed rapidly after the appearance of the first printed book. Sometime between 1435 and 1455, in the German city of Mainz, Johannes Gutenberg discovered a process for casting individual letterforms by using an alloy of lead and antimony. The letterforms could be composed into pages of type and then printed on a wooden standing press using ink made of lampblack and oil varnish. Although the Chinese alchemist Pi Sheng had invented movable type in 1045 CE, now, for the first time, the technology was available in the West, and identical copies of written works could be reproduced over and over again.

In 1455, Gutenberg published his first major work, the *Forty-Two Line Bible* (**Fig. 10-2**)—so named because

each column of type contains 42 lines—the first substantial book to be published from movable type in Europe. An artist added the colorful decorative design of the marginalia and capitals by hand after the book was printed. By the middle of the sixteenth century, roughly one hundred years after this Bible was published, 3,830 editions of the Bible had been published in Europe—altogether about one million copies.

Meanwhile, printing presses were churning out a wide variety of books throughout Europe, and many were illustrated. *The Nuremberg Chronicle*, published in 1493 by one of the first professional book publishers in history, Anton Koberger, contains many

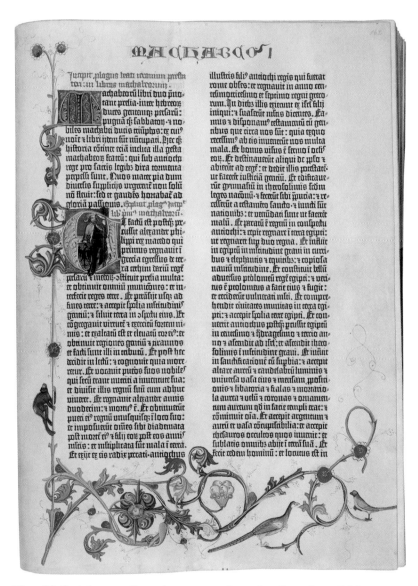

Fig. 10-2 Johannes Gutenberg, page from the *Gutenberg Bible*, text printed with movable letters and hand-painted initials and marginalia: page 162 recto with initials "M" and "E" and depiction of Alexander the Great, Mainz, 1455–56.

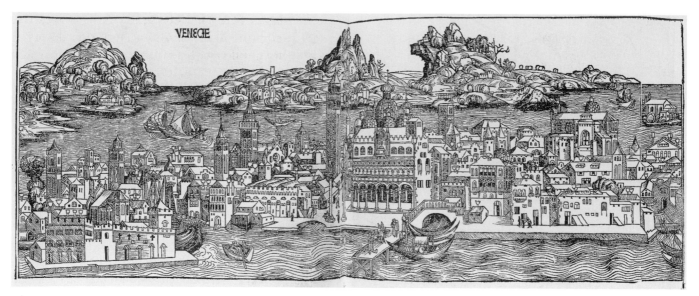

Fig. 10-3 Hartmann Schedel, *The Nuremberg Chronicle: View of Venice*, 1493.
Woodcut, illustration size approximately 10 × 20 in. The Metropolitan Museum of Art, New York, NY, U.S.A. Rogers Fund, 1921. (21.36.145).

Thinking Thematically: See **Art, Politics, and Community** on myartslab.com

prints. Appearing in two editions, one in black and white (**Fig. 10-3**), and another much more costly edition with hand-colored illustrations, *The Nuremberg Chronicle* was intended as a history of the world. A bestseller in its day, it contained more than 1,800 pictures, though only 654 different blocks were employed. Forty-four images of men and women were repeated 226 times to represent different famous historical characters, and depictions of many different cities utilized the same woodcut.

For centuries, prints were primarily used in books, but since the nineteenth century, and increasingly since World War II, the art world has witnessed what might well be called an explosion of prints. The reasons for this are many. For one thing, the fact that prints exist in multiple numbers seems to many artists absolutely in keeping with an era of mass production and distribution. The print allows the contemporary artist, in an age increasingly dominated by the mass media and mechanical modes of reproduction such as photography, to investigate the meaning of mechanically reproduced imagery. An even more important reason is that a unique work of art—a painting or a sculpture—has become, during the twentieth century, too expensive for the average collector, and the size of the purchasing public has, as a consequence, diminished considerably. Far less expensive than unique paintings, prints are an avenue through which artists can more readily reach a wider audience.

A **print** is defined as a single **impression**, or example, of an image that has been transferred through pressure onto paper from a **matrix**, the surface upon which the design has been created. A single matrix can be used to make many virtually identical impressions. These multiple impressions, made on paper from the same matrix, are called an **edition**. As collectors have come to value prints more and more highly, the somewhat confusing concept of the **original print** has come into being. How, one wonders, can an image that exists in multiple be considered "original"? By and large, an original print can be distinguished from a *reproductive* print—one printed mechanically—by the fact that the artist alone has created it, and that it has been printed by the artist or under the artist's supervision. Since the late nineteenth century, artists have signed and numbered each impression—for example, the number 3/35 at the bottom of a print means that this is the third impression in an edition of 35. Often, artists reserve a small number of additional **proofs**—trial impressions made before the final edition is run—for personal use. These are usually designated "AP," meaning "artist's proof." After the edition is made, the original plate is destroyed or canceled by incising lines across it. This is done to protect the collector against a misrepresentation about the number of prints in a given edition.

Today, prints provide many people with aesthetic pleasure. There are five basic processes of printmaking—relief, intaglio, lithography, silkscreen, and monotype—and we will consider them all in this chapter.

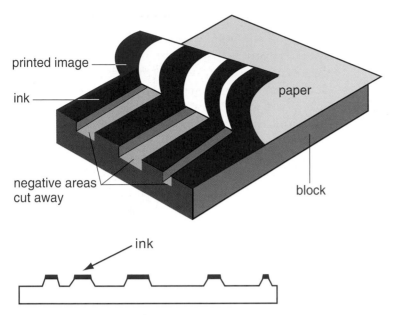

printed image

ink

negative areas
cut away

paper

block

ink

Fig. 10-4 Relief-printing technique.

👁️ **Watch** a video about the woodcut process on myartslab.com

side of it. This elevated surface—like the elevated letterform of the printing press—is then rolled with a relatively viscous ink, thick and sticky enough that it will not flow into the hollows **(Fig. 10-4)**. Paper is then rolled through a press directly against this inked and raised surface.

The woodcut print offers the artist a means of achieving great contrast between light and dark, and, as a result, dramatic emotional effects. In the twentieth century, the expressive potential of the medium was recognized, particularly by the German Expressionists. In Emil Nolde's *Prophet* (**Fig. 10-5**), we do not merely sense the pain and anguish of the prophet's life, the burden that prophesy entails, but we also feel the portrait emerging out of the very gouges Nolde's knife made in the block.

Relief Processes

The term **relief** refers to any printmaking process in which the image to be printed is raised off the background in reverse. Common rubber stamps use the relief process. If you have a stamp with your name on it, you will know that the letters of your name are raised off it in reverse. You press the letters into an ink pad, and then to paper, and your name is printed right side up. All relief processes rely on this basic principle.

WOODCUT

The earliest prints, such as the illustrations for the *Diamond Sutra* and *The Nuremberg Chronicle*, were woodcuts. A design is drawn on the surface of a wood block, and the parts that are to print white are cut or gouged away, usually with a knife or chisel. This process leaves the areas that are to be black elevated. A black line is created, for instance, by cutting away the block on each

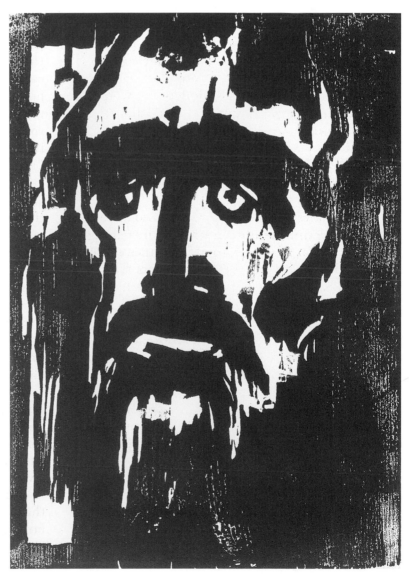

Fig. 10-5 Emil Nolde, *Prophet*, 1912. Woodcut (Schiefler/Mosel 1966 [W] 110 only), image: $12^5/8 \times 8^7/8$ in.; sheet: $15^3/4 \times 13^5/16$ in. National Gallery of Art, Washington, D.C. Rosenwald Collection.
Courtesy Stiftung Seebull, Ada and Emil Nolde.

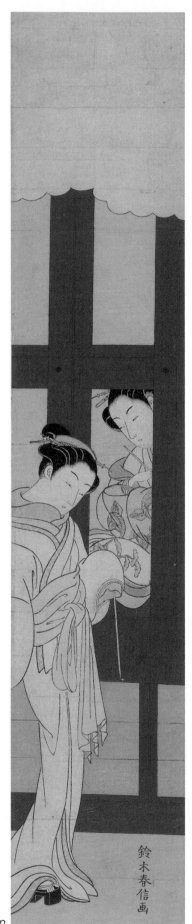

Fig. 10-6 Suzuki Harunobu, *Two Courtesans, Inside and Outside the Display Window*, Japanese, Edo period, about 1768–69.

Woodblock print (*nishiki-e*), ink and color on paper, 26³/₈ × 5¹/₁₆ in. Museum of Fine Arts, Boston. Denman Waldo Ross Collection, 1906. 06.1248.

Photograph © 2012 Museum of Fine Arts, Boston.

Thinking Thematically: See **Art, Gender, and Identity** on myartslab.com

But the rough gouging and cutting of the block evident in the Nolde woodcut does not reflect the historical refinement of the medium. By the mid-eighteenth century, technology developed by the Chinese for making color woodblock prints from multiple blocks was beginning to be popularized in Japan. The resulting images, known as *nishiki-e*, or "brocade pictures"—so named because they were felt to resemble brocade fabrics—were, at first, commissioned by a group of wealthy Japanese who, among various other intellectual pursuits, routinely exchanged elaborately decorated calendars on each New Year's Day. Since the government held a monopoly on the printing of all calendars, the artists making these *nishiki-e* calendars went to elaborate lengths to disguise their efforts, and the symbols for the months were introduced into the compositions in the most subtle ways.

The first and most prominent of the artists to produce *nishiki-e* calendars was Suzuki Harunobu. So admired were his designs that by 1766 they were widely distributed commercially—minus, of course, their calendar symbols. Before his death in 1770, Harunobu produced hundreds of *nishiki-e* prints, many of them dedicated to illustrating the most elegant aspects of eighteenth-century Japanese life, and his prints were, if not the first, then certainly the most influential early examples of what would soon become known as *ukiyo-e*, "pictures of the transient world of everyday life" (see *The Creative Process*, pp. 204–205). He was especially renowned for his ability to portray women of great beauty, and some of his favorite subjects were the beautiful courtesans in the Yoshiwara pleasure district of Edo (modern Tokyo), of which *Two Courtesans, Inside and Outside the Display Window* (**Fig. 10-6**) is a striking example. The display window, or *harimise*, is the lattice-windowed area in the front of a brothel where the potential client might choose the courtesan of his pleasure. This print is remarkable for both its graphic simplicity and its subtle evocation of traditional Japanese culture and values. Instead of showing the entirety of the window, Harunobu depicts just one section, creating a powerfully realized grid structure into which he has placed his figures. In other words, the delicate, rounded lines of the courtesans' features and clothing contrast dramatically with the broad two-dimensional structure of the *harimise*. This graphic contrast, equally realized in the contrast between the inside and outside of the *harimise*, as well as the fact that one courtesan stands while the other sits, reflects the philosophy embodied in the traditional Japanese principle of complementarity, which

itself originates in Chinese Taoist philosophy. Representing unity within diversity, opposites organized in perfect harmony, the ancient symbol for this principle is the famous *yin* and *yang*:

Yin is generative, nurturing, soft, and passive, and is associated with feminine principles. *Yang* is active, hard, and aggressive, and is associated with the masculine. Thus, Harunobu's print is not merely a depiction of everyday life in the Yashiwara pleasure district, but also a subtle philosophical defense of the era's sexual mores.

Harunobu did not limit his production to depictions of daily life. Another of his most favorite subjects was the life of the most beautiful poet of the Heian court, Ono no Komachi. By the eighteenth century, the Heian period (785–1185) was considered the classical age of Japanese culture, a period of extraordinary refinement and style. In the famous scene from Komachi's life represented here (**Fig. 10-7**), she has promised a would-be lover that if he could visit her house for one hundred consecutive nights without looking upon her, she would grant him a rendezvous. She stands on the veranda, looking down upon a servant who counts the days on her fingers. After ninety-nine successful nights spent on the mounting block of Komachi's carriage, he has, in fact, failed due to the untimely death of his father, and the box above the servant's head is Komachi's poem to the absent lover:

> In the early dawn
> You marked up a hundred nights
> On the mounting block—
> But the night you failed to come
> It was I who counted that

The poem surrounds a small picture of a man shielding himself under an umbrella, a traditional symbol of male sexuality, as if shielding himself also from his desire. Note how Harunobu sets the two women in an architecture that, rising as it does straight up from the servant's head to the image above, implies the presence of the male principle in the scene very much in the manner of the window frame in Fig. 10-6.

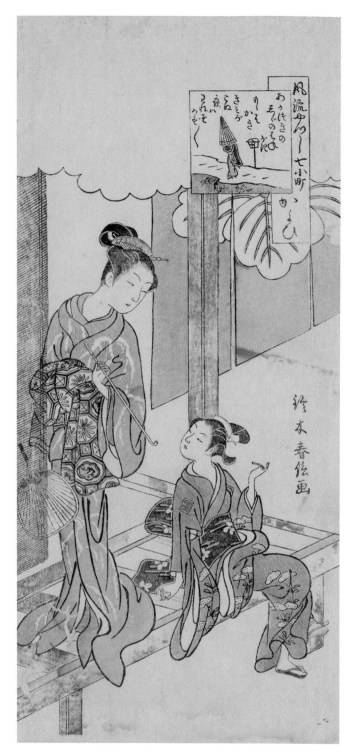

Fig. 10-7 Suzuki Harunobu, *Visiting* (*Kayoi*), from the series *Seven Komachi in Fashionable Disguise* (*Fûryû yatsushi nana Komachi*) Japanese, Edo period, about 1766–67.

Woodblock print (nishiki-e), ink and color on paper, $12^{1}/_{16} \times 5^{5}/_{16}$ in. Museum of Fine Arts, Boston. William Sturgis Bigelow Collection, 1911. 11.16497.

Photograph © 2012 Museum of Fine Arts, Boston.

THE CREATIVE PROCESS

Most Japanese prints are examples of what is called *ukiyo-e*, or "pictures of the transient world of everyday life." Inspired in the late seventeenth century by a Chinese manual on the art of painting entitled *The Mustard-Seed Garden*, which contained many woodcuts in both color and black and white, *ukiyo-e* prints were commonplace in Japan by the middle of the eighteenth century. Between 1743 and 1765, Japanese artists like Suzuki Harunobu (see Figs. 10-6 and 10-7) developed their distinctive method for color printing from multiple blocks.

The subject matter of these prints is usually concerned with the pleasures of contemporary life—hairdos and wardrobes, daily rituals such as bathing, theatrical entertainments, life in the Tokyo brothels, and so on, in endless combination. Utamaro's depiction of *The Fickle Type*, from his series *Ten Physiognomies of Women* (**Fig. 10-8**), embodies the sensuality of the world that the *ukiyo-e* print so often reveals. Hokusai's view of the eternal Mount Fuji in *The Great Wave off Kanagawa* (see Fig. 8-21), which we have already studied in connection with its play with questions of scale, was probably conceived as commentaries on the self-indulgence of the genre of *ukiyo-e* as a whole. The mountain—and, by extension, the values it stood for, the traditional values of the nation itself—is depicted in these works as transcending the fleeting pleasures of daily life.

Traditionally, the creation of a Japanese print was a team effort, and the publisher, the designer (such as Utamaro), the carver, and the printer were all considered essentially equal in the creative process. The head of the project was the publisher, who often conceived of the ideas for the prints, financing individual works or series of works that the public would, in his estimation, be likely to buy. Utamaro's depiction of his studio in a publisher's establishment (**Fig. 10-9**)

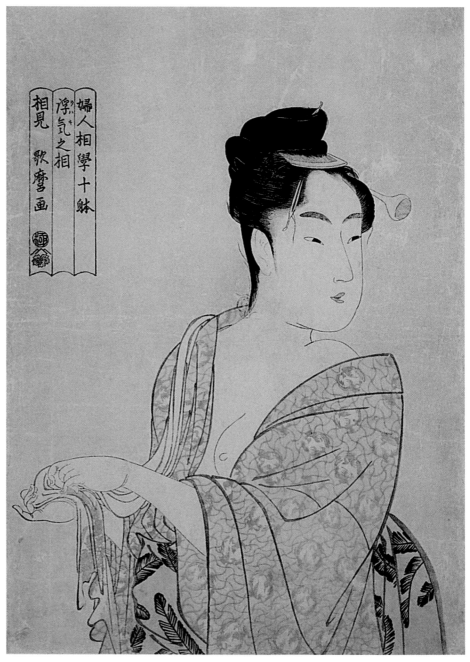

Fig. 10-8 Kitagawa Utamaro, *The Fickle Type*, from the series *Ten Physiognomies of Women*, c. 1793. Woodcut, 14 × 9⁷/₈ in.

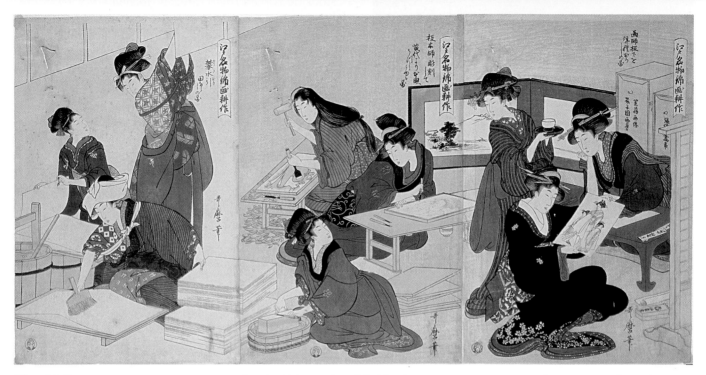

Fig. 10-9 Kitagawa Utamaro, *Utamaro's Studio, Eshi . . . dosa-hiki* (the three primary steps in producing a print from drawing to glazing), from the series *Edo meibutsu nishiki-e kosaku*, c. 1790.
Oban triptych, ink and color on paper, 24³/₄ × 9⁵/₈ in. Published by Tsuruya Kiemon. The Art Institute of Chicago. Clarence Buckingham Collection. 1939.2141.
Photography © The Art Institute of Chicago.

is a *mitate*, or fanciful picture. Each of the workers in the studio is a pretty girl—hence, the print's status as a *mitate*—and they are engaged, according to the caption on the print, in "making the famous Edo [present-day Tokyo] color prints." Utamaro depicts himself at the right, dressed in women's clothing and holding a finished print. His publisher, also dressed as a woman, looks on from behind his desk. On the left of the triptych is a depiction of workers preparing paper. They are **sizing** it—that is, brushing the surface with an astringent crystalline substance called *alum* that reduces the absorbency of the paper so that ink will not run along its fibers—then hanging the sized prints to dry. The paper was traditionally made from the inside of the bark of the mulberry tree mixed with bamboo fiber, and, after sizing, it was kept damp for six hours before printing.

In the middle section of the print, the block is actually prepared. In the foreground, a worker

sharpens her chisel on a stone. Behind her is a stack of blocks with brush drawings made by Utamaro stuck face-down on them with a weak rice starch dissolved in water. The woman seated at the desk in the middle rubs the back of the drawing to remove several layers of fiber. She then saturates what remains with oil until it becomes transparent. At this point, the original drawing looks as if it were drawn on the block.

Next the workers carve the block, and we can see here large white areas being chiseled out of the block by the woman seated in the back. Black-and-white prints of this design are made and then returned to the artist, who indicates the colors for the prints, one color to a sheet. The cutter then carves each sheet on a separate block. The final print is, in essence, an accumulation of the individually colored blocks, requiring a separate printing for each color.

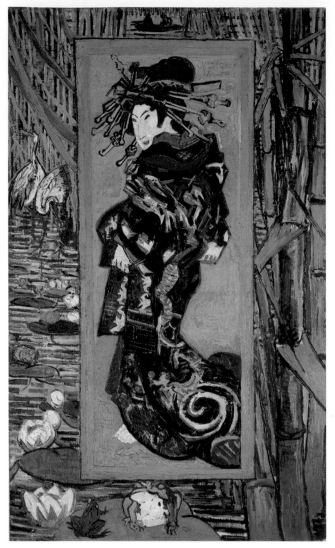

Fig. 10-10 Vincent van Gogh, *Japonaiserie: The Courtesan (after Kesai Eisen)*, 1887.
Oil on canvas, 41³/₈ × 24 in.
Van Gogh Museum, Amsterdam (Vincent van Gogh Foundation).

European artists became particularly interested in the woodblock process in the nineteenth century through their introduction to the Japanese woodblock print. Woodblock printing had essentially died as an art form in Europe as early as the Renaissance, but not long after Commodore Matthew C. Perry's arrival in Japan in July 1853, ending 215 years of isolation from the rest of the world, Japanese prints flooded the European market, and they were received with enthusiasm. Part of their attraction was their exotic subject matter, but artists were also intrigued by the range of color in the prints, their subtle and economical use of line, and their novel use of pictorial space.

Impressionist artists such as Edouard Manet, Edgar Degas, and Mary Cassatt were particularly influenced by Japanese prints. But the artist most enthusiastic about Japanese prints was Vincent van Gogh. He owned prints by the hundreds, and on numerous occasions he copied them directly. *Japonaiserie: The Courtesan (after Kesai Eisen)* (**Fig. 10-10**) is an example. The central figure in the painting is copied from a print by Kesai Eisen that van Gogh saw on the cover of a special Japanese issue of *Paris Illustré* published in May 1886 (**Fig. 10-11**). All the other elements of the painting are derived from other Japanese prints, except perhaps the boat at the very top, which appears Western in conception. The frogs were copied from Yoshimaro's *New Book of Insects*, and both the cranes and the bamboo stalks are derived from prints by Hokusai, whose *Great Wave off Kanagawa* we saw in Chapter 8 (see Fig. 8-21). Van Gogh's intentions in combining all these elements become clear when we recognize that the central figure is a courtesan (her tortoiseshell hair ornaments signify her profession), and that the words *grue* (crane) and *grenouille* (frog) were common Parisian words for prostitutes. Van Gogh explained his interest in Japanese prints in a letter

Fig. 10-11 "Le Japon," cover of *Paris Illustré*, May 1886.
Van Gogh Museum, Amsterdam (Vincent van Gogh Foundation).

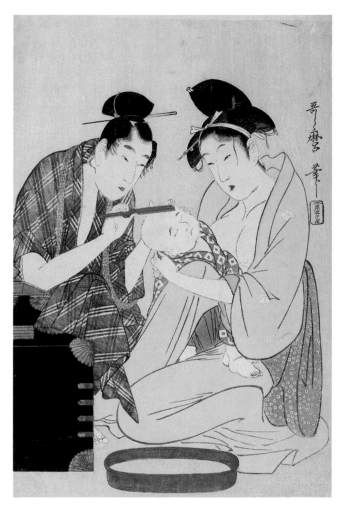

Fig. 10-12 Kitagawa Utamaro, *Shaving a Boy's Head*, c. 1795.
Color woodblock print, 15⅛ × 10¼ in. The Minneapolis Institute of Arts. Bequest of Richard P. Gale. 74.1.153.

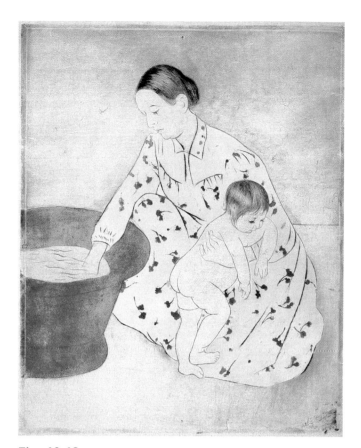

Fig. 10-13 Mary Cassatt, *The Bath*, 1890–91.
Drypoint and aquatint on laid paper, plate: 12⁹/₁₆" × 9¹³/₁₆"; sheet: 14⁷/₁₆" × 10¹³/₁₆". National Gallery of Art, Washington, D.C. Rosenwald Collection.

Photograph © Board of Trustees, National Gallery of Art, Washington, D.C. Photo: Dean Beasom.

written in September 1888: "Whatever one says," he wrote, "I admire the most popular Japanese prints, colored in flat areas, and for the same reasons that I admire Rubens and Veronese. I am absolutely certain that this is no primitive art."

Of all the Impressionists, perhaps the American Mary Cassatt, who exhibited with the group beginning in 1867, was most taken with the Japanese tradition. She was especially impressed with its interest in the intimate world of women, the daily routines of domestic existence. She consciously imitated works like Utamaro's *Shaving a Boy's Head* (**Fig. 10-12**). Cassatt's *The Bath* (**Fig. 10-13**), one of ten prints inspired by an April 1890 exhibition of Japanese woodblocks at the École des Beaux-Arts in Paris, exploits the same contrasts between printed textiles and bare skin, between colored fabric and the absence of color in space. Her whole composition is made up of flatly silhouetted shapes against a bare ground, the whole devoid of the traditional shading and tonal variations that create the illusion of depth in Western art.

WOOD ENGRAVING

By the late nineteenth century, woodcut illustration had reached a level of extraordinary sophistication. Illustrators commonly employed a method known as **wood engraving**. Wood engraving is a "white-line" technique in which the fine, narrow grooves cut into the block do not hold ink. The grainy end of a section of wood—comparable to the rough end of a 4 × 4—is utilized instead of the smooth side of a board, as it is in woodcut proper. The end grain can be cut in any direction without splintering, and thus extremely delicate modeling can be achieved by means of careful hatching in any direction.

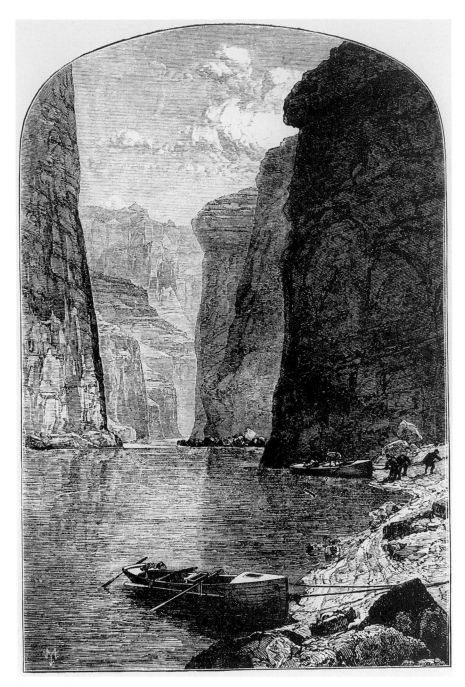

Fig. 10-14 J. W. Powell, *Noon-Day Rest in Marble Canyon*, from *Exploration of the Colorado River of the West*, 1875.

Plate 25 opposite page 75. Wood engraving after an original sketch by Thomas Moran, 6 1/2 × 4 3/8 in.

Courtesy Colorado Historical Society. 978.06/P871eS.

Thinking Thematically: See **Art, Science, and the Environment** on myartslab.com

The wood engraving used to illustrate Captain J. W. Powell's 1875 *Exploration of the Colorado River of the West* (**Fig. 10-14**) was copied by a professional wood engraver from an original sketch, executed on the site, by American painter Thomas Moran (his signature mark, in the lower left corner, is an "M" crossed by a "T" with an arrow pointing downward). A narrative of the first exploration of the Colorado River canyon from Green River, in Wyoming, to the lower end of the Grand Canyon, the book—together with a number of paintings executed by Moran from the same sketches—presented America with its first views of the great Western canyonlands.

LINOCUT

A **linocut** is similar to a woodcut, except, as its name suggests, the block is made of linoleum instead of wood. Softer than wood, linoleum is easier to cut but wears down more quickly under pressure, resulting in smaller editions. As in woodcut, color can also be added to a linocut print by creating a series of different blocks, one for each different color, each of which is aligned with the others in a process known as **registration** (the same process used, incidentally, by Japanese *ukiyo-e* printers to align the different-colored blocks of their prints). British artist Cyril E. Power's linocut *The Tube Train* (**Fig. 10-15**) is composed of four separate linoleum blocks printed in yellow, red, light cobalt blue, and dark blue, respectively. It depicts life in the city of London as workers head home on the underground, their heads buried in their papers. Here, rhythm and repetition create both a sense of the movement of modern life and its monotony.

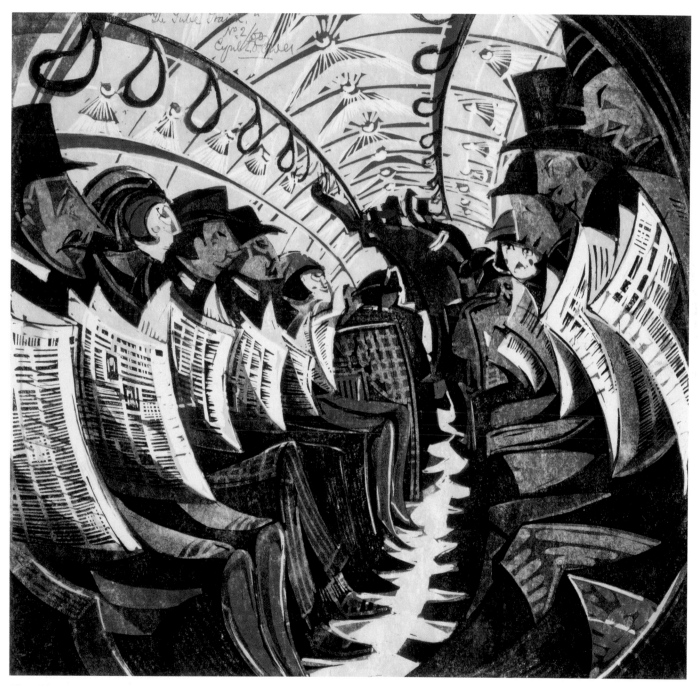

Fig. 10-15 Cyril E. Power, *The Tube Train*, about 1934.
Color linocut, completed edition print on very thin off-white Asian paper, 12 5/16 × 12 11/16 in. The Metropolitan Museum of Art, New York. Partial and promised gift of Johanna and Leslie Garfield, 2005 (2005.470.7).

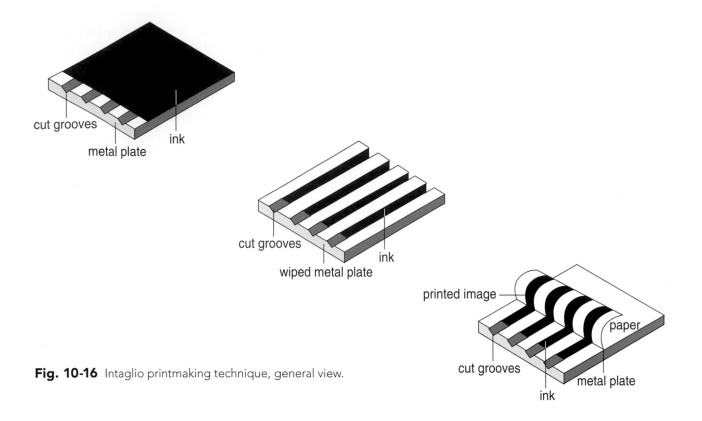

Fig. 10-16 Intaglio printmaking technique, general view.

👁—Watch a video about intaglio processes on myartslab.com

Intaglio Processes

Relief processes rely on a raised surface for printing. With the **intaglio** process, on the other hand, the areas to be printed are below the surface of the plate. *Intaglio* is the Italian word for "engraving," and the method itself was derived from engraving techniques practiced by goldsmiths and armorers in the Middle Ages. One of its earliest masters was Albrecht Dürer, himself the son of a goldsmith (see *The Creative Process*, pp. 204–205). In general, intaglio refers to any process in which the cut or incised lines on the plate are filled with ink (**Figs. 10-16** and **10-17**). The surface of the plate is wiped clean, and a sheet of dampened paper is pressed into the plate with a very powerful roller so that the paper picks up the ink in the depressed grooves. Since the paper is essentially pushed into the plate in order to be inked, a subtle but detectable elevation of the lines that result is always evident in the final print. Modeling and shading are achieved in the same way as in drawing, by hatching, cross-hatching, and often **stippling**—where, instead of lines, dots are employed in greater and greater density the deeper and darker the shadow.

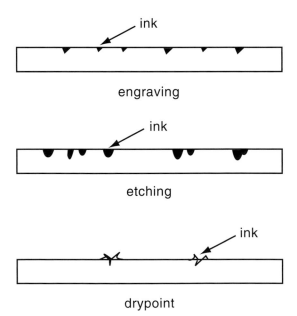

Fig. 10-17 Intaglio printmaking techniques, side views.

ENGRAVING

Engraving is accomplished by pushing a small V-shaped metal rod, called a **burin**, across a metal plate, usually of copper or zinc, forcing the metal up in slivers in front of the line. These slivers are then removed from the plate with a hard metal scraper. Depending on the size of the burin used and the force with which it is applied to the plate, the results can range from almost microscopically fine lines to ones so broad and coarse that they can be felt with a fingertip.

Line engravings were commonly used to illustrate books and reproduce works of art in the era before the invention of photography, and for many years after. We know, for instance, Raphael's painting *The Judgment of Paris* only through Marcantonio Raimondi's engraving after the original (see Fig. 3-6). Illustrated here is an engraving done on a steel plate (steel was capable of producing many more copies than either copper or zinc) of J. M. W. Turner's painting *Snow Storm: Steamboat off a Harbor's Mouth* (**Fig. 10-18**).

The anonymous engraver captures the play of light and dark in the original by using a great variety of lines of differing width, length, and density.

ETCHING

Etching is a much more fluid and free process than engraving and is capable of capturing something of the same sense of immediacy as the sketch. As a result, master draftsmen, such as Rembrandt, readily took to the medium. It satisfied their love for spontaneity of line. Yet the medium also requires the utmost calculation and planning; an ability to manipulate chemicals that verges, especially in Rembrandt's greatest etchings, on wizardry; and a certain willingness to risk losing everything in order to achieve the desired effect.

Creating an etching is a twofold process, consisting of a drawing stage and an etching stage. The metal plate is first coated with an acid-resistant substance called a **ground**, and this ground is drawn upon. If a hard ground is chosen, then an etching needle is

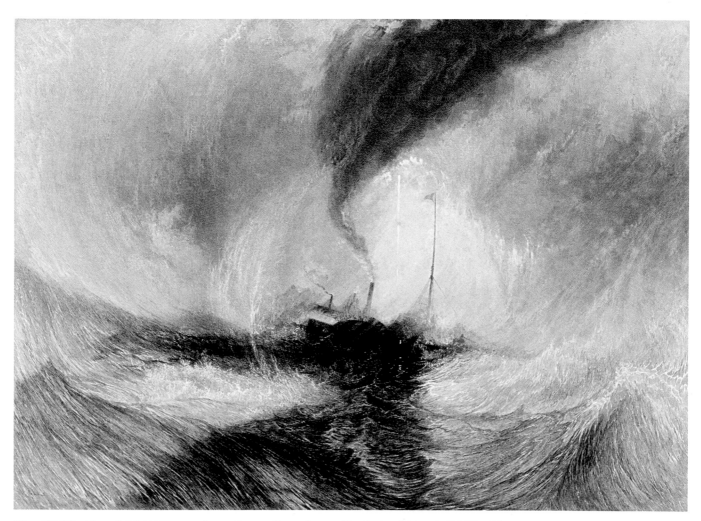

Fig. 10-18 After J. M. W. Turner, *Snow Storm: Steamboat off a Harbor's Mouth (1842)*, 1891. Engraving on steel.

THE CREATIVE PROCESS

One of the greatest of the early masters of the intaglio process was Albrecht Dürer. Trained in Nuremberg from 1486 to 1490, he was the godson of Anton Koberger, publisher of *The Nuremberg Chronicle*. As an apprentice in the studio of Michael Wolgemut, who was responsible for many of the major designs in the *Chronicle*, Dürer may, in fact, have carved several of the book's woodcuts. By the end of the century, at any rate, Dürer was recognized as the preeminent woodcut artist of the day, and he had mastered the art of engraving as well.

Dürer's engraving of *Adam and Eve* is one of his finest. It is also the first of his works to be "signed" with the artist's characteristic tablet, including his Latinized name and the date of composition, here tied to a bough of the tree above Adam's right shoulder. Two of Dürer's trial proofs (**Figs. 10-19** and **10-20**) survive, providing us with the opportunity to consider the progress of Dürer's print. The artist pulled each of these **states**, or stages in the process, so that he could consider how well his incised lines would hold ink and transfer it to paper, as well as to see the actual image, since on the plate it is reversed. In the white areas of both states we can see how Dürer outlined his entire composition with lightly incised lines. In the first state, all of the background has been incised, except for the area behind Eve's left shoulder. Adam himself is barely realized. Dürer has only just begun to define his leg with hatching and cross-hatching. In the second state, Adam's entire lower body and the ground around his left foot have been realized. Notice how hatching and cross-hatching create a sense of real volume in Adam's figure.

The final print (**Fig. 10-21**) is rich in iconographical meaning. The cat at Eve's feet—a symbol of deceit, and perhaps sexuality as well—suggests not only Eve's feline character but also, as it prepares to pounce on the mouse at Adam's feet, Adam's susceptibility to the

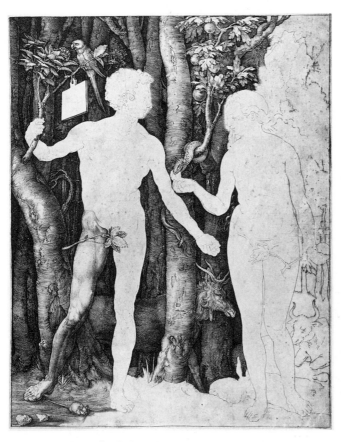 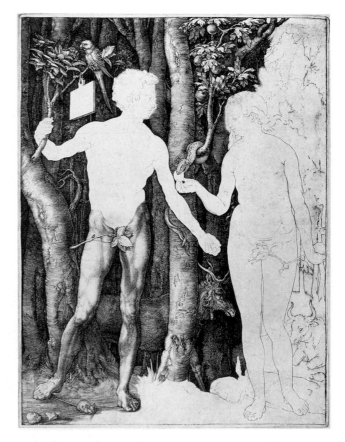

Figs. 10-19 and 10-20 Albrecht Dürer, *Adam and Eve*, First State and Second State, 1504. Engravings, each 9⁷/₈ × 7⁵/₈ in.
Graphische Sammlung, Albertina, Wien.

female's wiles. The parrot perched over the sign is the embodiment of both wisdom and language. It contrasts with the evil snake that Eve is feeding. Spatially, then, the parrot and its attributes are associated with Adam, the snake and its characteristics with Eve. An early sixteenth-century audience would have immediately understood that the four animals on the right were intended to represent the four *humors*, the four bodily fluids thought to make up the human constitution. The elk represents melancholy (black bile); the cat, anger and cruelty (yellow bile); the rabbit, sensuality (blood); and the ox, sluggishness or laziness (phlegm). The engraving technique makes it possible for Dürer to realize this wealth of detail.

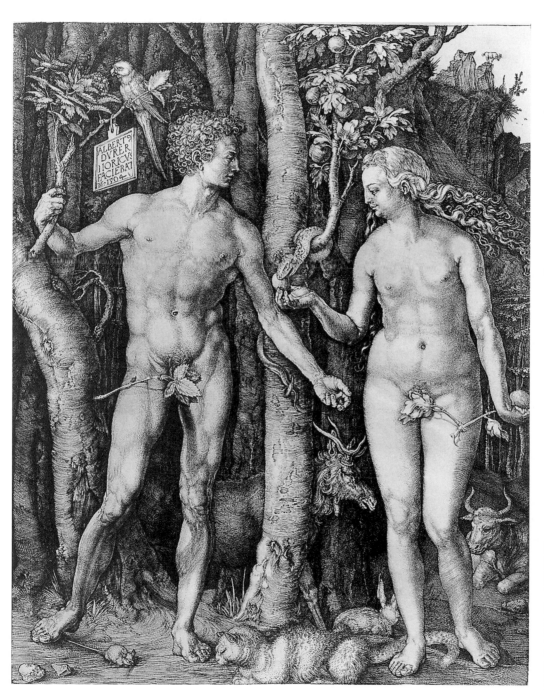

View the Closer Look on *Adam and Eve* on myartslab.com

Fig. 10-21 Albrecht Dürer, *Adam and Eve* (1471–1528), Fourth State, 1504.
Engraving, $9^7/_8 \times 7^5/_8$ in. (25.1 × 20.0 cm) The Metropolitan Museum of Art, New York, NY, U.S.A. Fletcher Fund, 1919. (19.73.1).

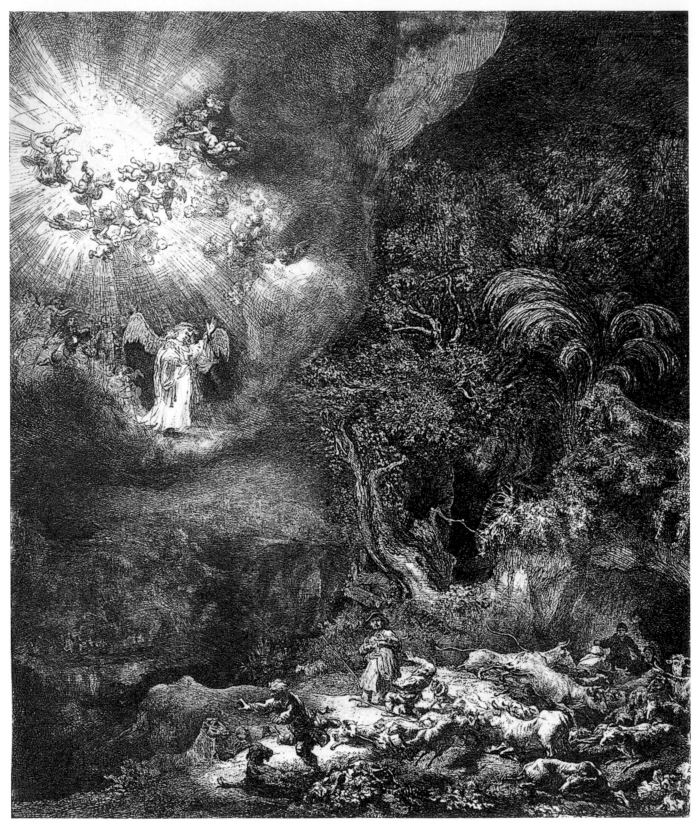

Fig. 10-22 Rembrandt van Rijn, *The Angel Appearing to the Shepherds*, 1634.
Etching, 10¼ × 8½ in. Rijksmuseum, Amsterdam.

required to break through the ground and expose the plate. Hard grounds are employed for finely detailed linear work. Soft grounds, made of tallow or petroleum jelly, can also be used, and virtually any tool, including the artist's finger, can be used to expose the plate. The traditional soft-ground technique is often called *crayon manner* or *pencil manner* because the final product so closely resembles crayon and pencil drawing. In this technique, a thin sheet of paper is placed on top of the ground and is drawn on with a soft pencil or crayon. When the paper is removed, it lifts the ground where the drawing instrument was pressed into the paper.

Whichever kind of ground is employed, the drawn plate is then set in an acid bath, and those areas that have been drawn are eaten into, or *etched*, by the acid. The undrawn areas of the plate are, of course, unaffected by the acid. The longer the exposed plate is left in the bath, and the stronger the solution, the greater the width and depth of the etched line. The strength of individual lines or areas can be controlled by removing the plate from the bath and **stopping out** a section by applying a varnish or another coat of ground over the etched surface. The plate is then resubmerged into the bath. The stopped-out lines will be lighter than those that are again exposed to the acid. When the plate is ready for printing, the ground is removed with solvent, and the print is made in the intaglio method.

Rembrandt's *The Angel Appearing to the Shepherds* (**Fig. 10-22**) is one of the most fully realized etchings ever printed, pushing the medium to its very limits. For this print, Rembrandt altered the usual etching process. Fascinated by the play of light and dark, he wanted to create the feeling that the angel, and the light associated with her, were emerging out of the darkness. Normally, in etching, the background is white, since it is unetched and there are no lines on it to hold ink. Here Rembrandt wanted a black background, and he worked first on the darkest areas of the composition, creating an intricately cross-hatched landscape of ever-deepening shadow. Only the white areas bathed in the angel's light remained undrawn. At this point, the plate was placed in acid and bitten as deeply as possible. Finally, the angel and the frightened shepherds in the foreground were worked up in a more traditional manner of etched line on a largely white ground. It is as if, at this crucial moment of

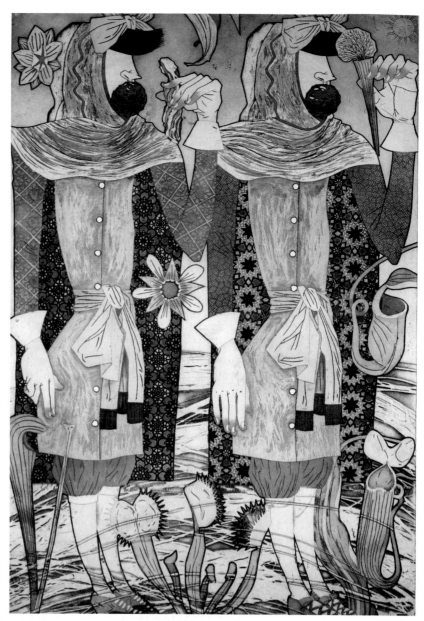

Fig. 10-23 Yuji Hiratsuka, *Epicure Extravaganza*, 2011. 4-color intaglio (etching, aquatint) on Japanese Kozo (mulberry) paper, 30 × 24 in.
Courtesy of the artist.

the New Testament, when the angel announces the birth of Jesus, Rembrandt reenacts, in his manipulation of light and dark, the opening scenes of the Old Testament—God's pronouncement in Genesis, "Let there be light."

Like woodcut prints, colored etchings require separate printings for each color, but whereas Utamaro used separate individually colored blocks for each color (see Fig. 10-9), in etching any section not requiring the new color can be stopped out. Yuji Hiratsuka's *Epicure Extravaganza* (**Fig. 10-23**) is a four-color print produced by this means. Hiratsuka, who can be seen making an etching in the intaglio video in myartslab, creates prints that might be called contemporary *ukiyo-e*, revealing "the transient

Fig. 10-24 Mary Cassatt, *The Map (The Lesson)*, 1890.
Drypoint, 6³/₁₆ × 9³/₁₆ in. The Art Institute of Chicago. Joseph Brooks Fair Collection. 1933.537.

world of everyday life" in parodic terms. Here. the covered mouths of the two figures suggest their reticence about what they eat, as well as the faddish concerns about diet in contemporary society. The figure on the left holds a piece of bacon. The one on the right holds a green beet-like vegetable. Ironically, they stand amidst a group of carnivorous plants—Venus flytraps and pitcher plants. Remember, Hiratsuka laughs, "Vegetables eat meat!"

DRYPOINT

A third form of intaglio printing is known as **drypoint**. The drypoint line is scratched into the copper plate with a metal point that is pulled across the surface, not pushed as in engraving. A ridge of metal, called a **burr**, is pushed up along each side of the line, giving a rich, velvety, soft texture to the print when inked, as is evident in Mary Cassatt's *The Map* (**Fig. 10-24**). The softness of line generated by the drypoint process is especially appealing. Because this burr quickly wears off in the printing process, it is rare to find a drypoint edition of more than 25 numbers, and the earliest numbers in the edition are often the finest.

MEZZOTINT AND AQUATINT

Two other intaglio techniques should be mentioned—mezzotint and aquatint. **Mezzotint** is, in effect, a negative process. That is, the plate is first ground all over using a sharp, curved tool called a **rocker**, leaving a burr over the entire surface that, if inked, would result in a solid black print. The surface is then lightened by scraping away the burr to a greater or lesser degree. One of the earliest practitioners of the mezzotint process was Prince Rupert, son of Elizabeth Stuart of the British royal family and Frederick V of Germany, who learned the process from its inventor in 1654. Rupert is credited, in fact, with the invention of the rocking tool used to darken the plate. His *Standard Bearer* (**Fig. 10-25**) reveals the deep blacks from which the image has been scraped.

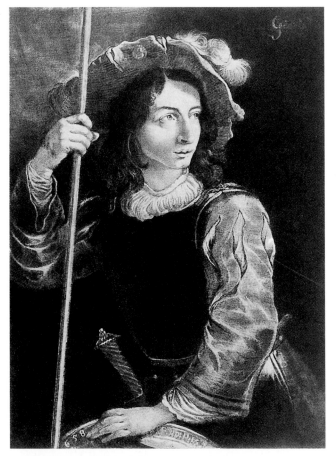

Fig. 10-25 Prince Rupert, *The Standard Bearer*, 1658.
Mezzotint, 11 × 11⁷/₈ in. The Metropolitan Museum of Art, New York, NY, U.S.A. Harris Brisbane Dick Fund, 1933. 32.52.32.

Like mezzotint, **aquatint** relies for its effect not on line, but rather on tonal areas of light and dark (Yuji Hiratsuka uses the technique in sections of *Epicure Extravaganza*, Fig. 10-23). Invented in France in the 1760s, the method involves coating the surface of the plate with a porous ground through which acid can penetrate. Usually consisting of particles of resin or powder, the ground is dusted onto the plate, then set in

place by heating it until it melts. The acid bites around each particle into the surface of the plate, creating a sandpaper-like texture. The denser the resin, the lighter the tone of the resulting surface. Line is often added later, usually by means of etching or drypoint.

Jane Dickson's *Stairwell* (**Fig. 10-26**) is a pure aquatint, printed in three colors, in which the roughness of the method's surface serves to underscore the emotional turmoil and psychological isolation embodied in her subject matter. "I'm interested," Dickson says, "in the ominous underside of contemporary culture that lurks as an ever present possibility in our lives. . . . I aim to portray psychological states that everyone experiences." In looking at this print, one can almost feel the acid biting into the plate, as if the process itself is a metaphor for the pain and isolation of the figure leaning forlornly over the banister.

Lithography

Lithography—meaning, literally, "stone writing"—is the chief **planographic printmaking process**, meaning that the printing surface is flat. There is no raised or depressed surface on the plate to hold ink. Rather, the method depends on the fact that grease and water don't mix.

The process was discovered accidentally by a young German playwright named Alois Senefelder in the 1790s in Munich. Unsuccessful in his occupation, Senefelder was determined to reduce the cost of publishing his plays by writing them backwards on a copper plate in a wax and soap ground and then etching the text. But with only one good piece of copper to his name, he knew he needed to practice writing backwards on less expensive material, and he chose a smooth piece of Kelheim limestone, the material used to line the Munich streets, which was abundantly available. As he was practicing one day, his laundry woman arrived to pick up his clothes and, with no paper or ink on the premises, he jotted down what she had taken on the prepared limestone slab. It dawned on him to bathe the stone with nitric acid and water, and when he did so, he found that the acid had etched the stone and left his writing raised in relief above its surface.

Recognizing the commercial potential of his invention, he abandoned playwriting to perfect

👁—⎡**Watch** a video about the lithography process on myartslab.com

Fig. 10-27 Honoré Daumier, *Rue Transnonain, April 15, 1834*, 1834.
Lithograph, 11¹/₂ × 17⁵/₈ in. The Art Institute of Chicago. The Charles Derring Collection. 1953.530.

Thinking Thematically: See **Art, Politics, and Community** on myartslab.com

the process. By 1798, he had discovered that if he drew directly on the stone with a greasy crayon, and then treated the entire stone with nitric acid, water, and gum arabic (a very tough substance, obtained from the acacia tree, that attracts and holds water), the ink would stick to the grease drawing but not to the treated and dampened stone. He also discovered that the acid and gum arabic solution did not actually etch the limestone. As a result, the same stone could be used again and again. The essential processes of lithography had been invented.

Possibly because it is so direct a process, actually a kind of drawing on stone, lithography has been the favorite printmaking medium of artists since the nineteenth century. In the hands of Honoré Daumier, who turned to lithography to depict actual current events, the feeling of immediacy that the lithograph could inspire was most fully realized. From the early 1830s until his death in 1872, Daumier was employed by the

French press as an illustrator and political caricaturist. Recognized as the greatest lithographer of his day, Daumier did some of his finest work in the 1830s for the monthly publication *L'Association Mensuelle*, each issue of which contained an original lithograph. His famous print *Rue Transnonain* (**Fig. 10-27**) is direct reportage of the outrages committed by government troops during an insurrection in the Parisian workers' quarters. He illustrates what happened in a building at 12 rue Transnonain on the night of April 15, 1834, when police, responding to a sniper's bullet that had killed one of their number and had appeared to originate from the building, revenged their colleague's death by slaughtering everyone inside. The father of a family, who had evidently been sleeping, lies dead by his bed, his child crushed beneath him, his dead wife to his right, and an elder parent to his left. The foreshortening of the scene draws us into the lithograph's visual space, making the horror of the scene all the more real.

While lithography flourished as a medium throughout the twentieth century, it has enjoyed a marked increase in popularity since the late 1950s. In 1957, Tatyana Grosman established Universal Limited Art Editions (ULAE) in West Islip, New York. Three years later, June Wayne founded the Tamarind Lithography Workshop in Los Angeles with a grant from the Ford Foundation (see *The Creative Process*, pp. 204–205, for examples of Wayne's own lithography). While Grosman's primary motivation was to make available to the best artists a quality printmaking environment, one of Wayne's main purposes was to train the printers themselves. Due to her influence, workshops sprang up across the country, including Gemini G.E.L. in Los Angeles, Tyler Graphics in Mount Kisco, New York, Landfall Press in Chicago, Cirrus Editions in Los Angeles, and Derriére l'Etoile in New York City.

Robert Rauschenberg's *Accident* (**Fig. 10-28**) was printed at Universal Limited Art Editions in 1963. It represents the spirit of innovation and experiment found in so much contemporary printmaking. At first, Rauschenberg, a post-Abstract Expressionist painter who included everyday materials and objects in his canvases, was reluctant to undertake printmaking. "Drawing on rocks," as he put it, seemed to him archaic. But Grosman was insistent that he try his hand at making lithographs at her West Islip studio. "Tatyana called me so often that I figured the only way I could stop her was to go out there," Rauschenberg said. He experimented with pressing all manner of materials down on the stone in order to see if they contained enough natural oil to leave an imprint that would hold ink. He dipped zinc cuts of old newspaper photos in **tusche**—a greasing liquid—which also comes in a hardened, crayon-like form, made of wax, tallow, soap, shellac, and lampblack, and which is the best material for drawing on a lithographic stone. *Accident* was created with these tusche-dipped zinc cuts.

As the first printing began, the stone broke under the press, and Rauschenberg was forced to prepare a new version of the piece on a second stone. Only a few proofs of this second state had been pulled when it, too, broke, an almost unprecedented series of catastrophes. It turned out that a small

Fig. 10-28 Robert Rauschenberg, *Accident*, 1963.
Lithograph on paper, 40 × 28 ¹/₂ in. Corcoran Gallery of Art (64.93.2). Art. Gift of the Women's Committee.
© Estate of Robert Rauschenberg/Licensed by VAGA, New York, NY.

piece of cardboard lodged under the press's roller was causing uneven pressure to be applied to the stones. Rauschenberg was undaunted. He dipped the broken chips of the second stone in tusche, set the two large pieces back on the press, and lay the chips beneath them. Then, with great difficulty, his printer, Robert Blackburn, printed the edition of 29 plus artist's proofs. *Accident* was awarded the grand prize at the Fifth International Print Exhibition in Ljubljana, Yugoslavia, in 1963. According to Grosman, Rauschenberg continually brought "something new, some new discovery" to the process of printmaking.

THE CREATIVE PROCESS

One of the great innovators of the lithographic process in the last 50 years was June Wayne, founder of the Tamarind Lithography Workshop. She founded the workshop because lithography was, in 1960, on the verge of extinction, like "the great white whooping crane," she says. "In all the world there were only 36 cranes left, and in the United States there were no master printers able to work with the creative spectrum of our artists. The artist-lithographers, like the cranes, needed a protected environment and a concerned public so that, once rescued from extinction, they could make a go of it on their own." By 1970, Wayne felt that lithography had been saved, and she arranged for Tamarind to move to the University of New Mexico, where it remains, training master printers and bringing artists to Albuquerque to work with them.

Wayne lived and worked in the original Tamarind Avenue studio in Los Angeles until her death in 2011. "Every day," she claimed, "I push lithography and it reveals something new." With Edward Hamilton, who was trained at Tamarind and who was her personal printer for 14 years beginning in 1974, Wayne continually discovered new processes. She was inspired by the energy made visible in Leonardo da Vinci's drawings (see Fig. 9-5), and she is equally inspired by modern science and space exploration—in her own words, by "the ineffably beautiful but hostile wilderness of astrophysical space." She regularly visited the observatory at Mount Palomar above Los Angeles, she was acquainted with leading physicists and astronauts, and she routinely reviewed the images returned to earth by unmanned space probes. In 1975, experimenting with zinc plates and liquid tusche, she discovered that the two oxidized when combined and that the resultant textures created patterns reminiscent of skin, clusters of nebulae, magnetic fields, solar flares, or astral winds. In prints such as *Stellar Roil* (**Fig. 10-29**), she felt that she was harnessing in the lithographic process the same primordial energies that drive the universe.

A long-time feminist, who sponsored the famous "Joan of Art" seminars in the 1970s, designed to help women understand their professional possibilities, Wayne turned her attention, in her 1996 print *Knockout* (**Fig. 10-30**), to a scientific discovery with implications about sexual politics. In November 1995, *The New York Times* reported that scientists had discovered that a brain chemical, nitric oxide, which plays a significant role in human strokes, also controls aggressive and sexual behavior in male mice. Experiments in mice had indicated that by blocking the enzyme responsible for producing nitric oxide, incidence of stroke can be reduced by 70 percent. But in the course of experiments on so-called "knockout" mice, from whom the gene responsible for the enzyme had been genetically eliminated, scientists found that the male mice would fight until the dominant one in any cage would kill the others. Furthermore,

Fig. 10-29 June Wayne, *Stellar Roil, Stellar Winds 5*, 1978. Lithograph, image: 11 × 9¼ in.; paper: 18¾ × 14¾ in. Art. © June Wayne/Licensed by VAGA, New York, NY.

paired with females, the male mice were violently ardent. "They would keep trying to mount the female no matter how much she screamed," according to the *Times*. It would appear, then, that nitric oxide curbs aggressive and sexual appetites, and it also appears that this function is sex-specific. Female mice lacking the same gene show no significant change in behavior.

It is, of course, dangerous to extrapolate human behavior from the behavior of rodents, but from a feminist point of view, the implications of this discovery are enormous. The study suggests that male violence may in fact be genetically coded. *Knockout* is, in this sense, a feminist print, and Wayne's choice of a printer underscores this—Judith Solodkin of Solo Impression, Inc. in New York, the first woman trained at Tamarind to become a master printer.

Knockout is an explosion of light, its deep black inks accentuating the whiteness of the paper, the shattered white bands piercing the darkness like screams of horror. At the bottom, three crouching spectators look on as a giant mouse, perhaps a product of genetic engineering, attacks a human victim.

Fig. 10-30 June Wayne, *Knockout*, 1996.
Lithograph, image: 28¼ × 35⅜ in.; paper: bleed. Art.
© June Wayne/Licensed by VAGA, New York, NY.

Silkscreen Printing

Silkscreens are more formally known as **serigraphs**, from the Greek *graphos*, "to write," and the Latin *seri*, "silk." Unlike other printmaking media, no expensive, heavy machinery is needed to make a serigraph. Although simple silkscreens are often used to print T-shirts, as the myartslab video demonstrating the silkscreen process makes clear, even T-shirt printers have developed relatively sophisticated silkscreen machinery. And, as the large-scale print production of Lorna Simpson's *The Park* (see Fig. 2-4), makes clear, elaborate serigraphy studios such as Jean Noblet's in New York do exist. The principles used are essentially the same as those required for stenciling, where a shape is cut out of a piece of material and that shape is reproduced over and over on other surfaces by spreading ink or paint over the cutout. In serigraphy proper, shapes are not actually cut out. Rather, the fabric—silk, or more commonly today, nylon or polyester—is stretched tightly on a frame, and a stencil is made by painting a substance such as glue across the fabric in the areas where the artist does not want ink to pass through. Alternately, special films can be cut out and stuck to the fabric, or tusche can be used. This last method allows the artist a freedom of drawing that is close to the lithographic process. The areas that are left uncovered are those that will print. Silkscreen inks are very thick, so that they will not run beneath the edge of the cutout, and must be pushed through the open areas of the fabric with the blade of a tool called a squeegee.

Serigraphy is the newest form of printmaking, although related stencil techniques were employed in textile printing in China and Japan as early as 550 CE. Until the 1960s, serigraphy was used primarily in commercial printing, especially by the advertising industry. In fact, the word "serigraphy" was coined in 1935 by the curator of the Philadelphia Museum of Fine Arts in order to differentiate the work of artists using the silkscreen in creative ways from that of their commercially oriented counterparts.

In *Enter the Rice Cooker* (**Fig. 10-31**), Roger Shimomura addresses the tension between the two cultures within and between which he lives, the American culture in which he was raised, and the Japanese culture that is his heritage. A *shoji* screen, a Japanese room partition or sliding panel made of squares of translucent rice paper framed in black lacquered wood, divides the image. Behind the screen is a 1950s-type American woman, wearing a red evening glove and applying lipstick. On this side of the screen is a samurai warrior holding a modern electric rice cooker, a figure at once ferocious and, given the rice cooker, oddly domesticated. The title of the print is purposefully vague: Does it refer to the rice cooker he holds, or is he, in something of a racial slur, the "rice cooker"? (It is worth pointing out, in this context, that an electric rice cooker was the very first product of the Sony Corporation, introduced soon after World War II.) The print, in other words, addresses both racial and sexual stereotypes, even as it parodies the *ukiyo-e* tradition, especially *shunga*,

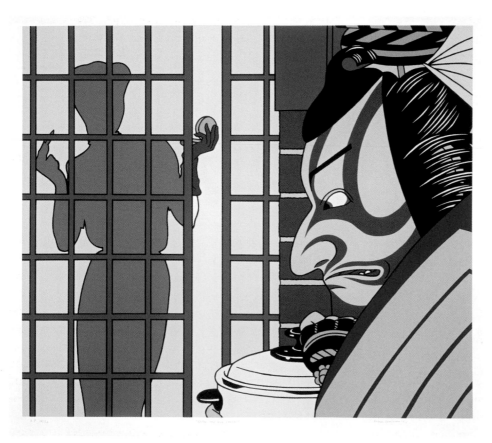

Fig. 10-31 Roger Shimomura, *Enter the Rice Cooker*, 1994. Color screen print on Saudners 410 gram HP, image 37 × 41 in. edition: 170. Spencer Museum of Art, University of Kansas. Gift of the artist, 2005.0072.

or erotic, *ukiyo-e* prints. At the same time, Shimomura has used the silkscreen technique to evoke the banal world of Pop art, which itself parodied the crass commercialism of Hollywood sexuality.

Peter Halley's *Exploding Cell* (**Fig. 10-32**) consists of nine silkscreen prints mounted on black-and-white silkscreened wallpaper using the same imagery. The work is based on the motif Halley has explored in his paintings since the early 1980s, the "cell and conduit," which usually consists of a large central rectangle (the "cell") connected to one or more circuits (the "conduits"). For Halley, this imagery is symbolic of modern industrial life: "Space," Halley writes,

> is divided into discrete, isolated cells, explicitly determined as to extent and function. Cells are reached through complex networks of corridors and roadways that must be traveled at prescribed speeds and at prescribed times. The constant increase in the complexity and scale of these geometries continuously transforms the landscape. . . . The regimentation of human movement, activity, and perception accompanies the geometric division of space.

The *Exploding Cell* silkscreens illustrate the inevitable outcome of life in this environment. Reading like a comic strip from the top left, the cell's unified whole is gradually filled to capacity (as if overloaded with complexity), until it explodes, its remnants falling to the ground in the next-to-last print, the entire narrative concluding in a dark field of static. Given the history of silkscreen printing in the advertising industry, it seems a particularly appropriate medium for Halley to use in rendering his parable of modern life.

Monotypes

There is one last kind of printmaking for us to consider, one that has much in common with painting and drawing. However, **monotypes** are generally classified as a kind of printmaking because they use both a plate and a press in the making of the image. Unlike other prints, however, a monotype is a unique image. Once it is printed, it can never be printed again.

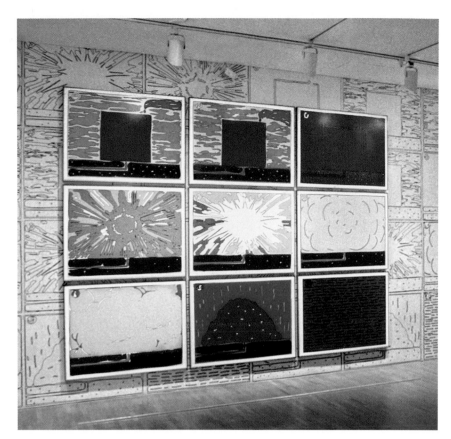

Fig. 10-32 Peter Halley, *Exploding Cell*, 1994.
Series of nine screenprints, composition and sheet (each): 36½ × 47⅛ in. Printer: Heinrici Silkscreen, New York. Publisher: Edition Schellmann, New York. Edition: 32. Museum of Modern Art, New York. Gift of the artist.
© Peter Halley.

👁 **Watch** a video about the woodcut process on myartslab.com

In monotypes, the artist forms an image on a plate with printer's ink or paints, and the image is transferred to paper under pressure, usually by means of an etching press. Part of the difficulty and challenge of the process is that if a top layer of paint is applied over a bottom layer of paint on the plate, when printed, the original bottom layer will be the top layer and vice versa. Thus, the foreground elements of a composition must be painted first on the plate, and the background elements over them. The process requires considerable planning.

Native American artist Fritz Scholder is a master of the medium. Scholder often works in series. Whenever he lifts a full impression of an image, a "ghost" of the original remains on the plate. He then reworks that ghost, revising and renewing it to make

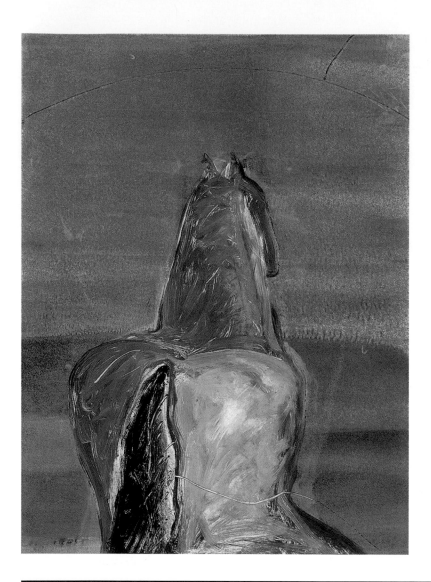

a new image. Since each print is itself a surprise—the artist never knows until the image is printed just what the work will look like—and since each print leaves a "ghost" that will spur him to new discoveries, the process is one of perpetual discovery and renewal. His *Dream Horse* monotypes (**Fig. 10-33**) are symbolic of this process. The artist figuratively "rides" the horse, and its image, on his continuing imaginative journey.

Scholder's process is, in another sense, a summation of the possibilities of printmaking as a whole. As new techniques have been invented—from the relief processes to those of intaglio, lithography, silkscreen printing, and the monotype— the artist's imagination has been freed to discover new means of representation and expression. The variety of visual effects achievable in printmaking is virtually unlimited.

Fig. 10-33 Fritz Scholder, *Dream Horse G,* 1986.
Monotype, 30 × 22 in.
Courtesy of the artist.

THINKING BACK

✓—[Study and review on myartslab.com

What defines a print?

A print is a single impression of an image that has been transferred through pressure to a surface (usually paper). The image is transferred from a matrix, where the design has originally been created. A single matrix can be used to make many impressions, which are typically almost identical. What is an edition? How does an original print differ from a reproductive print? What are proofs?

What are relief processes in printmaking?

Relief refers to any printmaking process in which the image to be printed is raised from the background in reverse. Woodcuts and rubber stamps are examples of relief printmaking processes. What are *nishiki-e* prints? What defines the method known as wood engraving? What is a linocut?

What are intaglio processes in printmaking?

In intaglio processes, the areas to be printed are below the surface of the plate. The matrix is a plate in which incised lines are filled with ink. Pressure transfers this ink to a surface, typically paper. The term *intaglio* comes from the Italian word for "engraving." What is stippling? How does engraving differ from etching? What defines the process known as mezzotint?

How are lithographs made?

Lithography means "stone writing." It is the chief planographic printmaking process, meaning that the surface of the matrix is flat. In lithography, the method for creating a printable image involves writing on a stone with a greasy crayon, which holds ink. Who invented lithography and for what purpose? What is a tusche? How did Robert Rauschenberg approach the medium of lithography?

THE CRITICAL PROCESS
Thinking about Printmaking

Like both Roger Shimomura and Peter Halley, Andy Warhol was a Pop artist who recognized in silkscreen printing possibilities not only for making images but also for commenting on American culture in general. In his many silkscreen images of Marilyn Monroe, almost all made within three or four years of her death in 1962, he depicted her in garish, conflicting colors (**Fig. 10-34**). Twenty years later, he created a series of silkscreen prints, commissioned by New York art dealer Ronald Feldman, of endangered species. What do the Marilyn silkscreens and the images like *Silverspot* (**Fig. 10-35**) from the *Endangered Species* series have in common? Think of Monroe as both a person and a Hollywood image. What does it mean to be an "image"? How, in the case of the endangered species, might existing as an "image" be more useful than not? Consider the quality of color in both silkscreens. How does color affect the meaning of both works? Why do you think that Warhol resorts to such garish, bright coloration? Finally, how do both images suggest that Warhol was something of a social critic intent on challenging the values of mainstream America?

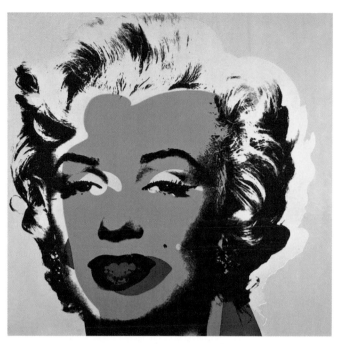

Fig. 10-34 Andy Warhol, *Marilyn Monroe*, 1967. Serigraph, 37¹/₂ × 37¹/₂ in. Chazen Museum of Art, University of Wisconsin, Madison. Robert Gale Doyon Fund and Harold F. Bishop Fund purchase. 1978-252.

Thinking Thematically: See **Art, Gender, and Identity** on myartslab.com

Fig. 10-35 Andy Warhol, *San Francisco Silverspot*, from the *Endangered Species Series*, 1983. Screenprint, 38 × 38 in. Courtesy Ronald Feldman Fine Arts, New York / www.feldmangallery.com. Photo: Dr. James Dee.

Thinking Thematically: See **Art, Science, and the Environment** on myartslab.com

11 | Painting

Fig. 11-1 Giorgio Vasari, *The Art of Painting*, 1542.
Fresco of the vault of the Main Room, Arezzo, Casa Vasari.
Thinking Thematically: See Art, Gender, and Identity on myartslab.com

THINKING AHEAD

How does buon fresco *differ from* fresco secco?

What are some of the advantages of oil paint?

How are watercolor paintings made?

What is mixed media work?

((●–[Listen to the chapter audio on myartslab.com

Early in the fifteenth century, a figure known as *La Pittura*—literally, "the picture"—began to appear in Italian art (**Fig. 11-1**). As art historian Mary D. Garrard has noted, the emergence of the figure of *La Pittura*, the personification of painting, could be said to announce the cultural arrival of painting as an art. In the Middle Ages, painting was never included among the liberal arts—those areas of knowledge that were thought to develop general intellectual capacity—which included rhetoric, arithmetic,

geometry, astrology, and music. While the liberal arts were understood to involve inspiration and creative invention, painting was considered merely a mechanical skill, involving, at most, the ability to copy. The emergence of *La Pittura* announced that painting was finally something more than mere copywork, that it was an intellectual pursuit equal to the other liberal arts, all of which had been given similar personification early in the Middle Ages.

In her *Self-Portrait as the Allegory of Painting* (**Fig. 11-2**), Artemisia Gentileschi presents herself as both a real person and as the personification of *La Pittura*. Iconographically speaking, Gentileschi may be recognized as *La Pittura* by virtue of the pendant around her neck that symbolizes *imitation*. And Gentileschi can imitate the appearance of things very well—she presents us with a portrait of herself as she really looks. Still, in Renaissance terms, imitation means more than simply copying appearances: It is the representation of nature as seen by and through the artist's imagination. On the one hand, Gentileschi's multicolored garment alludes to her craft and skill as a copyist—she can imitate the effects of color—but on the other hand, her unruly hair stands for the imaginative frenzy of the artist's temperament. Thus, in this painting, she portrays herself both as a real woman and as an idealized personification of artistic genius, possessing all the intellectual authority and dignity of a Leonardo or a Michelangelo. Though in her time it was commonplace to think of women as intellectually inferior to men—"women have long dresses and short intellects" was a popular saying—here Gentileschi transforms painting from mere copywork, and, in the process, transforms her own possibilities as a creative person.

Nevertheless, from the earliest times, one of the major concerns of Western painting has been representing the appearance of things in the natural world. There is a famous story told by the historian Pliny about a contest between the Greek painters Parrhasius and Zeuxis as to who could make the most realistic image:

Zeuxis produced a picture of grapes so dexterously represented that birds began to fly down to eat from the painted vine. Whereupon Parrhasius designed so lifelike a picture of a curtain that Zeuxis, proud of the verdict of the birds, requested that the curtain should now be drawn back and the picture displayed. When he realized his mistake, with a modesty that did him honor, he yielded up the palm, saying that whereas he had managed to deceive only birds, Parrhasius had deceived an artist.

Fig. 11-2 Artemisia Gentileschi, *Self-Portrait as the Allegory of Painting,* 1630.
Oil on canvas, 35¼ × 29 in. The Royal Collection.
© 2012 Her Majesty Queen Elizabeth II. Photo by A. C. Cooper Ltd.

This tradition, which views the painter's task as rivaling the truth of nature, has survived to the present day.

In this chapter, we will consider the art of painting, paying particular attention to how its various media developed in response to artists' desires to imitate reality and express themselves more fluently. But before we begin our discussion of these various painting media, we should be familiar with a number of terms that all the media share and that are crucial to understanding how paintings are made.

From prehistoric times to the present day, the painting process has remained basically the same. As in drawing, artists use pigments, or powdered colors, suspended in a **medium** or **binder** that holds the particles of pigment together. The binder protects the pigment from changes and serves as an adhesive to anchor the pigment to the **support**, or the surface on which the artist paints—a wall, a panel of wood, a sheet of paper, or a canvas. Different binders have different characteristics. Some dry more quickly than others. Some create an almost transparent paint, while others are opaque—that is, they cannot be seen through. The same pigment used in different binders will look different because of the varying degrees of each binder's transparency.

Since most supports are too absorbent to allow the easy application of paint, artists often *prime* (pre-treat) a support with a paint-like material called a **ground**. Grounds also make the support surface smoother or more uniform in texture. Many grounds, especially white grounds, increase the brightness of the final picture.

Finally, artists use a **solvent** or **vehicle**, a thinner that enables the paint to flow more readily and that also cleans brushes. All water-based paints use water for a vehicle. Other types of paints require a different thinner—in the case of oil-based paint, turpentine.

Each painting medium has unique characteristics and has flourished at particular historical moments. Though many media have been largely abandoned as new media have been discovered—media that allow the artist to create a more believable image or that are simply easier to use—almost all media continue to be used to some extent, and older media, such as encaustic and fresco, sometimes find fresh uses in the hands of contemporary artists.

Encaustic

Encaustic, made by combining pigment with a binder of hot wax, is one of the oldest painting media. It was widely used in classical Greece, most famously by Polygnotus, but his work, as well as all other Greek painting except that on vases, has entirely perished. (The contest between Zeuxis and Parrhasius was probably conducted in encaustic.)

Fig. 11-3 *Mummy Portrait of a Man*, Egyption (Fayum), c. 160–170 A.D.
Encaustic on wood, 14 × 18 in. (35.56 × 20.32 cm). Charles Clifton Fund, 1938.

Most of the surviving encaustic paintings from the ancient world come from Faiyum in Egypt, which, in the second century CE, was a thriving Roman province about 60 miles south of present-day Cairo. The Faiyum paintings are funeral portraits, which were attached to the mummy cases of the deceased, and they are the only indication we have of the painting techniques used by the Greeks. A transplanted Greek artist may, in fact, have been responsible for *Mummy Portrait of a Man* (**Fig. 11-3**), though we cannot be sure.

What is clear, though, is the artist's remarkable skill with the brush. The encaustic medium is a demanding one, requiring the painter to work quickly so that the wax will stay liquid. Looking at *Mummy Portrait of a Man*, we notice that while the neck and shoulders have been rendered with simplified forms, which gives them a sense of strength that is almost tangible, the face has been painted in a very naturalistic and sensitive way. The wide, expressive eyes and the delicate modeling of the cheeks make us feel that we are looking at a "real" person, which was clearly the artist's intention.

The extraordinary luminosity of the encaustic medium has led to its revival in recent years. Of all contemporary artists working in the medium, no one has perfected its use more than Jasper Johns, whose encaustic *Three Flags* (see Fig. 1-21) we saw in Chapter 1.

Fresco

Wall painting was practiced by the ancient Egyptians, Greeks, and Romans, as well as by Italian painters of the Renaissance. Numerous examples survive from Aegean civilizations of the Cyclades and Crete (see Fig. 17-16), to which later Greek culture traced its roots. In the eighteenth century, a great many frescoes were discovered at Pompeii and nearby Herculaneum, where they had been buried under volcanic ash since the eruption of Mt. Vesuvius in 79 CE. A series of still-life paintings was unearthed in 1755–57 that proved so popular in France that they led to the renewed popularity of the still-life genre. This *Still Life with Eggs and Thrushes* (**Fig. 11-4**), from the Villa of Julia Felix, is particularly notable, especially the realism of

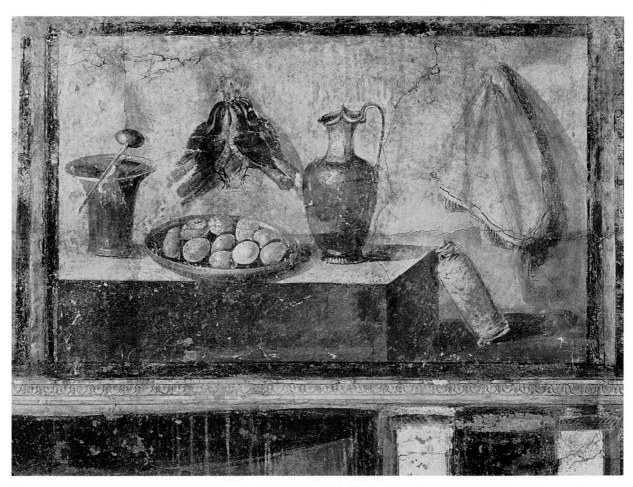

Fig. 11-4 *Still Life with Eggs and Thrushes,* Villa of Julia Felix, Pompeii, before 79 CE. Fresco, 35 × 48 in. National Museum, Naples.

the dish of eggs, which seems to hang over the edge of the painting and push forward into our space. The fact that all the objects in the still life have been painted life-size adds to the work's sense of realism.

The preferred medium for wall painting for centuries was **fresco**, in which pigment is mixed with limewater (a solution containing calcium hydroxide, or slaked lime) and then applied to a lime plaster wall that is either still wet or hardened and dry. If the paint is applied to a wet wall, the process is called buon fresco (Italian for "good" or "true fresco"), and if it is applied to a dry wall, it is called fresco secco, or "dry fresco." In *buon fresco*, the wet plaster absorbs the wet pigment, and the painting literally becomes part of the wall. The artist must work quickly, plastering only as much wall as can be painted before the plaster dries, but the advantage of the process is that it is extremely durable. In *fresco secco*, on the other hand, the

pigment is combined with binders such as egg yolk, oil, or wax and applied separately, at virtually any pace the artist desires. As a result, the artist can render an object with extraordinary care and meticulousness. The disadvantage of the *fresco secco* technique is that moisture can creep in between the plaster and the paint, causing the paint to flake off the wall. This is what happened to Leonardo da Vinci's *Last Supper* in Milan (see Fig. 5-12), which peeled away to such a tragic degree that the image almost disappeared. Beginning in 1979, it underwent careful restoration, a job finally completed in 1999.

Nevertheless, in extremely dry environments, such as the Buddhist caves at Ajanta, India, fresco secco has proven extremely durable (**Fig. 11-5**). Painting in the fifth century CE, the artists at Ajanta covered the walls of the caves with a mixture of mud and cow dung, bound together with straw or animal hair.

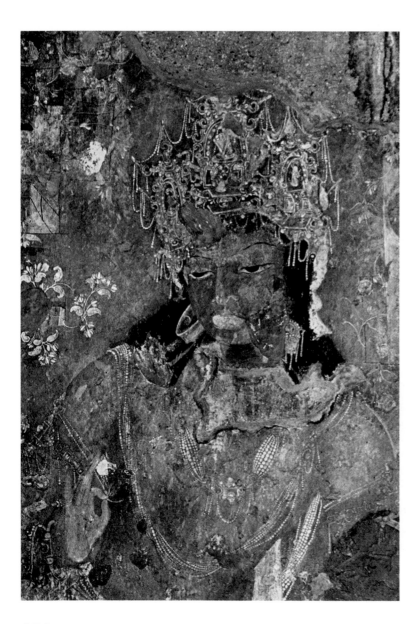

Once dry, this mud mixture was smoothed over with a layer of gypsum or lime plaster, which served as the ground for the painting. The artists' technique is fully described in the *Samarangana Sutra Dhara*, an encyclopedic work on Indian architecture written in the early eleventh century CE. The artist first outlined his subject in iron ore, then filled in the outline with color, building up the figure's features from darker to lighter tones to create the subtle gradations of modeling required to achieve a sense of a three-dimensional body. Protruding features, such as shoulders, nose, brow, and, on this figure especially, the right hand, thus resonate against the dark background of the painting, as if reaching out of the darkness of the cave into the light.

This figure is a *bodhisattva*, an enlightened being who, in order to help others achieve enlightenment, postpones joining Buddha in *nirvana*—not exactly heaven, but the state of being freed from suffering and the cycle of rebirth. It is one of two large *bodhisattvas* that flank the entrance to a large hall in Cave I at Ajanta, built into the caves around the sides of which are monks' cells with a Buddha shrine at the back. Lavishly adorned with jewelry, including long strands of pearls and an ornate crown, the delicate

Fig. 11-5 *Bodhisattva*, detail of a fresco wall painting in Cave I, Ajanta, Maharashtra, India, c. 475 CE.

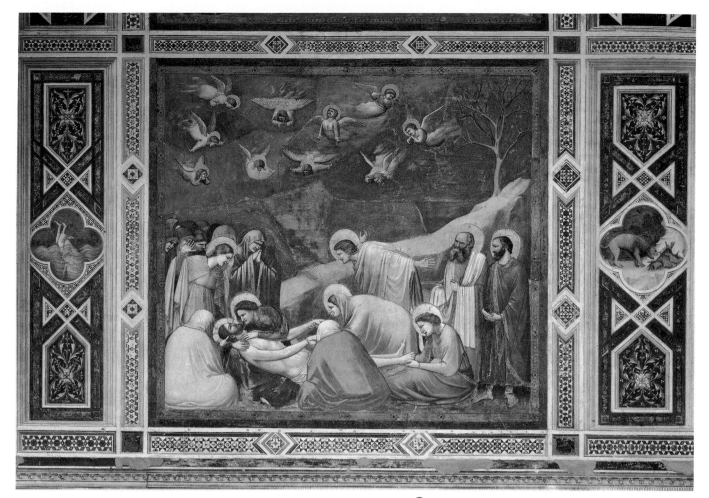

Fig. 11-6 Giotto, *Lamentation*, c. 1305.
Fresco, approximately 70 × 78 in. Scrovegni Chapel, Padua, Italy.

View the Closer Look on the Scrovegni Chapel on myartslab.com

Thinking Thematically: See Art and the Passage of Time on myartslab.com

gesture of the right hand forming the teaching *mudra* (see Chapter 2), the figure seems intended to suggest to the viewer the joys of following the path of Buddha.

In Europe, the goal of creating the illusion of reality dominates fresco painting from the early Renaissance in the fourteenth century through the Baroque period of the late seventeenth century. It is as if painting at the scale of the wall invites, even demands, the creation of "real" space. In one of the great sets of frescoes of the early Renaissance, painted by Giotto in the Scrovegni Chapel in Padua, Italy, this realist impulse is especially apparent. (Because it stands at one end of an ancient Roman arena, it is sometimes called the Arena Chapel.)

The Scrovegni Chapel was specially designed for the Scrovegni family, possibly by Giotto himself, to house frescoes, and it contains 38 individual scenes that tell the stories of the lives of the Virgin and Christ. In the Lamentation (**Fig. 11-6**), the two crouching figures with their backs to us extend into

our space in a manner similar to the bowl of eggs in the Roman fresco. Here, the result is to involve us in the sorrow of the scene. As the hand of the left most figure cradles Christ's head, it is almost as if the hand were our own. One of the more remarkable aspects of this fresco, however, is the placement of its focal point—Christ's face—in the lower-left-hand corner of the composition, at the base of the diagonal formed by the stone ledge. Just as the angels in the sky seem to be plummeting toward the fallen Christ, the tall figure on the right leans forward in a sweeping gesture of grief that mimics the angels' descending flight.

Lines dividing various sections of Giotto's fresco are clearly apparent, especially in the sky. In the lower half of the painting these divisions tend to follow the contours of the various figures. These sections, known as **giornate**, literally a "day's work" in Italian, are the areas that Giotto was able to complete in a single sitting. Since in *buon fresco* the paint had to be applied on a wet wall, Giotto could only paint an area that he

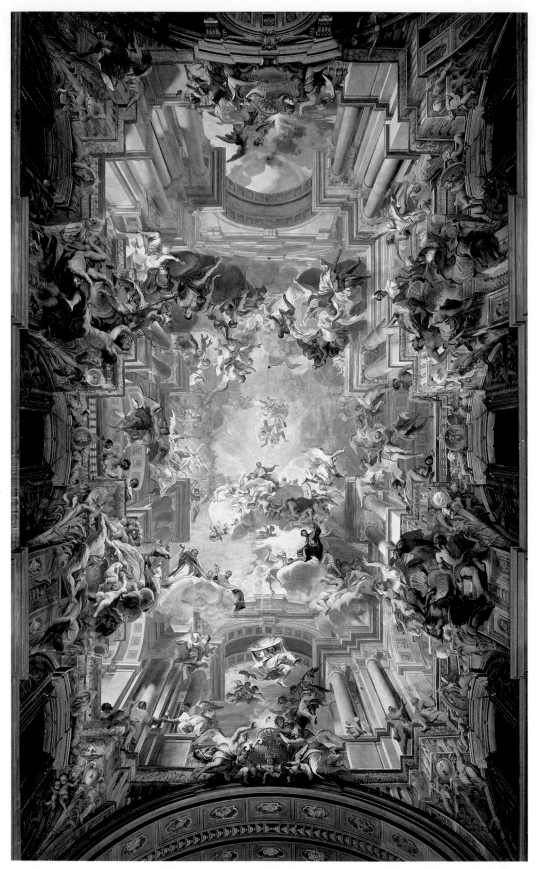

Fig. 11-7 Fra Andrea Pozzo, *The Glorification of Saint Ignatius*, 1691–94.
Ceiling fresco, approx. 56 × 115 ft. Nave of Sant' Ignazio, Rome.

could complete before the plaster coat set. If the area to be painted was complex—a face, for instance—the *giornata* might be no larger. Extremely detailed work would be added later, as in *fresco secco*.

The fresco artists' interest in illusionism culminated in Michelangelo's frescoes for the Sistine Chapel (see *The Creative Process*, pp. 234–235) and in the Baroque ceiling designs of the late seventeenth century. Among the most remarkable of these is *The Glorification of Saint Ignatius* (**Fig. 11-7**), which Fra Andrea Pozzo painted for the church of Sant' Ignazio in Rome. Standing in the nave, or central portion of the church, and looking upward, the congregation had the illusion that the roof of the church had been removed, revealing the glories of Heaven. A master of perspective, about which he wrote an influential treatise, Pozzo realized his effects by extending the architecture in paint one story above the actual windows in the vault. Saint Ignatius, the founder of the Jesuit order, is shown being transported on a cloud toward the waiting Christ. The foreshortening of the many figures, becoming ever smaller in size as they rise toward the center of the ceiling, greatly adds to the realistic, yet awe-inspiring, effect.

Tempera

Most artists in the early Renaissance who painted frescoes also worked in **tempera**, a medium made by combining water, pigment, and some gummy material, usually egg yolk. The paint was meticulously applied with the point of a fine red sable brush. Colors could not readily be blended, and, as a result, effects of *chiaroscuro* were accomplished by means of careful and gradual hatching. In order to use tempera, the painting surface, often a wood panel, had to be prepared with a very smooth ground, not unlike the smooth plaster wall prepared for *buon*

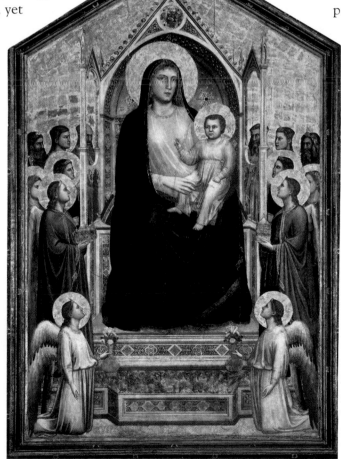

Fig. 11-8 Giotto, *Madonna and Child Enthroned*, c. 1310. Tempera on panel, 10 ft. 8 in. × 6 ft. 8¼ in. Galleria degli Uffizi, Florence.

fresco. **Gesso**, made from glue and plaster of Paris or chalk, is the most common ground, and, like wet plaster, it is fully absorbent, combining with the tempera paint to create an extremely durable and softly glowing surface unmatched by any other medium.

To early Renaissance eyes, Giotto's *Madonna and Child* (**Fig. 11-8**) represented, like his frescoes in the Arena chapel, a significant "advance" in the era's increasingly insistent desire to create ever more realistic work. It is possible, for instance, to feel the volume of the Madonna's knee in Giotto's altarpiece, to sense actual bodies beneath the draperies that clothe his models. The neck of Giotto's Madonna is modeled and curves round beneath her cape. Her face is sculptural, as if real bones lie beneath her skin.

What motivated this drive toward realism? Painting, it should be remembered, can suggest at least as much, and probably more, than it portrays. Another way to say this is that painting can be understood in terms of its **connotation** as well as its **denotation**. What a painting denotes is clearly before us: Giotto has painted a Madonna and Child surrounded by angels. But what this painting connotes is something else. To a thirteenth- or fourteenth-century Italian audience, the altarpiece would have been understood as depicting the ideal of love that lies between mother and child—and, by extension, the greater love of God for humanity. Although the relative realism of Giotto's painting is what secures its place in art history, its **didacticism**—that is, its ability to teach, to elevate the mind, in this case, to the contemplation of salvation—was at least as important to its original audience. Its truth to nature was, in fact, probably inspired by Giotto's desire to make an image with which its audience could readily identify. It seemed increasingly important to capture not the spirituality of religious figures, but their humanity.

On May 10, 1506, Michelangelo received an advance payment from Pope Julius II to undertake the task of frescoing the ceiling of the Sistine Chapel at the Vatican in Rome. By the end of July, a scaffolding had been erected. By September 1508, Michelangelo was painting, and for the next four and a half years, he worked almost without interruption on the project.

According to Michelangelo's later recounting of events, Julius had originally envisioned a design in which the central part of the ceiling would be filled with "ornaments according to custom" (apparently a field of geometric ornaments) surrounded by the 12 apostles in the 12 spandrels. Michelangelo protested, assuring Julius that it would be "a poor design" since the apostles were themselves "poor too." Apparently convinced, the pope then freed Michelangelo to paint anything he liked. Instead of the apostles, Michelangelo created a scheme of 12 Old Testament prophets alternating with 12 sibyls, women of classical antiquity who were said to possess prophetic powers. The center of the ceiling would be filled with nine scenes from Genesis.

As the scaffolding was erected, specially designed by the artist so that he could walk around and paint from a standing position, Michelangelo set to work preparing hundreds of drawings for the ceiling. These drawings were then transferred to full-size cartoons, which would be laid up against the moist surface of the fresco as it was prepared, their outlines traced through with a stylus. None of these cartoons, and surprisingly few of Michelangelo's drawings, have survived.

One of the greatest, and most revealing, of the surviving drawings is a *Studies for the Libyan Sibyl* (**Fig. 11-9**). Each of the sibyls holds a book of prophecy—though not Christian figures, they prophesy the revelation of the New Testament in the events of the Old Testament that they surround. *The Libyan Sibyl* (**Fig. 11-10**) is the last sibyl that Michelangelo would paint. She is positioned next to the *Separation of Light from Darkness*, the last of the central panels, which is directly over the altarpiece. The Libyan sibyl herself turns to close her book and place it on the desk behind her. Even as she does so, she steps down from her throne, creating a stunning opposition of directional forces, an exaggerated, almost spiral *contrapposto*. She abandons her book of prophecy as she turns to participate in the celebration of the Eucharist on the altar below.

The severity of this downward twisting motion obviously came late in Michelangelo's work on the figure. In the drawing, the sibyl's hands are balanced evenly, across an almost horizontal plane. But the idea of dropping the left hand, in order to emphasize more emphatically the sibyl's downward movement, came almost immediately, for just below her left arm is a second variation, in which the upper arm drops perceptively downward and the left hand is parallel to the face instead of the forehead, matching the positions of the final painting. In the drawing, the sibyl is nude, and apparently Michelangelo's model is male, his musculature more closely defined than in the final

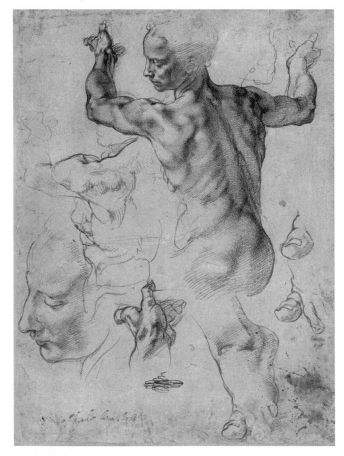

Fig. 11-9 Michelangelo Buonarroti (1475–564), *Studies for the Libyan Sibyl*, c. 1510.
Red chalk on paper, 11⅜ × 8 7/16 in. (28.9 × 21.4 cm)
The Metropolitan Museum of Art, New York , NY, U.S.A.
Purchase, Joseph Pulitzer Bequest, 1924 (24.197.2).

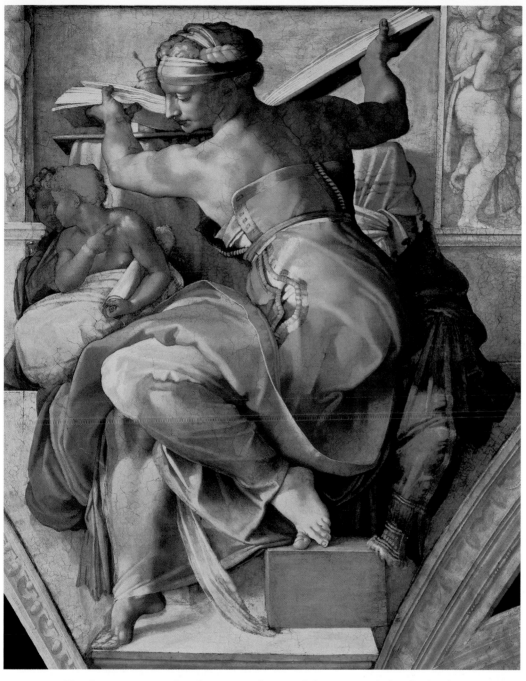

✳ **Explore** the architectural panorama of the Sistine Chapel ceiling on myartslab.com

Fig. 11-10 Michelangelo Buonarroti, *The Libyan Sibyl*, 1511–12.
Fresco, detail of the Sistine Ceiling, Sistine Chapel, Vatican City.

painting. Furthermore, in the drawing, the model's face is redone to the lower left, her lips made fuller and feminized, the severity of the original model's brow and cheek softened. The magnificently foreshortened left hand is redone in larger scale, as if in preparation for the cartoon, and so is the left foot. There are, in fact, working upward from the bottom of the drawing, three versions of the big toe, and, again, the second and third are closer to the final painted version than the first, more fully realized foot, the second toe splaying more radically backward, again to emphasize downward pressure and movement. It is upon this foot that, in the final painting, Michelangelo directs our attention, illuminating it like no other portion of the figure, the fulcrum upon which the sibyl turns from her pagan past to the Christian present.

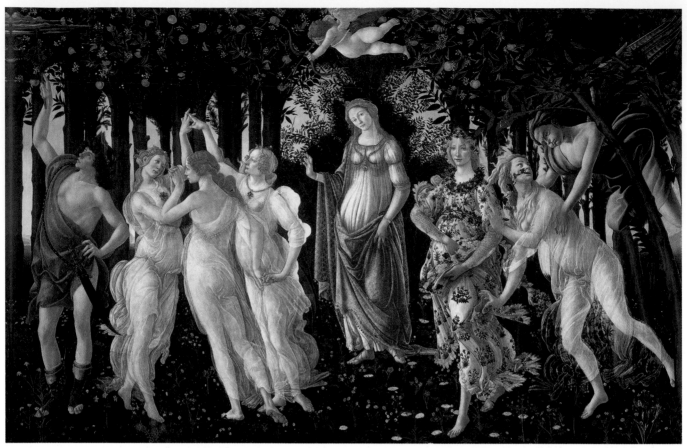

Fig. 11-11 Sandro Botticelli, *Primavera*, c. 1482.
Tempera on a gesso ground on poplar panel, 80 × 123¼ in. Galleria degli Uffizi, Florence.

Thinking Thematically: See Art and Beauty on myartslab.com

View the Closer Look on *Primavera* on myartslab.com

Sandro Botticelli's *Primavera* (**Fig. 11-11**), painted for a chamber next to the bedroom of his patron Lorenzo di Pierfrancesco de'Medici, is one of the greatest tempera paintings ever made. As a result of its restoration in 1978, we know a good deal about how it was painted. The support consists of eight poplar panels, arranged vertically and fastened by two horizontal strips of spruce. This support is covered with a gesso ground that hid the seams between the panels. Botticelli next outlined the trees and his human figures on the gesso and then painted the sky, laying blue tempera directly on the ground. The figures and trees were painted on an undercoat—white for the figures, black for the trees. The transparency of the drapery was achieved by layering thin yellow washes of transparent medium over the white undercoat. As many as 30 coats of color, transparent or opaque depending on the relative light or shadow of the area being painted, were required to create each figure.

Watch a video on tempera on myartslab.com

Julie Green takes full advantage of the possibility of creating transparent washes of color with egg tempera in her painting *Don't Name Fish after Friends* (**Fig. 11-12**), a painting she worked on for over a decade. It began as a portrait of a Hasidic Jewish man whose well-made and somewhat flamboyant clothing attracted Green's interest. Traces of herringbone can still be seen at the water's edge. The painting then underwent a dozen transformations, including a depiction of an armadillo crossing the basketball court across from Green's house in Norman, Oklahoma. It is as if, looking into the water, traces of these earlier paintings shimmer beneath the surface, all scraped away but leaving some mark behind.

The final painting memorializes the fate of the koi living in the pond behind her house and named after two close friends, Roger and Janet. Green dreamed one night that her one-eyed cat Rio had eaten Janet. When she awoke, the pond was in a shambles,

its water lilies knocked over, and Janet was missing. Janet II was purchased, but the new Janet and Roger did not seem to get along. A wire cover was put over the pond, and a year passed without incident, but when Green returned from a brief vacation, Janet II was discovered belly-up, probably succumbing to over-feeding by a neighbor. "With plans to paint a *momento mori*," Green says, "I set departed Janet II on top of the compost pile and went off for paint supplies. Twenty minutes later I returned to find a lovely white fish bone, nothing else." Today, Janet III swims happily beside the original Roger in the pond. The painting, of course, stands on its own even if the viewer lacks knowledge of its history, but its surface, and the layers of paint half visible beneath it, suggest precisely such a story.

Oil Painting

Even as Botticelli was creating stunning effects by layering transparent washes of tempera on his canvases, painters in northern Europe were coming to the realization that similar effects could be both more readily and more effectively achieved in **oil paint**. Oil paint is a far more versatile medium than tempera. It can be blended on the painting surface to create a continuous scale of tones and hues, many of which, especially darker shades, were not possible before oil paint's invention. As a result, the painter who uses oils can render the most subtle changes in light and achieve the most realistic three-dimensional effects, rivaling sculpture in this regard. Thinned with turpentine, oil paint can become almost transparent. Used directly from the tube, with no thinner at all, it can be molded and shaped to create three-dimensional surfaces, a technique referred to as impasto. Perhaps most important, because its binder is linseed oil, oil painting is slow to dry. Whereas with other painting media artists had to work quickly, with oil they could rework their images almost endlessly.

The ability to create such a sense of reality is a virtue of oil painting that makes the medium particularly suitable to the celebration of material things. By glazing the surface of the painting with thin films of transparent color, the artist creates a sense of luminous materiality. Light penetrates this glaze, bounces off the opaque underpainting beneath, and is reflected back up through the glaze (**Fig. 11-13**). Painted objects thus seem to reflect light as if they were real, and the play of light through the painted surfaces gives them a sense of tangible presence.

Fig. 11-12 Julie Green, *Don't Name Fish after Friends,* 1999–2009.

Egg tempera on panel, 24 × 18 in.
Courtesy of the artist.

Watch a video about making oil paint on myartslab.com

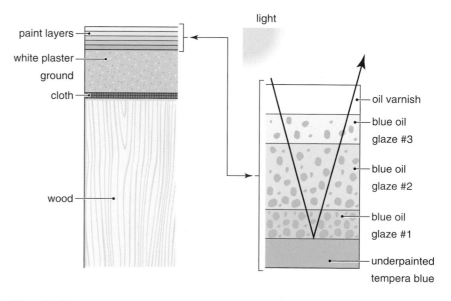

Fig. 11-13 Diagram of a section of a fifteenth-century oil painting demonstrating the luminosity of the medium.

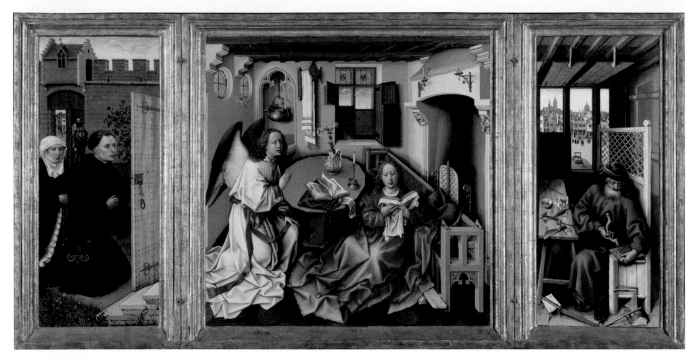

Fig. 11-14 Robert Campin (ca.1375/9–1444), *The Annunciation* (*The Mérode Altarpiece*), ca. 1425.
Oil on wood, triptych, overall (open): 25⅜ × 46⅜ in. (64.5 × 117.8 cm) central panel: 25¼ × 24⅞ in (64.1 × 63.2 cm).; each wing: 25⅜ × 10¾ in. (64.5 × 27.3 cm) The Metropolitan Museum of Art, New York, NY, U.S.A. The Cloisters Collection, 1956 (56.70).
© The Metropolitan Museum of Art. Image source: Art Resource, NY.

Thinking Thematically: See **Art and Spiritual Belief** on myartslab.com

View the Closer Look on *The Mérode Altarpiece* on myartslab.com

Although the ancient Romans had used oil paint to decorate furniture, the medium was first used in painting in the early fifteenth century in Flanders. The so-called Master of Flémalle, probably the artist Robert Campin, in all likelihood working with other artists in his workshop, was among the first to recognize the realistic effects that could be achieved with the new medium. In *The Mérode Altarpiece* (**Fig. 11-14**), the Christian story of the Annunciation of the Virgin—the revelation to Mary that she will conceive a child to be born the Son of God—takes place in a fully realized Flemish domestic interior. The archangel Gabriel approaches Mary from the left, almost blocking the view of the two altarpiece's donors, the couple who commissioned it, dressed in fashionable fifteenth-century clothing and standing outside the door at the left. Seven rays of sunlight illuminate the room and fall directly on Mary's abdomen. On one of the rays, a miniature Christ, carrying a cross, flies into the scene (**Fig. 11-15**). Campin is telling the viewers that the entire life of Christ, including the Passion itself, enters Mary's body at the moment of conception. The scene is not idealized. In the right-hand panel, Joseph the carpenter works as a real fifteenth-century carpenter might have. In front of him is a recently

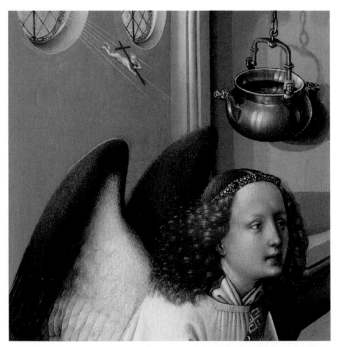

Fig. 11-15 Robert Campin (ca.1375/9–1444), *The Annunciation Triptych* (*The Mérode Altarpiece*), detail, ca. 1425
Oil on wood, triptych, overall (open): 25⅜ × 46⅜ in. (64.5 × 117.8 cm); central panel: 25¼ × 24⅞ in. (64.1 × 63.2 cm); each wing: 25⅜ × 10¾ in. (64.5 × 27.3 cm) The Metropolitan Museum of Art, New York, NY, U.S.A. The Cloisters Collection, 1956 (56.70).

completed mousetrap. Another mousetrap sits outside on the window ledge, apparently for sale. These are real people with real daily concerns. The objects in the room—from the vase and flowers to the book and candle—seem to possess a material reality that lends a sense of reality to the story of the Annunciation itself. In fact, the archangel Gabriel appears no less (and no more) "real" than the brass pot above his head.

Another noteworthy aspect of Campin's altarpiece is its astonishingly small size. If its two side panels are closed over the central panel, as they are designed to work, the altarpiece is just over two feet square—making it entirely portable. This little altarpiece is itself a material object, so intimate and detailed that it functions more like the book that lies open on the table than a painting. It is very different from the altarpieces being made in Italy during the same period. Most of those were monumental in scale and painted in fresco, permanently embedded in the wall, and therefore not portable. Campin's altarpiece is made to be held up close, in the hands, not surveyed from afar, suggesting its function as a private, rather than public, devotional object.

By 1608, the Netherlands had freed itself from Spanish rule and become, by virtue of its almost total dominance of world trade, the wealthiest nation in the world. By that time, artists had become extremely skillful at using the medium of oil paint to represent these material riches. One critic has called the Dutch preoccupation with still life "a dialogue between the newly affluent society and its material possessions." In a painting such as Jan de Heem's *Still Life with Lobster* (**Fig. 11-16**), we are witness to the remains of a most extravagant meal, most of which has been left uneaten. This luxuriant and conspicuous display of wealth is deliberate. Southern fruit in a cold climate is a luxury, and the peeled lemon, otherwise untouched, is a sign of almost wanton consumption. For de Heem,

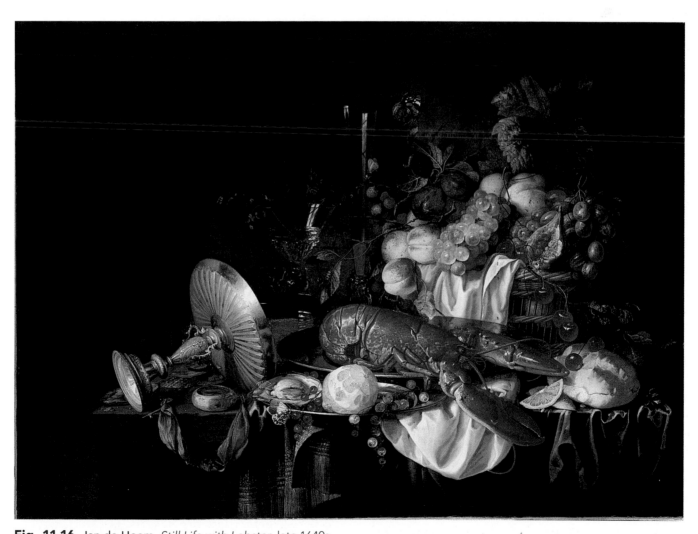

Fig. 11-16 Jan de Heem, *Still Life with Lobster*, late 1640s.
Oil on canvas, 25⅛ × 33¼ in. Toledo Museum of Art, Toledo, Ohio. Purchased with funds from the Libbey Endowment. Gift of Edward Drummond Libbey.

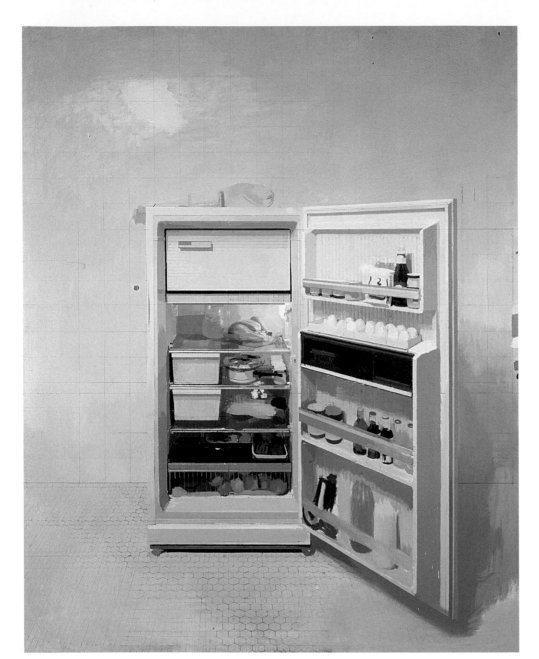

Fig. 11-17 Antonio López García, *New Refrigerator,* 1991–94.

Oil on canvas, 94½ × 74 ¹³⁄₁₆ in. Collection of the artist.

Photograph © Unidad Movil U & M Fotografia Especializada.

Watch a video about oil painting on myartslab.com

the painting was at least in part a celebration, an invitation to share, at least visually and thus imaginatively, in its world. The feast on the table was a feast for the eyes.

But de Heem's painting was also a warning, an example of vanitas painting. The *vanitas* tradition of still-life painting is specifically designed to induce the spectator to a higher order of thought. *Vanitas* is the Latin term for "vanity," and *vanitas* paintings, especially popular in northern Europe in the seventeenth century, remind us of the vanity, or frivolous quality, of human existence. If one ordinarily associates the contemplation of the normal subjects of still-life paintings with the enjoyment of the pleasurable things in life, here they take on another connotation as well. The overturned goblet, the half-peeled lemon, the oyster on the half-shell (which spoils quickly), the timepiece beside it, all remind the viewer that the material world celebrated in the painting is not as long-lasting as the spiritual, and that spiritual well-being may be of greater importance than material wealth.

Contemporary Spanish artist Antonio López García has revisited the *vanitas* tradition in many of his highly realistic still lifes and interiors. *New Refrigerator* (**Fig. 11-17**) is a modern still life, the objects of traditional still life removed from the tabletop into the refrigerator. Of particular note in López García's painting is the contrast between the extreme attention he pays to capturing the light in the room—note the light reflecting off the white tiled floor and the tiled wall behind the refrigerator—and the way he has rendered the objects in the open refrigerator, which

are simply abstract blotches of local color. In fact, the abstraction of the still-life objects is echoed in the white blotch on the upper wall, which appears to be a highly realistic rendering of a plaster patch. In this painting, the complex interchange between reality and spirituality that *vanitas* still-life painting embodies is transformed into an interchange between the objective and the subjective, between the material world and the artist's mental or emotional conception of that world.

Virtually since its inception, oil painting's *expressive* potential has been recognized as fundamental to its power. Much more than in fresco, where the artist's gesture was lost in the plaster, and much more than in tempera, where the artist was forced to use brushes so small that gestural freedom was absorbed by the scale of the image, oil paint could record and trace the artist's presence before the canvas.

Pat Passlof begins with abstraction. Her painting *Dancing Shoes* (**Fig. 11-18**), like many of her larger paintings, began with leftover paint from a smaller work, which she distributed in odd amounts over the surface of the 11-foot canvas. The painting developed as a predominantly yellow field that threatened, even with its syncopation of darker, loosely rectangular medium-yellow shapes, to flatten out. In response to these yellow shapes, Passlof added sap-green blocks of color, so dark that they read as black. These immediately animated the surface, creating an uneven choreography of short leaps and intervals across the painting's surface that at first glance seems to fit into a grid but reveals itself to be much freer, the space between elements lengthening itself out across the canvas with a greater and greater sense of abandon.

From her husband, the painter Milton Resnick, Passlof learned to appreciate a sense of discontinuity or displacement between elements in a composition that creates surprise, excitement, and even a degree of existential trembling, a sense of being frightened before the work (see *The Creative Process*, pp. 242–243). It is, perhaps, this leap that *Dancing Shoes* so successfully exploits, as each "step" or block in the composition stands in surprising relation to the next, not as an impossible "next move," but not in the rhythm of a natural pace either. It is as if, in looking at the painting, we can hear the syncopation of its jazz beat.

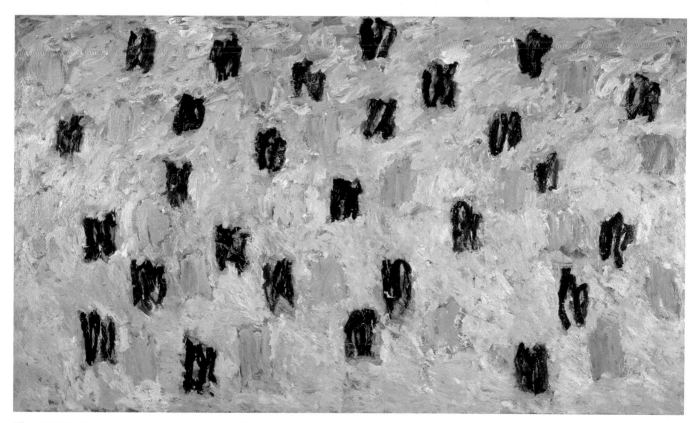

Fig. 11-18 Pat Passlof, *Dancing Shoes*, 1998.
Oil on linen, 80 × 132 in.
Courtesy of the artis and Elizabeth Harris Gallery.

On July 25, 1995, Abstract Expressionist painter Milton Resnick began five new large paintings. They would sum up, he hoped, what he had learned over the years as a painter. He had left home in his late teens to become an artist and lived through the heyday of Abstract Expressionist painting in New York, where, as one of the leaders of what would come to be known as the New York School, he had worked with Willem de Kooning, Jackson Pollock, and Franz Kline. He continued to work up until his death in March 2004, longer than any of his contemporaries. These new paintings would take Resnick full circle, back to his beginnings and forward again into the present. And it was, in fact, beginnings that would lend the new paintings their theme—Genesis, the first book of the Bible, Adam and Eve, the Garden of Eden, the Tree of the Knowledge of Good and Evil, and the serpent, Satan. Pat Passlof, Resnick's wife and fellow painter, suggested that the figures in the new work had a more general significance as well, that they were "you and me." The name stuck, though modified to *U + Me*, because, Resnick said, "it's easier to write."

On July 25, Resnick painted on all five canvases in his Eldridge Street studio in Chinatown, a two-story brick-walled space with large windows that had been, in the first decades of the twentieth century,

a Jewish synagogue. It was Resnick's practice to begin painting without a plan and without preliminary drawings—with nothing but a brushmark and a feeling about where he's going. "This feeling doesn't have to be physical," he explained, "but it has to be as if I come at you and you're frightened. That's the feeling. It's like if you have a glass and there's something in it and it's a kind of funny color. And someone says, 'Drink it.' And you say, 'What's in it?' And they say, 'Drink it or else!' And so you have to drink it. So that's the feeling. I'm going to drink something, and I don't know what's going to happen to me."

Pictured on these pages is one of the *U + Me* paintings at three different stages in its development—two studio photographs taken on each of the first two days, July 25 and July 26 (**Fig. 11-19**), and the finished painting as it appeared in February 1996 in an exhibition of the new *U + Me* paintings at the Robert Miller Gallery in New York (**Fig. 11-20**).

In the first stages of the painting there are two figures, the one on the right kicking forward to meet the other, who seems to be striding forward in greeting. The major difference in the work from day one to day two is color. The exuberant red and yellow of the first brushstrokes is suppressed in an overall brownish-green over-painting. The figures

Fig. 11-19 Milton Resnick's *U + Me* in progress.
Left: July 25, 1995; right: July 26, 1995.

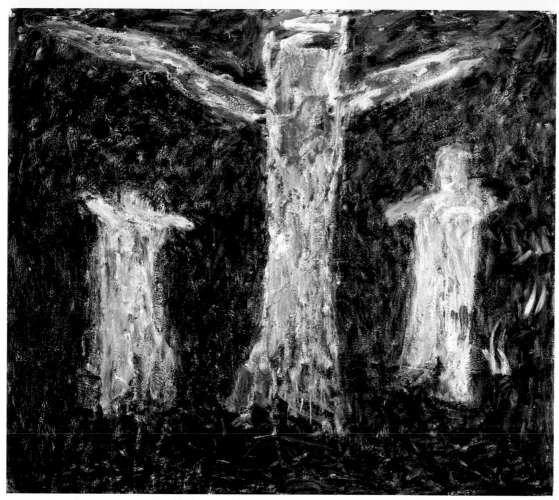

Fig. 11-20 Milton Resnick, *U + Me*, 1995.
Oil on canvas, 93¼ × 104½ in.
© Milton Resnick. Courtesy Cheim & Read, New York.

are smaller and darker, the gestural marks appear denser, and the surface begins to have a much more layered feel.

The final painting, in fact, is a culmination of layer upon layer of paint being added to the work over the course of several months, each revealing itself at different points across the canvas. For instance, the second day's brownish-green layer can be seen in the final work above the top of the tree, and rich dapples of differently colored layers appear throughout the dark layer of paint of the ground behind the figures and tree.

If the final work seems dramatically different from its beginnings, that is not least of all because Resnick has added a tree. "I put it in the middle," he related, "because that's the most difficult place"—difficult because the tree makes the painting so symmetrical and balanced that it risks losing any sense of tension or energy. But Resnick's tree also has symbolic resonance, prefiguring the cross. By looking forward to the crucifixion from the Garden of Eden, Resnick changes the image. The figures have changed as well, giving up their sense of physical motion. "The figures have to have a vitality but not be in motion," Resnick concluded. "They have to be animated with some force . . . with some energy. That's what the paint is doing. Paint has the energy."

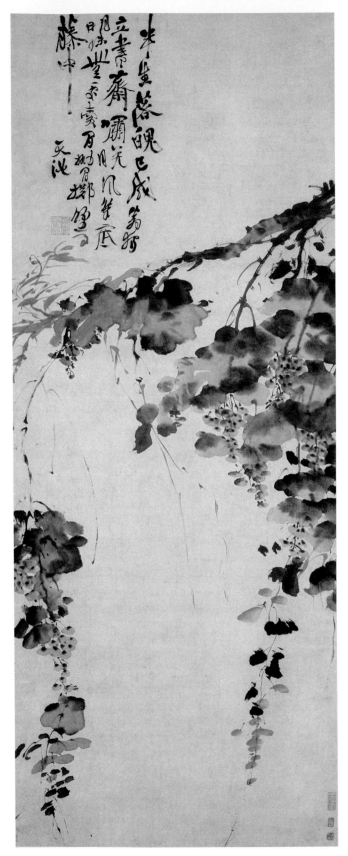

Fig. 11-21 Xu Wei, *Grapes*, Ming Dynasty, c. 1580–93. Hanging scroll, ink on paper, 65¼ × 25⅜ in. Palace Museum, Beijing. Collection of The Palace Museum, Beijing.

Watercolor

Of all the painting media, **watercolor** is potentially one of the most expressive. The ancient Egyptians used it to illustrate papyrus scrolls, and it was employed intermittently by other artists down through the centuries, notably by Albrecht Dürer and Peter Paul Rubens. The medium, it quickly became evident, was especially suitable for artists who wished to explore the expressive potential of painting, rather than pursue purely representational ends.

Watercolor paintings are made by applying pigments suspended in a solution of water and gum arabic to dampened paper. Historically, watercolor has often been used as a sketching tool. Certainly, as a medium, watercolor can possess all of the spontaneity of a high-quality sketch. Working quickly, it is possible to achieve gestural effects that are very close to those possible with brush and ink, and, in fact, the roots of Chinese watercolor techniques can be traced back to the sixteenth-century ink paintings of Xu Wei. Xu Wei led a troubled life. Suffering from severe depression and paranoia, he attempted suicide on several occasions, and then murdered his wife, an act for which he was imprisoned at age 46 in 1567. Upon his release seven years later, he supported himself, as best he could, by selling paintings. *Grapes* (**Fig. 11-21**) is testament to both his failure as an artist and his genius.

Until Xu Wei, Chinese watercolor had been dominated by meticulous, finely detailed rendering that employed carefully controlled line. Xu Wei introduced a more free-form and expressive style, known as *xie yi*, meaning "sketching idea." *Grapes* is painted with ink mixed with gelatin and alum, a water-soluble, transparent mineral. The vines and grapes are composed of areas of wash, some more transparent than others, depending upon the amount of ink in the gelatin and alum binder. The aim is to capture the spirit or essence of nature, not copy it in precise detail.

Despite the inventiveness of his style, in the poem at the top of the painting Xu Wei expresses his frustration as an artist. In essence, it reads:

> *Being frustrated in the first half of my life,*
> *Now I have become an old man.*
> *Standing lonely in my studio, I cry loudly in the*
> * evening wind,*
> *There's nowhere to sell the bright pearls from my brush,*
> *I have to cast them, now and then, into the wild vine.*

Xu Wei's work was, in fact, never appreciated in his lifetime, but after his death, his style would come to absolutely dominate Chinese painting.

Depending on the absorbency of the paper and the amount of watercolor on the brush, like Xu

Wei's ink, watercolor spreads along the fibers of the paper when it is applied. Thin solutions of pigment and binder have the appearance of soft, transparent washes, while dense solutions can become almost opaque. The play between the transparent and the opaque qualities of the medium is central to Winslow Homer's *A Wall, Nassau* (**Fig. 11-22**). Both the wall and the sky behind it are transparent washes, and the textural ribbons and spots of white on the coral limestone wall are actually unpainted paper. Between these two light bands of color lies the densely painted foliage of the garden and, to the right, the sea, which becomes a deeper and deeper blue as it stretches toward the horizon. A white sailboat heads out to sea on the right. Almost everything of visual interest in this painting takes place between the sky above and the wall below. Even the red leaves of the giant poinsettia plant that is the painting's focal point turn down toward this middle ground. Pointing up from the top of the wall, framing this middle area from below, is something far more ominous—dark, almost black shards of broken glass. Suddenly, the painting is transformed. No longer just a pretty view of a garden, it begins to speak of privacy and intrusion, and of the divided social world of the Bahamas at the turn of the century, the islands given over to tourism and its associated wealth at the expense of the local black population. The wall holds back those outside it from the beauty and luxury within, separating them from the freedom offered, for instance, by the boat as it sails away.

The expressive potential of watercolor became especially apparent in the early years of the twentieth century as artists began to abandon the representational aims of painting in favor of realizing more abstract ends. Influenced by developments in Europe, where the

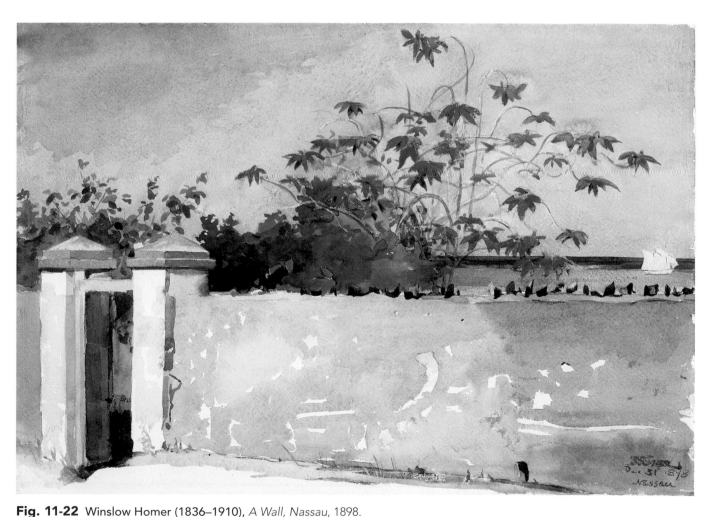

Fig. 11-22 Winslow Homer (1836–1910), *A Wall, Nassau*, 1898.
Watercolor and pencil on paper, 14¾ × 21½ in. The Metropolitan Museum of Art, New York, NY, U.S.A. Amelia B. Lazarus Fund, 1910 (10.228.90).

Thinking Thematically: See Art, Politics, and Community on myartslab.com

👁️—**Watch** a video about watercolor on myartslab.com

likes of Georges Braque (see Fig. 1-4) and Pablo Picasso (see Fig. 1-17) were creating more and more abstract works of art, American painters like John Marin, who lived in Paris from 1905 to 1911 and witnessed this shift first hand, began to explore the possibilities of abstraction themselves. A painting like Marin's *Untitled (The Blue Sea)* (**Fig. 11-23**) is the result. Rather than a visual recording of the Maine coast where he lived, it is a evocation of the feelings that the coast engendered in him. Writing in 1913, Marin explained:

We have been told somewhere that a work of art is a thing alive. You cannot create a work of art unless the things you behold respond to something within you. . . . It is this "moving of me" that I try to express so that I may recall the spell I have been under and behold the expression of the different emotions that have been called into being.

In *Untitled (The Blue Sea)*, the basic forms of the landscape are still visible—the rocky coastline moving in a diagonal from left to right in the foreground, a peninsula jutting out into ocean at the horizon line, the blue sky, the yellow light of a setting sun—but the gestural sweep of Marin's line, the sense of immediacy and energy in his application of washes of watercolor, realizes precisely that "moving of me" he seeks to capture. In fact, it is very likely that this painting is one

Fig. 11-23 John Marin, *Untitled (The Blue Sea)*, ca. 1921. Watercolor and charcoal on paper, 16 ½ × 19 ⅝ in. Smithsonian American Art Museum, Washington, D.C. Museum Purchase. 1964.2V.

Fig. 11-24 Jacob Lawrence, No. 15: *You can buy bootleg whiskey for twenty-five cents a quart*, from the *Harlem Series*, 1942–43.

Gouache on paper, 15½ × 22½ in. Portland Art Museum, Portland, Oregon. Helen Thurston Ayer Fund.

that he exhibited in a retrospective exhibition at the Museum of Modern Art in 1936 under the title *Movement, the Blue Sea*.

Gouache

Derived from the Italian word *guazzo*, meaning "puddle," **gouache** is essentially watercolor mixed with Chinese white chalk. The medium is opaque, and, while gouache colors display a light-reflecting brilliance, it is difficult to blend brushstrokes of gouache together. Thus, the medium lends itself to the creation of large, flat, colored forms. It is this abstract quality that attracted Jacob Lawrence to it. Everything in the painting *No 15: You can buy bootleg whiskey for twenty-five cents a quart* (**Fig. 11-24**) tips forward. This not only creates a sense of disorienting and drunken imbalance, but also emphasizes the flat two-dimensional quality of the painting's space. Lawrence's dramatically intense complementary colors blare like the jazz we can almost hear coming from the radio.

Synthetic Media

Because of its slow-drying characteristics and the preparation necessary to ready the painting surface, oil painting lacks the sense of immediacy so readily apparent in more direct media like drawing or watercolor. For the same reasons, the medium is not particularly suitable for painting out of doors, where one is continually exposed to the elements.

The first artists to experiment with synthetic media were a group of Mexican painters, led by David Alfaro Siqueiros and Diego Rivera, whose goal was to create large-scale revolutionary mural art (see Fig. 21-13). Painting outdoors, where their celebrations of the struggles of the working class could easily be seen, Siqueiros, Rivera, and José Clemente Orozco—*Los Tres Grandes*, as they are known—worked first in fresco and then in oil paint, but the sun, rain, and humidity of Mexico quickly ruined their efforts. In 1937, Siqueiros organized a workshop in New York, closer to the chemical industry, expressly to develop and experiment with new synthetic paints. One of the first media used at the workshop was pyroxylin, commonly known as Duco, a lacquer developed as an automobile paint.

In the early 1950s, Helen Frankenthaler gave up the gestural qualities of the brush loaded with oil paint and began to stain raw, unprimed canvas with greatly thinned oil pigments, soaking color into the surface in what has been called an art of "stain-gesture" by moving the unprimed, unstretched canvas around to allow the paint to flow over it. Her technique soon attracted a number of painters who were themselves experimenting with Magna, a paint made from **acrylic** resins—materials used to make plastic—mixed with turpentine. Staining canvas with oil created a messy, brownish "halo" around each stain or puddle of paint, but the painters realized that the "halo" disappeared when they stained the canvas with Magna, the paint and canvas really becoming one.

At almost exactly this time, researchers in both Mexico and the United States discovered a way to mix acrylic resins with water, and by 1956, water-based acrylic paints were on the market. These media were inorganic and, as a result, much better suited to staining raw canvas than turpentine or oil-based media, since no chemical interaction could take place that might threaten the life of the painting.

Inevitably, Frankenthaler gave up staining her canvases with oil and moved to acrylic in 1963. With this medium, she was able to create such intensely atmospheric paintings as *The Bay* (**Fig. 11-25**). Working on the floor and pouring paint directly on the canvas, the artist was able to make the painting seem spontaneous, even though it is quite large. "A really good picture," Frankenthaler says, "looks as if it's happened at once. . . . It looks as if it were born in a minute."

The usefulness of acrylic for outdoor mural painting was immediately apparent. Once dried, the acrylic surface was relatively immune to the vicissitudes of weather. Judith F. Baca, whose mural for the University of Southern California student center we considered in Chapter 8, put the medium to use in 1976 for *The Great Wall of Los Angeles*, a mural that would be more than a mile long. It is located in the Tujunga Wash of the Los Angeles River, which had been entirely concreted over by developers as Los Angeles grew. The river, as a result, seemed to Baca "a giant scar across the land which served to further divide an already divided city." She thought of her mural, which depicts the history of the indigenous peoples, immigrant minorities, and women of the area from prehistory to the present, as a healing gesture: "Just as young Chicanos tattoo battle scars on their bodies, *Great Wall of Los Angeles* is a tattoo on a scar where the river once ran." Illustrated here (**Fig. 11-26**) is a 13-foot-high section depicting the intersection of four major freeways in the middle of East Los Angeles, the traditional center of Chicano life in the city, freeways that divided the community and weakened it. To the right, for instance, a Mexican woman protests the building of Dodger Stadium, which displaced the traditional Mexican community in Chavez Ravine, a theme Baca also explores in the mural at USC.

Baca worked on the *Great Wall* project more as a director and facilitator than as a painter. Nearly 400 inner-city youth, many of them recruited through the juvenile justice system from rival gangs, did the actual painting and design. They represented, in real terms, the divided city itself. "The thing about muralism," Baca says, "is that collaboration is a requirement. . . . [The] focus is cooperation."

Acrylic paint in aerosol cans is, of course, the very foundation of the graffiti writer's craft. Aerosol spray paint was first invented in 1949 by Ed Seymour, the owner of a Sycamore, Illinois, paint company, who used it to spray aluminum coating on radiators. By the early 1970s the home-decorating companies Krylon and Rust-Oleum were producing hundreds of millions of cans of acrylic spray paint a year. Not only small and easy to carry, these cans were also easy to steal, and graffiti writing exploded onto the scene

Fig. 11-25 Helen Frankenthaler, *The Bay*, 1963.
Acrylic on canvas, 6 ft. 8¾ in × 6 ft. The Detroit Institute of Arts, Founders Society Purchase, Dr. & Mrs. Hilbert H. Delawter Fund.

Fig. 11-26 Judith F. Baca (1946–1983), *The Great Wall of Los Angeles*, detail, *Division of the Barrios and Chavez Ravine*, 1976–continuing.
Mural, height 13 ft. (whole mural more than 1 mile long). Tujunga Wash, Los Angeles, CA.
Courtesy of SPARC (sparcmurals.org).

in the 1970s, borne of the same cultural climate that produced the popular poetry/music/performance/ dance phenomenon known as rap, or hip-hop. While still considered by many criminal activity, graffiti has entered the mainstream artworld in, for instance, the work of Jean-Michel Basquiat (see Fig. 2-23) or even on the walls of art spaces such as the former Dietch Projects space, now curated by Hole Gallery, on Houston Street in New York's Soho district (**Fig. 11-27**), where beginning in 2008, the wall's owner has invited numerous artists to create work. Pictured here is a mural by Kenny Scharf, which he painted without a predetermined plan in 5 days in late November 2010. It required over 200 cans of spray paint and was in place until late June 2011.

Fig. 11-27 Kenny Scharf mural on Houston Street, Soho, Manhattan, New York, as it appeared on May 31, 2011.

Mixed Media

All of the painting media we have so far considered can be combined with other media, from drawing to fiber and wood, as well as found objects, to make new works of art. In the twentieth century in particular, artists purposefully and increasingly combined various media. The result is **mixed media** work. The motives for working with mixed media are many, but the primary formal one is that mixed media artworks violate the integrity of painting as a medium. They do this by introducing into the space of painting materials from the everyday world.

COLLAGE

The two-dimensional space of the canvas was first challenged by Pablo Picasso and his close associate Georges Braque when they began to utilize collage in their work. **Collage** is the process of pasting or gluing fragments of printed matter, fabric, natural material—anything that is relatively flat—onto the two-dimensional surface of a canvas or panel. Collage creates, in essence, a low-relief assemblage.

A good example of collage is one created soon after Picasso and Braque began using the new technique by their colleague Juan Gris. Although no one would mistake *The Table* (**Fig. 11-28**) painting for an accurate rendering of reality, it is designed to raise the question of just what, in art, is "real" and what is "false" by bringing elements from the real world into the space of the painting. The woodgrain of the tabletop is both woodgrain-printed wallpaper and paper with the woodgrain drawn on it by hand. Thus it is both "false" wood and "real" wallpaper, as well as "real" drawing. The fragment of the newspaper headline—it's a "real" piece of newspaper, incidentally—reads "*Le Vrai et le Faux*" ("The True and the False"). A novel lies open at the base of the table. Is it any less "real" as a novel just because it is a work of fiction? The key in the table drawer offers us a witty insight into the complexity of the work, for in French the word for "key," *clé*, also means "problem." In this painting, the problematic interchange between art and reality that painting embodies is fully highlighted. If painting is, after all, a mental construction, an artificial reality and not reality itself, are not mental constructions as real as anything else?

Because it brings "reality" into the space of painting, collage offers artists a direct means of commenting on the social or political environment in which they work (for an example of a Nazi-era political collage, see *The Creative Process*, pp. 252–253). The African-American artist Romare Bearden was inspired particularly by the African-American writer Ralph Ellison's 1952 novel *Invisible Man*. One of Ellison's narrator's most vital realizations is that he must assert, above all else, his blackness, not hide from it. He must not allow himself to be absorbed into white society. "Must I strive toward colorlessness?" he asks.

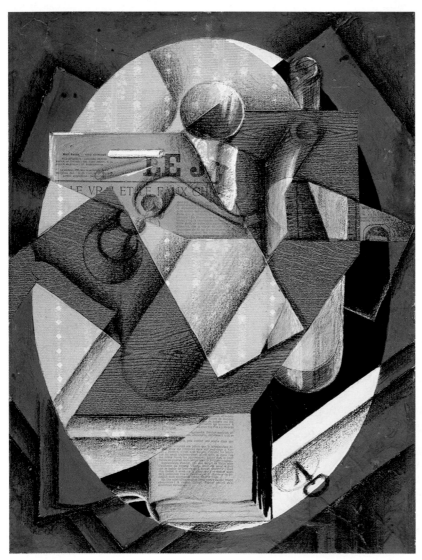

Fig. 11-28 Juan Gris, *The Table*, 1914.
Colored papers, printed matter, charcoal on paper mounted on canvas, 23 ½ × 17½ in. © Philadelphia Museum of Art. A. E. Gallatin Collection.

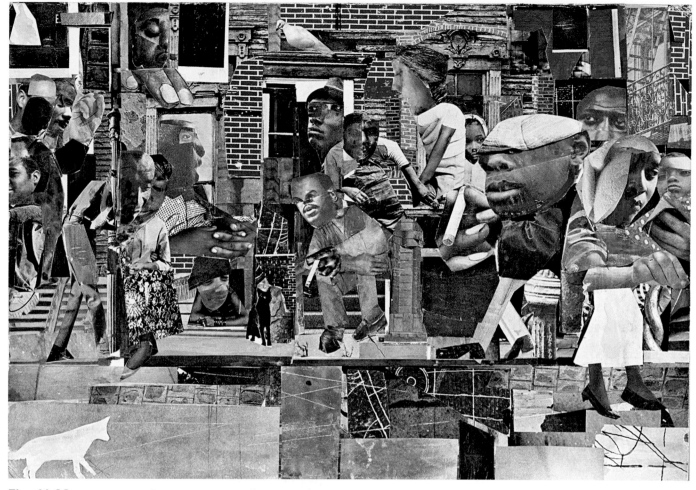

Fig. 11-29 Romare Bearden (1914–1988), *The Dove*, 1964.
Cut-and-pasted photoreproductions and papers, gouache, pencil, and colored pencil on cardboard, 13⅜ × 18¾ in. Art. Museum of Modern Art, New York. Blanchette Rockefeller Fund.
© Romare Bearden Foundation/Licensed by VAGA, NY. Art © Romare Bearden Foundation/Licensed by VAGA, New York, NY.

But seriously, and without snobbery, think of what the world would lose if that should happen. America is woven of many strands; I would recognize them and let it so remain. . . . Our fate is to become one, and yet many—this is not prophecy, but description.

There could be no better description of Bearden's collages. Bearden had worked for two decades in an almost entirely abstract vein, but, inspired by Ellison, in the early 1960s, he began to tear images out of *Ebony*, *Look*, and *Life* magazines and assemble them into depictions of the black experience. *The Dove* (**Fig. 11-29**)— so named for the white dove that is perched over the central door, a symbol of peace and harmony—combines forms of shifting scale and different orders of fragmentation, so that, for instance, a giant cigarette extends from the hand of the dandy, sporting a cap, at the right,

or the giant fingers of a woman's hand reach over the windowsill at the top left. The resulting effect is almost kaleidoscopic, an urban panorama of a conservatively dressed older generation and hipper, younger people gathered into a scene nearly bursting with energy—the "one, and yet many." As Ellison wrote of Bearden's art in 1968:

Bearden's meaning is identical with his method. His combination of technique is in itself eloquent of the sharp breaks, leaps of consciousness, distortions, paradoxes, reversals, telescoping of time and surreal blending of styles, values, hopes, and dreams which characterize much of American history.

Mixed media, in other words, provide Bearden with the means to bring the diverse elements of urban African-American life into a formally unified, yet still distinctly fragmented, whole.

Given collage's inclusiveness, it is hardly surprising that it is among the most political of media. In Germany, after World War I, as the forces that would lead to the rise of Hitler's Nazi party began to assert themselves, a number of artists in Berlin, among them Hannah Höch, began to protest the growing nationalism of the country in their art. Reacting to the dehumanizing speed, technology, industrialization, and consumerism of the modern age, they saw in collage, and in its more representational cousin, photomontage—collage constructed of photographic fragments—the possibility of reflecting the kaleidoscopic pace, complexity, and fragmentation of everyday life. Höch was particularly friendly with Raoul Hausmann, whose colleague Richard Hulsenbeck had met a group of so-called Dada artists in Zurich, Switzerland, in 1916. The anarchic behavior of these "anti-artists" had impressed both men, and with Höch and others they inaugurated a series of Dada evenings in Berlin, the first such event occurring on April 12, 1918. Hulsenbeck read a manifesto, others read sound or noise poetry, and all were accompanied by drums, instruments, and audience noise. On June 20, 1920, they opened a Dada Fair in a three-room apartment covered from floor to ceiling with a chaotic display of photomontages, Dada periodicals, drawings, and assemblages, one of which has been described as looking like "the aftermath of an accident between a trolley car and a newspaper kiosk." On one wall was Hannah Höch's photomontage *Cut with the Kitchen Knife Dada through the Last Weimar Beer Belly Cultural Epoch of Germany* (**Fig. 11-31**).

We are able to identify many of the figures in Höch's work with the help of a preparatory drawing (**Fig. 11-30**). The top right-hand corner is occupied by the forces of repression. The recently deposed emperor Wilhelm II, with two wrestlers forming his mustache, gazes out below the words "Die anti-dadistische Bewegung," or "the anti-Dada movement," the leader of what Höch calls in her title "the Weimar beer belly." On Wilhelm's shoulder rests an exotic dancer with the head of General Field Marshal Friedrich von Hindenburg. Below them are other generals and, behind Wilhelm, a photograph of people waiting in line at a Berlin employment office.

The upper left focuses on Albert Einstein, out of whose brain Dada slogans seem to burst, as if the theory of relativity, overturning traditional physics as it did, was a proto-Dada event. In the very center of the collage is a headless dancer, and above her floats the head of printmaker Kathë Kollwitz. To the right of her are the words "*Die grosse Welt dada,*" and then, further down, "*Dadaisten,*" "the great dada World," and "Dadaists." Directly above these words are Lenin, whose head tops a figure dressed in hearts, and Karl Marx, whose head seems to emanate from a machine. Raoul Hausmann, one of the founders of Berlin Dada, stands just below in a diver's suit. A tiny picture of Höch herself is situated at the bottom right, partially on the map of Europe that depicts the progress of women's enfranchisement. To the left a figure stands above the crowd shouting "*Tretet Dada bei*"—"Join Dada."

Fig. 11-30 Hannah Höch, *Study for Collage "Cut with the Kitchen Knife Dada through the Last Weimar Beer Belly Cultural Epoch of Germany,"* 1919.

Ballpoint pen sketch on white board, 10⅝ × 8⅝ in. Staatliche Museen zu Berlin, Preussischer Kulturbesitz Nationalgalerie/NG 57/61.

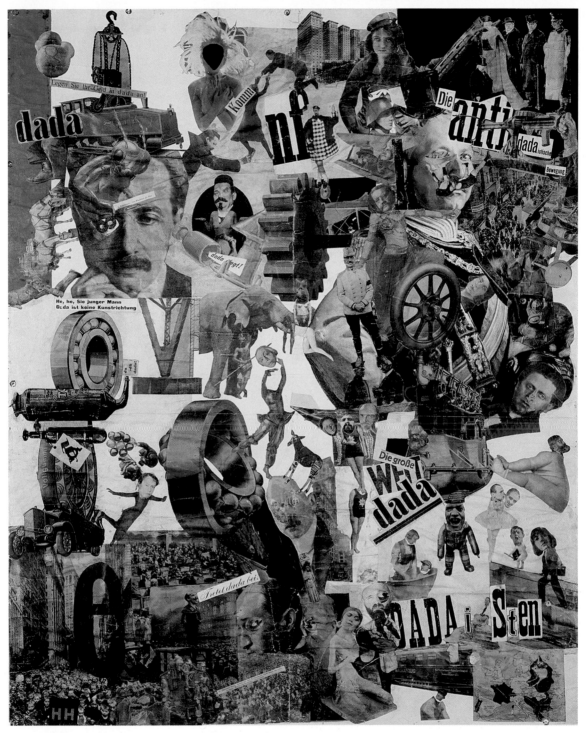

Fig. 11-31 Hannah Höch, *Cut with the Kitchen Knife Dada through the Last Weimar Beer Belly Cultural Epoch of Germany*, 1919.
Collage, 44⅞ × 35⅞₆ in. Staatliche Museen zu Berlin, Preussischer Kulturbesitz Nationalgalerie/NG57/61.

PAINTING BEYOND THE FRAME

One of the most important results of mixed media has been to extend what might be called "the space of art." If this space was once defined by the picture frame—if art was once understood as something that was contained within that boundary and hung on a wall—that definition of space was extended in the hands of mixed-media artists, out of the two-dimensional and into the three-dimensional space.

Patricia Patterson's *The Kitchen* (**Fig. 11-32**) is a celebration of family life on the island of Inishmore, the largest of the Aran Islands in Galway Bay on the west coast of Ireland. On the gallery wall to the right hangs Patterson's painting *Cóilin and Patricia*, in which Cóilin Hernon, head of the Inishmore Hernon family, gives the artist a jovial hug. The human warmth of the scene extends beyond the frame into a replication of the Hernon family kitchen itself, with its table and hearth. On the mantel is a watercolor of Nan Hernon and a drawing of the Hernon family dog, along with a ceramic rooster and chicken, an alarm

clock, and other objects—like the table and chairs, all duplicates of objects in the actual Hernon home. The colors Patterson employs in the tile and walls are the same as those found on the doors, windows, and furniture of Inishmore itself. In fact, Patterson, who was born in New Jersey to Irish-American parents, began visiting Inishmore regularly beginning in 1960 and was moved not only by the warmth of its people but by their steadfast loyalty to Irish culture and the Irish language. In its quiet orderliness, *The Kitchen* brings something of that world out of the painting's frame and into the museum.

At first glance, Kara Walker's installations, such as *Insurrection! (Our Tools Were Rudimentary, Yet We Pressed On)* (**Figs. 11-33** and **11-34**), seem almost doggedly unsculptural. Her primary tool, after all, is the silhouette, a form of art that was popularized in the courts of Europe in the early eighteenth century. It takes its name from the Finance Minister of France, Etienne de Silhouette, an ardent silhouette artist who in the 1750s and '60s was in charge of the king's

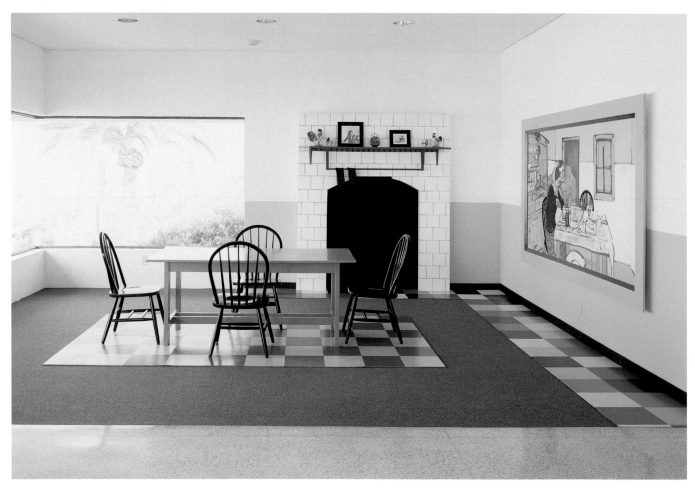

Fig. 11-32 Patricia Patterson, *The Kitchen*, 1985.
Table, chairs, mantel, objects, floor tiles, and casein on canvas painting; painting: 60 × 107 in; overall dimensions vary with each installation (as illustrated: 80 × 144 × 180 in.). Museum of Contemporary Art, San Diego. Museum Purchase, 90:11.1–43.
© 1985 Patricia Patterson.

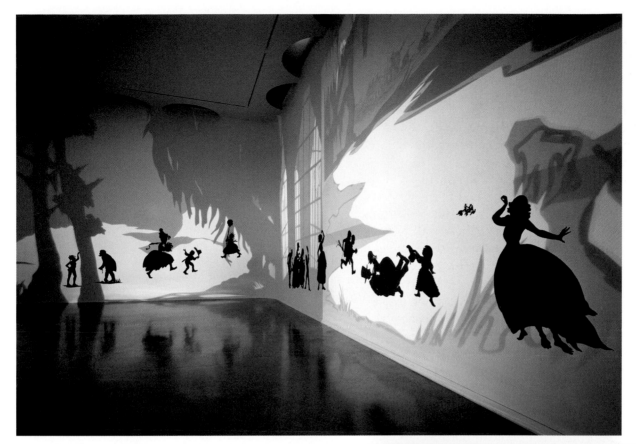

Figs. 11-33 and 11-34 Kara Walker, *Insurrection! (Our Tools Were Rudimentary, Yet We Pressed On)*, installation views, 2000.

Cut paper silhouettes and light projections, site-specific dimensions. Solomon R. Guggenheim Museum, New York. Purchased with funds contributed by the International Director's Council and Executive Committee Members, 2000.

Courtesy of the artist and Sikkema Jenkins & Co.

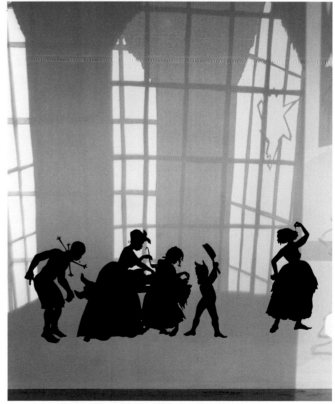

merciless taxation of the French people. Peasants, in fact, took to wearing only black in protest: "We are dressing à la Silhouette," so the saying went. "We are shadows, too poor to wear color. We are Silhouettes!"

Walker's silhouette works reflect the political context of the medium's origins, except that she has translated it to the master-slave relationship in the nineteenth-century antebellum South. In fact, throughout the nineteenth century, silhouette artists traveled across the United States catering especially to the wealthy, Southern plantation owners chief among them. In *Insurrection!*, a series of grisly scenes unfolds across three walls. On the back wall, a plantation owner propositions a naked slave who hides from him behind a tree. A woman with a tiny baby on her head escapes a lynching. In the corner, on the right wall, in a scene barely visible in Fig. 11-33, but reproduced in its entirety in Fig. 11-34, slaves disembowel a plantation owner with a soup ladle, as another readies to strike him with a frying pan, and another, at the right, raises her fist in defiance.

But what really transforms this installation into a sculptural piece are light projections from the ceiling that throw light onto the walls. These projections are not only metaphoric—as viewers project their own

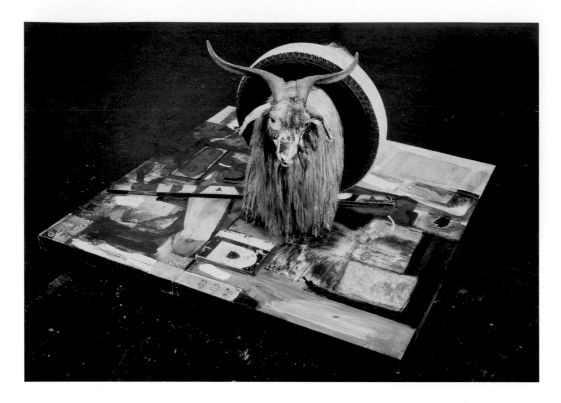

fears and desires onto other bodies—but they also activate the space by projecting the viewers' shadows onto the walls so that they themselves become implicated in the scene.

This movement is nowhere more forcefully stated than in the work of Robert Rauschenberg. Rauschenberg's painting *Monogram* (**Fig. 11-35**) literally moves "off the wall"—the title of Calvin Tomkins's biography of the artist—onto the floor. A **combine-painting**, or high-relief collage, Rauschenberg worked on the canvas over a five-year period from 1955 to 1959.

The composer John Cage once defined Rauschenberg's combine-paintings as "a situation involving multiplicity." They are a kind of collage, but more lenient than other collages about what they will admit into their space. They will, in fact, admit anything, because unity is not something they are particularly interested in. They bring together objects of diverse and various kinds and simply allow them to coexist beside one another in the same space. In Rauschenberg's words, "A pair of socks is no less suitable to make a painting with than wood, nails, turpentine, oil, and fabric." Nor, apparently, is a stuffed Angora goat.

Rauschenberg discovered the goat in a second-hand office-furniture store in Manhattan. The problem it presented, as Tomkins has explained, was how "to make the animal look as if it belonged in a painting." In its earliest recorded state (**Fig. 11-36**) the goat is mounted on a ledge in profile in the top half of a 6-foot

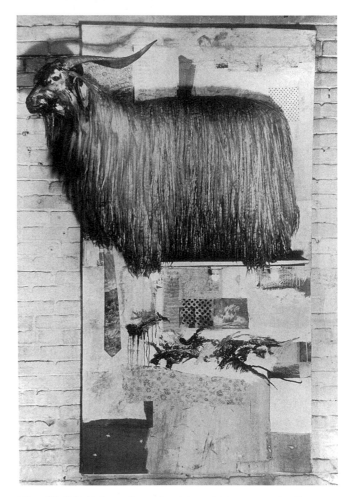

Fig. 11-36 Robert Rauschenberg, *Monogram*, 1st State.
Photo: Harry Shunk. Art © Estate of Robert Rauschenberg/Licensed by VAGA, New York, NY.

painting. It peers over the edge of the painting and casts a shadow on the wall. Compared to later states of the work, the goat is integrated into the two-dimensional surface, or as integrated as an object of its size could be.

In the second state, Rauschenberg brought the goat off its perch and set it on a platform in front of another combine-painting, this one nearly 10 feet high. Now it seemed about to walk forward into our space, dragging the painting behind it. At this point, Rauschenberg also placed an automobile tire around the goat's midsection, which asserted the volume and three-dimensionality of the goat.

But Rauschenberg was not happy with this design, either. Finally, he put the combine-painting flat on the floor, creating what he called a "pasture" for the goat. Here, Rauschenberg manages to accomplish what seems logically impossible: The goat is at once fully contained within the boundaries of the picture frame and totally liberated from the wall. Painting has become sculpture.

And painting can also become integral to architecture, literally creating architectural space. This is, of course, something of the same purpose as Michelangelo's Sistine Chapel paintings (see Fig. 11-10), but a more recent example is German artist Franz Ackermann's painting *Coming Home and (Meet Me) At the Waterfall* (**Fig. 11-37**), installed in 2009 in the new Dallas Cowboys Stadium in Arlington, Texas. Ackermann's paintings are grounded in his travels, and represent visually the rhythm of his encounters—in this case, the journey from his home in Berlin to the environs of North Texas. The painting works to underscore the vertical space of the stadium, the horizontal flow of its five tiers, and the diagonals of the stairs and escalators rising through it. We find ourselves literally "in the painting," as if, on the escalators we are traveling, not through the architecture of the space so much as through the mindscape of Ackermann himself.

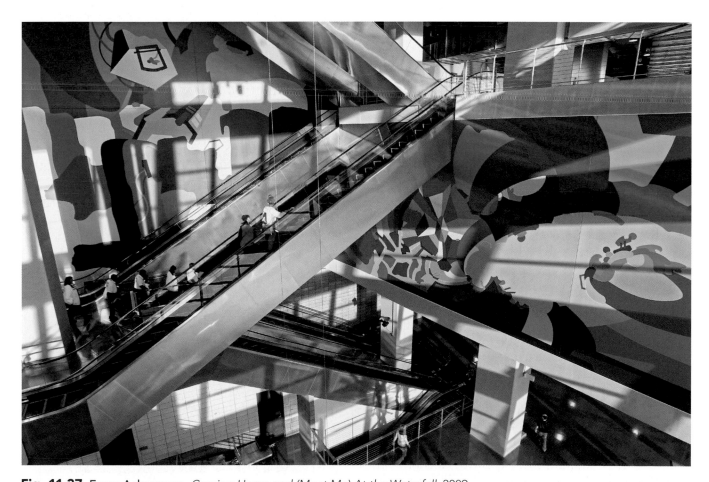

Fig. 11-37 Franz Ackermann, *Coming Home and (Meet Me) At the Waterfall*, 2009.
Acrylic on wall, dimensions variable. SW Monumental Staircase, Dallas Cowboys Stadium, Arlington, Texas.
Courtesy of the artist and White Cube.

How does buon fresco *differ from* fresco secco?

For centuries, the preferred medium for wall painting has been fresco, in which pigment, mixed with lime water, is applied to a plaster wall. In *buon fresco*, the pigment is applied to a wet wall, while in *fresco secco*, the pigment is applied to a dry wall. Why has *fresco secco* been particularly durable at the Buddhist caves at Ajanta? What is a *giornata*?

What are some of the advantages of oil paint?

Oil paint is a highly versatile medium. It can be blended on the painting's surface to create a continuous scale of tones and hues, fostering a superior illusion of three dimensions. It can also be applied in thin layers called glazes, which promote luminosity. What is impasto? Why does oil paint have superior *expressive* potential?

How are watercolor paintings made?

Watercolor paint is made from pigment suspended in gum arabic. To make a watercolor painting, this paint is combined with water and applied to paper. What defines the style known as *xie yi*? How does Winslow Homer create visual interest in his watercolor *A Wall, Nassau*?

What is mixed media work?

Painting media can often be used in combination with each other and with other media, such as drawing, fiber, and found objects. Many artists, particularly beginning in the twentieth century, have been interested in challenging tradition by violating the integrity of painting. What is collage, and why is it often used for political goals? How can mixed media be used to extend the "space of art"? What is combine-painting?

THE CRITICAL PROCESS

Thinking about Painting

In this chapter, we have considered all of the painting media—encaustic, fresco, tempera, oil paint, watercolor, gouache, acrylic paints, and mixed media—and we have discussed not only how these media are used but also why artists have favored them. One of the most important factors in the development of new painting media has always been the desire of artists to represent the world more and more faithfully. But representation is not the only goal of painting. If we recall Artemisia Gentileschi's *Self-Portrait* at the beginning of this chapter (see Fig. 11-2), she is not simply representing the way she looks but also the way she feels. In her hands, paint becomes an expressive tool. Some painting media—oil paint, watercolor, and acrylics—are better suited to expressive ends than others because they are more fluid or can be manipulated more easily. But the possibilities of painting are as vast as the human imagination itself. In painting, anything is possible.

And, as we have seen in the last section of this chapter, the possibilities of painting media can be extended even further when they are combined with other media. The art of Fred Tomaselli is a case in

point. In the late 1980s, Tomaselli began producing mixed-media works that combine pills (over-the-counter medicines, prescription pharmaceuticals, and street drugs), leaves (including marijuana leaves), insects, butterflies, and various cutout elements, including floral designs, representations of animals, and body parts. The resulting images constitute for Tomaselli a kind of cartography—he sees them as "maps" describing his place in the world. *Airborne Event* (**Fig. 11-38**) might well be considered an image of a psychedelic high. But Tomaselli, born in the late 1950s, is well aware of the high price first hippie and then punk cultures have paid for their hallucinogenic indulgences. Another way to read this painting is as a critique of what has been called "the jewel-like nature of a pill." That is, Tomaselli's work might also be considered an essay on the toxic nature of beauty or "airborne events" such as disease or disaster. How does it suggest that the world it depicts is as artificial as it is visionary? In order to answer this question, it might be useful to compare Tomaselli's mixed-media work to Fra Andrea Pozzo's *Glorification of Saint Ignatius* (see Fig. 11-7).

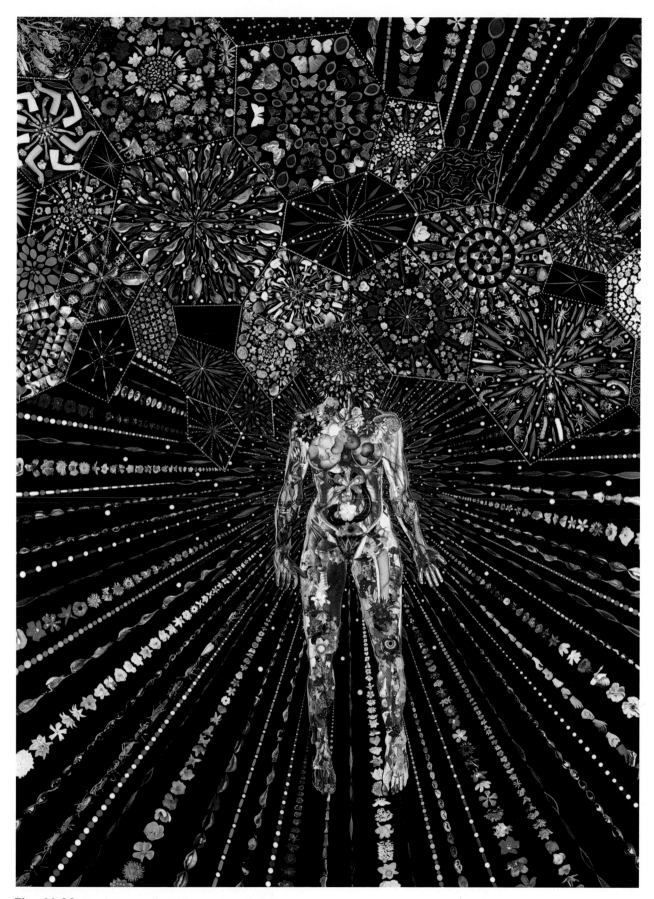

Fig. 11-38 Fred Tomaselli, *Airborne Event*, 2003.
Mixed media, acrylic, and resin on wood, 84 × 60 × 1¹/₂ in.
Image Courtesy of James Cohan Gallery, New York.

12 | Photography and Time-Based Media

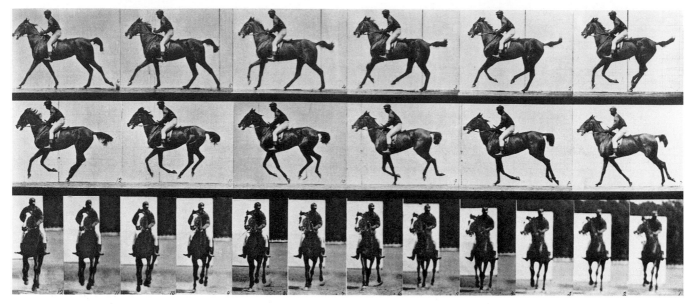

Fig. 12-1 Eadweard Muybridge, *Annie G, Cantering, Saddled*, December 1887.
Collotype print, sheet: 19 × 24 in., image: 7¹/₂ × 16¹/₈ in. Philadelphia Museum of Art. City of Philadelphia,
Trade & Convention Center, Dept. of Commerce, 1962-135-280.

Thinking Thematically: See **Art and the Passage of Time** on myartslab.com

 View the Closer Look on *Annie G. Cantering*
on myartslab.com

THINKING AHEAD

What is photogenic drawing?

What is the Zone System?

What is editing in film?

What are some of the advantages and disadvantages of video art?

 Listen to the chapter audio on myartslab.com

Thus far in Part 3 we have discussed the two-dimensional media of drawing, printmaking, and painting. Now we turn to the rest of the two-dimensional media, photography and the other camera arts, which also allow the artist to explore the fourth dimension—time.

The images that come from still, motion-picture, and video cameras are, first and foremost, informational. Cameras record the world around us, and the history of the camera is a history of technologies that record our world with ever-increasing sophistication and expertise. Photography began, in about 1838, with still images, but the still image almost immediately generated the thought that it might be possible to capture the object in motion as well. Such a dream seemed even more possible when photographs of a horse trotting were published by Eadweard Muybridge in *La Nature* in 1878 (**Fig. 12-1**). Muybridge had used a trip-wire device in an experiment commissioned by California Governor Leland Stanford to settle a bet about whether there

were moments in the stride of a trotting or galloping horse when it was entirely free of the ground.

Work such as Muybridge's soon inspired Thomas Edison and W. K. Laurie Dickson to invent, between 1888 and 1892, the Kinetoscope, the first continuous-film motion-picture viewing machine, itself made possible by George Eastman's introduction of celluloid film that came on a roll, produced expressly for his new camera, the Kodak. Dickson devised a sprocket wheel that would advance the regularly perforated roll of film, and Edison decided on a 35 mm width for the strip of film (eventually the industry standard). But Edison's films were only viewable on the Kinetoscope through a peep hole, one person at a time.

The first projected motion pictures available to a large audience had their public debut on December 28, 1895, in Paris, when August and Louis Lumière showed 10 films, projected by their *Cinématographe*, that lasted for about 20 minutes. Among the most popular of their early films was *Waterer and Watered* (**Fig. 12-2**), in which a boy steps on a gardener's hose, stopping the flow of water. When the gardener looks at the nozzle, the boy steps off the hose, and the gardener douses himself. A brief chase ensues, with both boy and gardener leaving the frame of the stationary camera for a full two seconds. Audiences howled with delight.

To the silent moving image, sound was soon added. To the "talkie" was added color. And film developed in its audience a taste for "live" action, a taste satisfied by live television transmission, video images that allow us to view anything happening in the world as it happens. Thus, not unlike the history of painting, the history of the time-based media is a history of increasing immediacy and verisimilitude, or semblance to the truth. In this chapter, we will survey that history, starting with still photography, moving to film, and, finally, to video. Our focus will be on artistic uses of these media.

Photography

Photography (from the Greek *phos*, "light," and *graphos*, "writing," literally "writing with light") is, like collage, at least potentially an inclusive rather than an exclusive medium. You can photograph anything you can see. According to artist Robert Rauschenberg, whose combine-paintings we studied in the last chapter (see Fig. 11-35), "The world is essentially a storehouse of visual information. Creation is the process of assemblage. The photograph is a process of instant assemblage, instant collage." Walker Evans's photograph *Roadside Stand Near Birmingham, Alabama* (**Fig. 12-3**) is an example of just such "instant collage."

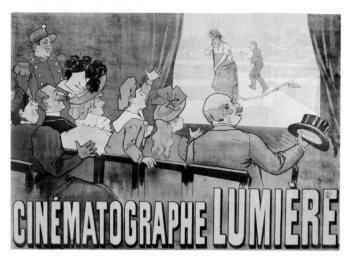

Fig. 12-2 Poster for the Cinématographe, with the Lumière Brothers film *L'Arroseur arrosé* (*Waterer and Watered*) on screen, 1895.
British Film Institute.
Mary Evans Picture Library/Everett Collection.

Evans's mission as a photographer was to capture every aspect of American visual reality, and his work has been called a "photographic equivalent to the Sears, Roebuck catalog of the day." But the urge to make such instant visual assemblages—to capture a moment in time—is as old as the desire to represent the world accurately. We begin our discussion of photography by considering the development of the technology itself, and then we will consider the fundamental aesthetic problem photography faces—the tension between form and content, the tension between the way a photograph is formally organized as a composition and what it expresses or means.

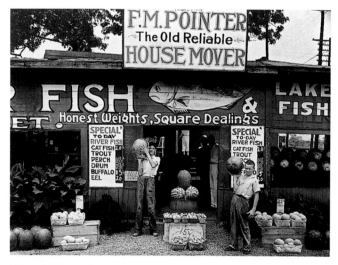

Fig. 12-3 Walker Evans, *Roadside Stand Near Birmingham, Alabama*, 1936.

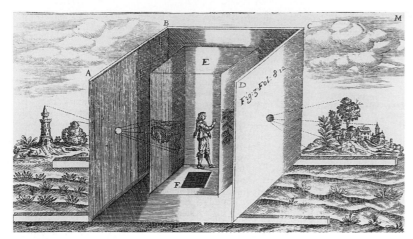

Fig. 12-4 Unidentified Photographer, *Camera Obscura*. The first illustration of a *camera obscura* used to observe a solar eclipse, published 1544 by Dutch physician and mathematician Reinerius Gemma-Frisius.
Engraving. George Eastman House.

Thinking Thematically: See **Art, Science, and the Environment** on myartslab.com

EARLY HISTORY

The word *camera* is the Latin word for "room." And, in fact, by the sixteenth century, a darkened room, called a *camera obscura*, was routinely used by artists to copy nature accurately. The scientific principle employed is essentially the same as that used by the camera today. A small hole on the side of a light-tight room admits a ray of light that projects a scene, upside down, directly across from the hole onto a semitransparent white scrim. The *camera obscura* depicted here (**Fig. 12-4**) is a double one, with images entering the room from both sides. It is also portable, allowing the artist to set up in front of any subject matter.

But working with the *camera obscura* was a tedious proposition, even after small portable dark boxes came into use. The major drawback of the *camera obscura* was that while it could capture the image, it could not preserve it. In 1839, that problem was solved simultaneously in England and France, and the public was introduced to a new way of representing the world.

In England, William Henry Fox Talbot presented a process for fixing negative images on paper coated with light-sensitive chemicals, a process that he called **photogenic drawing** (**Fig. 12-5**). In France, a different process, which yielded a positive image on a polished metal plate, was named the **daguerreotype** (**Fig. 12-6**), after one of its two inventors, Louis-Jacques-Mandé Daguerre (Nicéphore Niépce had died in 1833, leaving Daguerre to perfect the process and garner the laurels). Public reaction was wildly enthusiastic, and the French and English press faithfully reported every development in the greatest detail.

When he saw his first daguerreotype, the French painter Paul Delaroche is reported to have exclaimed, "From now on, painting is dead!" Delaroche may have overreacted, but he nevertheless understood the potential of the new medium of photography to usurp painting's historical role of representing the world.

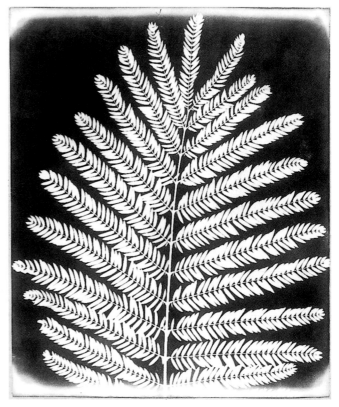

Fig. 12-5 William Henry Fox Talbot, *Mimosoidea Suchas, Acacia*, c. 1839.
Photogenic drawing, Fox Talbot Collection, National Museum of Photography, London.

In fact, photographic portraiture quickly became a successful industry. As early as 1841, a daguerreotype portrait could be had in Paris for 15 francs. That same year in London, Richard Beard opened the first British portrait studio, bringing a true sense of showmanship to the process. One of his first customers, the novelist Maria Edgeworth (**Fig. 12-7**), described having her portrait done at Beard's in a breathless letter dated May 25, 1841: "It is a wonderful mysterious operation.

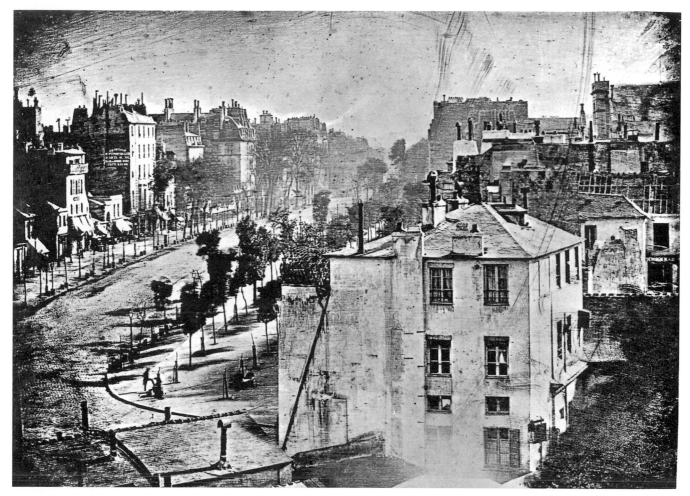

Fig. 12-6 Louis-Jacques-Mandé Daguerre, *Le Boulevard du Temple*, 1839. Daguerreotype. Bayerisches National Museum, Munich.

You are taken from one room into another upstairs and down and you see various people whispering and hear them in neighboring passages and rooms unseen and the whole apparatus and stool on a high platform under a glass dome casting a snapdragon blue light making all look like spectres and the men in black gliding about. . . ."

In the face of such a "miracle," the art of portrait painting underwent a rapid decline. Of the 1,278 paintings exhibited at the Royal Academy in London in 1830, more than 300 were miniatures, the most popular form of the portrait; in 1870, only 33 miniatures were exhibited. In 1849 alone, 100,000 daguerreotype portraits were sold in Paris. Not only had photography replaced painting as the preferred medium for portraiture, but it had democratized the genre as well, making portraits available not only to the wealthy, but also to the middle class, and even, with some sacrifice, to the working class.

The daguerreotype itself had some real disadvantages as a medium, however. In the first place, it

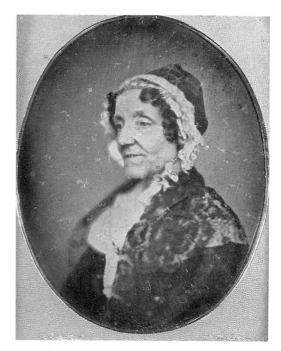

Fig. 12-7 Richard Beard, *Maria Edgeworth*, 1841. Daguerreotype, 2¹⁄₈ × 1³⁄₄ in.
By courtesy of the National Portrait Gallery, London.

Fig. 12-8 William Henry Fox Talbot, *The Open Door*, 1843.
Calotype. Fox Talbot Collection, National Museum of Photography, London.

required considerable time to prepare, expose, and develop the plate. Iodine was vaporized on a copper sheet to create light-sensitive silver iodide. The plate then had to be kept in total darkness until the camera lens was opened to expose it. At the time Daguerre first made the process public in 1839, imprinting an image on the plate took from 8 to 10 minutes in bright summer light. His own view of the Boulevard du Temple (see Fig. 12-6) was exposed for so long that none of the people in the street, moving about their business, left any impression on the plate, save for one solitary figure at the lower left, who is having his shoes shined. By 1841, the discovery of so-called chemical "accelerators" had made it possible to expose the plate for only one minute, but a sitter could not move in that time for fear of blurring the image. The plate was finally developed by suspending it face down in heated mercury, which deposited a white film over the exposed areas. The unexposed silver iodide was dissolved with salt. The plate then had to be rinsed and dried with the utmost care.

An even greater drawback of the daguerreotype was that it could not be reproduced. Using paper instead of a metal plate, Fox Talbot's photogenic process made multiple prints a possibility. Talbot quickly learned that he could reverse the negative image of the photogenic drawings by placing sheets of sensitized paper over them and exposing both again to sunlight. Talbot also discovered that sensitized paper, exposed for even a few seconds, held a latent image that could be brought out and developed by dipping the paper in gallic acid. This calotype process is the basis of modern photography.

In 1843, Talbot made a picture, which he called *The Open Door* (**Fig. 12-8**), that convinced him that the calotype could not only document the world as we know it, but also become a work of art in its own right. When he published this calotype in his book *The Pencil of Nature*, the first book of photographs ever produced, he captioned it as follows: "A painter's eye will often be arrested where ordinary people see nothing remarkable. A casual gleam of sunshine, or a shadow thrown

across his path, a time-withered oak, or a moss-covered stone may awaken a train of thoughts and feelings, and picturesque imaginings." For Talbot, at least, painters and photographers saw the world as one.

In 1850, the English sculptor Frederick Archer introduced a new **wet-plate collodion** photographic process that was almost universally adopted within five years. In a darkened room, he poured liquid collodion—made of pyroxyline dissolved in alcohol or ether—over a glass plate bathed in a solution of silver nitrate. The plate had to be prepared, exposed, and developed all within 15 minutes and while still wet. The process was cumbersome, but the exposure time was short and the rewards were quickly realized. On her forty-ninth birthday, in 1864, Julia Margaret Cameron, the wife of a high-placed British civil servant and friend to many of the most famous people of her day, was given a camera and collodion-processing equipment by her daughter and son-in-law. "It may amuse you, Mother, to photograph," the accompanying note said.

Cameron set up a studio in a chicken coop at her home on the Isle of Wight, and over the course of the next 10 years convinced almost everyone she knew to pose for her, among them the greatest men of British art, literature, and science. She often blurred their features slightly, believing this technique drew attention away from mere physical appearance and revealed more of her sitter's inner character. Commenting on her photographs of famous men like Thomas Carlyle (**Fig. 12-9**), she wrote, "When I have had such men before my camera, my whole soul has endeavored to do its duty towards them in recording faithfully the greatness of the inner man as well as the features of the outer

man. The photograph thus taken has been almost the embodiment of a prayer."

More than anything else, the ability of the portrait photographer to expose, as it were, the "soul" of the sitter led the French government to give photography the legal status of art as early as 1862. But from the beginning, photography served a documentary function as well—it recorded and preserved important events. Photographs of war, which at first startled audiences, were first published during the Crimean War, fought between Russia and an alliance of European countries and the declining Ottoman Empire in 1854–56. At the outbreak of the American Civil War, in 1861, Mathew Brady spent the

Fig. 12-9 Julia Margaret Cameron, *Portrait of Thomas Carlyle,* 1863.
Silver print, 10 × 8 in. The Royal Photographic Society, London.

Fig. 12-10 Timothy O'Sullivan (negative) and Alexander Gardner (print), *A Harvest of Death, Gettysburg, Pennsylvania, July 1863*, from Alexander Gardner's *Photographic Sketchbook of the War*, 1866. Albumen silver print (also available as a stereocard), 6¼ × 7¹³/₁₆ in. The New York Public Library, New York.

entirety of his considerable fortune to outfit a band of photographers to document the war. When Brady insisted that he owned the copyright for every photograph made by anyone in his employ, whether it was made on the job or not, several of his best photographers quit, among them Timothy O'Sullivan and Alexander Gardner. *A Harvest of Death, Gettysburg, Pennsylvania* (**Fig. 12-10**) was published after the war in 1866 in *Gardner's Photographic Sketchbook of the War*, probably the first book-length photo essay. It is a condemnation of the horrors of war, with the Battle of Gettysburg at its center. O'Sullivan's matter-of-fact photograph is accompanied by the following caption:

The rebels represented in the photograph are without shoes. These were always removed from the feet of the dead on account of the pressing need of the survivors. The pockets turned inside out also show that appropriation did not cease with the coverings of the feet. Around is scattered the litter of the battlefield, accoutrements, ammunitions, rags, cups and canteens, crackers, haversacks, and letters that may tell the name of the owner, although the majority will surely be buried unknown by strangers, and in a strange land.

In O'Sullivan's photograph, both foreground and background are purposefully blurred to draw attention to the central corpses. Such focus was made possible by the introduction of albumen paper, which retained a high degree of sharpness on its glossy surface. "Such a picture," Gardner wrote, "conveys a useful moral: It shows the blank horror and reality of war, in opposition to the pageantry. Here are the dreadful details! Let them aid in preventing such another calamity falling upon the nation." One of the first great photojournalists, O'Sullivan is reported to have photographed calmly during the most horrendous bombardments, twice having his camera hit by shell fragments.

Fig. 12-11 Alfred Stieglitz (1864–1946), *The Steerage*, 1907.

Photogravure, $12^{5}/_{8} \times 10^{3}/_{16} \times 10^{3}/_{8}$ in. Provenance unknown. (436.1986). The Museum of Modern Art, New York, NY, U.S.A.

Thinking Thematically: See **Art and Beauty** on myartslab.com

FORM AND CONTENT

It might be said that every photograph is an abstraction, a simplification of reality that substitutes two-dimensional for three-dimensional space; an instant of perception for the seamless continuity of time; and, in black-and-white work at least, the gray scale for color. By emphasizing formal elements over representational concerns, the artist further underscores this abstract side of the medium (see, for instance, the photographs by Umbo and Paul Strand, Figs. 5-24 and 5-25). One of the greatest sources of photography's hold on the popular imagination lies in this ability to aestheticize the everyday—to reveal as beautiful that which we normally take for granted. When he shot his ground-breaking photograph *The Steerage* (**Fig. 12-11**) in 1907,

American photographer Alfred Stieglitz was transfixed not by the literal figures and objects in his viewfinder, but by the spatial relations. "There were men, women, and children," he wrote,

on the lower level of the steerage [the lower class deck of a steamship]. . . . The scene fascinated me: A round straw hat; the funnel leaning left, the stairway leaning right; the white drawbridge, its railings made of chain; white suspenders crossed on the back of a man below; circular iron machinery; a mast that cut into the sky, completing a triangle. I stood spellbound for a while. I saw shapes related to one another—a picture of shapes, and underlying it, a new vision that held me. . . .

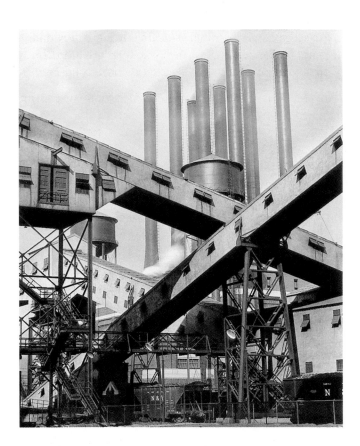

Fig. 12-12 Charles Sheeler, *Criss-Crossed Conveyors—Ford Plant*, 1927.
Gelatin silver print, 10 × 8 in. Museum of Fine Arts, Boston. The Land Collection.
Photograph © 2012 Museum of Fine Arts, Boston.

It is no coincidence, given this point of view, that Stieglitz was the first to reproduce the photographs of Paul Strand—*Abstraction, Porch Shadows* in particular (see Fig. 5-25)—in his photography magazine *Camera Work*, which he published from 1903 to 1916. And the geometric beauty of Stieglitz's work deeply influenced Charles Sheeler, who was hired by Henry Ford to photograph the new Ford factory at River Rouge in the late 1920s (**Fig. 12-12**). Sheeler's precise task was to aestheticize Ford's plant. His photographs, which were immediately recognized for their artistic merit and subsequently exhibited around the world, were designed to celebrate industry. They revealed, in the smokestacks, conveyors, and iron latticework of the factory, a grandeur and proportion not unlike that of the great Gothic cathedrals of Europe.

Even when the intention is simply to bring the facts to light, as is often true in photojournalism,

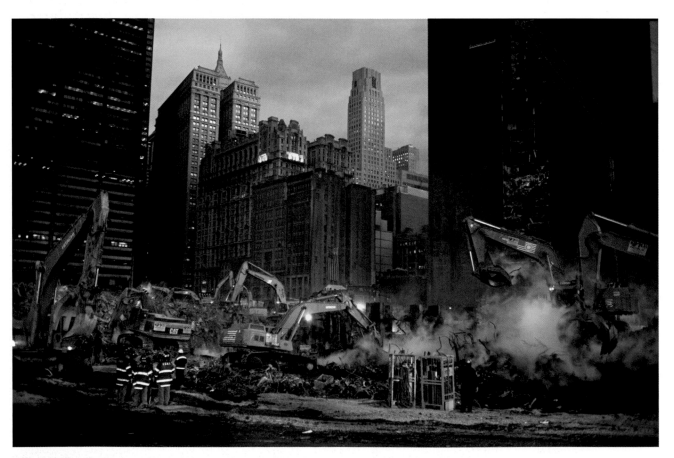

Fig. 12-13 Joel Meyerowitz, *Ten Grapplers Daisy-Chaining at Dusk*, November 5, 2001, from *Aftermath: World Trade Center Archive*, Phaidon Press, 2006.
© Joel Meyerowitz, courtesy Edwynn Houk Gallery.

the power of the photograph often comes from the aesthetic power of the work lent to it by its formal composition. When the tragedy at the World Trade Center occurred on September 11, 2001, Joel Meyerowitz was at his studio on Cape Cod preparing an exhibition of photographs of Lower Manhattan, taken from the window of his loft on 19th Street over the course of several seasons. The Trade Center featured prominently in them, and he was driven by a compelling need to record the aftermath of one of the most devastating events in American history. He was, at first, banned from the site, but beginning on September 23 and for nine months thereafter, he managed to document the clean-up operation, never officially, but, in the end, with the cooperation of the police officers, firefighters, construction workers, engineers, and volunteers at work there. The result is a massive book, *Aftermath: World Trade Center Archive*, which contains over 270 photographs, many of them of disconcerting beauty. Meyerowitz has this to say, for instance, about *Ten Grapplers Daisy-Chaining at Dusk* (**Fig. 12-13**):

It's hard to come to terms with the awful beauty of a place like this. After all, the site—thick with grief and death—was dangerous, noisy, dirty, poisonous, and costly almost beyond measure. And yet the demolition at Ground Zero was also a spectacle with a cast of thousands, lit by a master lighter and played out on a stage of immense proportions. As I stood there on the November evening, watching the light play and fade on the buildings as the dinosaurs beneath them danced their mad to-and-fro, it all looked wondrous.

Here, the visual rhythm of the grapplers, raising steam and smoke like dinosaurs breathing in the cold air, is framed by the dark forms of the buildings at either edge, all set against the stunning color of the building rising behind them.

Meyerowitz's work depends for much of its power not only on the elegance of its formal composition but our own certainty that the image is authentic, a depiction of the actual clean-up work at Ground Zero. Vietnam-born but American-educated An-My Lê's work contests the boundaries of the actual. Her series of photographs *Small Wars* (**Fig. 12-14**) depicts the activities of a group of men who meet regularly in Virginia and North Carolina to recreate the Vietnam War. The ambush depicted is not real; in other words, it is a reenactment. This is not the real Vietnam War with which Lê, born in Saigon in 1960, grew up, but it is, as she says, "the Vietnam of the mind." She explains:

When you're not looking at the real thing, you can see more clearly. You start thinking about the lessons learned or not learned. When you know it's not real, you think about the role of movies in perpetrating or glorifying or not glorifying war. And you think of all the literature about war.

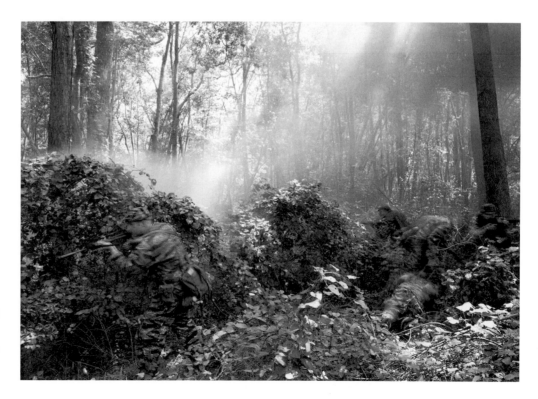

Fig. 12-14 An-My Lê, *Small Wars (Ambush I)*, 1999–2002. Gelatin silver print, 26 × 37½ in. Edition of 5.
Courtesy of Murray Guy, New York.

And you think as well of the photographs of war, such as O'Sullivan's *Harvest of Death* (see Fig.12-11). It turns out that O'Sullivan and his fellow photographers working for Mathew Brady often staged their photographs, not out of any sense of deceit but in order to heighten the dramatic effect of the image. O'Sullivan may or may not have moved the bodies of the soldiers in his photograph to heighten its visual impact, but he did lower the camera angle and raise the horizon line to fill as much of the image as possible with the dead. It was not factual but emotional truth that was O'Sullivan's object. Likewise, if the "battle" in the woods of Virginia that Lê has photographed is staged, as if her image were a black-and-white film still from, say, Francis Ford Coppola's *Apocalypse Now*, it nonetheless embodies something of the national psyche. It represents at some level who Lê believes the American people are.

The ambiguity of An-My Lê's image is analogous, in fact, to the chief characteristic of its formal composition—the tension between the crisp clarity of the foliage in the scene and the blurred action of the would-be combatants. Talking about the ways in which he arrives at the photographic image, Henri Cartier-Bresson described the relationship between form and content in the following terms:

We must place ourselves and our camera in the right relationship with the subject, and it is in fitting the latter into the frame of the viewfinder that the problems of composition begin. This recognition, in real life, of a rhythm of surfaces, lines, and values is for me the essence of photography. . . . We compose almost at the moment of pressing the shutter. . . . Sometimes one remains motionless, waiting for something to happen; sometimes the situation is resolved and there is nothing to photograph. If something should happen, you remain alert, wait a bit, then shoot and go off with the sensation of having got something. Later you can amuse yourself by tracing out on the photo the geometrical pattern, or spatial relationships, realizing that, by releasing the shutter at that precise instant, you had instinctively selected an exact geometrical harmony, and that without this the photograph would have been lifeless.

Thus, in looking at this photograph (**Fig. 12-15**), we can imagine Cartier-Bresson walking down a street in Athens, Greece one day in 1953, and coming across the second-story balcony with its references to the classical past. Despite the doorways behind the balcony, the second story appears to be a mere facade. Cartier-Bresson stops, studies the scene, waits, and then spies two women walking up the street in

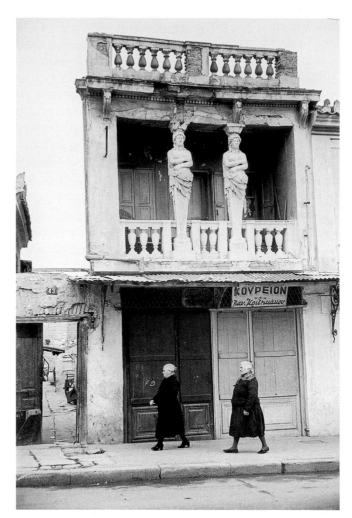

Fig. 12-15 Henri Cartier-Bresson, *Athens*, 1953.
Henri Cartier-Bresson/Magnum Photos, Inc.

his direction. They pass beneath the two female forms on the balcony above, and, at precisely that instant, he releases the shutter. Cartier-Bresson called this "the decisive moment." Later, in the studio, the parallels and harmonies between street and balcony, antiquity and the present moment, youth and age, white marble and black dresses, stasis and change—all captured in this photograph—become apparent to him, and he prints the image.

THE PHOTOGRAPHIC PRINT AND ITS MANIPULATION

For many photographers, the real art of photography takes place not behind the viewfinder but in the darkroom (see *The Creative Process*, pp. 272–273, for an example of Jerry Uelsmann's darkroom techniques). Among the masters of darkroom techniques was Ansel Adams who, with colleague Fred Archer, developed the **Zone System** in the late 1930s.

Adams defined the Zone System as "a framework for understanding exposures and development, and visualizing their effect in advance." A zone represents the relation of the image's (or a portion of the image's) brightness to the value or tone that the photographer wishes it to appear in the final print. Thus each picture is broken up into zones ranging from black to white with nine shades of gray in between—a photographic gray scale (see Fig. 6-15).

Over the course of his career, Adams became adept at anticipating the zonal relationships that he desired in the final print, even as he was first exposing his negatives to light. As a result, just in setting his camera's **aperture**—the size of the opening of the lens—he could go a long way toward establishing the luminescence of the scene that he wanted. "I began to think about how the print would appear and if it would transmit any of the feeling of the . . . shape before me in terms of its expressive-emotional quality," he wrote in his autobiography. "I began to see in my mind's eye the finished print I desired." He called this a process of "visualization," a process never fully realized until he was working in the darkroom. He often spent hours and hours in the darkroom creating the image that he felt represented his initial visualization. There he employed the techniques of **dodging** and **burning** to attain the finish he desired. Dodging decreases the exposure of selected areas of the print that the photographer wishes to be lighter; burning increases the exposure to areas of the print that should be darker. To dodge an area of a print, he might hold a piece of cardboard over it. To burn an area, he might hold a thick piece of paper with a hole cut out of it over the area that he wished to darken.

In one of his most famous prints, *Moonrise, Hernandez, New Mexico* (**Fig. 12-16**), large parts of the sky are burned, while the village, which was fast falling into darkness as the sun set on the afternoon that he took this photograph, is dodged to bring out more of its detail. If the sky was actually never this dark against the rising moon, and if the village was more in shadow, the stunning contrast between light and dark, as if we stand in this photograph at the very cusp of day's transition into night, captures the emotional feelings of Adams when he saw the scene, drove his car into the deep shoulder of the road, and hauled his equipment into place to take the photograph. It represents the essence, he felt, of a changing world.

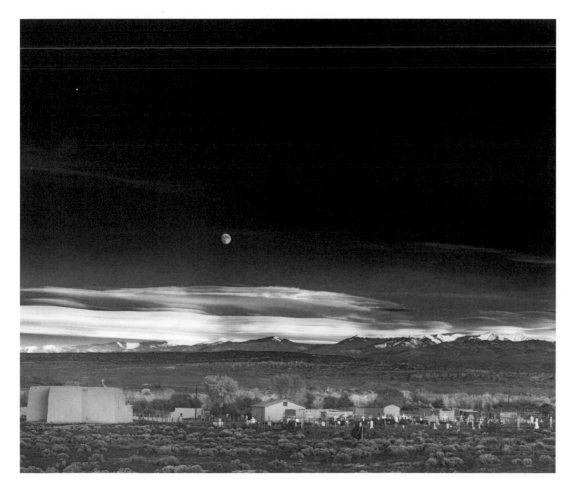

Fig. 12-16 Ansel Adams, *Moonrise, Hernandez, New Mexico*, 1941. Gelatin silver print, 18½ × 23 in.

Jerry Uelsmann considers his camera "a license to explore." In many ways, for him photography is not so much the act of capturing a "decisive moment" on film, but the activity that occurs afterwards, in the darkroom. The darkroom is a laboratory, where the real implications of what he has photographed can be explored. For Uelsmann, this process is called "post-visualization."

Uelsmann begins by photographing both the natural world and the human figure. Sometimes, though not always, the two come together in the finished work. He examines his contact sheets, looking for material that interests him and that somehow, in his imagination, might fit together—a rock with a splattering of bird excrement (**Fig. 12-17**), a grove of trees (**Fig. 12-18**), hands about to touch each other (**Fig. 12-19**). He then covers over all the other information in the photograph, framing the material of interest. Each image rests on its own enlarger, and moving from one enlarger to the next, he prints each part in sequence on the final print. Reflecting the collage techniques of Robert Rauschenberg (see Fig. 11-35),

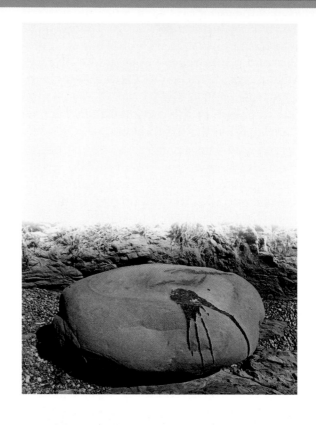

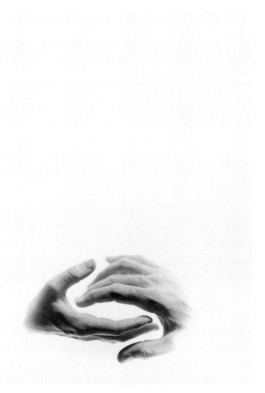

Figs. 12-17, 12-18 and 12-19 Jerry N. Uelsmann, *Untitled.*

Fig. 12-20 Jerry N. Uelsmann, *Untitled* (first version).
© Jerry Uelsmann.

Fig. 12-21 Jerry N. Uelsmann, *Untitled* (second version).
© Jerry Uelsmann.

the resulting image possesses something of the character of a Surrealist landscape (see Chapter 21). As Uelsmann explains:

> I am involved with a kind of reality that transcends surface reality. More than physical reality, it is emotional, irrational, intellectual, and psychological. It is because of the fact that these other forms of reality don't exist as specific, tangible objects that I can honestly say that subject matter is only a minor consideration which proceeds after the fact and not before.

In other words, what drives Uelsmann first and foremost is the formal relation among the elements—the formal similarity between, say, the shape of the hands and that of the rock—the way in which the images seem to work together whatever their actual content.

One of the most powerful transformations generated in the post-visualization process is the effect of a wound on one of the two hands, and with it the suggestion of a healing touch or at least a helpful hand being offered by one hand to the other. In the first version of the print (**Fig. 12-20**), the stone containing the hands thus becomes an egg-like symbol of nurturing, a sort of life force lying beneath the roots of nature itself. But Uelsmann was by no means satisfied with the image, and he returned to his contact sheets. In a second version (**Fig. 12-21**), he placed the hands and stone in the foreground of a mountain landscape. Here the lines of the hands formally echo the lines of the mountains beyond. The final print seems more mysterious than the earlier version. It is, as Uelsmann is fond of saying, "obviously symbolic, but not symbolically obvious.

COLOR PHOTOGRAPHY

In color photography, the formal tensions of black-and-white photography are not necessarily lost. Early in his career, Joel Meyerowitz worked mostly in black and white, but in the mid-1970s, in a continuing series of photographs taken at Cape Cod, in Massachusetts, he started to work in color. He often takes advantage of dynamic color contrasts, especially complementary color schemes that create much of the same kind of tension that we discover in black-and-white work. In *Porch, Provincetown* (**Fig. 12-22**), the deep blue sky, lit up by a bolt of lightning, contrasts dramatically with the hot orange electric light emanating from the interior of the house. Here we have a perfect example of what Cartier-Bresson described as "the decisive moment." By releasing the shutter at this precise instant, Meyerowitz not only captures the contrasting colors of the scene, but he

also underscores the tension between the peacefulness of the porch and the wildness of the night in the contrast between the geometry of the house and the jagged line of the lightning bolt itself.

Until the late 1960s, color was largely ignored by fine art photographers, who associated it with advertising. In fact, until the 1960s, color could only be processed in commercial labs and the images tended to discolor rapidly, so most photographers worked with the technology they could control—black and white. But in the 1970s, Kodak introduced new color technologies that allowed for far greater fidelity, control, luminosity, and durability, and Meyerowitz was among the first photographers to exploit them.

Portrait photographer Annie Leibovitz began her career in 1970 as a photographer for *Rolling Stone*, and she quickly developed a reputation for her sometimes uncanny ability to capture something of the spirit

Fig. 12-22 Joel Meyerowitz, *Porch, Provincetown*, 1977.
(Lightning bolt, C/L Plate 7.)
© Joel Meyerowitz, courtesy Edwynn Houk Gallery.

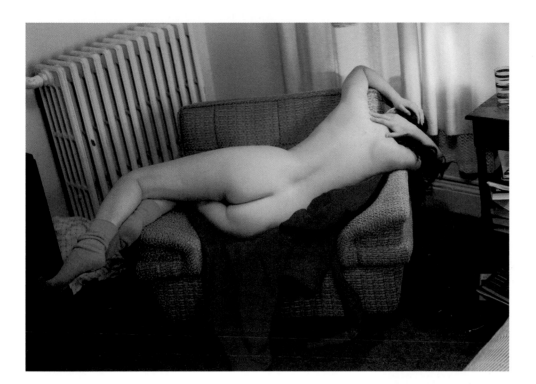

Fig. 12-23 Annie Leibovitz, *Karen Finley at her home in Nyack, New York*, 1992. Chromogenic print, 39 1/16 × 49 1/8 in. Courtesy of the artist.

of celebrity—the tension between the public face of stardom and the private person behind the mask. When *Rolling Stone* began publishing in color in 1974, she soon developed a personal style recognizable for its brilliant color (which, not coincidentally, printed well in the magazine). *Karen Finley at her home in Nyack, New York* (**Fig. 12-23**), with its stunning complementary contrast of red and green, is exemplary of her luminous use of color. It is also exemplary of her enormous wit. At the time this photograph was taken, Finley was shocking audiences across the country by undressing before them as she railed about society's reactions to female sexuality (sometimes smearing herself in chocolate in the process—making herself "eye candy" even as the chocolate evoked other less palatable associations). But Leibovitz's photograph presents Finley not as the rabid, aggressive feminist that she projected in her performances, but as a classical nude, modeled, in fact, on a famous late-nineteenth-century photograph by Impressionist painter Edgar Degas (**Fig. 12-24**). Degas used photographs such as this one as studies for his many pastel portraits of women at their bath (see Fig. 9-14). As writer Susan Sontag put it in the introduction to Leibovitz's 2001 exhibition *Women*, "Just as photography has done so much to confirm these stereotypes [about women in the past], it can engage in complicating and undermining them." Rather than a classic nude, or a soft-core pornographic photograph, Leibovitz's portrait seems instead to confirm Finley's personal vulnerability.

Fig. 12-24 Edgar Degas, *After the Bath, Woman Drying Her Back*, 1896. Gelatin silver print, 6 1/2 × 4 11/16 in. (16.5 × 12 cm) The J. Paul Getty Museum, Los Angeles. © J. Paul Getty Trust.

Fig. 12-25 Andreas Gursky, *Ocean II*, 2010.
Chromogenic print, 134¼ × 98⅛ × 2 ½ in.
VG BILD-KUNST, Bonn.

Today, digital technologies have transformed the world of photography, rendering film obsolete and transforming photography into a highly manipulable medium. One of the most renowned masters of the digital medium is Andreas Gursky, whose *Oceans II* (**Fig. 12-25**) is one of six similarly large views of the world's oceans. To the left, is the Labrador/Newfoundland coast, Greenland at the center top, Iceland at the top right, and at the bottom right, the northwest coast of Africa and the Cape Verde Islands. The works were inspired by the flight monitor on a jet one night when Gursky was flying from Dubai to Melbourne. Over the Indian Ocean he saw, on the monitor, the Horn of Africa to the far left, a tip of Australia to the far right—and there in between the vast blue expanse of the sea. To make these pictures, Gursky used high-definition satellite photographs which he augmented from various picture sources on the Internet. The satellite photos were restricted, however, to exposures of sharply contoured land masses. Consequently the transitional zones between land and water—as well as the oceans themselves, which are cloudless—had to be generated digitally.

DIGITAL PHOTOGRAPHY

We tend to forget today that color photography was once a new technology, introduced to the public at large in the 1950s and '60s. The rise of color photography in the 1960s coincided with the growing popularity of color television. On February 17, 1961, when NBC first aired all of its programs in color, only 1 percent of American homes possessed color sets. By 1969, 33 percent of American homes had color TVs, and today they command 100 percent of the market. The advent of the Polaroid camera and film, and inexpensive color processing for Kodak film, both contributed to a growing cultural taste for color images.

That all these pieces nevertheless convey the feeling of real subaquatic depths is due solely to the precision of Gursky's visual work. He even consulted shoal maps to get the right color nuances for the water surfaces.

The images are very disconcerting, something like an inside-out atlas where instead of land masses edged by oceans, we see oceans edged by fingers of land. And the remarkable depth and density of Gursky's blue contrasts vividly with mapping's standard robin's-egg blues. The pictures are large enough that when standing in front of them, one feels surrounded by water. We do not float above the ocean, like human satellites, but instead float in it. We are immersed in it, swallowed up in its vast expanse. The immensity of the photographs somehow manages to convey the immensity of the oceans themselves, and their centrality to our life on the planet.

To create digital photographs like *Untitled (House in the Road)* (**Fig. 12-26**), Gregory Crewdson works like a film director and producer, hiring large crews of actors, lighting technicians and set designers—and often using passersby as extras—to compose his shot. What inspired him to drop a house into the middle of a street is impossible to say, but the photograph lends an uncanny reality to his vision, as if his dreamworld has turned real. He is particularly fond of shooting at dawn or twilight, when the raking light of the sun heightens the drama of the scene.

Crewdson uses an 8 × 10–inch view camera to shoot his scenes, using multiple light sources to shoot different aspects of the composition, and different focal lengths to make sure all spatial planes are equally in focus. He then refines each shot digitally, and creates the final photograph by digitally assembling the

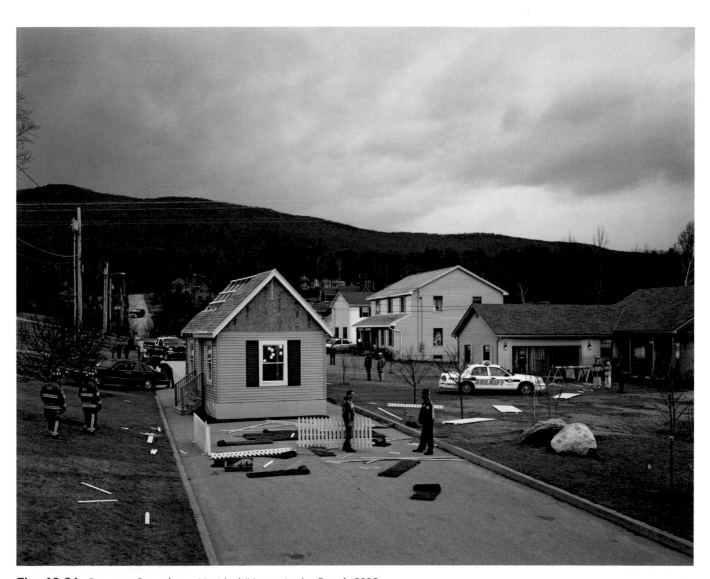

Fig. 12-26 Gregory Crewdson, *Untitled (House in the Road)*, 2002.
C-print mounted on aluminum, edition 3 of 10, 53¹/₂ × 65¹/₂ in. Phoenix Art Museum Collection.
© Gregory Crewdson. Courtesy Gagosian Gallery.

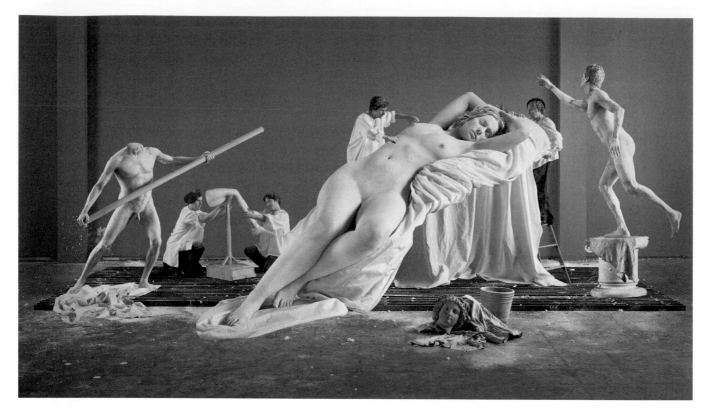

Fig. 12-27 Eleanor Antin, *Constructing Helen*, from *Helen's Odyssey*, 2007.
Chromogenic print, 68 × 199 in.
Courtesy of the artist and Ronald Feldman Fine Arts, New York.

Thinking Thematically: See Art, Gender, and Identity on myartslab.com

various shots. The result is 5- to 7-foot prints of remarkable clarity.

In Eleanor Antin's *Constructing Helen* (**Fig. 12-27**), the final photograph in her series *Helen's Odyssey*, we are witness to the history of Helen as the monumental creation of a patriarchal culture—from Homer to the nineteenth century—that Antin parodies from the vantage point of contemporary feminist thought. In spirit, this Helen—an actual model transformed digitally into a gigantic sculpture—is a parody of late nineteenth-century academic paintings like Alexander Cabanel's *Birth of Venus* (**Fig. 12-28**), which, at the Salon of 1863, was purchased by no less an admirer than Napoleon III. The series *Helen's Odyssey* is, in fact, designed to revise our sense of Greek history by focusing not on the heroes of the Homeric epic, but on Helen herself: "Her story comes down to us from European literature's founding epic," Antin says. "But what do we know of her? After three thousand years of notoriety she remains strangely silent as the most beautiful and disastrous objectification of male anxiety and desire." Antin calls her images "historical takes,"

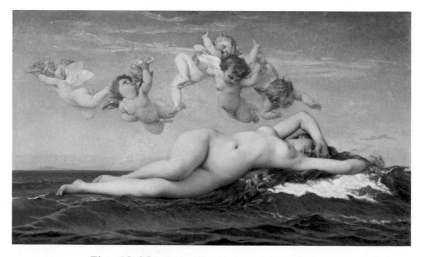

Fig. 12-28 Alexandre Cabanel, *The Birth of Venus*, Salon of 1863.
Oli on canvas, 52 × 90 in. Musée d'Orsay, Paris.
Réunion des Musées Nationaux/Art Resource, NY.

by which she means both her own "take" on history and the cinematic "take," the filming of a scene. Very much like Gregroy Crewdson, Antin is the director and producer of the digital scene before us.

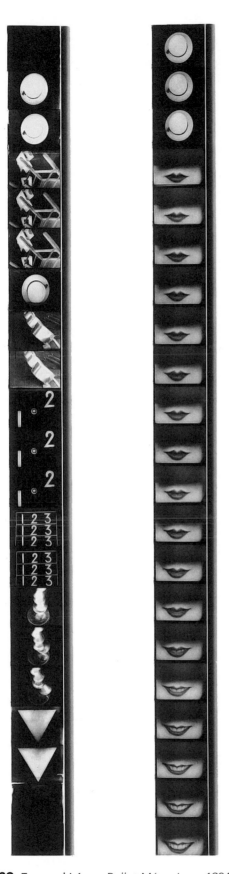

Film

As we noted at the beginning of the chapter, almost as soon as photography was invented, people sought to extend its capacities to capture motion. Eadweard Muybridge captured the locomotion of animals (see Fig. 12-1) and Etienne-Jules Marey the locomotion of human beings (see Fig. 3-8) in sequences of rapidly exposed photos. It was, in fact, the formal revelations of film that first attracted artists to it. As forms and shapes repeated themselves in time across the motion picture screen, the medium seemed to invite the exploration of rhythm and repetition as principles of design. In his 1924 film *Ballet Mécanique* (**Fig. 12-29**), the Cubist painter Fernand Léger chose to study a number of different images—smiling lips, wine bottles, metal discs, working mechanisms, and pure shapes such as circles, squares, and triangles. By repeating the same image again and again at separate points in the film, Léger was able to create a visual rhythm that, to his mind, embodied the beauty—the ballet—of machines and machine manufacture in the modern world.

Assembling a film—the process of editing—is a sort of linear collage, as Léger plainly shows. Although the movies may seem true to life, as if they were occurring in real time and space, this effect is only an illusion accomplished by means of editing. **Editing** is the process of arranging the sequences of a film after it has been shot in its entirety. It is perhaps not coincidental that as film began to come into its own in the second decade of the twentieth century, collage, constructed by cutting and pasting together a variety of fragments, was itself invented.

The first great master of editing was D. W. Griffith who, in *The Birth of a Nation* (**Fig. 12-30**), essentially

Fig. 12-29 Fernand Léger, *Ballet Mécanique*, 1924.
Courtesy of The Humanities Film Collection, Center for the Humanities, Oregon State University.

Fig. 12-30 D. W. Griffith, battle scene from *The Birth of a Nation*, 1915.

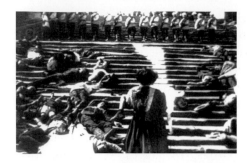

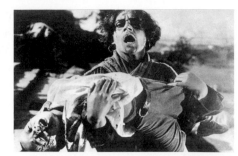

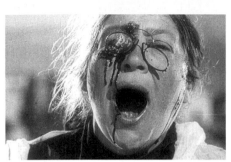

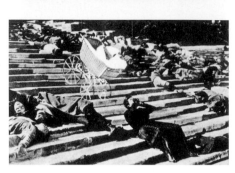

Fig. 12-31 Sergei Eisenstein, four stills from *Battleship Potemkin*, 1925.

Thinking Thematically: See Art, Politics, and Community on myartslab.com

 View the Closer Look on the "Odessa Steps Sequence" on myartslab.com

invented the standard vocabulary of filmmaking. Griffith sought to create visual variety in the film by alternating between and among a repertoire of **shots**, each one a continuous sequence of film frames. A **full shot** shows the actor from head to toe, a **medium shot** from the waist up, a **close-up** the head and shoulders, and an **extreme close-up** a portion of the face. The image of the battle scene reproduced here is a **long shot**, a shot that takes in a wide expanse and many characters at once. Griffith makes use of another of his techniques in this shot as well—the frame slowly opens in a widening circle as a scene begins or slowly blacks out in a shrinking circle to end a scene. This is called an **iris shot**.

Related to the long shot is the **pan**, a name given to the panoramic vista, in which the camera moves across the scene from one side to the other. Griffith also invented the **traveling shot**, in which the camera moves back to front or front to back. In editing, Griffith combined these various shots in order to tell his story. Two of his more famous editing techniques are cross-cutting and flashbacks. The **flashback**, in which the editor cuts to narrative episodes that are supposed to have taken place before the start of the film, is now standard in film practice, but it was an entirely original idea when Griffith first used it. **Cross-cutting** is an editing technique meant to create high drama. The editor moves back and forth between two separate events in ever-shorter sequences, the rhythm of shots eventually becoming furiously paced. Griffith borrowed these techniques of fiction writing to tell a visual story in film.

A film about the Civil War and Reconstruction, *The Birth of a Nation* is unrepentant in its racism,

culminating in a tightly edited cross-cut sequence in which a white woman tries to fend off the sexual advances of a black man as the Ku Klux Klan rides to her rescue, which led the NAACP (National Association for the Advancement of Colored People), newly formed in 1915 when the film was released, to seek to have it banned. Riots broke out in Boston and Philadelphia, while Denver, Pittsburgh, St. Louis, Minneapolis, and eight states denied its release. But Griffith's film remains one of the highest-grossing movies in film history, in no small part due to its inventive editing.

One of the other great innovators of film editing was the Russian filmmaker Sergei Eisenstein. Eisenstein did his greatest work in Bolshevik Russia after the 1917 revolution, in a newly formed state whose leader, Vladimir Lenin, had said, "Of all the arts, for us the cinema is the most important." In this atmosphere, Eisenstein created what he considered a revolutionary new use of the medium. Rather than concentrating on narrative sequencing, he sought to create a shock in his film that would ideally lead the audience to perception and knowledge. He called his technique **montage**—the sequencing of widely disparate images to create a fast-paced, multifaceted image. In the famous "Odessa Steps Sequence" of his 1925 film *Battleship Potemkin*, four frames of which are reproduced here (**Fig. 12-31**), Eisenstein used 155 separate shots in 4 minutes 20 seconds of film, an astonishing rate of 1.6 seconds per shot (the sequence is widely available on the Internet). The movie is based on the story of an unsuccessful uprising against the Russian monarchy in 1905, and the sequence depicts the moment when the crowd pours into the port city of Odessa's harbor to welcome the liberated ship *Potemkin*. Behind them, at the top of the steps leading down to the pier, soldiers appear, firing on the crowd. In the scene, the soldiers fire, a mother lifts her dead child to face the soldiers, women weep, and a baby carriage careens down the steps. Eisenstein's "image"

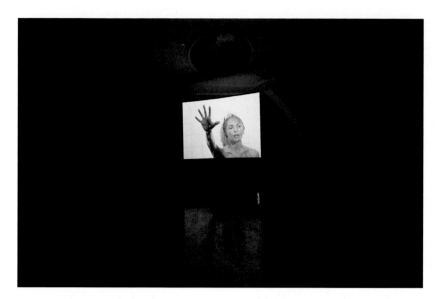

Fig. 12-32 Douglas Gordon, *24 Hour Psycho*, 1993.
Photo: Studio lost but found (Bert Ross). © 2011 Studio lost but found. Courtesy Gagosian Gallery from Psycho, 1960, USA. Directed and produced by Alfred Hitchcock. Distributed by Paramount Pictures © Universal City Studios, Inc.

Thinking Thematically: See Art and the Passage of Time on myartslab.com

is all of these shots combined and more. "The strength of montage resides in this," he wrote, "that it involves the creative process—the emotions and mind of the spectator . . . assemble the image."

The thrust of Eisenstein's work is to emphasize action and emotion through enhanced time sequencing. Just the opposite effect is created by Douglas Gordon in his 1993 *24 Hour Psycho* (**Fig. 12-32**). Gordon's work is an extreme slow-motion video projection of Alfred Hitchcock's 1960 classic film *Psycho*. As opposed to the standard 24 frames per second, Gordon projects the film at 2 frames per second, extending the playing time of the movie to a full 24 hours. Hitchcock's original in fact utilizes many of Eisenstein's time sequencings to create a film of uncanny tension. But Gordon's version so slows Hitchcock's pace that each action is extended, sometimes excruciatingly so—as in the famous shower scene. To view either film is to understand the idea of *duration* in terms one might have never before experienced.

THE POPULAR CINEMA

However interesting Gordon's *24 Hour Psycho* might be on an intellectual level, and however much it might transform our experience of and appreciation for Hitchcock's film, it is not the kind of movie that most audiences would appreciate. Audiences expect a narrative, or story, to unfold, characters with whom they can identify, and action that thrills their imaginations. In short, they want to be entertained. After World War I, American movies dominated the screens of the world like no other mass media in history, precisely because they entertained audiences so completely. And the name of the town where these entertainments were made became synonymous with the industry itself—Hollywood.

The major players in Hollywood were Fox and Paramount, the two largest film companies, followed by Universal and Metro-Goldwyn-Mayer (M-G-M). With the introduction of sound into the motion picture business in 1926, Warner Brothers came to the forefront as well. In addition, a few well-known actors, notably Douglas Fairbanks, Mary Pickford, and Charlie Chaplin, maintained control over the financing and distribution of their own work by forming their own company, United Artists. Their ability to do so, despite the power of the other major film companies, is testimony to the power of the **star** in Hollywood.

The greatest of these stars was Charlie Chaplin, who, in his famous role of the tramp, managed to merge humor with a deeply sympathetic character who could pull the heartstrings of audiences everywhere. In *The Gold Rush*, an 80-minute film made in 1925, much of it filmed on location near Lake Tahoe in the Sierra Nevada mountains of California, he portrayed the abysmal conditions faced by miners working in the Klondike gold fields during the Alaska gold rush of 1898. One scene in this movie is particularly poignant—and astonishingly funny: Together with a fellow prospector, Big Jim, a starving Charlie cooks and eats, with relish and delight, his old leather shoe (**Fig. 12-33**).

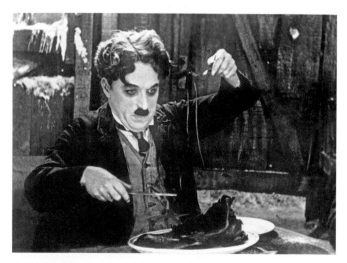

Fig. 12-33 Charlie Chaplin in *The Gold Rush*, 1925.
United Artists.
Everett Collection.

The Gold Rush is a silent film, but a year after it was made, Warner Brothers and Fox were busy installing speakers and amplification systems in theaters as they perfected competing sound-on-film technologies. On October 6, 1927, the first words of synchronous speech uttered by a performer in a feature film were spoken by Al Jolson in *The Jazz Singer*: "Wait a minute. Wait a minute. You ain't heard nothing yet." By 1930, the conversion to sound was complete.

For the next decade, the movie industry produced films in a wide variety of genres, or narrative types—comedies, romantic dramas, war films, horror films, gangster films, and musicals. By 1939, Hollywood had reached a zenith. Some of the greatest films of all time date from that year, including the classic western *Stagecoach*, starring John Wayne; *Gone with the Wind*, starring Vivien Leigh and Clark Gable; and *Mr. Smith Goes to Washington*, starring Jimmy Stewart. But perhaps the greatest event of the year was the arrival of 24-year-old Orson Welles in Hollywood. Welles had made a name for himself in 1938 when a Halloween-night radio broadcast of H. G. Wells's novel *War of the Worlds* convinced many listeners that Martians had invaded New Jersey. Gathering the most talented people in Hollywood around him, he produced, directed, wrote, and

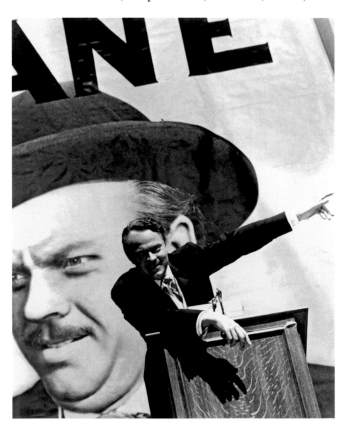

Fig. 12-34 Orson Welles as Kane campaigning for governor in *Citizen Kane*, 1941.
RKO.
Everett Collection.

starred in *Citizen Kane*, the story of a media baron modeled loosely on newspaper publisher William Randolph Hearst. Released in 1941 to rave reviews, the film used every known trick of the filmmaker's trade, with high-angle and low-angle shots (**Fig. 12-34**); a wide variety of editing effects, including dissolves between scenes; and a narrative technique, fragmented and consisting of different points of view, unique to film at the time. All combined to make a work of remarkable total effect that still stands as one of the greatest achievements of American popular cinema.

The year 1939 also marked the emergence of color as a major force in the motion picture business. The first successful full-length Technicolor film had been *The Black Pirate*, starring Douglas Fairbanks, released in 1926, but color was considered an unnecessary ornament, and audiences were indifferent to it. However, when, in *The Wizard of Oz*, Dorothy arrives in a full-color Oz, having been carried off by a tornado from a black-and-white Kansas, the magical transformation of color become stunningly evident. And audiences were stunned by the release of *Gone with the Wind*, with its four hours of color production. Much of that film's success can be attributed to art director William Cameron Menzies. Menzies had worked for years in Hollywood, and for such an ambitious project, he realized he needed to start working far in advance of production. Two years before production began, he started creating **storyboards**—panels of rough sketches outlining the shot sequences—for each of the movie's scenes. These storyboards helped to determine camera angles, locations, lighting, and even the editing sequence well in advance of actual shooting. His panoramic overviews, for which the camera had to pull back above a huge railway platform full of wounded Confederate soldiers, required the building of a crane, and they became famous as a technological achievement. For the film's burning-of-Atlanta sequence (**Figs. 12-35** and **12-36**), Menzies's storyboard shows seven shots, beginning and ending with a panoramic overview, with cuts to close-ups of both Rhett Butler and Scarlett O'Hara fully indicated.

Meanwhile, Walt Disney had begun to create feature-length animated films in full color. The first was *Snow White and the Seven Dwarfs*, in 1937, which was followed, in 1940, by both *Pinocchio* and *Fantasia*. **Animation**, which means "bringing to life," was suggested to filmmakers from the earliest days of the industry when it became evident that film itself was a series of "stills" animated by their movement in sequence. Obviously, one could draw these stills as well as photograph them. But in order for motion to appear seamless, and not jerky, literally thousands of drawings need to be executed for each film, up to 24 per second of film time.

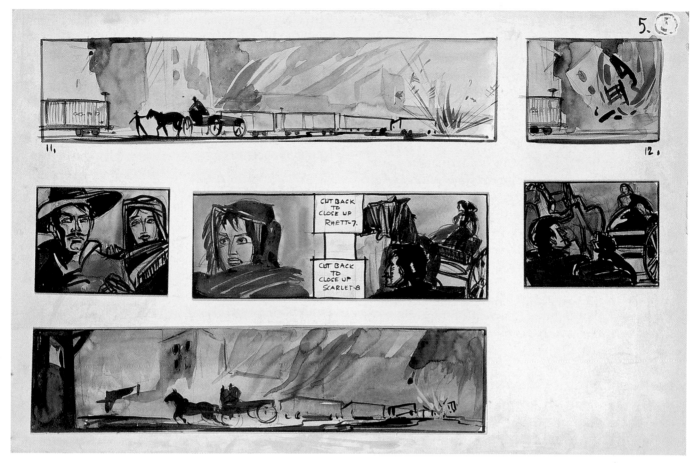

Fig. 12-35 William Cameron Menzies, storyboard for the burning-of-Atlanta scene from *Gone with the Wind*, 1939. MGM/Photofest.

In the years after World War II, the idea of film as a potential art form resurfaced, especially in Europe. Fostered in large part by international film festivals, particularly in Venice and Cannes, this new "art cinema" brought directors to the fore, seeing themselves as the **auteurs**, or "authors," of their works. Chief among these was the Italian director Federico Fellini, whose film about the decadent lifestyle of 1960s Rome, *La Dolce Vita*, earned him an international reputation. Close on his heels was the Swedish director Ingmar Bergman and the French "New Wave" directors Jean-Luc Godard and Alain Resnais.

By the end of the 1960s, Hollywood had lost its hold on the film industry, and most films had become international productions. But, a decade later, Hollywood regained control of the medium when, in 1977, George Lucas's *Star Wars* swept onto the scene. In many ways an anthology of stunning special effects, the movie had made over $200 million even before its highly successful twentieth-anniversary re-release in 1997, and it inaugurated an era of "blockbuster" Hollywood attractions, including *E.T.*, *Titanic*, *The Lord of the Rings* trilogy, and series like the *Harry Potter* and *Twilight* films.

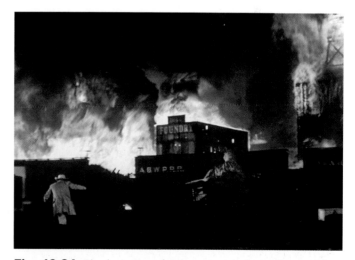

Fig. 12-36 The burning-of-Atlanta scene from *Gone with the Wind*, 1939. MGM/Photofest.

Video

One of the primary difficulties faced by artists who wish to explore film as a medium is the sheer expense of using it. The more sophisticated a film is in terms of its camera work, lighting, sound equipment, editing techniques, and special effects, the more expensive it is to produce. With the introduction in 1965 of a relatively inexpensive hand-held video camera, the Sony Portapak, artists were suddenly able to explore the implications of seeing in time. Video is not only cheaper than film but it is also more immediate—that is, what is seen on the recorder is simultaneously seen on the monitor. While video art tends to exploit this immediacy, commercial television tends to hide it by attempting to make videotaped images look like film.

Korean-born Nam June Paik was one of the first people in New York to buy a Portapak. His video installations explore the limits and defining characteristics of the medium. By the mid-1960s, Paik's "altered TVs" displayed images altered by magnets combined with video feedback and other technologies that produced shifted patterns of shape and color. Until his death in 2006, he continued to produce large-scale video installations, including the 1995 *Megatron*, which consisted of 215 monitors programmed with both live video images from the Seoul Olympic Games and animated montages of nudes, rock concert clips, national flags, and other symbolic imagery. In 1985–86, he began to use the American flag as the basis for computer sculpture, making three separate flag sculptures: *Video Flag X* (Chase Manhattan Bank collection), *Video Flag Y* (The Detroit Institute of Arts), and *Video Flag Z* (Los Angeles County Museum of Art).

Today, *Video Flag Z*, a 6-foot-high grid of 84 white Quasar monitors that once flashed a pulsating montage of red, white, and blue images across its surface, is packed away in the Los Angeles County Museum's warehouse. "We can't find replacement parts anymore," the museum's curator explains. And this is a danger most electronic media face as they fall victim to the ever-increasing rate of technological change. Jon Ippolito, the Guggenheim Museum's associate curator of media arts, warns, "There's a looming threat of mass extinction on the media-arts landscape." One solution is for media artists to re-engineer their works, which is precisely what Paik has done for his *Video Flag* (**Fig. 12-37**) at the Hirshhorn Museum in Washington, D.C. The monitors incorporate a face that morphs through every U.S. president of the Information Age, from Harry S. Truman to Bill Clinton. Built a decade after the earlier flags, the Hirshhorn's *Video Flag* incorporates what were then (1996) the latest advances in technology, such as laser disks, automatic switchers, 13-inch monitors (rather than the 10-inch monitors used in previous versions), and other devices. But today, as the electronics industry has ceased producing both video equipment and videotape itself, it too is threatened by the anachronism of its working parts.

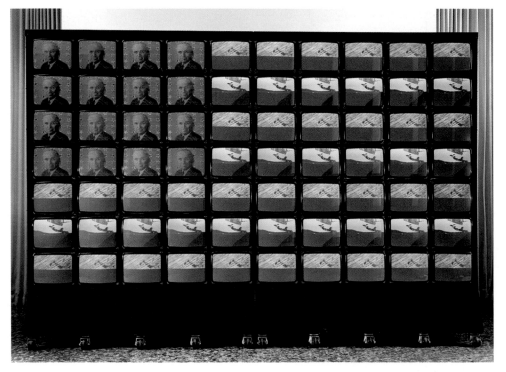

Fig. 12-37 Nam June Paik (American, b. Seoul, Korea, 1932–2006), *Video Flag*, 1985–96. 70 video monitors, 4 laser disc players, computer, timers, electrical devices, wood and metal housing on rubber wheels, 94 3/8 × 139 3/4 × 47 3/4 in. (239.6 × 354.8 × 119.9 cm) Hirshhorn Museum and Sculpture Garden, Smithsonian Institution, Gift of Joseph H. Hirshhorn, 1996 (96.4).

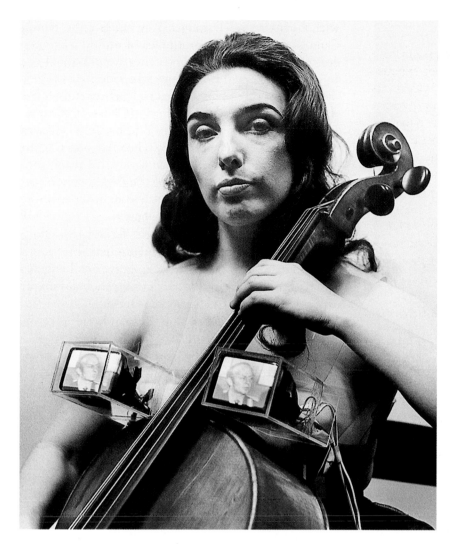

Fig. 12-38 Nam June Paik, *TV Bra for Living Sculpture*, 1969.
Performance by Charlotte Moorman with television sets and cello.
Photo: Peter Moore. © The Estate of Peter Moore/Licensed by VAGA, New York, NY.

a serious intent. For Paik and Moorman, it was an attempt "to humanize the technology . . . and also stimulate viewers . . . to look for new, imaginative, and humanistic ways of using our technology." *TV Bra*, in other words, is an attempt to rescue the boob tube from mindlessness.

Archival footage of early 1960s and '70s videos of performance art is increasingly becoming available on commercial DVD. Among the more interesting is a compilation of early dance works by Trisha Brown (*Trisha Brown: Early Works 1966–1979*; distributed by ARTPIX Notebooks), which includes footage of her company dancing on the walls of the Whitney Museum of American Art in New York suspended in harnesses from the ceiling (**Fig. 12-39**). The work is exemplary of the ways in which performance purposefully blurred the boundaries between the arts, as dance here moves off the floor and onto the wall.

Paik was also instrumental in the development of another of video's roles in the arts, using it to record the time-based medium of **performance art.** Performance art is more or less theatrical work by artists staged in gallery or museum spaces. By definition short-lived and temporal, video seemed the obvious means to document performance events. Paik's *TV Bra for Living Sculpture* (**Fig. 12-38**) is a literal realization of the "boob tube." The piece is a collaborative performance, executed with the avant-garde musician Charlotte Moorman. Soon after Paik's arrival in New York in 1964, he was introduced to Moorman by the composer Karlheinz Stockhausen. Moorman wanted to perform a Stockhausen piece called *Originale*, but the composer would grant permission only if it was done with the assistance of Paik, who had performed the work many times. Paik's role was to cover his entire head with shaving cream, sprinkle it with rice, plunge his head into a bucket of cold water, and then accompany Moorman's cello on the piano as if nothing strange had occurred. So began a long collaboration. Like all of Paik's works, *TV Bra*'s humor masks

Fig. 12-39 Trisha Brown, *Walking on the Wall*, from Another Fearless Dance Concert, March 30–31, 1971.
As part of the Composer's Showcase series at the Whitney Museum of American Art, New York.
Photo by Peter Moore © Estate of Peter Moore/Licensed by VAGA, NYC.

Fig. 12-40 Robert Rauschenberg, *Open Score at 9 Evening: Theatre & Engineering*, October 1966.
Performance at the 69th Regiment Armory, New York.
Courtesy of Julie Martin/Experiments in Art and Technology. Art © Estate of Robert Rauschenberg/Licensed by VAGA, New York, NY.

One of the more remarkable surviving videos is *Open Score*, directed and conceived by Robert Rauschenberg for a series entitled *9 Evenings* that took place in October 1966 at the 69th Regiment Armory in New York City (*Open Score at 9 Evening: Theatre & Engineering by Robert Rauschenberg*; distributed by Microcinema International). The series as a whole consisted of collaborations between individual artists, dancers, and musicians and a team of scientists and engineers from Bell Laboratories in New Jersey, and was produced under the auspices of E.A.T., Experiments in Art and Technology, an organization designed to facilitate face-to-face interchanges between artists and engineers. Rauschenberg's work began with a tennis game between painter Frank Stella and his tennis partner, Mimi Kararek, on a full-size tennis court laid out on the Armory floor (**Fig. 12-40**). As Rauschenberg explained: "Tennis is movement, put in the context of theater it is a formal dance improvisation." The tennis rackets themselves were wired by the Bell Lab engineers with tin FM transmitters so that each time the contestants hit the ball a loud BONG was produced that echoed throughout the Armory and turned off one of the lights illuminating the court. The game continued until the Armory was completely dark. A group of 500 volunteers entered the Armory in the darkness, videotaped by infrared cameras. They performed a series of movements—"touch someone who is not touching you; hug someone quickly; move closer together; move apart . . ." and so on—as indicated by signals from a bank of flashlights attached to the balcony railings. These movements were projected onto three large screens hung over the audience. Finally, as the house lights slowly came back up, a single spotlight focused on a figure—dancer Simone Forti—who sat in the middle of the floor in a sack singing a Tuscan folk song. To conclude the evening, Rauschenberg picked her up and set her down, first in one place, then another, several times as she continued to sing. While it is safe to say that Rauschenberg's performance does not aspire to be meaningful in any conventional way, his intentions seem reasonably clear. Each of the performance's actions was designed to complicate the audience's sensory expectations: the sound of someone hitting a tennis ball results in a total loss of vision; what cannot be seen literally in the dark appears through infrared projection; a song emanates from a gunny sack. And Rauschenberg's *Open Score* challenges not only our senses but our very expectations about the nature of art itself.

Perhaps no artist in the 1970s challenged the expectations of art audiences more hilariously than William Wegman, whose series of short videos has also recently been reissued on DVD (*William Wegman: Video Works 1970–1999*; distributed by ART-PIX Notebooks). In one, called *Deodorant*, the artist simply sprays an entire can of deodorant under one armpit while he extols its virtues. The video, which is about the same length as a normal television commercial, is an exercise in consumerism run amok. In *Rage and Depression* (**Fig. 12-41**), Wegman sits smiling at the camera as he speaks the following monologue:

I had these terrible fits of rage and depression all the time. It just got worse and worse and worse. Finally my parents had me committed. They tried all kinds

Fig. 12-41 William Wegman, still from *Rage and Depression, Reel 3*, 1972–73.
Video, approximately 1 min.
Courtesy of the artist.

of therapy. Finally they settled on shock. The doctors brought me into this room in a straitjacket because I still had this terrible, terrible temper. I was just the meanest cuss you could imagine, and when they put this cold, metal electrode, or whatever it was, to my chest, I started to giggle and then when they shocked me, it froze on my face into this smile, and even though I'm still incredibly depressed—everyone thinks I'm happy. I don't know what I'm going to do.

Wegman completely undermines the authority of visual experience here. What our eyes see is an illusion. He implies that we can never trust what we see, just as we should not trust television's objectivity as a medium.

While archival video footage is becoming increasingly available, the work of most contemporary artists working with time-based media (video art *per se* no longer exists—the medium has become entirely digital) is available for viewing only at museums and galleries. Artists tend to produce their work in very limited editions designed to maximize competition among museum collectors for copies of their works. There are some exceptions. Bill Viola has released a number of his early works on DVD (distributed by Éditions à Voir), including *Selected Works 1976–1981*; *Hatsu-Yume (First Dream)* (1981), a visual foray into the nature of light and darkness as metaphors for life and death; *I Do Not Know What It Is I Am Like* (1986), an investigation of humanity's relation to nature; and *The Passing* (1991), like *Hatsu-Yume* a meditation on the endless cycle of birth and death, but focused on Viola's own family. (One of the video installations he created as the American representative to the Venice Biennale in 1995 is the subject of *The Creative Process* on pp. 288–289.)

Viola's short video *The Reflecting Pool* (**Fig. 12-42**) demonstrates his technical prowess. The video lasts for 7 minutes. The camera is stationary, overlooking a pool that fills the foreground. Light filters through the forest behind the pool. Throughout the tape there is the sound of water gently streaming into the pool, and

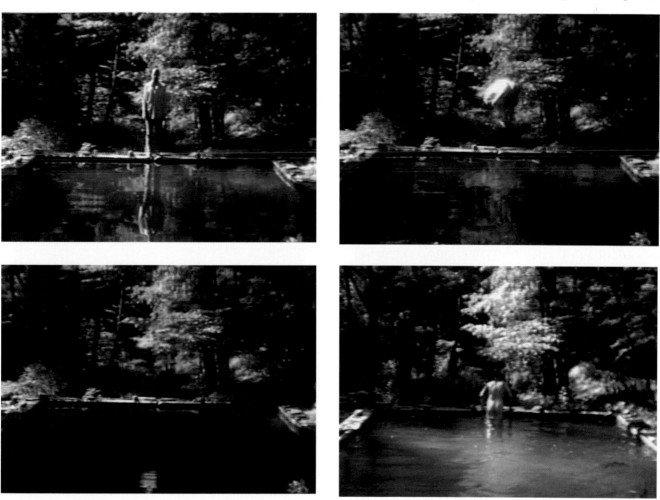

Fig. 12-42 Bill Viola, four stills from *The Reflecting Pool*, 1977–79.
Video, color, mono sound, 7 min.
© Bill Viola Studio. Photos: Kira Perov.

Thinking Thematically: See Art and Spiritual Belief on myartslab.com

THE CREATIVE PROCESS

When video artist Bill Viola first saw a reproduction of Jacopo da Pontormo's 1528 painting *The Visitation* (**Fig. 12-44**), he knew that he had to do something with it. Asked to be the American representative at the 1995 Venice Biennale, perhaps the oldest and most prestigious international arts festival, he decided to see if he could create a piece based on Pontormo's painting for the exhibition. He intended to convert the entire United States Pavilion into a series of five independent video installations, which he called, as a whole, *Buried Secrets*. By "buried secrets" he meant to refer to our emotions, which have for too long lain hidden within us. "Emotions," he says, "are precisely the missing key that has thrown things out of balance, and the restoration to their right place as one of the higher orders of the mind of a human being cannot happen fast enough."

What fascinated Viola about Pontormo's painting was, first of all, the scene itself. Two women meet each other in the street. They embrace as two other women look on. An instantaneous knowledge and understanding seems to pass between their eyes. The visit, as told in the Bible by Luke (I:36–56), is of the Virgin Mary to Elizabeth. Mary has just been told by the angel Gabriel: "You shall conceive and bear a son, and you shall give him the name Jesus"—the moment of the Annunciation. In Pontormo's painting, the two women, one newly pregnant with Jesus, the other six months pregnant, after a lifetime of barrenness, with the child who would grow to be John the Baptist, share each other's joy. For Viola, looking at this work, it was their shared intimacy—that moment of contact in which the nature of their relationship is permanently changed—that most fascinated him. Here is the instant when we leave the isolation of ourselves and enter into social relations with others. Viola decided that he wanted to re-create this encounter, to try to capture in media such as film or video—media that can depict the passing of time—the emotions buried in the moment of the greeting itself.

In order to re-create the work, Viola turned his attention to other aspects of the composition. He was particularly interested in how the piece depicted space. There seemed to him to be a clear tension between the deep space of the street behind the women and the space occupied by the women themselves. He made a series of sketches of the hypothetical street

behind the women (**Fig. 12-43**); then, working with a set designer, re-created it. The steep, odd perspective of the buildings had to fit into a 20-foot-deep sound stage. He discovered that if he filled the foreground with four women, as in the Pontormo painting, much of the background would be lost. Furthermore, the fourth woman in the painting presented dramatic difficulties. Removed from the main group as she is, there was really little for her to do in a re-creation of the scene involving live action.

A costume designer was hired; actors auditioned, were cast, and then rehearsed. On Monday, April 3, 1995, on a sound stage in Culver City, California, Viola shot *The Greeting*. He had earlier decided to shoot the piece on film, not video, because he wanted to capture every nuance of the moment. On an earlier project, he had used a special high-speed

Fig. 12-43 Bill Viola, sketch for *The Greeting* set, 1995.
© Bill Viola Studio. Photos: Kira Perov.

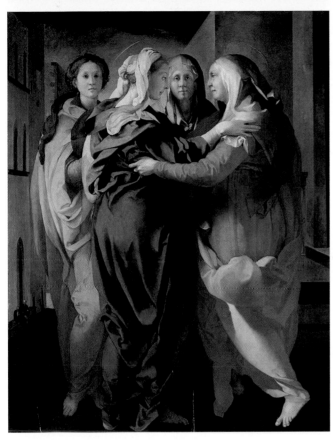

Fig. 12-44 Jacopo da Pontormo, *The Visitation*, 1528. Oil on canvas, 79 1/2 × 61 3/8 in. Pieve di S. Michele, Carmignano, Italy.
© Canali Photobank, Capriolo, Italy.

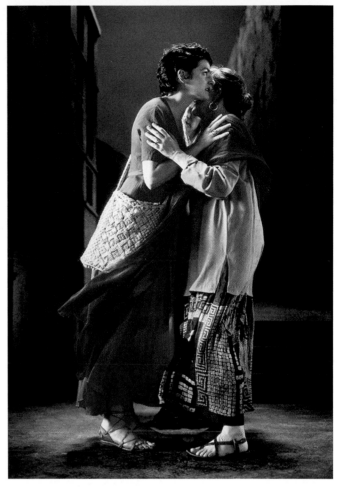

Fig. 12-45 Bill Viola, *The Greeting*, 1995. Video/sound installation exhibition, *Buried Secrets*. United States Pavilion, Venice Biennale, 1995 Commissioner, Marilyn Zeitlin. Arizona State University Art Museum, Tempe, Arizona.
© Bill Viola Studio. Photo: Kira Perov.

35-millimeter camera that was capable of shooting an entire roll of film in about 45 seconds at a rate of 300 frames per second. The camera was exactly what he needed for this project. The finished film would run for more than 10 minutes. The action it would record would last for 45 seconds.

"I never felt more like a painter," Viola says of the piece. "It was like I was moving color around, but on film." For 10 slow-motion minutes, the camera never shifts its point of view. Two women stand talking on a street, and a third enters from the left to greet them. An embrace follows (**Fig. 12-45**).

Viola knew, as soon as he saw the unedited film, that he had what he wanted, but questions still remained. How large should he show the piece? On a table monitor, or larger than life size, projected on a wall? He could not decide at first, but at the last minute he determined that he would project it. On the day of the Venice Biennale opening, he saw it in its completed state for the first time, and for the first time since filming it, he saw it with the other key element in video—sound. It seemed complete as it never had before. Gusts of wind echo through the scene. Then the woman in red leans across to the other and whispers, "Can you help me? I need to talk with you right away." Joy rises to their faces. Their emotions surface. The wind lifts their dresses, and they are transformed.

then, covering it during the opening shots, a drone that resembles the sound of a truck or plane passing by. Viola emerges from the forest, wearing a shirt and trousers. He walks up to the edge of the pool, and he is reflected in the water. Then suddenly, with a grunt, he jumps out over the pool, but his body freezes in the fetal position in midair above the water. In the pool the light changes, the water stills, and then is animated in three successive sequences by concentric circles of ripples as if a fish has risen to the surface or something (invisible) has dropped into the water from the feet of the suspended figure above. A reflected figure walks along the pool from left to right, and as it does so the frozen figure suspended above the pool gradually fades into the landscape. Two reflected figures, a woman and a man, move along the right edge of the pool and then across the far side until they stop at the far left corner. The circles of water implode inward in backward motion. The water turns black, as if in the bottom half of the image it is night, reflecting the single figure again, now bathed in light. He moves off to the right. Then the pool returns to daylight, and suddenly Viola emerges from the water naked, his back to us. He climbs onto the edge of the pool and walks away, in small fragmented segments, into the forest.

The stationary camera is key to the work. It allowed him to work with three separate recordings of the space and recombine them within the (apparently) coherent space of the frame by registering them much in the manner that a printmaker registers the different colors in pulling a single print. First is a series of recordings made by using very slow dissolves between each action (throwing things into the water to create the rippling effects, the reflection of himself walking around the edge of the pool). Some of these actions were recorded in real time, but others, like the changing light on the pool surface, using time-lapse technique, and still others, like the imploding circle of concentric ripples, in reverse motion. The second recording consisted of Viola walking out of the forest to the edge of the pool and then jumping into the air. This recording ends in a freeze frame of about three or four minutes duration during which time it undergoes a slow fade so that the figure appears to dissolve into the background. The final recording consisted of simply the empty scene in real time. It is this space that comprises the forest background into which the leaping figure disappears. The final tape appears to record a completely coherent time and space, a coherence supported by the soundtrack.

As it turns out, one of the seminal time-based works of the late twentieth century, *The Way Things Go*, is widely available on DVD (released by First Run/

Icarus Films). The work of Swiss artists Peter Fischli and David Weiss, the film was first screened in 1987 at Documenta, the international art fair that takes place every five years in Kassel, Germany. There it caused an immediate sensation, and since then it has been screened in museums around the world. It consists of a kinetic sculptural installation inside a 100-foot-long warehouse that begins when a black plastic bag (full of who knows quite what), suspended from the ceiling, spins downward until it hits a tire on top of a slightly inclined orange-colored board and nudges it over a small strip of wood down the shallow slope. This initiates a series of physical and chemical cause-and-effect chain reactions in which ordinary household objects slide, crash, spew liquids onto, and ignite one another in a linear 30-minute sequence of self-destructing interactions (**Fig. 12-46**). In part a metaphor for the history of Western culture, in part a hilarious slapstick comedy of errors, for many viewers *The Way Things Go* captures the spirit of modern life.

Fig. 12-46 Peter Fischli and David Weiss, stills from *Der Lauf der Dinge* (*The Way Things Go*), 1987.
16mm color film, 30 min.
© Peter Fischli David Weiss, Courtesy of Matthew Marks Gallery, New York.

Computer- and Internet-based Art Media

If the image on a computer monitor is literally two-dimensional, the screenspace occupied by the image is, increasingly, theatrical, interactive, and time-based. In his groundbreaking study of the global digital network, *E-topia* (MIT Press, 1999), William J. Mitchell, Dean of the School of Architecture and Planning at the Massachusetts Institute of Technology, puts it this way:

In the early days of PCs, you just saw scrolling text through the rectangular aperture [of your personal computer], and the theatrical roots of the configuration were obscured. . . . [But] with the emergence of the PC, the growth of networks, and ongoing advances in display technology, countless millions of glowing glass rectangles scattered through the world have served to construct an increasingly intricate interweaving of cyberspace and architecture. . . . As static tesserae [pieces of glass or ceramic used to make mosaics] were to the Romans, active pixels are to us. Signs and labels are becoming dynamic, text is jumping off the page into three-dimensional space, murals are being set in motion, and the immaterial is blending seamlessly with the material.

The advances in technology are startling. At the time he made *The Reflecting Pool*, Bill Viola used the new CMX 600 nonlinear editing system at the WNET Television Laboratory in New York, the first system to free video editors from working chronologically from the beginning of the tape to the end, giving them the ability to retrieve any segment of original video footage at any time and place it anywhere in the sequence. It was not until 10 years later, in 1989, that Avid's Media Composer system was launched, a digital nonlinear editing program that provided editors with the ability to copy videotape footage in real time to digital hard disks. This invention allowed a video editor to use a computer to easily view shots, make cuts, and rearrange sequences faster than traditional tape-based methods. The cost was about $100,000. Today, comparable software costs less than $300. In 1990, when Steven Spielberg began discussions about transforming Michael Crichton's novel *Jurassic Park* into a movie, CGI (computer-generated imaging) did not exist. Three years later, the movie made its stunning animated dinosaurs (**Fig. 12-47**) come to life. Today,

Fig. 12-47 Still from Steven Spielberg's *Jurassic Park*, 1993.
Courtesy of Universal Studios LLC.

far greater capabilities are available for use on your laptop, employing the same software used to create *Star Wars* I and II, for around $1,500.

It is, finally, in the virtual space of the computer that Chinese artist Cao Fei works. She has created an online virtual *RMB City* (**Fig. 12-48**), a sort of Beijing gone mad in which her avatar, China Tracy, invites the public and various invited artists to explore issues from art and architecture to literature, cinema, and politics, functioning not as themselves but as their avatar personalities. Here the virtual becomes real.

Watch a video on Cao Fei's avatars on myartslab.com

Fig. 12-48 Cao Fei, *RMB City*, 2008.
Digital print.

What is photogenic drawing?

In 1839, Englishman William Henry Fox Talbot presented a process for fixing negative images on paper coated with light-sensitive chemicals. This process, which Talbot called photogenic drawing, resulted in some of the first photographs. How does photogenic drawing differ from dauguerreotype photography? What is the calotype process?

What is the Zone System?

Developed by Ansel Adams and Fred Archer in the 1930s, the Zone System is, in Adams' words, "a framework for understanding exposures and development, and visualizing their effect in advance." A zone represents the relation of an image's (or portion of an image's) brightness to the tone that the photographer wishes to see in the final print. What is a camera's aperture? What is involved in the techniques of dodging and burning?

What is editing in film?

Editing is the process of arranging the sequences of a film after it has been shot in its entirety. The first great master of editing was D.W. Griffith, who, in *The Birth of a Nation*, essentially invented the standard vocabulary of filmmaking. How does a full shot differ from a medium shot? What is a flashback? What is cross-cutting?

What are some of the advantages and disadvantages of video art?

Video art allows artists to work with time-based media at less expense than film requires. Video can be instrumental in documenting performance art. However, video often suffers from the threat of rapid technological change, quickly rendering media extinct. What role did the Portapak play in the development of video art? What does Nam June Paik express in *TV Bra for Living Sculpture*?

THE CRITICAL PROCESS
Thinking about the Camera Arts

Jeff Wall's *A Sudden Gust of Wind* (**Fig. 12-49**) is a large, backlit photographic image modeled on a nineteenth-century Japanese print by Hokusai, *Shunshuu Ejiri* (**Fig. 12-50**), from the series *Thirty-Six Views of Mount Fuji*, which also includes *The Great Wave off Kanagawa* (see Fig. 8-21). Wall's interest lies, at least in part, in the transformations contemporary culture has worked on traditional media. Thus his billboard-like photograph creates a scene radically different from the original. What sorts of transformations can you describe? Consider, first of all, the content of Wall's piece. What does it mean that businessmen inhabit the scene rather than Japanese in traditional dress? How has the plain at Ejiri—considered one of the most beautiful locations in all of Japan—been translated by Wall? And though Hokusai indicates Mount Fuji with a simple line drawing, why has Wall eliminated the mountain altogether? (Remember, Fuji is, for the Japanese, a national symbol, and it is held in spiritual reverence.)

But perhaps the greatest transformation of all is from the print to the photograph. Wall's format, in fact, is meant to invoke cinema, and the scene is anything but the result of some chance photographic encounter. Wall employed professional actors, staged the scene carefully, and shot it over the course of nearly five months. The final image consists of 50 separate pieces of film spliced together through digital technology to create a completely artificial but absolutely realistic scene. For Wall, photography has become "the perfect synthetic technology," as conducive to the creation of propaganda as to art. What is cinematic about this piece? What does this say about the nature of film as a medium—not only photographic film but motion picture film? Where does "truth" lie? Can we—indeed, should we—trust what we see? If we can so easily create "believeable" imagery, what are the possibilities for belief itself? And, perhaps most important of all, why must we, engaged in the critical process, consider not just the image itself, but also the way the image is made, the artistic process?

Fig. 12-49 Jeff Wall, *A Sudden Gust of Wind (After Hokusai)*, 1993.
Fluorescent light and display case, 90³/₁₆ × 148⁷/₁₆ in. Tate Gallery, London.
Courtesty of the artist.

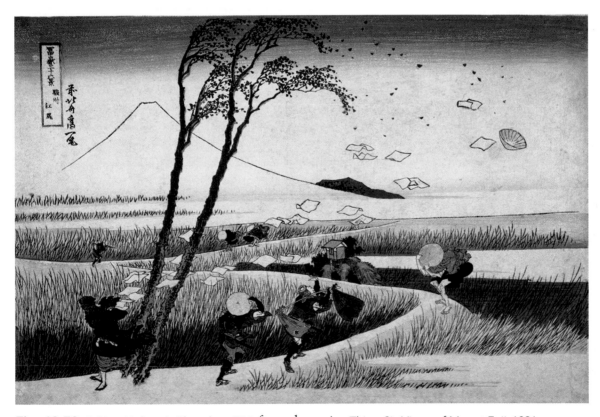

Fig. 12-50 Sakino Hokusai, *Shunshuu Ejiri*, from the series *Thirty-Six Views of Mount Fuji*, 1831.
Color woodblock, 30¹/₂ × 46 in. The Japan Ukiyo-e Museum, Matsumoto City, Japan.

13 | Sculpture

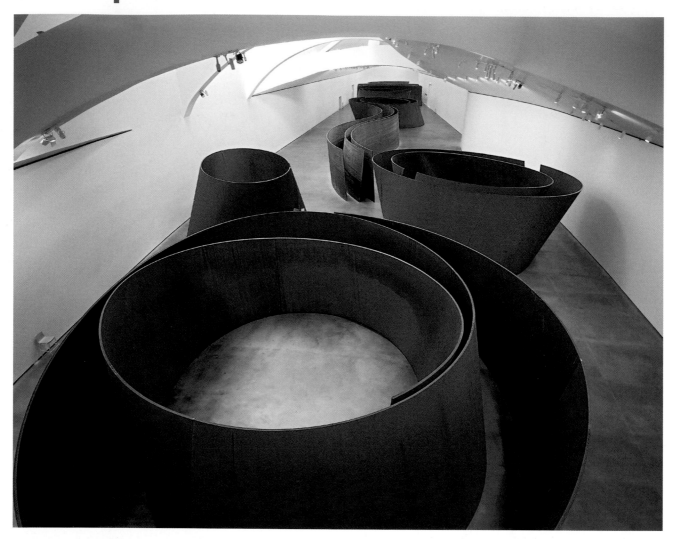

Fig. 13-1 Richard Serra, *The Matter of Time*, 2005.
Installation of seven sculptures, weatherproof steel, varying dimensions. Guggenheim Bilbao Museoa, GBM1996–2005.

Thinking Thematically: See Art and the Passage of Time on myartslab.com

THINKING AHEAD

How does relief sculpture differ from sculpture-in-the-round?

How do subtractive processes differ from additive processes?

What is involved in casting processes?

What is assemblage?

((•⟶[Listen** to the chapter audio on myartslab.com

All of the media we have so far considered—drawing, printmaking, painting, photography, and time-based media—are generally considered two-dimensional media. In this chapter, we turn to a discussion of the three-dimensional media and their relation to the time and space we ourselves occupy.

American sculptor Richard Serra's *The Matter of Time* (**Fig. 13-1**) directly addresses the relation of sculpture to both time and space. A huge installation in its own long gallery at the Guggenheim Museum, Bilbao, it is, in fact, composed of eight separate pieces.

Serra has directly addressed his intentions in creating the piece:

> As [this work] developed, there was more flux in the experience of time. Duration became the issue. Even as you follow a given path in the Spirals, everything on both sides of you—right and left, up and down—changes as you walk, and that either contracts the time, or extends it, making you anxious or relaxed as you anticipate what will happen next or recollect what has just happened. . . . As the pieces become more complex, so too does the temporality they create. It's not time on the clock, not literal time; it's subliminal, it's subjective. . . .

The sculpture possesses both a physical presence (its "matter"), one that is variously exciting and intimidating, and a temporal dimension (the "time" that its audience experiences walking in and through each of the pieces). As the viewer walks between the 2-inch-thick rolled steel plates, which twist at different angles, and open wide or close into almost impassable narrowness, the nature of space seems unstable, and time itself seems to speed up or slow down (not unlike the slow motion some people claim to have experienced in an accident). This, Serra explains, is what "differentiates the experience of the sculptures from daily experience."

Sculpture is one of the oldest and most enduring of all the arts. The types of sculpture considered in this chapter—carving, modeling, casting, construction and assemblage, installation art, and earthworks—employ two basic processes: They are either subtractive or additive in nature. In **subtractive** processes, the sculptor begins with a mass of material larger than the finished work and removes material, subtracting from that mass until the work achieves its finished form. Carving is a subtractive process. In **additive** processes, the sculptor builds the work, adding material as the work proceeds. Modeling, construction, and assemblage are additive processes. Casting, in which material in a liquid state is poured into a mold and allowed to harden, has additive aspects, but, as we shall see, it is in many ways a process of its own. Earthworks often utilize both additive and subtractive processes. Installations are essentially additive, transforming a given space by addition of new elements, including the live human body.

In addition to these processes, there are three basic ways in which we experience sculpture in three-dimensional space—as relief, in the round, and as an environment. If you recall the process for making woodblock prints, which is described in Chapter 10, you will quickly understand that the raised portion of a woodblock plate stands out in relief against the background. The woodblock plate is, in essence, a carved relief sculpture, a sculpture that has three-dimensional depth but is meant to be seen from only one side. **Relief** sculpture is meant to be seen from one side only—in other words, it is **frontal**, meant to be viewed from the front—and it is very often used to decorate architecture.

Among the great masters of relief sculpture were the Egyptians, who often decorated the walls of their temples and burial complexes with intricate raised relief sculpture, most of which was originally painted. Some of the best preserved of these are from the so-called "White Chapel," built by Senwosret I in about 1930 BCE at Karnak, Thebes, near the modern city of Luxor in the Nile River Valley. The scene depicted here (**Fig. 13-2**) is a traditional one, showing Senwosret I in the company of two Egyptian deities and surrounded by hieroglyphs, the pictorial Egyptian writing system. On the left is Amun, the chief god of Thebes, recognizable by the two plumes that form his headdress and by his erect penis. In the middle,

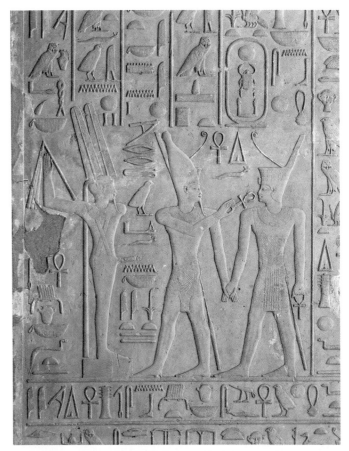

Fig. 13-2 *Senwosret I led by Atum to Amun-Re*, from the White Chapel at Karnak, Thebes, c. 1930 BCE.
Limestone, raised relief, height 13 ft. 6 in.
Scala/Art Resource, NY.

leading Senwosret, is Atum, the creator god. By holding the hieroglyph *ankh* (a sort of cross with a rounded top) to Senwosret I's nose, he symbolically grants him life. Like many great archaeological finds, the White Chapel has survived, paradoxically, because it was destroyed. In this case, 550 years after its construction, King Amenhotep III dismantled it and used it as filling material for a monumental gateway to his own temple at Karnak. Archaeologists have thus been able to reconstruct it almost whole.

Like the Egyptians, the Greeks used the sculptural art of relief as a means of decoration and to embellish the beauty of their great architectural achievements. Forms and figures carved in relief are spoken of as done in either **low relief** or **high relief**. (Some people prefer the French terms *bas-relief* and *haut-relief*.) The very shallow depth of the Egyptian raised reliefs is characteristic of low relief, though technically any sculpture that extends from the plane behind it less than 180 degrees is considered low relief. High-relief sculptures project forward from their base by at least half their depth, and often several elements will be fully in the round. Thus, even though it possesses much greater depth than the Egyptian raised relief at Karnak, the fragment from the **frieze**, or sculptural band, on the Parthenon called the *Maidens and Stewards* (**Fig. 13-3**) projects only a little distance from the background, and no sculptural element is detached entirely from it. It is thus still considered low relief.

The naturalism of the Parthenon frieze is especially worth noting. Figures overlap one another and are shown in three-quarter view, making the space seem far deeper than it actually is. The figures themselves seem almost to move in slow procession, and the garments they wear reveal real flesh and limbs beneath them. The carving of this drapery invites a play of light and shadow that further activates the surface, increasing the sense of movement.

Yu the Great Taming the Waters (**Fig. 13-4**), carved into the largest single piece of jade ever found, is a remarkable example of high-relief sculpture. In the late 1770s, near the city of Khotan in far western China, workers unearthed a stone 7 feet 4 inches high, over 3 feet in diameter, and weighing nearly 6 tons. The Chinese emperor immediately understood the stone's value—not just as an enormous piece of highly valued jade but as a natural wonder of potentially limitless propagandistic value. He himself picked the subject to be carved on the stone: it would be based on an anonymous Song painting in his collection depicting the mythical emperor Yu the Great, who ruled, it was believed, in the second millennium BCE, taming a flood.

It took three years to bring the stone to Beijing, transported on a huge wagon drawn by 100 horses, and a retinue of 1,000 men to construct the necessary roads and bridges. The court kept meticulous records of the jade's carving. Workers first made a full-size wax model of the stone. Then artists in the imperial household carved it to resemble what was to be the finished work. The emperor personally viewed and approved the carved model in 1781. A team of craftsmen from southern China carved the stone in 7 years

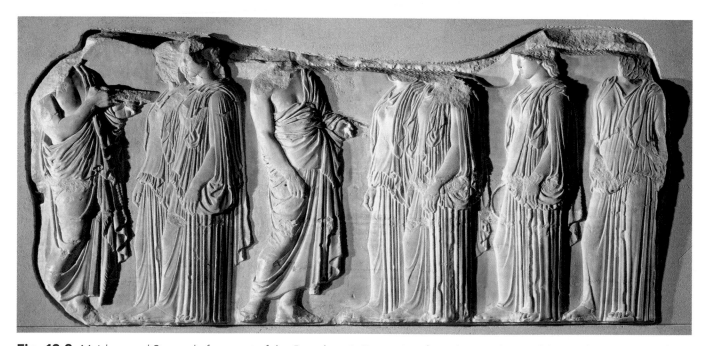

Fig. 13-3 *Maidens and Stewards*, fragment of the *Panathenaic Procession*, from the east frieze of the Parthenon, Acropolis, Athens, 442–438 BCE. Marble, height approximately 43 in. Musée du Louvre, Paris.

8 months—a total of 150,000 working days! When the jade was completed in 1787, it was placed on the spot in the Beijing palace where it still stands today.

The first written account of the story of Yu the Great appears in *The Book of History* (*Shu jing*), collected and edited by Confucius in the fourth century BCE. The story goes that a great flood inundated the valley of the Yellow River, covering even the hills, so that the people could find no food. King Shun ordered the official Yu to control it. Yu organized the princes who ruled various localities and the people in them to cut channels and build other projects to drain the waters away to the sea. He worked for 13 years before bringing the flood under control. *Yu the Great Taming the Waters* is not, in other words, the representation of a miracle, but a celebration of hard work, organizational skill, and dedicated service to one's ruler—traditional Confucian values embodied, in fact, in the hard work of the sculptors who carved the stone itself. The figures, trees, and landscape project at least half their circumference from the stone, and some figures are fully rounded. It is difficult to say just which of the many figures is Yu, because all are equally at work, digging, building, and pumping the waters of the Yellow River to the sea. The black area at the sculpture's base, full of swirling waves, represents the waters that Yu is taming. The implication is that, as the water recedes, the green plenty of the earth (represented by the green jade) will be restored. Formally, in the way that a set of flowing curves seems to hold the strong diagonals of the jade and broad sweeps of stone balance its intimate detail, the sculpture also suggests the overall unity of purpose that characterizes the ideal Chinese state.

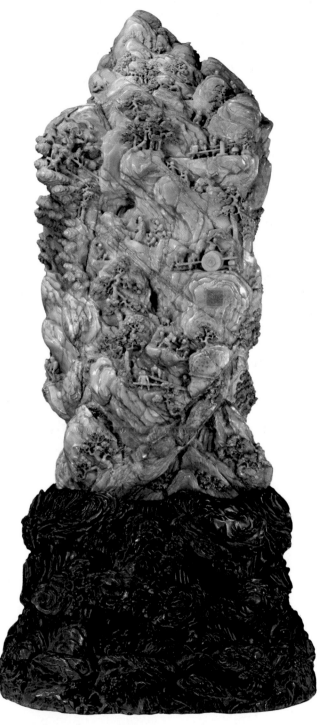

Fig. 13-4 *Yu the Great Taming the Waters*, and detail, Qing dynasty, completed 1787.
Jade, height 7 ft. 4¼ in. × 3 ft. 1¾ in. Collection of The Palace Museum, Beijing.

Fig. 13-5 Giambologna, *Capture of the Sabine Women*, completed 1583.
Marble, height 13 ft. 6 in. Loggia dei Lanzi, Florence.

Fig. 13-6 Giambologna, *Capture of the Sabine Women*, completed 1583.
Marble, height 13 ft. 6 in. Loggia dei Lanzi, Florence.

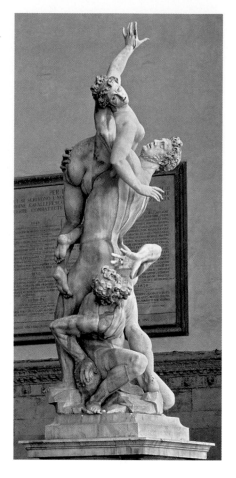

Perhaps because the human figure has traditionally been one of the chief subjects of sculpture, movement is one of the defining characteristics of the medium. Even in relief sculptures, it is as if the figures want to escape the confines of their base. **Sculpture-in-the-round** literally demands movement. It is meant to be seen from all sides, and the viewer must move around it. Giambologna's *Capture of the Sabine Women* (**Figs. 13-5** and **13-6**) is impossible to represent in a single photograph. Its figures rise in a spiral, and the sculpture changes dramatically as the viewer walks around it and experiences it from each side. It is in part the horror of the scene that lends the sculpture its power, for as it draws us around it, in order to see more of what is happening, it involves us both physically and emotionally in the scene it depicts.

The viewer is even more engaged in the other sculptural media we will discuss in this chapter—environments. An **environment** is a sculptural space into which you can physically enter either indoors, where it is generally referred to as an **installation**, or out-of-doors, where its most common form is that of the **earthwork**. With these terms in mind—*relief sculpture, sculpture-in-the-round,* and *environments*—we can now turn to the specific methods of making sculpture.

Carving

Carving is a subtractive process in which the material being carved is chipped, gouged, or hammered away from an inert, raw block of material. Wood and stone are the two most common carving materials. Both materials present problems for the artist to solve. Sculptors who work in wood must pay attention to the wood's grain, since wood will only split in the direction it grew. To work "against the grain" is to risk destroying the block. Sculptors who work in stone must take into account the different characteristics of each type of stone. Sandstone is gritty and coarse, marble soft and crystalline, granite dense and hard. Each must be dealt with differently. For Michelangelo, each stone held within it the secret of what it might become as a sculpture. "The best artist," he wrote, "has no concept which some single marble does not enclose within its mass. . . . Taking away . . . brings out a living figure in alpine and hard stone, which . . . grows the more as the stone is chipped away." But carving is so difficult that even Michelangelo often failed to realize his concept. In his *"Atlas" Slave* (**Fig. 13-7**), he has given up. The block of stone resists Michelangelo's desire to transform it, as if refusing to release the figure it holds enslaved within it. Yet, arguably, the power of Michelangelo's imagination lies in his willingness to leave the figure unrealized. Atlas, condemned to bearing the weight of the world on his shoulders forever as punishment for challenging the Greek gods, is literally held captive in the stone.

Nativity (**Fig. 13-8**), by the Taos, New Mexico–born Hispanic sculptor Patrocinio Barela, is carved out of the aromatic juniper tree that grows across the arid landscape of the Southwest. Barela's forms are clearly dependent on the original shape of the juniper itself. The lines of his figures, verging on abstraction, follow the natural contours of the wood and its grain.

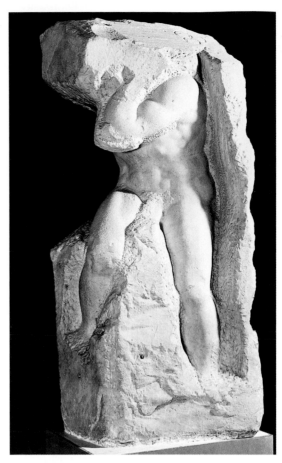

Fig. 13-7 Michelangelo, *"Atlas" Slave*, c. 1513–20. Marble, 9 ft. 2 in. Accademia, Florence.

👁—|**Watch** a video about carving on myartslab.com

The group of animals at the far left, for instance, is supported by a natural fork in the branch that is incorporated into the sculpture. The human figures in Barela's work are closely related to *santos*, images of the saints. Those who carve *santos* are known as *santeros*. Both have been an important part of Southwestern Hispanic culture since the seventeenth century, serving to give concrete identity to the abstractions of Catholic religious doctrine. By choosing to work in local wood, Barela ties the local world of the everyday to the universal realm of religion, uniting material and spiritual reality.

Fig. 13-8 Patrocinio Barela, *Nativity*, c. 1966.
Juniper wood, height of tallest figure 33 in. Peabody Essex Museum, Salem, Massachusetts. Courtesty of the artist.

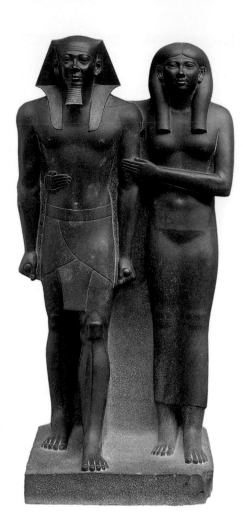

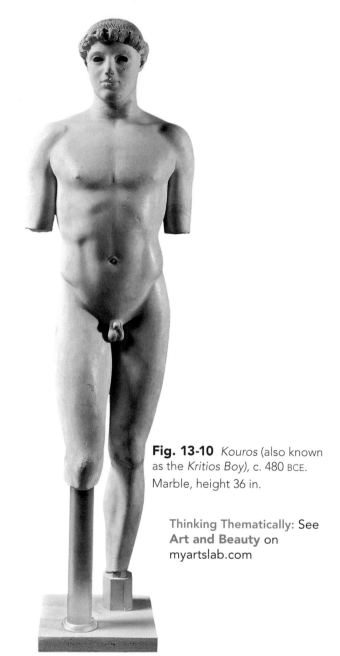

Fig. 13-9 *Menkaure with a Woman*, probably Khamerernebty, from valley temple of Menkaure, Giza. Dynasty 4, ca. 2460 BCE. Schist, height 54½ in. Reproduced with permission. © 2006 Museum of Fine Arts, Boston. Harvard University-Boston Museum of Fine Arts, 11.1738.

Photograph © 2012 Museum of Fine Arts, Boston.

Fig. 13-10 *Kouros* (also known as the *Kritios Boy*), c. 480 BCE. Marble, height 36 in.

Thinking Thematically: See **Art and Beauty** on myartslab.com

This desire to unify the material and the spiritual worlds has been a goal of sculpture from the earliest times. In Egypt, for example, stone funerary figures (**Fig. 13-9**) were carved to bear the *ka*, or individual spirit, of the deceased into the eternity of the afterlife. The permanence of the stone was felt to guarantee the *ka*'s immortality. (For a contemporary sculptor's take on the idea of stone's permanence, see *The Creative Process*, pp. 302–303). For the ancient Greeks, only the gods were immortal. What tied the world of the gods to the world of humanity was beauty itself, and the most beautiful thing of all was the perfectly proportioned, usually athletic, male form.

Egyptian sculpture was known to the Greeks as early as the seventh century BCE, and Greek sculpture is indebted to it, but the Greeks quickly evolved a much more naturalistic style. In other words, compared with the rigidity of the Egyptian figures, this *Kouros*, or youth (**Fig. 13-10**), is both more at ease and more lifelike. Despite the fact that his feet have been lost, we can see that the weight of his body is on his left leg, allowing his right leg to relax completely. This youth, then, begins to move. The sculpture begins to be animated, to portray not just the figure but also its

movement. It is as if the stone has begun to come to life. Furthermore, the *Kouros* is much more anatomically correct than his Egyptian forebear. In fact, by the fifth century BCE, the practice of medicine had established itself as a respected field of study in Greece, and anatomical investigations were commonplace. At the time that the Kouros was sculpted, the body was an object of empirical study, and its parts were understood to be unified in a single, flowing harmony.

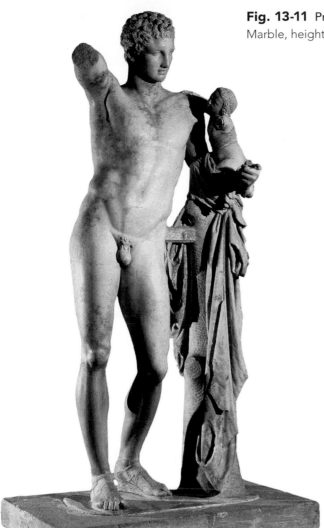

Fig. 13-11 Praxiteles, *Hermes and Dionysos*, c. 330 BCE. Marble, height 7 ft. 1 in. National Archaeological Museum, Athens.

This flowing harmony was further developed by Praxiteles, the most famous sculptor of his day. In works such as *Hermes and Dionysos* (**Fig. 13-11**), he shifted the weight of the body even more dynamically, in a pose known as **contrapposto**, or counterbalance. In *contrapposto*, the weight falls on one foot, raising the corresponding hip. This shift in weight is countered by a turn of the shoulders, so that the figure stands in a sort of S-curve. The result is an even greater sense of naturalism and movement.

Such naturalism is perhaps nowhere more fully realized in Greek sculpture than in the grouping *Three Goddesses* (**Fig. 13-12**), from the east pediment, or triangular roof gable, of the Parthenon. Though actually freestanding when seen from the ground, as they are displayed today in the British Museum, with the wall of the pediment behind them, the goddesses—commonly believed to be Aphrodite, the goddess of beauty, her mother Dione, and Hestia, the goddess of the hearth—would have looked as if they had been carved in high relief. As daylight shifted across the surface of their bodies, it is easy to imagine the goddesses seeming to move beneath the swirling, clinging, almost transparent folds of cloth, as if brought to life by light itself.

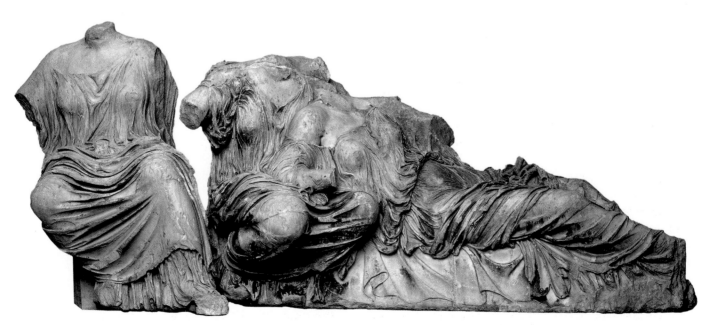

Fig. 13-12 *Three Goddesses*, from the east pediment of the Parthenon, Acropolis, Athens, c. 438–432 BCE. Marble, over-life-size. British Museum, London.

THE CREATIVE PROCESS

Stone is a symbol of permanence, and of all stones, black granite is one of the hardest and most durable. Thus, in 1988, when sculptor Jim Sardonis chose the stone out of which to carve his tribute to the whale, *Reverence* (**Fig. 13-14**), black granite seemed the most suitable medium. Not only was its color close to that of the whales themselves, but also the permanence of the stone stood in stark contrast to the species's threatened survival. Sardonis wanted the work to have a positive impact. He wanted it to help raise the national consciousness about the plight of the whale, and he wanted to use the piece to help raise funds for both the Environmental Law Foundation and the National Wildlife Federation, two organizations actively engaged in wildlife conservation efforts.

The idea for the sculpture first came to Sardonis in a dream—two whale tails rising out of the sea. When he woke he saw the sculpture as rising out of the land, as if the land were an imaginary ocean surface. And, surprisingly, whales were not unknown to the area of New England where Sardonis worked. In 1849, while constructing the first railroad between Rutland and Burlington, Vermont, workers unearthed a mysterious set of bones near the town of Charlotte. Buried nearly 10 feet below the surface in a thick blue clay, they were ultimately determined to be the bones of a beluga or "white" whale, an animal that inhabits arctic and subarctic marine waters. Because Charlotte is far inland (more than 150 miles from the nearest ocean), early naturalists were at a loss to explain the bones of a marine whale buried beneath the fields of rural Vermont. But the Charlotte whale was preserved in the sediments of the Champlain Sea, an arm of the ocean that extended into the Champlain Valley for 2,500 years following the retreat of the glaciers 12,500 years ago.

Sculptures of the size that Sardonis envisioned are not easily realized without financial backing. A local developer, who envisioned the piece installed at the entrance of a planned motel and conference center, supported the idea, and Sardonis was able to begin. The piece would require more space, and more complicated equipment, than Sardonis had available in his own studio, so he arranged to work at Granite Importers, an operation in Barre, Vermont, that could move stones weighing 22 and 14 tons, respectively, and that possessed diamond saws as large as 11 feet for cutting the stones.

Sardonis recognized that it would be easier to carve each tail in two pieces, a tall vertical piece and the horizontal flukes, so he began by having each of the two stones cut in half by the 11-foot saw. Large saws roughed out the shapes, and then Sardonis began to work on the four individual pieces by hand (**Fig. 13-13**). As a mass, such granite is extremely hard, but in thin slabs, it is relatively easy to break away. The sculptor's technique is to saw the stone, in a series of parallel cuts, down to within 2 to 6 inches of the final form, then break each piece out with a hammer. This "cut-and-break" method results in an extremely rough approximation of the final piece that is subsequently realized by means of smaller saws and grinders.

Fig. 13-13 Jim Sardonis's *Reverence* in progress, 1988–89. Photos courtesy of the artist.

When the pieces were finally assembled, they seemed even larger to Sardonis than he had imagined. But as forms, they were just what he wanted: As a pair, they suggest a relationship that extends beyond themselves to the rest of us. The name of the piece, *Reverence*, suggests a respect for nature that is tinged with awe, not only for the largest mammals on the planet, but also for the responsibility we all share to protect all nature. The whale, as the largest creature, becomes a symbol for all species and for the fragility and interconnection of all life on earth.

The project had taken almost a year, and by midsummer 1989, the site at the prospective conference center was being prepared. Though the pair of forms were installed, when funding for the conference center fell through, they were moved to a new site, just south of Burlington, Vermont on Interstate 89, where they overlook the Champlain Valley.

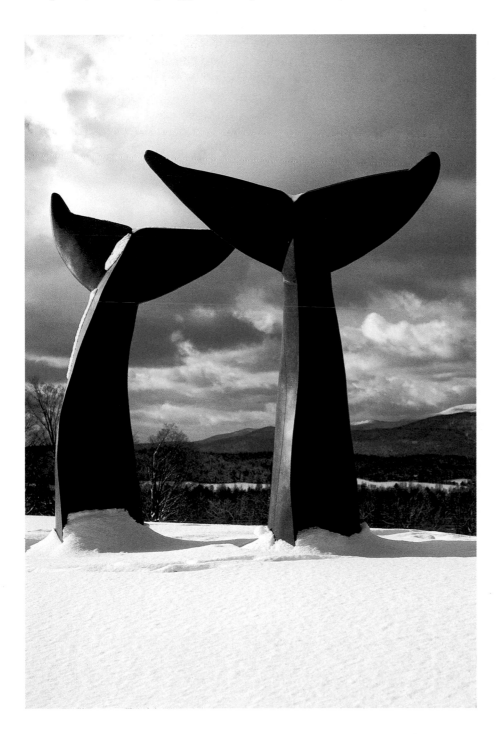

Fig. 13-14 Jim Sardonis, *Reverence*, 1989.

Black granite, height 13 ft. Beside Interstate 89, south of Burlington, Vermont.

Photo courtesy of the artist. © 1989 Jim Sardonis.

Modeling

When you pick up a handful of clay, you almost instinctively know what to do with it. You smack it with your hand, pull it, squeeze it, bend it, pinch it between your fingers, roll it, slice it with a knife, and shape it. Then you grab another handful, repeat the process, and add it to the first, building a form piece by piece. These are the basic gestures of the additive process of modeling, in which a pliant substance, usually clay, is molded.

Clay, a natural material found worldwide, has been used by artists to make everything from pots to sculptures since the earliest times. Its appeal is largely due to its capacity to be molded into forms that retain their shape. Once formed, the durability of the material can be ensured by **firing** it—that is, baking it—at temperatures normally ranging between 1,200 and 2,700 degrees Fahrenheit in a **kiln**, or oven, designed especially for the process. This causes it to become hard and waterproof. We call all works made of clay **ceramics**.

Robert Arneson's *Case of Bottles* (**Fig. 13-15**) is a ceramic sculpture. The rough handmade quality of Arneson's work, a quality that clay lends itself to especially well, contrasts dramatically with his subject matter, mass-produced consumer products. He underscores this contrast by including in the case of Pepsi a single real 7-Up bottle. He has even allowed the work to crack by firing it too quickly. The piece stands in stark defiance to the assembly line.

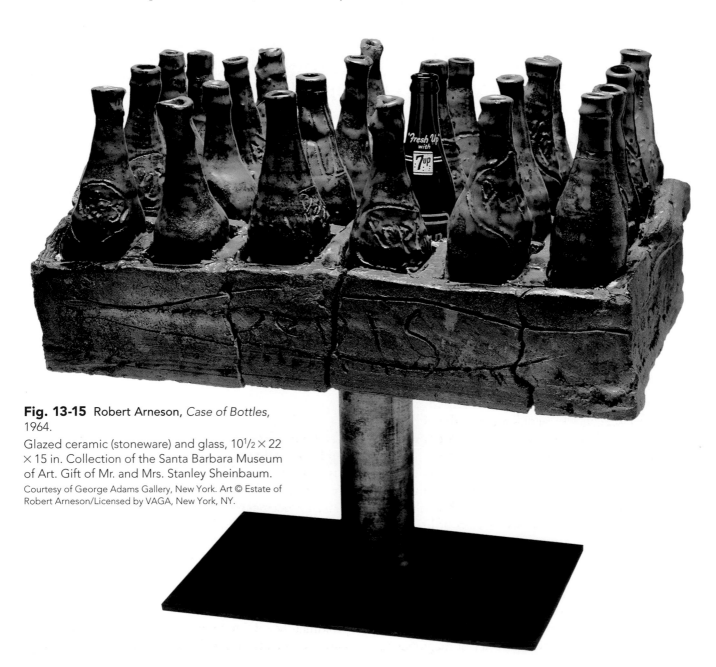

Fig. 13-15 Robert Arneson, *Case of Bottles*, 1964.
Glazed ceramic (stoneware) and glass, 10$\frac{1}{2}$ × 22 × 15 in. Collection of the Santa Barbara Museum of Art. Gift of Mr. and Mrs. Stanley Sheinbaum.
Courtesy of George Adams Gallery, New York. Art © Estate of Robert Arneson/Licensed by VAGA, New York, NY.

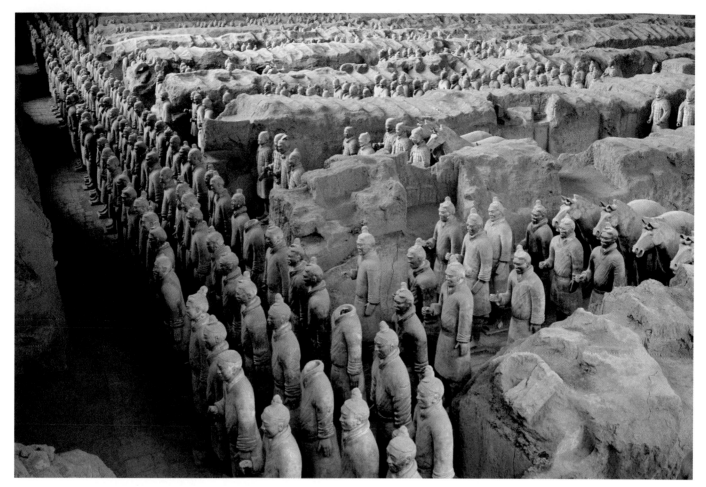

Fig. 13-16 Tomb of the emperor Qin Shihuangdi, 221–206 BCE. Painted ceramic figures, life-size.

Thinking Thematically: See Art, Politics, and Community on myartslab.com

Throughout history, the Chinese have made extraordinary ceramic works, including the finest porcelains of fine, pure white clay. We tacitly acknowledge their expertise when we refer to our own "best" dinner plates as "china." But the most massive display of the Chinese mastery of ceramic art was discovered in 1974 by well diggers who accidentally drilled into the tomb of Qin Shihuangdi, the first emperor of China (**Fig. 13-16**). In 221 BCE, Qin Shihuangdi united the country under one rule and imposed order, establishing a single code of law and requiring the use of a single written language. Under his rule, the Great Wall was built, and construction of his tomb required a force of more than 700,000 men. Qin Shihuangdi was buried near the central Chinese city of Xian, and his tomb contained more than 6,000 life-size, and extraordinarily lifelike, ceramic figures of soldiers and horses, immortal bodyguards for the emperor. More recently, clerks, scribes, and other court figures have been discovered, as well as a set of magnificent bronze horses and chariots. Compared to Arneson's rough work, the figures created by the ancient Chinese masters are incredibly refined, but between the two of them we can see how versatile clay is as a material.

Casting

The body parts of the warriors in Qin Shihuangdi's tomb were all first modeled by the emperor's army of artisans. Then, molds were made of the various parts, and they were filled with liquid clay and fired over high heat, a process repeated over and over again. Artisans then assembled the soldiers, choosing different heads, bodies, arms and legs in order to give each sculpture a sense of individual identity. We call this process *casting*.

Casting employs a mold into which some molten material is poured and allowed to harden. It is an invention of the Bronze Age (beginning in approximately 2500 BCE), when it was first used to make various utensils by simply pouring liquid bronze into

open-faced molds. The technology is not much more complicated than that of a gelatin mold. You pour gelatin into the mold and let it harden. When you remove the gelatin, it is shaped like the inside of the mold. Small figures made of bronze are similarly produced by making a simple mold of an original modeled form, filling the mold with bronze, and then breaking the mold away.

As the example of gelatin demonstrates, bronze is not the only material that can be cast. In the kingdom of Benin, located in southern Nigeria, on the coastal plain west of the Niger River, brass casting reached a level of extraordinary accomplishment as early as the late fourteenth century. Brass, which is a compound composed of copper and zinc, is similar to bronze but contains less copper and is yellower in color. When, after 1475, the people of Benin began to trade with the Portuguese for copper and brass, an explosion of brass casting occurred. A brass head of an *oba*, or king of a dynasty, which dates from the eighteenth century (**Fig. 13-17**), is an example of a cast brass sculpture. When an *oba* dies, one of the first duties of the new *oba* is to establish an altar commemorating his father and to decorate it with newly cast brass heads. The heads are not portraits. Rather, they are generalized images that emphasize the king's coral-bead crown and high bead collar, the symbols of his authority. The head has a special significance in Benin ritual. According to British anthropologist R. E. Bradbury, the head

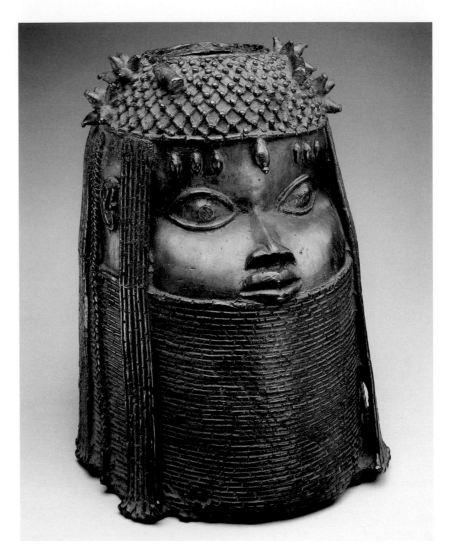

Fig. 13-17 *Head of an Oba*, Edo, Court of Benin, Nigeria, Guinea Coast. eighteenth century.
Brass and iron, height 13 1/8 in. The Metropolitan Museum of Art, New York, NY, U.S.A. Gift of Mr. and Mrs. Klaus G. Perls, 1991 (1991.17.2).
Image copyright © The Metropolitan Museum of Art. Image source: Art Resource, NY.

symbolizes life and behavior in this world, the capacity to organize one's actions in such a way as to survive and prosper. It is one's Head that 'leads one through life.' . . . On a man's Head depends not only his own well-being but that of his wives and children. . . . At the state level, the welfare of the people as a whole depends on the Oba's Head which is the object of worship at the main event of the state ritual year.

The *oba* head is an example of one of the most enduring, and one of the most complicated, processes for casting metal. The **lost-wax process**, also known as **cire-perdue**, was perfected by the Greeks if not actually invented by them. Because metal is both

expensive and heavy, a technique had to be developed to create hollow images rather than solid ones, a process schematized in simplified terms in the diagram in **Fig. 13-18**.

In the lost-wax method, the sculpture is first modeled in some soft, pliable material, such as clay, wax, or plaster in a putty state. This model looks just like the finished sculpture, but the material of which it is composed is of course nowhere near as durable as metal. As the process proceeds, this core is at least theoretically disposable, though many sculptors, including Auguste Rodin (see Fig. 8-28), have habitually retained these cores for possible re-casting.

Fig. 13-18 The Lost-Wax Casting Process.

A positive model (1), often created with clay, is used to make a negative mold (2). The mold is coated with wax, the wax shell is filled with a cool fireclay, and the mold is removed (3). Metal rods, to hold the shell in place, and wax rods, to vent the mold, are then added (4). The whole is placed in sand, and the wax is burned out (5). Molten bronze is poured in where the wax used to be. When the bronze has hardened, the whole is removed from the sand, and the rods and vents are removed (6).

👁—**Watch** a video about the lost-wax process on myartslab.com

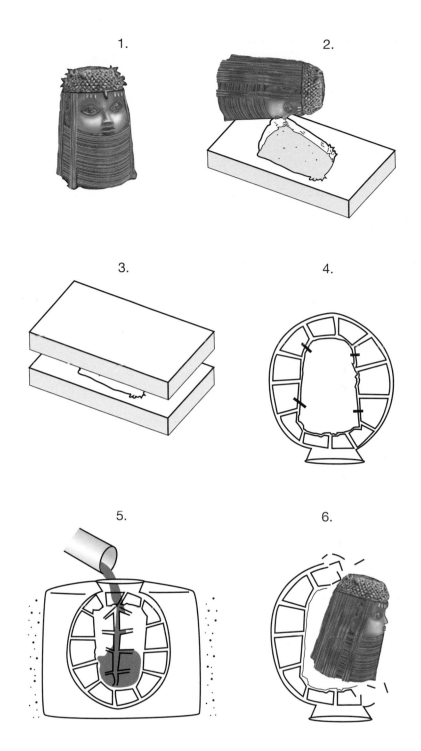

A mold is then made of the model (today, synthetic rubber is most commonly used to make this mold), and when it is removed, we are left with a negative impression of the original—in other words, something like a gelatin mold of the object. Molten wax is then poured or brushed into this impression to the same thickness desired for the final sculpture—about an eighth of an inch. The space inside this wax lining is filled with an **investment**—a mixture of water, plaster, and powder made from ground-up pottery. The mold is then removed, and we are left with a wax casting, identical to the original model, that is filled with the investment material. Rods of wax are then applied to the wax casting; they stick out from it like giant hairs. They will carry off melted wax during baking and will eventually provide channels through which the molten bronze will be poured. The sculpture now consists of a thin layer of wax supported by the investment. Sometimes bronze pins are driven through the wax into the investment in order to hold investment, casting, and channels in place.

This wax cast, with its wax channels, is ready to be covered with another outer mold of investment. When this outer mold cures, it is then baked in a kiln at a temperature of 1,500 degrees Fahrenheit, with the wax replica inside it. The wax rods melt, providing channels for the rest of the wax to run out as well—hence the term lost-wax. A thin space where the wax once was now lies empty between the inner core and the outer mold, the separation maintained by the bronze pins.

Molten bronze is poured into the casting gate, an opening in the top of the mold, filling the cavity where the wax once was. Hence, many people refer to casting as a **replacement process**—bronze replaces wax. When the bronze has cooled, the mold and the investment are removed, and we are left with a bronze replica of the wax form, complete with the latticework of rods. The rods are cut from the bronze cast, and the surface is smoothed and finished.

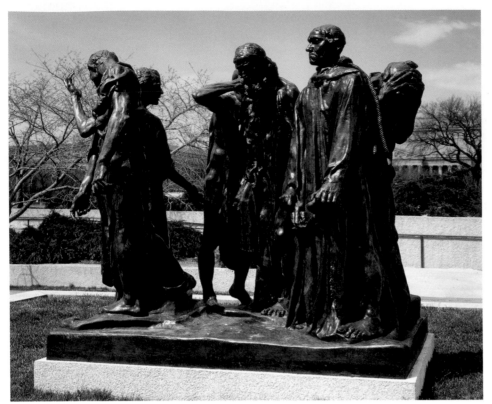

Fig. 13-19 Auguste Rodin, *The Burghers of Calais*, 1884–85. Bronze, 79³/₈ × 80⁷/₈ in. Hirshhorn Museum and Sculpture Garden, Smithsonian Institution, Washington, D.C. Gift of Joseph H. Hirshhorn, 1966. 66.4340. Photo: Lee Stalsworth.

to the enemy for execution. Rodin depicts them, dressed in sackcloth with rope halters, about to give themselves up to the English. Each is caught up in his own thoughts—they are, alternately, angry, resentful, resigned, distraught, and fearful. Their hands and feet are purposefully elongated, exaggerating their pathos. Rodin felt that the hand was capable of expressing the full range of human emotion. In this work, the hands give, they suffer, they hold at bay, they turn inward. The piece, all told, is a remarkable example of sculpture in the round, an assemblage of individual fragments that the viewer can only experience by walking around the whole and taking in each element from a different point of view. As it turns

Bronze is so soft and malleable that the individual pieces can easily be joined in either of two ways: pounded together with a hammer, the procedure used in Greek times, or welded, the more usual procedure today. Finally, the shell is reassembled to form a perfect hollow replica of the original model. Large pieces such as Auguste Rodin's *Burghers of Calais* (**Fig. 13-19**) was, in fact, cast in several pieces and then welded together. Rodin's sculpture was commissioned by the city of Calais to commemorate six of its leading citizens (or burghers) who, during the Hundred Years' War in 1347, agreed to sacrifice themselves and free the city of siege by the English by turning themselves over

Fig. 13-20 Nancy Graves, *Variability and Repetition of Similar Forms, II*, 1979. Bronze with white pigmented wax patina on Cor-Ten steel base, 6 × 12 × 16 ft. Akron Art Museum. Mary S. and Louis S. Myers Foundation, the Firestone Foundation, National Endowment for the Arts, and the Museum Acquisition Fund. Art © Nancy Graves Foundation/Licensed by VAGA, New York, NY.

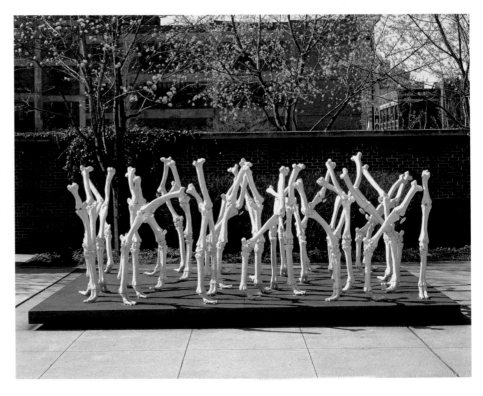

out, the story has a happy ending. The English queen, upon seeing the courage of the burghers, implored her husband to have mercy on them, and he agreed. Still, Rodin depicts them as they trudge toward what they believe will be their final destiny. In fact, the Calais city fathers wanted to raise the sculpture on a pedestal, but Rodin insisted that it remain on level ground, where citizens could identify with the burghers' sacrifice and make their heroism at least potentially their own.

In her *Variability and Repetition of Similar Forms, II* (**Fig. 13-20**), Nancy Graves pays homage to Rodin's *Burghers*. The work consists of 36 leg bones, modeled after life-size camel bones and arranged across a large, flat base. Each leg appears unique, but, in fact, each

Fig. 13-21 Luis Jiménez, *Howl*, 1986.
Fiberglass and acrylic urethane, 60 × 29 × 29 in. Spencer Museum of Art at the University of Kansas. Museum purchase, 93.282.

is derived from three or four models, which Graves refashioned in a variety of ways and covered with a white-wax **patina**—that is, a chemical compound applied to the bronze by the artist that forms a film or encrustation on the surface after exposure to the elements.

A decade before this work was completed, in 1969, Graves had exhibited life-size, fully representational camels made of wood, steel, burlap, polyurethane, animal skin, wax, acrylic, oil paint, and fiberglass at the Whitney Museum of American Art—the first one-person show ever given to a woman artist at the Whitney. A year later, in 1970, Graves made a film entitled *Izy Boukir* in Morocco, an examination of the interrelationships of line and form produced by the movements of a caravan of closely grouped camels. *Variability and Repetition of Similar Forms* is based on what Graves learned about the movement of camels while making her film. "Why camels?" Graves was once asked. "Because they shouldn't exist," she replied. "They have flesh on their hoofs, four stomachs, a dislocated jaw. Yet with all of the illogical form the camel still functions. And though they may be amusing, they are still wonderful to watch." They are, in other words, like Rodin's *Burghers of Calais*, animals seemingly at the very edge of extinction that somehow, heroically, manage to survive, even thrive.

Although, because of its durability, bronze is a favorite material for casting sculptures meant for the out-of-doors, other materials have become available to artists in recent years, including aluminum and fiberglass. Luis Jiménez chose fiberglass for his depiction of a wounded coyote, *Howl* (**Fig. 13-21**). "My main concern," Jiménez explains, "is creating an 'American art' using symbols and icons. Sources for the work come out of popular art and aesthetic (cowboys, western Indians, the Statue of Liberty, motorcycles), as does the material—plastic (surfboard, boats, cars). I feel I am a traditional artist working with images and materials that are of 'my' time."

Assemblage

To the degree that they are composed of separately cast pieces later welded together, works like Rodin's *Burghers of Calais* and Graves's *Variability and Repetition of Similar Forms, II* are examples of **assemblage**, the process of bringing individual objects or pieces together to form a larger whole. But as a process, assemblage is more often associated with the transformation of common materials into art, in which the artist, rather than forming all of the parts that are put together, finds the parts in the world. For instance,

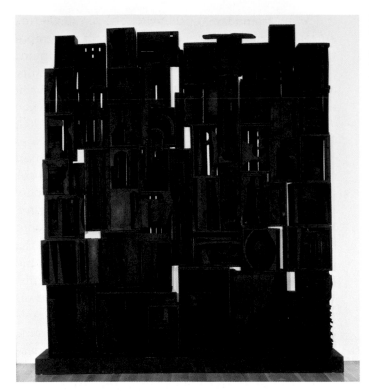

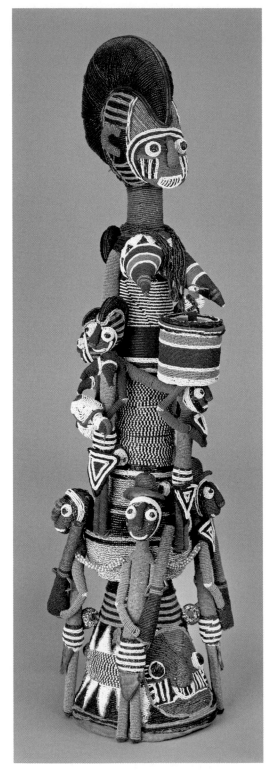

Fig. 13-23 Display piece, Yoruba culture, early twentieth century.
Cloth, basketry, beads, and fiber; height 41¼ in. The British Museum, London.

Louise Nelson's *Sky Cathedral* (**Fig. 13-22**) is a giant assemblage of wooden boxes, wood working remnants and scraps, and found objects. It is entirely frontal and functions like a giant high-relief altarpiece—hence its name—transforming and elevating its materials to an almost spiritual dimension. Nevelson manages to make a piece of almost endless variety and difference appear unified and coherent through the asymmetrical balance of its grid structure, the repetition of forms and shapes, and, above all, its overall black coloring. The black lends the piece a certain mystery—a fact heightened by the way in which it is lit in the museum, with diffuse light from the sides which deepens the work's shadows. But, according to Nevelson, "Black means totality. It means: contains all. . . . Because black encompasses all colors. Black is the most aristocratic color of all. The only aristocratic color. . . . I have seen things that were transformed into black that took on just greatness. I don't want to use a lesser word."

Many African cultures use assemblage to create objects of sacred or spiritual significance. The *nkisi* figure from the Kongo (see Fig. 1-14) is an example. In the Yoruba cultures of western Nigeria and southern Benin, the artworks produced for the king and his court—particularly crowns and other display pieces—are composed of a variety of materials. The display piece commissioned in the early twentieth century by the king of a small Yoruba kingdom combines beadwork, cloth, basketry, and other fiber into a sculptural representation of a royal wife (**Fig. 13-23**). With

crested hairdo and child on her back, she is portrayed presenting a lidded offering bowl, which she holds below her conical breasts. Attendants are attached to her body, one of whom helps her hold the offering bowl by balancing it on her head. Around the bottom of her body, four male figures, wearing top hats, offer her their protection, guns at their sides. The beadwork defining all of the sculpture's various elements is itself an assemblage of various geometric designs and patterns. For the Yoruba, geometric shapes, divided into smaller geometric shapes, suggest the infinitude of forces in the cosmos. As in all Yoruba beadwork, the play between different geometric patterns and elements creates a sense of visual dynamism and movement, which the Yoruba call the principle of "shine." Shine not only refers to the shiny characteristics of the glass beadwork itself, but suggests as well the idea of completeness or wholeness. On the one hand, the sculpture is meant to reflect the power of the king, but it is, simultaneously, an acknowledgment, on the king's part, of the power of women, and his incompleteness without them. The Yoruba, in fact, have a deep belief in the powers of what they call "Our Mothers," a term that refers to all Yoruba female ancestors. Kings cannot rule without drawing upon the powers of Our Mothers.

👁—**Watch** a video with Jeff Koons on myartslab.com

Many assemblages, like Nevelson's *Sky Cathedral*, are made from the throw-away remnants of contemporary commodity culture, transforming them into art. Jeff Koons's scuptures are re-creations of commodity culture itself, ranging from three basketballs floating in a half-filled tank of water (*Three Ball Total Equilibrium Tank [Two Dr J Silver Series, Spalding NBA Tip-Off]*, 1985) to life-size porcelain and gold-plated statues of Michael Jackson cuddling his pet chimpanzee (*Michael Jackson and Bubbles*, 1988). By taking the basketballs out of circulation, in the former, he transforms them into fetish objects, commenting wryly on the culture's adulation of athletic prowess. The latter culminated his *Banality* series, which also included *Pink Panther*, a life-size porcelain sculpture of the Pink Panther in the arms of a bare-breasted blonde. But one of his most audacious works—and one of his most popular—is *Puppy* (**Fig. 13-24**), shown here installed in front of the Guggenheim Bilbao museum. An assemblage consisting of an armature of stainless steel, an irrigation system, and live flowering plants, it is nothing other than a Chia Pet grown large. In an Art21 video available on myartslab, Koons comments that when he conceived of *Puppy*, he was thinking of Louis XIV of France, whose palace at Versailles, outside Paris,

Fig. 13-24 Jeff Koons, *Puppy*, 1992.
Stainless steel, soil, geotextile fabric, internal irrigation system, and live flowering plants, 40 feet 8³/₁₆ inches × 27 feet 2³/₄ inches × 29 feet 10¹/₄ inches (12 meters 40 cm × 830 cm × 910 cm) The Solomon R. Guggenheim Foundation, New York.
Art © Jeff Koons.

was the most magnificent royal residence in Europe. "It's the type of work," Koons says of *Puppy*, "that Louis would have had the fantasy for. You know, he'd wake up in the morning . . . and think, 'What do I want to see today? I want to see a puppy. I want to it made out of 60,000 plants, and I want to see it by this evening.' And he would come home that night, and *voilà*, there it would be." It is an image, in other words, that reflects the taste of arguably the most profligate king in history, a taste for extravagance appealing equally, it would seem, to the public today. But however kitschy, *Puppy* insists on its status as art, even as it causes us to reflect on the commodity status of art itself (see Chapter 3).

Robert Gober's sculptural assemblages evolve from fragments of our everyday domestic lives that are juxtaposed with one another to create haunting objects that seem to exist halfway between reality and the fitful nightmare of a dreamscape. Gober repeatedly returns to the same fundamental repertoire of objects—body parts (made of plaster and beeswax for skin), particularly lower legs, usually graced with actual body hair, shoes, and socks; storm drains; pipes;

Fig. 13-25 Robert Gober, *Untitled*, 1999.
Plaster, beeswax, human hair, cotton, leather, aluminum, and enamel. 33$\frac{1}{2}$ × 40 × 24 in. Philadelphia Museum of Art. Gift (by exchange) of Mrs. Arthur Barnwell.

doors; children's furniture; and, his most ubiquitous image, a common domestic sink. His work, in essence, does not include, as the saying goes, "everything but the kitchen sink," it includes everything and the kitchen sink. *Untitled* (**Fig. 13-25**) is, in this sense, standard Gober fare. But despite the repetition of certain objects across the body of his work, each new sculpture seems entirely fresh.

Part of the power of Gober's works is that their meaning is open-ended, even as they continually evoke a wide range of American clichés. His objects invite multiple interpretations, none of which can ever take priority over any of the others. Consider, for instance, a sink. A sink is, first of all, a place for cleansing, its white enamel sparkling in a kind of hygienic purity. But this one is nonfunctional, its drain leading nowhere—a sort of "sinkhole." While looking at it, the viewer begins to get a "sinking" feeling that there is more to this image than might have been apparent at first. Of course, the two legs suspended over the basin instead of water spigots has suggested this to even the unthoughtful viewer all along.

They are, evidently, the legs of a young girl. Although not visible in a photograph, they are covered with a light dusting of actual human hair. Oddly enough, they are both left feet, suggesting adolescent awkwardness (a person who can't dance is said to have "two left feet"). More to the point, hanging over the sink, they evoke something akin to bathroom humor even as they seem to suggest the psychological mire of some vaguely sexual dread.

An example of an assemblage with more spiritual overtones is Clyde Connell's *Swamp Ritual* (**Fig. 13-26**), fabricated of parts from rusted-out tractors and machines, discarded building materials and logs, and papier-mâché made from the classified sections of the *Shreveport Journal and Times*. The use of papier-mâché developed out of Connell's desire to find a material capable of binding the wooden and iron elements of her work. By soaking the newsprint in hot water until its ink began to turn it a uniform gray, and then mixing it with Elmer's Glue, Connell was able to create a claylike material possessing, when dry, the texture of wasps' nests or rough gray stone.

Connell developed her method of working very slowly, over the course of about a decade, beginning in 1959 when, at age 58, she moved to a small cabin on Lake Bistineau, 17 miles southeast of Shreveport, Louisiana. She was totally isolated. "Nobody is going to look at these sculptures," she thought. "Nobody was coming here. It was just for me because I wanted to do it. . . . I said to myself, 'I'm just going to start to make sculpture because I think it would be great if there were sculptures here under the trees.'"

Fig. 13-26 Clyde Connell, *Swamp Ritual*, 1972. Mixed media, 81 × 24 × 22 in. Collection Tyler Museum of Art, Tyler, Texas. A gift from Atlantic Richfield Company.

In the late 1960s, Connell, by then in her late sixties, discovered the work of another assembler of nontraditional materials, the much younger artist Eva Hesse, who died of cancer at age 34 in 1970. Hesse's work is marked by its use of the most outlandish materials—rope, latex, rubberized cheesecloth, fiberglass, and cheap synthetic fabrics—which she used in strangely appealing, even elegant, assemblages. *Contingent* (**Fig. 13-27**) consists of eight cheesecloth and fiberglass sheets that catch light in different ways, producing different colors—an effect almost impossible to capture in a photograph. It seems at once to hang ponderously and to float effortlessly away.

Each piece, Hesse explained in a catalogue statement in 1969, is "in itself a complete statement," and yet grouped as an assemblage, they created a much more complex whole. As she wrote:

> textures, coarse, rough, changing.
> see through, not see through, consistent, inconsistent.
> they are tight and formal but very ethereal, sensitive, fragile. . . .
> not painting, not sculpture, it's there though . . .
> non, nothing,
> everything. . . .

Connell particularly admired Hesse's desire to make art in the face of all odds. She sensed in Hesse's work an almost obstinate insistence on being: "No matter what it was," she said about Hesse's work, "it looked like it had life in it." Connell wanted to capture this sense of life—what she calls Hesse's "deep quality"—in her own sculpture. In *Swamp Ritual*, the middle of Connell's figure is hollowed out, creating a cavity filled with stones. Rather than thinking of this space in sexual terms—as a womb, for instance—it is, in Connell's words, a "ritual space" in which she might deposit small objects from nature, not unlike the *bilongo* found in the stomach hallows of *nkisi nkonde* figures in Central Africa (see Fig. 1-14). "I began to think about putting things in there, of having a gathering place, not for mementos but for things you wanted to save. The ritual place is an inner sanctuary. . . . Everybody has this interior space."

Fig. 13-27 Eva Hesse, *Contingent*, 1969. Reinforced fiberglass and latex over cheesecloth, height of each of 8 units 114–118 in.; width of each of 8 units, 36–48 in. Collection of the National Gallery of Australia, Canberra. Copyright The Estate of Eva Hesse. Courtesy Robert Miller Gallery, New York.

Installation and Site-Specific Art

Obviously, the introduction of any work of art into a given space changes it. But installation art does this radically by introducing sculptural and other materials into a space in order to transform our experience of it. Installations can be site-specific—that is, designed for a particular space, as the case with Nancy Rubins's *Pleasure Point* (**Fig. 13-28**)—or, like Sol LeWitt's instructions for installing his drawings (see Fig. 4-18), they can be modified to fit into any number of spaces.

Rubins's *Pleasure Point* was commissioned by the Museum of Contemporary Art, San Diego for the ocean side of its building in La Jolla. An assemblage of rowboats, canoes, jet skis, and surfboards, it is attached to the roof of the museum by high-tension stainless steel wire. As it cantilevers precariously out over the oceanfront plaza of the museum, it seems to draw, as if by some unseen magnetic force, the various seacraft that compose it into a single point. Rubins has worked with the discarded refuse of consumer culture, such as water heaters, mattresses, and airplane parts, since

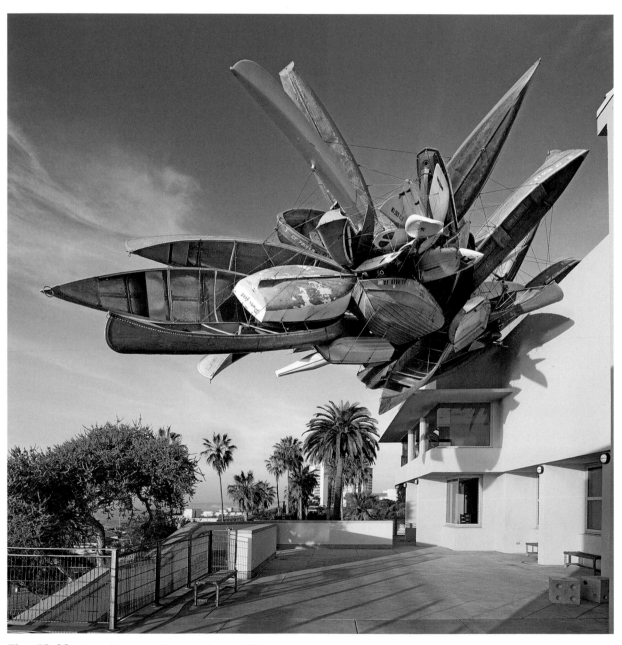

Fig. 13-28 Nancy Rubins, *Pleasure Point*, 2006.
Nautical vessels, stainless steel, stainless steel wire, and boats, 304 × 637 × 288 in. (772.2 × 1618 × 731.5 cm)
Museum of Contemporary Art, San Diego. Museum Purchase, International and Contemporary Collectors Funds.
Collection Photo: Pablo Mason. Courtesy of the artist and Gagosian Gallery.

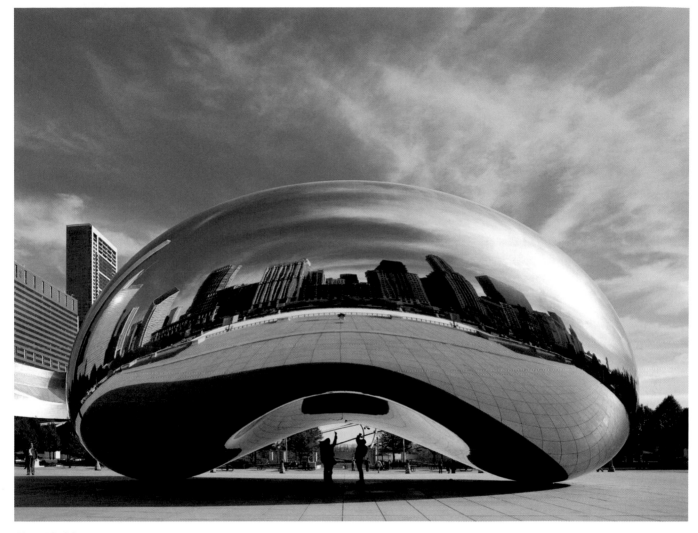

Fig. 13-29 Anish Kapoor, *Cloud Gate*, 2004.
Stainless steel, 33 ft. × 66 ft. × 42 ft. Millennium Park, Chicago. Courtesy City of Chicago and Gladstone Gallery.
© Anish Kapoor.

the mid-1970s. Boats have a special appeal to her. The inspiration for this work, in fact, derives from her witnessing a cache of boats at Pleasure Point Marina in a Southern California resort community. "Boats are ancient," Rubins explains, "They have been with us throughout all of history and they have a very simple structure and functionality." Her sculpture, of course, confronts that functionality, transforming the boats—literally elevating them out of their element, the ocean—into the space of art. They are no longer just boats, but an exuberant composition of color and form.

Cloud Gate (**Fig. 13-29**) is a site-specific sculpture designed by India-born British artist Anish Kapoor expressly for the City of Chicago's Millennium Park. Shaped like a giant bean, its underlying structure is covered with 168 highly polished stainless steel plates seamlessly welded together. "What I wanted to do in Millennium Park," Kapoor explains, "is make something that would engage the Chicago skyline . . . so that

one will see the clouds kind of floating in, with those very tall buildings reflected in the work. And then, since it is in the form of a gate, the participant, the viewer, will be able to enter into this very deep chamber that does, in a way, the same thing to one's reflection as the exterior of the piece is doing to the reflection of the city around." Reflected across its surface is the Chicago skyline, the skyscapers along Michigan Avenue to the west and those north of Randolph Avenue to the north. Although the *Gate* weighs some 100 tons, its reflective surface, as well as its poised balance on the two ends, renders it almost weightless to the eye. In fact, in the right light, and standing in the right position, it is sometimes difficult to distinguish where the sculpture ends and the sky begins. This sense of ethereal reflection is countered when the viewer walks under the 12-foot arch beneath the piece—into what Kapoor calls its "navel"—where the sculpture seems to draw its outside surroundings into the itself in a kind of vortex of reflection.

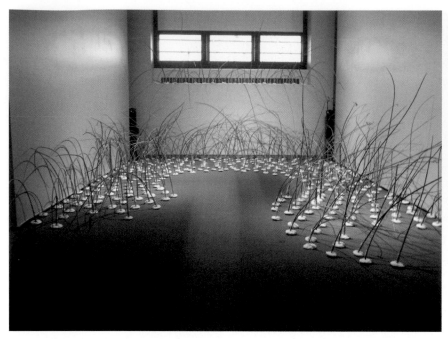

Fig. 13-30 Angela Behrends, *Sway*, and detail, 2011.
365 glass vials each 3 in. tall, plaster, wild onion stalks, and 2 oscillating fans, dimensions variable.
Courtesy of the artist.

While the dimensions of site-specific works are generally predetermined, installations can vary in size depending upon where they are placed. Angela Behrends' *Sway* (**Fig. 13-30**) consists of 365 glass vials, one for each day of the year, each containing a wild onion stalk. Oscillating tower fans stand in the back corners of the space, causing the onion stalks to slowly move as the air from the fans moves over them. The piece can be set into any floor space, and arranged so that viewers can walk into it. Behrends was inspired by a hair follicle study describing the tickling sensation caused by air blowing across the hairs on a person's forearm. "I wanted to make that feeling larger," she says, "turn it into a visual experience. Since the plaster pores are convex, they can rock gently. Stalks are placed (but not secured) in the vials and are free to twirl in air currents."

Many installations incorporate film and video in a sculptural or architectural setting. Eleanor Antin's 1995 *Minetta Lane—A Ghost Story* consists of a re-creation of three buildings on an actual street in New York City's Greenwich Village that runs for two blocks between MacDougal Street and Sixth Avenue (**Fig. 13-31**). In the late 1940s and early 1950s, it was the site of a low-rent artists' community, and Antin seeks to recreate the bohemian scene of that lost world. For the installation, Antin prepared three narrative films, transferred them onto video disc, and back-projected them onto tenement windows of the reconstructed lane. The viewer, passing through the scene, thus voyeuristically sees in each window what transpires inside. In one window (**Fig. 13-32**), a pair of lovers sport in a kitchen tub. In a second (**Fig. 13-33**), an Abstract Expressionist painter is at work. And in a third, an old man tucks in his family of caged birds for the night. These characters are the ghosts of a past time, but their world is inhabited by another ghost. A little girl, who is apparently invisible to those in the scene but clearly visible to us, paints a giant "X" across the artist's canvas and destroys the relationship of the lovers in the tub. She represents a destructive force that, in Antin's view, is present in all of us. The little girl is to the film's characters as they are to us. For the artist, the lovers, and the old man represent the parts of us that we have lost—like our very youth. They represent ideas about art, sexuality, and life, that, despite our nostalgia for them, no longer pertain.

Artist James Turrell has been studying the psychological and physiological effects of light for almost his entire career. It has been said of him that he manipulates light as a sculptor would clay. Turrell's most famous work is probably his ongoing project at Roden Crater, a remote cinder volcanic crater on the western edge of Arizona's Painted Desert purchased by Turrell in 1977. The site will serve, when it is completed, as a naked-eye observatory for the observation of celestial phenomena. There Turrell is literally sculpting the earth, leveling the crater rim, for instance, so that

Figs. 13-31, 13-32, and **13-33** Eleanor Antin, *Minetta Lane—A Ghost Story,* 1995.
Mixed media installation. Installation view (top left), two video projections (top right and bottom right). Top right: Actors Amy McKenna and Joshua Coleman. Bottom right: Artist's window with Miriam (the Ghost).
Courtesy the artist and Ronald Feldman Fine Arts, New York.

Thinking Thematically: See **Art, Gender, and Identity** on myartslab.com

when the sky is viewed from the bottom of the crater, it will seem to the eye to form a dome.

A Frontal Passage (**Fig. 13-34**) is such a piece, part of a larger series of works called *Wedgework,* which he began in the late 1960s. The viewer approaches the work through a blackened hallway, which lets out into a chamber barely illuminated on one side by reddish fluorescent lights. The lights seem to cut, like a scrim, at a diagonal across the room, slicing it in two. But this is pure illusion, a "spatial manipulation," according to Turrell. As one's eyes adjust to the darkness, the diagonal's substance begins to come into question. Is it somehow projected across the room? Is it a wall? Is it just light? Is there in fact anything there at all? The viewer feels absorbed into a dense, haze-like atmosphere in which boundaries and the definition of surrounding space seem to be thoroughly dissolved. As the viewer's sense of walls and boundaries, defined space, disappears, the space seems to become limitless, like standing on earth at the threshold, a "frontal passage" into the heavens.

The illusory space created by *A Frontal Passage* is related to a visual field called a *Ganzfeld,* German for "total field." Comparable to a white-out in a blinding snowstorm, Ganzfelds are visual phenomena where depth, surface, color, and brightness all register as a homogenous whole. If one were to walk into such a space, all sense of up and down would likely disappear,

Fig. 13-34 James Turrell, *A Frontal Passage,* 1994.
Fluorescent light, 12 ft. 10 in. × 22 ft. 6 in. × 34 ft. Robert and Meryl Meltzer, Michael and Judy Ovitz, and Mr. and Mrs. Gifford Phillips Funds. (185.1994). The Museum of Modern Art, New York, USA.
Courtesy of the artist.

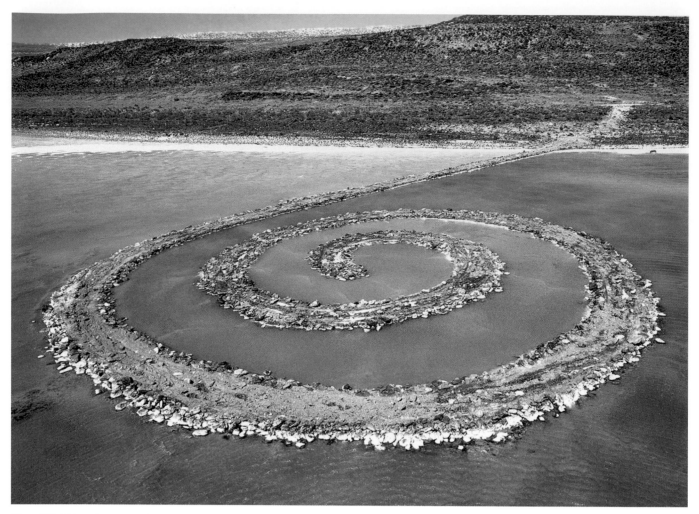

Fig. 13-35 Robert Smithson, *Spiral Jetty*, April 1970.
Great Salt Lake, Utah. Black rock, salt crystals, earth, red water (algae). 3¹/₂ ft. × 15 ft. × 1,500 ft.
Courtesy James Cohan Gallery, New York. Collection: DIA Center for the Arts, New York. Photo: Gianfranco Goroni. Art
© Estate of Robert Smithson/Licensed by VAGA, New York, NY.

✴ **Explore** the Google Earth link for *Spiral Jetty* on myartslab.com

Thinking Thematically: See Art, Science, and the Environment on myartslab.com

causing one at least to teeter and fall, and often creating a sense of nausea or vertigo. With such effects, Turrell's works bring the viewer into a state of almost hyper-self-consciousness and awareness, as if one can see oneself seeing.

Earthworks

The larger a work, the more our visual experience of it depends on multiple points of view. Since the late 1960s, one of the focuses of modern sculpture has been the creation of large-scale out-of-doors environments, generally referred to as *earthworks*. Robert Smithson's *Spiral Jetty* (**Fig. 13-35**) is a classic example of the medium. Stretching into the Great Salt Lake at a point near the Golden Spike National Monument, which marks the spot where the rails of the first transcontinental

railroad were joined, *Spiral Jetty* literally is landscape. Made of mud, salt crystals, rocks, and water, it is a record of the geological history of the place. But it is landscape that has been created by man. The spiral form makes this clear. The spiral is one of the most widespread of all ornamental and symbolic designs on earth. In Egyptian culture, the spiral designated the motion of cosmic forms and the relationship between unity and multiplicity, in a manner similar to the Chinese *yin* and *yang*. The spiral is, furthermore, found in three main natural forms: expanding like a nebula, contracting like a whirlpool, or ossified like a snail's shell. Smithson's work suggests the way in which these contradictory forces are simultaneously at work in the universe. Thus the *Jetty* gives form to the feelings of contradiction he felt as a contemporary inhabitant of

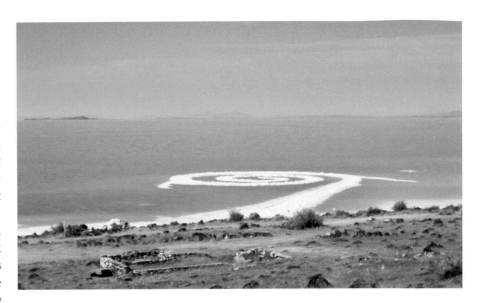

Fig. 13-36 Robert Smithson, *Spiral Jetty*, as it appeared in August 2003.
Photographed by Sandy Brooke. Art © Estate of Robert Smithson/Licensed by VAGA, New York, NY.

his world. Motion and stasis, expansion and contraction, life and death, all are simultaneously suggested by the 1,500-foot coil, the artist's creation extending into the Great Salt Lake, America's Dead Sea.

Smithson also understood that, in time, this monumental earthwork would be subject to the vast changes in water level that characterize the Great Salt Lake. In fact, not long after its completion, *Spiral Jetty* disappeared as the lake rose, only to reappear in 2003 as the lake fell again. The work was now completely transformed, encrusted in salt crystals (**Fig. 13-36**), re-created, as it were, by the slow workings of nature itself.

Spiral Jetty was directly inspired by the Great Serpent Mound, an ancient Native American earthwork in Adams County, Ohio (**Fig. 13-37**). Built by the Hopewell culture sometime between 600 BCE and 200 CE, it is nearly a quarter of a mile long. And though almost all other Hopewell mounds contain burials, this one does not. Its "head" consists of an oval enclosure that may have served some ceremonial purpose, and its tail is a spiral. The spiral would, in fact, become a favorite decorative form of the later Mississippian cultures. The monumental achievement of Smithson's *Spiral Jetty*, made with dump trucks and bulldozers, is dwarfed by the extraordinary workmanship and energy that must have gone into the construction of this prehistoric earthwork.

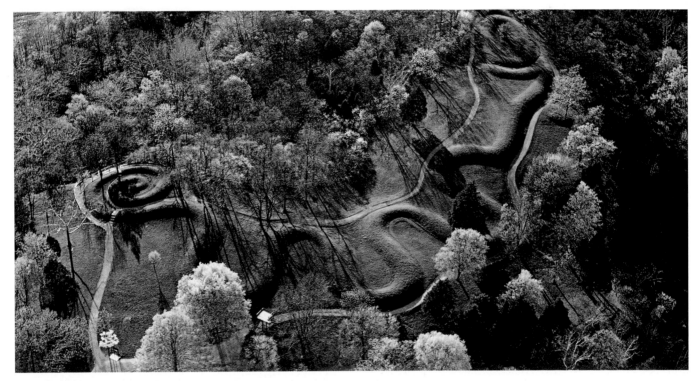

Fig. 13-37 Great Serpent Mound, Adams County, Ohio. Hopewell culture, c. 600 BCE–200 CE. Length approximately 1,254 ft.

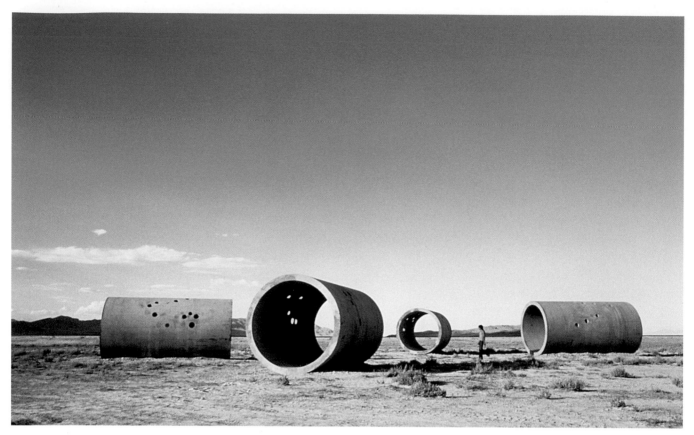

Fig. 13-38 Nancy Holt, *Sun Tunnels*, Great Basin Desert, Utah, 1973–76 (four showing).
Four tunnels, each 18 ft. long, 9 ft. 4 in. in diameter; each axis 86 ft. long.
Art © Nancy Holt/Licensed by VAGA, New York, NY. Courtesy John Weber Gallery, New York.

Fig. 13-39 Nancy Holt, *Sun Tunnels*, Great Basin Desert, Utah, 1973–76 (one front view).
Four tunnels, each 18 ft. long 9 ft. 4 in. in diameter; each axis 86 ft. long.
Courtesy John Weber Gallery, New York. Art © Nancy Holt/Licensed by VAGA, New York, NY.

Nancy Holt's *Sun Tunnels* (**Figs. 13-38** and **13-39**) consists of four 22-ton concrete tunnels that align with the rising and setting of the sun during the summer and winter solstices. The holes cut into the walls of the tunnels duplicate the arrangement of the stars in four constellations—Draco, Perseus, Columba, and Capricorn—and the size of each hole is relative to the magnitude of each star. The work is designed to be experienced on site, imparting to viewers a sense of their own relation to the cosmos. "Only 10 miles south of *Sun Tunnels*," Holt writes, "are the Bonneville Salt Flats, one of the few areas in the world where you can actually see the curvature of the earth. Being part of that kind of landscape . . . evokes a sense of being on this planet, rotating in space, in universal time."

When artists manipulate the landscape like Smithson and Holt, it becomes clear that their work has much in common with landscape design in general, from golf courses to parks and landfills. Indeed, part of the power of their work consists in the relationship they establish and the tension they embody between the natural world and civilization. A series of interventions conceived by sculptor Karen McCoy for Stone Quarry Hill Art Park in Cazenovia, New

Figs. 13-40 and **13-41** Karen McCoy, *Considering Mother's Mantle,* Project for Stone Quarry Hill Art Park, Cazenovia, NY, 1992.
View of gridded pond made by transplanting arrowhead leaf plants, 40 × 50 ft. Detail (right).
Photos courtesy of the artist.

York, including the grid made of arrowhead leaf plants in a small pond, illustrated here (**Figs. 13-40** and **13-41**), underscores this. The work was guided by a concern for land use and was designed to respond to the concerns of local citizens who felt their rural habitat was rapidly becoming victim to the development and expansion of nearby Syracuse, New York. Thus, McCoy's grid purposefully evokes the orderly and regimented forces of civilization, from the fence rows of early white settlers to the street plans of modern suburban developers, but it represents these forces benignly. The softness and fragility of the grid's flowers, rising delicately from the quiet pond, seem to argue that the acts of man can work at one with nature, rather than in opposition to it.

Performance Art as Living Sculpture

If installations are works created to fill an interior architectural space and earthworks are created to occupy exterior spaces, both are activated by the presence of human beings in the space. It should come as no surprise that many performance artists would in turn come to concern themselves with the live human activity that goes on in space. Many even conceived of themselves, or other people in their works, as something akin to live sculptures.

One of the innovators of performance art was Allan Kaprow, who, in the late 1950s, "invented" what he called **Happenings**, which he defined as "assemblages of events performed or perceived in more than one time and place. . . . A Happening . . . is art but seems closer to life." It was, in fact, the work of Jackson Pollock that inspired Kaprow to invent the form. The inclusiveness of paintings containing whatever he chose to drop into them, not only paint but nails, tacks, buttons, a key, coins, cigarettes, and matches, gave Kaprow the freedom to bring everything, including the activity of real people acting in real time, into the space of art. "Pollock," Kaprow wrote in 1958, "left us at the point where we must become preoccupied with and even dazzled by

Fig. 13-42 Allan Kaprow, *Household*, 1964.
Licking jam off a car hood, near Ithaca, New York.
Sol Goldberg / Cornell University Photography.

In much performance art, the physical presence of the body in space becomes a primary concern (consider the work of the Chicago-based performance group Goat Island in *The Creative Process*, pp. 302–303). The performance team of Marina Abramović and Uwe Laysiepen (known as Ulay) made this especially clear in works such as *Imponderabilia*, performed in 1977 at a gallery in Milan, Italy (**Fig. 13-43**). They stood less than a foot apart, naked and facing each other, in the main entrance to the gallery, so that people entering the space had to choose which body—male or female—to face as they squeezed between them. A hidden camera filmed each member of the public as he or she passed through the "living door," and their "passage" was then projected on the gallery wall. Choosing which body to face, rub against,

the space and objects of our everyday life, either our bodies, clothes, rooms, or, if need be, the vastness of Forty-Second Street. . . . Objects of every sort are materials for the new art: paint, chairs, food, electric and neon signs, smoke, water, old socks, a dog, movies, a thousand other things will be discovered by the present generation of artists. . . . The young artist of today need no longer say, 'I am a painter,' or 'a poet' or 'a dancer.' He is simply an 'artist.' All of life will be open to him."

In the Happening *Household* (**FIG 13-42**), there were no spectators, only participants, and the event was choreographed in advance by Kaprow. The site was a dump near Cornell University in Ithaca, New York. At 11 AM on the day of the Happening, the men who were participating built a wooden tower of trash, while the women built a nest of saplings and string. A smoking, wrecked car was towed onto the site, and the men covered it with strawberry jam. The women, who had been screeching inside the nest, came out to the car and licked the jam as the men destroyed their nest. Then the men returned to the wreck, and slapping white bread over it, began to eat the jam themselves. As the men ate, the women destroyed their tower. Eventually, as the men took sledgehammers to the wreck and set it on fire, the animosity between the two groups began to wane. Everyone gathered and watched until the car was burned up, and then left quietly. What this Happening means, precisely, is not entirely clear, but it does draw attention to the violence of relations between men and women in our society and the frightening way in which violence can draw us together as well as drive us apart.

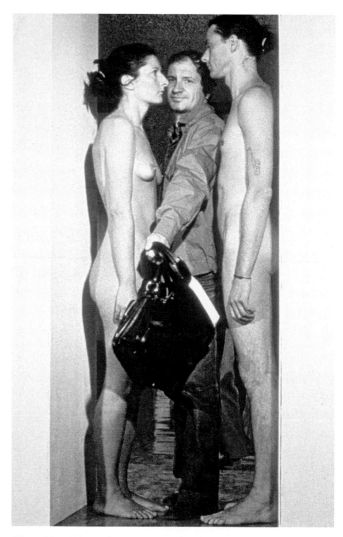

Fig. 13-43 Marina Abramović and Ulay, *Imponderabilia*,
Performance at the Galleria Communale d'Arte Moderna,
Bologna, Italy, 1977.
Photograph by Giovanna del Magro.

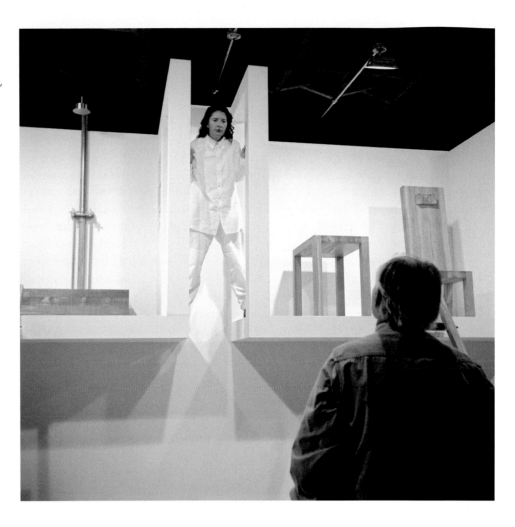

Fig. 13-44 Marina Abramović,
*The House with the Ocean View—
Nov. 22 9:54 AM, 2002.*
Living installation, November 15–26,
2002.
Photo Steven P. Harris, New York.

and literally feel, forced each viewer to confront their own attitudes and feelings about sexuality and gender. Abramović and Ulay's bodies composed the material substance of the work and so did the bodies of the audience members, who suddenly found themselves part of the artwork itself—at least they did for 90 minutes, until the police stopped the performance. For Abramović's 2010 retrospective exhibition at the Museum of Modern Art in New York, *Imponderabilia* was reperformed continuously in shifts by four couples for the duration of the exhibition—about 700 hours.

Working on her own, Abramović has continued to explore a similar terrain, what she calls "the space in-between, like airports, or hotel rooms, waiting rooms, or lobbies . . . all the spaces where you are not actually at home"—not least of all the space between her and Ulay in her earlier work. She feels that we are most vulnerable in such spaces, and vulnerability, for her, means that "we are completely alive." *The House with the Ocean View* (**Fig. 13-44**)

was performed on November 15–26, 2002, at the Sean Kelly Gallery in New York. Abramović lived in three rooms, situated 6 feet above the gallery floor, a toilet and shower in one, a chair and table in another, and clothes and a mattress in the third. The three rooms were connected to the floor by three ladders with butcher's knives for rungs. For 12 days she did not eat, read, write, or speak. She drank water, relieved herself, and sang and hummed as she chose. She slept in the gallery every night, and during the day the public was invited to participate in what she called an "energy dialogue" with the artist. What lay "in-between" the artist and her audience were those ladders. She could stare across at her audience, and her audience back at her, feelings could even be transmitted, but the space "in between" could not be bridged except at unthinkable risk. The work is at once a metaphor for geopolitical daily domestic realities, a sobering realization of our separation from one another, and a call for us to exert the energy necessary to change.

THE CREATIVE PROCESS

Before the group disbanded in 2009, Goat Island's work was collaborative in nature. The group's four performers and its director, Lin Hixson, all contributed to the writing, choreography, and conceptual aspects of each work. Founded in 1987, the group created nine performance events, one of which is *How Dear to Me the Hour When Daylight Dies*, which premiered in Glasgow, Scotland, in May 1996, and then subsequently toured across Scotland and England.

In each piece, the troupe focuses on five major concerns: (1) They try to establish a conceptual and spatial relationship with the audience by treating the performance space, for instance, as a parade ground or a sporting arena; (2) they involve movement in a way that is demanding to the point of exhaustion; (3) they incorporate personal, political, and social issues into the work directly through spoken text; (4) they stage their performances in nontheatrical spaces within the community, such as gyms or street sites; and (5) they seek to create striking visual images that encapsulate their thematic concerns.

The subject matter of their works is always eclectic, an assemblage of visual images, ideas, texts, physical movements, and music that often have only the most poetic connection to each other. *How Dear to Me the Hour When Daylight Dies* began with Goat Island's desire to share an intense group experience. To that end, in July 1994, the troupe traveled to Ireland to participate in the massive Croagh Patrick pilgrimage, a grueling four-hour climb up a mountain on the western seacoast near Westport, County Mayo to a tiny church at the summit, where St. Patrick spent 40 days and 40 nights exorcising the snakes from Ireland. Eleven days before the pilgrimage, on July 20, the father of Greg and Timothy McCain, two members of the troupe who have subsequently moved on to other endeavors, died in Indianapolis. The elder McCain had seen every Goat Island piece, some of them three times. The pilgrimage thus became not only an act of faith and penance, but one of mourning.

How Dear to Me opens with the troupe performing a sequence of hand gestures, silently, 30 times, that evokes for them the memory of Mr. McCain (**Fig. 13-45**). The minimal exertion of these gestures contrasts dramatically with the intense physicality of the pilgrimage. But both actions, the hand movements and the pilgrimage, are acts of memory. And memory is, in turn, the focus of the next set of images in the performance.

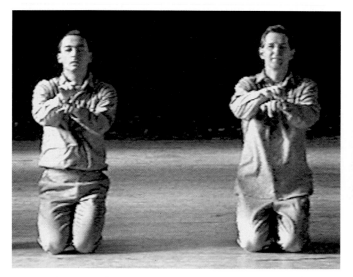 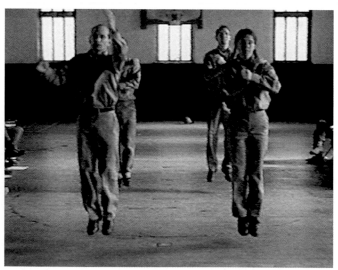

Figs. 13-45 and **13-46** Goat Island, *How Dear to Me the Hour When Daylight Dies*, 1995–96. Images from video documentation of work in progress, January 20, 1996.

Matthew Goulish plays the part of Mr. Memory, a sort of traveling sideshow character who claimed to commit to memory 50 new facts a day and who could answer virtually any question posed to him by an audience. After he answers a series of questions, the troupe breaks into a long dance number (**Fig. 13-46**). As all four perform this arduous and complex dance in absolute synchronous movement, it becomes clear that it is, at once, another version of the pilgrimage—the same physical exercise performed year after year, again and again—and an exercise in collaborative and communal memory, as each member of the troupe remembers just what movement comes next in the dance sequence.

After the dance, Mr. Memory is asked, "Who was the first woman to fly across the Atlantic Ocean?" The answer is Amelia Earhart, and, at that, Karen Christopher dons a flying cap and becomes Amelia Earhart herself. The mystery surrounding Earhart's death in the South Pacific in World War II is evoked; the mystery of her death is symbolic of the mystery of all death. Later in the performance we witness the transformation of Christopher from her Earhart character into Mike Walker, "the world's fattest man," who in 1971 weighed 1,187 pounds (**Fig. 13-47**). This transformation was necessitated by the discovery, during rehearsals, that Christopher was diabetic and would, as a result, need to eat during the course of each performance. The image of the three men carrying her emphasizes not only her weight but the gravity of her situation.

Many more images and ideas collide in the course of this one-and-a-half-hour performance, too many to outline here, but this overview provides a sense of the remarkable energy, power, and inventiveness of Goat Island's collaborative and open-ended process.

Fig. 13-47 Goat Island, *How Dear to Me the Hour When Daylight Dies*, 1995–96. Image from video documentation of work in progress, January 20, 1996. Courtesy Goat Island.

How does relief sculpture differ from sculpture-in-the-round?

Relief sculpture has three-dimensional depth but is attached to a surface, and it is typically meant to be seen frontally. Sculpture-in-the-round, by contrast, is unattached to any surfaces, and it is typically meant to be viewed from all sides. How does low relief differ from high relief? What is a frieze?

How do subtractive processes differ from additive processes?

In subtractive processes, the sculptor begins with a larger mass and removes material to achieve the final result. In additive processes, by contrast, the sculptor builds the work, adding material to achieve the final result. How are *santos* created? What role does a kiln play in ceramics?

What is involved in casting processes?

Casting is a replacement process. It involves the creation of a form (often made using modeling), then building a mold around the form and pouring a material into the mold, which dries in the form of the original form. The poured material is often a molten metal, as in the lost-wax process. How is an investment used in casting? What is a patina?

What is assemblage?

Assemblage is the process of bringing individual objects together to form a larger whole. As a process, assemblage is often associated with the transformation of common materials into art. How does Robert Gober use a combination of materials to create meaning in *Untitled*? What qualities do Clyde Cornell and Eva Hesse share in their work?

THE CRITICAL PROCESS

Thinking about Sculpture

In 1992, the artists Christo (born Christo Vladimirov Javacheff in Bulgaria on June 13, 1935) and his wife, Jeanne-Claude (French-born Jeanne-Claude Denat de Guillebon, born the same day in 1935) announced plans to drape nearly 6 miles of silvery, luminous fabric panels above the Arkansas River along a 42-mile stretch of the river between Salida and Cañon City in south-central Colorado. The fabric panels, they proposed, would be suspended for two weeks at eight distinct areas of the river that were selected by the artists for their aesthetic merits and technical viability. As with all Christo and Jeanne-Claude projects, the proposal met with immediate, and sustained, criticism.

What impact, environmentalists quickly retaliated, would the project have on bighorn sheep populations in the area? What about fish and birds? How, people asked, could Christo and Jeanne-Claude justify the expense—a projected $50 million that, many argued, could be far better spent? Why "desecrate" the already beautiful Arkansas River canyon? Why, in fact, pick the Arkansas River canyon at all?

Responding to the environmental issues, Christo told the *New York Times*: "Every artist in the world likes his or her work to make people think. Imagine how many people were thinking, how many professionals were thinking and writing in preparing that environmental impact statement." Theirs was, in fact, the first Environmental Impact Statement ever required of a work of art. In November of 2011, federal regulators with the Bureau of Land Management approved Christo's plan, and it will be installed, at the earliest, in the summer of 2015.

As for the cost: Christo funds the costs associated with the project in their entirety through the sale of artworks such as the two illustrated here (**Figs. 13-48** and **13-49**). The project requires no public subsidy or taxpayer support, nor does Christo accept sponsorship or endorsement fees.

Why the Arkansas River? Christo and Jeanne-Claude, who passed away in November 2011, traveled 14,000 miles and visited 89 rivers in seven Rocky Mountain states looking for the right site. The Arkansas between Salida and Cañon City was chosen for several reasons: the east/west orientation of the river, which will allow the fabric panels to better reflect sunlight from morning to evening; high river banks suitable for the suspension of steel cables; the fact that U.S. Route 50 runs continuously along the

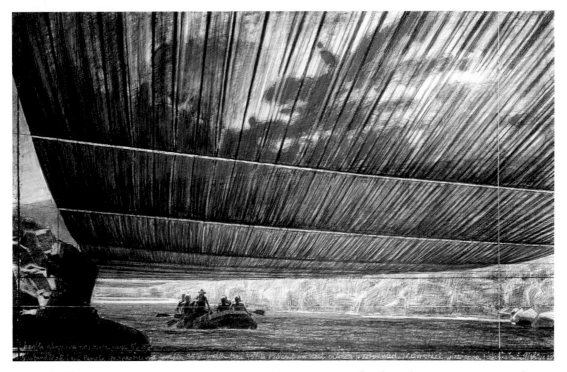

Fig. 13-48 Christo and Jeanne-Claude, *Over the River, Project for the Arkansas River, State of Colorado*, 2010.
Drawing in 2 parts (detail), pencil, charcoal, pastel, wax crayon, enamel paint, wash, fabric sample, hand-drawn topographic map and technical data, detail size: 42 × 96 in.
Courtesy of Christo and Jeanne-Claude.

river to facilitate viewing; the presence of a nearby railroad that can provide essential access and supply lines; and rafting conditions that allow for viewers to see the work of art from the river.

Over The River involves two different viewing experiences: one from the highway, where the fabric will reflect the colors of the sky and clouds from sunrise to sunset; the other at water level, where rafters, kayakers, and canoeists will be able to view the clouds, sky and mountains through the translucent fabric. How is *Over the River*, then, similar to sculpture-in-the-round? In what more specific ways is it similar to Anish Kapoor's *Cloud Gate*? Obviously, one of the ways *Over the River* differs most dramatically from *Cloud Gate* is its temporary, two-week display. Why do you suppose Christo and Jeanne-Claude prefer temporary installations rather than permanent ones? Christo and Jeanne-Claude also enjoy the controversy that their projects inevitably generate. Why? What important issues does a work like *Over the River* raise other than environmental ones?

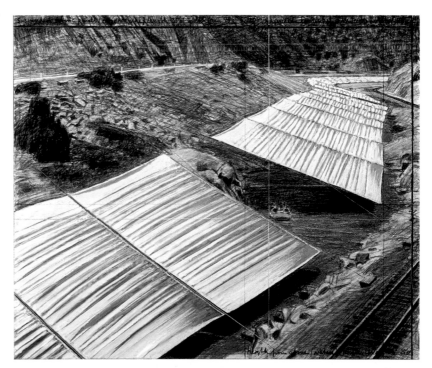

Fig. 13-49 Christo and Jeanne-Claude, *Over the River, Project for the Arkansas River, State of Colorado*, 2011.
Drawing in 2 parts (detail), pencil, charcoal, pastel, wax crayon, enamel paint, aerial photograph with topographic elevations and fabric sample, detail size: 42 × 65 in.
Courtesy of Christo and Jeanne-Claude

14 | The Crafts as Fine Art

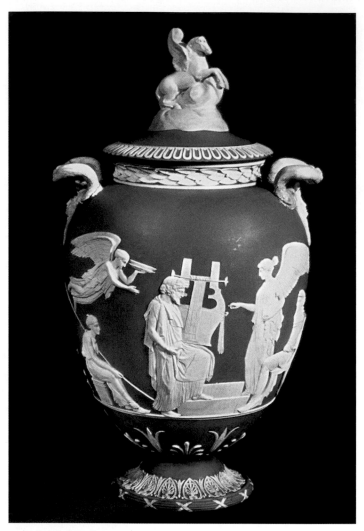

Fig. 14-1 Josiah Wedgwood, *Apotheosis of Homer* vase, 1786.
Blue Jasperware, height 18 in.
Courtesy of the Wedgwood Museum Trust Limited, Barlaston, Staffordshire, England.

THINKING AHEAD

How are ceramics made?

How are glass objects made?

How is the technique of weaving performed?

Why has gold been a favored material since ancient times?

((•–[Listen to the chapter audio on myartslab.com

The many so-called "craft" media—ceramics, glass, fiber, metal, and wood in particular—have traditionally been distinguished from the fine arts because they are employed to make **functional objects**, from the utensils with which we eat to the clothes we wear. In the hands of an artist, however, these media can be employed to make objects that are not only of great beauty but that also must be appreciated as works of art in their own right.

The line between the arts and the crafts is a fine one. The crafts are works of expert handiwork or craftsmanship, done by the artist's own hand with extraordinary skill. But despite the fact that painters and sculptors and printmakers are all expert with their hands as well, we don't call their work "craft." Indeed, many artists feel insulted if their work is described as being "craftful." These artists probably feel that a craft must be functional. But the distinction between craft and artwork is not that clear-cut. Perhaps the only meaningful distinction we can draw between art and craft is this: If a work is primarily made to be used, it is craft, but if it is primarily made to be seen, it is art. However, the artist's intention may be irrelevant. If you buy an object because you enjoy looking at it, then whatever its usefulness, it is, for you at least, a work of art.

Historically, the distinction between the crafts and fine arts can be traced back to the beginnings of the Industrial Revolution, when, on May 1, 1759, in Staffordshire, England, a 28-year-old man by the name of Josiah Wedgwood opened his own pottery manufacturing plant. With extraordinary foresight, Wedgwood chose to make two very different kinds of pottery: one he called "ornamental ware" (**Fig. 14-1**), the other "useful ware" (**Fig. 14-2**). The first consisted of elegant handmade luxury items, the work of highly skilled craftsmen. The second were described in his catalogue as "a species of earthenware for the table, quite new in appearance . . . manufactured with ease and expedition, and consequently cheap." This new earthenware was made by machine. Until this moment, almost everything people used was handmade, and thus unique. With the advent of machine mass-manufacturing, the look of the world changed forever.

Wedgwood depended upon his "useful" ware to support his business. His cream-colored earthenware (dubbed "Queen's Ware" because the English royal family quickly became interested in it) was made by casting liquid clay in molds instead of by throwing individual pieces and shaping them by hand. Designs were chosen from a pattern book and printed by mechanical means directly on the

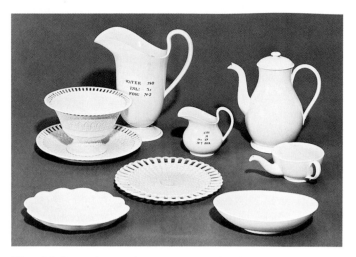

Fig. 14-2 Wedgwood Queen's Ware kitchenware, c. 1850.
Courtesy of the Wedgwood Museum Trust Limited, Barlaston, Staffordshire, England.

pottery. Because Wedgwood could mass-produce his earthenware both quickly and efficiently, a reliable, quality tableware was made available to the middle-class markets of Europe and America.

But his ornamental ware he considered artwork. Like artists, producers of ornamental ware had a hands-on relation to the objects they made. Wedgwood's ornamental ware is aesthetic in its intention and was meant to be received as an object of fine art. It was almost always decorated with low-relief Greek figures intended to evoke both the white marble statuary of the ancient Greeks and their ceramic vases, such as Euthymides's *Revelers* (**Fig. 14-3**). An amphora, or two-handled vase, *Dancing revelers* is a kind of pot designed to store provisions such as wine, oil, or honey. But an inscription on its bottom taunts the maker's chief competitor—"Euphronios never did anything like it," it reads—indicating the growing self-consciousness of the Greek artist, the sense that he was producing not just a useful object but a thing of beauty, an artwork in its own right.

Fig. 14-3 Euthymides, *Dancing revelers*, found in a tomb at Vulci, made in Athens Red-figured amphora, ca. 510–500 BCE. Height approximately 24 in. (60 cm) Museum Antiker Kleinkunst, Munich. Staatliche Antikensammlungen, Munich, Germany.

Ceramics

Euthymides's vase and both Wedgwood's ornamental and useful wares are examples of **ceramics**. As we saw in the previous chapter, ceramics are objects that are formed out of clay and then hardened by **firing**, or baking in a very hot oven, called a **kiln**. Ceramic objects are generally either flat and relief-like (think of a plate or a square of tile), or hollow, like cast sculpture (think of a pitcher). Unlike metal casts, the hollowness of ceramic objects is not a requirement of weight or cost as much as it is of utility (ceramic objects are made to hold things), and of the firing process itself. Solid clay pieces tend to hold moisture deep inside, where it cannot easily evaporate, and during firing, as this moisture becomes super-heated, it can cause the object to explode. In order to make hollow ceramic objects, a number of techniques have been developed.

Most ceramic objects are created by one of three means—slab construction, coiling, or throwing on a potter's wheel—as discussed below. Pieces made by any one of these techniques are then painted with **glazing**. Ceramic glazes consist of powdered minerals suspended in water, which are applied to the object after the first firing. When the object is fired a second time, the minerals dissolve and fuse into a glassy, nonporous coating that bonds to the ceramic clay. Glazes serve many purposes. They were probably first created to seal clay vessels, which might otherwise absorb food or drink, thus stimulating the growth of bacteria (if in the ancient world the existence of bacteria *per se*

was unknown, the odor they produced was well understood). But the chemical reaction of firing the glaze also produces colors, and these colors have become an important aesthetic element in the creation of ceramics as works of art.

Koetsu's *Tea Bowl Named Amagumo* (rain clouds) (**Fig. 14-4**) is an example of **slab construction**. Clay is rolled out flat, rather like a pie crust, and then shaped by hand. The tea bowl has a special place in the Japanese tea ceremony, the Way of the Tea. In small tea rooms specifically designed for the purpose and often decorated with calligraphy on hanging scrolls or screens, the guest was invited to leave the concerns of the daily world behind and enter a timeless world of ease, harmony, and mutual respect. Koetsu was an accomplished tea master. At each tea ceremony, the master would assemble a variety of different objects and utensils used to make tea, together with a collection of painting and calligraphy. Through this ensemble the master expressed his artistic sensibility, a sensibility shared with his guest, so that guest and host collaborated to make the ceremony itself a work of art.

This tea bowl, shaped perfectly to fit the hand, was made in the early seventeenth century at one of the "Six Ancient Kilns," the traditional centers of wood-fired ceramics in Japan. These early kilns, known as *anagama*, were narrow underground tunnels, dug out following the contour of a hillside. The pit was filled with pottery, and heat moved through the tunnel from the firebox at the lower end to the chimney at the upper end. The firing would take an average of seven days, during which time temperatures would reach 2,500 degrees Fahrenheit. The coloration that distinguished these pieces results from wood ash in the kiln melting and fusing into glass on the pottery. The simplicity of these wood-fired pieces appealed to the devotee of the tea ceremony, and tea masters such as Koetsu often named their pieces after the accidental effects of coloration achieved in firing. The most prized effect is a scorch, or *koge*, when the firing has oxidized the natural glass glaze completely, leaving only a gray-black area. Such a *koge* forms the "rain clouds" on Koetsu's tea bowl.

In 1976, a young American ceramic artist by the name of Peter Callas built the first traditional Japanese *anagama*, or wood-burning kiln, in the United States in Piermont, New York. Three years later, California artist Peter Voulkos was regularly firing his work in Callas's kiln. Voulkos's work is particularly suited to the wood-firing process, in which the artist must give up control of his work and resign himself to

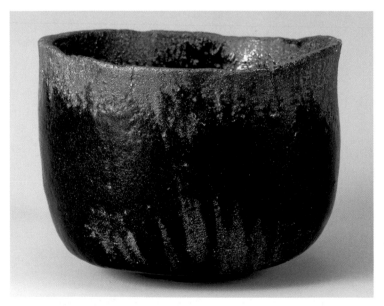

Fig. 14-4 Hon'ami Koetsu (1558–1637), *Tea Bowl Named Amagumo*, Momoyama, early Edo period, early seventeenth century. 3¹/₂ × 4⁹/₁₀ in. (8.8 cm × 12.3 cm) Mitsui Bunko Museum, Tokyo.

the accidental effects that result from submitting the work to a heat of 2,500 degrees Fahrenheit over the course of a seven-day firing. His "stacks," giant bottle-like pyramids of clay that average about 250 pounds, are so named because Voulkos literally stacks clay cylinders one on top of the other to create his form. Before they are quite dry, he gouges them, draws on them with various tools, and drags through the clay in giant sweeps across the form's surface. Then he fires it in the *anagama*. Anything can happen in the firing. Depending on such factors as how the pieces in the kiln are stacked, the direction of the flame, where ash is deposited on the surface of the work, how a section near a flame might or might not melt, and undetectable irregularities in the clay itself, each stack will turn out differently. The Japanese call this a "controlled accident." For Voulkos, it is the source of excitement in the work, "the expectancy of the unknown" that is fundamental to the process.

This interest in the possibilities of the accidental evidences itself in other ways in Voulkos's work. In many of his works, including the *X-Neck* stack (**Fig. 14-5**), a ragged "x" seems to be the focus of the piece. The "x" is, of course, a standard signature for those who cannot write, the signature of an absolute novice in the art of calligraphy. As was pointed out in the catalogue to Voulkos's 1995 retrospective exhibition, the "x" is also a reference to the Zen practice of *shoshin*, which means "beginner's mind." It is Voulkos's way of keeping in touch with what the Zen master Shunryu Suzuki describes as "the limitless potential of original mind, which is rich and sufficient within itself. For in the beginner's mind there are many possibilities; in the expert's mind there are few." The form of the stacks of clay, however, is not accidental. It is a direct reference to the pyramid form, not only to the pyramids of ancient Egypt, but also those of ancient Mexican Aztec and Mayan cultures. For Voulkos, the pyramid represents the mystery of the unknown. In utilizing this form, Voulkos makes contact between the ancient and the modern, between himself and the forces that have driven the human race for centuries.

Fig. 14-5 Peter Voulkos, *X-Neck*, 1990.
Woodfired stoneware stack, height 34½ in.; diameter 21 in.
Private collection.
Photo: Schopplein Studio, Berkeley, California. © 1997 Peter Voulkos.

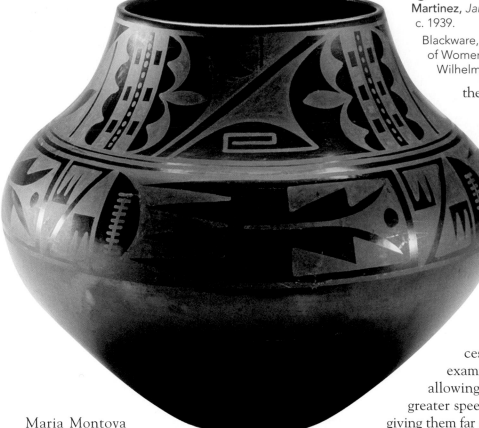

Fig. 14-6 Maria Montoya Martinez and Julian Martinez, *Jar*, San Ildefonso Pueblo, New Mexico, c. 1939.

Blackware, 11⅛ × 13 in. The National Museum of Women in the Arts. Gift of Wallace and Wilhelmina Holladay.

the slip remaining matte, or dull; and the other areas taking on a highly glossed, shiny finish.

Native American cultures relied on coiling techniques, whereas peoples of most other parts of the world used the potter's wheel. Egyptian potters employed a wheel by about 4000 BCE, and their basic invention has remained in use ever since. The ancient Greeks became particularly skillful with the process (the amphora, Fig. 14-3, is an example), which has the advantage of allowing potters to create works with far greater speed than hand-building, as well as giving them far greater control of a pot's thickness and shape. The potter's wheel is a flat disk attached to a flywheel below it, which is kicked by the potter (or, in modern times, driven by electricity) to make the upper disk turn. A slab of clay, from which air pockets have been removed by slamming it against a hard surface, is centered on the wheel (**Fig. 14-7**). As the slab turns, the potter pinches the clay between fingers and thumb, sometimes using both hands at once, and pulls it upward in a round, symmetrical shape, making it wider or narrower as the form demands and shaping both the inside and outside simultaneously. The most skilled potters apply even pressure on all sides of the pot as it is thrown.

Maria Montoya Martinez's black jar (**Fig. 14-6**) is an example of a second technique often used in ceramic construction, **coiling**, in which the clay is rolled out in long, rope-like strands that are coiled on top of each other and then smoothed. This pot is a specific example of a technique developed by Maria and her husband Julián in about 1919. The red clay pot was smoothed to an extremely smooth sheen and then a design was painted on it with liquid clay—a **slip**, as it is known. The pot was smothered in dung partway through the firing, with the resulting smoke blackening the clay; the areas painted with

Fig. 14-7 Pottery wheel-throwing, from *Craft and Art of Clay*.
Courtesy of Lawrence King Publishing Ltd.

◉━ **Watch** a video about ceramics on myartslab.com

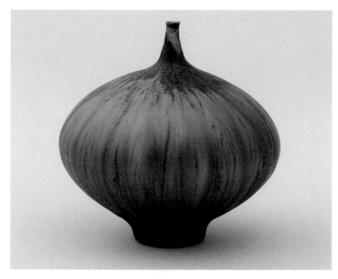

Fig. 14-8 Rose Cabat, *Onion Feelie*, n.d.
Ceramic, height: 8¼ in.; diameter 5⅛ in. Arizona State University Art Museum.

Rose Cabat's *Onion Feelie* (**Fig. 14-8**) is a thrown pot. Called "feelies" because her pots are glazed with a feathery mix that makes them soft and silky to the touch, they rise in the symmetrical roundness characteristic of thrown pots to small, narrow necks reminiscent of garden vegetables and gourds. But beyond the organic metaphor that these necks suggest, they also undermine the pot's functionality, rendering its possible uses as a container minimal at best and announcing its status as a work of art.

There are three basic types of ceramics. **Earthenware**, made of porous clay and fired at low temperatures, must be glazed if it is to hold liquid. **Stoneware** is impermeable to water because it is fired at high temperatures, and it is commonly used for dinnerware today. Finally, **porcelain**, fired at the highest temperatures of all, is a smooth-textured clay that becomes virtually translucent and extremely glossy in finish during firing. The first true porcelain was made in China during the T'ang Dynasty (618–906 CE). By the time of the Ming Dynasty (1368–1644), the official kilns at Jingdezhen had become a huge industrial center, producing ceramics for export. Just as the Greek artist painted his revelers on the red-orange amphora, Chinese artists painted elaborate designs onto the glazed surface of the porcelain. Originally, Islamic countries were the primary market for the distinctive blue-and-white patterns of Ming porcelain (**Fig. 14-9**), but as trade with Europe increased, so too did Europe's demand for Ming design.

Fig. 14-9 Plate, Ming Dynasty, late sixteenth–early seventeenth century, *Kraakporselein*, probably from the Jingdezhen kilns.
Porcelain, painted in underglaze blue, diameter 14¼ in. The Metropolitan Museum of Art, New York. Rogers Fund, 1916 (16.13). The Metropolitan Museum of Art, New York, NY, U.S.A.
Image © The Metropolitan Museum of Art. Image source: Art Resource, NY.

Thinking Thematically: See Art, Politics, and Community on myartslab.com

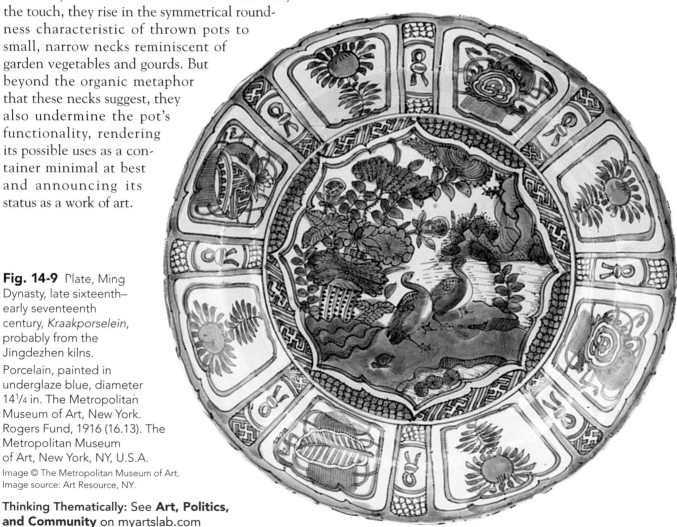

In the hands of many other contemporary artists such as Betty Woodman, the boundary between art and craft virtually disappears. "It makes good sense to use clay for pots, vases, pitchers, and platters," Woodman says, "but I like to have things both ways. I make things that could be functional, but I really want them to be considered works of art." In fact, vessels of some kind or another dominate her work, but they are vessels of unique character. They might take the form of a pillow, or of a human or animal body. Sometimes they are shaped like flowers, baskets, or cups. "The container is a universal symbol," she says, "it holds and pours all fluids, stores foods, and contains everything from our final remains to flowers." In one of the more humorous manifestations of the form, Woodman produced a vessel in the form of a tortilla, wrapped to contain the stuffings of a burrito. *Floral Vase and Shadow* (**Fig. 14-10**) underscores the painterly side of Woodman's art. The amphora-like vase, with its handles of brushstroke-like ribbons, is realized in green, yellow, and black glazes. It casts a ceramic orange shadow onto the wall behind it. Here Woodman's play with the contrast between two- and three-dimensional realizations of the vase echoes the play of her works between utility and art.

For many years, in the United States especially, crafts were strongly associated with women's work—decorative design of a more or less domestic bent. In the mid-1970s, the Holly Solomon Gallery in New York City's SoHo neighborhood (meaning "south of Houston Street") became the focus of a Pattern and

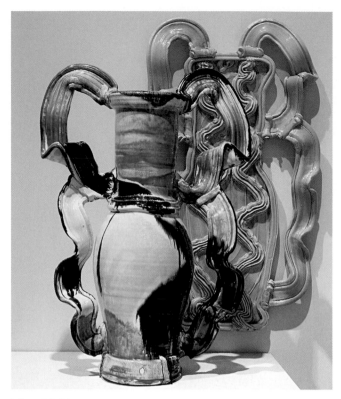

Fig. 14-10 Betty Woodman, *Floral Vase and Shadow*, 1983. Glazed ceramic.
Courtesy of Max Protetch.

Decoration movement that sought to elevate the so-called "minor arts" of crafts to the level of "high art." Miriam Schapiro's fabric fans, which we saw in Chapter 7 (see Fig. 7-9), are a manifestation of this movement. Joyce Kozloff's ceramic tile murals (**Fig. 14-11**) are another. This example, commissioned by the city of Pasadena, California in 1990, its floral designs erupting from their trellis-like background, celebrates Pasadena as the "City of Roses." Before turning to tile, Kozloff had executed paintings based on tile designs. But she began using actual decorative tile in her work when, between 1979

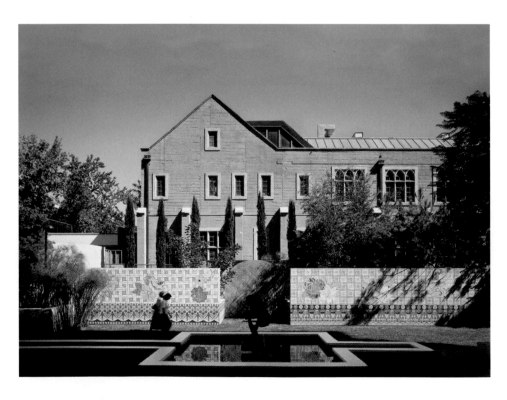

Fig. 14-11 Joyce Kozloff, *Plaza Las Fuentes*, Pasadena, California, 1990.
Glazed ceramic tiles; landscape architect: Lawrence Halprin; architects: Moore, Ruble, Yudell; developers: Maguire Thomas Partners; sculpture: Michael Lucero.
Photo: Tom Vinetz. DC Moore Gallery, New York.

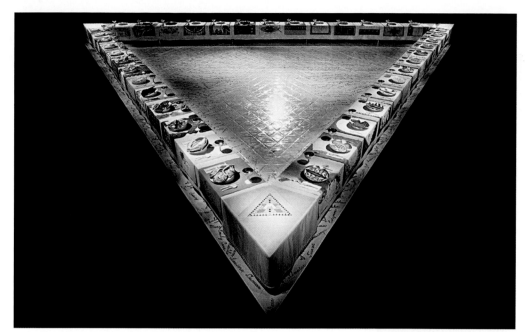

Fig. 14-12 Judy Chicago, *The Dinner Party*, 1979.

Mixed media, 48 × 48 × 48 ft. installed. Collection of the Brooklyn Museum of Art. Gift of the Elizabeth A. Sackler Foundation.

Photograph © Donald Woodman.

Thinking Thematically: See **Art, Gender, and Identity** on myartslab.com

and 1985, she was commissioned to design ceramic tile mosaics for subway and train stations in Wilmington, Delaware; Buffalo, New York; Philadelphia, Pennsylvania; Cambridge, Massachusetts; and for the international terminal of San Francisco International Airport. Among the sources of her designs are Native American pottery, Moroccan ceramics, and Viennese Art Nouveau architectural ornamentation.

A work that contributed significantly to the resuscitation of so-called "women's work" in the art world was Judy Chicago's *The Dinner Party* (**Fig. 14-12**). Chicago was trained as a painter, but she abandoned painting because, in the 1960s and 1970s, it was dominated by what she saw as men's way of thinking. The art world at the time emphasized formal issues but, working together with Schapiro, Kozloff, and Suzanne Lacy (see Figs. 3-18 and 3-19), Chicago sought to define the place of women in both the art world and society as a whole by exploring the artistic possibilities offered by traditional craft media and collaborative art processes.

The Dinner Party was a collaborative project that involved more than 300 female artisans working together over a period of five years to create a visual celebration of women's history. Shaped as a triangle, the earliest symbol of female power, it is set with 39 places, 13 on a side, each celebrating a woman who has made an important contribution to world history. The names of 999 additional women, all of whom have made significant contributions to history in their own right, are inscribed in ceramic tiles along the table's base. Around the table, the likes of Eleanor of Aquitaine, English author Virginia Woolf, and painters Georgia O'Keeffe and Artemisia Gentileschi

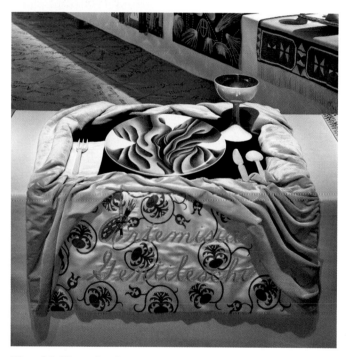

Fig. 14-13 Judy Chicago, *The Dinner Party* (Artemisia Gentileschi place setting), 1974–79.

Mixed media: ceramic, porcelain, textile. Brooklyn Museum, Gift of the Elizabeth A. Sackler Foundation, 2002.10.

Photograph by Jook Leung Photography.

(see *Judith and Maidservant with the Head of Holofernes*, Fig. 6-7) (**Fig. 14-13**) are celebrated. According to Chicago, the "twisting and turning forms" on Gentileschi's plate serve to represent the "extraordinary efforts required of any women of [Gentileschi's] time who desired to become an artist." (For a contrasting set of dinner plates, see Julie Green's *The Last Supper* in *The Creative Process*, pp. 336–337.)

If the business of storing and serving foodstuffs has traditionally fallen to ceramic wares, modern and contemporary artists have often abandoned this functionality in favor of more aesthetic concerns. But artist Julie Green, whose work as a tempera painter we have already encountered (see Fig. 11-12), has transformed the traditional role of ceramics into a powerful aesthetic—and political—statement.

In 2000, Green began a project called *The Last Supper* (**Fig. 14-14**). In order to draw attention to the number of Americans executed each year under various death penalty laws from state to state, as well as to the basic humanity of each of these individuals living on death row, Green began querying the states about the menu each requested for his or her "last meal." Each of these meals she depicted on a different plate, blue on white, in the traditional manner of Chinese porcelain (see Fig. 14-9). But the blue color has specific religious connotations as well. In the sixteenth century, the Catholic Church reserved the color blue (made predominantly from the relatively rare and

certainly expensive gemstone lapis lazuli) for depictions of the Virgin Mary. Thus, her color scheme recalls not only the Last Supper of Christ— "Do this in remembrance of me," Christ said to the Apostles—but also Christ's mother and, by extension, the mothers of all her subjects. But the blue color is even more complex than that: "The blue in *The Last Supper*," Green explains, "refers to the blues, blue-plate specials, heavenly blue, and old-style prison uniforms and mattresses of navy-and-white striped fabric. Also there is something cartoon-like and absurd about blue tacos, blue pizza, blue ketchup, blue bread."

Each of the plates is titled by the state of exectuion and date—no names of the inmates are given. But each tells us something remarkably personal about the inmate in question. Consider the three plates illustrated here (**Fig. 14-15**). At the top left is *Georgia, 26 June 2007*: "Four fried pork chops, collard greens with boiled okra, fried fatback, fried green tomatoes, cornbread, lemonade, one pint of strawberry ice cream, and three glazed donuts." Below

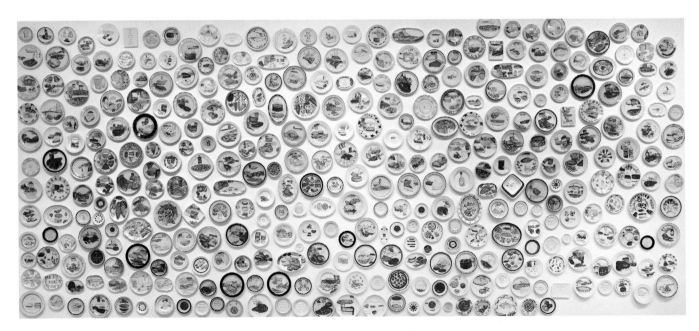

Fig. 14-14 Julie Green, *The Last Supper*, 2000-ongoing.
Installation view of 357 plates in the 2009 exhibition *Counter Intelligence*, California State University, Los Angeles.
Courtesy of the artist.

it is *Texas, 22 january 2009*: "Twenty-four hot dog chicken wings, two cheeseburgers with everything, four slices of pizza with jalapeños, three slices of buttered toast, one sweet potato pie, rainbow sherbet ice cream, and twelve cans of Dr. Pepper/Big Red." The oval-shaped plate on the right is *Indiana, 5 May 2007*: "Pizza and birthday cake shared with fifteen family and friends." Quoted on the plate are the words of a prison official— "He never had a birthday cake so we ordered a birthday cake for him."

When Green first began painting the plates over a decade ago—they now number over 500—she wanted them to be "institutional-looking and awkward, lacking in richness," but over the years, they have become much more complex and painterly. In part, this is because she has mastered the technique of applying the thick and oily mineral-based paint to the porcelain plates, but it also reflects her growing understanding of the complexities of the inmates themselves, as well as the complex feelings that the death penalty itself generates. Thus, some of her plainest plates—*Virginia 27 April 2006* simply states: "Requested that last meal not be released to the public"—are among the most poignant. All of the plates are viewable online at greenjulie.com.

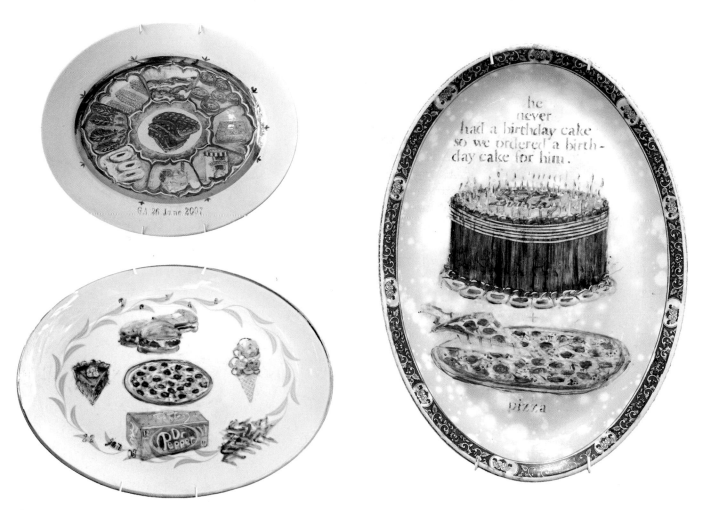

Fig. 14-15 Julie Green, *The Last Supper*, 2000-ongoing. 3 details. Top left: *Georgia, 26 June 2007*. Bottom Left: *Texas, 22 January 2009*. Right: *Indiana, 5 May 2007*.
Courtesy of the artist.

Fig. 14-16 Mosaic glass bowl, fused and slumped, Roman, 25 BCE–50 CE.
Height 4½ in. Victoria and Albert Museum, London.
V&A Images, London / Art Resource, NY.

Glass

Since ancient times, glassware was made either by forming the hot liquid glass, made principally of silica, or sand, mixed with soda ash, on a core or by casting it in a mold. The invention of glassblowing techniques late in the first century BCE so revolutionized the process that, in the Roman world, glassmaking quickly became a major industry. To blow glass, the artist dips the end of a pipe into molten glass and then blows through the pipe to produce a bubble. While it is still hot, the bubble is shaped and cut.

This glass bowl (**Fig. 14-16**) was probably made near Rome in the second half of the first century CE, before glassblowing took hold. It is made of opaque chips of colored glass. These chips expanded and elongated in the oven as they were heated over a core ceramic form. As the glass chips melted, they fused together and fell downward over the form, creating a decorative patchwork of dripping blobs and splotches. By the time this vase was made, demand for glass was so great that many craftsmen had moved from the Middle East to Italy to be near the expanding European markets.

In twelfth-century Europe, blown glass was used to make the great stained-glass windows that decorated the era's cathedrals. Stained glass is made by adding metallic salts to the glass during manufacture. A variety of different colors were blown by artisans and rolled out into square pieces. These pieces were then broken or cut into smaller fragments and then assembled over a drawing marked out in chalk dust.

Fig. 14-17 Moses window, Abbey Church of Saint-Denis, Saint-Denis, France, 1140–44.
© Achim Bednorz, Koln.

Features of people and other figures were painted on the glass in dark pigments, and the fragments were joined by strips of lead. The whole window was then strengthened with an armature of iron bands, at first stretched over the windows in a grid, but later shaped to follow the outlines of the design itself.

Among the very first stained-glass windows were those commissioned by the Abbot Suger for the royal abbey of Saint-Denis just north of Paris, dedicated by King Louis VII and his queen, Eleanor of Aquitaine, on June 11, 1144. Suger had long dreamed of making his abbey the most beautiful in all of France. In preparing his plans, he read what he believed to be the writings of the original Saint Denis. (We now know that he was reading the mystical tracts of a fifth- to sixth-century Athenian, today known as the pseudo-Dionysius whom Suger mistakenly believed to be a close associate of Saint Paul.) Light, these writings instructed, was the physical and material manifestation of Divine Spirit. And so, stained glass became a fundamental component of his design (**Fig. 14-17**). Suger would later survey the accomplishments of his administration and explain his religious rationale for his beautification of Saint-Denis:

> Marvel not at the gold and the expense but at the craftsmanship of the work.
> Bright is the noble work; but being nobly bright, the work
> Should brighten the minds, so that they may travel, through the true lights,
> To the True Light where Christ is the true door.

As beautiful as the church might be, it was designed to elevate the soul to the realm of God.

Today, the Pilchuck Glass School in Washington State is one of the leading centers of glassblowing in the world, surpassed only by the traditional glassblowing industry of Venice, Italy. Dale Chihuly, one of Pilchuck's cofounders, has been instrumental in transforming the medium from its utilitarian purposes into more sculptural ends. Chihuly's floating and hanging glass works are extraordinary installation pieces designed to animate large interior spaces such as the rotunda, or main entrance, of the Victoria and Albert Museum in London (**Fig. 14-18**). Over 30 feet high, it was commissioned by the museum after the rotunda dome was reinforced to both inaugurate the ongoing modernization of the museum's

facilities and underscore the museum's commitment to modern design. Lit by spotlights, the piece vibrates with what the artist calls "ice blue" and "spring green" lights, and the inspiration, as with so much of his work, is at once the sea, especially the waters of Puget Sound near his boyhood home in Tacoma, Washington, and flowers, which thrived in his mother's garden when he was a child. For Chihuly, the distinction between art and craft is irrelevant. "I don't really care if they call it art or craft," he says, "it really doesn't make any difference to me, but I do like the fact that people want to see it." In fact, Chihuly has been instrumental in establishing glass as a viable art medium, even inspiring the construction of a new Museum of Glass in his native Tacoma that opened to the public in 2002.

Fig. 14-18 Dale Chihuly, Rotunda Chandelier (Victoria and Albert Chandelier). 1999.
Glass, 27 × 12 × 12 ft.
Courtesy Marlborough Gallery for artist.

Fred Wilson is an artist and curator who has spent much of his career looking at and thinking about the arts and crafts of American society. He is especially adept at sifting through existing museum collections, reorganizing some objects and bringing others out of storage, in order to create commentaries on the history of American racism and the sociopolitical realities of the American museum system (see *The Creative Process*, pp. 336–337, for an exhibit he created from the collections of the Maryland Historical Society). In 2001, Wilson began working with glass as he prepared to be the American representative at the 2003 Venice Biennale. Given Venice's preeminence as a glass manufacturing city, glass seemed a natural choice, and he hired the famed glassworkers on the island of Murano to create the pieces that he designed. But it was a difficult medium for him to work with. With glass, he says, "it's hard to make anything that has a lot of meaning—or where the meaning is at least as strong as the beauty of the material. Infusing meaning is what I'm really interested in."

Wilson chose to work with black glass, because black as a color is so obviously a metaphor for African Americans, but also because it refers to the long history of black Africans in Venice, epitomized in Western consciousness by Shakespeare's *Othello: The Moor of Venice*. Inspired by the watery canals and lagoons of Venice, he shaped the glass so that it appeared to be liquid—ink, oil, tar. In *Drip Drop Plop* (**Fig. 14-19**), what appear to be glass tears descend the wall to form puddles of black liquid on the floor. Some of the tears and puddles have eyes: "Because of 1930s cartoons that were recycled in my childhood in the 1960s, these cartoon eyes on a black object represent African Americans in a very derogatory way. . . . So I sort of view them as black tears." But the glass tears suggest other things as well—the degradation of the environment, for one, as they fall off the wall like a spill from an oil tanker. They also take on the appearance of sperm, suggesting an almost masturbatory ineffectuality. All these meanings are at least partially at work, and they underscore the ways in which art and craft differ. Art, in essence, goes far beyond mere utility. It provokes thought, and it produces meaning.

Fiber

We do not usually think of fiber as a three-dimensional medium. However, fiber arts are traditionally used to fill three-dimensional space, in the way that a carpet fills a room or that clothing drapes across a body.

Fig. 14-19 Fred Wilson, *Drip Drop Plop*, 2001.
Glass, approximately 99 × 72 × 62 in.
Photograph by Ellen Labenski, Courtesy The Pace Gallery, New York.
© Fred Wilson, courtesy The Pace Gallery.

In the Middle Ages, tapestry hangings such as *The Unicorn in Captivity* (**Fig. 14-20**) were hung on the stone walls of huge mansions and castles to warm and visually soften the stone. Fiber is an extraordinarily textural medium, and, as a result, it has recently become an increasingly favored medium for sculpture.

But all fiber arts, sculptural or not, trace their origins back to **weaving**, a technique for constructing fabrics by means of interlacing horizontal and vertical threads. The vertical threads—called the **warp**—are held taut on a loom or frame, and the horizontal threads—the **weft** or **woof**—are woven loosely over and under the warp. A **tapestry** is a special kind of weaving in which the weft yarns are of several colors and the weaver manipulates the colors to make an intricate design.

In **embroidery**, a second traditional fiber art, the design is made by needlework. From the early eighteenth century onward, the town of Chamba was one of the centers of the art of embroidery in India. It was known,

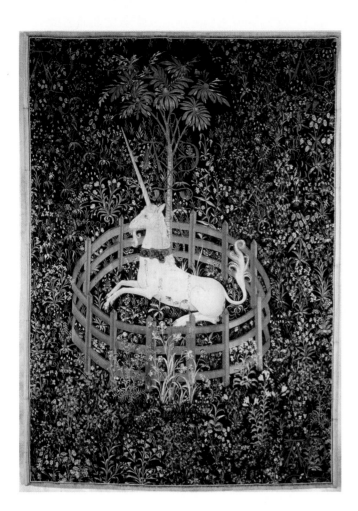

Fig. 14-20 *The Unicorn in Captivity, from The Hunt of the Unicorn*, Franco-Flemish, sixteenth century, c. 1500.
One of six hangings and two fragments from two or more sets of tapestries. Wool Warp, Silk, wool, silver and silver-gilt threads, 12 ft. 1 in. × 8 ft. 3 in. (368 × 251.5 cm). The Metropolitan Museum of Art, New York, NY, U.S.A. Gift of John D. Rockefeller, Jr. 1937 (37.80.6)

Thinking Thematically: See **Art and Beauty** on myartslab.com

particularly, for its *rumals*, embroidered muslin textiles that were used as wrappings for gifts (**Fig. 14-21**). If an offering was to be made at a temple, or if gifts were to be exchanged between families of a bride and groom, an embroidered *rumal* was always used as a wrapping.

The composition of the Chamba *rumals* is consistent. A floral border encloses a dense series of images, first drawn in charcoal and then embroidered, on a plain white muslin background. For a wedding gift, as in the *rumal* illustrated here, the designs might depict the wedding itself. The designs were double-darned, so that an identical scene appeared on both sides of the cloth. Because of its location in the foothills and mountains of the Himalayas, offering relief from the heat of the Indian plains, the region around Chamba was a favorite summer retreat for British colonists, and its embroidery arts became very popular in nineteenth-century England.

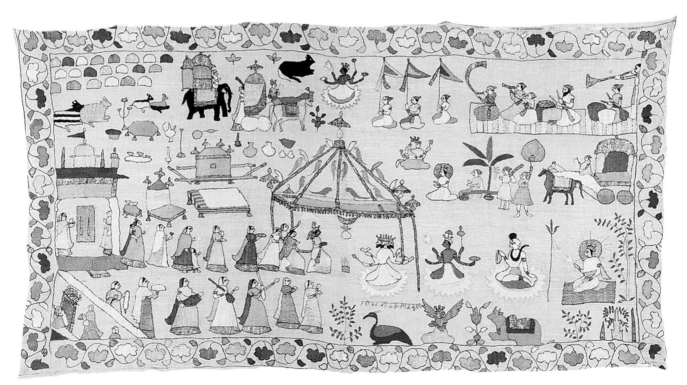

Fig. 14-21 Embroidered *rumal*, late eighteenth century. Muslin and colored silks. Victorian and Albert Museum.
V & A Images/Victoria and Albert Museum.

Fred Wilson is a contemporary artist who has transformed the problem of exhibition design by exposing the cultural, political, and socioeconomic assumptions that underlie the modern museum space. Traditionally, museums have tried to create coherent, even homogeneous, spaces in which to view exhibitions. The "white room" effect is one such design principle—that is, the walls of the space are uniform and white so as not to detract from the work on the walls. Even when more elaborate design ideas come into play—for instance, when an architectural setting is re-created in order to reconstruct the original era or setting of the works on display—the principle of an intellectually coherent space, one that helps the viewer to understand and contextualize the work, predominates.

Wilson believes that this traditional curatorial stance has caused most museums to "bury" or ignore works that do not fit easily into the dominant "story" that the museum tells. In 1992, The Contemporary, a museum exhibiting in temporary spaces in Baltimore, Maryland, arranged for Wilson to install an exhibition at the Maryland Historical Society. Wilson saw it as an opportunity to reinterpret the Historical Society's collection and present a larger story about Maryland history than the museum was used to telling.

Wilson begins all of his projects with a research phase—in this case, into the history of Baltimore and the people who lived there. "When I go into a project," he says, "I'm not looking to bring something to it. I'm responding more than anything else. You can still get a very personal emotional response from a situation or an individual who lived a hundred years ago. It's connecting over time that I'm responding to." In the archives and collections of the museum, Wilson was able to discover a wealth of material that the museum had never exhibited, not least of all because it related to a part of Maryland history that embarrassed and even shamed many

viewers—the reality of slavery. Wilson brought these materials to light by juxtaposing them with elements of the collection that viewers were used to seeing.

Behind a "punt gun" ostensibly used for hunting game birds on Chesapeake Bay, Wilson placed reward notices for runaway slaves. A document discovered in the archives, an inventory of the estate of one Nicholas Carroll (**Fig. 14-22**), lists all his slaves and animals together with their estimated value. What jars the contemporary reader is the fact that least valuable of all, valued at a mere dollar, is the "negro woman Hannah seventy-three years of age." Even

Fig. 14-22 Nicholas Carroll Estate Inventory, MS 2634, c. 1812. Manuscripts Division, Maryland Historical Society Library. The Maryland Historical Society, Baltimore, Maryland.

the "old Mule called Coby" is worth five times as much. In the middle of a display of silver repoussé objects made by Maryland craftsmen in the early 1800s (**Fig. 14-24**), Wilson placed a set of iron slave shackles, underscoring the fact that Maryland's luxury economy was built on slavery. Similarly, in a display of Maryland cabinetmaking, he placed a whipping post (**Fig. 14-23**) that was used until 1938 in front of the Baltimore city jail, and that the museum had ignored for years, storing it with its collection of fine antique cabinets.

Wilson was equally struck by what was missing from the museum's collection. While the museum possessed marble busts of Henry Clay, Napoleon Bonaparte, and Andrew Jackson, none of whom had any particular impact on Maryland history, it possessed no busts of three great black Marylanders—Harriet Tubman, Frederick Douglass, and the astronomer and mathematician Benjamin Banneker. Thus, at the entrance to the museum, across from the three marble busts in the museum's collection, he placed three empty pedestals, each identified with the name of its "missing" subject.

"Objects," Wilson says, "speak to me." As an artist, curator, and exhibition designer, Wilson translates what these objects say to him for all of us to hear. "I am trying to root out . . . denial," he says. "Museums are afraid of what they will bring to the surface and how people will feel about issues that are long buried. They keep it buried, as if it doesn't exist, as though people aren't feeling these things anyway, instead of opening that sore and cleaning it out so it can heal."

Figs. 14-23 and 14-24 Fred Wilson, *Mining the Museum*, 1992. Installation detail: Whipping Post and Chairs for Cabinetmaking, 1820–1960. Left: Silver Vessels and Slave Shackles for Metalwork.
Photo: Jeff D. Goldman © Contemporary Museum.

One of the most important textile designers of the twentieth century was Anni Albers. This wall hanging (**Fig. 14-25**) was done on a 12-harness loom, each harness capable of supporting a 4-inch band of weaving. Consequently, Albers designed a 48-inch-wide grid composed of 12 of the 4-inch-wide units. Each unit is a vertical rectangle, variable only in its patterning, which is either solid or striped. The striped rectangles are themselves divided into units of 12 alternating stripes. Occasional cubes are formed when two rectangles of the same pattern appear side by side.

Anni Albers regarded such geometric play as rooted in nature. Inspired by reading *The Metamorphosis of Plants* by Johann Wolfgang von Goethe, the eighteenth-century German poet and philosopher, she was fascinated by the way a simple, basic pattern could generate, in nature, infinite variety. There is, in the design here, no apparent pattern in the occurrence of solid or striped rectangles or in the colors employed in them. This variability of particular detail within an overall geometric scheme is, from Albers's point of view, as natural and as inevitable as the repetition itself.

In 2003, the Museum of Fine Arts, Houston, organized an exhibit of quilts made by the women from the isolated community of Gee's Bend, Alabama. It surprised the American art world by revealing an indigenous grassroots approach to textile design that rivaled in every way the inventiveness of more sophisticated avant-garde artists like Albers. Consisting of 60 quilts by 42 women spanning four generations, the quilts reveal a genius for color and geometry. Jessie T. Pettway's *Bars and String-Pieced Columns* (**Fig. 14-26**) veers back and forth between its highly structured three-column organization and the almost giddy sense of imbalance created by the rise and fall of the horizontal bars of color between the solid red bars. The women themselves were stunned by the attention the art world suddenly bestowed on them. "We never thought that our quilts was artwork; we never heard about a quilt hanging on a wall in a museum," quilter Arlonzia Pettway says. "Everybody went to talking about our quilts and

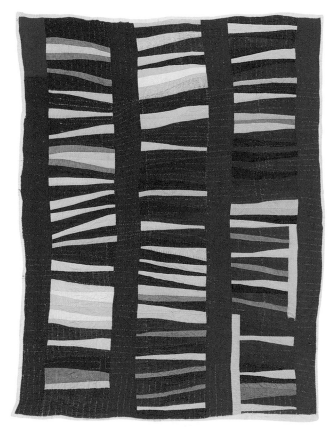

Fig. 14-25 Anni Albers, Wall Hanging, 1926.
Silk (two-ply weave), 72 × 48 in. (182.9 × 122 cm) The Busch-Reisinger Museum, Harvard University Art Museums. Association Fund.

Photograph by Michael Nedzweski © President and Fellows of Harvard College, Harvard University. BR48.132.

Fig. 14-26 Jessie T. Pettway, *Bars and String-Pieced Columns*, 1950s.
Cotton quilt, 95 × 76 in.

Photo: Steve Pitking/Pitking Studios. © 2003. Provided by Tinwood Alliance Collection, Atlanta (www.tinwoodmedia.com).

everybody wanted to meet us and see us and that's what happened." But however practical the quilts were designed to be, heaped on beds to keep their makers' families warm, their artistry could hardly be denied. It was as if, working together, the women of Gee's Bend had forged a unique abstract style of their own.

In the early 1970s, Faith Ringgold, whose earlier painting we saw in Chapter 1 (see Fig. 1-22), began to paint on soft fabrics and frame her images with decorative quilted borders made by her mother. After her mother's death in 1981, Ringgold created the quilt borders herself, and she began writing an autobiography, published in 1995 as *We Flew over the Bridge: The Memoirs of Faith Ringgold*, which she incorporated into her painting/quilts. *Tar Beach* (**Fig. 14-27**) is one of these. "Tar Beach" refers to the roof of the apartment building where Ringgold's family would sleep on hot summer nights when she was growing up. The fictional narrator of this story is an eight-year-old girl named Cassie, shown lying on a quilt (within the quilt) with her brother at the lower right while her parents sit at a nearby table playing cards. A second Cassie flies over the George Washington Bridge at the top of the painting, a manifestation of the child's dreams. In the accompanying story, she imagines she can fly, taking the bridge for her own, claiming a union building for her father (half black, half Indian, he had helped to build it, but owing to his race, could not join the union himself) and an ice cream factory for her mother, who deserved to eat "ice cream every night for dessert." The painting is a parable of the African-American experience, portraying at once the hopes and aspirations of the African-American community even as it embodies the stark reality of its members' lives.

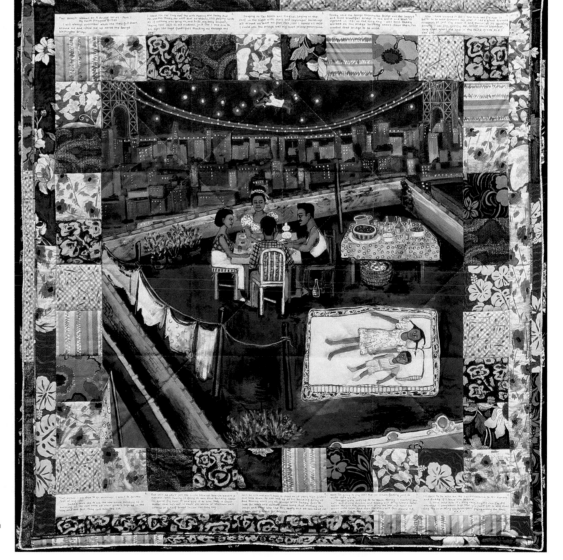

Fig. 14-27 Faith Ringgold, *Tar Beach* (Part I from the *Woman on a Bridge* series), 1988.

Acrylic on tie dyed and pieced fabric. 74 × 69 in.

© 1988. Collection: The Solomon R. Guggenheim Museum, New York.

The principles of quilt-making are quite simple. Quilt-maker Clay Lohmann, who as a male quilt-maker remains something of a rarity in the art world, points out that most modern athletic shoes are made like quilts and basic home construction uses the same principles as well—an interior wall, an exterior wall, wall studs serving as the quilting pattern, and most often fiberglass insulation as the batting between them. Lohmann makes what he calls "anatomy" quilts, which take advantage of his training in drawing and anatomy. *Black Lung* (**Fig. 14-28**) refers to the lung disease that develops from inhaling coal dust. The profile of a stern-looking man rises from the neckline of what appears to be a dress, but may well be a hospital robe. The black bands at top and bottom lend the quilt the aura of a funeral shroud. The quilting at the bottom of the lavender and gold bands suggests perspectival space, as if the figure is fading away. The pattern in the gold band is, incidentally, composed of the numbers 1-9, the alphabet, and an address. All suggests a history, something of a tragic story. "I grew up around and slept under quilts made by family members," Lohmann says. "All of my quilting is homage to the unsung, underappreciated and most often women quilters who, no matter what level of artistic achievement, simply are not recognized as 'artists.' I incorporate bits of lace, embroidered tea towels, pillowcases, tablecloths, and in a nod to punk fashion, safety pins."

The narrative bent of both Lohmann's and Ringgold's quilts is also reflected in a unique work by Marilyn Lanfear created by sewing mother-of-pearl and bone buttons onto linen. *Aunt Billie* (**Fig. 14-29**) is the first of three large panels in the triptych *Uncle Clarence's Three Wives*, each of which is a portrait of one of the artist's aunts. The buttons create an image that is composed of large pixel-like dots, but because of the different reflective qualities of mother of pearl—and the more matte finish of the bone buttons—the surface of the image shimmers and glows in the light. The overall effect is dreamlike, as if the eye is at the edge of capturing a fleeting memory of the past. Because her Uncle Clarence worked the oil fields of East Texas in the boom days before the Second

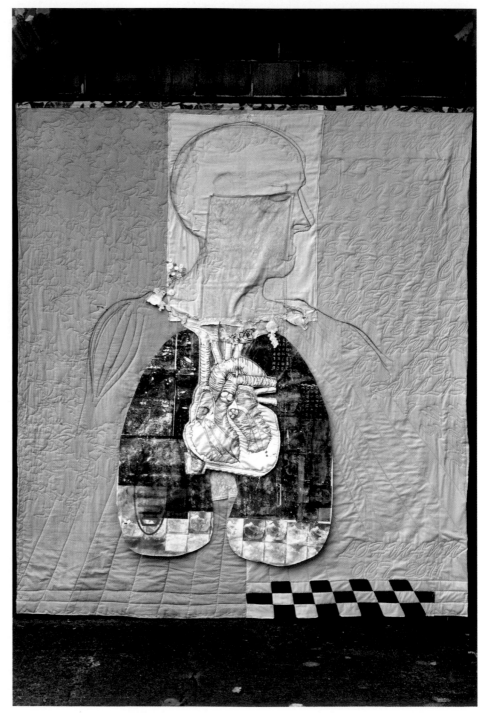

Fig. 14-28 Clay Lohmann,
Black Lung, 2011.
Cotton cloth, thread, silk batting, inflatable lung, buttons, tubing, safety pins, 90 × 80 in.
Courtesy of the artist.

World War and then, after the war, was among the first to man an anchor handling tug supply (AHTS) vessel in the Texas Gulf, supplying the newly designed oil rigs, towing them to location, and anchoring them in place, her triptych is also a history of the oil industry in Texas from the point of view of a worker's family.

Aunt Billie, as it turns out, died in 1937, the victim of one of the great tragedies of the East Texas oil fields. As a result of the oil boom, the town of New London, just south of Longview, was one of the richest communities in the United States, and it had built a lavish new school building. In order to heat the facility, the school district had tapped into the residue gas lines from the oil fields, gas that would normally have been flared off as waste. Unbenownst to anyone, natural gas had been leaking from the tap on the residue line and building up in the crawl space under the 253-foot-long building. On the afternoon of March 18, 1937, a spark from an electric sander being used by a maintenance worker caused the gas to explode. Of the approximately 600 students and 40 teachers in the building at the time, only about 130 escaped without serious injury, and 295 were killed. Aunt Billie, who had gone to the building to meet her sister, was one of those who died. To reduce the risk of future leaks going undetected, the Texas Legislature began mandating within weeks of the explosion that thiols, compounds of sulfur and hydrogen that have a very strong odor, be added to all natural gas. The practice quickly spread worldwide. In Lanfear's portrait, Billie stands before the school, just as it begins to explode—parts of it rising to the right of the arch. In this context, the buttons have a profoundly haunting effect, functioning like talismans of the tragedy.

Fig. 14-29 Marilyn Lanfear, *Aunt Billie*, from the triptych *Uncle Clarence's Three Wives*, and detail, 2007. Mother-of-pearl and bone buttons sewn to linen, 8 × 4¹/₂ ft. Courtesy of the artist.

Fig. 14-30 Atelier Joana Vasconcelos, *Contamination*, 2008–2010.
Hand-knitted and crocheted elements, applications in felt, industrial mesh, fabric, ornaments, polystyrene, polyester, steel cables, dimensions variable. Palazzo Grassi, Venice, Italy.
Courtesy Galerie Nathalie Obadia.

In 2008, Portuguese artist Atelier Joana Vasconcelos installed her work *Contamination* (**Fig. 14-30**) at the Pinacoteca de Estado in São Paolo, Brazil, and subsequently at the Berardo Museum in Lisbon and the Centre Culturel Calouste Gulbenkin in Paris. In the summer of 2011, it was installed at the Palazzo Grassi in Venice, Italy. As it has moved from country to country, it has morphed as Vasconcelos has continued to add new elements to it—fabric samples, jeweled insects, children's toys, sequins, pom-poms, beach towels—the detritus of consumer culture that proliferates and contaminates contemporary life. All this she and her assistants sew, knit, and crochet in place, allowing its amoeba-like forms to spread like a viral contagion, as if reproducing in wild sexual abandon, across, around, and through whatever architectural space it finds itself in.

It was in the hands of Magdalena Abakanowicz, in this century, that fiber became a tool of serious artistic expression, freed of any associations with utilitarian crafts. In the early 1970s, using traditional fiber materials such as burlap and string, Abakanowicz began to make forms based on the human anatomy (**Fig. 14-31**). She presses these fibers into a plaster mold, creating a series of multiples that, though generally uniform, are strikingly different from piece to piece, the materials lending each figure an individual identity.

As Anni Albers's work also demonstrates, pattern and repetition have always played an important role in textile design. Abakanowicz brings new meaning to the traditional functions of repetitive pattern. These forms, all bent over in prayer, or perhaps pain, speak to our condition as humans, our spiritual emptiness—these are hollow forms—and our mass anxiety.

The textile wrappings also remind us of the traditional function of clothing—to protect us from the elements. Here, huddled against the sun and rain, each figure is shrouded in a wrap that seems at once clothing and bandage. It is as if the figures are wounded, cold, impoverished, homeless—the universal condition. As Abakanowicz reminds us,

It is from fiber that all living organisms are built—the tissues of plants, and ourselves. Our nerves, our genetic code, the canals of our veins, our muscles. We are fibrous structures. Our heart is surrounded by the coronary plexus, the plexus of most vital threads. Handling fiber, we handle mystery. . . . When the biology of our body breaks down, the skin has to be cut so as to give access to the inside, later it has to be sewn, like fabric. Fabric is our covering and our attire. Made with our hands, it is a record of our souls.

Fig. 14-31 Magdalena Abakanowicz, *Backs in Landscape*, 1978–81.
Eighty sculptures of burlap and resin molded from plaster casts, over-life-size.
Photo: Dirk Bakker, 1982. © Magdalena Abakanowicz, courtesy Marlborough Gallery, New York.

This, too, is the subject for artist Yinka Shonibare. Like Chris Ofili (see Fig. 3-4), Shonibare was born in England to Nigerian parents, but unlike Ofili he was raised in Nigeria before returning to art school in London. In the mid-1990s, he began making works out of the colorful printed fabrics that are worn throughout West Africa (**Fig. 14-32**), all of which are created by English and Dutch designers, manufactured in Europe, then exported to Africa, from where they are in turn remarketed in the West as authentic African designs. In this sense, the fabrics are the very record of Shonibare's soul, traveling back and forth, from continent to continent. "By making hybrid clothes," Shonibare explains,

I collapse the idea of a European dichotomy against an African one. There is no way you can work out where the opposites are. There is no way you can work out the precise nationality of my dresses,

Fig. 14-32 Yinka Shonibare, *Victorian Couple*, 1999.
Wax-printed cotton textile, left approximately 60 × 36 × 36 in; right approximately 60 × 24 × 24 in.
Courtesy of the artist, Stephen Friedman Gallery, London, and James Cohan Gallery, New York.

because they do not have one. And there is no way you can work out the precise economic status of the people who would've worn those dresses because the economic status and the class status are confused in these objects.

In fact, the era of these costumes is even drawn into question. The bustle on the woman's dress is distinctly nineteenth-century, while the man's entire wardrobe seems distinctly out of the 1960s American hippie movement, especially given the decorative effect of the trumpets on his trouser legs.

Metal

Perhaps the most durable of all craft media is metal, and, as a result, it has been employed for centuries to make vessels for food and drink, tools for agriculture and building, and weapons for war. We have discussed traditional metal-casting techniques in Chapter 13, but it is worth remembering that Chinese artisans had developed a sophisticated bronze-casting technique as early as the sixteenth century BCE, many centuries before the advent of the lost-wax technique in the West. The Chinese apparently constructed two-piece "sandwich" molds that did not require wax to hold the two sides apart. For an example, see Chapter 17, "The Ancient World," Figure 17-14.

Of all metals, gold is the easiest to work, being relatively soft and occurring as it does in an almost pure state. Since the earliest times, its brilliance has been linked to royalty. In ancient Egyptian culture, it was closely associated with both the sun god, Re, and the king himself, who was considered the son of Re. Because of its permanence—it neither corrodes nor tarnishes—it was further associated with the *ka*, the eternal life of the ruler, similar to the "soul" or "life force" in other religions. A representation of King Tutankhamun hunting, found in his grave, is typical of Egyptian gold ornamentation (**Fig. 14-33**). The work is an example of gold **repoussé**—that is, its design was realized by hammering the image from the reverse side. The design on the front was then refined by means of **embossing**—the reverse of repoussé.

Over the years, metals, especially gold and silver, have also been lavishly

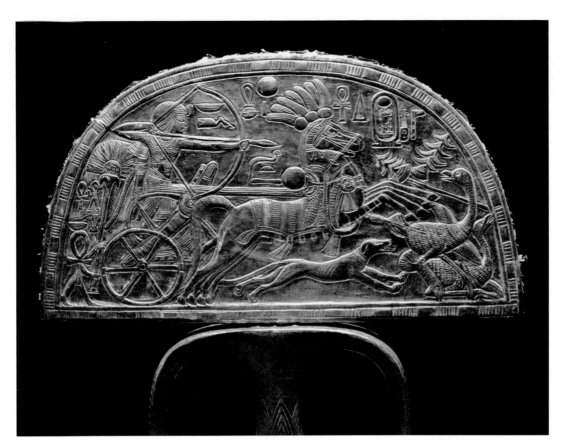

Fig. 14-33
Tutankhamun Hunting Ostriches from His Chariot, base of the king's ostrich-feather fan, c. 1335–1327 BCE.
Beaten gold, 4 × 7¼ in. Egyptian Museum, Cairo.

used in the creation of jewelry. The Persian griffin bracelet pictured here (**Fig. 14-34**) was discovered in 1877 as part of the Oxus treasure, named after the river in Soviet Central Asia where it was found. The griffin is a mythological beast, half eagle, half lion, that symbolized vigilance and courage and was believed by the Persians to guard the gold of India, and the story associated with the discovery of this bracelet is indeed one of heroism and courage. Originally sold to Muslim merchants, the Oxus treasure was soon stolen by bandits, who were intent on dividing the loot evenly by melting it down. Captain F. C. Burton, a British officer in Pakistan, heard of the robbery, rescued the treasure, and returned it to the merchants, asking only that he be given one of two griffin bracelets as his reward. He subsequently donated it to the Victoria and Albert Museum while its companion piece, illustrated here, eventually found its way to the British Museum. Considered one of the most beautiful works of jewelry ever made, the bracelet was originally inlaid with colored stones. The minute detail of the griffins—especially the feathers on wings and necks, as well as the clawed feet—must have suggested, inlaid with stone, the finest Asian silk drapery.

The Oxus treasure was almost surely a royal hoard, and, throughout history, the most elaborate

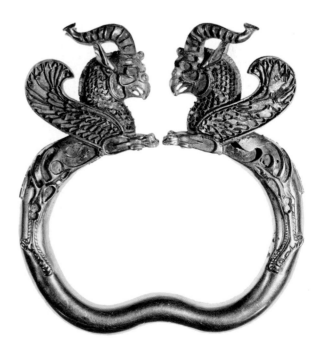

Fig. 14-34 Griffin bracelet, from the Oxus treasure, c. 500–400 BCE.
Gold and stones, diameter 5 in. British Museum, London.

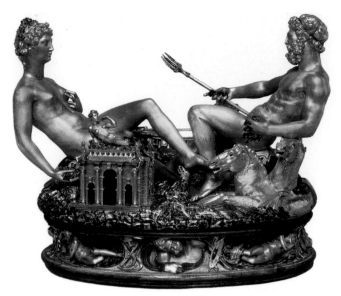

Fig. 14-35 Benvenuto Cellini, *Saliera (saltcellar), Neptune (sea) and Tellus (earth)*, 1540–43.
Gold, niello work, and ebony base, height 10¼ in. Kunsthistorisches Museum, Vienna.
Kunsthistorisches Museum, Vienna, Austria.

metal designs have always been commissioned by royalty. In 1539, Benvenuto Cellini designed a saltcellar (**Fig. 14-35**) for Francis I of France. Made of gold and enamel, it is actually a functional salt and pepper dispenser. Salt is represented by the male figure, Neptune, god of the sea, and hence overlord of the sea's salt. Pepper is the provenance of earth, represented by the female figure. Along the base of the saltcellar is a complex array of allegorical figures depicting the four seasons and the four parts of the day, embodying both seasonal festivities and the daily meal schedule. In his autobiography, Cellini described the work as follows:

I first laid down an oval framework and upon this ground, wishing to suggest the interminglement of land and ocean, I modeled two figures, one considerably taller than a palm in height, which were seated with their legs interlaced, suggesting those lengthier branches of the sea which run up into the continents. The sea was a man, and in his hand I placed a ship, elaborately wrought in all its details, and well adapted to hold a quantity of salt. Beneath him I grouped the four sea-horses, and in his right hand he held his trident. The earth I fashioned like a woman, with all the beauty of form, the grace, and charm of which my art was capable. She had a richly decorated temple firmly based upon the ground at one side; and here her hand rested. This I intended to receive the pepper. In her other hand

I put a cornucopia, overflowing with all the natural treasures I could think of. Below the goddess, on the part which represented earth, I collected the fairest animals that haunt our globe. In the quarter presided over by the deity of ocean, I fashioned such choice kinds of fishes and shells as could be properly displayed in that small space.

While Cellini apparently later changed the positions of the hands and what they were holding, the description, which must have been written some 20 years after the fact, is accurate. When a Vatican cardinal saw the model, he told Cellini: "Unless you make it for the King, to whom I mean to take you, I do not think that you will make it for another man alive."

A more contemporary example of metalwork at its finest is Susan R. Ewing's *Inner Circle Teapot II* (**Fig. 14-36**). Ewing works out the ideas for such pieces by bending and turning everyday materials such as cardboard, common tubing, and the like until she has found a form that seems pleasing. Here she evokes a kind of terrestrial globe orbited by the teapot's handle and spout. The pattern on the teapot is created through a technique known as *vermeil*, pronounced "vair-MAY," in which a microscopically thin layer of gold is plated to the finished silver form.

Fig. 14-36 Susan R. Ewing, *Inner Circle Teapot II*, 1991.
Sterling silver, 24K Vermeil, 9¾ × 10¼ × 8½ in.
Courtesy of the artist. Photo: Carl Potteiger.

Metalsmith Nathan Dube creates high-end toys that evoke childhood play while at the same time exploring the relationship of men's idealized memories of their youth to questions of masculinity and the mid-life crisis. *S.P.I.T.* (**Fig. 14-37**), for instance, is a spit-wad shooter made of precious metals. Its small, pocket-sized case contains assembly instructions, papers, a loader, and a shooter in three parts that screw together. As Dube explains his work:

The appearance of each piece affords the object a level of authority, convincing the viewer that each piece is the result of years of industrial research and development for actual products. At the same time this authority is subverted by the absurdity of each piece's function. For instance, the piece entitled S.P.I.T., which functions as a spit-wad shooter, is extremely detailed, exquisitely crafted and constructed of precious materials. These eclectic toys are meant to comment on the absurd lengths men will sometimes go to in order to recapture their youth.

The art of the piece rests in the playful tension it creates between its high-end fabrication and its juvenile functionality.

Wood

Because it is so easy to carve, and because it is so widely available, artisans have favored wood as a medium throughout history. Yet because it is organic material, wood is also extremely fragile, and few wood artifacts survive from ancient cultures.

Of all woods, cedar, native to the Northwest American coast, is a particular favorite of Native American artists in that region because of its relative impermeability to weather, its resistance to insect

Fig. 14-37 Nathan Dube, *S.P.I.T.* (Saliva and Paper Instigating Trauma), 2005.
Precious metals, dimensions of case $2^3/4 \times 4^1/4$ in.
Courtesy of the artist.

attack, and its protective, aromatic odor. Chests such as this Heiltsuk example (**Fig. 14-38**) were designed to contain family heirlooms and clan regalia and were opened only on ceremonial occasions. Often such a chest also served as the ceremonial seat of the clan leader, who sat upon it, literally supported by his heritage.

Wood has also been a favorite, even preferred, material for making furniture, and in the hands of accomplished artists, a piece of furniture can be transformed into a work of art in its own right. The earliest Americans understood this from the outset. Some of the most magnificent furniture designed in the newly founded American colonies in the seventeenth century came from Ipswich, Massachusetts. There, by the 1660s, two "joiners," or furniture makers, William Searle and his son-in-law Thomas Dennis, were crafting some of the most beautiful trunks and chests

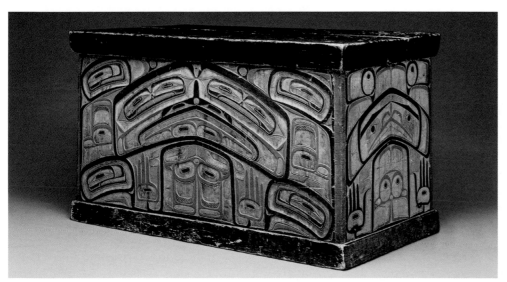

Fig. 14-38 Heiltsuk, *Bent-Corner Chest (Kook)*, c. 1860.
Yellow and red cedar, and paint, H. $21^1/4 \times$ W. $35^3/4 \times$ D. $20^1/2$ in.
The Seattle Art Museum. Gift of John H. Hauberg and John and Grace Putnam.
Photo by Paul Macapia.

Thinking Thematically: See Art and Spiritual Belief on myartslab.com

produced in seventeenth-century New England. The panels of the chest illustrated here (**Fig. 14-39**) are carved in a design popular in Searle's and Dennis's native Devonshire, England. Stalks of flowers and leaves emerge from an urn, only the opening of which is visible at the bottom of each of the three panels. Formally, the chest is notable for the symmetry of its design, the two outside panels bracketing the center one. But perhaps more striking is the very richness of the design, its elaborate, even exuberant celebration of the natural world.

Americans, raised with the story of the Mayflower and Plymouth Plantation, most especially the image of that first winter of 1620–21, when nearly half the population of that first settlement succumbed to the harshness of their circumstances, rarely appreciate the feelings that the Puritans had for the natural beauty—and bounty—of the place they now called home.

Fig. 14-39 Attributed to Thomas Dennis or William Searle, Chest, made in Ipswich, Massachusetts, 1660–1680.

Red oak, white oak, 29³/₄ × 49¹/₈ × 21³/₈ in. Metropolitan Museum of Art, New York. Gift of Mrs. Russell Sage, 1909 (10.125.685).

At the time of their arrival, most of the eastern United States was covered in tall forests of oak, pine, hemlock, maple, ash, and birch. It was in fact the ready availability of high-quality wood scoured from the landscape, oak in particular, that so attracted Searle and Dennis to Ipswich in the first place. There they could still search the nearby forests for a good tree. The oaks they cut were at least two hundred years old, many much older, and they were very close-ringed, as many as 15 to 20 rings per inch (a modern-day oak would be notable if it possessed 10 per inch). This chest is an image of that bounty.

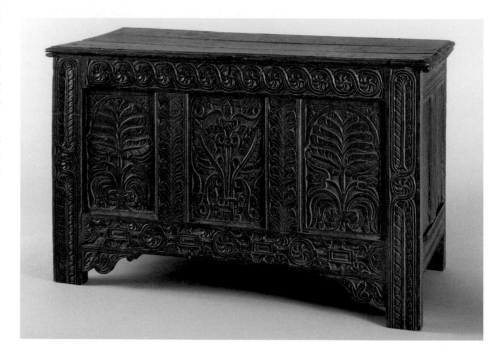

THINKING BACK

✓—Study and review on myartslab.com

How are ceramics made?

Ceramics are objects that are formed out of clay and then hardened by firing in a very hot oven called a kiln. Ceramic objects can be formed in a few different ways: slab construction, coiling, and throwing on a potter's wheel. How does a ceramist use slip? What distinguishes earthenware, stoneware, and porcelain?

How are glass objects made?

Around the first century BCE, glassblowing techniques were developed, turning glass into a major industry. In this process, the glassblower dips the end of a pipe into molten glass and then blows through the pipe to produce a bubble, which is then shaped and cut. How is stained glass made? What role has Dale Chihuly played in defining the medium of glass today?

How is the technique of weaving performed?

Weaving is a technique for constructing fabrics in which vertical threads (the warp) are interlaced with horizontal threads (the weft, or woof). The warp threads are held tightly on a frame, and the weft threads are continuously pulled above and below. What distinguishes a tapestry? What defines the technique of embroidery? What are *rumals*?

Why has gold been a favored material since ancient times?

Perhaps the most durable of all craft media is metal. Of all metals, gold is the easiest to work. It is relatively soft, occurs in an almost pure state, and consequently, has, since ancient times, been linked with royalty. How does repoussé differ from embossing? What features of the Oxus treasure would point to it coming from a royal hoard?

THE CRITICAL PROCESS

Thinking about the Crafts as Fine Art

A fascinating intervention of the crafts into the worlds of both art and science is *Crochet Coral and Anemone Garden* (**Fig. 14-40**), a project sponsored by the Institute for Figuring in Los Angeles, an organization that explores the aesthetic dimensions of science, mathematics and the arts, according to its website, "from the physics of snowflakes and the hyperbolic geometry of sea slugs, to the mathematics of paper folding and graphical models of the human mind." It was founded in 2003 by sisters Margaret Wertheim, a science writer, and Christine Wertheim, an artist. The two grew up in Queensland, Australia, where the Great Barrier Reef, one of the natural wonders of the world, has undergone severe environmental damage in the last few decades as vast sections of the coral reef have died. In order to draw attention to the devastation, the sisters inaugurated *The Coral Reef Project*, of which *Crochet Coral and Anemone Garden* is a part.

The installation is based on the findings of mathematician Daina Taimina, who in 2001 argued that crocheting offered one of the best ways to model hyperbolic geometry, and that, in turn, coral was a hyperbolic geometric structure in its own right. Thousands of people—by and large women, but a number of men as well—have contributed to the *The Coral Reef Project*, and *Crochet Coral and Anemone Garden* is but one of a number of installations, among them *Toxic Reef*, crocheted from yarn and plastic trash.

As "women's work," crocheting is a traditional craft done at one remove from "high art." That in its structure it symbolizes, even mirrors, what we might call "high mathematics" was particularly attractive to the Wertheims, not because this fact elevated crocheting to the level of "high art," but because it suggested something about the nature of political and economic power in modern society. Can you articulate what commentary on society they may have recognized in the analogy between crocheting and hyperbolic geometry? Normally, crocheting is done for utilitarian purposes—for clothing, for instance—but here it serves a purely aesthetic function. Or does it? What utilitarian purpose does it still serve? What traditional role of the artist do the many people who have worked on *The Coral Reef Project* play?

Fig. 14-40 The Institute for Figuring, and companions, *Crochet Coral and Anemone Garden*, 2005-ongoing. Created and curated by Margaret and Christine Wertheim.
Photo © the IFF.

Thinking Thematically: See Art, Science, and the Environment on myartslab.com

15 | Architecture

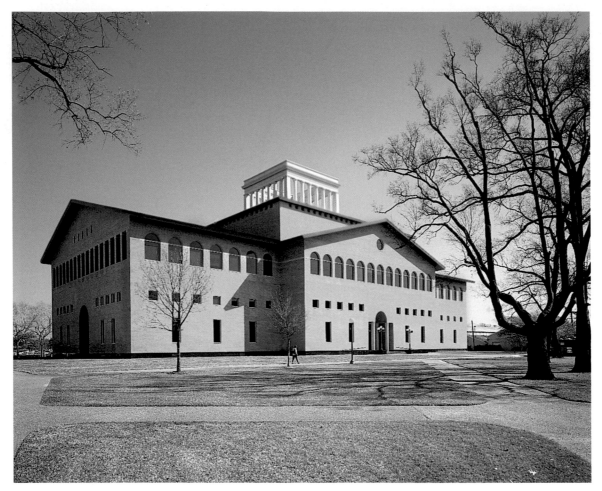

Fig. 15-1 Philip Johnson and John Burgee, College of Architecture, University of Houston, 1983–85.
Photo: Richard Payne, FAIA.

THINKING AHEAD

How do the columns of the three Greek architectural orders differ?

What advantages did the arch afford the ancient Romans?

What architectural innovations led to skyscraper construction?

What are some of the principles of green architecture?

((•─[Listen the chapter audio on myartslab.com

The building that houses the College of Architecture at the University of Houston (**Fig. 15-1**), designed by architects Philip Johnson and John Burgee, is a sort of history of Western architecture from the Greeks to the present. Resting on its top is a model of a Greek temple. The main building below is reminiscent of Italian country villas of the Renaissance. The entire building was inspired by an eighteenth-century plan for a House of Education designed by Claude-Nicolas Ledoux (**Fig. 15-2**) for a proposed utopian community at Chaux, France, that

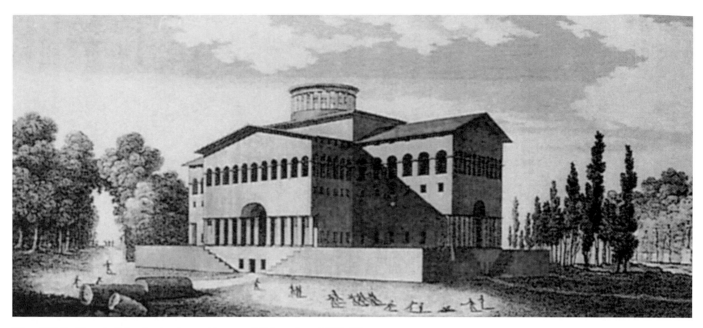

Fig. 15-2 Claude-Nicolas Ledoux, *House of Education*, 1773–79.
Courtesy of The Library of Congress.

never came into being. And the building itself is distinctly postmodern in spirit—it revels in a sense of discontinuity between its parts. One has the feeling that the Greek temple fits on the building's roof about as well as a maraschino cherry would on a scoop of potato salad.

In this chapter, we will consider how our built environment has developed—how we have traveled, in effect, from Greek temples and Anasazi cliff dwellings to skyscrapers and postmodernist designs. We will see that the "look" of our buildings and our communities depends on two different factors and their interrelation—**environment**, or the distinct landscape characteristics of the local site, including its climatic features, and **technology**, the materials and methods available to a given culture. Johnson and Burgee's design for the College of Architecture at the University of Houston takes advantage of many of the technologies developed over the centuries, but at first glance, it seems to ignore the local environment altogether. However, when we consider its interior (**Fig. 15-3**), we can see that the cool atrium space that lies under the colonnade on the roof offers a respite from the hot Texas sun. The site has had a considerable influence on the design. Thus, the key to understanding and appreciating architecture always involves both technology and environment. We will consider environment first.

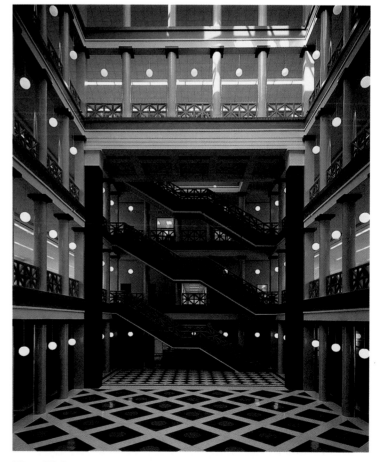

Fig. 15-3 Philip Johnson and John Burgee, College of Architecture, University of Houston, interior, 1983–85.
Photo: Richard Payne, FAIA.

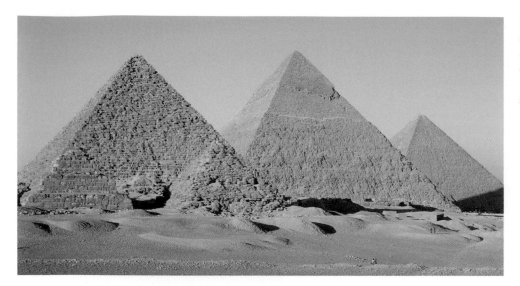

Fig. 15-4 Pyramids of Menkaure (c. 2470 BCE), Khafre (c. 2500 BCE), and Khufu (c. 2530 BCE).
Original height of Pyramid of Khufu 480 ft., length of each side at base 755 ft.

Environment

The built environment reflects the natural world and the conception of the people who inhabit it of their place within the natural scheme of things. A building's form might echo the world around it, or it might contrast with it. It also might respond to the climate of the place. In each case, the choices builders make reveal their attitudes toward the world around them.

The architecture of the vast majority of early civilizations was designed to imitate natural forms. The significance of the pyramids of Egypt (**Fig. 15-4**) is the subject of much debate, but their form may well derive from the image of the god Re, who in ancient Egypt was symbolized by the rays of the sun descending to earth. A text in one pyramid reads: "I have trodden these rays as ramps under my feet." As one approached the mammoth pyramids, covered in limestone to reflect the light of the sun, the eye was carried skyward to Re, the Sun itself, who was, in the desert, the central

fact of life. In contrast, the pyramidlike structures of Mesopotamia, known as *ziggurats* (**Fig. 15-5**), are flatter and wider than their Egyptian counterparts, as if imitating the shape of the foothills that lead up to the mountains. The Sumerians believed that the mountaintops were not only the source of precious water, but also the dwelling place of the gods. The ziggurat was constructed as an artificial mountain in which a god could reside. It was, after all, topped by a sanctuary, and thus might well have symbolized a bridge between heaven and earth. C. Leonard Woolley, the British archeologist who supervised the excavation of Ur and the reconstruction of the first platform and stairway in the 1930s, speculated that the platforms of the temple were originally not paved but, mountain-like, covered with soil and planted with trees, an idea that modern archeologists no longer accept.

The designs of many buildings, in fact, reflect the climatic conditions of environments. When African

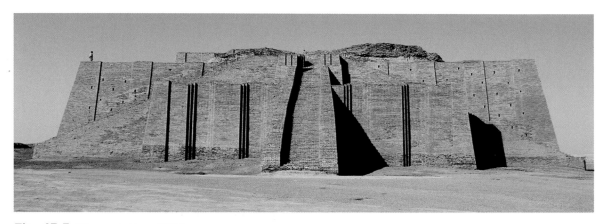

Fig. 15-5 Ziggurat, Ur, c. 2100 BCE.
Fired brick over mud brick core, 210 × 150 ft. at base.
© Michael S. Yamashita/CORBIS.

slaves arrived in the Americas in the eighteenth century, they found themselves living in a climate very much like that they had left in Africa. A late eighteenth-century painting of the Mulberry Plantation in South Carolina (**Fig. 15-6**) depicts slave houses with steeply pitched roofs similar to the thatched-roof houses of the same era found in West Africa. The roof comprises over half the height of the house, allowing warm air to rise in the interior and trap cooler air beneath it—a distinct advantage in the hot and humid climates of both Africa and the Carolinas.

The Anasazi cliff dwelling known as Spruce Tree House (**Fig. 15-7**) at Mesa Verde National Park in southwestern Colorado reflects a similar relation between humans and their environment. The Anasazi lived in these cliffside caves

Fig. 15-6 Thomas Coram, *View of Mulberry House and Street*, c. 1800. Oil on paper. Gibbes Museum of Art, Charleston, SC. Carolina Art Association, 1968.1968.18.01.

for hundreds, perhaps thousands, of years. The cave not only provided security, but also brought the people living there closer to their origin and, therefore, to the source of their strength. For unknown reasons, the Anasazi abandoned their cliff dwellings in about 1300 CE. One possible cause was a severe drought that lasted from 1276 to 1299. It is also possible that disease, a shortened growing season, or war with Apache and Shoshone tribes caused the Anasazi to leave the highland mesas and migrate south into Arizona and New Mexico.

At the heart of the Anasazi culture was the **kiva**, a round, covered hole in the center of the communal plaza in which all ceremonial life took place. The roofs of two underground kivas on the north end of the ruin have been restored. They are constructed of horizontally laid logs built up to form a dome with an access hole (**Fig. 15-8**). The people utilized these roofs as a common area. Down below, in the enclosed kiva floor, was a *sipapu*, a small, round hole symbolic of the Anasazi creation myth, which told of the emergence of the Anasazi's ancestors from the depths of the earth. In the parched Southwestern desert country it is equally true that water, like life itself, also seeps out of small fissures in the earth. Thus, it is as if the entire Anasazi community, and everything necessary to its survival, emerges from mother earth.

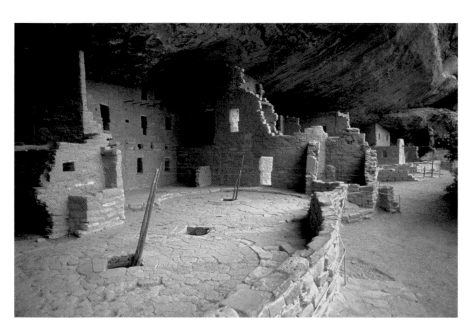

Fig. 15-7 Mesa Verde, Spruce Tree House, c. 1200–1300 CE. Courtyard formed by restoration of the roofs over two underground kivas. John Deeks/Photo Researchers, Inc.

Fig. 15-8 Cribbed roof construction of a kiva. After a National Park Service pamphlet.

Technology

The structure of the kiva's roof represents a technological innovation of the Anasazi culture. Thus, while it responds directly to the environment of the place, it also reflects the technology available to the builder. The basic technological challenge faced by architecture is to construct upright walls and put a roof over the empty space they enclose. Walls may employ one of two basic structural systems: the **shell system**, in which one basic material provides both the structural support and the outside covering of the building, and the **skeleton-and-skin system**, which consists of a basic interior frame, the skeleton, that supports the more fragile outer covering, the skin.

In a building that is several stories tall, the walls or frame of the lower floors must also support the weight of the upper floors. The ability of a given building material to support weight is thus a determining factor in how high the building can be. The walls or frame also support the roof. The span between the elements of the supporting structure—between, for instance, stone walls, columns, or steel beams—is determined by the tensile strength of the roof material. **Tensile strength** is the ability of a building material to span horizontal distances without support and without buckling in the middle. The greater the tensile strength of a material, the wider its potential span. Almost all technological advances in the history of architecture depend on either the invention of new ways to distribute weight or the discovery of new materials with greater tensile strength. We begin our survey with the most basic technology and move forward to the most advanced.

LOAD-BEARING CONSTRUCTION

The simplest method of making a building is to make the walls **load-bearing**—make the walls themselves bear the weight of the roof. One does this by piling and stacking any material—stones, bricks, mud and straw—right up to roof level. Many load-bearing structures, such as the pyramids and the ziggurats we have already seen, are solid almost all the way through, with only small

👁—**Watch** an architectural simulation of post-and-lintel construction on myartslab.com

Fig. 15-9 *The Lion Gate*, Mycenae, Greece, 1250 BCE.

open chambers inside them. Though the Anasazi cliff dwelling contains more livable space than a pyramid or a ziggurat, it too is a load-bearing construction. The kiva is built of adobe bricks—bricks made of dried clay—piled on top of one another, and the roof is built of wood. The complex roof of the kiva spans a greater circumference than would be possible with just wood, and it supports the weight of the community in the plaza above. This is achieved by the downward pressure exerted on the wooden beams by the stones and fill on top of them above the outside wall, which counters the tendency of the roof to buckle.

POST-AND-LINTEL CONSTRUCTION

The walls surrounding the Lion Gate at Mycenae in Greece (**Fig. 15-9**) are load-bearing construction. But the gate itself represents another form of construction: post-and-lintel. **Post-and-lintel construction** consists of a horizontal beam supported at each end by a vertical post or a wall. In essence, the downward force of the horizontal bridge holds the vertical posts in an upright position, and, conversely, the posts support the stone above in a give-and-take of directional force and balance. So large are the stones used to build this gate—both the length of the lintel and the total height of the post-and-lintel structure are roughly 13 feet—that later Greeks believed it could only have been built by the mythological race of one-eyed giants, the Cyclops.

Post-and-lintel construction is fundamental to all Greek architecture. As can be seen in the First Temple of Hera, at Paestum, Italy (**Fig. 15-10**), the columns, or

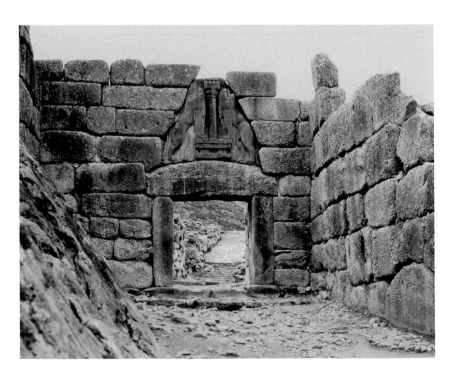

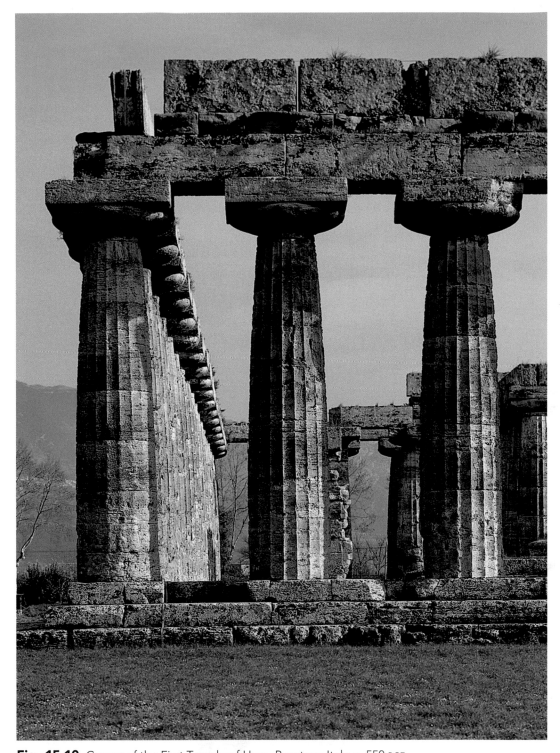

Fig. 15-10 Corner of the First Temple of Hera, Paestum, Italy, c. 550 BCE.
Thinking Thematically: See Art, Politics, and Community on myartslab.com

posts, supporting the structure were placed relatively close together. This was done for a practical reason: If stone lintels, especially of marble, were required to span too great a distance, they were likely to crack and eventually collapse. Each of the columns in the temple is made of several pieces of stone, called **drums**. Grooves carved in the stone, called **fluting**, run the length of the column and unite the individual drums into a single unit. Each column tapers dramatically toward the top and slightly toward the bottom, an architectural feature known as **entasis**. Entasis deceives the eye and makes the column look absolutely vertical. It also gives the column a sense of almost human musculature and strength. The columns suggest the bodies of human beings, holding up the roof like miniature versions of the giant Atlas, who carried the world on his shoulders.

The values of the Greek city-state were embodied in its temples. The temple was usually situated on an elevated site above the city—an **acropolis**, from *akros*, meaning "top," of the *polis*, "city"—and was conceived as the center of civic life. Its **colonnade**, a row of columns set at regular intervals around the building and supporting the base of the roof, was constructed according to the rules of geometry and embodied cultural values of equality and proportion. So consistent were the Greeks in developing a generalized architectural type for their temples that it is possible to speak of them in terms of three distinct architectural types—the Doric, the Ionic, and the Corinthian, the last of which was rarely used by the Greeks themselves but later became the standard order in Roman architecture (**Fig. 15-11**). In ancient times, the heavier Doric order was considered masculine, and the more graceful Ionic order feminine. It is true that the Ionic order is slimmer and much lighter in feeling than the Doric.

The vertical design, or **elevation**, of the Greek temple is composed of three elements—the **platform**, the **column**, and the **entablature**. The relationship among these three units is referred to as its **order**. The Doric, the earliest and plainest of the three, is used in the temple at Paestum. The Ionic is later, more elaborate, and organic, while the Corinthian is more organic and decorative still. The elevation of each order begins with its floor, the **stylobate**, or the top step of the platform on which the building rests. The column in the Doric order consists of two parts, the **shaft** and the **capital**, to which both the Ionic and Corinthian orders add a base. The orders are most quickly distinguished by their capitals. The Doric capital is plain, marked only by a subtle outward curve. The Ionic capital is much more elaborate and is distinguished by its scroll. The Corinthian capital is decorated with stylized acanthus leaves. The entablature consists of three parts: the **architrave**, or weight-bearing and weight-distributing element; the **frieze**, the horizontal band just above the architrave that is generally decorated with relief sculptural elements; and the **cornice**, the horizontal molded projection that crowns or completes the wall.

👁—**Watch** an architectural simulation of the Greek orders on myartslab.com

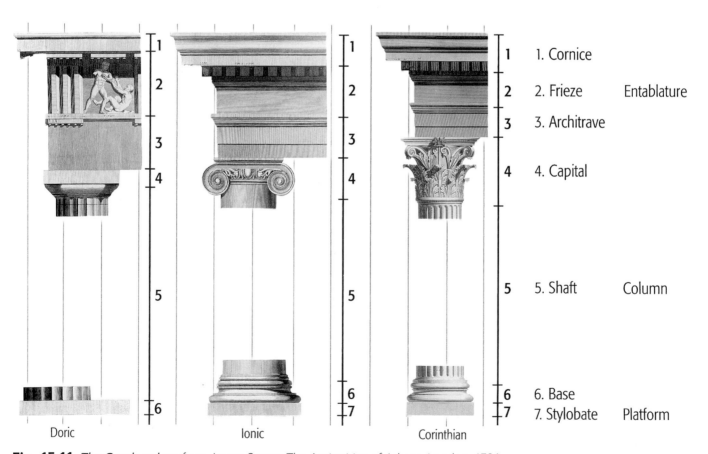

1. Cornice
2. Frieze — Entablature
3. Architrave
4. Capital
5. Shaft — Column
6. Base
7. Stylobate — Platform

Doric Ionic Corinthian

Fig. 15-11 *The Greek orders,* from James Stuart, *The Antiquities of Athens,* London, 1794.
Courtesy of The Library of Congress.

ARCHES, VAULTS, AND DOMES

The geometrical order of the Greek temple suggests a conscious desire to control the natural world. So strong was this impulse that Greek architecture seems defiant in its belief that the intellect is superior to the irrational forces of nature. We can read this same impulse in Roman architecture—the will to dominate the site. Though the Romans made considerable use of colonnades—rows of columns—they also perfected the use of the **round arch** (**Fig. 15-12**), an innovation that revolutionized the built environment. The Romans recognized that the arch would allow them to make structures with a much larger span than was possible with post-and-lintel construction. Made of wedge-shaped stones, called **voussoirs**, each cut to fit into the semicircular form, an arch is not stable until the **keystone**, the stone at the very top, has been put into place. At this point, equal pressure is exerted by each stone on its neighbors, and the scaffolding that is necessary to support the arch while it is under construction can be removed. The arch supports itself, with the weight of the whole transferred downward to the posts. A series of arches could be made to span a wide canyon with relative ease. One of the most successful Roman structures is the Pont du Gard (**Fig. 15-13**), an aqueduct used to

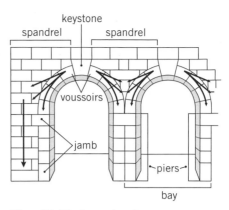

Fig. 15-12 Round arch.

👁 **Watch** an architectural simulation of the round arch on myartslab.com

carry water from the distant hills to the Roman compound in Nîmes, France. Still intact today, it is an engineering feat remarkable not only for its durability, but also, like most examples of Roman architecture, for its incredible size.

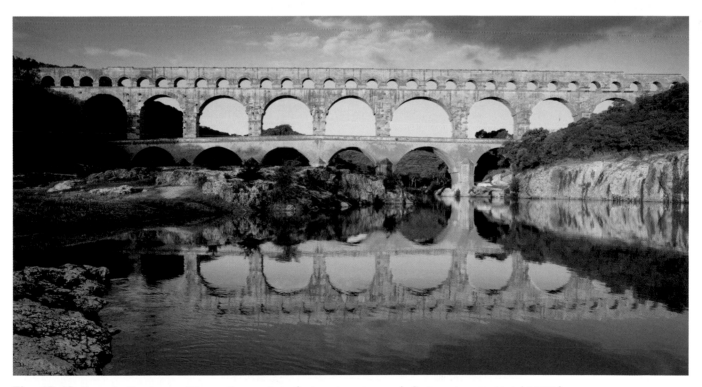

Fig. 15-13 Pont du Gard, near Nîmes, France. Late first century BCE–early first century CE. Height 180 ft.

Thinking Thematically: See Art, Science, and the Environment on myartslab.com

Fig. 15-14 Barrel vault (left) and groin vault (right).

👁 **Watch** an architectural simulation of barrel and groin vaults on myartslab.com

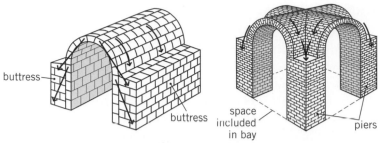

buttress

buttress

space included in bay

piers

With the development of the **barrel vault,** or **tunnel vault** (**Fig. 15-14,** left), which is essentially an extension in depth of the single arch by lining up one arch behind another, the Romans were able to create large, uninterrupted interior spaces. The strength of the vaulting structure of the Roman Colosseum (**Figs. 15-15** and **15-16**) allowed more than 50,000 spectators to be seated in it. The Colosseum is an example of an **amphitheater** (literally meaning a "double theater"), in which two semicircular theaters are brought face to face, a building type invented by the Romans to accommodate large crowds. Built for gladiatorial games and other "sporting" events, including mock naval battles and fights to the death between humans and animals, the Colosseum is constructed both with barrel vaults and with **groin vaults** (**Fig. 15-14,** right), the latter created when two barrel vaults are made to meet at right angles. These vaults were made possible by the Roman invention of concrete. The Romans discovered that if they added volcanic aggregate, such as that found near Naples and Pompeii, to the concrete mixture, it would both set faster and be stronger. The Colosseum is constructed of these concrete blocks, held together by metal clamps and dowels. They were originally covered with stone and elaborate stucco decorations.

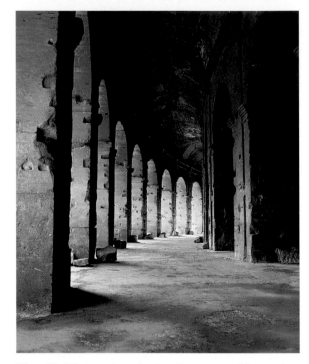

Fig. 15-15 Barrel-vaulted gallery, ground floor of the Colosseum, Rome.
Scala/Art Resource, NY.

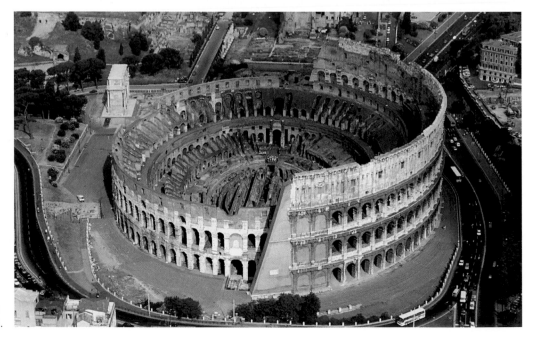

Fig. 15-16 The Colosseum (aerial view), Rome, 72–80 CE.

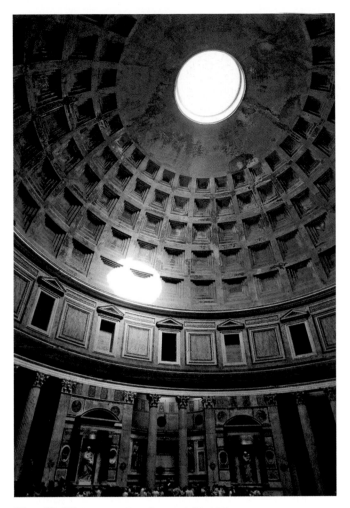

Fig. 15-17 Interior, Pantheon, 117–125 CE.

Thinking Thematically: See Art and the Passage of Time on myartslab.com

The Romans were also the first to perfect the **dome**, which takes the shape of a hemisphere, sometimes defined as a continuous arch rotated 360 degrees on its axis. Conceived as a temple to celebrate all their gods, the Roman Pantheon (**Fig. 15-17**)—from the Greek words *pan* ("every") and *theos* ("god")—consists of a 142-foot-high dome set on a cylindrical wall 140 feet in diameter. Every interior dimension appears equal and proportionate, even as its scale overwhelms the viewer. The dome is concrete, which was poured in sections over a huge mold supported by a complex scaffolding. Over 20 feet thick where it meets the walls—the **springing**, or the point where an arch or dome rises from its support—the dome thins to only 6 feet at the circular opening, 30 feet in diameter, at the dome's top. Through this **oculus** (Latin for "eye"),

the building's only source of illumination, worshippers could make contact with the heavens. As the sun shone through it, casting a round spotlight into the interior, it seemed as if the eye of Jupiter, king of the gods, shone upon the Pantheon walls. Seen from the street (**Fig. 15-18**), where it was originally approached between parallel colonnades that culminated in a podium now lost to the rise of the area's street level, its interior space could only be intuited. Instead, the viewer was confronted by a portico composed of eight mammoth Corinthian columns made of polished granite rising to a pediment some 121 feet wide.

Even though their use of concrete had been forgotten, the architectural inventions of the Romans provided the basis for building construction in the Western world for nearly 2,000 years. The idealism, even mysticism, of the Pantheon's vast interior space, with its evocation of the symbolic presence of Jupiter, found its way into churches as the Christian religion came to dominate the West. Large congregations could gather beneath the high barrel vaults of churches, which were constructed on Roman architectural principles. Vault construction in stone was employed especially in Romanesque architecture—so called because it used so many Roman methods and architectural forms.

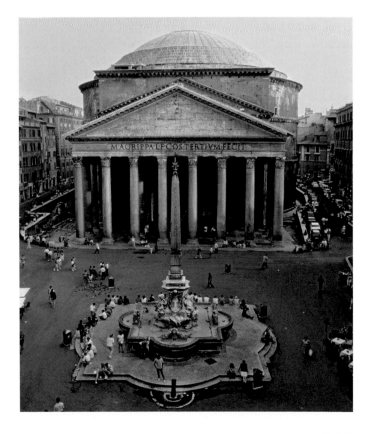

Fig. 15-18 Exterior, Pantheon, 117–125 CE.
Canali Photobank, Milan, Italy.

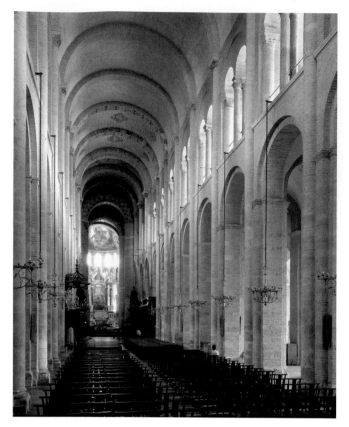

Fig. 15-19 Interior view of nave, St. Sernin, Toulouse, France, c. 1080–1120.
© Bildarchiv Monheim GmbH / Alamy.

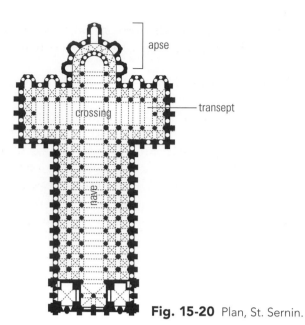

Fig. 15-20 Plan, St. Sernin.

Thinking Thematically: See Art and Spiritual Belief on myartslab.com

The barrel vault at St. Sernin, in Toulouse, France (**Fig. 15-19**), is a magnificent example of Romanesque architecture. The plan of this church is one of great symmetry and geometric simplicity (**Fig. 15-20**). It reflects the Romanesque preference for rational order and logical development. Every measurement is based on the central square at the **crossing**, where the two **transepts**, or side wings, cross the length of the **nave**, the central aisle of the church used by the congregation, and the **apse**, the semicircular projection at the end of the church that is topped by a Roman half-dome. Each square in the aisles, for instance, is one-quarter the size of the crossing square. Each transept extends two full squares from the center. The tower that rises over the crossing, incidentally, was completed in later times and is taller than it was originally intended to be.

The immense interior space of the great Gothic cathedrals, which arose throughout Europe beginning in about 1150 CE, culminates this direction in architecture. A building such as the Pantheon, with a 30-foot hole in its roof, was simply impractical in the severe climates of northern Europe. As if in response to the dark and dreary climate outside, the interior of the Gothic cathedral rises to an incredible height,

lit by stained-glass windows that transform a dull day with a warm and richly radiant light. The enormous interior space of Amiens Cathedral (**Fig. 15-21**), with an interior height of 142 feet and a total interior surface of more than 26,000 square feet, leaves any viewer in awe. At the center of the nave is a complex maze, laid down in 1288, praising the three master masons who built the complex, Robert de Luzarches

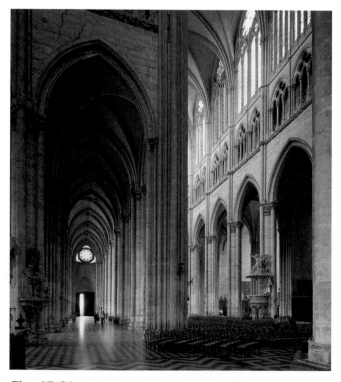

Fig. 15-21 Amiens Cathedral, begun 1220.
© Achim Bednorz, Koln.

and Thomas and Renaud de Cormont, who succeeded in creating the largest Gothic cathedral ever built in Northern Europe.

The great height of the Gothic cathedral's interior space is achieved by means of a system of pointed, rather than round, arches. The height of a rounded arch is determined by its width, but the height of a pointed arch (**Fig. 15-22**) can readily be extended by straightening the curve of the sides upward to a point, the weight descending much more directly down the wall. By using the pointed arch in a scheme of groined vaults, the almost ethereal space of the Gothic cathedral, soaring upward as if toward God, is realized.

All arches tend to spread outward, creating a risk of collapse, and, early on, the Romans learned to support the sides of the arch to counteract this lateral thrust. In the great French cathedrals, the support was provided by building a series of arches on the outside whose thrusts would counteract the outward force of the interior arches. Extending inward from a series of columns or piers, these **flying buttresses** (**Figs. 15-23** and **15-24**), so named because they lend to the massive stone architecture a sense of lightness and flight, are an aesthetic response to a practical problem. Together with the stunning height of the nave allowed by the **pointed arch**, the flying buttresses reveal the desire of the builder to elevate the cathedral above the humdrum of daily life in the medieval world. The cathedral became a symbol not only of the divine, but also of the human ability to exceed, in art and in imagination, our own limitations and circumstances.

✳ Explore an architectural panorama of the Cathedral of Notre-Dame on myartslab.com

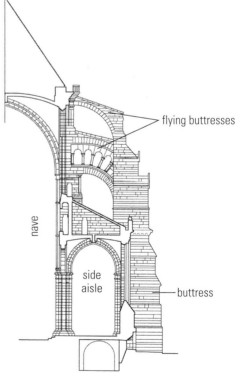

Fig. 15-22 Pointed arch.

flying buttresses

nave

side aisle

buttress

Figs. 15-23 and 15-24 Flying buttresses, Cathedral of Notre-Dame, Paris, 1211–1290, and diagram (after Acland).
© Achim Bednorz, Koln.

Cast-Iron Construction

Until the nineteenth century, the history of architecture was determined by innovations in the ways the same materials—mostly stone—could be employed. In the nineteenth century, iron, a material that had been known for thousands of years, but never employed in architecture, absolutely transformed the built environment. Wrought iron was soft and flexible, and, when heated, it could be easily turned and twisted into a variety of forms. But engineers discovered that, by adding carbon to iron, they could create a much more rigid and strong material—**cast iron**. The French engineer Gustave Eiffel used cast iron in his new lattice-beam construction technique, which produces structures of the maximum rigidity with the minimum weight by exploiting the way in which girders can be used to brace one another in three dimensions.

The most influential result was the Eiffel Tower (**Fig. 15-25**), designed as a monument to industry and the centerpiece of the international Paris Exposition of 1889. Over 1,000 feet high, and at that time by far the tallest structure in the world, the tower posed a particular problem—how to build a structure of such a height, yet one that could resist the wind. Eiffel's solution was simple but brilliant: Construct a skeleton, an open lattice-beam framework that would allow the wind to pass through it. Though it served for many years as a radio tower—on July 1, 1913, the first signal transmitted around the world was broadcast from its top, inaugurating the global electronic network—the tower was essentially useless, nothing more than a monument. Many Parisians hated it at first, feeling that it was a blight on the skyline. Newspapers jokingly held contests to "clothe" it. The French writer Guy de Maupassant often took his lunch at the restaurant in the tower, despite the fact that the food was not

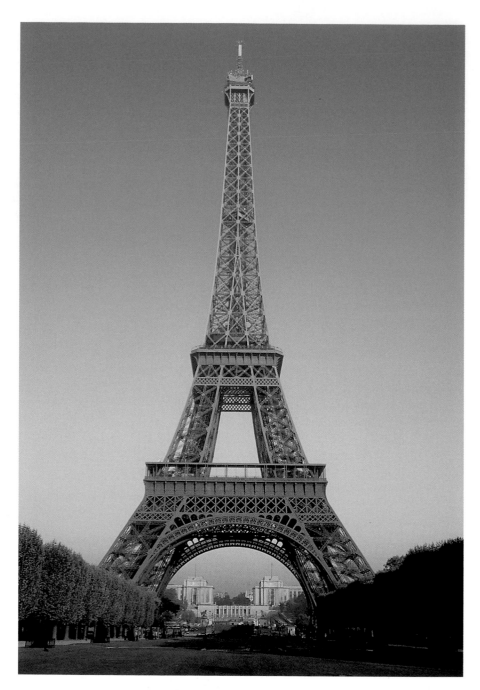

Fig. 15-25 **Gustave Eiffel**, Eiffel Tower, 1887–89. Seen from Champs de Mars. Height of tower 1,051 ft. Alain Evrard / Photo Researchers, Inc.

Explore an architectural panorama of the Eiffel Tower on myartslab.com

particularly appealing: "It's the only place in Paris," he said, "where I don't have to see it." But by the early years of the twentieth century the tower had become the symbol of Paris itself, probably the most famous structure in the world. But most important, it demonstrated the possibility of building to very great height without load-bearing walls. The tower gave birth to the skeleton-and-skin system of building. And the idea of designing "clothes" to cover such a structure soon became a reality.

Frame Construction

The role of iron and steel in changing the course of architecture in the nineteenth century cannot be underestimated—and we will consider steel in even more detail in a moment—but two more humble technological innovations had almost as significant an impact, determining the look of our built environment down to the present day. The mass production of the common nail, together with improved methods and standardization in the process of milling lumber, led to a revolution in home building techniques.

Lumber cannot easily support structures of great height, but it is perfect for domestic architecture. In 1833, in Chicago, the common **wood-frame** construction (**Fig. 15-26**), a true skeleton-and-skin building method, was introduced. Sometimes called **balloon-frame** construction, because early skeptics believed houses built in this manner would explode like balloons, the method is both inexpensive and relatively easy. A framework skeleton of, generally, 2 × 4-inch beams is nailed together. Windows and doors are placed in the wall using basic post-and-lintel design principles, and the whole is sheathed with planks, clapboard, shingles, or any other suitable material. The roof is somewhat more complex, but as early as the construction of Old St. Peter's Basilica in Rome in the fourth century CE (**Fig. 15-27**), the basic principles were in use. The walls of St. Peter's were composed of columns and arches made of stone and brick, but the roof was wood. And notice the angled beams supporting the roof over the aisles. These are elementary forms of the **truss**, prefabricated versions of which most home builders today use for the roofs of their

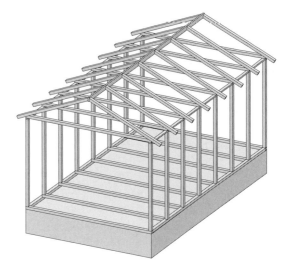

Fig. 15-26 Wood-frame construction

Fig. 15-28 Truss.

houses. One of the most rigid structural forms in architecture, the truss (**Fig. 15-28**) is a triangular framework that, because of its rigidity, can span much wider areas than a single wooden beam.

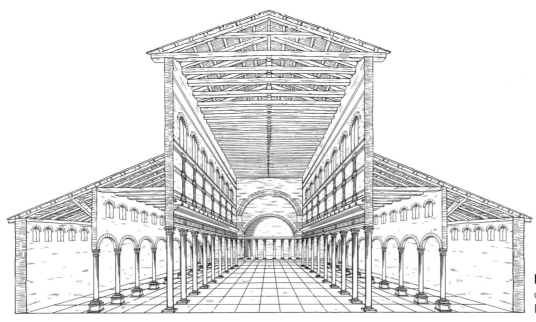

Fig. 15-27 Reconstruction drawing of Old St. Peter's Basilica, Rome, c. 320–27.

Wood-frame construction is, of course, the foundation of American domestic architecture, and it is versatile enough to accommodate a variety of styles. Compare, for instance, two residences built near the end of the eighteenth century, the Harrison Gray Otis House in Boston, Massachusetts (**Fig. 15-29**), and the Parlange Mansion, built on an indigo plantation north of Baton Rouge, Louisiana (**Fig. 15-30**). The Otis House was designed by Charles Bulfinch, America's first native-born professional architect, and its simple, clearly articulated exterior brick-clad facade with its five window bays set a stylistic standard for the city. Brick was chosen to cover the wood-frame construction beneath to provide insulation and protection against New England's severe winter weather. The Parlange mansion likewise uses brick, made in this case by the plantation's slaves. The upper floor rests above a half-buried brick basement with brick pillars supporting the open-air gallery that surrounds the second story. The walls, both inside and out, are plastered with a mixture of mud, sand, Spanish moss and deer hair, and painted white, providing cooling insulation in the hot and humid Louisiana summers. The upper

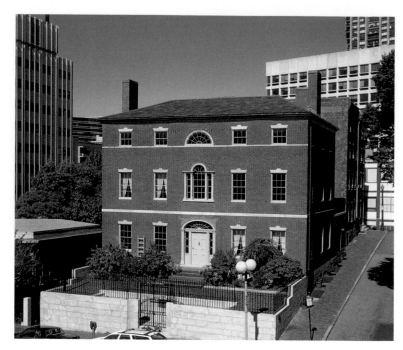

Fig. 15-29 Charles Bulfinch, Harrison Gray Otis House, Boston, Massachusetts, 1795–96.

Courtesy of Historic New England. Photograph by David Carmack.

Fig. 15-30 Architect unknown, Mansion at Parlange Plantation, New Roads, Louisiana. c. 1785–95.

Fig. 15-31 Christian Gladu, *The Birch*, The Bungalow Company, North Town Woods, Bainbridge Island, Washington, 1998. Photo courtesy of The Bungalow Company.

level contains the main living quarters. Each room in the house, on both the upper and lower levels, opens on to the surrounding galleries, which serve as hallways for the house, protecting the inner rooms from direct sunlight.

Early in the twentieth century, wood-frame construction formed the basis of a widespread "bungalow" style of architecture, which has enjoyed a revival in the last decade (**Fig. 15-31**). It became popular when furniture designer Gustav Stickley began publishing bungalow designs in his magazine *The Craftsman*. From the beginning, the bungalow was conceived as a form of domestic architecture available to everyone. Like Stickley's furniture, which he thought of as "made" for bungalows, it was democratic. It embodied, from Stickley's point of view, "that plainness which is beauty." The hand-hewn local materials—stone and shingles—employed in the construction tied the home to its natural environment. And so did its porches, which tied the interior to the world outside, and which, with their sturdy, wide-set pillars, bespoke functional solidity. By the late 1920s, as many as 100,000 stock plans had been sold by both national architectural companies and local lumber and building firms, and, across America, bungalows popped up everywhere. In the popular imagination, the word "bungalow" was synonymous with "quality."

Steel-and-Reinforced-Concrete Construction

It was in Chicago that frame construction began, and it was Chicago that most impressed C. R. Ashbee, a representative of the British National Trust, when he visited America in 1900: "Chicago is the only American city I have seen where something absolutely distinctive in the aesthetic handling of material has been evolved out of the Industrial system." A young architect named Frank Lloyd Wright impressed him most, but it was Wright's mentor, Louis Sullivan, who was perhaps most responsible for the sense of vitality to which Ashbee was responding.

For Sullivan, the foremost problem that the modern architect had to address was how the building might transcend the "sinister" urban conditions out of which, of necessity, it had to rise. The development of steel construction techniques, combined with what Sullivan called "a system of ornament," offered him a way to mitigate the urban malaise. A fireproof steel skeletal frame, suggested by wood-frame construction, freed the wall of load-bearing necessity and opened it both to ornament and to large numbers of exterior windows. The vertical emphasis of the building's exterior lines echoed the upward sweep of the steel skeleton. As a result, the exterior of the tall building no longer seemed massive; rather, it might rise with an almost organic lightness into the skies.

Fig. 15-32 Louis H. Sullivan, Bayard (Condict) Building, New York, 1897–98.
© Angelo Hornak/Corbis.

Fig. 15-33 Louis H. Sullivan, Bayard (Condict) Building, New York, 1897–98.
© Nathan Benn/Corbis.

The building's real identity depended on the ornamentation that could now be freely distributed across its facade. Ornament was, according to Sullivan, "spirit." The inorganic, rigid, and geometric lines of the steel frame would flow, through the ornamental detail that covered it, into "graceful curves," and angularities would "disappear in a mystical blending of surface." Thus, at the top of Sullivan's Bayard Building (**Figs. 15-32** and **15-33**)—a New York, rather than a Chicago, building—the vertical columns that rise between the windows blossom in an explosion of floral decoration.

Such ornamentation might seem to contradict completely the dictum for which Sullivan is most famous—"Form follows function." If the function of the urban building is to provide a well-lighted and ventilated place in which to work, then the steel-frame structure and the abundance of windows on the building's facade make sense. But what about the ornamentation? How does it follow from the structure's function? Isn't it simply an example of purposeless excess?

Down through the twentieth century, Sullivan's original meaning has largely been forgotten. He was not promoting a notion of design akin to the sense of practical utility that can be discovered in, for instance, a Model T Ford. For Sullivan, "The function of all functions is the Infinite Creative Spirit," and this spirit could be revealed in the rhythm of growth and decay that we find in nature. Thus, the elaborate, organic forms that cover his buildings were intended to evoke the Infinite. For Sullivan, the primary function of a building was to elevate the spirit of those who worked in it.

Almost all of Sullivan's ornamental exuberance seems to have disappeared in the architecture of Frank Lloyd Wright, whom many consider the first truly modern architect. But from 1888 to 1893, Wright worked as chief draftsman in Sullivan's Chicago firm, and Sullivan's belief in the unity of design and nature can still be understood as instrumental to Wright's work. In an article written for the *Architectural Record* in 1908, Wright emphasized that "a sense of the organic is indispensable to an architect," and as early as the 1890s, he was routinely "translating" the natural and the organic into what he called "the terms of building stone."

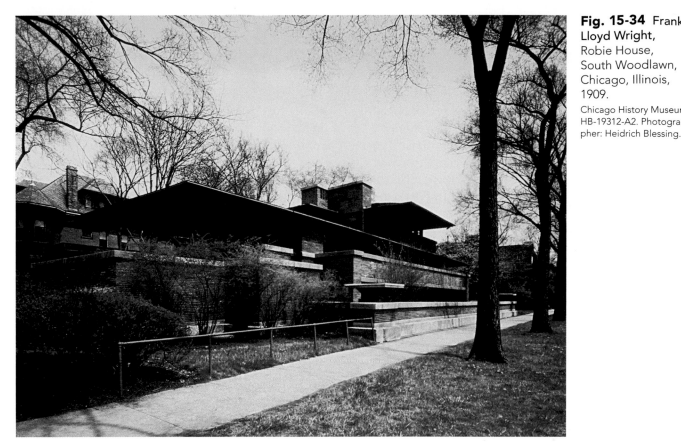

Fig. 15-34 Frank Lloyd Wright, Robie House, South Woodlawn, Chicago, Illinois, 1909. Chicago History Museum. HB-19312-A2. Photographer: Heidrich Blessing.

The ultimate expression of Wright's intentions is the so-called Prairie House, the most notable example of which is the Robie House in Chicago, designed in 1906 and built in 1909 (**Figs. 15-34** and **15-35**). Although the house is contemporary in feeling—with its wide overhanging roof extending out into space, its fluid, open interiors, and its rigidly geometric lines—it was, from Wright's point of view, purely "organic" in conception.

Wright spoke of the Prairie House as "of" the land, not "on" it, and the horizontal sweep of the roof and the open interior space reflect the flat expanses of the Midwestern prairie landscape. Alternatively, in a different environment, a house might reflect the cliffs of a Pennsylvania ravine (see *The Creative Process*, on pp. 374–375). The **cantilever**, a horizontal form supported on one end and jutting out into space on the other, was made possible by newly invented steel-and-reinforced-concrete construction techniques. Under a cantilevered roof, one could be simultaneously outside and protected. The roof thus ties together the interior space of the house and the natural world outside. Furthermore, the house itself was built of materials—brick, stone, and wood, especially oak—native to its surroundings.

The architectural innovations of Wright's teacher, Louis Sullivan, led directly to the skyscraper.

It is the sheer strength of steel that makes the modern skyscraper a reality. Structures with stone walls require thicker walls on the ground floor as they rise higher. A 16-story building, for instance, would require ground-floor walls approximately 6 feet thick. But the steel cage, connected by floors made of **reinforced concrete**—concrete in which steel

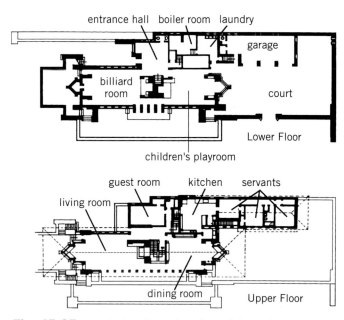

Fig. 15-35 Frank Lloyd Wright, Plan of the Robie House, South Woodlawn, Chicago, Illinois, 1909.

THE CREATIVE PROCESS

Kaufmann Fallingwater (**Fig. 15-36**), Frank Lloyd Wright's name for the house he designed for Edgar and Lillian Kaufmann in 1935, is arguably the most famous modern house in the world. Edgar Kaufmann was owner of Kaufmann's Store in Pittsburgh, the largest ready-made men's clothing store in the country, and his son had begun to study with Wright in 1934. In November of that year, Wright first visited the site. There are no known design drawings until the following September. Writing a few years before about his own design process, Wright stated that the architect should "conceive the building in the imagination, not on paper but in the mind, thoroughly—before touching paper. Let it live there—gradually taking more definite form before committing it to the draughting board. When the thing lives for you, start to plan it with tools. Not before. . . . It is best to cultivate the imagination to construct and complete the building before working on it with T-square and triangle."

The first drawings were done in two hours when Kaufmann made a surprise call to Wright and told him he was in the neighborhood and would like to see something. Using a different colored pencil for each of the house's three floors on the site plan, Wright completed not only a floor plan, but a north-south cross-section and a view of the exterior from across the stream (**Fig. 15-37**). The drawings were remarkably close to the final house.

Wright thought of the house as entirely consistent with his earlier Prairie Houses. It was, like them, wedded to its site, only the site was markedly different. The reinforced concrete cantilevers mirrored the natural cliffs of the hillside down and over which the stream, Bear Run, cascades. By the end of 1935, Wright had opened a quarry on the site to extract local stone for the house's construction.

Meanwhile, the radical style of the house had made Kaufmann nervous. He hired engineers to

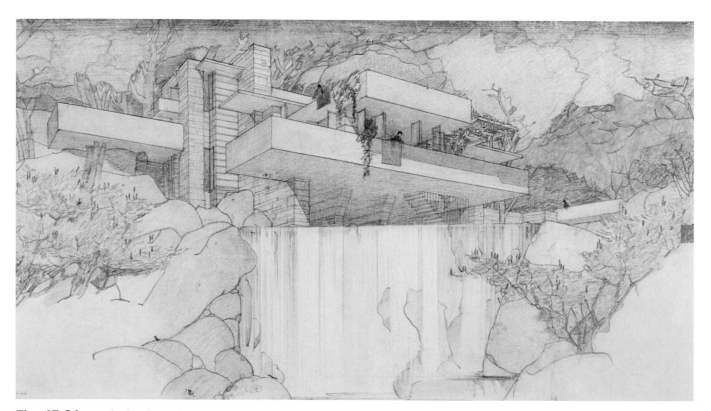

Fig. 15-36 Frank Lloyd Wright (1867–1959), *Kaufmann Fallingwater*, Kaufmann House, Bear Run, Pennsylvania, 1936. Presentation Drawing. Color pencil on tracing paper. 15³/₈ × 27¹/₄ in. The Frank Lloyd Wright Foundation, Scottsdale, Arizona, U.S.A.

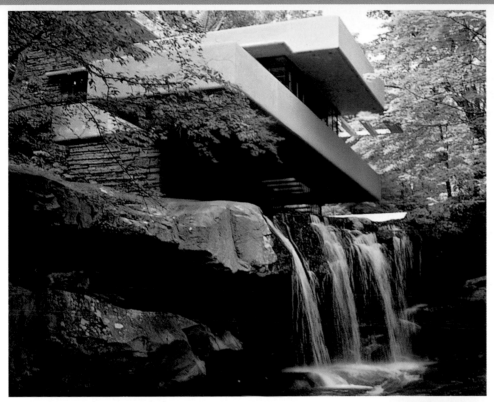

✳ Explore architectural panoramas of *Fallingwater* on myartslab.com

Fig. 15-37 Frank Lloyd Wright, *Fallingwater*, Kaufmann House, Bear Run, Pennsylvania, 1936.
Art Resource, NY.

review Wright's plan, and they were doubtful that reinforced concrete could sustain the 18-foot cantilevers that Wright proposed. When Kaufmann sent the engineers' reports to Wright, Wright told him to return the plans to him "since he did not deserve the house." Kaufmann apologized for his lack of faith, and work on the house proceeded.

Still, the contractor and engineer didn't trust Wright's plans for reinforcing the concrete for the cantilevers, and before the first slab was poured, they put in nearly twice as much steel as Wright had called for. As a result, the main cantilever droops to this day. Wright was incensed that no one trusted his calculations. After the first slab was set, but still heavily braced with wooden framing (**Fig. 15-38**), Wright walked under the house and kicked a number of the wooden braces out.

The house, finally, is in complete harmony with its site. "I came to see a building," Wright wrote in 1936, as the house was nearing completion, "primarily . . . as a broad shelter in the open, related to vista; vista without and vista within. You may see in these various feelings, all taking the same direction, that I was born an American, child of the ground and of space."

Fig. 15-38 Frank Lloyd Wright, *Fallingwater scaffolding*, from the Fallingwater Collection at the Avery Architectural and Fine Arts Library, Columbia University, New York.

© The Frank Lloyd Wright Fdn, AZ / Art Resource, NY. © 2012 The Frank Lloyd Wright Foundation, Scottsdale, AZ/Artists Rights Society (ARS). NY.

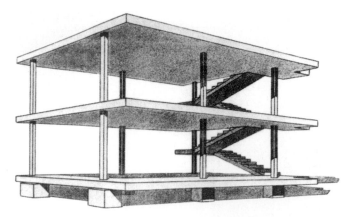

Fig. 15-39 Le Corbusier, Perspective drawing for Domino Housing Project, 1914. French Embassy.

reinforcement bars, or **rebars**, are placed to both strengthen it and make it less brittle—overcomes this necessity. The simplicity of the resulting structure can be seen clearly in French architect Le Corbusier's 1914 drawing for the Domino Housing Project (**Fig. 15-39**). The design is almost infinitely expandable, both sideways and upward. Any combination of windows and walls can be hung on the frame. Internal divisions can be freely designed in an endless variety of ways, or, indeed, the space can be left entirely open. Even the stairwell can be moved to any location within the structural frame.

In 1932, Alfred H. Barr, Jr., a young curator at the Museum of Modern Art in New York City, who would later become one of the most influential historians of modern art, identified Le Corbusier as one of the founders of a new "International Style." In an exhibition on "Modern Architecture," Barr wrote:

Slender steel posts and beams, and concrete reinforced by steel have made possible structures of skeletonlike strength and lightness. The modern architect working in the new style conceives of his building . . . as a skeleton enclosed by a thin light shell. He thinks in terms of volume—of space enclosed by planes and surfaces—as opposed to mass and solidity. This principle of volume leads him to make his walls seem thin flat surfaces by eliminating moldings and by making his windows and doors flush with the surface.

Taking advantage of the strength of concrete-and-steel construction, Le Corbusier lifted his houses on stilts (**Fig. 15-40**), thus creating, out of the heaviest of materials, a sense of lightness, even flight. The entire structure is composed of primary forms (that is, rectangles, circles, and so on). Writing in his first book, *Towards a New Architecture*, translated into English in 1925, Le Corbusier put it this way: "Primary forms are beautiful forms because they can be clearly appreciated." "A house," he said, "is a machine for living in!"—functional and precise, with no redundant parts.

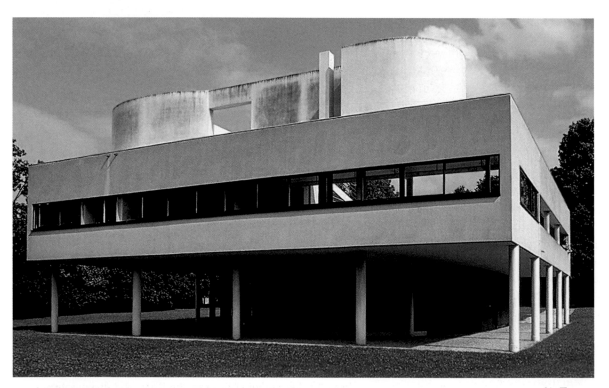

Fig. 15-40 Le Corbusier and Pierre Jeanneret, Villa Savoye, Poissy-sur-Seine, France, 1928–30.
Anthony Scibilia/Art Resource, N.Y. © 2012 Artists Rights Society (ARS), New York/ADAGP, Paris/FLC.

❋ **Explore** architectural panoramas of the Villa Savoye on myartslab.com

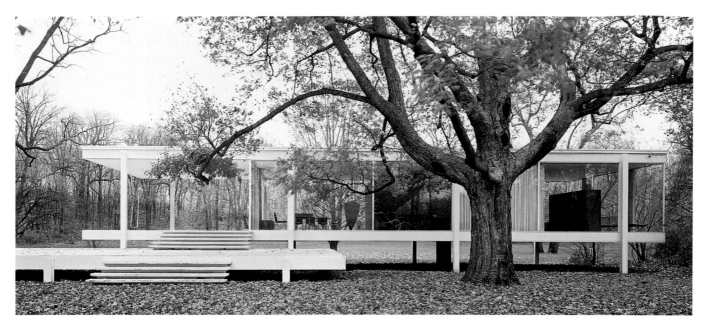

Fig. 15-41 Ludwig Miës van der Rohe, Farnsworth House, Fox River, Plano, Illinois, 1950.
Hedrich Blessing.

For Barr, Ludwig Miës van der Rohe was the other great innovator of the International Style. His Farnsworth House (**Fig. 15-41**), which was built in 1950, opens itself to its surroundings. An homage to Le Corbusier's Villa Savoye, the house is virtually transparent—both opening itself out into the environment and inviting it in.

But the culmination of Le Corbusier's steel-and-reinforced-concrete Domino plan is the so-called International Style skyscraper, the most notable of which is the Seagram Building in New York City (**Fig. 15-42**), a collaboration between Miës van der Rohe and Philip Johnson. Johnson is the architect whose design for the College of Architecture at the University of Houston opened this chapter and who, in 1932, had written the foreword to Barr's "Modern Architecture" catalogue. The **International Style** is marked by its austere geometric simplicity, and the design solution presented by the Seagram Building is extremely elegant. The exposed structural I-beams (that is, steel beams that seen in cross-section look like the capital letter "I") are finished in bronze to match the amber-tinted glass sheath. At the base, these exterior beams drop, unsheathed, to the courtyard, creating an open-air steel colonnade around a recessed glass lobby. New York law requires that buildings must conform to a "setback" restriction: Buildings that at ground level occupy an entire site must stagger-step inward as they rise in order to avoid "walling-in" the city's inhabitants. But the Seagram Building occupies less than one-half its site, and as a result, it is free to rise vertically out of the plaza at its base. At night, the lighted windows activate the building's

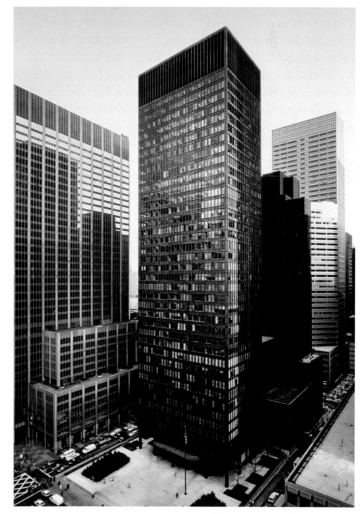

Fig. 15-42 Ludwig Miës van der Rohe and Philip Johnson, Seagram Building, New York City, 1958.
© Andrew Gam.

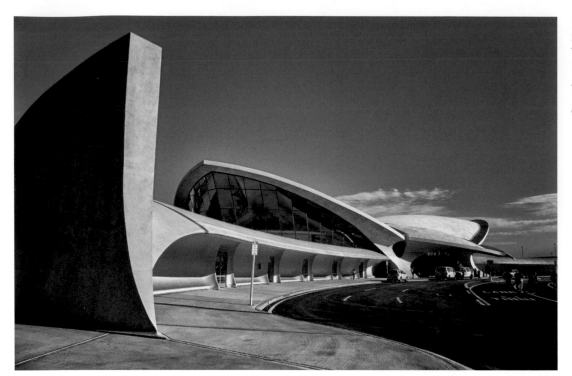

Fig. 15-43 Eero Saarinen, TWA Terminal, John F. Kennedy International Airport, New York, 1962.
© Karen Johnson.

exterior, and by day, the surface of the opaque glass reflects the changing world around the building.

Rejecting the International Style's emphasis on primary geometric forms, the architecture of Eero Saarinen demonstrates how steel and reinforced concrete construction can be utilized in other ways. One of his most successful buildings is the TWA Terminal at Kennedy International Airport in New York (**Figs. 15-43** and **15-44**), designed in 1956 and completed after Saarinen's death in 1961. It is defined by a contrast between the openness provided by the broad expanses of window and the sculptural mass of the reinforced concrete walls and roof. What results is a constant play of light and shadow throughout the space. The exterior—two huge concrete wings that appear to hover above the runways—is a symbolic rendering of flight.

Increasingly, contemporary architecture has largely become a question of creating distinctive buildings that stand out in the vast sameness of the "world metropolis," the vast interconnected fabric of places where people "do business," and among which they travel, the hubs (all served by airports) of today's mobile society. It is also a question of creating buildings of distinction—contemporary architecture is highly competitive. Most major commissions are awarded through competitions, and most cities compete for the best, most distinctive architects.

The Asian city is particularly intriguing to postmodern architects because, much more than the American city, where, by and large, people don't live where they work, Asian cities possess a mix of

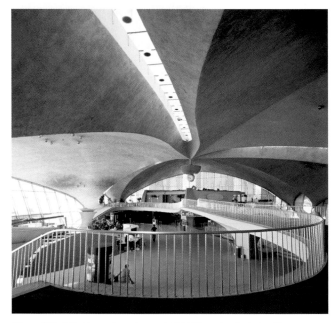

Fig. 15-44 Eero Saarinen, TWA Terminal, John F. Kennedy International Airport, New York, 1962.
© Angelo Hornak/Corbis.

functions and scales, tall buildings that rise in the midst of jumbled smaller structures that seem to change rapidly almost from one day to the next. One of the most intriguing new projects in Asia is the work of the Rotterdam-based Office for Metropolitan Architecture (OMA), headed by Rem Koolhaas. Since 1995, Koolhaas has been a professor at Harvard University, where he is leading a series of research projects for Harvard's "Project on the City," a student-based research group

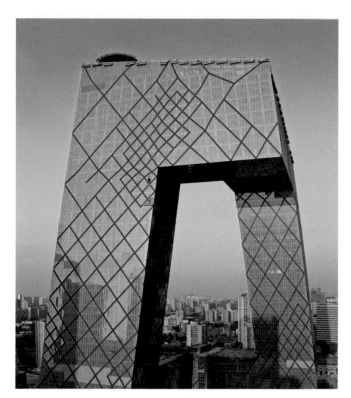

Fig. 15-45 Rem Koolhaas and Ole Scheeren, OMA, New Headquarters, Central Chinese Television CCTV, Beijing, China, 2008.
© Keren Su / CORBIS.

whose recent projects include a study of five cities in the Pearl River Delta of China, and "Shopping," an analysis of the role of retail consumption in the contemporary city. His OMA firm's most recent work includes the new Museum of Modern Art in New York, the new Seattle Public Library, and Central China Television's headquarters (**Fig. 15-45**), completed for the Beijing Olympics in 2008. The CCTV tower is 750 feet high, an icon for the Olympics themselves. But, perhaps in keeping with the international spirit of the Games, it possesses many identities. As Koolhaas explained to an interviewer in 2008, just as the tower was coming to completion: "It looks different from every angle, no matter where you stand. Foreground and background are constantly shifting. We didn't create a single identity, but 400 identities. That was what we wanted: To create ambiguity and complexity, so as to escape the constraints of the explicit."

Probably no two countries in the world, however, have defined themselves more as centers of international architectural experimentation than Spain and the United Arab Emirates. Drawing on the talents of architects from around the world—to say nothing of the possibilities for design offered these architects by computer technologies—Spain has capitalized on the momentum generated by the 1992 Olympics in

Barcelona, which required a massive building effort, and the excitement generated by Frank Gehry's computer-designed Guggenheim Museum in Bilbao (see *The Creative Process*, p. 380), completed in 1997. Jean Nouvel's Torre Agbar (**Fig. 15-46**), completed in 2005 in Barcelona, is just one example of the innovative architecture that is erupting across the country. Thirty-one stories high, the bullet-shaped building is the centerpiece of a new commercial district planned by the city. The reinforced-concrete structure, crowned by a glass-and-steel dome, has a multicolored facade of aluminum panels, behind glass louvers, in 25 different colors. There are 4,400 windows and 56,619 transparent and translucent glass plates. The louvers are tilted at different angles calculated to deflect the direct sunlight. At night, 4,500 yellow, blue, pink, and red lights, placed over the facade, illuminate the entire tower.

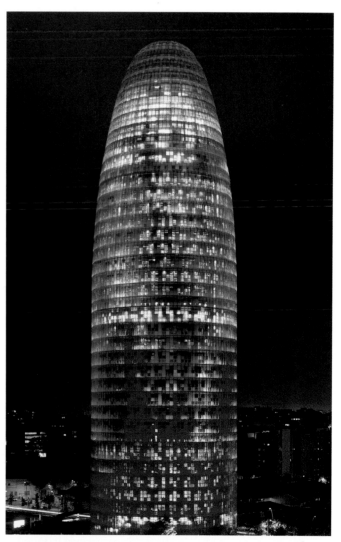

Fig. 15-46 Jean Nouvel/Ateliers, Jean Nouvel with b720 Arquitectos, Torre Agbar, Barcelona, 2005.
Lighting design by Yann Kersalé.
Photo © Roland Halbe.

THE CREATIVE PROCESS

Frank Gehry's *Guggenheim Museum Bilbao*

"I start drawing sometimes," architect Frank Gehry has said, "not knowing exactly where I am going. I use familiar strokes that evolve into the building. Sometimes it seems directionless, not going anywhere for sure. It's like feeling your way along in the dark, anticipating that something will come out usually. I become voyeur of my own thoughts as they develop, and wander about them. Sometimes I say 'boy, here it is, here it is, it's coming. ' I understand it. I get all excited."

Gehry's early drawings of the north, riverfront facade for the Guggenheim Museum in Bilbao, Spain (**Fig. 15-47**), executed only three months after he had won the competition to design the building in 1991, reveal his process of searching for the form his buildings eventually take. These semiautomatic "doodles" are explorations that are surprisingly close to Gehry's finished building (**Fig. 15-48**). They capture the fluidity of its lines, the flowing movement of the building along the riverfront space.

Gehry moves quickly from such sketches to actual scale models. The models, for Gehry, are like sculpture: "You forget about it as architecture, because you're focused on this sculpting process." The models, finally, are transformed into actual buildings by means of Catia, a computer program originally developed for the French aerospace industry (**Fig. 15-49**). This program demonstrated to builders and contractors—and the client—that Gehry's plan was not only buildable, but affordably so.

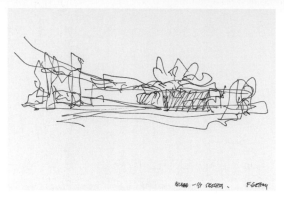

Fig. 15-47 Frank Gehry, *Guggenheim Museum Bilbao, north elevations,* October 1991.
Sketch by Frank Gehry, 1991.
Sketch by Frank Gehry, 1991. © Frank O. Gehry & Associates.

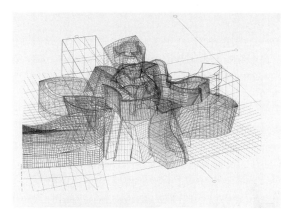

Fig. 15-49 Frank Gehry, *Guggenheim Museum Bilbao.*
© Gehry Partners, LLP.

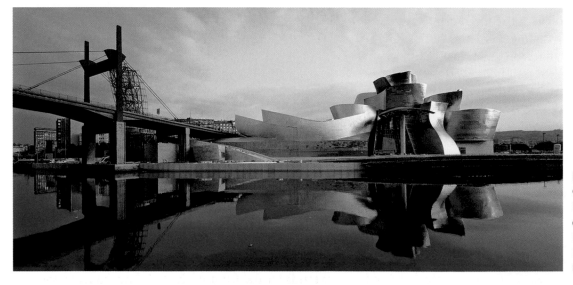

Fig. 15-48 Frank Gehry, *Guggenheim Museum Bilbao,* 1997.
© The Solomon R. Guggenheim Foundation, New York.
Photo: David Heald.

Dubai, in the United Arab Emirates, is the most rapidly growing city in the world, so much so that in 2008 Rem Koolhaas was commissioned by a Dubai-based developer to propose a 1.5-billion-square-foot Waterfront City that would approximate the density of Manhattan on an artificial island surrounded by water from the Persian Gulf channeled into canals dug out of the desert. Koolhaas has conceived of the island as a perfect square, with the tallest towers concentrated along its southern edge to shield the interior blocks from the hot desert sun.

Koolhaas's extravagant project is in keeping with the architectural ambitions of Dubai itself. As of 2008, the city boasted 390 completed high-rise buildings, 313 more under construction, and yet another 445 approved for construction. The tallest of these—indeed the tallest free-standing structure in the world at 2,684 feet (more than twice as high as the Empire State Building)—is the Burj Khalifa (**Fig. 15-50**). Burj is Arabic for "tower," and this tower is the centerpiece of yet another real-estate development that will include 30,000 homes, 9 hotels, over 7 acres of parkland, at least 19 residential towers, the Dubai Mall, and a 30-acre man-made lake. Designed by Adrian Smith of the New York architecture firm Skidmore, Owings & Merrill, the structure opened in January 2010.

But perhaps the gem of Dubai is the Burj Al-Arab (**Fig. 15-51**), a luxury hotel perched on its own island like some enormous wind-filled sail in the blue waters of the Persian Gulf. Designed by British architect Tom Wills-Wright, the hotel rises over the Gulf some 1,053 feet. Its main lobby rises over 500 feet, high enough to accommodate the Statue of Liberty. Essentially a glass tower, its windows are covered by a double-knit Teflon fabric that reflects over 70 percent of the light and heat from the outside. A round cantilevered helipad,

Fig. 15-51 Tom Wills-Wright, Burj Al-Arab, Dubai, United Arab Emirates, 1999.
© Skyscan/CORBIS.

which also serves as the world's highest tennis court, extends off the front of the building from the twenty-eighth floor.

"Green" Architecture

Aside from the fact that they take steps to allay, in some measure, the heat of the desert, and thus cut down on energy consumption, the high-rises of Dubai are not just monumental, but monumentally at odds with the environment. It is not just that they embody a drive toward a density of population that their desert environs do not seem capable of sustaining, but, situated as they are in the oil-rich Arab world, they could be said to symbolize the unbridled consumption of fossil fuels that has contributed, in no small part, to global warming. In response to the direction in architecture that buildings such as the Dubai towers represent, a different practice, more environmentally friendly and sustainable, has developed—so-called **green architecture**.

One of the masterpieces of green architecture is Renzo Piano's Jean-Marie Tjibaou Cultural Center in New Caledonia (see Fig. 1-12). As Piano's design suggests, green architecture is characterized by a number of different principles, but usually only some of these principles are realized in a given project:

1) *Smaller buildings.* This represents an attitude that is the very opposite of the Dubai model, and it is no accident that residential architecture, such as the 2,800-square-foot Brunsell Residence designed by Obie Bowman at Sea Ranch, California (**Fig. 15-52**), has led the way in the development of sustainable, green architecture.

2) *Integration and compatibility with the natural environment.* Although only portions of Bowman's structure are 4 feet underground, he has created a rooftop meadow of the same grass species as the surrounding headlands, thus creating the feeling that the structure is almost entirely buried in the earth. As Bowman explains: "The places we make emphasize their connectedness to the character and quality of the setting and are designed as part of the landscape rather than as isolated objects placed down upon it."

3) *Energy efficiency and solar orientation.* The rooftop meadow on the Sea Ranch house helps to stabilize interior temperatures. In addition, solar collectors capture the sunlight to heat the residence's water, and it is sited specifically to protect the house from the prevailing winds. A south-facing solarium provides winter warmth.

4) *Use of recycled, reusable, and sustainable materials.* Brockholes Visitor Center, near Preston, Lancashire, in the United Kingdom, designed by architect Adam Kahn (**Fig. 15-53**), is clad in oak shake tiles formed out of tree stumps, which would otherwise be burned as waste. Insulation in the walls of the building consists of recycled newspapers. Set in the middle of a low-lying wildlife refuge, the building floats (thereby dispensing, with the need for concrete foundations). Beds of reeds have been planted around the steep-pitched roofs so that, in time, the roofs will appear to emerge from them.

Fig. 15-52 Obie Bowman, Brunsell Residence, Sea Ranch, California, 1987.
Courtesy Obie G. Bowman, Architect & Christian Heath, Associate.

Fig. 15-53 Adam Kahn, The Brockholes Visitor Center at the Lancashire Wildlife Trust reserve in Preston, Lancashire, United Kingdom, 2011.
© Ashley Cooper/Corbis.

These principles are, of course, harder to implement in densely populated urban environments. But when the city of Fukuoka, Japan, realized that the only space available for a much-needed government office building was a large two-block park that also happened to be the last remaining green space in the city center, Argentine-American architect Emilio Ambasz presented a plan that successfully maintained, and even improved upon, the green space (**Fig. 15-54**). A heavily planted and pedestrian-friendly stepped terrace descends down the entire park side of the building. Reflecting pools on each level are connected by upwardly spraying jets of water to create a ladder-like climbing waterfall, which also serves to mask the noise of the city streets beyond. Under the building's 14 terraces lie more than one million square feet of space, including a 2,000-seat theater, all cooled by the gardens on the outside. The building is not entirely green—it is constructed of steel-framed reinforced concrete—and its interior spaces are defined by an unremarkable and bland white that might be found in any modern high-rise office building. Still, the building suggests many new possibilities for reconceptualizing the urban environment in more environmentally friendly terms.

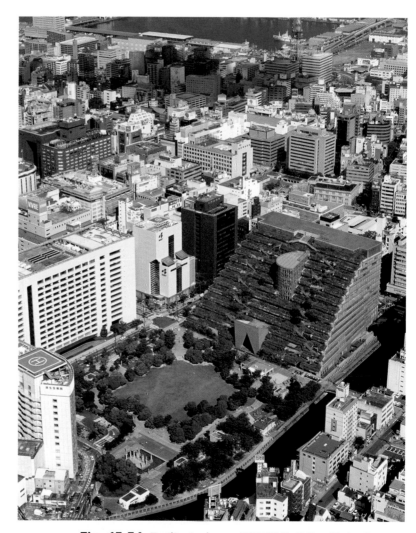

Fig. 15-54 Emilio Ambasz, ACROS Building (Fukuoka Prefecturial International Hall), Fukuoka, Japan, 1989–95.
Emilio Ambasz & Associates, Inc./Photographer Hiromi Watanabe.

Community Life

However lovely we find the Seagram Building, the uniformity of its grid-like facade, in the hands of less-skillful architects, came to represent, for many, the impersonality and anonymity of urban life. The skyscraper became, by the 1960s, the embodiment of conformity and mediocrity in the modern world. Rather than a symbol of community, it became a symbol of human anonymity and loneliness.

Nevertheless, the idea of community remains a driving impulse in American architecture and design. Richard Meier's Atheneum (**Fig. 15-55**), in New Harmony, Indiana, is a tribute to this spirit. New Harmony is the site of two of America's great utopian communities. The first, Harmonie on the Wabash (1814–24), was founded by the Harmony Society, a group of separatists from the German Lutheran Church. In 1825, Robert Owen, Welsh-born industrialist and social philosopher, bought their Indiana town and the surrounding lands for his own utopian experiment. Owen's ambition was to create a more perfect society through free education and the abolition of social classes and personal wealth. World-renowned scientists and educators settled in New Harmony. With the help of William Maclure, the Scottish geologist and businessman, they introduced vocational education, kindergarten, and other educational reforms.

Meier's Atheneum serves as the visitors' center and introduction to historic New Harmony. It is a building oriented, on the one hand, to the orderly grid of New Harmony itself, and, on the other, to the Wabash River, which swings at an angle to the city. Thus, the angular wall that the visitor sees on first approaching the building points to the river, and the uncontrollable forces of nature. The glass walls and the vistas they provide serve to connect the visitor to the surrounding landscape. But overall, the building's formal structure recalls Le Corbusier's Villa Savoye (see Fig. 15-40) and the International Style as a whole. It is this tension between man and nature upon which all "harmony" depends.

Since the middle of the nineteenth century, there have been numerous attempts to incorporate the natural world into the urban context. New York's Central Park (**Fig. 15-56**), designed by Frederick Law Olmsted and Calvert Vaux after the city of New York acquired the 840-acre tract of land in 1856, is an attempt to put city-dwelling humans back in touch with their roots in nature. Olmsted developed a system of paths, fields,

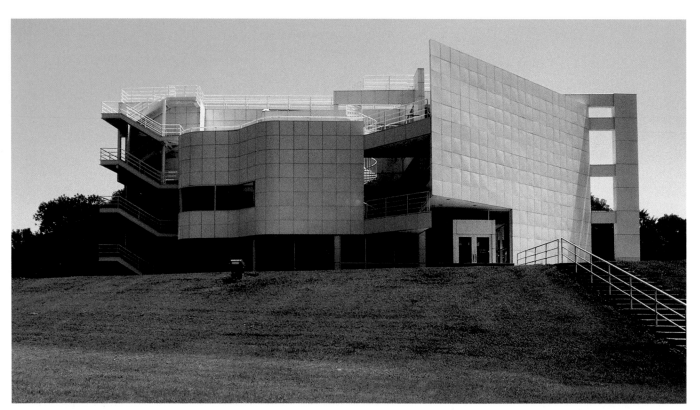

Fig. 15-55 Richard Meier, Atheneum, New Harmony, Indiana, 1979.
Digital imaging project.
Photo © Mary Ann Sullivan, sullivanm@bluffton.edu.

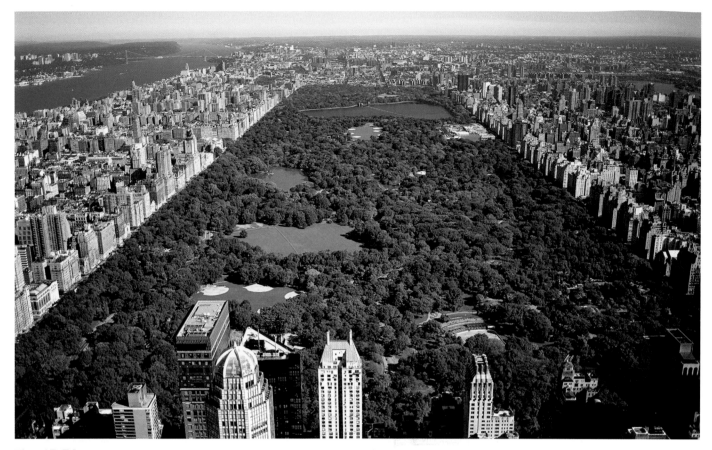

Fig. 15-56 Frederick Law Olmsted and Calvert Vaux, Central Park, New York City, 1857–87. Aerial view as it appears today.
© Ball Miwako/Alamy.

Thinking Thematically: See Art, Politics, and Community on myartslab.com

👁—**Watch** an architectural simulation of Central Park on myartslab.com

and wooded areas modeled after the eighteenth-century gardens of English country estates. These estate gardens appeared wholly natural, but they were in actuality extremely artificial, with man-made lakes, carefully planted forests, landscaped meadows, meandering paths, and fake Greek ruins.

Olmsted favored a park similarly conceived, with, in his words, "gracefully curved lines, generous spaces, and the absence of sharp corners, the idea being to suggest and imply leisure, contemplativeness and happy tranquility." In such places, the rational eighteenth-century mind had sought refuge from the trials of daily life. Likewise, in Central Park, Olmsted imagined the city dweller escaping the rush of urban life. "At every center of commerce," he wrote, "more and more business tends to come under each roof, and, in the progress of building, walls are carried higher and higher, and deeper and deeper, so that now 'vertical railways' [elevators] are coming in vogue." For Olmsted, both the city itself and neoclassical Greek and Roman architectural features in the English garden offer geometries—emblems of reason and practicality—to

which the "gracefully curved" lines of the park and garden stand in counterpoint.

So successful was Olmsted's plan for Central Park that he was subsequently commissioned to design many other parks, including South Park in Chicago and the parkway system of the City of Boston, Mont Royal in Montreal, and the grounds at Stanford University and the University of California at Berkeley. But he perhaps showed the most foresight in his belief that the growing density of the city demanded the growth of what would later become known as the suburb, a residential community lying outside but within commuting distance of the city. "When not engaged in business," Olmsted wrote, the worker

has no occasion to be near his working place, but demands arrangements of a wholly different character. Families require to settle in certain localities which minister to their social and other wants, and yet are not willing to accept the conditions of town-life . . . but demand as much of the luxuries of free air, space, and abundant vegetation as, without loss of town-privileges, they can be enabled to secure.

As early as 1869, Olmsted laid out a general plan for the city of Riverside, Illinois, one of the first suburbs of Chicago (**Fig. 15-57**), which was situated along the Des Plaines River. The plan incorporated the railroad as the principal form of transportation into the city. Olmsted strived to create a communal spirit by subdividing the site into small "village" areas linked by drives and walks, all situated near common areas that were intended to have "the character of informal village greens, commons, and playgrounds."

Together with Forest Hills in New York, Llewellyn Park in New Jersey, and Lake Forest, also outside of Chicago, Olmsted's design for Riverside set the standard for suburban development in America. The pace of that development was steady but slow until the 1920s, when suburbia exploded. During that decade, the suburbs grew twice as fast as the central cities. Beverly Hills in Los Angeles grew by 2,500 percent, and Shaker Heights outside of Cleveland by 1,000 percent. The Great Depression and World War II slowed growth temporarily, but by 1950, the suburbs were growing at a rate 10 times that of the cities. Between 1950 and 1960, American cities grew by 6 million people or 11.6 percent. In that same decade, the suburban population grew by 19 million, a rate of 45.6 percent.

And, for the first time, some cities actually began to lose population: The populations of both Boston and St. Louis declined by 13 percent.

There were two great consequences of this suburban emigration: first, the development of the highway system, aided as well by the rise of the automobile as the primary means of transportation, and second, the collapse of the financial base of the urban center itself. As early as 1930, there were 800,000 automobiles in Los Angeles—two for every five people—and the city quite consciously decided not to spend public monies on mass transit but to support instead a giant freeway system (**Fig. 15-58**). The freeways essentially overlaid the rectilinear grid of the city's streets with continuous, streamlined ribbons of highway. Similarly, in 1940, Pennsylvania opened a turnpike that ran the length of the state. Public enthusiasm was enormous, and traffic volume far exceeded expectations. That same year, the first stretches of the Pasadena Freeway opened. Today it is estimated that roads and parking spaces for cars occupy between 60 and 70 percent of the total land area of Los Angeles.

However, not only automobiles but also money—the wealth of the middle class—drove down these highways, out of the core city and into the burgeoning suburbs. The cities were faced with discouraging and destructive urban decline. Most discouraging of all was the demise of the **infrastructure**, the systems that deliver services to people—water supply and waste removal, energy, transportation, and communications. The infrastructure is what determines the quality of city life. If we think about many of the works of art we have studied in this chapter, we can recognize that they were initially conceived as part of the infrastructure of their communities. For example, the Pont du Gard (see Fig. 15-14) is a water supply aqueduct. Public buildings such as temples, churches, and cathedrals provide places for people to congregate. Even skyscrapers are integral parts of the urban infrastructure, providing centralized places for people to work. As the infrastructure

Fig. 15-57 Olmsted, Vaux & Co. landscape architects, general plan of Riverside, Illinois, 1869.

Frances Loeb Library, Graduate School of Design, Harvard University.

collapses, businesses close down, industries relocate, the built environment deteriorates rapidly, and even social upheaval can follow. To this day, downtown Detroit has never recovered from the 1967 riots and the subsequent loss of jobs in the auto industry in the mid-1970s. Block after block of buildings that once housed thriving businesses lie decayed and unused.

Perhaps one of the most devastating assaults on a city's infrastructure occurred on September 11, 2001, when terrorists brought down the twin towers of the World Trade Center in New York City. Officials needed to find a suitable site for collecting and sorting through the debris. Because it was both convenient to the disaster site and large enough to accommodate the vast amount of debris from the World Trade Center, they chose Fresh Kills Landfill, which had served for years as the city's primary waste disposal site but which was, by 2001, in the process of being reclaimed as park lands, a project directed by artist Mierle Ukeles (see *The Creative Process* on p. 388). Almost immediately after the tragedy, plans were put in place to rebuild the site at Ground Zero, highlighted by an architectural competition. Problems of urban planning were paramount. Transportation issues involving the city's street and subway systems vied with retail and office commercial interests for consideration. But all designs had to address the heavy weight of the site's symbolic significance—the memory of the World Trade Center itself and the people who had worked there.

One of the most successful designs submitted for the site is by Spanish architect Santiago Calatrava. His plan for the Port Authority Trans Hudson (PATH) train station (**Fig. 15-59**) is based on a sketch that he drew of a child's hands

Fig. 15-58 Los Angeles Freeway Interchange.

releasing a bird into the air. Calatrava said that the goal of his design was to "use light as a construction material." At ground level, the station's steel, concrete, and glass canopy functions as a skylight that allows daylight to penetrate 60 feet to the tracks below. On nice days, the canopy's roof retracts to create a dome of sky above the station. A total of 14 subway lines will be accessible from the station, and it will also connect to ferry service and airport transportation. The Port Authority sees it as the centerpiece of a new regional transportation infrastructure designed to rejuvenate lower Manhattan. It should open sometime in 2015.

Fig. 15-59 Santiago **Calatrava,** Port Authority Trans Hudson (PATH) station, World Trade Center site, 2004.

AP Photo/Port Authority of New York and New Jersey.

Maintenance has been one of the major themes of Mierle Ukeles's multidisciplinary art. Her seminal 1969 Manifesto for *Maintenance Art* announced her belief that art can reveal, even transform, the discontinuity between society's promise of freedom for all and the unequal effects arising from our need to survive. Survival, she argues, has for too long led to gender, class, and race-based disenfranchisements. If earth is to be our "common home," these inequities must be addressed. Her own personal situation fueled her thinking: "I am an artist. I am a woman. I am a wife. (Random order)," she wrote. "I do a hell of a lot of washing, cleaning, cooking, renewing, supporting, preserving, etc. Also (up to now separately) I 'do' Art. Now I will simply do these maintenance things, and flush them up to consciousness, exhibit them, as Art."

In the first place, Ukeles wanted to challenge the notion of service work—i.e., "women's work"—and make it public. In her 1973 piece *Wash*, she scrubbed the sidewalk in front of A. I. R. Gallery in the SoHo neighborhood in New York City on her hands and knees, with a bucket of water, soap, and rags. In taking personal responsibility for maintaining the "cleanliness" of the area for five hours, she immediately wiped out any tracks made by those innocently passing by, following them, rag in hand, erasing their footsteps right up to the point of brushing the backs of their heels. The often-unstated power-based "social contract" of maintenance was made visible.

The city, she realized, was the ideal site for investigating the idea of maintenance. Maintenance of the city's infrastructure is an invisible process that is absolutely vital, and bringing the invisible to light is one of the artist's primary roles. For her *I Make Maintenance Art One Hour Every Day*, a 1976 project for a branch of the Whitney Museum of American Art located in New York's Chemical Bank Building, Ukeles invited the 300-person maintenance staff in the building, most of whom work invisibly at night, to designate one hour of their normal activities on the job as art, while she inhabited the building for seven weeks documenting their selections and exhibiting them daily.

Soon after, Ukeles became the unsalaried artist-in-residence for the New York City Department of Sanitation. In New York, the collection, transportation, and disposal of waste occurs 24 hours a day, every day of the year but Christmas. Her first piece was *Touch Sanitation*, a performance artwork in which, after one and a half years of preparatory research, she spent 11 months creating a physical portrait of New York City as "a living entity" by facing and shaking the hand of each of the Department's 8,500 employees, saying,

Fig. 15-60 Mierle Laderman Ukeles, *Fresh Kills Landfill*, daily operation.
Courtesy Ronald Feldman Fine Arts, Inc., New York.

"Thank you for keeping New York City alive," and walking thousands of city miles with them. She spent four more years creating an exhibition documenting this journey.

Her most ambitious project for the department is as artist of the Fresh Kills Landfill on Staten Island (**Figs. 15-60** and **15-61**), an ongoing collaboration in redesign, begun in 1977, with no end in sight. Landfills, she points out, are the city's largest remaining open spaces, and the Fresh Kills Landfill, at 3,000 acres, is the largest in the United States. She was designated to be part of a team that was to remediate, reshape, transform, and recapture the landfill as healed public space after its closure in 2001. But the events of history intervened in 2002, when Fresh Kills reopened as the repository for the bulk of the material recovered from the World Trade Center disaster of 9/11.

One area of her mega-project is based on re-envisioning the four images of earth that have yielded four traditions of creation. In each, the earth is imaged as female, often as seen by males. Earth as ancient mother, seen in sacred earth mounds, forever nourishes us and sustains us, producing in us an attitude of reverence and devotion. Earth as virgin, as seen in early American landscape painting as a virtually uninhabited boundless territory, is, she says, "forever fresh and young . . . available for the taking, producing in us (males) lust and acquisitiveness." Earth as wife is "enticingly wild and equally kempt . . . thoroughly domesticated because adequately husbanded." For her, the perfect image of earth as wife is the artificial wilderness of English landscape and Olmsted. Finally, there is the earth as old sick whore, once free and bountiful and endlessly available, then wasted, used up, dumped, and abandoned. To treat the earth as whore is to pretend that "one has no responsibility for one's actions." In Ukeles's plan for Fresh Kills Landfill, she asks,

> *Can we utilize the beauty of reverence, devotion, awe, craft, science, technology, and love that yielded the first three traditions while eliminating what has been essentially the obsession with domination and control that comes inevitably when one sex has rapacious power over the other, a power that pollutes all four traditions? Or can we simply un-gender our image of earth, so that we can re-invent our entire relationship, to create a new open interdependency in a more free and equal way?*

After 9/11, these questions resonate even more powerfully than before.

How do the columns of the three Greek architectural orders differ?

The relationship between the units of a Greek temple is known as its order. Columns in the Doric order are the plainest, while those of the Ionic order have a distinctive scroll, and those in the Corinthian order are decorated with stylized acanthus leaves. What is an elevation? What is entasis?

What advantages did the arch afford the ancient Romans?

The ancient Romans developed the arch, an innovation in which wedge-shaped voussoirs were cut to fit into a semicircular form, which was locked by a keystone at the top. The arch revolutionized the built environment, allowing the Romans to span much larger spaces than post-and-lintel construction would allow. What is a barrel vault, or tunnel vault? How are groined vaults created?

What architectural innovations led to skyscraper construction?

The sheer strength of steel was a major enabling factor in skyscraper construction, as it dispensed with the need for the thick walls required in the lower levels of stone buildings; Reinforced concrete (concrete with steel bars embedded) significantly promoted strength in skyscrapers. What is a cantilever? What characterizes the International Style?

What are some of the principles of green architecture?

Green architecture is defined by an environmentally friendly and sustainable approach to building. Its principles include smaller buildings; integration and compatibility with the natural environment; energy efficiency; and the employment of recycled, reusable, and sustainable materials. Why are the towers in Dubai at odds with the environment? How does Emilio Ambasz embody principles of green architecture in his ACROS Building in Fukuoka, Japan?

THE CRITICAL PROCESS
Thinking about Architecture

The attentive reader will have noticed that as this book has progressed it has become increasingly historical in its focus. Perhaps because developments in architecture are so closely tied to advances in technology, this chapter is perhaps the most historical of all, moving as it does from rudimentary post-and-lintel construction to advanced architectural accomplishments made possible by both computer technologies and the ability of architects themselves to move physically and communicate virtually on a global scale.

That said, it must be admitted, as the saying goes, that the more things change, the more things stay the same. The need of humans to dwell in suitable habitats and their desire to congregate in livable communities are timeless impulses. Consider, for instance, a kind of

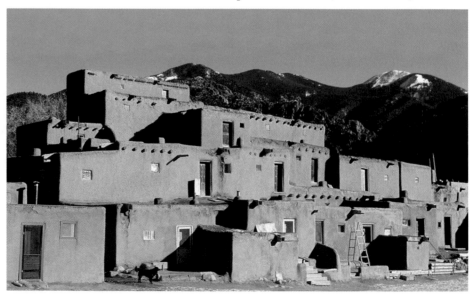

Fig. 15-62 Multistory apartment block, Taos Pueblo, New Mexico, originally built 1000–1450.
© Karl Weatherly/Corbis.

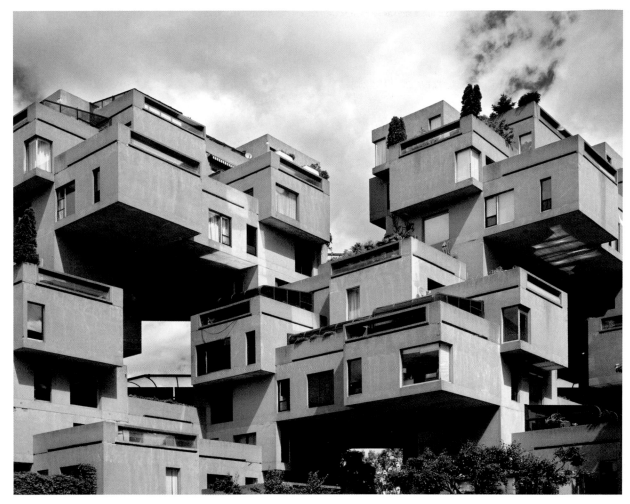

Fig. 15-63 Moshe Safdie, Habitat, Montreal, Canada, 1967.
© Michael Harding/Arcaid/Corbis.

dwelling that has survived from prehistoric times to the present, the apartment block. By 7000 BCE, across the Middle East, houses consisting of mud brick and timber stood side by side with abutting walls, often terraced in ways that probably resembled the Native American pueblos of the American Southwest. The main parts of the Taos Pueblo (**Fig. 15-62**) were most likely constructed between 1000 and 1450 and look today much as they did when Spanish explorers and missionaries first arrived in the area in the sixteenth century. The Pueblo is divided into two apartment blocks, which rise on either side of a vast dance plaza bisected by a stream. The Pueblo's walls, which are several feet thick, are made of **adobe**, a mixture of earth, water, and straw formed into sun-dried mud bricks. The roofs are supported by large wooden beams which are topped by smaller pieces of wood, and the whole roof is then covered with packed dirt. Each of the five stories is set back from the one below, thus forming terraces which serve as patios and viewing areas for ceremonial activities in the dance plaza below.

Taos Pueblo has much in common with Israeli architect Moshe Safdie's Habitat (**Fig. 15-63**), designed as an experimental housing project for Expo 67, the Montreal World's Fair, but today still serving a community of content residents, most of whom think of themselves as living in Montreal's "most prestigious apartment building." Safdie's design is based on modular prefabricated concrete blocks stacked in what Safdie called "confused order" and connected by internal steel cables. Safdie used 354 uniform blocks to make up 158 apartments of from one to four bedrooms. Each apartment has an outdoor living space, generally on the roof of the apartment directly below. The stacks are arranged to maximize privacy, access to views of the St. Lawrence River, and protection from the weather.

In what ways does Safdie's design evoke Southwest Native American pueblos? How does it differ? In what ways is Safdie's design reminiscent of Le Corbusier's Domino Housing Project (see Fig. 15-39)? How is it different?

16 | The Design Profession

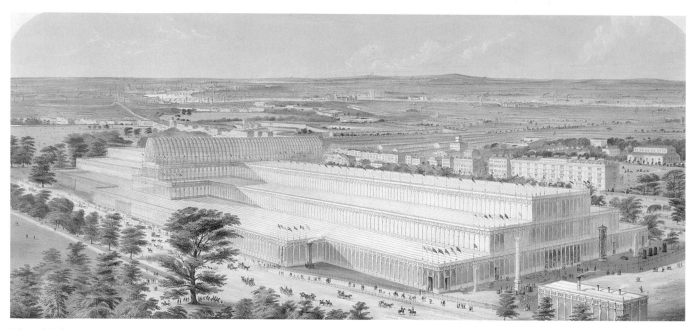

Fig. 16-1 Joseph Paxton, Crystal Palace, Great Exposition, London, 1851.
Iron, glass, and wood, 1,848 × 408 ft. Lithograph by Charles Burton, *Aeronautic View of the Palace of Industry for All Nations, from Kensington Gardens*, published by Ackerman (1851). Guildhall Library, City of London, UK.
Corporation of London, UK/The Bridgeman Art Library.

Thinking Thematically: See Art, Science, and the Environment on myartslab.com

THINKING AHEAD

What gave rise to design as a profession?

What are some of the defining features of Art Deco?

What characterizes De Stijl?

What is postmodernism in design?

During the 1920s in the United States, many people who had once described themselves as involved in the graphic arts, the industrial arts, the craft arts, or the arts allied to architecture, and even architects themselves, began to be referred to as *designers*. They were seen as serving industry. They could take any object or product—a shoe, a chair, a book, a poster, an automobile, or a building—and make it appealing, and thereby persuade the public to buy it or a client to build it. In fact, design is so intimately tied to industry that its origins as a profession can be traced back only to the beginnings of the industrial age, especially in the Arts and Crafts Movement, in opposition to mass production.

The Arts and Crafts Movement

While it would be possible to approach design by analyzing individual media—graphic design, furniture design, transportation design, and so on—beginning

with the Arts and Crafts Movement, the profession has been defined more by a series of successive movements and styles than by the characteristic properties of any given medium.

The Arts and Crafts Movement was itself a reaction to the fact that, during the first half of the nineteenth century, as mass production increasingly became the norm in England, the quality and aesthetic value of mass-produced goods declined. In order to demonstrate to the English the sorry state of modern design in their country, Henry Cole, a British civil servant who was himself a designer, organized the Great Exposition of 1851. The industrial products on exhibit showed, once and for all, just how bad the situation was. Almost everyone agreed with the assessment of Owen Jones: "We have no principles, no unity; the architect, the upholsterer, the weaver, the calico-painter, and the potter, run each their independent course; each struggles fruitlessly, each produces in art novelty without beauty, or beauty without intelligence."

The building that housed the exhibition in Hyde Park was an altogether different proposition. A totally new type of building, which became known as the Crystal Palace (**Figs. 16-1** and **16-2**), was designed by Joseph Paxton, who had once served as gardener to the Duke of Devonshire and had no formal training as an architect. Constructed of more than 900,000 square feet of glass set in prefabricated wood and cast iron, it was three stories tall and measured 1,848 by

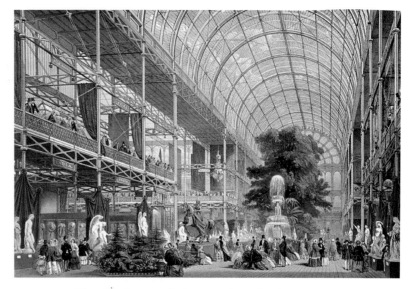

Fig. 16-2 Joseph Paxton, Crystal Palace, interior, Great Exposition, London, 1851.
Institute für Theorie der Architektur an der ETH, Zurich.
© Historical Picture Archive/CORBIS

408 feet. It required only nine months to build, and it ushered in a new age in construction. As one architect wrote at the time, "From such beginnings what glories may be in reserve. . . . We may trust ourselves to dream, but we dare not predict."

Not everyone agreed. A. W. N. Pugin, who had collaborated on the new Gothic-style Houses of Parliament, called the Crystal Palace a "glass monster," and the essayist and reformer John Ruskin, who likewise had championed a return to a preindustrial Gothic style in his book *The Stones of Venice*, called it a "cucumber frame." Under their influence, William Morris, a poet, artist, and ardent socialist, dedicated himself to the renewal of English design through the renewal of medieval craft traditions. In his own words: "At this time, the revival of Gothic architecture was making great progress in England. . . . I threw myself into these movements with all my heart; got a friend [Philip Webb] to build me a house very medieval in spirit . . . and set myself to decorating it." Built of traditional red brick, the house was called the Red House (**Fig. 16-3**), and nothing could be further in style from the Crystal Palace. Where the latter reveals itself to be the product of manufacture—engineered

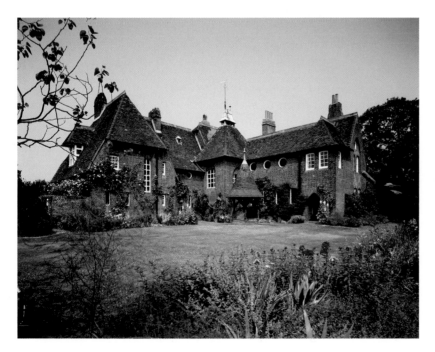

Fig. 16-3 Philip Webb, The Red House, Bexley Heath, UK, 1859.
Photo: Charlotte Wood.

out of prefabricated, factory-made parts and assembled, with minimal cost, by unspecialized workers in a matter of a few months—the former is a purposefully rural—even archaic—building that rejects the industrial spirit of Paxton's Palace. It signaled, Morris hoped, a return to craft traditions in which workers were intimately tied, from start to finish, to the design and manufacture of their products.

Morris longed to return to a handmade craft tradition for two related reasons. He felt that the mass-manufacturing process alienated workers from their labor, and he also missed the quality of handmade items. Industrial laborers had no stake in what they made, and thus no pride in their work. The result, he felt, was both shoddy workmanship and unhappy workers.

As a result of the experience of building the Red House and attempting to furnish it with objects of a medieval, handcrafted nature, a project that was frustrated at every turn, Morris decided to take matters into his own hands. In 1861, he founded the firm that would become Morris and Company. It was dedicated "to undertake any species of decoration, mural or otherwise, from pictures, properly so-called, down to the consideration of the smallest work susceptible of art beauty." To this end, the company was soon producing stained glass, painted tiles, furniture, embroidery, table glass, metalwork, chintzes, wallpaper, woven hangings, tapestries, and carpets.

In his designs, Morris constantly emphasized two principles: simplicity and utility. Desire for simplicity—"simplicity of life,"

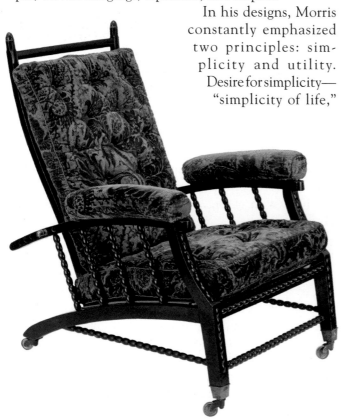

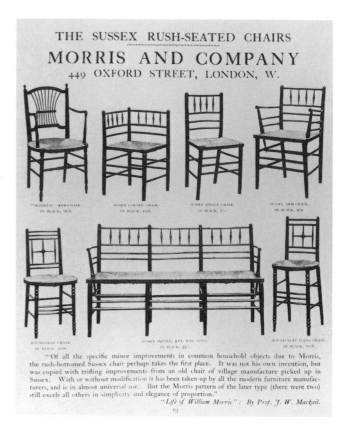

Fig. 16-4 Morris and Company, Sussex Rush-Seated Chairs. Fitzwilliam Museum, Cambridge, England.
Exhibition catalogue Fitzwilliam Museum, Cambridge University Press, 1980, pl. 49.

as he put it, "begetting simplicity of taste"—soon led him to create what he called "workaday furniture," the best examples of which are the company's line of Sussex rush-seated chairs (**Fig. 16-4**). Such furniture was meant to be "simple to the last degree" and to appeal to the common man. As Wedgwood had done 100 years earlier (see Chapter 14), Morris quickly came to distinguish this "workaday" furniture from his more costly "state furniture," for which, he wrote, "we need not spare ornament . . . but [may] make them as elaborate and elegant as we can with carving or inlaying or paintings; these are the blossoms of the art of furniture." An adjustable reclining chair (the forefather of all recliners) designed by Morris's friend, Philip Webb (**Fig. 16-5**), is the "state" version of the Sussex rush-seated chair. Covered in rich, embossed velvet, the chair quickly became a symbolic standard of good living. As Morris's colleague Walter Crane put it: "The

Fig. 16-5 William Morris, The Morris Adjustable Chair, designed by Philip Webb, made by Morris, Marshall, Faulkner & Co.
Ebonized wood, covered with Bord Design upholstery. Victoria and Albert Museum, London, Great Britain.

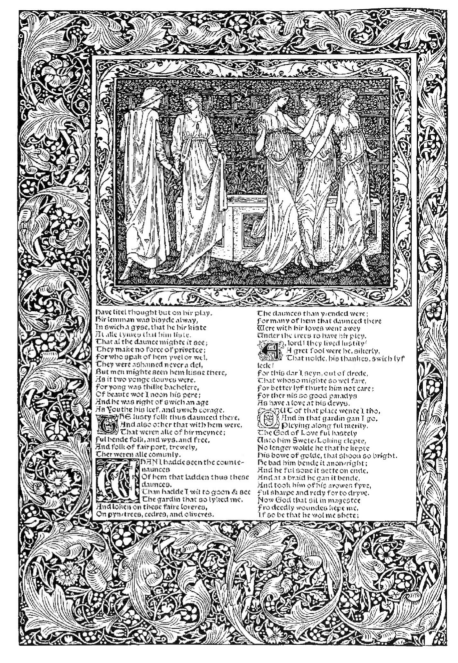

Fig. 16-6 William Morris (design) and Edward Burne-Jones (illustration), page opening of Geoffrey Chaucer, *The Works of Geoffrey Chaucer Newly Augmented,* Kelmscott Press, 1896.

Edition of 425 copies on paper, sheet 16³/₄ × 11¹/₂ in. Designed by William Morris (CT36648). Victoria and Albert Museum, London.

V&A Images, London/Art Resource, NY.

great advantage . . . of the Morrisian method is that it leads itself to either simplicity or splendor. You might be almost plain enough to please Thoreau, with a rush-bottomed chair, piece of matting, and oaken trestle-table; or you might have gold and luster gleaming from the side-board, and jeweled light in your windows, and walls hung with rich arras tapestry."

Perhaps nothing more underscores Morris's aesthetic taste than his work as bookmaker and typographer at the Kelmscott Press, which he founded in 1888. His edition of Chaucer's works (**Fig. 16-6**) is a direct expression of his belief in the values and practices of the Middle Ages. Morris commissioned handmade, wire-molded linen paper similar to that used in fifteenth-century Bologna. He designed a font, appropriately called "Chaucer," which was based on Gothic script. In order to make it more legible, he widened most letterforms, increased the differences between similar characters, and made curved characters rounder. "Books should be beautiful," he argued, "by force of mere typography." But he stopped at nothing to make the Chaucer beautiful in every detail. He set his type by hand, insisting upon a standard spacing between letters, words, and lines. He positioned material on the page in the manner of medieval bookmakers, and designed 14 large borders, 18 different frames for the illustrations, and 26 large initial words for the text. Finally, he commissioned 87 illustrations from the English painter Sir Edward Burne-Jones. The book, he felt, should be like architecture, every detail—paper, ink, type, spacing, margins, illustrations, and ornament—working together as a single design unit.

Morris claimed that his chief purpose as a designer was to elevate the circumstances of the common man.

"Every man's house will be fair and decent," he wrote, "all the works of man that we live amongst will be in harmony with nature . . . and every man will have his share of the best." But common people were in no position to afford the elegant creations of Morris and Company. Unlike Wedgwood (see Chapter 14), whose common, "useful" ware made the most money for the firm, it was the more expensive productions—the state furniture, tapestries, and embroideries—that kept Morris and Company financially afloat. Inevitably, Morris was forced to confront the inescapable conclusion that to hand-craft an object was to make it prohibitively expensive. With resignation and probably no small regret, he came to accept the necessity of mass manufacture.

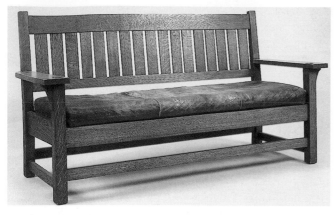

Fig. 16-7 Gustav Stickley, Settee (for the Craftsman Workshops), 1909.
Oak and leather, back: 38 × 71⁷/₁₆ × 22 in.; seat: 19 × 62 in.
The Art Institute of Chicago. Gift of Mr. and Mrs. John J. Evans, Jr., 1971.748.
Photography © The Art Institute of Chicago.

In the United States, Gustav Stickley's magazine *The Craftsman*, first published in 1901 in Syracuse, New York, was the most important supporter of the Arts and Crafts tradition. The magazine's self-proclaimed mission was "to promote and to extend the principles established by [William] Morris," and its first issue was dedicated exclusively to Morris. Likewise, the inaugural issue of *House Beautiful* magazine, published in Chicago in 1896, included articles on Morris and the English Arts and Crafts movement. Stickley, recognizing the expense of Morris's hand-crafted furniture and the philosophical dilemma that Morris faced in continuing to make it, accepted the necessity of machine-manufacturing his own work. Massive in appearance, lacking ornamentation, its aesthetic appeal depended, instead, on the beauty of its wood, usually oak (**Fig. 16-7**).

By the turn of the century, architect Frank Lloyd Wright was also deeply involved in furniture design. Like Morris before him, Wright felt compelled to design furniture for the interiors of his Prairie Houses that matched the design of the building as a whole (see Fig. 15-34). "It is quite impossible," Wright wrote, "to consider the building as one thing, its furnishings another, and its setting and environment still another. The Spirit in which these buildings are conceived sees these all together at work as one thing." The table lamp designed for the Lawrence Dana House in Springfield, Illinois (**Fig. 16-8**) is meant to reflect the dominant decorative feature of the house—a geometric rendering of the sumac plant that is found abundantly in the neighboring Illinois countryside, chosen because the site of the house itself was particularly lacking in vegetation. Given a very large budget, Wright designed 450 glass panels and 200 light fixtures for the house that are variations on the basic sumac theme. Each piece is unique and individually crafted.

The furniture designs of Morris, Stickley, and Wright point out the basic issues that design faced in the twentieth century. The first dilemma, to which we have been paying particular attention, was whether the product should be hand-crafted or mass-manufactured. But formal issues have arisen as well. If we compare Wright's designs to Morris's, we can see that they use line completely differently. Even though both find the source of their forms in nature, Wright's forms are rectilinear and geometric, Morris's curvilinear and organic. Both believed in "simplicity," but the word meant different things to the two men. Morris, as we have seen, equated simplicity with the natural. Wright, on the other hand, designed furniture for his houses because, he said, "simple things . . . were nowhere at hand. A piece of wood without a moulding was an anomaly, plain fabrics were nowhere to be found in stock." To Wright, simplicity meant plainness. The history of design continually confronts the choice between the geometric and the organic. The major design movement at the turn of the century, Art Nouveau, chose the latter.

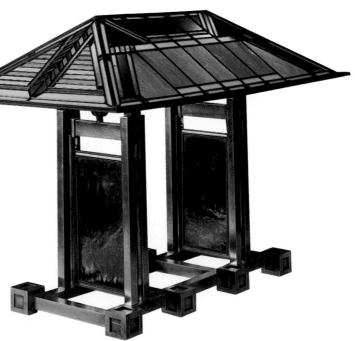

Fig. 16-8 Frank Lloyd Wright, table lamp, Susan Lawrence Dana House, 1903.
Bronze, leaded glass. Photo: Douglas Carr. Courtesy The Dana-Thomas House, The Illinois Historic Preservation Agency.
© 2012 Frank Lloyd Wright Foundation, Scottsdale, AZ/Artists Rights Society (ARS), NY.

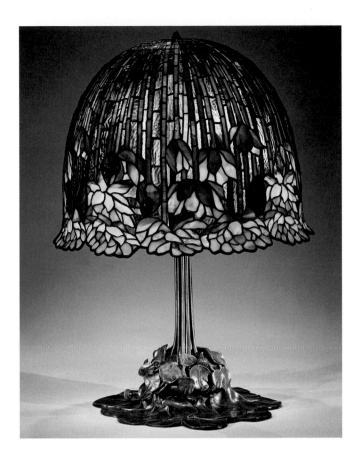

Fig. 16-9 Louis Comfort Tiffany (1848–1933), Tiffany Studios, water-lily table lamp, 20th Century, c. 1904–15. Leaded Favrile glass and bronze, height 26½ in. (67.3 cm) The Metropolitan Museum of Art, New York. Gift of Hugh J. Grant, 1974 (1974.214.15ab).

Image copyright © The Metropolitan Museum of Art. Image source: Art Resource, NY.

being replaced by electric lights—Thomas Edison had startled the French public with his demonstration of electricity at the 1889 International Exhibition—Bing placed considerable emphasis on new, modern modes of lighting. From his point of view, a new light and a new art went hand in hand. And Tiffany's stained-glass lamps (**Fig. 16-9**), backlit by electric light, brought a completely new sense of vibrant color to interior space.

Even more than his stained glass, Bing admired Tiffany's iridescent Favrile glassware, which was named after the obsolete English word for handmade, "fabrile." The distinctive feature of this type of glassware is that nothing of the design is painted, etched, or burned into the surface. Instead, every detail is built up by the craftsperson out of what Tiffany liked to call "genuine glass." In the vase illustrated here (**Fig. 16-10**), we can see many of the design characteristics most

Art Nouveau

The day after Christmas in 1895, a shop opened in Paris named the Galeries de l'Art Nouveau. It was operated by one S. Bing, whose first name was Siegfried, though art history has almost universally referred to him as Samuel, perpetuating a mistake made in his obituary in 1905. Bing's new gallery was a success, and in 1900, at the International Exposition in Paris, he opened his own pavilion, Art Nouveau Bing. By the time the Exposition ended, the name **Art Nouveau** had come to designate not merely the work he displayed but also a decorative arts movement of international dimension.

Bing had visited the United States in 1894. The result was a short book titled *Artistic Culture in America*, in which he praised America's architecture, painting, and sculpture, but most of all its arts and crafts. The American who fascinated him most was the glassmaker Louis Comfort Tiffany, son of the founder of the famous New York jewelry firm Tiffany and Co. The younger Tiffany's work inspired Bing to create his new design movement, and Bing contracted with the American to produce a series of stained-glass windows designed by such French artists as Henri de Toulouse-Lautrec and Pierre Bonnard. Because oil lamps were at that very moment

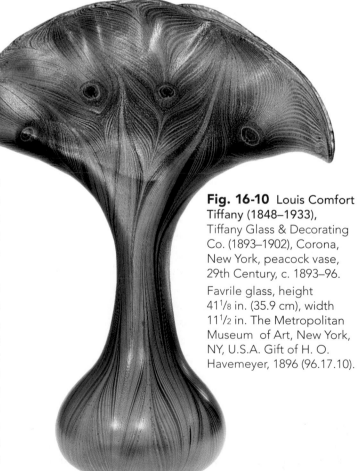

Fig. 16-10 Louis Comfort Tiffany (1848–1933), Tiffany Glass & Decorating Co. (1893–1902), Corona, New York, peacock vase, 29th Century, c. 1893–96.

Favrile glass, height 41⅛ in. (35.9 cm), width 11½ in. The Metropolitan Museum of Art, New York, NY, U.S.A. Gift of H. O. Havemeyer, 1896 (96.17.10).

often associated with Art Nouveau, from the wave-like line of the peacock feathers to the self-conscious asymmetry of the whole. In fact, the formal vocabulary of Art Nouveau could be said to consist of young saplings and shoots, willow trees, buds, vines—anything organic and undulating, including snakes and, especially, women's hair. The Dutch artist Jan Toorop's advertising poster for a peanut-based salad oil (**Fig. 16-11**) flattens the long, spiraling hair of the two women preparing salad into a pattern very like the elaborate wrought-iron grillwork also characteristic of

Art Nouveau design. Writing about Bing's installation at the 1900 Universal Exposition, one writer described Art Nouveau's use of line this way: "[In] the encounter of the two lines . . . the ornamenting art is born—an indescribable curving and whirling ornament, which laces and winds itself with almost convulsive energy across the surface of the [design]!"

Yet, for many, Art Nouveau seemed excessively subjective and personal, especially for public forms such as architecture. Through the example of posters like Toorop's, Art Nouveau became associated with an interior world of aristocratic wealth, refinement, and even emotional and sexual abandon. It seemed the very opposite of the geometric and rectilinear design practiced by the likes of Frank Lloyd Wright, and a new geometric design gradually replaced it. By the Exposition Internationale des Arts Décoratifs et Industriels Modernes—the International Exposition of Modern Decorative and Industrial Arts—in Paris in 1925, geometric design held sway.

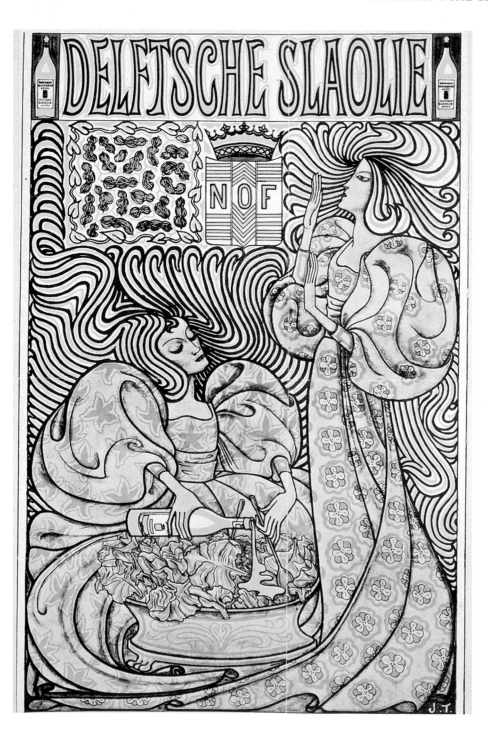

Fig. 16-11 Jan Toorop, Poster for *Delftsche Slaolie* (Salad Oil), 1894. Dutch advertisement poster.
Scala/Art Resource, NY.

Thinking Thematically: See Art and Beauty on myartslab.com

Art Deco

The Exposition Internationale des Arts Décoratifs et Industriels Modernes was planned as early as 1907, during the height of Art Nouveau, but logistical problems—especially the outbreak of World War I—postponed it for almost 20 years. A very influential event, the exposition was the most extensive international showcase of the style of design then called Art Moderne and, since 1968, better known as **Art Deco**.

Art Deco designers tended to prefer up-to-date materials—chrome, steel, and Bakelite plastic—and sought to give expression to everyday "moderne" life. The *Skyscraper Bookcase* by the American designer Paul T. Frankl (**Fig. 16-12**), made of maple wood and Bakelite, is all sharp angles that rise into the air, like the brand-new skyscrapers that were beginning to dominate America's urban landscape.

This movement toward the geometric is perhaps the defining characteristic of Art Deco. Even the leading fashion magazines of the day reflect this in their covers and layouts. In Eduardo Benito's *Vogue* magazine cover (**Fig. 16-13**), we can see an impulse toward simplicity and rectilinearity comparable to Frankl's bookcase. The world of fashion embraced the new geometric look. During the 1920s, the boyish silhouette became increasingly fashionable. The curves of the female body were suppressed (**Fig. 16-14**), and the waistline disappeared in tubular, "barrel"-line skirts. Even long, wavy hair, one of the defining features of Art Nouveau style, was abandoned, and the schoolboyish "Eton crop" became the hairstyle of the day.

Fig. 16-13 Eduardo Garcia Benito, *Vogue*, May 25, 1929 cover.
© Vogue/Condé Nast Publications, Inc.

Fig. 16-14 Unidentified illustrator, corset, *Vogue*, October 25, 1924.
© Vogue/Condé Nast Publications, Inc.

The Avant-Gardes

At the 1925 Paris Exposition, one designer's pavilion stood apart from all the rest, not because it was better than the others, but because it was so different. As early as 1920, the architect Le Corbusier (see Figs. 15-39 and 15-40) had written in his new magazine *L'Esprit Nouveau* (*The New Spirit*) that "decorative art, as opposed to the machine phenomenon, is the final twitch of the old manual modes; a dying thing." He proposed a *Pavillon de l'Esprit Nouveau* (Pavilion of the New Spirit) for the exposition that would contain "only standard things created by industry in factories and mass-produced; objects truly of the style of today."

For Le Corbusier, making expensive, hand-crafted objects amounted to making antiques in a contemporary world. From his point of view, the other designers at the 1925 exposition were out of step with the times. The modern world was dominated by the machine, and though designers had shown disgust for machine-manufacture ever since the time of Morris and Company, they did so at the risk of living forever in the past. "The house," as Le Corbusier had declared, "is a machine for living."

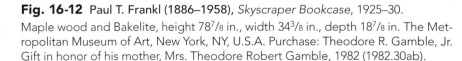

Fig. 16-12 Paul T. Frankl (1886–1958), *Skyscraper Bookcase*, 1925–30. Maple wood and Bakelite, height 78⅞ in., width 34⅜ in., depth 18⅞ in. The Metropolitan Museum of Art, New York, NY, U.S.A. Purchase: Theodore R. Gamble, Jr. Gift in honor of his mother, Mrs. Theodore Robert Gamble, 1982 (1982.30ab).

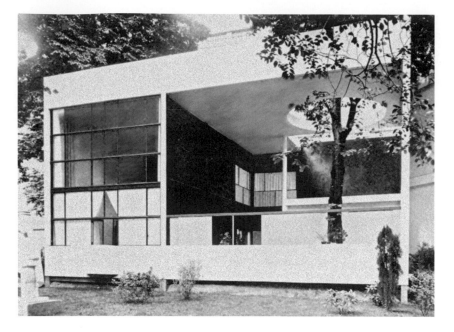

Fig. 16-15 Le Corbusier, *Pavillon de l'Esprit Nouveau*, Exposition Internationale des Arts Décoratifs et Industriels Modernes, Paris, 1925.

Copyrighted from LeCorbusier, *My Work* (London: Architectural Press, 1960), p. 72.
© 2012 Artists Rights Society (ARS), New York/ADAGP, Paris//FLC

Le Corbusier's "new spirit" horrified the exposition's organizers, and, accordingly, they gave him a parcel of ground for his pavilion between two wings of the Grand Palais, with a tree, which could not be removed, growing right in the middle of it. Undaunted, Le Corbusier built a modular version of his Domino Housing Project design (see Fig. 15-39) right around the tree, cutting a hole in the roof to accommodate it (**Fig. 16-15**). So distressed were Exposition officials that they ordered a high fence to be built completely around the site in order to hide it from public view. Le Corbusier appealed to the Ministry of Fine Arts, and, finally, the fence was removed. "Right now," Le Corbusier announced in triumph, "one thing is sure: 1925 marks the decisive turning point in the quarrel between the old and the new. After 1925, the antique lovers will have virtually ended their lives, and productive industrial effort will be based on the 'new.'"

The geometric starkness of Le Corbusier's design had been anticipated by developments in the arts that began to take place in Europe before World War I. A number of new avant-garde (from the French, meaning "advance guard") groups had sprung up, often with radical political agendas, and dedicated to overturning the traditional and established means of art-making through experimental techniques and styles.

One of the most important was the De Stijl movement in Holland. **De Stijl**, which is Dutch for "The Style," took its lead, like all the avant-garde styles, from the painting of Picasso and Braque, in which the elements of the real world were simplified into a vocabulary of geometric forms. The De Stijl artists, chief among them Mondrian (see Fig. 21-16), simplified the vocabulary of art and design even further, employing only the primary colors—red, blue, and yellow—plus black and white. Their design relied on a vertical and horizontal grid, often dynamically broken by a curve, circle, or diagonal line. Rather than enclosing forms, their compositions seemed to open out into the space surrounding them.

Gerrit Rietveld's famous chair (**Fig. 16-16**) is a summation of these De Stijl design principles. The chair is designed against, as it were, the traditional elements of the armchair. Both the arms and the

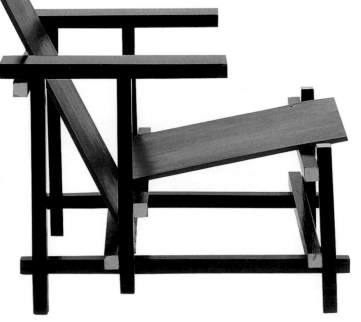

Fig.16-16 Gerrit Rietveld, *Red and Blue Chair*, c. 1918. Wood, painted, height 34⅛ in., width 26 in., depth 26½ in., seat height 13 in. The Museum of Modern Art, New York, U.S.A. Gift of Philip Johnson.

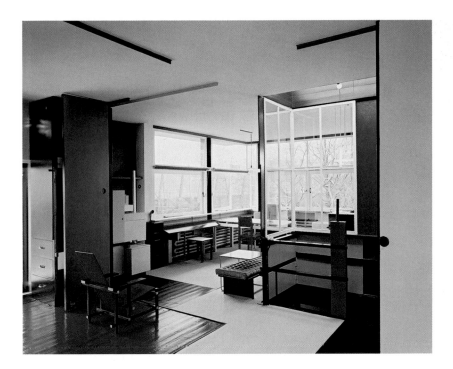

Fig. 16-17 Gerrit Rietveld, Schröder house, first floor, 1987, view of the stairwell/landing and the living-dining area. In the foreground is the *Red and Blue Chair*. Rietveld Schröderhlis, 1924, Utrecht, The Netherlands.
c/o Stichting Beeldrecht, Anstelveen. Centraal Museum Utrecht/Rietveld-Schröder Archive. Photo: Ernst Moritz, The Hague.

This notion of dynamic space can also be found in Russian **Constructivism**, a movement in the new postrevolutionary Soviet state that dreamed of uniting art and everyday life through mass-production and industry. The artists, the Constructivists believed, should "go into the factory, where the real body of life is made." They believed, especially, in employing non-objective formal elements in functional ways. El Lissitzky's design for the poster *Beat the Whites with the Red Wedge* (**Fig. 16-18**), for instance, is a formal design with propagandistic aims. It presents the "Red" Bolshevik cause as an aggressive red triangle attacking a defensive and static "White" Russian circle. Although the elements employed are starkly simple, the implications are disturbingly sexual—as if the Reds are male and active, while the Whites are female and passive—and the sense of aggressive action, originating both literally and figuratively from "the left," is unmistakable.

base of the chair are insistently locked in a vertical and horizontal grid. But the two planes that function as the seat and the back seem almost to float free from the closed-in structure of the frame. Rietveld dramatized their separateness from the black grid of frame by painting the seat blue and the back red.

Rietveld's Schröder House, built in 1925, is an extension of the principles guiding his chair design. The interior of the box-shaped house is completely open in plan. The view represented here (**Fig. 16-17**) is from the living and dining area toward a bedroom. Sliding walls can shut off the space for privacy, but it is the sense of openness that is most important to Rietveld. Space implies movement. The more open the space, the more possibility for movement in it. Rietveld's design, in other words, is meant to immerse its occupants in a dynamic situation that might, ideally, release their own creative energies.

Fig. 16-18 El Lissitzky, *Beat the Whites with the Red Wedge*, 1919. Lithograph. Collection Stedelijk Van Abbemuseum, Eindhoven, Holland.
© 2012 Artists Rights Society (ARS), New York/VG Bild-Kunst, Bonn.

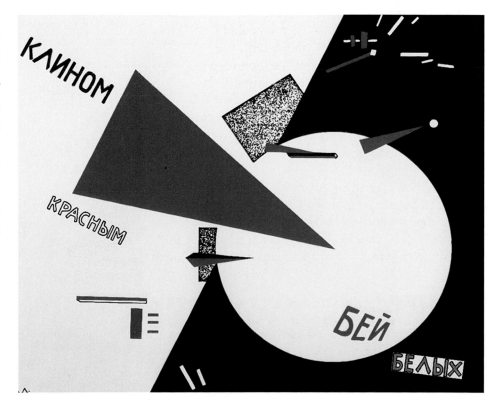

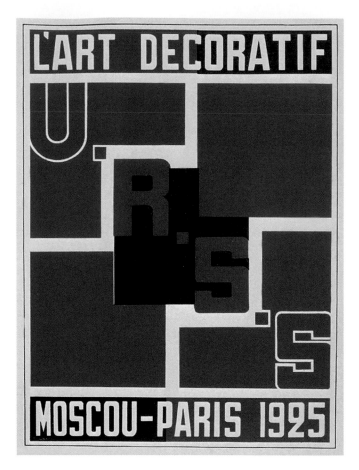

Fig. 16-19 Alexander Rodchenko, *L'Art Décoratif, Moscow-Paris*, 1925.

Design for catalog cover, Russian section, Exposition International des Arts Décoratifs et Industriels, Paris, 1925. Rodchenko Archive, Moscow, Russia.

Art © Estate of Alexander Rodchenko/RAO, Russia/Licensed by VAGA, New York, NY.

and the cover design echoes and embodies his design for the club. The furniture, as Rodchenko described it, emphasized "simplicity of use, standardization, and the necessity of being able to expand or contract the numbers of its parts." It was painted in only four colors—white, red, gray, and black—alone or in combination, and employed only rectilinear geometric forms. Chairs could be stacked and folded, tables could serve as screens and display boards if turned on their sides, and everything was moveable and interchangeable.

Typography, too, reflected this emphasis on standardization and simplicity. Gone were the ornamental effects of **serif type** styles—that is, letterforms, such as the font used in this text, that have small lines at the end of the letter's main stroke—and in their place plain and geometric **sans serif** ("without serif") fonts came to the fore. One of the great proponents of this new typography was the French poster designer Cassandre. "The poster is not meant to be a unique specimen conceived to satisfy a single art lover," Cassandre wrote, "but a mass-produced object that must have a commercial function. Designing a poster means solving a technical and commercial problem . . . in a language that can be understood by the common man." The poster campaign Cassandre created for the aperitif Dubonnet (**Fig. 16-20**) is conceived entirely as

This same sense of geometrical simplification can be found in Alexander Rodchenko's design for a catalog cover for the Russian exhibition at the 1925 Paris Exposition (**Fig. 16-19**). Rodchenko had designed the interiors and furnishings of the Workers' Club, which was included in the Soviet exhibit at the Exposition,

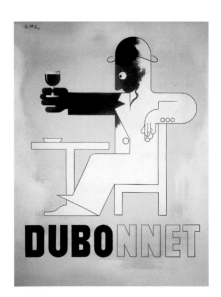
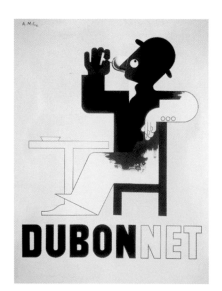
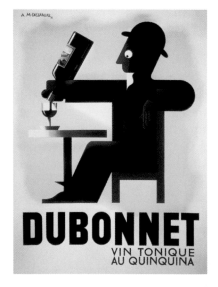

Fig. 16-20 Cassandre, poster for Dubonnet, 1932.

a play on words, but one any Frenchman would understand and appreciate. A man sits at a café table gazing at a glass of wine in his hand. The copy reads simply DUBO, or "*du beau*" ("something beautiful"). Next, we read DUBON, "*du bon*" ("something good"), and the color that was evident only in the glass, arm, and face in the first scene now extends to his stomach. Finally, above the full brand name, the fully colored, and apparently content, gentleman pours himself another glass. The geometrical letterforms of the sans-serif capitals echo the forms of the man himself—the "D" in his hat, the "B" in his elbow, the "N" in his leg's relation to the chair, and the "T" in the table. In this version of the campaign, Cassandre split the image into three separate posters, to be seen consecutively from the window of a train. His typographic style, thus viewed by millions, helped to popularize the geometric simplicity championed by the avant-gardes.

The Bauhaus

At the German pavilion at the 1925 Paris Exposition, one could see a variety of new machines designed to make the trials of everyday life easier, such as an electric washing machine and an electric armoire in which clothes could be tumble-dried. When asked who could afford such things, Walter Gropius, who in 1919 had founded a school of arts and crafts in Weimar, Germany, known as the **Bauhaus**, replied, "To begin with, royalty. Later on, everybody."

Like Le Corbusier, Gropius saw in the machine the salvation of humanity. And he thoroughly sympathized with Le Corbusier, whose major difficulty in putting together his *Pavillon de l'Esprit Nouveau* had been the unavailability of furniture that would satisfy his desire for "standard things created by industry in factories and mass-produced; objects truly of the style of today." Ironically, at almost exactly that moment, Marcel Breuer, a furniture designer working at Gropius's Bauhaus, was doing just that.

In the spring of 1925, Breuer purchased a new bicycle, manufactured out of tubular steel by the Adler company. Impressed by the bicycle's strength—it could easily support the weight of two riders—its lightness, and its apparent indestructibility, Breuer envisioned furniture made of this most modern of materials. "In fact," Breuer later recalled, speaking of the armchair that he began to design soon after his purchase (**Fig. 16-21**), "I took the pipe dimensions from my bicycle. I didn't know where else to get it or how to figure it out."

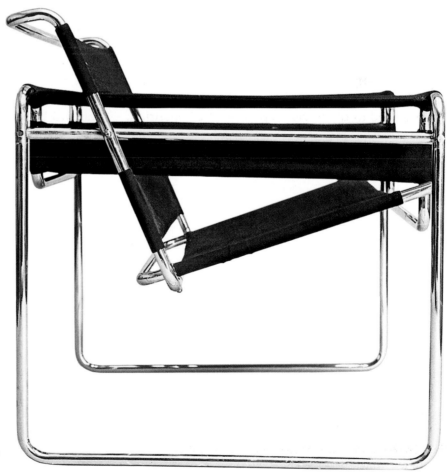

Fig. 16-21 Marcel Breuer, armchair, Model B3, late 1927 or early 1928.
Chrome-plated tubular steel with canvas slings, height 28$\frac{1}{8}$ in., width 30$\frac{1}{4}$ in., depth 27$\frac{3}{4}$ in. (71.4 × 76.8 × 70.5 cm) The Museum of Modern Art, New York, NY, U.S.A. Gift of Herbert Bayer.
Digital Image © The Museum of Modern Art/ Licensed by SCALA/Art Resource, NY.

Thinking Thematically: See Art, Gender, and Identity on myartslab.com

The chair is clearly related to Rietveld's *Red and Blue Chair* (see Fig. 16-16), consisting of two diagonals for seat and back set in a cubic frame. It is easily mass-produced—and, in fact, is still in production today. But its appeal was due, perhaps most of all, to the fact that it looked absolutely new, and it soon became an icon of the machine age. Gropius quickly saw how appropriate Breuer's design would be for the new Bauhaus building in Dessau. By early 1926, Breuer was at work designing modular tubular-steel seating for the school's auditorium, as well as stools and side chairs to be used throughout the educational complex. As a result, Breuer's furniture became identified with the Bauhaus.

But the Bauhaus was much more. In 1919, Gropius was determined to break down the barriers between the crafts and the fine arts and to rescue each from its isolation by training craftspeople, painters, and sculptors to work on cooperative ventures. There was, Gropius said, "no essential difference" between the crafts and the fine arts. There were no "teachers," either; there were only "masters, journeymen, and apprentices." All of this led to what Gropius believed was the one place where all of the media could interact and all of the arts work cooperatively together. "The ultimate aim of all creative activity," Gropius declared, "is the building," and the name itself is derived from the German words for building (*Bau*) and house (*Haus*).

We can understand Gropius's goals if we look at Herbert Bayer's design for the cover of the first issue of *Bauhaus* magazine, which was published in 1928 (**Fig. 16-22**). Each of the three-dimensional forms—cube, sphere, and cone—casts a two-dimensional shadow. The design is marked by the letterforms Bayer employs in the masthead. This is Bayer's Universal Alphabet, which he created to eliminate what he believed to be needless typographical flourishes, including capital letters. Bayer, furthermore, constructed the image in the studio and then photographed it, relying on mechanical reproduction instead of the hand-crafted, highly individualistic medium of

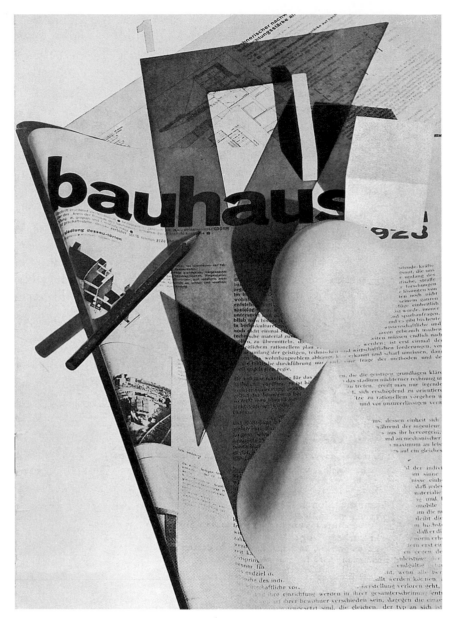

Fig. 16-22 Herbert Bayer, Cover for *Bauhaus* 1, 1928. Photomontage.
Photo: Bauhaus–Archiv, Berlin.

drawing. The pencil and triangle suggest that any drawing to be done is mechanical drawing, governed by geometry and mathematics. Finally, the story on the cover of the first issue of *Bauhaus* is concerned with architecture, to Gropius the ultimate creative activity.

Streamlining

Even as the geometry of the machine began to dominate design, finding particular favor among the architects of the International Style (see Chapter 15), in the ebb and flow between the organic and the geometric that dominates design history, the organic began to flow back into the scene as a result of advances in

scientific knowledge. In 1926, the Daniel Guggenheim Fund for the Promotion of Aeronautics granted $2.5 million to the Massachusetts Institute of Technology, the California Institute of Technology, the University of Michigan, and New York University to build wind tunnels. Designers quickly discovered that by eliminating extraneous detail on the surface of a plane, boat, automobile, or train, and by rounding its edges so that each subform merged into the next by means of smooth transitional curves, air would flow smoothly across the surface of the machine. Drag would thereby be dramatically reduced, and the machine could move faster with less expenditure of energy. "Streamlining" became the transportation cry of the day.

The nation's railroads were quickly redesigned to take advantage of this new technological information. Since a standard train engine would expend 350 horsepower more than a streamlined one operating at top speed, 70 to 110 mph, streamlining would increase pulling capacity by 12 percent. It was clearly economical for the railroads to streamline.

At just after 5 o'clock on the morning of May 26, 1934, a brand new streamlined train called the Burlington Zephyr (**Fig. 16-23**) departed Union Station in Denver bound for Chicago. Normally, the 1,015-mile trip took 26 hours, but this day, averaging 77.61 miles per hour and reaching a top speed of 112 miles per hour, the Zephyr arrived in Chicago in a mere 13 hours and 5 minutes. The total fuel cost for the haul, at 5¢ per gallon, was only $14.64. When the train arrived later that same evening at the Century of Progress Exposition on the Chicago lakefront, it was mobbed by a wildly enthusiastic public. If the railroad was enthralled by the streamlined train's efficiency, the public was captivated by its speed. It was, in fact, through the mystique of speed that the Burlington Railroad meant to recapture dwindling passenger revenues. Ralph Budd, president of the railroad, deliberately chose not to paint the Zephyr's stainless steel sheath. To him it signified "the motif of speed" itself.

But the Zephyr was more than its sheath. It weighed one-third less than a conventional train, and its center of gravity was so much lower that it could take curves at 60 miles per hour that a normal train could only negotiate at 40. Because regular welding techniques severely damaged stainless steel, engineers had invented and patented an electric welding process to join its stainless steel parts. All in all, the train became the symbol of a new age. After its trips to Chicago, it traveled more than 30,000 miles, visiting 222 cities. Well over 2 million people paid a dime each to tour it, and millions more viewed it from the outside. Late in the year, it became the feature attraction of a new film, *The Silver Streak*, a somewhat improbable drama about a high-speed train commandeered to deliver iron lungs to a disease-stricken Nevada town.

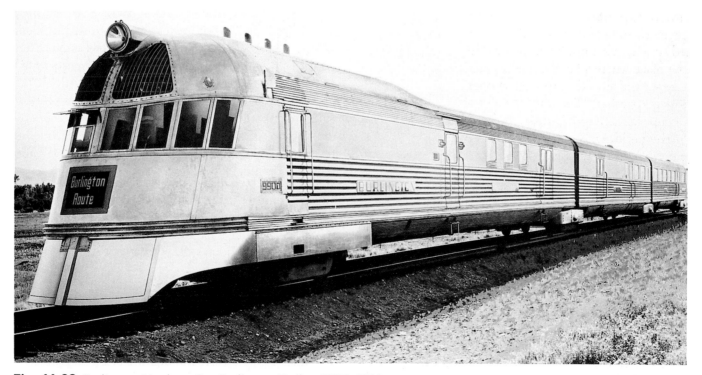

Fig. 16-23 Burlington Northern Co., Burlington Zephyr #9900, 1934.
© Bettmann/CORBIS.

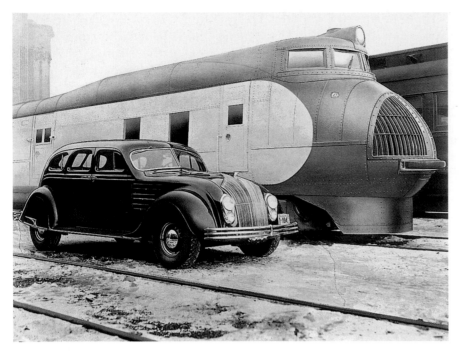

Fig. 16-24 Chrysler Airflow 4-door sedan, 1934.
Daimler Chrysler Historical Collection, Detroit, Michigan.
Courtesy of Chrysler Group LLC.

Wind-tunnel testing had revealed that the ideal streamlined form most closely resembled a teardrop. A long train could hardly achieve such a shape—at best it resembled a snake. But the automobile offered other possibilities. The first production-model stream-lined car was the Chrysler Airflow (**Fig. 16-24**), which abandoned the teardrop ideal and adopted the look of the new streamlined trains. (It is pictured here with the 1934 Union Pacific Streamliner.) The man who inspired Chrysler to develop the automobile was Norman Bel Geddes. Bel Geddes was a poster and theatrical designer when he began experiment-ing, in the late 1920s, with the design of planes, boats, automobiles, and trains—things he thought of as "more vitally akin to life today than the theatre." After the stock market crash in 1929, his staff of 20 engineers, architects, and draftsmen found themselves with little or nothing to do, so Bel Geddes turned them loose on a series of imaginative projects, including the challenge to dream up some way to transport "a thousand luxury lovers from New York to Paris fast. Forget the limitations." The specific result was his

Fig. 16-25 Norman Bel Geddes, with Dr. Otto Koller, *Air Liner Number 4*, 1929.
Norman Bel Geddes Collection, Theatre Arts Collection, Harry Ransom Humanities Research Center, The University of Texas at Austin.
Courtesy of Edith Lutyens Bel Geddes, Executrix.

Air Liner Number 4 (**Fig. 16-25**), designed with the assistance of Dr. Otto Koller, a veteran airplane designer. With a wingspan of 528 feet, Bel Geddes estimated that it could carry 451 passengers and 115 crew members from Chicago to London in 42 hours. Its passenger decks in-cluded a dining room, game deck, solarium, barber shop and beauty salon, nursery, and private suites for all on board. Among the crew were a nursemaid, a physician, a mas-seuse and a masseur, wine stewards, waiters, and an orchestra.

Although Bel Geddes insisted that the plane could be built, it was the theatricality and daring of the proposal that really captured the imagination of the American pub-lic. Bel Geddes was something of a showman. In November 1932, he published a book entitled *Horizons* that included most of the experi-mental designs he and his staff had been working on since the stock market collapse. It was wildly popular. And its popularity prompted Chrysler to go forward with the Airflow. Walter P. Chrysler hired Bel Geddes to coordinate publicity for the new automobile. In one ad, Bel Geddes himself, tabbed "America's foremost industrial designer," was the spokesman, calling the Airflow "the first sincere and authentic streamlined car . . . the first real motor car." Despite this, the car was not a success. Though it drew record orders after its introduction in January 1934, the company failed to reach full production before April, by which time many orders had been withdrawn, and serious produc-tion defects were evident in those cars the company did manage to get off the line. The Airflow attracted more than 11,000 buyers in 1934, but by 1937 only 4,600 were sold, and Chrysler dropped the model.

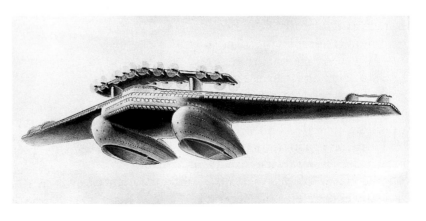

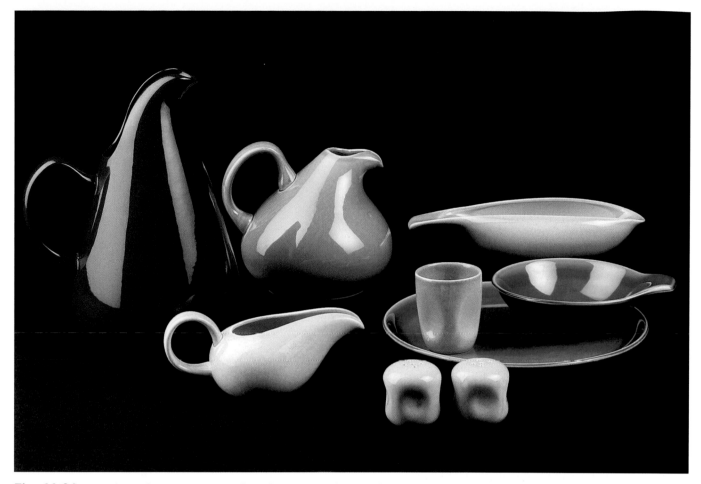

Fig. 16-26 Russel Wright, American Modern dinnerware, designed 1937, introduced 1939. Glazed earthenware. Department of Special Collections, Russel Wright papers. Syracuse University Library, Syracuse, New York.

However, streamlining had caught on, and other designers quickly joined the rush. One of the most successful American designers, Raymond Loewy, declared that streamlining was "the perfect interpretation of the modern beat." To Russel Wright, the designer of the tableware illustrated here (**Fig. 16-26**), streamlining captured the "American character." It was the essence of a "distinct American design." And it seemed as if almost everything, from pencil sharpeners to meat grinders to vacuum cleaners (**Fig. 16-27**), had to be streamlined. To be modern was to be streamlined. Even more important, to be streamlined was to be distinctly American in style. Thus, to be modern was to be American, an equation that dominated industrial and product design worldwide through at least the 1960s, until the Japanese began to dominate industrial design, especially in the electronics industry.

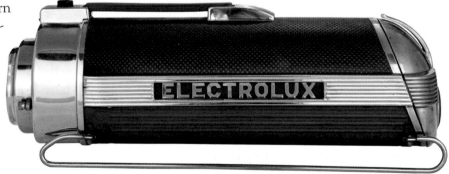

Fig. 16-27 Lurelle Guild (American, 1898–1986), Electrolux vacuum cleaner, ca. 1937.

Chromed, polished and enameled steel; cast aluminum; vinyl; rubber, $8^{1}/_2 \times 23 \times 7^{3}/_4$ in. Brooklyn Museum of Art, Gift of Fifty/50. 86.15a-f.

The Forties and Fifties

The fully organic forms of Russel Wright's "American Modern" dinnerware announced a major shift in direction away from design dominated by the right angle and toward a looser, more curvilinear style. This direction was further highlighted when, in 1940, the Museum of Modern Art held a competition titled "Organic Design in Home Furnishings." The first prize in that competition was awarded jointly to Charles Eames and Eero Saarinen, both young instructors at the Cranbrook Academy of Art in Michigan. Under the direction of the architect Eliel Saarinen, Eero's father, Cranbrook was similar in many respects to the Bauhaus, especially in terms of its emphasis on interdisciplinary work on architectural environments. It was, however, considerably more open to experiment and innovation than the Bauhaus, and the Eames-Saarinen entry in the Museum of Modern Art competition was the direct result of the elder Saarinen encouraging his young staff to rethink entirely just what furniture should be.

All of the furniture submitted to the show by Eames and Saarinen used molded plywood shells in which the wood veneers were laminated to layers of glue. The resulting forms almost demand to be seen from more than a single point of view. The problem, as Eames wrote, "becomes a sculptural one." The furniture was very strong, comfortable, and reasonably priced. Because of the war, production and distribution were necessarily limited, but in 1946, the Herman Miller Company made 5,000 units of a chair Eames designed with his wife, Ray Eames, also a Cranbrook graduate (**Fig. 16-28**). Instantly popular and still in production today, the chair consists of two molded-plywood forms that float on elegantly simple steel rods. The effect is amazingly dynamic: The back panel has been described as "a rectangle about to turn into an oval," and the seat almost seems to have molded itself to the sitter in advance.

Eero Saarinen, who would later design the TWA terminal at John F. Kennedy International Airport (see Figs. 15-43 and 15-44), took the innovations he and Eames had made in the "Organic Design in Home Furnishings" competition in a somewhat different direction. Unlike Eames, who in his 1946 chair had clearly abandoned the notion of the one-piece unit as impractical, Saarinen continued to seek a more unified design approach, feeling that it was more economical to stamp furniture from a single piece of material in a machine. His *Tulip Pedestal* furniture (**Fig. 16-29**)

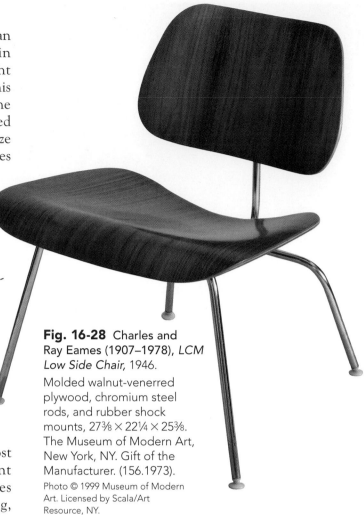

Fig. 16-28 Charles and Ray Eames (1907–1978), *LCM Low Side Chair*, 1946.
Molded walnut-venerred plywood, chromium steel rods, and rubber shock mounts, 27⅜ × 22¼ × 25⅜. The Museum of Modern Art, New York, NY. Gift of the Manufacturer. (156.1973).
Photo © 1999 Museum of Modern Art. Licensed by Scala/Art Resource, NY.

is one of his most successful solutions. Saarinen had planned to make the pedestal chair entirely out of plastic, in keeping with his unified approach, but he discovered that a plastic stem would not take the necessary strain. Forced, as a result, to make the base out of cast aluminum, he nevertheless painted it the same color as the plastic in order to make the chair appear of a piece.

The end of World War II heralded an explosion of new American design, particularly attributable to the rapid expansion of the economy, as 12 million military men and women were demobilized. New home starts rose from about 200,000 in 1945 to 1,154,000 in 1950. These homes had to be furnished, and new products were needed to do the job. Passenger car production soared from 70,000 a year in 1945 to 6,665,000 in 1950, and in the following 10 years, Americans built and sold more than 58 million automobiles. In tune with the organic look of the new furniture designs, these cars soon sported fins, suggesting both that they

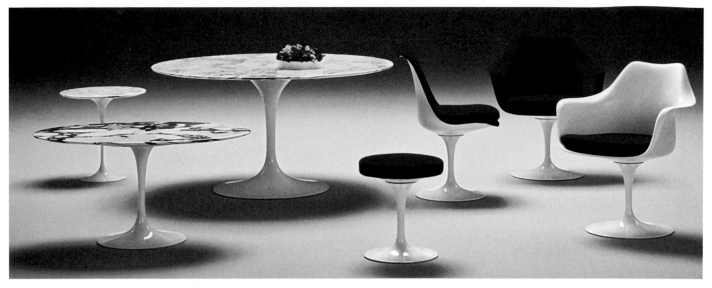

Fig. 16-29 Eero Saarinen, *Tulip Pedestal* furniture, 1955–57.
Chairs: plastic seat, painted metal base; tables: wood or marble top, plastic laminate base. Saarinen Collection designed by Eero Saarinen in 1956 and 1957.
Courtesy of Knoll Inc.

moved as gracefully as fish and that their speed was so great that they needed stabilizers. The fins were inspired by the tail fins on the U.S. Air Force's P-38 *Lightning* fighter plane (**Fig. 16-30**), which Harley Earl, chief stylist at General Motors, had seen during the war. He designed them into the 1948 Cadillac as an aerodynamic symbol. But by 1959, when the craze hit its peak, fins no longer had anything to do with aerodynamics. As the Cadillac (**Fig. 16-31**) made clear, it had simply become a matter of "the bigger, the better." And, in many ways, the Cadillac's excess defines American style in the 1950s. This was the decade that brought the world fast food (both the McDonald's hamburger and the TV dinner), Las Vegas, *Playboy* magazine, and a TV in almost every home.

Fig. 16-30 Four Lockheed P-38 *Lightning* fighters in formation, c. 1942–45.
© Museum of Flight/Corbis.

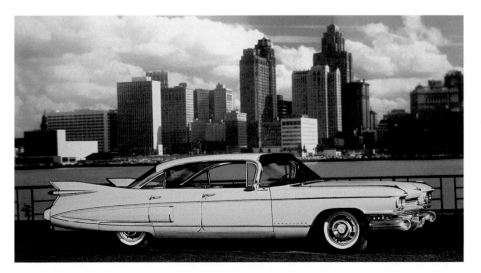

Fig. 16-31 General Motors 1959 Cadillac Fleetwood.
General Motors LLC. Used with permission, GM Media Archives.

Fig. 16-32 Chris Strach, 300 dpi color illustration of Apple computer logo with an old side and a new side, 2007. *San Jose Mercury News*, with CPT-APPLE:SJ, *San Jose Mercury News*, by Troy Wolverton.

Postmodern Design

One way to view the evolution of design since 1960 is to recognize a growing tendency to accept the splits between the organic and the geometric, and the natural and the mechanical, that dominate its history as not so much an either/or situation but as a question of both/and. In its unification of competing and contrasting elements, the Eames chair, with its contrasting steel-support structure and molded-plywood seat and back, is the bellwether of this trend.

The contemporary has been marked by a willingness to incorporate anything and everything into a given design. This is not simply a question of the organic versus the geometric. It is, even more, a question of the collisions of competing cultures of an almost incomprehensible diversity and range. On our shrinking globe, united by television and the telephone, by the fax machine and the copier, e-mail and the Internet, and especially by increasingly interdependent economies, we are learning to accept, perhaps faster than we realize, a plurality of styles. This describes the societal condition that we have come to call **postmodernism**.

What we mean when we speak of the stylistic pluralism of postmodern design is clear if we compare a traditional corporate identity package with a conspicuously postmodern one. From the Macintosh computer to the iPod, the "look" of Apple products is simple and consistent, a consistency that has been reinforced by a logo design that has remained remarkably consistent over the years. The company's very first logo, designed by founders Steve Jobs and Ronald Wayne in 1971, depicted Sir Isaac Newton sitting under an apple tree, an apple about to fall on his head. It was replaced by one designed by Rob Janoff in 1976, the famous "rainbow Apple," with a bite—perhaps a pun on "byte," the basic unit of measurement in computer information systems—taken out of its side. The image also suggests the moment in the biblical account in Genesis of Eve taking a bite out of the apple, which for better or worse resulted in humankind acquiring knowledge itself. The shape of the Apple logo has remained almost identical ever since, although, beginning in 1998, the company switched to a monochromatic look that is meant to convey a more "high-tech" feel. This shift is reflected in an illustration from the *San Jose Mercury News* (**Fig. 16-32**).

Where Apple's appeal to individual tastes lies in the variety of technological features and innovations available to each individual user, by way of contrast, the designers of Swatch watches, the Swiss husband and wife team Jean Robert and Käti Durrer, conceive of their design identities as kinetic, ever-changing variations on a basic theme (**Fig. 16-33**). In recent years, both the television and music industries have increasingly turned from producing shows and recordings designed to appeal to the widest possible audience to a concentration on appealing to more narrowly defined, specialized audiences. Television learned this lesson with the series *St. Elsewhere*, which had very low overall ratings, but which attracted large numbers of married, young, upper-middle-class professionals—yuppies—with enough disposable income to attract, in turn, major advertising accounts.

In light of this situation, it is no longer necessary to standardize a corporate identity. It may not even be desirable. Illustrated here are 8 of the approximately 300 watch designs produced by Robert and Durrer between 1983 and 1988, which were inspired by a variety of styles and cultures—from Japanese to Native American. Each watch is designed to allow the wearer's individuality to assert itself. "In 1984," Robert and Durrer recall, "we saw a gentleman sitting in the back of his Rolls Royce. We couldn't help noticing a Swatch on his wrist. That showed us how great the breakthrough had been."

Fig. 16-33 Jean Robert and Käti Durrer, Swatch watches, 1983–88.
Courtesy Swatch AG, Biel, Switzerland.

Robert and Durrer cater to an increasingly individualistic taste, a challenge to corporate identity systems, which must, simultaneously, cater to these tastes and create a recognizable corporate image. Swatch manages this by being recognizably eclectic—bright colors, outrageous designs and patterns, and so on. The interchangeability of plastic faceplates for cellular telephones imitates the Swatch model.

But perhaps nothing transformed the design profession more than the computer itself (see *The Creative Process*, pp. 412–413, for a discussion of the work of April Greiman, a graphic designer who led the way in the computer revolution). Before 1990, most graphic design curricula emphasized the importance of craftsmanship and traditional drawing skills. Computer-generated design began among a generation of younger designers who worked in almost open defiance of mainstream design itself. The personal computer, Microsoft Word, Adobe's Photoshop and InDesign, and the scanner and printer quickly supplanted the ruler, the Exacto knife, hand-drawn calligraphy, the drafting table, and the light box. The laborious pace of hand-crafted design was replaced by the speed of electronic media. Speed, in turn, allowed for greater experimentation and freedom. And within a generation, computer-literate students had revolutionized the design processes that they had inherited from their professors, who in turn were forced to catch up with the students who were fast leaving them behind.

In this context, an image can suddenly "go viral," as Shepard Fairey's poster of Barack Obama did during the 2008 election campaign (**Fig. 16-34**). Fairey was a skateboard artist and trained graphic designer who first achieved notoriety in 1989 with a street sticker campaign, *Andre the Giant Has a Posse.* Inspired by Barack Obama's 2008 presidential campaign, Fairey

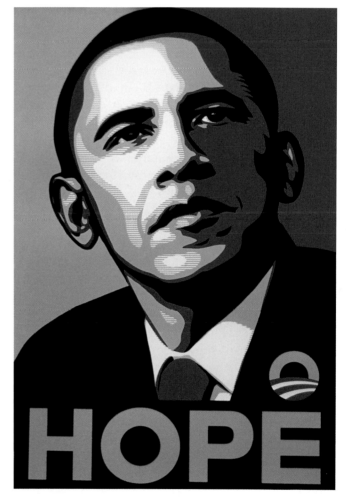

Fig. 16-34 Shepard Fairey, *Barack Obama "Hope" Poster*, 2008.
Screenprint, 36 × 24 in.
©Shepard Fairey/ObeyGiant.com.

Thinking Thematically: See Art, Politics, and Community on myartslab.com

Fig. 16-35 April Greiman, *Does It Make Sense?*, 1985.
Design Quarterly #133, Walker Art Center and MIT Press Publishers. Courtesy April Greiman.

The design career of April Greiman might best be looked at as a continual work in progress. Perhaps no other designer has more consistently recognized and utilized the possibilities offered by computer technologies for innovation in design, and, as these technologies have developed over the past 30 or 35 years, her design has developed with them.

Among her earliest works is a groundbreaking 1985 project comprising an entire issue of *Design Quarterly* entitled *Does It Make Sense?* (**Fig. 16-35**). The piece was composed and assembled as a single document on MacDraw—if not the first use in magazine production of this early vector-based drawing program, meaning one with which an object's properties and placement could be changed at any time, then certainly in 1985 by far the largest. The magazine unfolded into a life-size single-page self-portrait of a digitalized nude Greiman measuring some 2 feet by 6 feet, surrounded by images of a dinosaur and Stonehenge (on each side of her pubis), the earth rising over a lunar horizon and a cirrus cloud (on her legs), a prehistoric cave painting (floating over her breast), a brain above her head, a spiral galaxy below it, across the top, mudra-like hand gestures, and across the bottom astrological symbols. A timetable runs the length of the poster, marking the dates of such events as the invention of electricity, Greiman's birthday, and, at the bottom right, her

poster/magazine issue itself, reproduced in miniature. All deeply personal images, they announced Greiman's belief that design should "think with the heart" and reach its audience on an emotional level.

In 1985, working with MacDraw was a cumbersome process. The files were so large, and the equipment so slow, that when she quit work each evening she would send her file to the printer, and when she returned in the morning printing would just be finishing

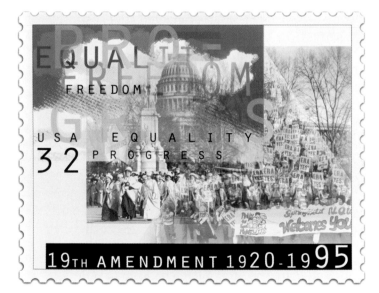

Fig. 16-36 April Greiman, *19th Amendment*, U.S. commemorative postage stamp, 1995.
© 1995 United States Postal Service. Displayed with permission. All rights reserved.

up. A decade later, when she was commissioned to design a commemorative stamp for the United States Postal Service celebrating the 75th anniversary of the 19th Amendment to the Constitution, giving women the right to vote (**Fig. 16-36**), digital technologies had advanced significantly—among other things, color had become far easier to work with. The size of Greiman's stamp is a fraction of that of the *Design Quarterly* project, but its scale is larger—larger, that is, than life-size. Time, and the eternal concepts of equality, freedom, and progress, are embedded not in a linear fashion to be read from left to right, but in layers of transparent color and light. In front of the Capitol and the Supreme Court are images of two great marches for equal rights, the first on February 28, 1913, in Washington, D.C., during the inauguration of President Woodrow Wilson, the second on May 16, 1976, when thousands of supporters of the proposed Equal Rights Amendment marched on the Illinois State Capitol.

As digital technologies have advanced into increasingly interactive modes of communication, Greiman's work has moved with them. For an example of her innovative Web design, visit the Web site of her design team, Made in Space, at http://aprilgreiman.com. Her innovative approach to book design is displayed in her 2001 *Something from Nothing*. Her fascination with digital photography and masterful sense of exhibition design were evident in a 2006 exhibition, *Drive-by Shooting*, at the Pasadena Museum of California Art, in which low-resolution digital images were blown up to large scale, creating extraordinarily rich images and color palettes that were cantilevered from the wall (**Figs. 16-37** and **16-38**), involving the viewer in their almost dizzying sense of speed and motion (see the text-and-image video of the work at http://drive-byshooting.com). "With technology today," Greiman says, "we can float ideas, text, and images in time and space."

Figs. 16-37 and 16-38 April Greiman, *Guardrail to Sevilla*, 2006, digital photograph and installation view of the exhibition *Drive-by Shooting: April Greiman Digital Photography*, Pasadena Museum of California Art, 2006.
Digital photograph, edition of 5, 42 × 56 in.
© Courtesy April Greiman.

designed and distributed the *Obama Hope* poster, at first without authorization from a campaign staff nervous about a street artist's participation in grassroots electioneering. But when all was said and done, Fairey had distributed over 300,000 stickers and 500,000 posters, and Obama had officially written to thank him for his work. "Your images have a profound effect on people, whether seen in a gallery or on a stop sign," the President wrote. Such a convergence of street art and high art is almost completely a function of mass distribution of ideas and images on the Internet. And it challenges notions of copyright and ownership as well. In fact, Associated Press photographer Mannie Garcia sued Fairey for copying his photograph of the President. The case was settled out of court.

The new computer-based design makes it possible to create imagery that might be used in a variety of media contexts. English graphic designer Chris Ede's illustration for the iTunes App store of Clear Channel (**Fig. 16-39**) digitally blends hand-drawn and photographic representations of sports and music—the two main focuses of his client. The piece works both as a still, one-frame image, as illustrated here, and as an animated Web banner (for the iheartradio section of their Web site), in which music flows from the speaker

Fig. 16-39 Chris Ede, illustration for Clear Channel Online Music & Radio (Josh Klenert, Creative Director), 2008. Courtesy of Chris Ede.

flower with iPhone petals in abstract colorful waves carrying the various graphic elements of the design. The desire of Ede's client for an image that can, as it were, transform itself from stillness into movement speaks to a change not only in design but in the very way we conceive of the human imagination. As the image increasingly manifests itself as no longer static but moving—in the video and film arts as well as Web design—perhaps the ways in which we think and create are changing as well.

THINKING BACK

✔•⎯Study and review on myartslab.com

What gave rise to design as a profession?

The people who first began, in the 1920s, to call themselves "designers," were seen as serving industry. In fact, design is so intimately tied to industry that its origins as a profession can be traced back only to the beginnings of the industrial age. What was the role of Morris & Co. in furthering the design movement? How did Art Nouveau reflect Morris's ideas?

What are some of the defining features of Art Deco?

Art Deco designers sought to give expression to everyday life in the twentieth century. They tended to prefer up-to-date materials such as chrome, steel, and Bakelite plastic. Movement toward the geometric is perhaps the defining characteristic of Art Deco. How does Edouardo Garcia Benito's 1929 cover of *Vogue* reflect the impulses of Art Deco? How did fashion express the interests of Art Deco?

What characterizes De Stijl?

The artists of De Stijl simplified the vocabulary of art and design, employing only the primary colors—red, yellow, and blue—plus black and white. Their designs relied on vertical and horizontal grids and compositions that seemed to open to the surrounding space. How does Gerrit Rietveld go against the traditional elements of the armchair in his *Red and Blue Chair*? How does De Stijl anticipate Le Corbusier's work?

What is the societal condition of postmodernism?

In an increasingly united world in the age of the Internet, we are exposed to a plurality of styles, and as a society, we are learning to accept this. The social condition of plurality is one of the hallmarks of postmodernism, and its effects can be seen in some of the design being created today. How do Jean Robert and Käti Durrer reflect the condition of postmodernism in their design of Swatch watches?

THE CRITICAL PROCESS
Thinking about Design

Like Krzysztof Wodiczko (see Figs. 3-16 and 3-17), Andrea Zittel bridges the gap between the functionality of designed objects and the creativity of artistic imagination, except that where Wodiczko creates habitats for the forgotten and the foresaken, Zittel draws attention to the ways in which the vast population of everyday working Americans create the day-to-day spaces in which they live. She has most especially addressed the cultural need for space—the seemingly unquenched thirst in American consumer society to inhabit and fill with things living spaces far larger than simple necessity might dictate. To that end, she has designed a variety of what she calls "Living Units," branding them A-Z (after her initials) as if she were a corporate giant. The idea for these "Living Units" arose when Zittel needed to maximize the space in her 200-square-foot studio in Brooklyn, New York, in 1992. Her *1994 Living Unit* (**Figs. 16-40** and **16-41**) folds up into a trunk for ease of transportation (a reflection of the fact that ours is an increasingly mobile and nomadic society). It unfolds into a space that she describes as organizing "everyday activities—eating, working, socializing, and resting—into streamlined experiences." The *Unit* itself is anything but "streamlined," but why does Zittel use the word?

What do you see as Zittel's relation to design as a profession? She has, in fact, addressed the issue: "I don't really consider myself a designer," Zittel explains, "but I think my work is about design, because its concerns interest me almost more than art issues. They're so symptomatic of the time that we live in. I'm not a designer because I don't design for the masses. I don't make products. I design experiments for myself." What design "concerns" do you think might interest Zittel most? If you were to visit the home interior store IKEA, you would find living spaces designed very much along the lines of Zittel's. Other than the fact that IKEA's spaces are "products," what else distinguishes them from her work? What role, for instance, does "personalized" design play in Zittel's work as opposed to IKEA's? What about the "uniqueness" of the design unit?

Figs. 16-40 and 16-41 Andrea Zittel, *A-Z 1994 Living Unit*, open (top); closed (bottom), 1994.

Steel, birch plywood, metal, mattress, glass, mirror, lighting fixture, stovetop, toaster oven, green velvet, and household objects, 36³/₄ × 84 × 38 in. closed.
© Andrea Zittel. Courtesy Andrea Rosen Gallery.

Thinking Thematically: See Art and the Passage of Time on myartslab.com

17

Part 4: The Visual Record:
Placing the Arts in Historical Context
The Ancient World

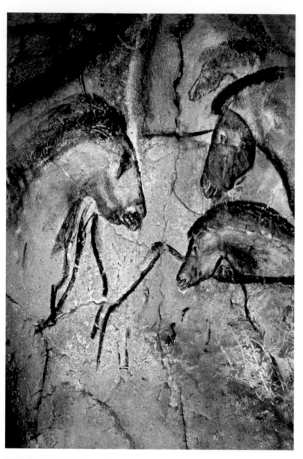

Fig. 17-1 Wall painting with three horses facing one another, Chauvet, Ardèche Gorge, France, c. 30,000 BCE.
© Ministere de la Culture et des Communication.

Thinking Thematically: See Art and Spiritual Belief on myartslab.com

THINKING AHEAD

What is a megalith?

What role did the ka play in Egyptian culture?

How did Lysippus challenge the Classical canon of proportions?

How did the ancient Romans respond to Greek art and culture?

((•—Listen to the chapter audio on myartslab.com

The following chapters are designed to help place the works of art so far discussed in *A World of Art* into a broader historical context. The brief chronological survey and illustrations trace the major developments and movements in art from the earliest to the most recent times.

The Earliest Art

Preserved in the depths of approximately fifty caves in France and Spain are thousands of wall paintings, most depicting animals—including large and powerful creatures that were rarely, if ever, hunted. The oldest known of these works, discovered in the deep recesses of the Chauvet cave in southern France, are also the most advanced in their realism, suggesting the artists'

Modern humans begin
world migration
100,000 BCE

Cave paintings in
France and Spain
30,000 BCE

120,000 BCE
Modern humans
emerge in Africa

8000 BCE
Beginnings of agriculture
in Middle East

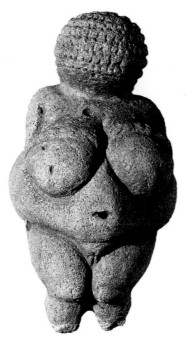

Fig. 17-2 Woman (once known as the *Venus of Willendorf*), Lower Austria, c. 25,000–20,000 BCE. Limestone, height 4½ in. Naturhistorisches Museum, Vienna.

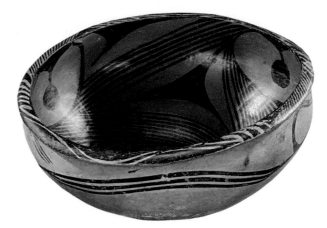

Fig. 17-3 Basin, Majiayao culture, Majiayao phase, Gansu Province, China, c. 3000–2700 BCE.
Earthenware with painted decoration, diameter 11 in. Metropolitan Museum of Art, New York. Anonymous Loan (L. 1996.55.6).
© Judith Miller/Wallis and Wallis/Dorling Kindersley.

desire to imitate the actual appearance of the animals represented. The artists have given the animals a sense of volume by using gradations of color—a technique not found in other cave paintings (**Fig. 17-1**). The artists further defined the animals' contours by scraping the wall so that the beasts seem to stand out against a deeper white background. Art, the Chauvet drawings suggest, does not evolve in a linear progression from awkward beginnings to more sophisticated representations. Apparently, from earliest times, human beings could choose to represent the world naturalistically or not, and the choice not to closely imitate reality should not necessarily be attributed to lack of skill or sophistication but to other, more culturally driven factors.

Early artists also created sculptural objects—small carved figures of people (mostly women) and animals. These reflect a more abstract and less naturalistic approach to representation, as illustrated in a limestone statuette of a woman found at Willendorf, in modern Austria (**Fig. 17-2**). Archaeologists originally named it the *Venus of Willendorf*, but its makers obviously had no knowledge of the Roman goddess). Here the breasts, belly, and genitals are exaggerated and the face lacks

defining features, suggesting a connection to fertility and child-bearing. We know, too, that the figurine was originally painted in red ochre, symbolic of menses. And, her navel is not carved; rather, it is a natural indentation in the stone. Whoever carved her seems to have recognized, in the raw stone, a connection to the origins of life. But such figures may have served other purposes as well. Perhaps they were dolls, guardian figures, or images of beauty in a cold, hostile world, where having body fat might have made the difference between survival and death.

As the Ice Age waned, around 8000 BCE, humans began to domesticate animals and cultivate food grains, practices that started in the Middle East and spread slowly across Greece and Europe for the next 6,000 years, reaching Britain last. Agriculture also developed in the southern part of China and spread to Japan and Southeast Asia; it arose independently in the Americas; and in Africa, herding, fishing, and farming communities dotted the continent. Gradually, Neolithic—or New Stone Age—peoples abandoned temporary shelters for permanent structures built of wood, brick, and stone. Religious rituals were regularized in shrines dedicated to that purpose. Crafts—pottery and weaving, in particular—began to flourish.

The Neolithic cultures that flourished along the banks of the Yellow River in China beginning in about 5000 BCE also produced large quantities of pottery (**Fig. 17-3**). These cultures were based on growing rice

Megalith construction
begins in western Europe
4000 BCE

6500 BCE

6500 BCE
Millet cultivation in Yellow River
Valley of China

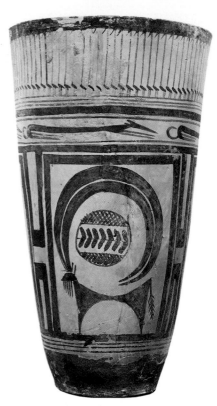

Fig. 17-4 Beaker with ibex, dogs, and long-necked birds, from southwest Iran, c. 5000–4000 BCE.
Réunion des Musées Nationaux/Art Resource, NY.

Thinking Thematically: See Art, Science, and the Environment on myartslab.com

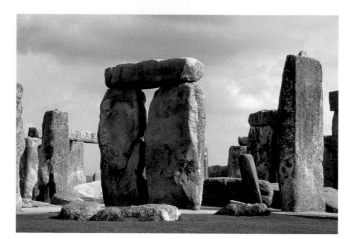

Fig. 17-5 Stonehenge, Salisbury Plain (Wiltshire), England, c. 2000 BCE.
Spencer Grant/PhotoEdit, Inc.

View the Closer Look on Stonehenge on myartslab.com

and millet (grains from the Near East would not be introduced for another 3,000 years), and this agricultural emphasis spawned towns and villages. In Gansu province, Neolithic potters began to add painted decoration to their work. The flowing, curvilinear forms painted on the shallow basin illustrated here include "hand" motifs on the outside and round, almost eye-like forms that flow into each other on the inside.

Some of the most remarkable Neolithic painted pottery comes from Susa, on the Iranian plateau. The patterns on one particular beaker (**Fig. 17-4**) from around 5000 to 4000 BCE are highly stylized animals, the largest of which is an ibex, a popular decorative feature of prehistoric ceramics from Iran. Associated with the hunt, the ibex may have been a symbol of plenty. The front and hind legs of the ibex are rendered as two triangles, the tail hangs behind it like a feather, the head is oddly disconnected from the body, and the horns rise in a large, exaggerated arc

to encircle a decorative circular form. Hounds race around the band above the ibex, and wading birds form a decorative band across the beaker's top.

In Northern Europe, especially in Britain and France, a distinctive kind of monumental stone architecture made its appearance late in the Neolithic period. Known as **megaliths**, or "big stones," these works were constructed without the use of mortar and represent the most basic form of architectural construction. Without doubt, the most famous megalithic structure in the world is a cromlech—from the Celtic *crom*, "circle," and *lech*, "place"—known as Stonehenge (**Fig. 17-5**), on the Salisbury Plain about 100 miles west of present-day London. A *henge* is a circle surrounded by a ditch with built-up embankments, presumably for fortification. The site at Stonehenge reflects four major building periods, extending from about 2750 to 1500 BCE. By about 2100 BCE, most of the elements visible today were in place.

Recently, archeologists at Stonehenge have uncovered a second cromlech-like circle at Durrington Wells, about 2 miles north of the stone megalith, consisting of a circular ditch surrounding a ring of postholes out of which very large timber posts would have risen. The circle was the center of a village consisting of as many as 300 houses. The two sites are connected by the River Avon. Archeologists speculate that Stonehenge was, in effect, one half of a huge monument complex, one half made of timber and representing the transience of life,

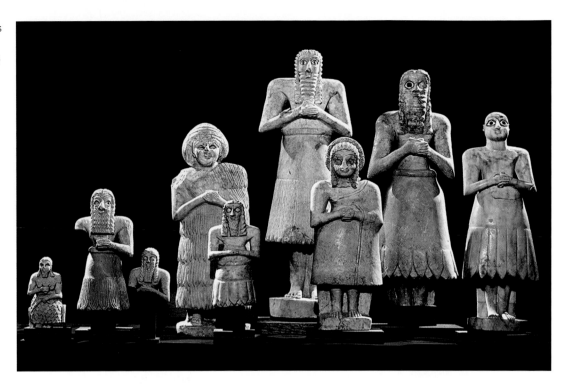

Fig. 17-6 Worshippers and deities from the Abu Temple, Tell Asmar, Iraq, c. 2900–2600 BCE.
Limestone, alabaster, and gypsum, height of tallest figure 30 in. Excavated by the Iraq Expedition of the Oriental Institute of the University of Chicago, February 13, 1934.
Courtesy Oriental Institute of the University of Chicago.

the other made of stone and signifying the eternity of ancestral life. The orientation of Stonehenge toward the rising sun at the summer solstice also indicates a connection to planting and harvest and the passing of time. The fact remains that the effort required for the construction of Stonehenge suggests that the late Neolithic peoples who built it were extremely social beings, capable of great cooperation. They worked together not only to find the giant stones that rise at the site, but also to quarry, transport, and raise them. Theirs was, in other words, a culture of some magnitude and no small skill. It was a culture capable of both solving great problems and organizing itself in the name of creating a great social center.

Mesopotamian Cultures

Between 4000 and 3000 BCE, irrigation techniques were developed on the Tigris and Euphrates rivers in Mesopotamia, allowing for more intensive agriculture and population growth. In the southern plains of Mesopotamia, a people known as the Sumerians developed writing, schools, libraries, and written laws. Ancient Sumer consisted of a dozen or more city-states, each with a population of between 10,000 and 50,000, and each with its own reigning deity. Each

of the local gods had the task of pleading the case of their particular communities with the other gods, who controlled the wind, the rain, and so on.

Communication with the god occurred in a ziggurat, a pyramidal temple structure consisting of successive platforms with outside staircases and a shrine at the top (see Fig. 15-5). An early Mesopotamian text calls the ziggurat "the bond between heaven and earth." Visitors—almost certainly limited to members of the priesthood—might bring an offering of food or an animal to be sacrificed to the resident god. Visitors often placed in the temple a statue that represented themselves in a state of perpetual prayer. We know this from inscriptions on many of the statues. One, dedicated to the goddess Tarsirsir, protector of Girsu, a city-state near the mouth of the Tigris River, reads in part, "May the statue, to which let my mistress turn her ear, speak my prayers." A group of such statues, found in the shrine room of the ziggurat at Tell Asmar, near modern Baghdad, includes seven men and two women (**Fig. 17-6**). The men wear belted, fringed skirts. The two women wear robes. They all have huge eyes, inlaid with lapis lazuli (a blue semi-precious stone) or shell. The figures clasp their hands in front of them, suggestive of prayer when empty

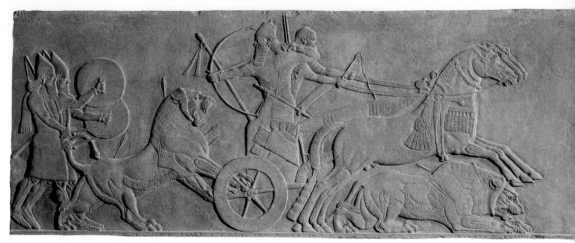

Fig. 17-8 *Assurnasirpal II Killing Lions*, from the palace complex of Assurnasirpal II, Kalhu (modern Nimrud, Iraq), c. 850 BCE.
Alabaster, height approximately 39 in. The British Museum, London.
Erich Lessing/Art Resource, NY.

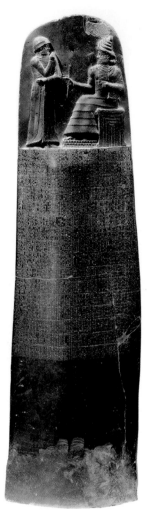

Fig. 17-7 *Stele of Hammurabi*, c. 1760 BCE.
Basalt, height of stele approximately 7 ft.; height of relief 28 in. Musée du Louvre, Paris.
Herve Lewandowski/Réunion des Musées Nationaux/Art Resource, NY.

Thinking Thematically: See Art Politics, and Community on myartslab.com

and of making an offering when holding a cup. Some scholars believe that the two tallest figures represent Abu, god of vegetation, and his consort, due to their especially large eyes, but all of the figures are probably worshippers.

One of the most influential Mesopotamian cultures was that of Babylon, which rose to power under the leadership of Hammurabi in the eighteenth century BCE. The so-called Law Code of Hammurabi is inscribed on a giant *stele*—an upright stone slab, carved with a commemorative design or inscription. It is a record of decisions and decrees made by Hammurabi (**Fig. 17-7**) over the course of some 40 years of his reign. In 282 separate "articles" which cover both sides of the basalt monument, the stele celebrates Hammurabi's sense of justice and the wisdom of his

rule. Atop the stele, Hammurabi receives the blessing of Shamash, the sun god, notable for the rays of light that emerge from his shoulders. The god is much larger than Hammurabi; in fact, he is to Hammurabi as Hammurabi is to his people. Hammurabi's Code was repeatedly copied for over a thousand years, establishing the rule of law in Mesopotamia for a millennium.

After the fall of Babylon in 1595 BCE, victim of a sudden invasion of Hittites from Turkey, only the Assyrians, who lived around the city of Assur in the north, managed to maintain a continuing cultural identity. By the time Assurnasirpal II came to power, in 883 BCE, the Assyrians dominated the entire region. Assurnasirpal II built a magnificent capital at Kalhu, on the Tigris River, surrounded by nearly 5 miles of walls, 120 feet thick and 42 feet high. A surviving inscription tells us that 69,574 people were invited by Assurnasirpal to celebrate the city's dedication. Many of its walls were decorated with alabaster reliefs, including a series of depictions of *Assurnasirpal Killing Lions* (**Fig. 17-8**). The scene depicts several consecutive actions at once: As soldiers drive the lion toward the king from the left, he shoots it.

Egyptian Civilization

At about the same time that Sumerian culture developed in Mesopotamia, Egyptian society began to flourish along the Nile River. The Nile flooded almost every

The Great River Valley Civilizations,
c. 2000 BCE.

year, leaving behind rich deposits of fertile soil that could be easily planted once the floodwater receded. The cycle of flood and sun made Egypt one of the most productive cultures in the ancient world and one of the most stable. For 3,000 years, from 3100 BCE until the defeat of Mark Antony and Cleopatra by the Roman general Octavian in 30 BCE, Egypt's institutions and culture remained remarkably unchanged. Its stability contrasted sharply with the conflicts and shifts in power that occurred in Mesopotamia.

Egyptian culture was dedicated to providing a home for the *ka*, that part of the human being that defines personality and that survives life on earth after death. The enduring nature of the *ka* required that

3000 BCE ————————————————————

Epic of Gilgamesh
written in Mesopotamia
2000 BCE

2500 BCE
Great Sphinx and
Pyramids of Gaza

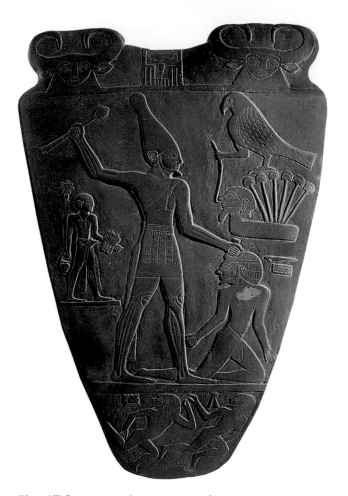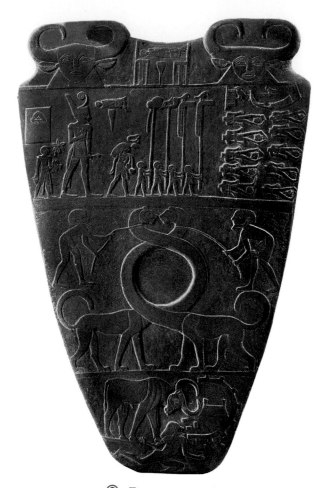

Fig. 17-9 *Palette of King Narmer* (front and back), Hierakonpolis, Upper Egypt, c. 3000 BCE.

Slate, height 25 in.

Werner Forman/Art Resource, NY.

View the Closer Look on *The Pallete of King Narmer* on myartslab.com

artisans decorate tombs with paintings that the spirit could enjoy after death. Small servant figures might be carved from wood to serve the departed in the afterlife. The *ka* could find a home in a statue of the deceased. Mummification—the preservation of the body by treating it with chemical solutions and then wrapping it in linen—provided a similar home, as did the elaborate coffins in which the mummy was placed. The pyramids (see Fig. 15-4) were, of course, the largest of the resting places designed to house the *ka*.

The enduring quality of the *ka* accounts for the unchanging way in which, over the centuries, Egyptian figures, especially the pharaohs, were represented. A canon of ideal proportions was developed that was almost universally applied. The figure is, in

effect, fitted into a grid. The feet rest on the bottom line of the grid, the ankles are placed on the first horizontal line, the knee on the sixth, the navel on the thirteenth (higher on the female), elbows on the fourteenth, and the shoulders on the nineteenth. These proportions are used in the *Palette of King Narmer* (**Fig. 17-9**), an object designed for grinding pigments and making body or eye paint. This palette was not meant for actual use but rather was a gift to a deity placed in a temple. The tablet celebrates the victory of Upper Egypt, led by King Narmer, over Lower Egypt, in a battle that united the country. Narmer is depicted holding an enemy by the hair, ready to finish him off. On the other side, he is seen reviewing the beheaded bodies of his foes. Narmer's pose is typical of Egyptian art. The lower body is in

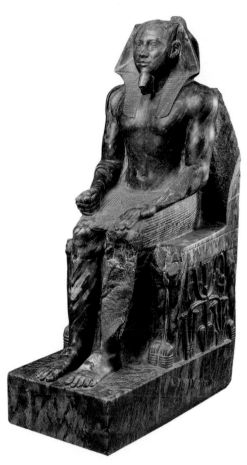

Fig. 17-10 *King Khafre*, Giza, Egypt, c. 2530 BCE.
Diorite, height 66¹/₈ in. Egyptian Museum, Cairo.
Araldo de Luca/The Egyptian Museum, Cairo/Index Ricerca Icongrafica.

with the *ka*, and introducing a form of monotheism (the worship of a single god) into polytheistic Egypt. The sun god, manifested as a radiant sun disc—the *Aten*—embodied all the characteristics of the other Egyptian deities, and thus made them superfluous. Though the traditional standardized proportions of the human body were only slightly modified, artists seemed more intent on depicting special features of the human body—hands and fingers, the details of a face. Nowhere is this attention to detail more evident than in the famous bust of Akhenaten's queen, Nefertiti (**Fig. 17-11**). Both the graceful curve of her neck and her almost completely relaxed look make for what seems to be a stunningly naturalistic piece of work, though it remains impossible to say if this is a true likeness or an idealized portrait.

profile, his torso and shoulders full front, his head in profile again, though a single eye is portrayed frontally.

The rigorous geometry governing Egyptian representation is apparent in the statue of Khafre (**Fig. 17-10**). Khafre's frontal pose is almost as rigid as the throne upon which he sits. It is as if he had been composed as a block of right angles. If it was the king's face that made his statue recognizable, it is also true that his official likeness might change several times during his reign, suggesting that the purpose of the royal sculpture was not just portraiture but also the creation of the ideal image of kingship.

For a brief period, in the fourteenth century BCE, under the rule of the Emperor Akhenaten, the conventions of Egyptian art and culture were transformed. Akhenaten declared an end to traditional Egyptian religious practices, relaxing especially the longstanding preoccupation

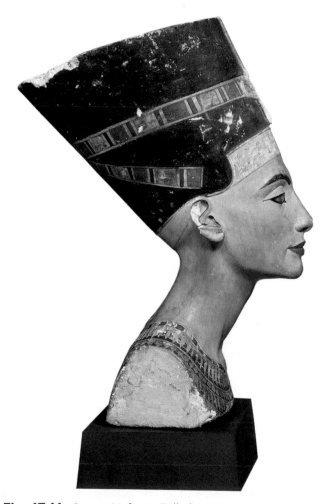

Fig. 17-11 *Queen Nefertiti*, Tell el Amarna, c. 1365 BCE.
Painted limestone, height 19⁵/₈ in. Ägyptisches Museum, Berlin.

2500 BCE

Shang dynasty, China
2000–1000 BCE

2500 BCE
Cities of Harappa and
Mohenjo-daro flourish in India

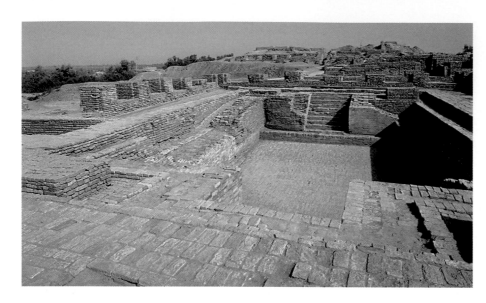

Fig. 17-12 Large water tank, possibly a public or ritual bathing area, from Mohenjo-Daro, Indus valley civilization, c. 2600–1900 BCE.

River Valley Societies of India and China

Indian civilization was born along the Indus River around 2700 BCE in an area known as Sind—from which the words India and Hindu originate. The earliest Indian peoples lived in at least two great cities in the Indus valley, Harappa and Mohenjo-daro, the better preserved of the two. Built atop a citadel is a complex of buildings, presumably a governmental or religious center, surrounded by a wall 50 feet high. Set among the buildings on the citadel is giant pool (**Fig. 17-12**). Perhaps a public bath or a ritual space, its finely fitted bricks, laid on edge and bound together with gypsum plaster, made it watertight. Outside the wall and below the citadel, a city of approximately 6 to 7 square miles, with broad avenues and narrow side streets, was laid out in a rough grid. It appears to have been home to a population of between 20,000 and 50,000. As the stone sculpture torso of a "priest-king" (**Fig. 17-13**) found at Mohenjo-daro demonstrates, the people of the city were accomplished artists. This figure, with his neatly trimmed beard is a forceful representation of a powerful personality, although his half-closed eyes suggest that this might have commemorated the figure's death.

The Indus valley civilizations began to collapse around 1800 BCE, perhaps as the result of a prolonged drought, and by 1000 BCE its cities had been abandoned. During its decline, the Vedic people, who called themselves Aryans, moved into the Indus Valley. Over time,

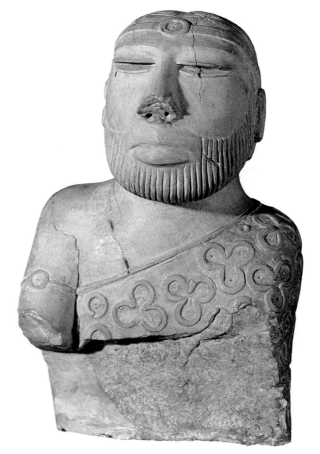

Fig. 17-13 Torso of a "priest-king," from Mohenjo-daro, Indus valley civilization, c. 200–190 BCE.
Steatite, height 7⁷/₉ in. National Museum of Pakistan, Karachi, Pakistan.
Scala/Art Resource, NY.

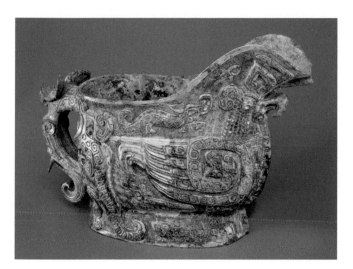

Fig. 17-14 Spouted ritual wine vessel (*Guang*), Shang dynasty, early Anyang period, (ca. 1300-ca. 1050 B.C.) 13th century BC. Bronze, H. 8½ in. (21.6 cm); W. 5¼ in. (13.3 cm); L. 13 in. (33 cm) The Metropolitan Museum of Art, New York, NY, U.S.A. Rogers Fund, 1943. 43.25.4. Photo: Lynton Gardiner. Image copyright © The Metropolitan Museum of Art. Image source: Art Resource, NY

their numbers increased and they spread cast to the Ganges River Valley as well as north and south. Their cultural heritage would provide the basis for the development of Hinduism and Hindu art, as we will see in Chapter 18.

In China, the Shang dynasty ruled the Yellow River Valley for most of the second millennium BCE, and Shang kings displayed their power with treasures made of jade, shells, bone, and lacquer. Through the manufacture of ritual vessels, such as the *guang*, or wine vessel, illustrated here (**Fig. 17-14**), the Shang devleoped an extremely sophisticated bronze-casting technology, as advanced as any ever used. Coiled serpents emerge from the vessel's wings, with tiger-dragons just above them. Serving as a handle is a horned bird that is transformed into a dragon-serpent—all figures symbolizing royal authority and strength. Made for offerings of food, water, and wine during ceremonies of ancestor worhip, these bronze vessels were kept in the ancestral hall and brought out for banquets. Like formal dinnerware, each type of vessel had a specific shape and purpose.

Complex Societies in the Americas

As early as 1500 BCE, a group known as the Olmec came to inhabit most of the area that we now refer to as Mesoamerica, from the southern tip of Mexico to

Honduras and El Salvador. They built huge ceremonial precincts in the middle of their communities and developed many of the characteristic features of later Mesoamerican culture, such as pyramids, ball courts, mirror-making, and a calendar system.

The Olmec built their cities on great earthen platforms, probably designed to protect their ceremonial centers from rain and flood. On these platforms, they erected giant pyramidal mounds, where an elite group of ruler-priests lived, supported by the general population that farmed the rich, sometimes swampy land that surrounded them. These pyramids may have been an architectural reference to the volcanoes that dominate Mexico, or they may have been tombs. Excavations may eventually tell us. At La Venta, very near the present-day city of Villahermosa, three colossal stone heads stood guard over the ceremonial center on the south end of the platform (**Fig. 17-15**), and a fourth

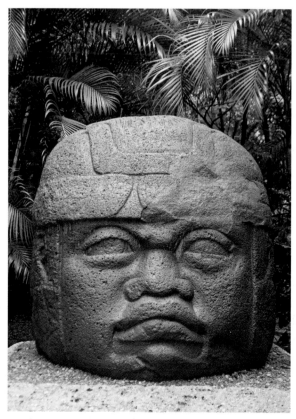

Fig. 17-15 Colossal head, Olmec culture, c. 900–500 BCE. Basalt, height 7 ft. 5 in. La Venta Park, Villahermosa, Tabasco, Mexico.
Carlos S. Pereya/Age Fotostock.

1200 BCE ──────

Decline of Mycenaean and
Minoan civilizations
1200 BCE

c. 1000 BCE
Agriculture practiced in village
communities in American Southwest

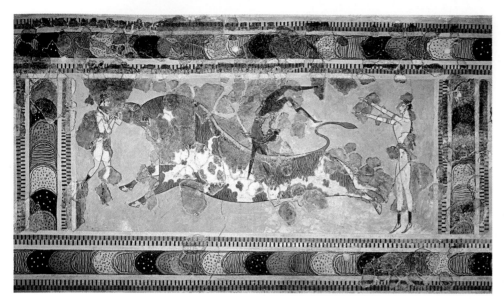

Fig. 17-16 The *"Toreador"* fresco, Knossos, Crete, c. 1500 BCE. Height, including upper border, approximately 24½ in. Archaeological Museum, Iraklion, Crete.
Archeological Museum, Iraklion, Crete/ Studio Kontos Photostock

guarded the north end by itself. Each head weighs between 11 and 24 tons, and each bears a unique emblem on its headgear, which is similar to old-style American leather football helmets. At other Olmec sites—San Lorenzo, for instance—as many as eight of these heads have been found, some up to 12 feet tall. They are carved of basalt, although the nearest basalt quarry is 50 miles to the south in the Tuxtla Mountains. They were evidently at least partially carved at the quarry, then loaded onto rafts and floated downriver to the Gulf of Mexico before going back upriver to their final positions. The stone heads are generally believed to be portraits of Olmec rulers, and they all share the same facial features, including wide, flat noses and thick lips. They suggest that the ruler was the culture's principal mediator with the gods, literally larger than life.

Aegean Civilizations

Impressive centers of power and wealth also appeared in the eastern Mediterranean, particularly those of the Minoan civilization on the island of Crete and the Mycenae on the Greek Peloponnesus, the southern peninsula of Greece. The origin of the Minoans is unclear—they may have arrived on the island as early as 6000 BCE—but their culture reached its peak between 1600 and 1400 BCE. The so-called *"Toreador"* fresco (**Fig. 17-16**) does not actually depict a bullfight, as its modern title suggests. Instead, a youthful acrobat can be seen vaulting over the bull's back as one maiden holds

the animal's horns and another waits to catch him (traditionally, as in Egyptian art, women are depicted with light skin, men with a darker complexion). The three almost nude figures appear to be toying with a charging bull in what may be a ritual activity, connected perhaps to a rite of passage, or in what may simply be a sporting event, designed to entertain the royal court.

In Minoan culture, the bull was an animal of sacred significance. Legend has it that the wife of King Minos, after whom the culture takes its name, gave birth to a creature half-human and half-bull—the Minotaur. Minos

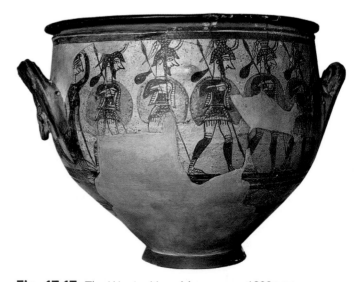

Fig. 17-17 *The Warrior Vase,* Mycenae, c. 1200 BCE. Height approximately 14 in. National Museum, Athens.
Scala/Art Resource, NY.

Rule of the
Hebrew King, David
960–933 BCE

c. 800 BCE
Homer writes
Iliad and *Odyssey*

700 BCE

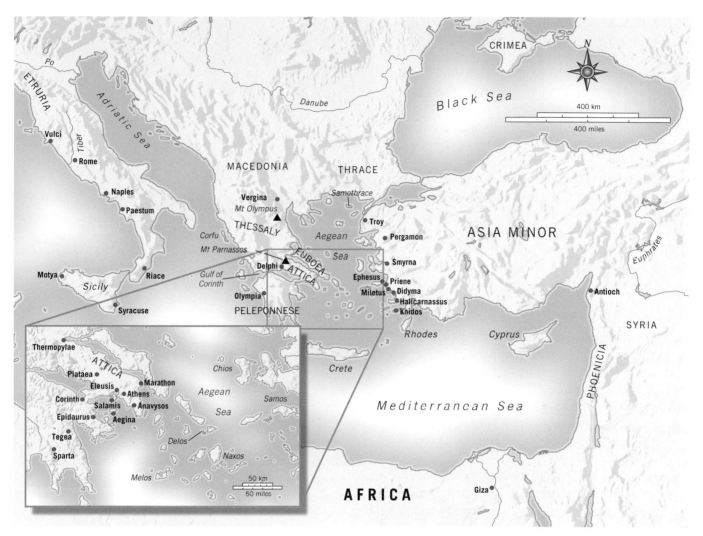

The City-States of Ancient Greece.

had a giant labyrinth, or maze, constructed to house the creature, to whom Athenian youths and maidens were sacrificed until it was killed by the hero Theseus. The legend of the labyrinth probably arose in response to the intricate design of the palaces built for the Minoan kings.

It is unclear why Minoan culture abruptly ended in approximately 1450 BCE. Great earthquakes and volcanic eruptions may have destroyed the civilization, or perhaps it fell victim to the warlike Mycenaeans from the mainland, whose culture flourished between 1400 and 1200 BCE. Theirs was a culture dominated by military values. In *The Warrior Vase* (**Fig. 17-17**), we see Mycenaean soldiers marching to war, perhaps to meet the Dorian invaders who destroyed their civilization soon after 1200 BCE. The Dorian weapons were made of iron and therefore were superior to the softer bronze Mycenaean spears. It is this culture, immortalized by Homer in the *Iliad* and the *Odyssey*, that sacked the great Trojan city of Troy. The Mycenaeans built stone fortresses on the hilltops of the Peloponnesus (see Fig. 15-9). They buried their dead in so-called beehive tombs, which, dome-shaped, were full of gold and silver, including masks of the royal dead, a burial practice similar to that of the Egyptians.

Greek Art

In about 1200 BCE, just after the fall of Mycenae, the Greek world consisted of various tribes separated by the geographical features of the peninsula, with its

700 BCE

Confucius in China
551–479 BCE

623–543 BCE
Buddha in India

539 BCE
Cyrus the Great establishes
the Persian Empire

deep bays, narrow valleys, and jagged mountains (see the map of Greece and its city-states above). These tribes soon developed into independent and often warring city-states, with their own constitutions, coinage, and armies. We know that in 776 BCE these feuding states declared a truce in order to hold the first Olympic games, a moment so significant that the Greeks later took it as the starting point of their history.

The rise of the Greek city-state, or *polis*, marks the moment when Western culture begins to celebrate its own human strengths and powers—the creative genius of the mind itself—over the power of nature. The Western world's gods now became personified, taking human form and assuming human weaknesses. Though immortal, they were otherwise versions of ourselves, no longer angry beasts or natural phenomena such as the earth, the sun, or the rain. In fact, if their gods looked and acted like people, that is because the Greeks were great students of human behavior and of the human form as well, which they portrayed in highly naturalistic detail. By the fifth century BCE, this interest in all aspects of the human condition was reflected throughout Greek culture. The physician Hippocrates systematically studied human disease, and the historian Herodotus, in his account of the Persian Wars, began to chronicle human history. Around 500 BCE in Athens, all free male citizens were included in the political system, and democracy—from *demos*, meaning "people," and *kratia*, meaning "power"—was born. It was not quite democracy as we think of it today: Slavery was considered natural, and women were excluded from political life. Nevertheless, the concept of individual freedom was cherished. And by the fourth century BCE, the philosopher Plato had developed theories not only about social and political relations but also about education and aesthetic pleasure.

The values of the Greek city-state were embodied in its temples. The temple was usually situated on an elevated site above the city, and the **acropolis**, from *akros*, meaning "top," and *polis*, "city," was conceived as the center of civic life. The crowning achievement of Greek architecture is the complex of buildings on the Acropolis in Athens (**Fig. 17-18**), which was built to replace those destroyed by the Persians in 480 BCE. Construction began in about 450 BCE under the leadership of the

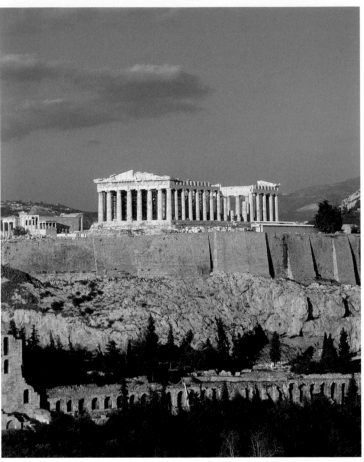

Fig. 17-18 The Acropolis, Athens, Greece, rebuilt in the second half of the 5th century BCE.
Marie Mauzy.

Thinking Thematically: See **Art and Beauty** on myartslab.com

great Athenian statesman Pericles. The central building of the new complex, designed by Iktinos and Kallikrates, was the Parthenon, dedicated to the city's namesake, Athena Parthenos, the goddess of wisdom. A Doric temple of the grandest scale, it is composed entirely of marble. At its center was an enormous ivory and gold statue of Athena, sculpted by Phidias, who was in charge of all the ornamentation and sculpture for the project. The Athena is long since lost, and we can imagine his achievement only by considering the sculpture on the building's pediment (see Fig. 13-12) and its friezes, all of which reflect Phidias's style and maybe his design.

The Phidian style is marked by its naturalness. The human figure often assumes a relaxed, seemingly effortless pose, or it may be caught in the act of movement, athletic or casual. In either case, the precision

Great age of Etruscan
bronze-making
500–250 BCE

400 BCE

509 BCE
Foundation of
Roman Republic

500–300 BCE
Golden Age of Greece

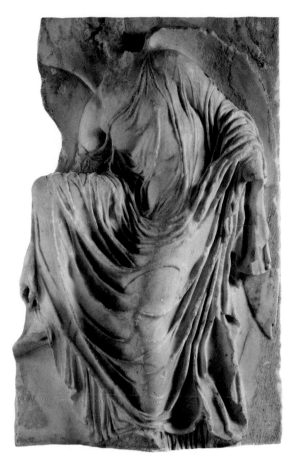

Fig. 17-19 *Nike*, from the balustrade of the Temple of
Athena Nike, c. 410–407 BCE. Marble, height 42 in.
Acropolis Museum, Athens, Greece.
Nimatallah/Art Resource, N.Y.

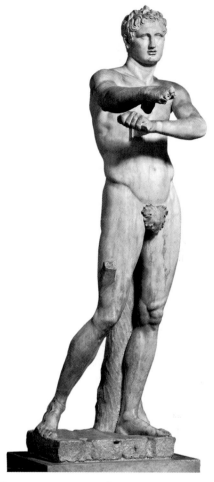

Fig. 17-20 *Apoxyomenos* (*The Scraper*), Roman copy of
an original Greek bronze by Lysippus, c. 350–325 BCE.
Marble, height 6 ft. 8½ in. Vatican Museums & Galleries, Rome.
Scala/Art Resource, NY.

with which the anatomy has been rendered is remark-
able. The relief of Nike (**Fig. 17-19**), goddess of victory,
from the balustrade of the Temple of Athena Nike on
the Acropolis in Athens, is a perfect example of the
Phidian style. As Nike bends to take off her sandal, the
drapery both reveals and conceals the body beneath.
Sometimes appearing to be transparent, sometimes
dropping in deep folds and hollows, it contributes
importantly to the sense of reality conveyed by the
sculpture. It is as if we can see the body literally push
forward out of the stone and press against the drapery.

The Greek passion for individualism, reason, and
accurate observation of the world continued even after
the disastrous defeat of Athens in the Peloponnesian
War in 404 BCE, which led to a great loss of Athenian
power. In 338 BCE, the army of Philip, King of Macedon,
conquered Greece, and after Philip's death two years

later, his son, Alexander the Great, came to power.
Because Philip greatly admired Athenian culture,
Alexander was educated by the philosopher Aristotle,
who persuaded the young king to impose Greek
culture throughout his empire. **Hellenism**, or the cul-
ture of Greece, thus came to dominate the Western
world. The court sculptor to Alexander the Great was
Lysippus, known to us only through later Roman copies
of his work. Lysippus challenged the Classical canon of
proportion created by Polyclitus (see Fig. 8-23), creat-
ing sculptures with smaller heads and slenderer bod-
ies that lent his figures a sense of greater height. In a
Roman copy of a lost original by Lysippus known as the
Apoxyomenos (**Fig. 17-20**), or *The Scraper*, an athlete re-
moves oil and dirt from his body with an instrument

| Death of Socrates | | Death of Aristotle |
| 399 BCE | | 322 BCE |

400 BCE

336–323 BCE
Conquests of
Alexander the Great

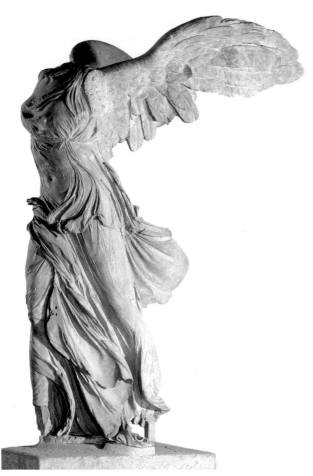

Fig. 17-21 *Nike of Samothrace*, c. 190 BCE.
Marble, height approximately 8 ft. Musée du Louvre, Paris.
Réunion des Musées Nationaux/Art Resource, NY.

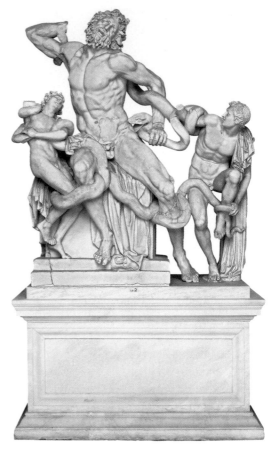

Fig. 17-22 *The Laocoön Group*, Roman copy, perhaps after Agesander, Athenodorus, and Polydorus of Rhodes, first century CE.
Marble, height 7 ft. The Vatican Museum, Rome.
Scala/Art Resource, NY.

Thinking Thematically: See Art and the Passage of Time on myartslab.com

called a *stirgil*. He seems detached from his circumstances, as if recalling his victory, both physically and mentally uncontained by the space in which he stands.

In the sculpture of the fourth century BCE, we discover a graceful, even sensuous, beauty marked by *contrapposto* and three-dimensional realism (see Fig. 13-11). The depiction of physical beauty becomes an end in itself, and sculpture increasingly seems to be more about the pleasures of seeing than anything else. At the same time, artists strove for an ever-greater degree of realism, and in the sculpture of the Hellenistic Age, we find an increasingly animated and dramatic treatment of the figure. The *Nike of Samothrace* (**Fig. 17-21**) is a masterpiece of Hellenistic realism. The goddess has been depicted as she alights on the prow of a victorious war galley, and one can almost feel the wind as it buffets her, and the

surf spray that has soaked her garment so that it clings revealingly to her torso.

The swirl of line that was once restricted to drapery overwhelms the entire composition of *The Laocoön Group* (**Fig. 17-22**), in which Laocoön, a Trojan priest, and his two sons are overwhelmed by serpents sent by the sea-god Poseidon. We are caught in the midst of the Trojan War. The Greeks have sent the Trojans a giant wooden horse as a "gift." Inside it are Greek soldiers, and Laocoön suspects as much. And so Poseidon, who favors the Greeks, has chosen to silence Laocoön forever. So theatrical is the group that to many eyes it verges on melodrama, but its expressive aims are undeniable. The sculptor is no

| Silk Road begins to connect lands of Asia **300 BCE** | **260 BCE** Archimedes lays the foundations of calculus | **265 BCE** |

300 BCE
Euclid establishes the basic principles of geometry

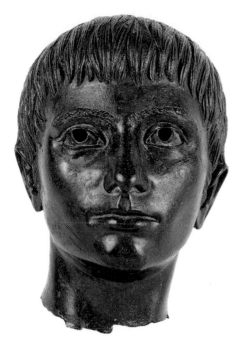

Fig. 17-23 *Portrait of a Boy*, early third century BCE. Bronze, height 9 in. Museo Archeologico Nazionale, Florence.
Nicolo Orsi Battaglini/Ikona

longer content simply to represent the figure realistically; sculpture must convey emotion as well.

Roman Art

Although the Romans conquered Greece (in 146 BCE), like Philip of Macedon and Alexander, they regarded Greek culture and art as superior to any other. Thus, like the Hellenistic Empire before it, the Roman Empire possessed a distinctly Greek character. The Romans imported thousands of original Greek artworks and had them copied in even greater numbers. In fact, much of what we know today about Greek art we know only through Roman copies. The Greek gods were adapted to the Roman religion, Jupiter bearing a strong resemblance to Zeus, Venus to Aphrodite, and so on. The Romans used the Greek architectural orders in their own buildings and temples, preferring especially the highly decorative Corinthian order. Many, if not most, of Rome's artists were of Greek extraction, though they were "Romanized" to the point of being indistinguishable from the Romans themselves.

Roman art derives, nevertheless, from at least one other source. Around 750 BCE, at about the same time

the Greeks first colonized the southern end of the Italian peninsula, the Etruscans, whose language has no relation to any known tongue, and whose origin is somewhat mysterious, established a vital set of city-states in the area between present-day Florence and Rome. Little remains of the Etruscan cities, which were destroyed and rebuilt by Roman armies in the second and third centuries BCE, and we know the Etruscans' culture largely through their sometimes richly decorated tombs. At Veii, just north of Rome, the Etruscans established a sculptural center that gave them a reputation as the finest metalworkers of the age. They traded widely, and from the sixth century on, a vast array of bronze objects, from statues to hand mirrors, were made for export. Etruscan art was influenced by the Greeks, as the life-size head of the bronze statue (**Fig. 17-23**), with its almost melancholy air, makes clear.

The Romans traced their ancestry to the Trojan prince Aeneas, who escaped after the sack of Troy and who appears in Homer's *Iliad*. The city of Rome itself was founded early in Etruscan times—in 753 BCE, the Romans believed—by Romulus and Remus, twins nurtured by a she-wolf (**Fig. 17-24**). Though Romulus and Remus are Renaissance additions to the original Etruscan bronze, the image served as the totem of the city of Rome from the day on which a statue of a she-wolf, possibly this very one, was dedicated on the

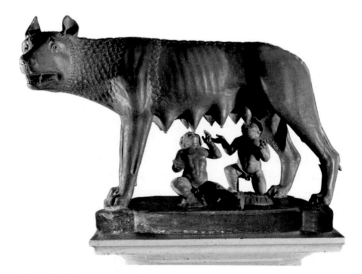

Fig. 17-24 *She-Wolf*, c. 500 BCE. Bronze, height 33½ in. Museo Capitolino, Rome.
Erich Lessing/Art Resource, NY.

265 BCE

Kushite Empire of Africa reaches its pinnacle
c. 250 BCE

Rome rules entire Mediterranean, after defeat of Carthage
146 BCE

265 BCE
Roman Republic rules all of Italy

44–14 BCE
End of Roman Republic, rule of Augustus

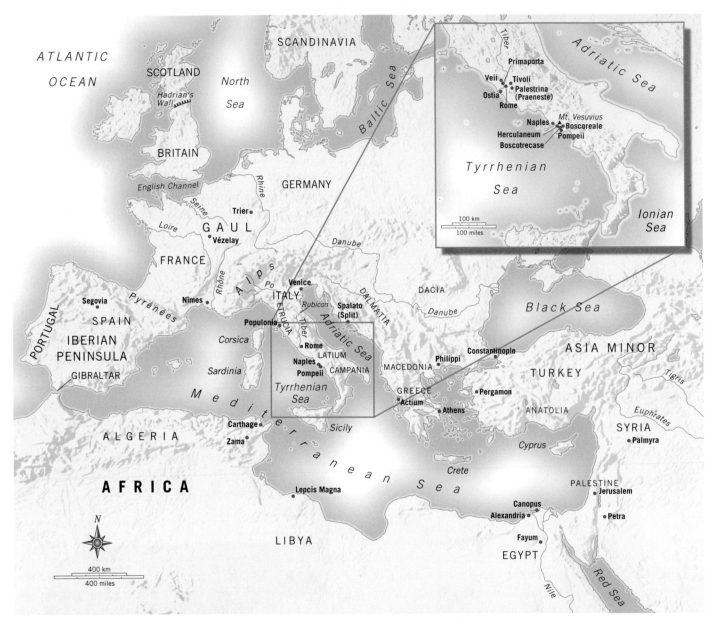

The Roman Empire at Its Greatest Extent, c. 180 CE.

Capitoline Hill in Rome in 296 BCE. The she-wolf reminded the Romans of the fiercely protective loyalty and power of their motherland.

Beginning in the fifth century BCE, Rome dedicated itself to conquest, eventually creating an empire that included all areas surrounding the Mediterranean and that stretched as far north as present-day England (see the map of the Roman Empire above). By the time the Romans conquered Greece, their interest in the accurate portrayal of human features was long established, and Hellenistic art only supported this tendency. A great ruler was fully capable of idealizing himself as a near-deity, as is evident in the *Augustus of Primaporta* (**Fig. 17-25**), so known because it was discovered at the home of Augustus's wife, Livia, at Primaporta, on the outskirts of Rome. The pose is directly indebted to the *Doryphoros* (*Spear Bearer*) of Polyclitus (see Fig. 8-23). The extended arm points

Romans destroy the
Hebrew Temple in Jerusalem
70

30
Crucifixion of Jesus

180
Pax Romana begins
to break down

200 CE

CE

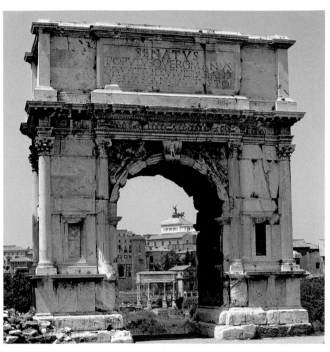

Fig. 17-26 The Arch of Titus, Rome, c. 81 CE.
Concrete with marble facade, height 50 ft., width 44 ft. 4 in.
Michael Larvey/Canali Photobank, Milan, Italy.

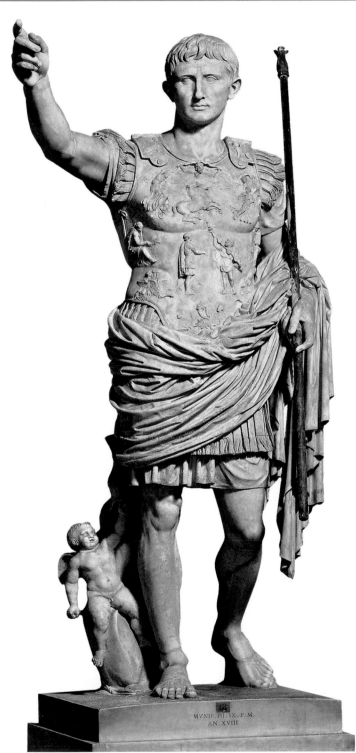

Fig. 17-25 *Augustus of Primaporta*, c. 20 BCE.
Marble, height 6 ft. 8 in. Vatican Museums & Galleries, Rome.
Vatican Museums & Galleries, Vatican City/Superstock.

Thinking Thematically: See Art, Politics, and Community
on myartslab.com

toward an unknown, but presumably greater, future. The military garb announces Augustus's role as commander in chief. The small Cupid riding a dolphin at his feet makes claim to Augustus's divine descent from Venus.

The perfection of the arch and dome and the development of structural concrete were, as we have seen in Part 3, the Romans' major architectural contributions. But they were also extraordinary monument builders. Upon the death of the emperor Titus, who defeated rebellious Jews in Palestine and sacked the Second Temple of Jerusalem in 70 CE, his brother, Domitian, constructed a memorial arch at the highest point on the Sacred Way in Rome to honor his victory (**Fig. 17-26**). Originally, this Arch of Titus was topped by a statue of a four-horse chariot and driver. Such **triumphal arches**, as they were called since triumphant armies marched through them, composed of a simple barrel vault enclosed within a rectangle, and enlivened with sculpture and decorative engaged columns, would deeply influence later architecture of the Renaissance, especially the facades of Renaissance cathedrals.

200 BCE ——————————————————— 323 CE

313 CE
The Edict of Milan grants religious freedom to
all and ends persecution of Christians

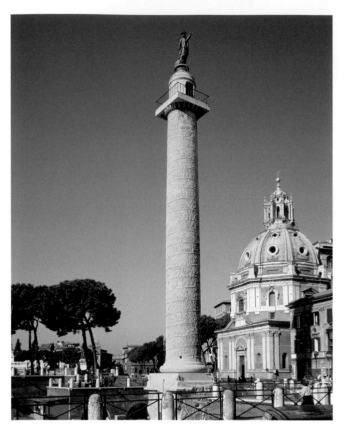

Fig. 17-27 Attributed to Apollodorus, Column of Trajan, Rome, 113 CE.

Marble, height originally 128 ft., length of frieze approximately 625 ft.

© Corbis Bridge/Alamy.

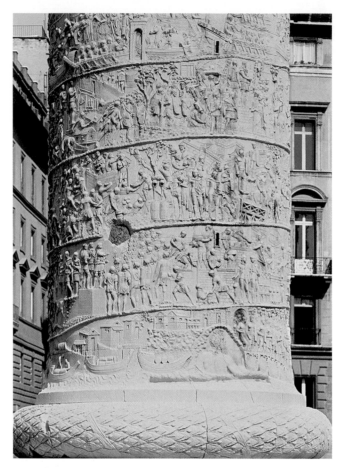

Fig. 17-28 Attributed to Apollodorus, Lower portion of the Column of Trajan, Rome, 113 CE.

Scala/Art Resource, NY.

View the Closer Look on the Column of Trajan on myartslab.com

Another remarkable symbol of Roman power is the Column of Trajan (**Figs. 17-27** and **17-28**). Encircled by a spiraling band of relief sculpture 50 inches high and, if it were unwound and stretched out, 625 feet long, the column details the Emperor Trajan's two successful campaigns in present-day Hungary and Romania in the first century BCE. The 150 separate episodes celebrate not only military victories, but Rome's civilizing mission as well.

As the empire solidified its strength under the Pax Romana—150 years of peace initiated by the Emperor Augustus in 27 BCE—a succession of emperors celebrated the glory of the empire in a variety of elaborate public works and monuments, including the Colosseum and the Pantheon (see Figs. 15-15 and 15-17). By the first century CE, Rome's population approached 1 million, with most of its inhabitants living in apartment buildings (an archival record indicates

that, at this time, there were only 1,797 private homes in the city). They congregated daily at the Forum, a site originally developed by the Etruscans as a marketplace, but in a plan developed by Julius Caesar and implemented by Augustus, a civic center symbolic of Roman power and grandeur, paved in marble and dominated by colonnaded public spaces, temples, basilicas, and state buildings such as the courts, the archives, and the *Curia*, or senate house.

Though Rome became extraordinarily wealthy, the empire began to falter after the death of the emperor Marcus Aurelius in 180 CE. Invasions of Germanic tribes from the north, Berbers from the south, and Persians from the east wreaked havoc upon the Empire's economic, administrative, and military

600 BCE —— **250 BCE** ——

c. 500–200 BCE
Rise of Taoist and Legalist schools
of thought in China

300 BCE
Cast iron is produced
in China

250 BCE
The crossbow is invented
in China

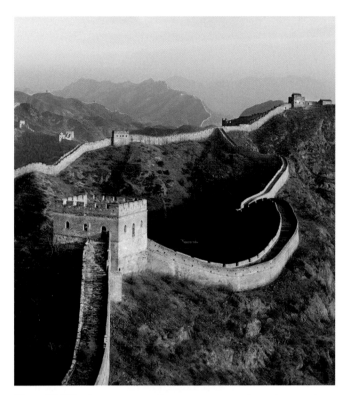

Fig. 17-29 The Great Wall, near Beijing, China, begun late 3rd century BCE.
Steve Bloom Images/Alamy.

structure. By the time the Emperor Constantine decided to move the capital to Byzantium in 323 CE—renaming it Constantinople, today's Istanbul—the empire was hopelessly divided, and the establishment of the new capital only underscored the division.

Developments in Asia

At about the same time that Rome began establishing its imperial authority over the Mediterranean world, one of several warring states in China, the Qin (the origin of our name for China), conquered the other states and unified them under the leadership of Qin Shihuangdi, who declared himself "First Emperor" in 221 BCE. The Qin worked very quickly to achieve a stable society. To discourage nomadic invaders from the north, they built the Great Wall of China (**Fig. 17-29**). The wall was constructed by soldiers, augmented by criminals, civil servants who found themselves in disfavor, and conscripts from across the countryside. Each family was required to provide one able-bodied adult male to work on the wall each year. It was made of rammed earth, reinforced by

continuous horizontal courses of brushwood, and faced with stone. Watchtowers were built at high points, and military barracks were built in the valleys below. At the same time, the Chinese constructed nearly 4,350 miles of roads, linking even the farthest reaches of the country to the Central Plain. By the end of the second century CE, China had some 22,000 miles of roads serving a country of nearly 1.5 million square miles.

Soon after the death of Qin Shihuangdi, whose tomb was another massive undertaking (see Fig. 13-16), the Qin collapsed and the Han dynasty came to power, inaugurating over 400 years of intellectual and cultural growth. What we know of everyday life in Han society comes mostly from surviving poetry, but our understanding of domestic architecture derives from ceramic models such as the model of a house found in a tomb, presumably for use of the departed in the afterlife (**Fig. 17-30**).

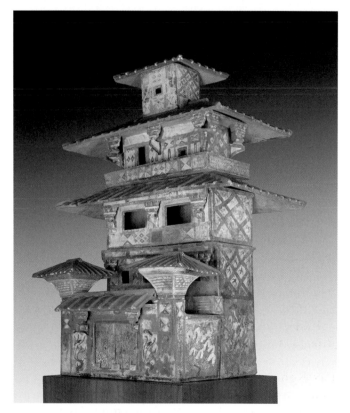

Fig. 17-30 Model of a Multi-Storied Tower, Chinese, Eastern Han Dynasty, first century CE.
Earthenware with unfired pigments, 52 × 33¹/₂ × 27 in. (132.1 × 85.1 × 68.6 cm) The Nelson-Atkins Museum of Art, Kansas City, Missouri. Purchase William Rockhill Nelson Trust. 33-521.
Photo credit: John Lamberton.

Kushite Empire of Africa
reaches its pinnacle
c. 250 BCE

Ch'in Emperor unites
all of China
221 BCE

250 BCE

c. 256–206 BCE
Original Great Wall
of China built

It is four stories high and topped by a watchtower. The family lived in the middle two stories, while livestock, probably pigs and oxen, were kept in the lower level with its courtyard extending in front of the house.

We know through surviving literary descriptions that the Han emperors built lavish palaces, richly decorated with wall paintings. In one of the few imperial Han tombs to have been discovered, that of the Emperor Wu Ti's brother and his wife, both bodies were dressed in suits made of more than 2,000 jade tablets sewn together with gold wire. The prosperity of the Han dynasty was due largely to the expansion of trade, particularly the export of silk. The silk-trading routes reached all the way to Imperial Rome.

The quality of Han silk is evident in a silk banner from the tomb of the wife of the Marquis of Dai discovered on the outskirts of present-day Changsha in Hunan (**Fig. 17-31**). Painted with scenes representing on each of three levels the underworld, the earthly realm, and the heavens, it represents the Han conception of the cosmos. Long, sinuous, tendril-like lines describing dragons' tails, coiling serpents, long-tailed birds, and flowing draperies unify the three realms. In the right corner of the heavenly realm, above the crossbar of the T, is an image of the sun containing a crow, and in the other corner is a crescent moon supporting a toad. The deceased noblewoman herself stands on the white platform in the middle region of the banner. Three attendants stand behind her and two figures kneel before her bearing gifts. On the white platform of the bottom realm, bronze vessels contain food and wine for the deceased.

Elsewhere in Asia, the philosophy of Buddha, "The Awakened One," was taking hold. Born Siddhartha Gautama—around 490 BCE, according to recent scholaship—Buddha achieved *nirvana*, the release from worldly desires that ends the cycle of death and reincarnation and begins a state of permanent bliss, in about 410 BCE. He preached a message of self-denial and meditation across northern India, attracting converts from all levels of Indian society. The religion gained strength for centuries after Buddha's death and finally became institutionalized in India under the rule of Asoka (273–232 BCE). Deeply saddened by the horrors of war, and believing that his power rested ultimately in religious virtue and not military force, Asoka became a great patron of the Buddhist monks, erecting some 84,000 shrines, called *stupas*, throughout India, all elaborately decorated

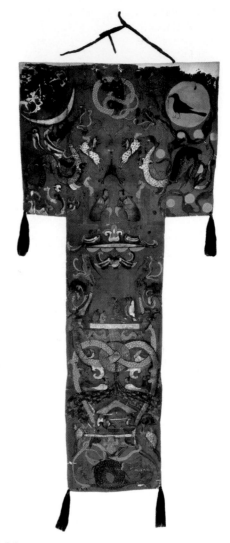

Fig. 17-31 *Lady of Dai with Attendants*, Han dynasty, after 168 BCE.
Painted silk banner from the tomb of Dai Hou Fu-ren, Mawangdui Tomb I, Changsha, Hunan, China.
Silk, height 6 ft. 8¼ in. Hunan Museum, Changsha, China.
© Asian Art & Archaeology, Inc./CORBIS.

with sculpture and painting. The **stupa** is literally a burial mound, dating from prehistoric times, but by the time the Great Stupa at Sanchi was made (**Fig. 17-32**)—it is the earliest surviving example of the form—it had come to house important relics of Buddha himself or the remains of later Buddhist holy persons. This stupa is made of rubble, piled on top of the original shrine, which has been faced with brick to form a hemispherical dome that symbolizes the earth itself. A railing—in this case, made of white stone and clearly visible in this

Spread of Buddhism throughout
Asia, reaching Japan in about 600
100–600

100 CE

CE

Fig. 17-32 The Great Stupa, Sanchi, Madhya Pradesh, India, view of the West Gateway, founded third century BCE, enlarged c. 150–50 BCE. Shrine height 50 ft., diameter 105 ft.
© Atlantide Phototravel/Corbis.

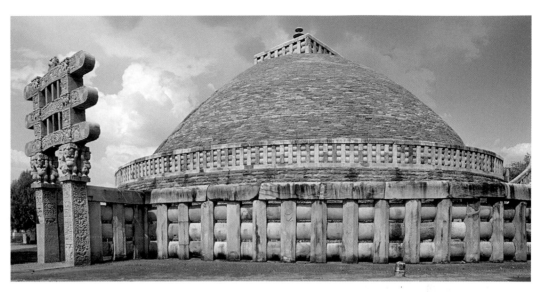

*Explore an architectural panorama of the Great Stupa on myartslab.com

View the Closer Look on the Great Stupa on myartslab.com

photograph—encircles the sphere. Ceremonial processions moved along the narrow path behind this railing. Pilgrims would circle the stupa in a clockwise direction on another wider path, at ground level, retracing the path of the sun, thus putting themselves in harmony with the cosmos and symbolically walking the Buddhist Path of Life around the World Mountain.

All the ancient centers of civilization underwent wars, conquests, and dramatic cultural changes. And all produced great philosophers, great art, and great writing, much of which we still find current and useful today. All were organized around religion, and with the dawn of the Christian era, religion continued to play a central role in defining culture.

THINKING BACK

Study and review on myartslab.com

What is a megalith?

In prehistoric Europe, especially Britain and France, a distinctive kind of monumental stone architecture was produced. Known as "megaliths," meaning "big stones," these works required significant organization and problem-solving skills to create. What is a henge? What do we know of the original purpose of Stonehenge?

What role did the ka play in Egyptian culture?

Egyptian culture was dedicated to providing a home for the *ka*, the part of the human being believed to define personality. Egyptians believed that the *ka* survived after death. They extensively decorated tombs and preserved bodies through mummification to appease the *ka*. What purpose did Egyptian pyramids serve? How were Egyptian pharaohs represented?

How did Lysippus challenge the Classical canon of proportions?

Court sculptor to Alexander the Great, Lysippus challenged the Classical canon of proportions created by Polyclitus. Lysippus sculpted figures with smaller heads and slimmer bodies than those of Polyclitus. This lent Lysippus's figures a sense of greater height. What is Hellenism? What is *contrapposto*?

How did the ancient Romans respond to Greek art and culture?

The Romans imported a large amount of Greek art, and in fact, much of our knowledge of Greek art comes from Roman copies. The Romans used the Greek architectural orders in their temples, which were in fact widely dedicated to gods incorporated from Greek culture. Many of Rome's artists were of Greek extraction. How does *Augustus of Primaporta* demonstrate Greek influence? How does the Arch of Titus both draw on Greek architectural tradition and diverge from it?

18 | The Age of Faith

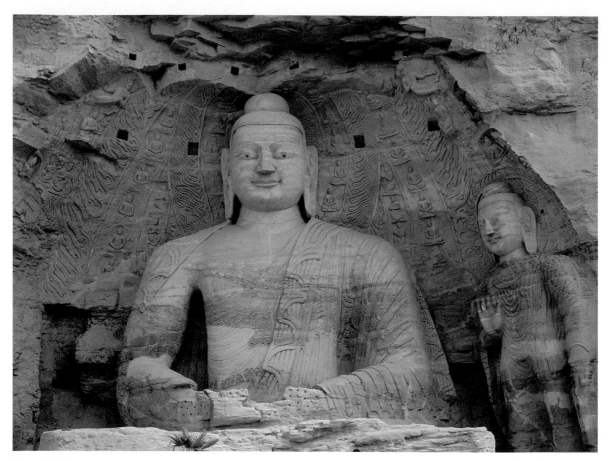

Fig. 18-1 *Large Seated Buddha with Standing Bodhisattva,* from Cave 20, Yungang, Shanxi Province, China, Northern Wei dynasty, c. 460–70 CE.
Stone, height 44 ft.
Werner Forman/Art Resource, NY.

🔍 **View** the Closer Look on *The Large Seated Buddha with Standing Bodhisattva* on myartslab.com

THINKING AHEAD

How were early Christian and Byzantine places of worship designed?

What are some of the features of a masjid, *or mosque?*

What features tend to define the Romanesque style?

What distinguishes Gothic architecture?

((•● **Listen** to the chapter audio on myartslab.com

Our study of the ancient world—from ancient fertility statues, to the Egyptian *ka,* to the rise of Buddhism—shows how powerful religion can be in setting the course of culture, and the advent of Christianity in the Western world makes this abundantly clear. So powerful was the Christian story that in the West the common calendar changed. From the sixth century on, time was recorded in terms of years "BC" (before Christ) and years "AD" (*anno Domini,* the year of our Lord, meaning the year of Christ's birth). Today, usage has changed somewhat—the preferred terms, as we have used them in this text, are BCE (before the

Camels first used for
trans-Saharan transport
c. 200

Augustine writes
The City of God
426

400 CE

c. 300
End of the Olmec
civilization in Mexico

common era) and CE (the common era)—but the West's calendar remains Christian.

In the East, Buddhism exerted the same power to stir the human imagination as Christianity did in the West. And as in the West images of Christ became a central feature of art, so too did images of Buddha in the East. In early Buddhist art, Buddha was never shown in figural form. He had said that he should not be depicted, for he did not matter—rather, his *dharma*, or teaching, did. But by the fourth century, during the reign of the Gupta rulers in India, Buddha was commonly represented (**Fig. 18-1**). Typically his head is oval, framed by a halo. Atop his head is a mound, symbolic of his spiritual wisdom. His demeanor is gentle, reposed, and meditative. His elongated ears refer to his royal origins. And his hands are set in one of several symbolic gestures, the mudras discussed in the section on iconography in Chapter 2. The seated Buddha illustrated here employs the Dhyana mudra, a gesture of meditation and balance. The lower hand represents the physical world of illusion, the upper nirvana and enlightenment. Together they symbolize the path to enlightenment. The *bodhisattva*—a person very near total enlightenment who has vowed to help others achieve it (see Fig. 11-5)—standing next to him employs the Abhaya mudra, a gesture of reassurance, blessing, and protection.

Other long-standing religions continued to exert enormous influence throughout the first millennium CE and beyond—the Hindu faith in India and Shinto in Japan. Judaism, the oldest continuing religion in the West, continued to be practiced, despite the fact that ever since the Babylonians had destroyed the Temple of Solomon in Jerusalem and deported the Hebrew people to Babylon in the sixth century BCE, the Jewish people had been scattered across the Mediterranean and Europe, a people without a homeland. Even so, Judaism remained the philosophical and historical foundation of both Christianity and the new Islamic faith, based on the teachings of Muhammad, which arose on the Arabian peninsula in the seventh century CE and rapidly spread throughout the Middle East, North Africa, and Spain at a rate far higher than the spread of either Christianity or Buddhism.

At the Dome of the Rock in Jerusalem (**Fig. 18-2**), all three of the great Western faiths—Judaism, Christianity, and Islam—intersect. In Jewish tradition, it was here that Abraham prepared to sacrifice his son

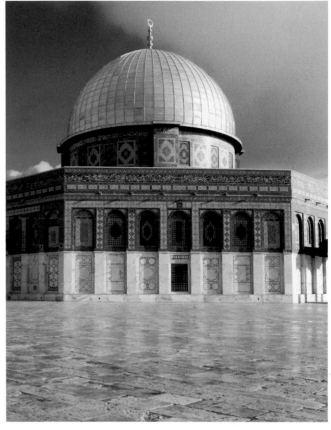

Fig. 18-2 The Dome of the Rock, Jerusalem, late 680s–91.
© Ivan Vdovin/Alamy.

Isaac. The Jewish Temple of Solomon originally stood here, and the site is further associated, in all three religions, with God's creation of Adam. The Second Temple of Jerusalem also stood on this spot until it was destroyed by Roman soldiers when they sacked the city in 70 CE to put down a Jewish revolt. Only the Wailing Wall remains, part of the original retaining wall for the platform supporting the Temple Mount and, for Jews, the most sacred site in Jerusalem. To this day, the plaza in front of the wall functions as an open-air synagogue where daily prayers are recited and other Jewish rituals are performed. On Tisha B'Av, the ninth day of the month of Av, which occurs either in July or August, a fast is held commemorating the destruction of the successive temples on this site, and people sit on the ground before the wall reciting the Book of Lamentations.

One of the earliest examples of Muslim architecture, built in the 680s, the Dome's **ambulatory**—its circular, colonnaded walkway—encloses a projected rock that lies

Last Roman emperor
dethroned
476

400

c. 400–500
Germanic tribes
invade Rome

directly beneath its golden dome. By the sixteenth century, Islamic faithful claimed that the Prophet Muhammad ascended to heaven from this spot, on a winged horse named Buraq, but there is no evidence that this story was in circulation when the Dome was originally built. Others thought that it represented the ascendency of Islam over Christianity in the Holy Land. Still others believed the rock to be the center of the world, or that it could refer to the Temple of Solomon, the importance of which is fully acknowledged by Muslims, who consider Solomon a founding father of their own faith. All of this suggests that the Dome was meant to proselytize, or convert both Jews and Christians to the Muslim faith. The sanctity of the spot, then, in the heart of Jerusalem, is recognized by Jews, Christians, and Muslims alike, and the intersection of these three religions, together with the spread of Buddhism in Asia and the growth of the Hindu faith in Southeast Asia, is the subject of this chapter. The powerful influence of all these religions throughout the first millennium and well into the second gave rise to an age of faith.

Early Christian and Byzantine Art

Christianity spread through the Roman world at a very rapid pace, in large part due to the missionary zeal of St. Paul. By 250 CE, fully 60 percent of Asia Minor had converted to the religion, and when the Roman Emperor Constantine legalized Christianity in the Edict of Milan in 313 CE, Christian art became imperial art. The classical art of Greece and Rome emphasized the humanity of its figures, their corporeal reality. But the Christian God was not mortal and could not even be comfortably represented in human terms. Though His Son, Jesus, was human enough, the mysteries of both Jesus's virgin birth and his rising from the dead most interested early Christian believers. The world that the Romans had celebrated on their walls in fresco—a world of still lifes and landscapes—was of little interest to Christians, who were more concerned with the spiritual and the heavenly than with their material surroundings.

Constantine chose to make early Christian places of worship as unlike classical temples as possible. The building type that he preferred was the rectangular **basilica**, which the Romans had used for public buildings, especially courthouses. The original St. Peter's in Rome, constructed around 333–390 CE but destroyed in the sixteenth century to make way for

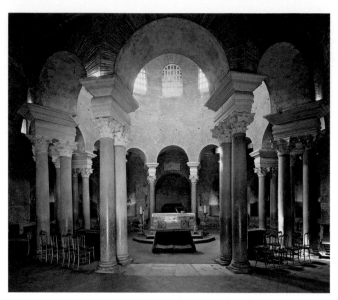

Fig. 18-3 Santa Costanza, Rome, c. 354 CE. Interior view.
Scala/Art Resource, NY.

✳ Explore an architectural panorama of Santa Costanza on myartslab.com

the present building, was a basilica (see Fig. 15-27). Equally important for the future of Christian religious architecture was Santa Costanza (**Fig. 18-3**), the small mausoleum built around 354 CE for the tomb of Constantine's daughter, Constantia. Circular in shape and topped with a dome supported by a barrel vault, the building defines the points of the traditional Greek cross, which has four equal arms. Surrounding the circular space is an ambulatory, similar to that found in the Dome of the Rock, that was used for ceremonial processions.

The circular form of Santa Costanza appears often in later Byzantine architecture. By the year 500, most of the western empire, traditionally Christian, had been overrun by barbarian forces from the north. When the Emperor Justinian assumed the throne in Constantinople in 527, he dreamed of restoring the lost empire. His armies quickly recaptured the Mediterranean world, and he began a massive program of public works. At Ravenna, Italy, at one time the imperial capital, Justinian built San Vitale, a new church modeled on the churches of Constantinople. Although the exterior is octagonal, the interior space is essentially circular, like Santa Costanza before it. Only in the altar and the apse, which lie to the right of the central domed area in the floor plan, is there any reference to the basilica structure

Founding of
Benedictine Order
529

550

529
Justinian's law code,
the *Corpus Juris Civilis*

Fig. 18-4 *Theodora and Her Attendants*, c. 547.
Mosaic, sidewall of the apse, San Vitale.
Canali Photobank, Milan, Italy.

Thinking Thematically: See Art, Gender, and Identity on myartslab.com

that dominates western church architecture. The facade of San Vitale is very plain, more or less unadorned, local brick. Inside, however, it is elaborately decorated with marble and glittering **mosaics**—small pieces of stone, glass, or tile arranged in a pattern or image. The architectural panorama of the church on myartslab is a stunning display of its interior decoration. Two elaborate mosaics face each other on the side walls of the apse, one depicting Theodora, the wife of Justinian (**Fig. 18-4**), and the other Justinian himself (**Fig. 18-5**). Theodora had at one time been a circus performer, but she became one of the emperor's most trusted advisors, sharing with him a vision of a Christian Roman Empire. In the mosaic, she carries a golden cup of wine, and Justinian, on the opposite wall, carries a bowl containing bread. Together they are bringing to the Church an offering of bread and wine for the celebration of the Eucharist. The haloed Justinian is to be identified with Christ, surrounded as he is by 12 advisors, like the 12 Apostles. And the haloed Theodora, with the three Magi bearing gifts to the Virgin and newborn Christ embroidered on the hem of her skirt, is to be understood as a figure for Mary. In this image, Church and state become one and the same.

✻ Explore an architectural panorama of San Vitale on on myartslab.com

Fig. 18-5 *Justinian and His Attendants*, c. 547.
Mosaic, sidewall of the apse, San Vitale.
Canali Photobank, Milan, Italy.

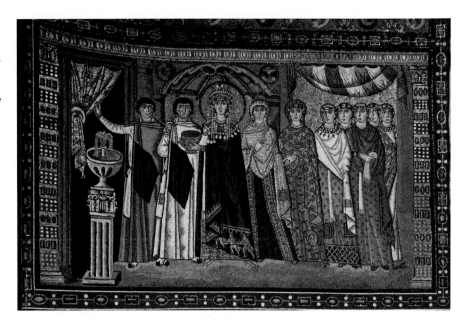

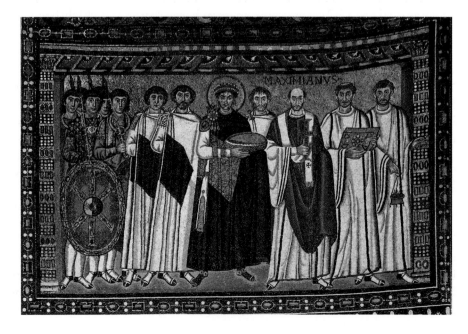

These mosaics bear no relation to the naturalism that dominated Greek and Roman culture. Here, the human figures are depicted wearing long robes that hide the musculature and cause a loss of individual identity. Although each face has unique features—some of Justinian's attendants, for example, are bearded, while others are not, and the hairstyles vary—all have identical wide-open eyes, curved brows, and long noses. The feet of the figures turn

400

Angles, Saxons, and Jutes
invade England
c. 450

Death of St. Patrick
in Ireland
461

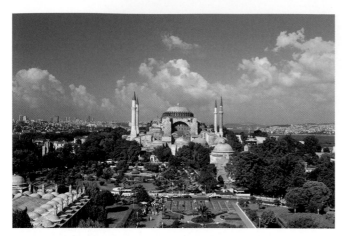

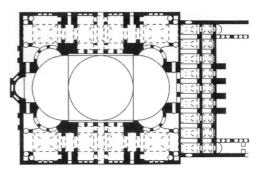

Watch an architectural simulation about pendentives
on myartslab.com

Fig. 18-6 Anthemius of Tralles and Isidorus of Miletus,
Hagia Sophia, Istanbul, and plan, 532–37.
© Achim Bednorz, Koln

outward, as if to flatten the space in which they stand.
They are disproportionately long and thin, a fact that
lends them a heavenly lightness. And they are mo-
tionless, standing before us without gesture, as if eter-
nally still. The Greek ideal of sculpture-in-the-round,
with its sense of the body caught in an intensely per-
sonal, even private moment—Nike taking off her san-
dal (see Fig. 17-19), for instance, or Laocoön caught in
the intensity of his torment (see Fig. 17-22)—is gone.
All sense of drama has been removed from the idea of
representation.

Mosaics are made of small pieces of stone called
tesserae, from the Greek word *tesseres*, meaning
"square." In ancient Rome, mosaics were a favorite
decorative element, used because of their durability,
especially to embellish villa floors. But the Romans
rarely used mosaic on their walls, where they pre-
ferred the more refined and naturalistic effects that
were possible with fresco. For no matter how skilled
the mosaic artist, the naturalism of the original draw-
ing would inevitably be lost when the small stones
were set in cement.

The Byzantine mosaic artists, however, had little
interest in naturalism. Their intention was to cre-
ate a symbolic, mystical art, something for which
the mosaic medium was perfectly suited. Gold *tes-
serae* were made by sandwiching gold leaf between
two small squares of glass, and polished glass was
also used. By setting the *tesserae* unevenly, at slight
angles, a shimmering and transcendent effect was

realized, which was heightened by the light from the
church's windows.

Justinian attached enormous importance to ar-
chitecture, believing that nothing better served to
underscore the power of the emperor. The church of
Hagia Sophia, meaning "Holy Wisdom," was his im-
perial place of worship in Constantinople (**Figs. 18-6**
and 18-7). The huge interior, crowned by a dome, is
reminiscent of the circular, central plan of Ravenna's
San Vitale, but this dome is abutted at either end by
half-domes that extend the central core of the church
along a longitudinal axis reminiscent of the basilica,
with the apse extending in another smaller half-
dome out one end of the axis. These half-domes cul-
minate in arches that are repeated on the two sides
of the dome as well. The architectural scheme is, in
fact, relatively simple—a dome supported by four
pendentives, the curved, inverted triangular shapes
that rise up to the rim of the dome between the four
arches themselves. This dome-on-pendentive design
was so enthusiastically received that it became the
standard for Byzantine church design.

Many of the original mosaics that decorated
Hagia Sophia were later destroyed or covered over.
During the eighth and ninth centuries, **iconoclasts**,
meaning "image-breakers," who believed literally
in the Bible's commandment against the worship
of "graven" images, destroyed much Byzantine art.
Forced to migrate westward, Byzantine artists discov-
ered Hellenistic naturalism and incorporated it into
later Byzantine design. The mosaic of Christ from
Hagia Sophia (**Fig. 18-8**) is representative of that
later synthesis.

Visigoths in Spain adopt
Western Christianity
589

600

597
St. Augustine in England

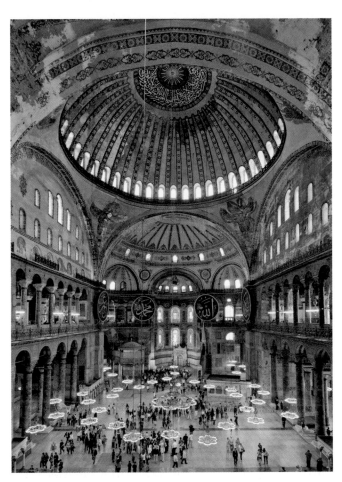

Fig. 18-7 Anthemius of Tralles and Isidorus of Miletus, Hagia Sophia, Istanbul, 532–37. Interior view.
Ayhan Altun/Altunimages.

Thinking Thematically: See Art and Beauty on myartslab.com

Though only a few of the original mosaics have been restored, and later mosaics were few, the light in the interior is still almost transcendental in feeling, and one can only imagine the heavenly aura when gold and glass reflect the light that enters the nave through the many windows that surround it. In Justinian's own words: "The sun's light and its shining rays fill the temple. One would say that the space is not lit by the sun without, but that the source of light is to be found within, such is the abundance of light. . . . The scintillations of the light forbid the spectator's gaze to linger on the details; each one attracts the eye and leads it on to the next. The circular motion of one's gaze reproduces itself to infinity. . . . The spirit rises toward God and floats in the air."

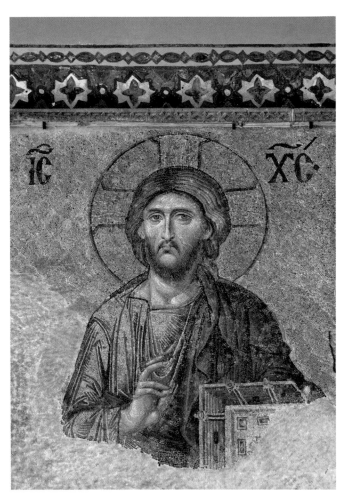

Fig. 18-8 *Christ*, from *Deësis* mosaic, thirteenth century. Hagia Sophia, Istanbul.
Ayhan Altun/Altunimages.

Thinking Thematically: See Art and Spiritual Belief on myartslab.com

Justinian's reign marked the apex of the early Christian and Byzantine era. By the seventh century, barbarian invaders had taken control of the western empire, and the new Muslim empire had begun to expand to the east. Reduced in area to the Balkans and Greece, the Byzantine empire nevertheless held on until 1453, when the Turks finally captured Constantinople and renamed it Istanbul, converting Hagia Sophia into a mosque.

The Rise of Islam

Born in Mecca on the Arabian peninsula in about 570 to a prominent family, Muhammad, the founder of the Islamic faith, was orphaned at age six and received little

600

644–56
Qur'an text established

First Muslim
invasion of India
c. 710

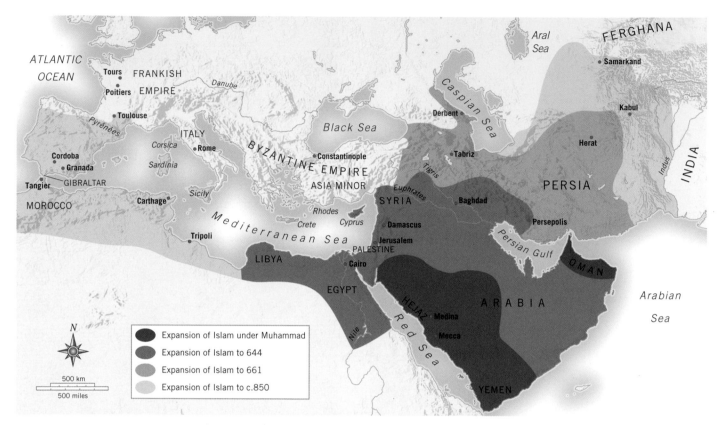

The Expansion of Islam to 850 CE.

formal education. He worked in the caravan trade in the Arabian desert, first as a camel driver for his uncle, and then, after marrying a wealthy widow 15 years his senior at age 25, as head of his wife's flourishing caravan firm. But at the age of 40, in 610, he heard a voice in Arabic—the Archangel Gabriel's, as the story goes—urging him, "Recite!" He responded "What shall I recite?" And for the next 22 years, he claimed to receive messages, or "recitations," from God through the agency of Gabriel. These he memorized and, probably later, scribes collected them to form the scriptures of Islam, the Qur'an (or Koran), which means "recitations." Muhammad also claimed that Gabriel commanded him to declare himself the "Seal of the Prophets," that is, the messenger of the one and only Allah (the Arab word for God) and the final prophet in a series of God's prophets on earth, extending from Abraham and Moses to Jesus.

At the core of Muhammad's revelations is the concept of submission to God—the word Islam, in fact, means "submission" or "surrender." God, or Allah, is all—all-powerful, all-seeing, all-merciful. Because the universe is his creation, it is necessarily good and beautiful, and the natural world reflects Allah's own goodness and beauty. To immerse oneself in nature is thus to be at one with God. But the most beautiful creation of Allah is humankind. As do Christians, Muslims believe that human beings possess immortal souls and that they can live eternally in heaven if they surrender to Allah and accept him as the one and only God.

In 622, Muhammad was forced to flee Mecca when its polytheistic leadership became irritated at his insistence on the worship of only one God. In a journey known as the *hijra* (or *hegira*, "emigration"), he and his followers fled to the oasis of Yathrib, 200 miles north, which they renamed al-Medina, meaning "the city of the Prophet." There, Muhammad created a community based not on kinship, the traditional basis of Arab society, but on common submission to the will of God.

At Medina, Muhammad also built a house that surrounded a large open courtyard, which served as a community gathering place, on the model of the Roman forum. There the men of the community would gather on Fridays to pray and listen to a sermon delivered by Muhammad.

732
Furthest Muslim advances
in Western Europe

Córdoba established as capital
of Muslim Spain
756

760

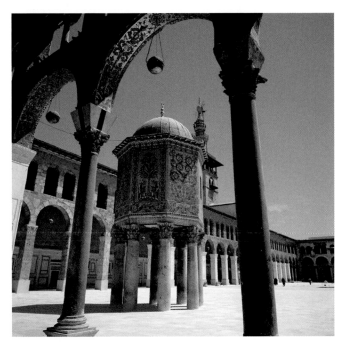

Fig. 18-9 Courtyard of the Great Mosque of Damascus, 705–16.

Christopher Rennie, Robert Harding World Imagery.

It thus became known as the *masjid*, the Arabic word for **mosque**, or "place of prostration." On the north and south ends of the courtyard, covered porches were erected, supported by palm tree trunks and roofed by thatched palm fronds, which protected the community from the hot Arabian sun. This many-columned covered area, known as a **hypostyle space** (from the Greek *hupostulos*, "resting upon pillars"), would later become a required feature of all Muslim mosques. Another required feature was the *qibla*, a wall that indicated the direction of Mecca. On this wall were both the *minbar*, or stepped pulpit for the preacher, and the *mihrab*, a niche commemorating the spot at Medina where Muhammad planted his lance to indicate the direction in which people should pray.

The Prophet's Mosque in Medina has been rebuilt so many times that its original character has long since been lost. But when, at Damascus in 705, the Muslim community had grown so large that radical steps had to be taken to accommodate it, a Byzantine church was torn down, leaving a large courtyard (**Fig. 18-9**), the compound walls of which were transformed into the walls of a new mosque. A large prayer hall was constructed against the *qibla* wall and decorated with an elaborate mosaic facade, some of which is visible in

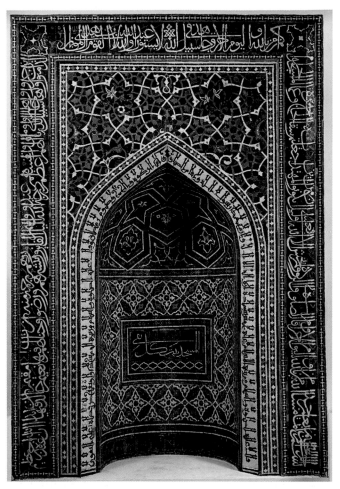

Fig. 18-10 Tile mosaic *mihrab*, from the Madrasa Imami, Isfahan, Persia (Iran), fourteenth century, c. 1354 (restored). Composite bidy, glazed, sawed to shape and assembled in mosaic, 11 ft. 3 in. × 7 ft. 6 in. (342.9 cm) The Metropolitan Museum of Art, New York, NY, U.S.A. Harris Brisbane Dick Fund (39.20). Image copyright © The Metropolitan Museum of Art. Image source: Art Resource, NY

the illustration, facing into the courtyard, while the street side of the mosque was left relatively plain.

As we saw in Chapter 2, one of the most important characteristics of Islamic culture is its emphasis on calligraphy (see Fig. 2-6), and the art of calligraphy was incorporated into Islamic architecture from the beginning. By the mid-ninth century, the walls of palaces and mosques were covered by it, and throughout the following centuries, the decoration became more and more elaborate. The mosaic *mihrab*, originally from a *madrasa*, or teaching college, in Iran, contains three different inscriptions from the Qur'an (**Fig. 18-10**). The outer frame

760

1071
Turks capture
Jerusalem

1096
Beginning of
First Crusade

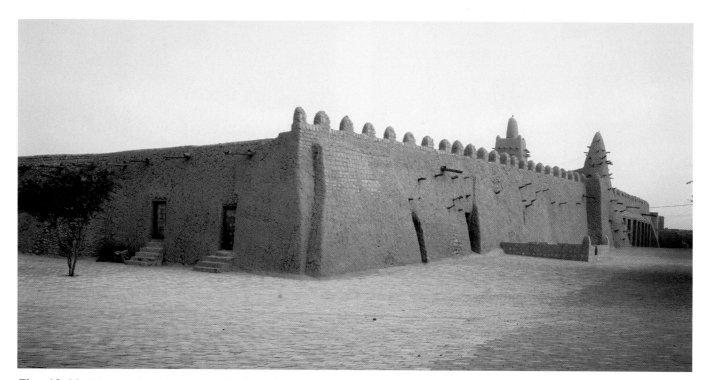

Fig. 18-11 Djingareyber Mosque, Timbuktu, eleventh century.
© Danita Delimont/Alamy.

Thinking Thematically: See **Art, Science, and the Environment** on myartslab.com

is a description of the duties of true believers and the heavenly rewards in store for those who build mosques. The next contains the Five Pillars of Islam, the duties every believer must perform, including, at least once in a lifetime, a pilgrimage to Mecca. And, finally, in the center of the inner wall, is the reminder, "The mosque is the house of every pious person." All of this is contained in a beautifully balanced and symmetrical design.

Since the Prophet Muhammad fled Mecca for Medina in 622, the Muslim empire had expanded rapidly (see the map showing the expansion of Islam, on p. 444). By 640, Muhammad's successors, the Caliphs, had conquered Syria, Palestine, and Iraq. Two years later, they defeated the army of Byzantium at Alexandria, and, by 710, they had captured all of northern Africa and had moved into Spain. They advanced north until 732, when Charles Martel, grandfather of Charlemagne, defeated them at Poitiers, France. But the Caliphs' foothold in Europe remained strong, and they did not leave Spain until 1492. Even the Crusades failed to reduce their power. During the First Crusade, 50,000 men were sent to the Middle East, where they managed to hold Jerusalem and much of Palestine for a short while. The

Second Crusade, in 1146, failed to regain control, and in 1187, the Muslim warrior Saladin reconquered Jerusalem. Finally, in 1192, Saladin defeated King Richard the Lion-Hearted of England in the Third Crusade.

The Muslim impact on the culture of North Africa cannot be overstated. Beginning in about 750, not long after Muslim armies had conquered most of North Africa, Muslim traders, following the trade routes created by the Saharan Berber peoples, began trading for salt, copper, dates, and especially gold with the sub-Saharan peoples of the Niger River drainage. Gradually they came to dominate the trans-Saharan trade routes, and Islam became the dominant faith of West Africa.

In 1312, a devout Muslim named Mansa Moussa came to the throne of Mali. He built magnificent mosques throughout his empire, including the Djingareyber Mosque in Timbuktu (**Fig. 18-11**). Still standing today and made of burnt brick and mud, it dominates the city. Under Moussa's patronage, the city of Timbuktu grew in wealth and prestige and became a cultural focal point for the finest poets, scholars, and artists of Africa and the Middle East. To draw further attention to Timbuktu, and to attract more scholars and poets to it, Mansa Moussa embarked on a pilgrimage

Mongols sack and
destroy Baghdad
1258

Most of Muslim Spain
falls to Christian reconquest
mid-1300s

1300

Fig. 18-12 Interior of the sanctuary of the Mosque at Córdoba, Spain, 786–987.
© Achim Bednorz, Koln

Thinking Thematically:
See **Art, Politics, and Community** on myartslab. com

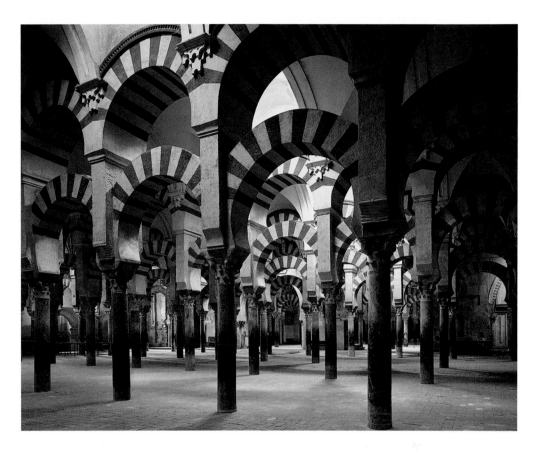

to Mecca in 1334. He arrived in Cairo at the head of a huge caravan of 60,000 people, including 12,000 servants, with 80 camels carrying more than two tons of gold to be distributed among the poor. In fact, Moussa distributed so much gold in Egypt that the value of the precious metal fell dramatically and did not recover for a number of years.

In Spain, the center of Muslim culture was originally Córdoba. For its mosque, Islamic rulers converted an existing Visigothic church. The Visigoths, who were a Christianized Germanic tribe who had invaded Spain three centuries earlier, had built their church with relatively short, stubby columns. To create the loftier space required by the mosque, the architects superimposed another set of columns on top, creating two tiers of arches, one over the other, using a distinctive alternation of stone and red brick voussoirs (**Fig. 18-12**). The use of two different materials is not only decorative but also functional, combining the flexibility of brick with the strength of stone. Finally, the hypostyle plan of the mosque was, in essence, infinitely expandable, and subsequent caliphs enlarged the mosque in 852, 950, 961–76, and 987, until it was over four times the size of the original and incorporated 1,200 columns. As in all Muslim design, where a visual rhythm is realized through symmetry and repetition of certain patterns and motifs, the rhythm of arches and columns unifies the interior of the Córdoba mosque.

Christian Art in Northern Europe

Until the year 1000, the center of Western civilization was located at Constantinople. In Europe, tribal groups with localized power held sway: the Lombards in what is now Italy, the Franks and the Burgundians in regions of France, and the Angles and Saxons in England. Though it possessed no real political power, the papacy in Rome had begun to work hard to convert the pagan tribes and to reassert the authority of the Church. As early as 496, the leader of the Franks, Clovis, was baptized into the Church. Even earlier (c. 430), St. Patrick had undertaken an evangelical mission to Ireland, establishing monasteries and quickly converting the native Celts. These new monasteries were designed to serve missionary as well as educational functions. At a time when only priests and

Slave trade between sub-Saharan
Africa and Mediterranean begins
c. 600

Anglo-Saxon epic
Beowulf is composed
7th century

600

633–725
Expansion of Islam

monks could read and write, the sacred texts they produced came to reflect native Celtic designs. These designs are elaborately decorative, highly abstract, and contain no naturalistic representation. Thus, Christian art fused with the native traditions, which employed the so-called *animal style*. Some of the best examples of this animal style, such as this purse cover (**Fig. 18-13**), have been found at Sutton Hoo, north of present-day London, in the grave of an unknown seventh-century East Anglian king. In this design two pairs of animals and birds, facing each other, are elongated into serpentine ribbons of decoration, a common Scandinavian motif. Below this, two Swedish hawks with curved beaks attack a pair of ducks. On each side of this design, a male figure stands between two animals. Note particularly the design's symmetry, its combination of interlaced organic and geometric shapes, and, of course, its animal motifs. Throughout the Middle Ages, this style was imitated in manuscripts, stone sculpture, church masonry, and wood sculpture.

In 597, Gregory the Great, the first monk to become pope, sent an emissary, later known as St. Augustine of Canterbury, on a mission to convert the Anglo-Saxons. This mission brought Roman religious and artistic traditions into direct contact with Celtic art, and, slowly but surely, Roman culture began to dominate the Celtic-Germanic world.

When Charlemagne (Charles, or Carolus, the Great) assumed leadership of the Franks in 771, this process of Romanization was assured. At the request of the pope, Charlemagne conquered the Lombards, becoming their king, and on Christmas Day 800, he was crowned Holy Roman Emperor by Pope Leo III at St. Peter's Basilica in Rome. The fusion of Germanic and Mediterranean styles that reflected this new alliance between Church and state is known as **Carolingian art**, a term referring to the art produced during the reign of Charlemagne and his immediate successors.

The transformation in style that Charlemagne effected is evident if we compare the work of an artist trained in the linear Celtic tradition to one created

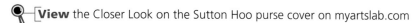

🔍 **View** the Closer Look on the Sutton Hoo purse cover on myartslab.com

Fig. 18-13 Purse cover, from Sutton Hoo burial ship. c. 625.
Gold with Indian garnets and cloisonné enamel, originally on an ivory or bone background (now lost), length 8 in.
© The Trustees of the British Museum/Art Resource, NY.

| Cluny monastery founded | Rise of Inca Empire in South America |
| 910 | c. 1000 |

| c. 800–1000 | 980s | 1000 |
| England and Europe invaded by Vikings, Magyars, and Muslims | Russia converted to Christianity | |

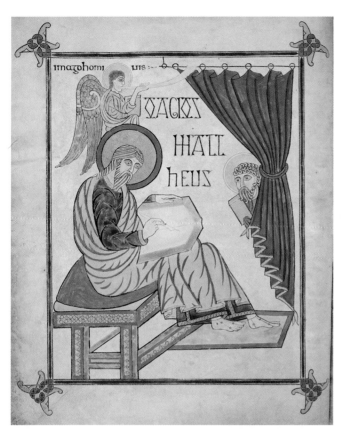

Fig. 18-14 *St. Matthew* from the *Lindisfarne Gospels*, c. 700. Approximately 11 × 9 in. British Library, London.
By permission of the British Library.

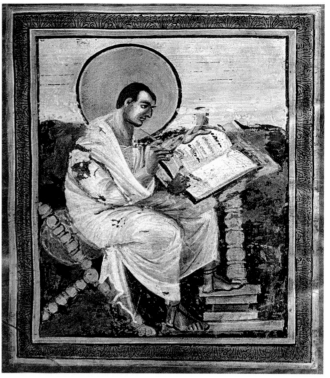

Fig. 18-15 *St. Matthew* from the *Gospel Book of Charlemagne*, c. 800–810.
Manuscript page, 12³/₄ × 9⁷/₈ in. Kunsthistorisches Museum, Austria, Vienna.

during Charlemagne's era. In the former (**Fig. 18-14**), copied from an earlier Italian original, the image is flat, the figure has not been modeled, and the perspective is completely askew. It is pattern—and the animal style—that really interests the artist, not accurate representation. But Charlemagne was intent on restoring the glories of Roman civilization. He actively collected and had copied the oldest surviving texts of the classical Latin authors. He created schools in monasteries and cathedrals across Europe in which classical Latin was the accepted language. A new script, with Roman capitals and new lowercase letters, the basis of modern type, was introduced. A second depiction of St. Matthew (**Fig. 18-15**), executed 100 years after the one on the left, demonstrates the impact of Roman realism on northern art. Found in Charlemagne's tomb, this illustration looks as if it could have been painted in classical Rome.

Romanesque Art

After the dissolution of the Carolingian state in the ninth and tenth centuries, Europe disintegrated into a large number of small feudal territories. The emperors were replaced by an array of rulers of varying power and prestige who controlled smaller or larger fiefdoms (areas of land worked by persons under obligation to the ruler) and whose authority was generally embodied in a chateau or castle surrounded by walls and moats. Despite this atomization of political life, a recognizable style that we have come to call **Romanesque** developed throughout Europe beginning in about 1050. Although details varied from place to place, certain features remained constant for nearly 200 years.

Romanesque architecture is characterized by its easily recognizable geometric masses—rectangles, cubes, cylinders, and half-cylinders. The wooden roof that St. Peter's Basilica had used was abandoned in favor of

Conquest of England
by the Norman French
1066

1000

1054
Schism between Latin and Greek
Christian churches

1071
The fork is introduced to Europe
by a Byzantine princess

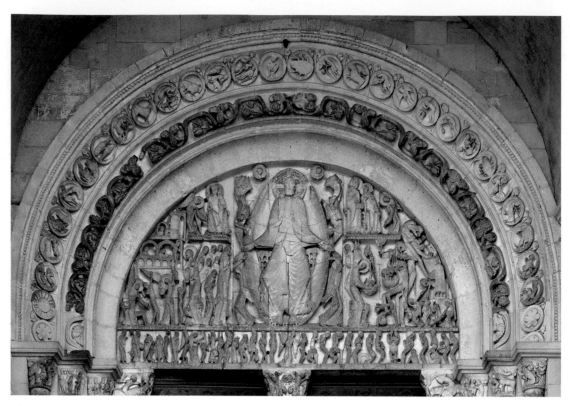

Fig. 18-16 Gislebertus, *Last Judgment*, tympanum and lintel, west portal, Cathedral, Autun, France, c. 1125–35.
Stone, approximately 12 ft. 6 in. × 22 ft.
© Achim Bednorz, Koln.

fireproof stone and masonry construction, apparently out of bitter experience with the invading nomadic tribes, who burned many of the churches of Europe in the ninth and tenth centuries. Flat roofs were replaced by vaulted ceilings. By structural necessity, these were supported by massive walls that often lacked windows sufficient to provide adequate lighting. The churches were often built along the roads leading to pilgrimage centers, usually monasteries that housed Christian relics, and they had to be large enough to accommodate large crowds of the faithful. For instance, St. Sernin, in Toulouse, France (see Figs. 15-19 and 15-20), was on the pilgrimage route to Santiago de Compostela, in Spain, where the body of St. James was believed to rest.

Thanks in large part to Charlemagne's emphasis on monastic learning, monasteries had flourished since the Carolingian period, many of them acting as feudal landlords as well. The largest and most powerful was Cluny, near Mâcon, France. Until the building of the new St. Peter's in Rome, the church at Cluny was the largest in the Christian world. It was 521 feet in length, and its nave vaults rose to a height of 100 feet. The height of the nave was made possible by the use of pointed arches. The church was destroyed in the French Revolution, and only part of one transept survives.

With the decline of the Roman Empire, the art of sculpture had largely declined in the West, but in the Romanesque period it began to reemerge. It is certain that the idea of educating the masses in the Christian message through architectural sculpture on the facades of the pilgrimage churches contributed to the art's rebirth. The most important sculptural work was usually located on the **tympanum** of the church, the semicircular arch above the lintel on the main door. It often showed Christ with his twelve apostles. Another favorite theme was the Last Judgment, full of depictions of sinners suffering the horrors of hellfire and damnation. To the left of Gislebertus's *Last Judgment* at Autun, France (**Fig. 18-16**), the blessed arrive in heaven, while on the right, the damned are

Rise of Chivalric poetry
written in the vernacular
12th century

1100
Third Pueblo period
in American Southwest

12th and 13th centuries
Growth of trade and towns
as trading centers

1100

seized by devils. Combining all manner of animal forms, the monstrosity of these creatures recalls the animal style of the Germanic tribes.

Gothic Art

The great era of **Gothic** art began in 1137 with the rebuilding of the choir of the abbey church of St. Denis, located just outside Paris. Abbot Suger of St. Denis saw his new church as both the political and the spiritual center of a new France, united under King Louis VI. Although he was familiar with Romanesque architecture, which was then at its height, Suger chose to abandon it in principle. The Romanesque church was difficult to light, because the structural need to support the nave walls from without meant that windows had to be eliminated. Suger envisioned something different. He wanted his church flooded with light as if by the light of Heaven itself. After careful planning, he began work in 1137, painting the old walls of the original abbey, which were nearly 300 years old, with gold and precious colors. Then he added a new facade with twin towers and a triple portal. Around the back of the ambulatory he added a circular string of chapels, all lit with large stained-glass windows, "by virtue of which," Suger wrote, "the whole would shine with the miraculous and uninterrupted light."

It was this light that proclaimed the new Gothic style. Light, he believed, was the physical and material manifestation of Divine Spirit. Suger wrote: "Marvel not at the gold and the expense but at the craftsmanship of the work. Bright is the noble work; but being nobly bright, the work should brighten the minds, so that they may travel, through the true lights, to the True Light where Christ is the true

✳ **Explore** an architectural panorama of Chartres Cathedral on myartslab.com

Fig. 18-17 West facade, Chartres Cathedral, c. 1134–1220; south spire, c. 1160; north spire 1507–13.

Robert Harding Picture Library, Ltd./Alamy.

door." As beautiful as the church might be, it was designed to elevate the soul to the realm of God.

As the Gothic style developed, French craftsmen became increasingly accomplished in working with stained-glass, creating windows such as Chartres Cathedral's famous Rose Window (see Fig. 8-9). Important architectural innovations also contributed to this goal (**Fig. 18-17**). The massive stonework of the Romanesque style was replaced by a light, almost lacy, play of thin columns and patterns of ribs and windows, all pointing upward in a rising crescendo that

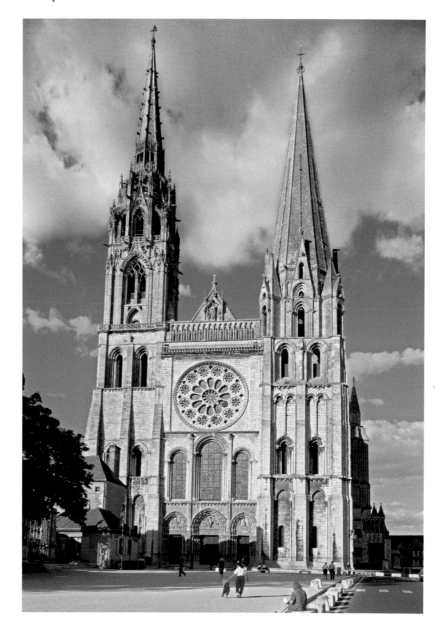

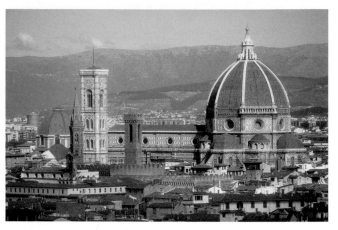

Fig. 18-19 Florence Cathedral (Santa Maria del Fiore), begun by Arnolfo de Cambio, 1296; dome by Filippo Brunelleschi, 1420–36.
Vanni/Art Resource, NY.

✳ **Explore** an architectural panorama of Florence Cathedral on myartslab.com

🔍 **View** the Closer Look on Filippo Brunelleschi's dome on myartslab.com

Thinking Thematically: See Art, Politics, and Community on myartslab.com

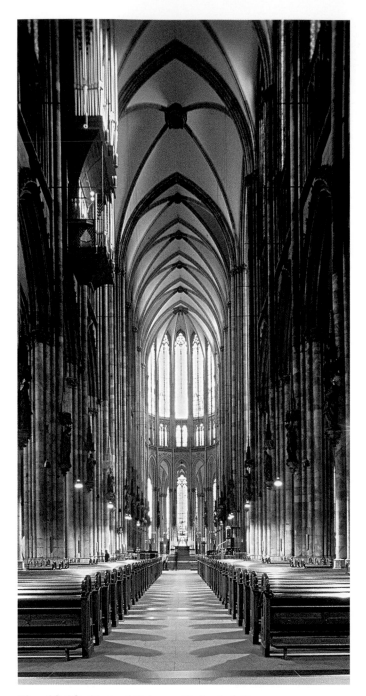

Fig. 18-18 Choir of Cologne Cathedral, Germany, thirteenth and fourteenth centuries.
Caisse Nationale des Monuments Historique.
© Svenja-Foto/zefa/Corbis.

seems to defy gravity, even as it carries the viewer's gaze toward the heavens. Compare, for instance, the Romanesque south tower of Chartres Cathedral to the fully Gothic north tower, which rises high above its

starkly symmetrical neighbor. Extremely high naves made possible by flying buttresses (see **Figs. 15-23** and **15-24**)—the nave at Chartres is 120 feet high, the one at Reims is 125, and highest of all is Beauvais at 157 (the equivalent of a 15-story building)—add to this emphasis on verticality. They contribute a sense of elevation that is at once physical and spiritual, as does the preponderance of pointed rather than rounded arches. In Germany's Cologne Cathedral (**Fig. 18-18**), the nave has been narrowed to such a degree that the vaults seem to rise higher than they actually do. The cathedral was not finished until the nineteenth century, though built strictly in accordance with thirteenth-century plans. The stonework is so slender, incorporating so much glass into its walls, that the effect is one of almost total weightlessness.

The Gothic style in Italy is unique. For instance, the exterior of Florence Cathedral (**Fig. 18-19**) is hardly Gothic at all. It was, in fact, designed to match the dogmatically Romanesque octagonal baptistry that stands in front of it. But the interior space is completely Gothic in character. Each side of the nave is flanked by

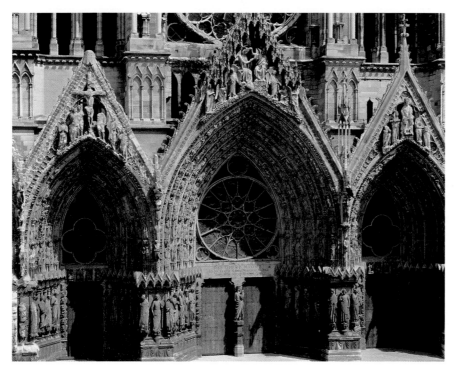

Fig. 18-20 Central portal of the west facade of Reims Cathedral, c. 1225–90.
Gianni Dagli Orti/The Art Archive at Art Resource, NY

and the figures assume more natural poses as well. The space they occupy is deeper—so much so that they appear to be fully realized sculpture-in-the-round, freed of the wall behind them. Most important of all, many of the figures seem to assert their own individuality, as if they were actual persons. The generalized "types" of Romanesque sculpture are beginning to disappear. The detail of figures at the bottom of the Reims portal (**Fig. 18-21**) suggests that each is engaged in a narrative scene. The angel on the left smiles at the more somber Virgin. The two at the right seem about to step off their pedestals. What is most remarkable is that the space between the figures is bridged by shared emotion, as if feeling can unite them in a common space.

an arcade that opens almost completely into the nave by virtue of four wide pointed arches. Thus nave and arcade become one, and the interior of the cathedral feels more spacious than any other. Nevertheless, rather than the mysterious and transcendental feelings evoked by most Gothic churches, Florence Cathedral produces a sense of tranquility and of measured, controlled calm. This sense of measured space is in large part a function of the enormous size of the dome above the crossing, the architectural feat of Filippo Brunelleschi, discussed in the Closer Look in myartslab.

The Gothic style in architecture inspired an outpouring of sculptural decoration. There was, for one thing, much more room for sculpture on the facade of the Gothic church than had been available on the facade of the Romanesque church. There were now three doors where there had been only one before, and doors were added to the transepts as well. The portal at Reims (**Fig. 18-20**), which notably substitutes a stained-glass rose window for the Romanesque tympanum and a pointed for a round arch, is sculpturally much lighter than, for instance, the tympanum at Autun, France (see Fig. 18-16). The elongated bodies of the Romanesque figures are distributed in a very shallow space. In contrast, the sculpture of the Gothic cathedral is more naturalistic. The proportions of the figures are more natural,

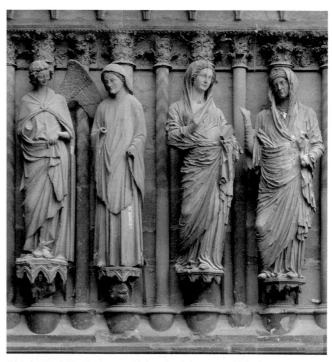

Fig. 18-21 *Annunciation and Visitation*, detail, west portal, Reims Cathedral, c. 1225–45.
© Angelo Hornak/Alamy.

CHAPTER 18 **THE AGE OF FAITH** 453

The Upanishads
c. 800–850

800

876
The symbol for "zero"
is first used in India

Developments in Asia

In Asia, Buddhism spread out of India and into China in the first century CE. By 600 CE, it had found its way into Japan. It would not take root in Southeast Asia until the thirteenth century. There the dominant religion was Hindusim.

INDIA

As early as 1500 BCE, Aryan tribesmen from northern Europe arrived in India, bringing a religion that would have as great an impact on the art of India as Islam had on the art of the Middle East. The Vedic traditions of the light-skinned Aryans, written in religious texts called the *Vedas*, allowed for the development of a class system based on racial distinctions. Status in one of the four classes—the priests (*Brahmans*), the warriors and rulers (*Kshatriyas*), the farmers and merchants (*Vaishayas*), and the serfs (*Shudras*)—was determined by birth, and one could escape one's caste only through reincarnation. Buddhism, which began about 563 BCE, was in many ways a reaction against the Vedic caste system, allowing for salvation by means of individual self-denial and meditation, and it gained many followers.

From the *Vedas* in turn came the *Upanishads*, a book of mystical and philosophical texts that date from sometime after 800 BCE. Taken together, the *Vedas* and the *Upanishads* form the basis of the Hindu religion, with Brahman, the universal soul, at its center. The religion has no single body of doctrine, nor any standard set of practices. It is defined above all by the diversity of its beliefs and deities.

As Hinduism developed, the functions of Brahman, the divine source of all being, were split among three gods—Brahma, the creator; Vishnu, the preserver; and Shiva, the destroyer—as well as various female deities. Vishnu was one of the most popular. In his role as preserver, he is the god of benevolence, forgiveness, and love, and like the other two main Hindu gods, he was believed capable of assuming human form, which he did more often than the other gods due to his great love for humankind. Among his most famous incarnations are his appearance as Rama, the ideal son, brother, husband, warrior, and king, who provides a model of righeous conduct, and as Krishna, a warrior who probably accounts in large part for Vishnu's popularity, since in the *Vishnu Puranas* (the "old stories" of Vishnu), collected about 500 CE, he is depicted as seducing one after another of his

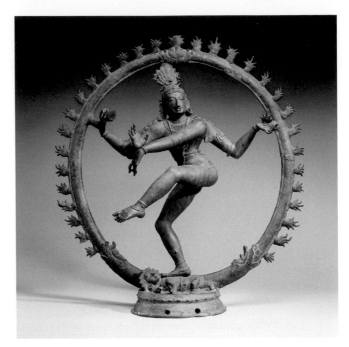

Fig. 18-22 *Shiva Nataraja, Lord of the Dance*, south India, Chola period, eleventh century.
Bronze, height. 43⅛ in. (111.5 × 101.65 cm) The Cleveland Museum of Art. Purchase from the J. H. Wade Fund, 1930.331. © The Cleveland Museum of Art.

devotees. His celebration of erotic love symbolizes the mingling of the self and the absolute spirit of Brahman.

If Brahma is the creator of the world, Shiva takes what Brahma has made and embodies the world's cyclic rhythms. Since in Hinduism the destruction of the old world is followed by the creation of a new world, Shiva's role as destroyer is required and a positive one. In this sense, he possesses reproductive powers, and in this manifestation of his being, he is often represented as a *lingam* (phallus), often carved in stone on temple grounds or at shrines. As early as the tenth and eleventh centuries, artists in the Tamil Nadu region of southern India began making large bronze and copper editions of Shiva in his manifestation as *Shiva Nataraja, Lord of the Dance* (**Fig. 18-22**). Such images were commissioned as icons for the region's many temples. Since Shiva embodies the rhythms of the universe, he is also a great dancer. All the gods were present when Shiva first danced, and they begged him to dance again. Shiva promised to do so in the hearts of his devotees as well as in a sacred grove in Tamil Nadu itself. As he dances, he is framed in a circle of fire, symbolic of both creation and destruction, the cycle of birth, death, and reincarnation.

Muslim invaders destroy Buddhist
and Hindu centers of worship in India
1050–1200

1000–1200
Islamic groups first
move into India

1200

Fig. 18-23 *The Goddess Durga Killing the Buffalo Demon, Mahisha (Mahishasuramardini)*, Bangladesh or India, Pala period (ca. 750–1200), twelfth century.
Argillite, height. 5⁵/₁₆ in. (13.5 cm) The Metropolitan Museum of Art, New York, NY, U.S.A. Diana and Arthur G. Altschul Gift, 1993. 1993.7.
© The Metropolitan Museum of Art. Image source: Art Resource, NY.

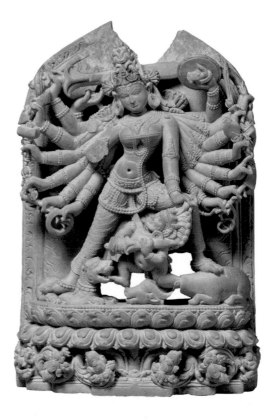

Goddess worship is fundamental to Hindu religion. Villages usually recognize goddesses as their protectors, and the goddess Devi is worshipped in many forms throughout India. She is the female aspect without whom the male aspect, which represents consciousness or discrimination, remains impotent and void. She is also synonymous with Shakti, the primordial cosmic energy, and represents the dynamic forces that move through the entire universe. Shaktism, a particular brand of Hindu faith that regards Devi as the Supreme Brahman itself, believes that all other forms of divinity, female or male, are themselves simply forms of Devi's diverse manifestations. But she has a number of particular manifestations. In an extraordinary miniature carving from the twelfth century, Devi is seen in her manifestation as Durga (**Fig. 18-23**), portrayed as the sixteen-armed slayer of a buffalo inhabited by the fierce demon Mahisha. Considered invincible, Mahisha threatens to destroy the world, but Durga comes to the rescue. In this image, she has just severed the buffalo's head and Mahisha, in the form of a tiny, chubby man, his hair composed of snake heads, emerges from the buffalo's decapitated body and looks up admiringly at Durga even as his toes are being bitten by her lion. Durga smiles serenely as she hoists Mahisha by his hair and treads gracefully on the buffalo's body.

The Hindu respect for sexuality is evident even in its architecture. The Kandarya Mahadeva temple (**Fig. 18-24**) represents the epitome of northern Hindu architecture. Its rising towers are meant to suggest the peaks of the Himalayas, home of the Hindu gods, and this analogy would have been even clearer when the temple was painted in its original white gesso. In the center of the temple is the *garbhagriha*, or "womb chamber," the symbolic sacred cavern at the heart of the sacred mountain/temple. Here rests the cult image of Brahman, in this case the *lingam*, or phallus, of Shiva. Although it is actually almost completely dark, the *garbhagriha* is considered by Hindu worshippers to be filled with the pure light of Brahman.

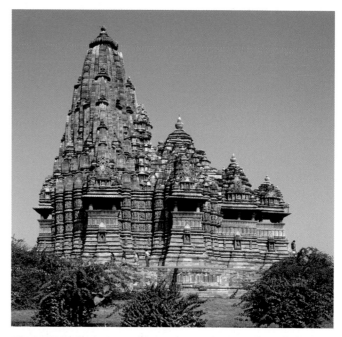

Fig. 18-24 Kandariya Mahadeva Temple, Khajuraho, Madhya Pradesh, India, Chandella dynasty, c. 1025–50.
© Neil Grant/Alamy.

A Chinese writer describes
three forms of gunpowder
c. 1040

1040

1090
First use of movable type
in China

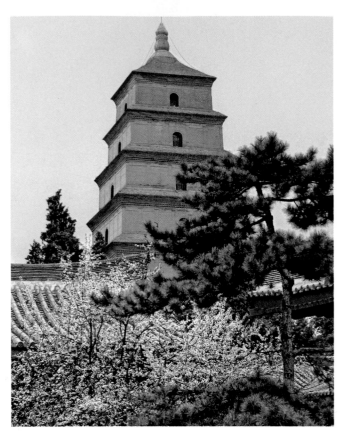

Fig. 18-25 Great Wild Goose Pagoda at Ci'en Temple, Xi'an, Shanxi, Tang dynasty, first erected 645 CE.
© Kevin O'Hara/Age Fotostock.

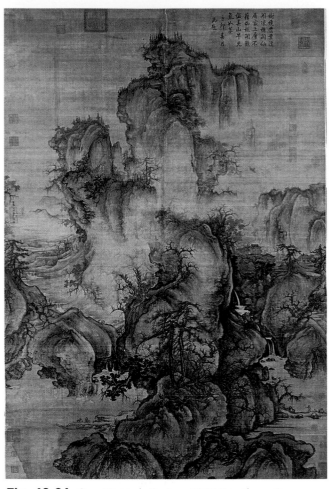

Fig. 18-26 Guo Xi, *Early Spring*, 1072 (Northern Song dynasty).
Hanging scroll, ink, and slight color on silk, length 60 in.
Collection of the National Palace Museum, Taipei, Taiwan, R.O.C.

View the Closer Look on *Early Spring* on myartslab.com

CHINA

Beginning in 618, at about the same time that Islam arose in the Middle East, the Tang dynasty reestablished a period of peace and prosperity in China that, except for a brief period of turmoil in the tenth century, would last 660 years. During this period, the pagoda became a favored architectural form in China. A pagoda is a multistoried structure of successively smaller, repeated stories, with projecting roofs at each story. The design derives from Indian stupas that had grown increasingly tower-like by the sixth century CE, as well as Han watchtowers. In fact, the pagoda was understood to offer the temple a certain protection. The Great Wild Goose Pagoda (**Fig. 18-25**) was built in 645 for the monk Xuanzang, who taught and translated the materials he brought back with him from a 16-year pilgrimage to India. In its simplicity and symmetry, it represents the essence of Tang architecture.

Since the time of the Song dynasty, which ruled the empire from 960 until it was overrun by Kublai Khan in 1279, the Taoists in China had emphasized the importance of self-expression, especially through the arts. Poets, calligraphers, and painters were appointed to the most important positions of state. After calligraphy, the Chinese valued landscape painting as the highest form of artistic endeavor. For them, the activity of painting was a search for the absolute truth embodied in nature, a search that was not so much intellectual as intuitive. They sought to understand the *li*, or "principle," upon which the universe is founded,

Mongol ruler Genghis Khan captures Beijing	Kublai Khan ascends to the Mongol throne and moves the capital to Beijing		
1215	**1264**		**1300**

1275
Marco Polo arrives in China

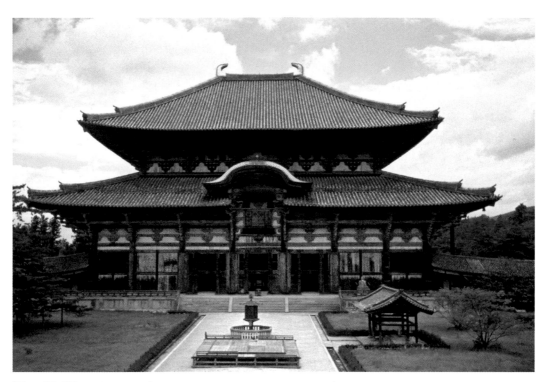

Fig. 18-27 Todaiji temple, Nara, Japan, 752, reconstructed 1709.
© Sakamoto Photo Research Laboratory/CORBIS.

and thus to understand the symbolic meaning and feeling that underlies every natural form. The symbolic meanings of Guo Xi's *Early Spring* (**Fig. 18-26**), for instance, have been recorded in a book authored by his son, Guo Si, titled *The Lofty Message of the Forests and Streams*. According to this book, the central peak here symbolizes the emperor, and its tall pines the gentlemanly ideals of the court. Around the emperor, the masses assume their natural place, just as around the mountain, the trees and hills fall, like the water itself, in the order and rhythms of nature.

JAPAN

Until the sixth century CE, Japan was a largely agricultural society that practiced Shinto, an indigenous system of belief involving the worship of *kami*, deities believed to inhabit many different aspects of nature, from trees and rocks to deer and other animals. But during the Asuka period (552–646 CE), the philosophy, medicine, music, food, and art and architecture of China and Korea were introduced to the culture. At about this same time, Buddhism was introduced into the country.

According to the *Kojiki*, or *Chronicles of Japan*, a collection of myths and stories dating from about 700 CE, a statue of Buddha and a collection of sacred Buddhist texts were given to Japanese rulers by a Korean king in 552. By 708, the Fujiwara clan had constructed a new capital at Nara and officially accepted Buddhism as the state religion. Magnificent temples and monasteries were constructed, including what would remain, for a thousand years, the largest wooden structure in the world, the Todaiji temple (**Fig. 18-27**). It houses a giant bronze, known as the Great Buddha, over 49 feet high and weighing approximately 380 tons. According to ancient records, as many as 2.6 million people were required to aid in the temple's construction, although that number represents close to half of Japan's population at the time and is probably an exaggeration. The original temple was twice destroyed by warring factions, in 1180 and again in 1567. The current Buddha is in fact a 1691 reconstruction of the original, and the Todaiji temple is itself a reconstruction from 1709. The restored temple is considerably smaller than the original, approximately two-thirds its size, and now stands 188 feet in width and 156-feet high.

CHAPTER 18 **THE AGE OF FAITH** 457

The Tale of Genji, arguably the first novel,
appears in the Heian court in Japan
1010–1030

800

The Heian Period in Japan
794–1185

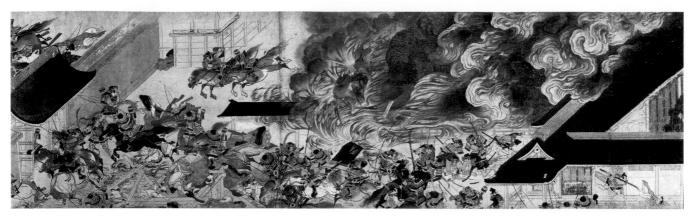

Fig. 18-28 *Night Attack on the Sanjo Palace*, detail, from the *Scrolls of Events of the Heiji Period*, Kamakura period, late thirteenth century.
Handscroll, ink and colors on paper, 16¼ × 27⁵¹/₂ in. Museum of Fine Arts, Boston. Fenollosa-Weld Collection (11.4000).
Photograph © 2012 The Museum of Fine Arts, Boston.

As early as the seventh century, Buddhist doctrine and Shinto had begun to influence each other. In the eighth century, the Great Buddha at Nara became identified with the principle Shinto goddess Amaterasu, from whom all Japanese emperors are said to have descended, and Buddhist ceremonies were incorporated into Shinto court ritual. But between 784 and 794, the capital of Japan was moved to Heiankyo— modern-day Kyoto— inaugurating the great elegance and refinement of the Heian period. Heiankyo quickly became the most densely populated city in the world. According to records, the move occurred because the secular court needed to distance itself from the religious influence of the Buddhist monks at Nara.

During the Heian period, the emperors had increasingly relied on regional warrior clans—*samurai* (literally, "those who serve")—to exercise military control, especially in the countryside. Over time these clans became more and more powerful, until, by 1100, they had begun to emerge as a major force in Japanese military and political life, inaugurating the Kamakura Period, which takes its name from the capital city of the most prominent of these clans, the Minamoto.

The Kamakura period actually began when the Minamoto clan defeated its chief rival, the Taira, in 1185, but the contest for power between the two dominated the last years of the Heian period. The complex relationship between the Fujiwara of the Heian era and the samurai clans of the Kamakura is embodied in a long handscroll narration of an important battle

of 1160, from the *Scrolls of Events of the Heiji Period*, painted by an unknown artist in the thirteenth century perhaps 100 years after the events themselves. In 1156, Go Shirakawa ascended to the throne of the Fujiwara to serve in what had become their traditional role as regent to the emperor, the highest position in the government. But Go Shirakawa resisted the Fujiwara attempt to take control of the government, and in 1157, the Fujiwara recruited one of the two most powerful samurai clans, the Minamoto, to help them stage a coup and imprison the emperor. *Night Attack on the Sanjo Palace* (**Fig. 18-28**) depicts the moment troops led by Fujiwara Nobuyori attacked the emperor's palace in the middle of the night, taking him prisoner and burning his palace to the ground. This is the central scene of the scroll, which begins with the army moving toward the palace from the right and ends with it leaving in triumph to the left. The chaos and violence of the events are captured by the sweeping linear ribbons of flame and smoke rising to the upper right and the confusion of horsemen, warriors, fleeing ladies, the dead, and the dying in the foreground, all framed by an architecture that falls at a steep diagonal to the bottom left.

The samurai warriors, dressed in elaborate iron armor, were master horsemen and archers. In this scene, many hold their bows, the lower portions of which are smaller than the top in order that they might pass over a horse's neck. They wore a special armor, known as *yoroi*, made of overlapping iron and lacquered leather scales (**Fig. 18-29**). A breastplate and backplate were strapped

The monk Eisai returns to Japan from China and begins
teaching Zen Buddhism
1191

1300

1185
Kamakura period begins in Japan as Minamoto Yoritomo is
appointed shogun, general-in-chief of the samurai

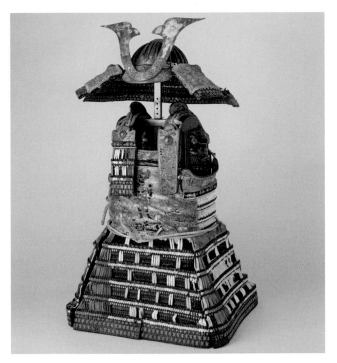

Fig. 18-29 Armor *(yoroi)*, late Kamakura period, early fourteenth century.

Lacquered iron and leather, silk, stenciled leather, gilt copper, height (as mounted) 37½ in. (95.25 cm) weight 22 in (55.88 cm); weight 38 lb. 3 oz. The Metropolitan Museum of Art, New York, NY, U.S.A. Gift of Bashford Dean, 1914 (14.100.121 b-e).

Image copyright © The Metropolitan Museum of Art. Image source: Art Resource, NY

together with leather thongs, and a separate piece of armor protected the right side, particularly vulnerable when the archer raised his arm to draw his bow. A four-sided skirt was attached to the armor to protect the upper legs. The helmet was made of iron plates from which a neckguard flared sharply outward. Diagonal bands of multicolored lacings originally decorated this *yoroi*, a symbol of the rainbow and a reminder that both beauty and good fortune are fleeting. Stenciled in the leather breastplate is an image of Fudo Myo-o ("The Immovable"), one of the five great guardians of the Buddhist faith. Because he is unshakable in his duty, fierce in his demeanor, and exercises strict mental discipline, Fudo Myo-o was a figure venerated by the samurai.

The Cultures of Africa

Just as in Europe and Asia, powerful kingdoms arose across Africa in the early centuries of the second millennium. As we have seen, the influence of Islam helped to establish a powerful culture in the kingdom of Mali (see Fig. 18-11). Further south, along the western coast of central Africa, the Yoruba state of Ife developed along the Niger River. Near the southeastern tip of Africa, the Shona civilization produced urban centers represented today by the ruins of "Great Zimbabwe." On the eastern side of Africa, the Zagwe dynasty maintained a long Christian heritage introduced in the first millennium from the Middle East.

By the middle of the twelfth century, Ife culture was producing highly naturalistic brass sculptures depicting its rulers. An example is the *Head of a King* (or *Oni*) (**Fig. 18-30**). The parallel lines that run down the face represent decorative effects made by scarring—**scarification**. The hole in the lower neck suggests that the head may have been attached to a wooden mannequin, and in memorial services the mannequin may

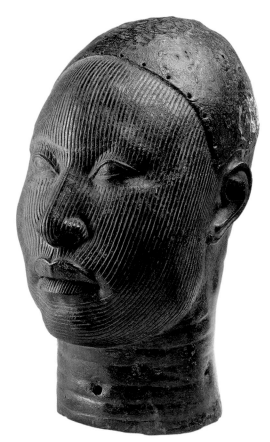

Fig. 18-30 *Head of a King* (Oni), Ife culture, Nigeria, c. thirteenth century.

Brass, height 11⁷/₁₆ in. Museum of Ife Antiquities, Ife, Nigeria Dirk Bakker.

Height of culture in
West Africa
1100–1300

1040

1200–1400
The Shona city known as the great Zimbabwe
rises in Southwest Africa

well have worn the royal robes of the Ife court. Small holes along the scalp line suggest that hair, or perhaps a veil of some sort, also adorned the head. But the head itself was, for the Ife, of supreme importance. It was the home of the spirit, the symbol of the king's capacity to organize the world and to prosper. Ife culture depended on its kings' heads for its own welfare. Since the Ife did not leave a written record of their cultural beliefs, we can best understand their ancient culture by looking at their contemporaries.

Inland from the southwestern coast of Africa, the Shona people built an entirely indigenous African civilization in the region of today's Zimbabwe beginning in about 1100. As trade developed along the African coast, the Shona positioned themselves as an inland hub where coastal traders could travel to procure goods for export. From surrounding regions they mined or imported copper and gold, and received in return exotic goods such as porcelain and glass from Asia and the Middle East.

Between the thirteenth and fifteenth centuries, the Shona erected the massive stone buildings and walls of a city known today as Great Zimbabwe. The origin of the Shona word *zimbabwe* is debated, but a composite of various meanings suggests that it referred to the "palaces of stone" in this city. A huge city for its time, its ruins cover one square mile and are believed to have housed a population of somewhere between 10,000 and 20,000. Great Zimbabwe has several distinct areas. The oldest of these, a hilltop enclosure known as the Hill Ruin, probably served as a lookout, but may also have been set apart for religious ceremonies or initiation rites. Built around 1250, it has a perimeter wall of smooth stone blocks that follows the contours of the hilltop. Inside this wall are several smaller enclosures with floors of clay that were hardened and polished to a shine. The enclosures also had ceremonial platforms decorated with carved geometric patterns and tall rock monoliths topped by carved birds (**Fig. 18-31**). The bird topping this monolith is not a recognizable species and includes certain human features, such as toes instead of talons. This has led to speculation that the figure may represent deceased Shona rulers who were believed to have the power to move between the spirit and human worlds. A crocodile, possibly another symbol of royalty, climbs up the front of the monolith.

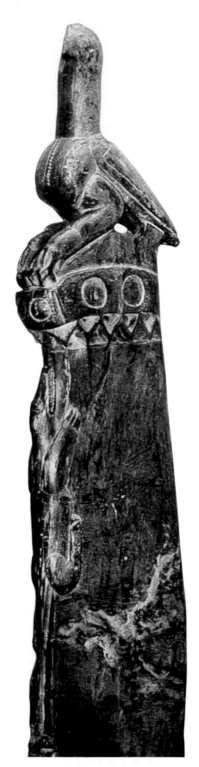

Fig. 18-31 Bird carved from soapstone, Great Zimbabwe, Zimbabwe, c. 1200–1400.

Height 14½ in., atop a stone monolith, total height 64 in. Great Zimbabwe Site Museum, Zimbabwe.

Fig. 18-32 Beta Ghiorghis
(House of St. George), Lalibela,
Ethiopia, thirteenth century.
© Kazuyoshi Nomachi/HAGA/ The Image
Works.

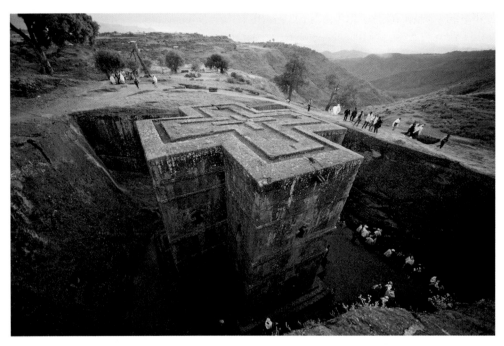

One of the dynasties of greatest cultural importance in medieval East Africa was that of the Zagwe, who reigned for approximately 150 years, from the early twelfth century to 1270. They carved massive rock churches into the soft rock of the region (**Fig. 18-32**). The most famous of these was commissioned by the emperor Lalibela. In the town now known by his name, he ordered the construction of a series of these sunken churches. Engineers had to conceive of the completed building in advance, including decorative details, because subtractive techniques such as carving do not allow for repair of mistakes.

Once the shell of the building was carved, the interior was hollowed out into rooms for use in Christian worship and study.

View the architectural panorama of Beta Ghiorgis on myartslab.com

THINKING BACK

Study and review on myartslab.com

How were early Christian and Byzantine places of worship designed?

The emperor Constantine chose to make early Christian places of worship as unlike classical temples as possible. He chose a rectangular building type called the basilica, which the ancient Romans had used for secular public functions. Early Christians and, later, Byzantines also used circular buildings, which derived from mausoleum architecture. What is an ambulatory? How is San Vitale decorated?

What are some of the features of a masjid, *or mosque?*

A many-columned area, known as a hypostyle space, would become a standard feature of mosques. Mosques are required to have a *qibla*, a wall that indicates the direction of Mecca. What is a *minbar*? What is a *mihrab*?

What features tend to define the Romanesque style?

Romanesque architecture is characterized by its easily recognizable geometric masses—rectangles, cylinders, and half-cylinders. Romanesque buildings have large vaulted ceilings, which require massive walls, typically lacking windows. The art of sculpture began to reemerge in the Romanesque period. What role did the pilgrimage route play in church building? What is a tympanum, and how would it be used in church decoration?

What distinguishes Gothic architecture?

Light is a defining feature of Gothic buildings. Unlike Romanesque structures, Gothic buildings are well lit. Light was believed to serve as a manifestation of the divine. Gothic buildings are defined by an emphasis on verticality. What role did Abbot Suger play in the development of Gothic style? How does the Gothic style in Italy differ from the French Gothic style?

CHAPTER 18 **THE AGE OF FAITH** 461

19 | The Renaissance through the Baroque

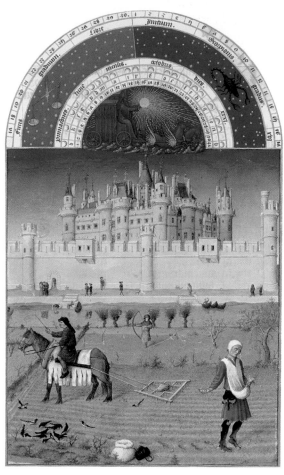

Fig. 19-1 The Limbourg Brothers, *October*, from *Les Très Riches Heures du Duc de Berry*, 1413–16. Manuscript illumination. Musée Condé, Chantilly, France.
Réunion des Musées Nationaux/Art Resource, NY.

Thinking Thematically: See **Art and the Passage of Time** on myartslab.com

THINKING AHEAD

Why does the Renaissance take its name from a word meaning "rebirth"?

How did African cultures regard the Portuguese?

What distinguishes the style known as Mannerism?

What are some defining characteristics of Baroque art and architecture?

(((•─[**Listen** to the chapter audio on myartslab.com

Just when the Gothic era ended and the Renaissance began is by no means certain. In Europe, toward the end of the thirteenth century, a new kind of art began to appear, at first in the south, and somewhat later in the north. By the beginning of the fifteenth century, this new era, marked by a revival of interest in arts and sciences that had been lost since antiquity, was firmly established. We have come to call this revival the **Renaissance**, meaning "rebirth."

The Gothic era has been called a long overture to the Renaissance, and we can see, perhaps, in the sculptures at Reims Cathedral (see Fig. 18-21), which date from the

Construction of the Duomo, Florence Cathedral, begins	Bubonic plague introduced to Europe, and the "Black Death" sweeps the continent	
1296	**1347**	**1400**

1345
Petrarch discovers the
letters of Cicero

first half of the thirteenth century, the beginnings of the spirit that would develop into the Renaissance sensibility. These figures are no longer archetypal and formulaic representations; they are almost real people, displaying real emotions. This tendency toward increasingly naturalistic representation in many ways defines Gothic art, but it is even more pronounced in Renaissance art. If the figures in the Reims portal seem about to step off their columns, Renaissance figures actually do so. By the time of the Limbourg Brothers' early-fifteenth-century manuscript illumination for *Les Très Riches Heures du Duc de Berry* (**Fig. 19-1**), human beings are represented, for the first time since classical antiquity, as casting actual shadows upon the ground. The architecture is also rendered with some measure of perspectival accuracy. The scene is full of realistic detail, and the potential of landscape to render a sense of actual space is fully realized.

The Early Renaissance

The Renaissance is, perhaps most of all, the era of the individual. As early as the 1330s, the poet and scholar Petrarch had conceived of a new *humanism*, a philosophy that emphasized the unique value of each person. Petrarch believed that the birth of Christ had ushered in an "age of faith," which had blinded the world to learning and thus condemned it to darkness. The study of classical languages, literature, history, and philosophy—what we call the "humanities"—could lead to a new, enlightened stage of history. People should be judged, Petrarch felt, by their actions. It was not God's will that determined who they were and what they were capable of; rather, glory and fame were available to anyone who dared to seize them.

Embodying this belief is a sculpture by Donato di Niccolò di Betto Bardi, known as Donatello, which turns its attention directly to the classical past. His *David* (**Fig. 19-2**) was, in fact, the first life-size nude sculpture since antiquity. He is posed in perfectly classical *contrapposto*. But the young hero—almost antiheroic in the youthful fragility of his physique—is also fully self-conscious, his attention turned, in what appears to be full-blown self-adoration, upon himself as an object of physical beauty. Writing in 1485, the philosopher Giovanni Pico della Mirandola—Pico, as he is known—addressed himself to every ordinary (male) person: "Thou, constrained by no limits, in

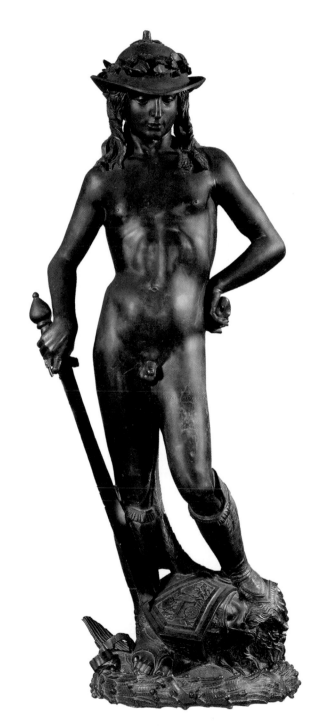

Fig. 19-2 Donatello, *David*, c. 1425–30.
Bronze, height 62¼ in. Museo Nazionale del Bargello, Florence.

Thinking Thematically: See **Art, Politics, and Community** on myartslab.com

English defeat French
in Battle of Agincourt
1415

Beginning of
Age of Exploration
1420

1400

early 15th century
Gunpowder first used
in Europe

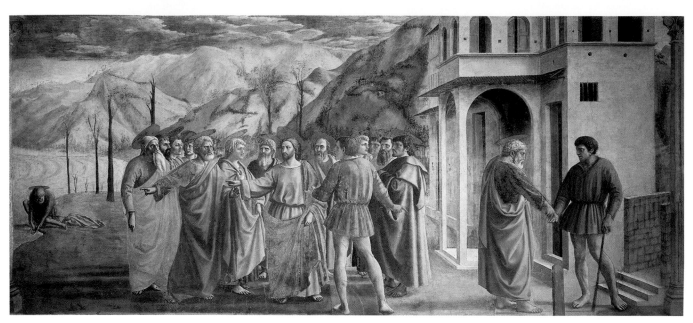

Fig. 19-3 Masaccio, *The Tribute Money*, c. 1427.
Fresco, 8 ft. 1 in. × 19 ft. 7 in. Brancacci Chapel, Santa Maria
del Carmine, Florence.
Scala/Art Resource, NY.

View the Closer Look on *The Tribute Money*
on myartslab.com

accordance with thine own free will . . . shalt ordain
for thyself the limits of thy nature. We have set thee at
the world's center . . . [and] thou mayst fashion thyself
in whatever shape thou shalt prefer." Out of such senti-
ments Donatello's *David* was born, as were the arche-
typal Renaissance geniuses—men like Michelangelo
and Leonardo—but also Niccolò Machiavelli's wily and
pragmatic Prince, for whom the ends justify any means,
and the legendary Faust, who sold his soul to the devil
in return for youth, knowledge, and magical power.

Donatello had traveled to Rome in 1402 with his
friend Filippo Brunelleschi, the inventor of geometric,
linear perspective (see Fig. 5-13), a system Brunelleschi
probably developed as he studied the ruins of ancient
Rome. It was Brunelleschi who accepted a commission to
design and build a dome over the crossing of the Florence
Cathedral (see Fig. 18-19). The other great innovator
of the day was the painter Masaccio, who died in 1428
at the age of 27, having worked only six years. He was
15 years younger than Donatello and 24 years younger
than Brunelleschi and learned from them both, trans-
lating Donatello's naturalism and Brunelleschi's sense
of proportion into the art of painting. In his *The Tribute
Money* (**Fig. 19-3**), painted around 1427, Christ's disciples,

especially St. Peter, wonder whether it is proper to pay
taxes to the Roman government when, from their point
of view, they owe allegiance to Christ, not Rome. But
Christ counsels them to separate their earthly affairs from
spiritual obligations—"Render therefore unto Caesar the
things which are Caesar's; and unto God the things that
are God's" (Matthew 22:21). To that end, Christ tells
St. Peter and the other disciples that they will find
the coin necessary to pay the imperial tax collector,
whose back is to us, in the mouth of a fish. At the left,
St. Peter extracts the coin from the fish's mouth, and, at
the right, he pays the required tribute money to the tax
collector. The figures here are modeled by means of chiar-
oscuro in a light that falls upon the scene from the right
(notice their cast shadows). We sense the physicality of
the figures beneath their robes. The landscape is rendered
through atmospheric perspective, and the building on the
right is rendered in a one-point perspective scheme, with
a vanishing point behind the head of Christ. All of these
artistic devices are in themselves innovations; together,
they constitute one of the most remarkable achieve-
ments in the history of art, an extraordinary change in
direction from the flat, motionless figures of the Middle
Ages toward a fully realistic representation.

Treaty of Troyes grants
French throne to the English king
1420

1431
Joan of Arc
executed as a heretic

1440

In the north of Europe, in Flanders particularly, a flourishing merchant society promoted artistic developments that in many ways rivaled those of Florence. The Italian revival of classical notions of order and measure was, for the most part, ignored in the north. Rather, the northern artists were deeply committed to rendering believable space in the greatest and most realistic detail. The *Mérode Altarpiece*, executed by Robert Campin (see Fig. 11-14), is almost exactly contemporary with Masaccio's *Tribute Money*, but in the precision and clarity of its detail—in fact, an explosion of detail—it is radically different in feel. The chief reason for the greater clarity is, as we discussed in Part 3, a question of medium. Northern painters developed oil paint in the first half of the fourteenth century. With oil paint, painters could achieve dazzling effects of light on the surface of the painting—as opposed to the matte, or nonreflective, surfaces of both fresco and tempera. These effects recall, on the one hand, the Gothic style's emphasis on the almost magical light of the stained-glass window. In that sense, the effect achieved seems transcendent. But it also lends the depicted objects a sense of material reality, and thus caters to the material desires of the north's rising mercantile class.

If we compare Rogier van der Weyden's *Deposition* (**Fig. 19-4**) to Piero della Francesca's *The Flagellation of Christ* (**Fig. 19-5**), the differences between the

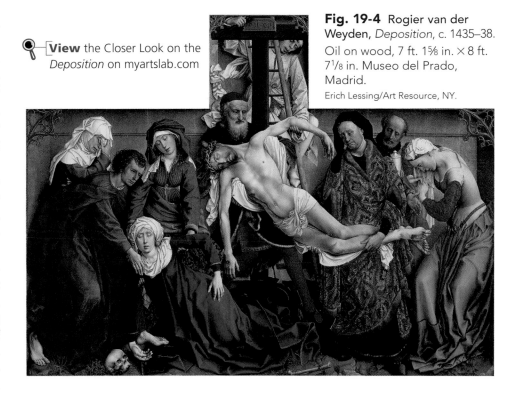

View the Closer Look on the *Deposition* on myartslab.com

Fig. 19-4 Rogier van der Weyden, *Deposition*, c. 1435–38. Oil on wood, 7 ft. 1⅝ in. × 8 ft. 7⅛ in. Museo del Prado, Madrid.
Erich Lessing/Art Resource, NY.

northern (Flemish) and the southern (Italian) sensibilities become evident. Virtually a demonstration of the rules of linear perspective, Piero's scene depicts Pontius Pilate watching as executioners whip Christ. Although it is much more architecturally unified, the painting pays homage to Masaccio's *Tribute Money*. Emotionally

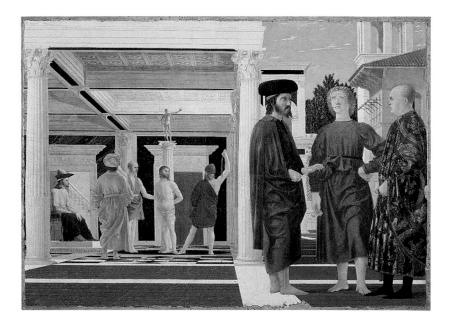

Fig. 19-5 Piero della Francesca, *The Flagellation of Christ*, c. 1451.
Tempera on wood, 32¾ × 23⅓ in. Palazzo Ducale, Galleria Nazionale delle Marche, Urbino.
Scala/Art Resource, NY.

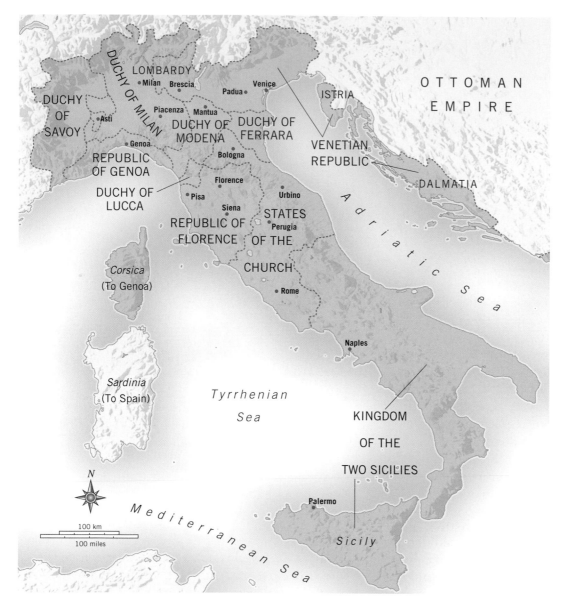

The Major Italian City-States during the Renaissance.

speaking, Rogier's *Deposition* has almost nothing in common with Piero's *Flagellation*. It is as if Piero has controlled the violence of his emotionally charged scene by means of mathematics, while Rogier has emphasized instead the pathos and human feeling that pervade his scene of Christ being lowered from the cross. While Piero's composition is essentially defined by a square and a rectangle, with figures arranged in an essentially triangular fashion, Rogier's composition is controlled by two parallel, deeply expressive, sweeping curves, one defined by the body of Christ and the other by the swooning figure below him. Next to the high drama of

Rogier's painting, Piero's seems almost static, but the understated brutality of Christ's flagellation in the background of Piero's painting is equally compelling.

The High Renaissance

When Lorenzo de' Medici assumed control of his family in 1469, Florence was still the cultural center of the Western world (see the map of Italy above). Lorenzo's predecessor had founded the Platonic Academy of Philosophy, where the artist Sandro Botticelli studied a brand of Neoplatonic thought that transformed the philosophic writings of Plato almost into a religion.

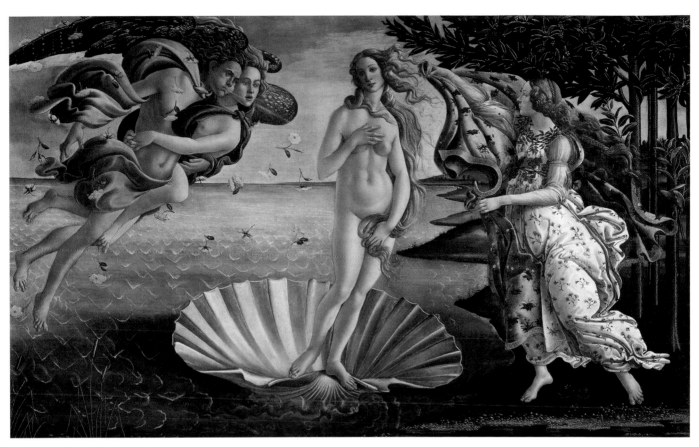

Fig. 19-6 Sandro Botticelli, *The Birth of Venus*, c. 1482.
Tempera on canvas, 5 ft. 8⅞ in. × 9 ft. 1⅞ in. Galleria degli Uffizi, Florence.
Canali Photobank, Milan, Italy.

Thinking Thematically: See **Art and Beauty** on myartslab.com

According to the Neoplatonists, in the contemplation of beauty, the inherently corrupt soul could transform its love for the physical and material into a purely spiritual love of God. Thus, Botticelli uses mythological themes to transform his pagan imagery into a source of Christian inspiration and love. His *Birth of Venus* (**Fig. 19-6**), the first monumental representation of the nude goddess since ancient times, represents innocence itself, a divine beauty free of any hint of the physical and the sensual. It was this form of beauty that the soul, aspiring to salvation, was expected to contemplate. But such meanings were by no means clear to the uninitiated, and when the Dominican monk Girolamo Savonarola denounced the Medicis as pagan, the majority of Florentines agreed. In 1494, the family was banished.

Still, for a short period at the outset of the sixteenth century, Florence was again the focal point of artistic activity. The three great artists of the High Renaissance—Leonardo, Michelangelo, and Raphael—all lived and worked in the city. As a young man, Michelangelo had been a member of Lorenzo de' Medici's circle, but with the Medicis' demise in 1494, he fled to Bologna. He returned to Florence seven years later to work on a giant piece of marble left over from an abandoned commission. Out of this, while still in his twenties, he carved his monolithic *David* (see Fig. 3-12).

Leonardo, some 23 years older than Michelangelo, had left Florence as early as 1481 for Milan. There he offered his services to the great Duke of Milan, Ludovico Sforza, first as a military engineer and, only secondarily, as an architect, sculptor, and painter. Ludovico was embroiled in military matters, and Leonardo pronounced himself the military engineer Ludovico was looking for, capable of constructing great "machines of war." Leonardo's restless imagination, in fact, led him to the study of almost everything: natural phenomena

Bartolomeu Dias
rounds the Cape of Good Hope
1488

Muslim Spain
falls to Christians
1492

1480

1483
Russians cross the Urals
into Asia

1492
Columbus makes landfall
in the Americas

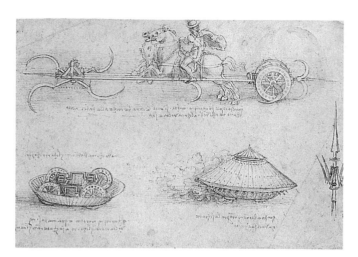

Fig. 19-7 Leonardo da Vinci, *A Scythed Chariot, Armored Car, and Pike*, c. 1487.

Pen and ink and wash, 6⅜ × 9¾ in. The British Museum Great Court, Ltd.

© The Trustees of the British Museum/Art Resource, NY.

like wind, storms, and the movement of water; anatomy and physiology; physics and mechanics; music; mathematics; plants and animals; geology; and astronomy, to say nothing of painting and drawing. His drawing of *A Scythed Chariot, Armored Car, and Pike* (**Fig. 19-7**) is indicative of his work for Sforza. "I will make covered vehicles," he wrote to the duke, "which will penetrate the enemy and their artillery, and there is no host of armed men so great that they will not be broken down by them." The chariot in the drawing is equipped with scythes to cut down the enemy, and the armored car, presented in an upside-down view as well as scooting along in a cloud of dust, was to be operated by eight men. But Leonardo's work for Sforza was not limited to military operations. From 1495 to 1498, he painted his world-famous fresco *The Last Supper* (see Fig. 5-15), which many consider to be the first painting of the High Renaissance, in Santa Maria delle Grazie, a monastic church under the protection of the Sforza family. Leonardo left Milan soon after the French invaded in October 1499, and by April he had returned to Florence, where he concentrated his energies on a life-size cartoon for *Madonna and Child with St. Anne and Infant St. John* (see Fig. 9-4). This became so famous that throngs of Florentines flocked to see it. At about this time he also painted the *Mona Lisa* (**Fig. 19-8**). Perhaps a portrait of the wife of the Florentine banker Zanobi del Giocondo, the painting conveys a psychological

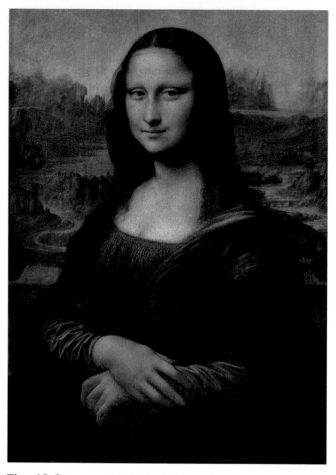

Fig. 19-8 Leonardo da Vinci, *Mona Lisa*, c. 1503–05.
Oil on wood, 30¼ × 21 in. Musée du Louvre, Paris.
Réunion des Musées Nationaux/Art Resource, NY.

View the Closer Look on the *Mona Lisa* on myartslab.com

depth that has continued to fascinate viewers up to the present day. Its power derives, at least in part, from a manipulation of light and shadow that imparts a blurred imprecision to the sitter's features, lending her an aura of ambiguity and mystery. This interest in the psychology, not just the physical looks, of the sitter is typical of the Renaissance imagination.

When Raphael, 21 years old, arrived in Florence in 1504, he discovered Leonardo and Michelangelo locked in a competition over who would get the commission to decorate the city council chamber in the Palazzo Vecchio with pictures celebrating the Florentine past. Leonardo painted a *Battle of Anghiari* and Michelangelo a *Battle of Cascina*, neither of which survives. We know

Population of Europe
begins to increase
late 15th century

1497
Vasco da Gama reaches
India by sea

1500

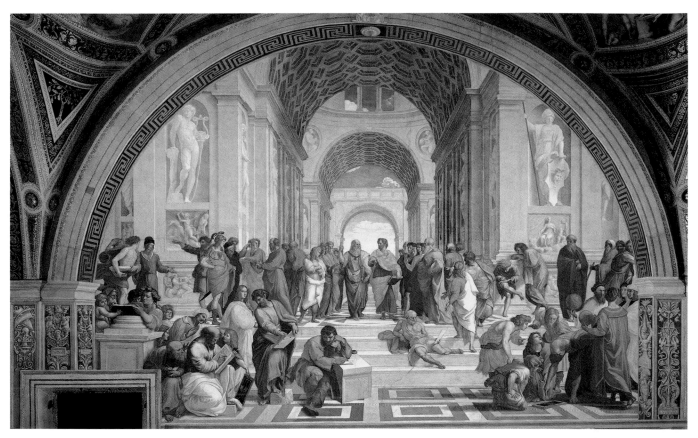

Fig. 19-9 Raphael, *The School of Athens*, 1510–11.
Fresco, 19 × 27 ft. Stanza della Segnatura, Vatican Palace, Rome.
Foto Musei Vaticani.

View the Closer Look on *The School of Athens*
on myartslab.com

the first today only by reputation and early drawings. A cartoon survived well into the seventeenth century and was widely copied, most faithfully by Peter Paul Rubens. Of the Michelangelo we know very little. What is clear, however, is that the young Raphael was immediately confronted by the cult of genius that in many ways has come to define the High Renaissance. Artists of genius and inspiration were considered different from everyone else, guided in their work by an insight that, according to the Neoplatonists, was divine in origin. The Neoplatonists believed that the goals of truth and beauty were not reached by following the universal rules and laws of classical antiquity—notions of proportion and mathematics. Nor, given the fallen condition of the world, would fidelity to visual reality guarantee beautiful results. Instead, the artist of genius had to rely on subjective and personal intuition—what the Neoplatonists called the "divine frenzy" of the creative act—to transcend the conditions of everyday life. Plato

had argued that painting was mere slavish imitation of an already existing thing—it was a diminished reality. The Neoplatonists turned this argument on its head. Art now exceeded reality. It was a window, not upon nature, but upon divine inspiration itself.

Raphael learned much from both Leonardo and Michelangelo, and, in 1508, he was awarded the largest commission of the day, the decoration of the papal apartments at the Vatican in Rome. On the four walls of the first room, the Stanza della Segnatura, he painted frescoes representing the four domains of knowledge—Theology, Law, Poetry, and Philosophy. The most famous of these is the last, *The School of Athens* **(Fig. 19-9)**. Raphael's painting depicts a gathering of the greatest philosophers and scientists of the ancient world. The centering of the composition is reminiscent of Leonardo's *Last Supper*, but the perspectival rendering of space is much deeper. Where in Leonardo's masterpiece, Christ is situated at the vanishing

Portuguese dominate
West Coast of Africa
1506

—**1500**—

c. 1500
Rise of modern
European nation-states

1513
The Prince is written by
Niccoló Machiavelli

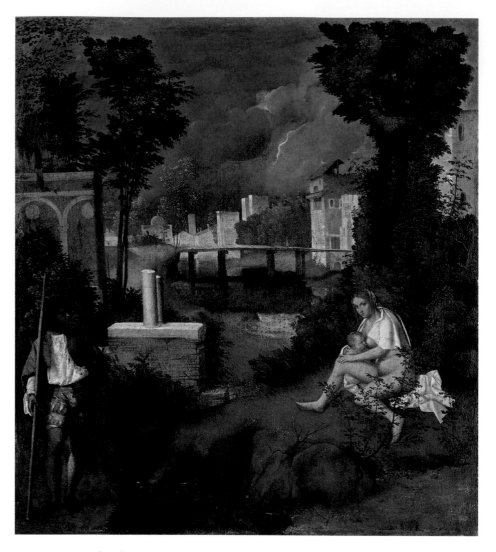

Fig. 19-10 Giorgione, *Tempest.*
c. 1509.

Oil on canvas, 31¼ × 28¾ in.
Gallerie dell'Accademia, Venice.
Cameraphoto Arte, Venice/Art Resource, NY.

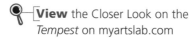
View the Closer Look on the
Tempest on myartslab.com

the Florentine manner. The emphasis in Venetian art is on the sensuousness of light and color and the pleasures of the senses. The closest we have come to it so far is in the mysterious glow that infuses Leonardo's *Mona Lisa*, but what is only hinted at in Leonardo's work explodes in Venetian painting as full-blown theatrical effect. Building up color by means of glazing, as Leonardo did in his soft, luminous landscapes (see Fig. 6-3), their paintings, like the great palaces of Venice whose reflections shimmered on the Grand Canal, demonstrate an exquisite sensitivity to the play of light and shadow and to the luxurious display of detail and design.

point, in Raphael's work, Plato and Aristotle occupy that position. These two figures represent the two great, opposing schools of philosophy: the Platonists, who were concerned with the spiritual world of ideas (thus, Plato points upwards), and the Aristotelians, who were concerned with the matter-of-factness of material reality (thus, Aristotle points over the ground upon which he walks). The expressive power of the figures owes much to Michelangelo, whom, it is generally believed, Raphael portrayed as the philosopher Heraclitus, the brooding, self-absorbed figure in the foreground.

Raphael's commission in Rome is typical of the rapid spread of the ideals of Italian Renaissance culture to the rest of Italy and Europe. In Venice, however, painting developed somewhat independently of

The mysterious qualities of Leonardo's highly charged atmospheric paintings are fully realized in Giorgione's *Tempest* (**Fig. 19-10**). The first known mention of the painting dates from 1530, when the painting surfaced in the collection of a Venetian patrician. We know almost nothing else about it, which contributes to its mystery. At the right, an almost nude young woman nurses her child. At the left, a somewhat disheveled young man, wearing the costume of a German mercenary soldier, gazes at the woman and child with evident pride. Between them, in the foreground, stands a pediment topped by two broken columns. A creaky wooden bridge crosses the estuary in the middle ground, and lightning flashes in the distance, illuminating a densely built cityscape. What, we must ask, is the relationship

Martin Luther posts his 95 theses,
inaugurating the Protestant Reformations
1517

First circumnavigation
of the world
1519–22

1530

1517
Spain authorizes slave trade betwen
West Africa and New World countries

Fig. 19-11 Titian, *Venus of Urbino*, 1538.
Oil on canvas, 47 × 65 in. Galleria degli Uffizi, Florence.
Scala/Art Resource, NY.

Thinking Thematically: See Art, Gender, and Identity
on myartslab.com

between the two figures? Are they husband and wife? Or are they lovers, whose own tempestuous affair has resulted in the birth of a child? These are questions that remain unanswered, but which the deeply atmospheric presentation of the scene sustains.

The almost comfortable sensuality of the scene—even its suggestion of outright sexuality—would become one of the chief subjects of Venetian art. When Giorgione died of the plague in 1510, at only 32 years of age, it seems likely that his friend Titian, 10 years younger, finished several of his paintings. While lacking the sense of intrigue that his elder mentor captured in *The Tempest*, Titian's *Venus of Urbino* (**Fig. 19-11**) is more frankly addressed to the sexual appetites of its viewers. Painted for Duke Guidobaldo della Rovere

of Urbino in 1538, this "Venus"—more a real woman than an ethereal goddess, and referred to by Guidobaldo as merely a "nude woman"—is frankly available. She stares out at the viewer, Guidobaldo himself, with matter-of-factness suggesting she is totally comfortable with her nudity. (Apparently the lady-in-waiting and maid at the rear of the palatial rooms are searching for suitably fine clothing in which to dress her.) Her hand both covers and draws attention to her genitals. Her dog, a traditional symbol of both fidelity and lust, sleeps lazily on the white sheets at her feet. She may be, ambiguously, either a courtesan or a bride. (The chest from which the servant is removing clothes is a traditional reference to marriage.) In either case she is, primarily, an object of desire.

CHAPTER 19 **THE RENAISSANCE THROUGH THE BAROQUE** **471**

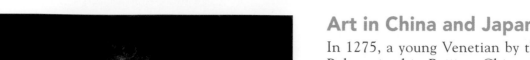

First Mongol invasion of Japan
1274

1200

1264–1368
Beijing thrives as Chinese
capital under Mongol rule

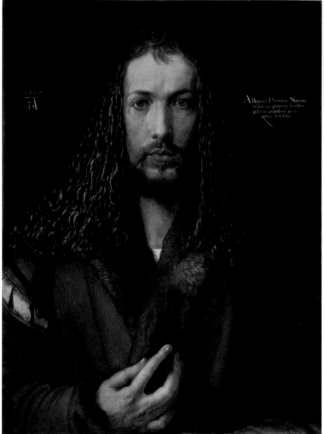

Fig. 19-12 Albrecht Dürer, *Self-Portrait*, 1500.
Oil on panel, 26¼ × 19¼ in. Alte Pinakothek, Munich.

In the north of Europe, the impact of the Italian Renaissance is perhaps best understood in the work of the German artist Albrecht Dürer. As a young man, he had copied Italian prints, and, in 1495, he traveled to Italy to study the Italian masters. From this point on, he strove to establish the ideals of the Renaissance in his native country. Perhaps the first artist to be fascinated by his own image, Dürer painted self-portraits throughout his career. In this act, he asserts his sense of the importance of the individual, especially the individual of genius and talent, such as he. Meaning to evoke his own spirituality, he presents himself almost as if he were Christ (**Fig. 19-12**). Yet, as his printmaking demonstrates (see Fig. 10-21), not even Dürer could quite synthesize the northern love for precise and accurate naturalism—the desire to render the world of real things—with the southern idealist desire to transcend the world of real things.

Art in China and Japan

In 1275, a young Venetian by the name of Marco Polo arrived in Beijing, China, and quickly established himself as a favorite of the Mongol ruler Kublai Khan, first emperor of the Yuan dynasty. Polo served in an administrative capacity in Kublai Khan's court and for three years ruled the city of Yangzhou. Shortly after his return to Venice in 1295, he was imprisoned after being captured by the army of Genoa in a battle with his native Venice. While there, he dictated an account of his travels. His description of the luxury and magnificence of the Far East, by all accounts reasonably accurate, was virtually the sole source of information about China available in Europe until the nineteenth century.

At the time of Marco Polo's arrival, many of the scholar-painters of the Chinese court, unwilling to serve under the foreign domination of Kublai Khan, were retreating into exile from public life. In exile, they conscientiously sought to keep traditional values and arts alive by cultivating earlier styles in both painting and calligraphy. According to the inscription on Cheng Sixiao's *Ink Orchids* (**Fig. 19-13**), this painting was done to protest the "theft of Chinese soil by invaders," referring to the Mongol conquest of China. The orchids, therefore, have been painted without soil around their roots, showing an art flourishing, even though what sustains it has been taken away.

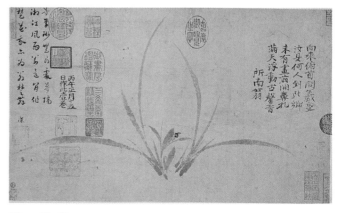

Fig. 19-13 Cheng Sixiao, *Ink Orchids*, Yuan dynasty, 1306.
Handscroll, ink on paper, 10⅛ × 16¾ in. Municipal Museum of Fine Arts, Osaka.
Galileo Picture Services, LLC/Pacific Press Service.

Chinese voyages
to India and Africa begin
1405

1450

1368
Founding of
Ming dynasty

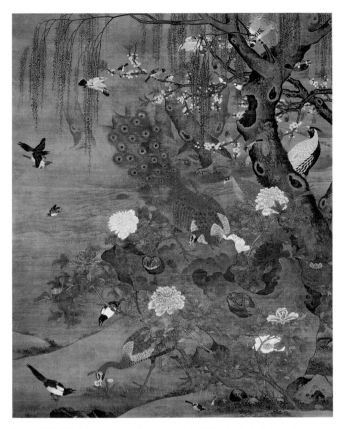

Fig. 19-14 Yin Hong, *Hundreds of Birds Admiring the Peacocks*, Ming dynasty, c. late fifteenth–early sixteenth century.
Hanging scroll, ink and color on silk, 7 ft. 10½ in × 6 ft. 5 in. The Cleveland Museum of Art. Purchase from the J. H. Wade Fund, 74.31.

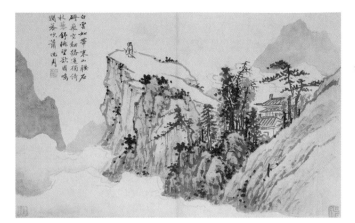

Fig. 19-15 Shen Zhou, *Poet on a Mountaintop*, leaf from an album of landscapes, painting mounted as part of a handscroll, Ming dynasty, c. 1500.
Ink and color on paper, 15¼ × 23¾ in. The Nelson-Atkins Museum of Art, Kansas City, Missouri. Purchase: William Rockhill Nelson Trust, 46-51/2.
Photo: Robert Newcombe.

Hundreds of Birds Admiring the Peacocks (**Fig. 19-14**) by Yin Hong, a court artist active in the late fifteenth and early sixteenth centuries, is an example of the northern school, conservative and traditional in its approach. It is defined by its highly refined decorative style, which emphasizes the technical skill of the painter, the rich use of color, and reliance on traditional Chinese painting—in this case the birds-and-flowers genre extremely popular in the Song dynasty. Like Guo Xi's Song dynasty painting, *Early Spring* (see Fig. 18-26), Yin Hong's painting takes on a symbolic meaning that refers directly to the emperor. Just as the central peak in Guo Xi's painting symbolizes the emperor himself, with the lower peaks and trees assuming a place of subservience to him, here the emperor is symbolized by the peacock around whom the "hundreds of birds"—that is, the court officials—gather in obeisance.

The southern style was unorthodox, radical, and inventive. Thus, a painting like *Poet on a Mountaintop* (**Fig. 19-15**) by Shen Zhou radicalizes traditional Chinese landscape. For the southern artist, reality rested in the mind, not the physical world, and thus self-expression was the ultimate aim. Here the poet stands as the central figure in the painting, facing out over an airy void in which hangs the very image of his mind, the poem inscribed in the top left of the painting:

In 1368, Zhu Yuanzhang (ruled 1368–98) drove the Mongols out of China and restored Chinese rule in the land, establishing the dynasty called the Ming ("bright" or "brilliant"), which lasted until 1644. Late in the Ming dynasty, an artist, calligrapher, theorist, and high official in the government bureaucracy, Dong Qichang, wrote an essay that has affected the way both the Chinese and Westerners have looked at the history of Chinese painting ever since, although many scholars, even in Dong Qichang's time, viewed it as oversimplistic. He divided the history of Chinese painting into two schools, northern and southern, although geography had little to do with it. It was not place but the spirit in which the artist approached his painting that determined to which school he belonged.

1400

Ashikaga shoguns build
elaborate palaces near Kyoto
1399–1483

Noh drama increasingly
popular in Japan
1380–1500

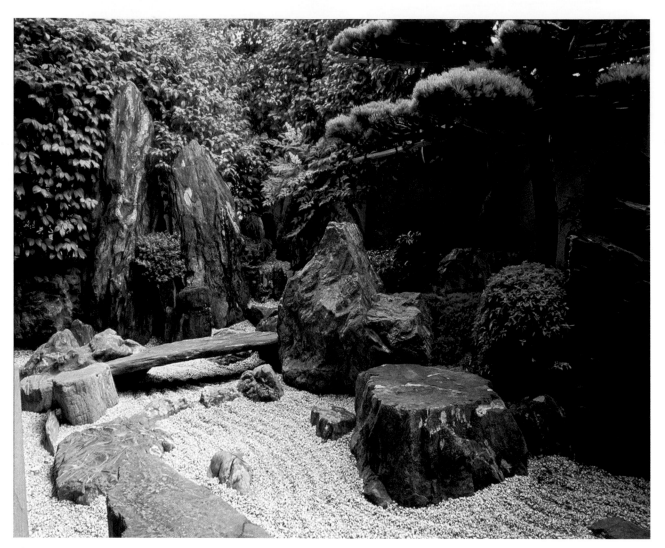

Fig. 19-16 Attributed to Soami, *Garden of the Dasisen-in of Daitokuji*, Kyoto, Japan, Morimachi period, c. 1510–25.
© Paul Quayle.

Thinking Thematically: See **Art and the Passage of Time** on myartslab.com

White clouds like a belt encircle the mountain's waist
A stone ledge flying in space and the far thin road.
I lean alone on my bramble staff and gazing contented
* into space*
Wish the sounding torrent would answer to your flute.

The southern style ideally synthesizes the three areas of endeavor that any member of the cultural elite—or literati, the literary intelligentsia—should have mastered: poetry, calligraphy, and painting.

In Japan, Zen Buddhists also responded to their religion in gardens, distinguished by extreme simplicity and carefully constructed, largely from small pebbles, rocks, and a few carefully groomed plantings. Their rock features evoke mountains and their expanses of pebbles and rocks bodies of water—streams, lakes, and even the ocean. An especially remarkable example is a garden usually attributed to a painter named Soami (**Fig. 19-16**). It consists of a series of miniature landscapes whose vertical rocks represent mountains. A waterfall, suggested by a vein of white quartz, cascades down one rock, forming a river of white gravel, across which a slab of stone has fallen like a natural bridge connecting islands in the stream.

Classic period of
Teotihuacán civilization
300–900 CE

300 BCE ——————————————————————— **1000**

c. 164 BCE
Oldest Mayan monuments

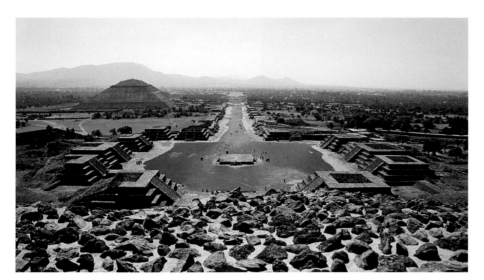

Fig. 19-17 Teotihuacán, Mexico, as seen from the Pyramid of the Moon, looking south down the Avenue of the Dead, the Pyramid of the Sun at the left, c. 350–650 CE.
Gina Martin/National Geographic Stock.

Art in Mexico and South America

By the time Christopher Columbus arrived in what he dubbed the "New World" in 1492, many significant cultures, like that of the Olmec (see Fig. 17-15), had already come and gone. By the fourth century CE, Teotihuacán (**Figs. 19-17** and **19-18**) had become an important commercial center inhabited by a people of unknown ethnic identity. As opposed to the later Mayan cities, many of which were quickly forgotten and overgrown in the jungle, Teotihuacán remained, a thousand years after it flourished, the mythic center of Mesoamerican civilization, the site of pilgrimages by even the most important Aztec rulers.

The city is laid out in a grid system, the basic unit of which is 614 square feet, and every detail is subjected to this scheme—the very image of power and mastery. A great broad avenue, known as the Avenue of the Dead, runs through the city. It links two great pyramids, the Pyramids of the Moon and the Sun, each surrounded by about 600 smaller

👁 **Watch** an architectural simulation of Teotihuacán on myartslab.com

Fig. 19-18 The Pyramid of the Moon, looking north up the Avenue of the Dead.
© Francesca Yorke/Dorling Kindersley.

pyramids, 500 workshops, numerous plazas, 2,000 apartment complexes, and a giant market area. The Pyramid of the Sun is oriented to mark the passage of the sun from east to west and the rising of the stellar constellation, the Pleiades, on the days of the equinox. Each of its two staircases contains 182 steps, which, when the platform at its apex is added, together total 365. The pyramid is thus an image of time. This representation of the solar calendar is echoed in another pyramid at Teotihuacán, the Temple of Quetzalcoatl, which is decorated with 364 serpent fangs.

At its height, in about 500 CE, the population of Teotihuacán was perhaps 200,000, making it one of the largest cities in the world. Scholars believe that a female deity, associated with the moon, as well as cave and mountain rituals, played an important role in Teotihuacán culture. The placement of the Pyramid of the Moon, in front of the dead volcano Cerro Gordo (see Fig. 19-18), supports this theory. It is as

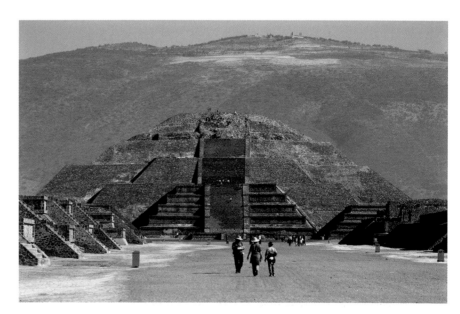

1000

c. 1000–1500
Inca civilization in
South America

Aztecs arrive in the
Valley of Mexico
c. 1325

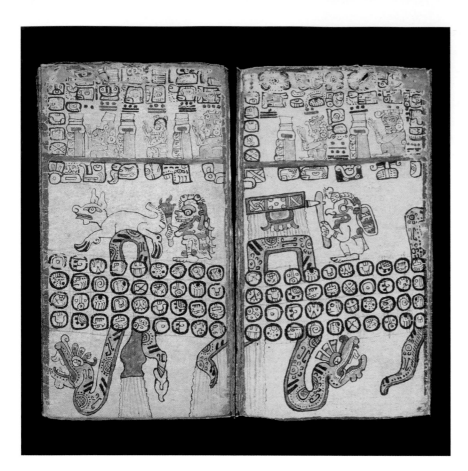

Fig. 19-19 Madrid Codex, leaves 13–16, c. 1400.

Amatl paper screenfold painted on both sides. 56 leaves. Museo del Americas, Madrid.

probably derives from the length of human gestation, from a pregnant woman's first missed menstrual period to birth. When both calendars were synchronized, it took exactly 52 years of 365 days for a given day to repeat itself—the so-called calendar round—and the end of each cycle was widely celebrated.

The Mayan calendar was put to many uses. An example is the Madrid Codex (**Fig. 19-19**), one of the four surviving Mayan codices (a *codex* is a book formatted like books today, with mulitple sheets, folded and stitched through, and bound together with a cover). The Madrid Codex consists of 56 stucco-coated bark-paper leaves, painted, with the exception of one page, on both sides. Over 250 separate "almanacs" that place events of both a sacred and secular nature within the 260-day Mesoamerican ritual calendar fill its pages. It records events concerning particularly the activities of daily life (planting, tending crops, the harvest, weaving, and hunting), rituals, astronomic events, offerings, and deities associated with them. The four horizontal rows in the lower half of each panel are composed of the glyphs of the 20 named days recycling 13 times. Sky serpents who send the rain and speak in thunder are shown weaving around the rows of glyphs. In the shorter top two leaves standard numerology can be seen. The Mayans wrote numbers in two ways: as a system of dots and bars, seen here, and in a set of pictorial variants. Twenty was expressed with a glyph of the moon, and zero with a shell glyph, a number, incidentally, used widely in Mesoamerica many centuries before Hindu mathematicians "discovered" it in India.

Particularly among the Aztecs, who traced their ancestry to the merging of Mayan and Toltec cultures

if the mountain, seen from a vantage point looking north up the Avenue of the Dead, embraces the pyramid in its flanks. And the pyramid, in turn, seems to channel the forces of nature—the water abundant on the mountain in particular—into the heart of the city.

To the south, another culture, that of the Maya, both predated and postdated that of Teotihuacán. The Maya occupied several regions: the highlands of Chiapas and Guatemala; the Southern lowlands of Guatemala, Honduras, El Salvador, Belize, and the Mexican states of Chiapas; and the Northern Lowlands in the states of Yucatan, Campeche, and Quintano Roo. They were never unified into a single political entity, but rather consisted of many small kingdoms that engaged in warfare with one another over land and resources. An elaborate calendar system enabled them to keep track of their history—and, evidence suggests, predict the future. It consisted of two interlocking ways of recording time, a 260-day calendar and a 365-day calendar. The 260-day calendar

at Chichen Itzá, on the Yucatán peninsula, the cal-
endar's tie to the menstrual cycle required blood sac-
rifice. *Coatlicue* (**Fig. 19-20**) was the Aztec goddess of
life and death. Her head is composed of two fanged
serpents, which are symbolic of flowing blood. She
wears a necklace of human hearts, severed hands, and
a skull. The connection of blood to fertility is clear in
the snake that descends between her legs, which sug-
gests both menstruation and the phallus.

Fig. 19-21 *Moche Lord with a Feline*, from Moche Valley,
Peru, Moche culture, c. 100 BCE–500 CE.
Painted ceramic, height 7½ in. Art Institute of Chicago,
Buckingham Fund, 1955–2281.
Photography © The Art Institute of Chicago.

Fig. 19-20 *Coatlicue*, Aztec, fifteenth century.
Basalt, height 8 ft. 3 in. National Museum of Anthropology,
Mexico City.
Werner Forman/Art Resource, NY.

 View the Closer Look on *Coatlicue* on myartslab.com

As in Mesoamerica, complex cultures developed
in South America during the period corresponding to
the Middle Ages in Europe, particularly in the area of
present-day Peru. Moche culture flourished there for
a thousand years, from about 200 BCE to 800 CE. The
Moche built large mound temples made entirely of
adobe bricks, sun-baked blocks of clay mixed with straw.
The largest, located in the Moche Valley, from which
the culture takes its name, is the so-called Pyramid of
the Sun. It is over 1,000 feet long and 500 feet wide,
and rises to a height of 59 feet. In these pyramids, peo-
ple buried their dead, accompanied by gold earrings,
pendants, necklaces, and other ornaments, as well as
elaborately decorated ceramic bowls, pots, and bottles.
The most distinctive bottles depict scenes representa-
tive of Moche culture as a whole (**Fig. 19-21**), usually
on bottles with distinctive stirrup spouts that curve
elegantly away from the body of the vessel. The list of
the subjects depicted is almost endless—animals of all
kinds, from seals to owls, warriors, plants, musicians,

1480

1488
Portuguese explore coast
of West Africa

Columbus makes landfall
in the Caribbean
1492

Cortés invades Mexico
1519

Fig. 19-22 Machu Picchu, Inca culture, Peru, c. 1450.

homes, children at play, women weaving, couples engaged in sex, a man washing his hair—as if the culture was intent on representing every facet of its daily life. Recent research suggests, however, that every one of these scenes has a ritual or symbolic function. Figure 19-21, for instance, may well represent the warrior priest who presided over Moche sacrifice ceremonies, in which prisoners captured in battle were sacrificed and their blood drunk by elaborately dressed warriors.

About 800 CE, the Moche suddenly vanished, many believe as a result of floods brought about by a series of weather events related to El Niño. This major temperature fluctuation of the waters of the Eastern Pacific Ocean results in substantial changes in rainfall levels both regionally and worldwide. The resulting political vacuum lasted for over four hundred years until, around 1300, Inca culture emerged. The Inca were, above all, sublime masons. Working with stone tools and without mortar, they crafted adjoining granite blocks that fit so snugly together that their walls have, for centuries, withstood earthquakes that have destroyed many a later structure. Few of the blocks are the same size, and some have as many as 30 faces. Still, the joints are so tight that even the thinnest of knife blades cannot be forced between the stones. Cuzco, the capital of the Inca empire, whose name means "navel of the earth," was laid out to resemble a giant puma, and its masonry, much of which still survives in the modern city, is unmatched anywhere in the world. At Machu Picchu (**Fig. 19-22**) stone buildings, whose thatched and gabled roofs have long since collapsed, are set on stone terraces in a setting that was a religious retreat or refuge for an Inca ruler who built the complex between 1460 and 1470. About 1,200 people lived in Machu Picchu's approximately 170 residences, most of them women, children, and priests. The Inca also created an extraordinary network of roads, ranging from as wide as 50 feet to as narrow as 3 feet, and extending from desert to Andes peaks for some 15,000 miles. Nearly a thousand lodgings were built along the routes, and relay runners could carry news across the region in less than a week.

Pizarro conquers Peru
1533

1551
Portuguese begin shipping thousands
of Africans to Brazil in the slave trade

1560

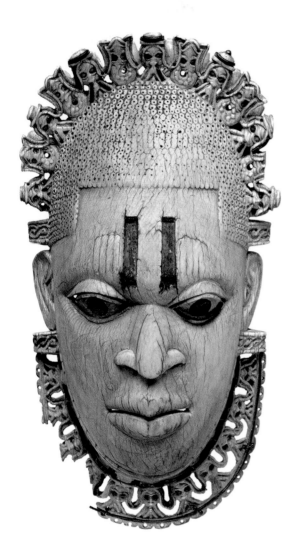

Fig. 19-23 Mask of an *iyoba* (queen mother), made by the Edo people, probably Idia, Court of Benin, Nigeria, sixteenth century, c. 1550.
Ivory, iron, and copper, height 9³/₈ in (23.8 cm). The Metropolitan Museum of Art, New York, NY, U.S.A. The Michael C. Rockefeller Collection, Gift of Nelson A. Rockefeller, 1972 (1978.412.323).

their own—rifles and musketry. A remarkable example of this association of the mudfish with the Portuguese is an alternating mudfish/Portuguese decorative design that forms the tiara of an ivory mask worn as a hip pendant by a West African queen (**Fig. 19-23**).

At first Benin had traded gold, ivory, rubber, and other forest products for beads and, particularly, brass. The standard medium of exchange was a horseshoe-shaped copper or brass object called a *manilla*, five of which appear in an early sixteenth-century Benin plaque portraying a Portuguese warrior (**Fig. 19-24**). Such metal plaques decorated the palace and royal altar area particularly, and here the soldier brings with him the very material out of which the plaque is made. If his weapons—trident and sword—suggest his power, it is a power in the service of the Benin king, at least from the Benin point of view.

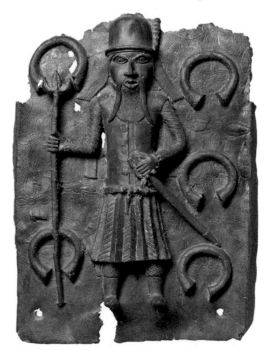

Fig. 19-24 *Portuguese Warrior Surrounded by Manillas*, Court of Benin, Nigeria, sixteenth century.
Bronze. Kunsthistorisches Museum and Museum für Völkerkunde, Vienna, Austria.

African Art of the Encounter

After Portugal began to explore the west coast of Africa, beginning in 1488, evidence of their presence quickly appeared in African art. The Portuguese enjoyed a certain status as divine visitors from the watery world, the realm of Olokun, god of the sea. They were considered to be the equivalent of the mudfish, because they could both "swim" (in their boats) and walk on land. The mudfish was sacred to the Benin people, who lived in the Niger basin just south of the Ife, and who saw it as a symbol of both transformation (it lies dormant all summer on dry mudflats and is seemingly "reborn" each fall when the rains come) and power (it can deliver strong electric shocks and possesses fatal spines). Likewise, the Portuguese seemed to be born of the sea and possessed fatal "spines" of

Luther translates
New Testament into German
1521–22

Copernicus publishes
On the Revolution of the Heavenly Spheres
1543

—**1500**—

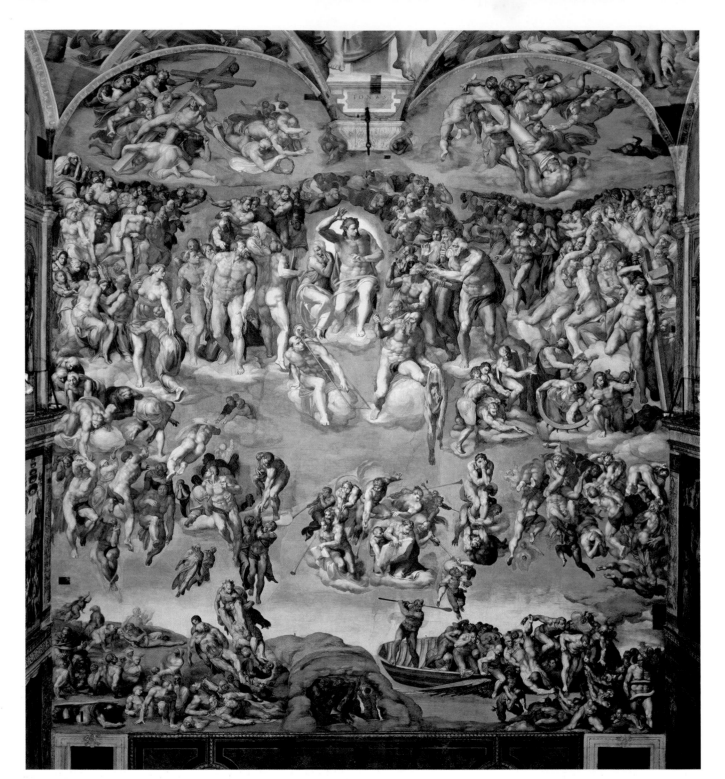

Fig. 19-25 Michelangelo Buonarroti, *The Last Judgment, "Giudizio Universale,"* on altar wall of Sistine Chapel, 1534–41. Fresco. The Vatican Museums, Rome.

Photo: A. Bracchetti/P. Zigrossi. Foto Musei Vaticani. **Thinking Thematically: See Art and Spiritual Belief** on myartslab.com

1545–63
Council of Trent reforms Catholic Church
in response to Reformation

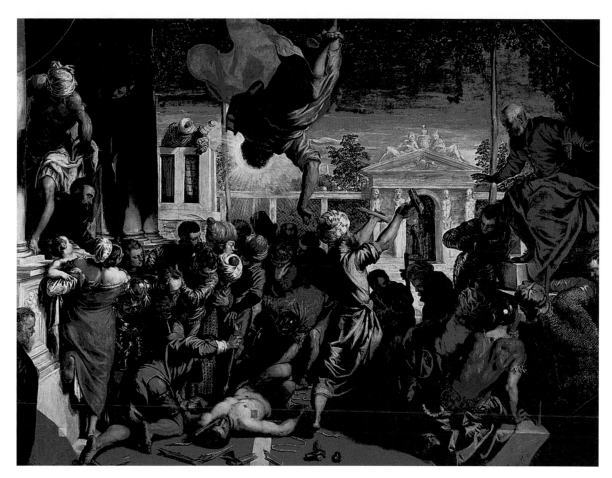

Fig. 19-26 Tintoretto, *The Miracle of the Slave*, 1548.
Oil on canvas, approximately 14 × 18 ft. Gallerie dell'Accademia, Venice.
Scala/Art Resource, NY.

The Mannerist Style in Europe

Shortly after the Spanish conquest of separatist states within Spain in 1519 and the death of Raphael in 1520, many Italian painters embarked on a stylistic course that came to be known as **Mannerism**. Highly individualistic and *mannered*, or consciously artificial, this Mannerist style was dedicated to "invention," and the technical and imaginative virtuosity of the artist became of paramount importance. Each Mannerist artist may, therefore, be identified by his own "signature" style. Where the art of the High Renaissance sought to create a feeling of balance and proportion, quite the opposite is the goal of Mannerist art. In the later work of Michelangelo, for example, particularly the great fresco of *The Last Judgment* on the altar wall of the Sistine Chapel (**Fig. 19-25**), executed in the years 1534 to 1541, we find figures of grotesque proportion arranged in an almost chaotic, certainly athletic, swirl of line. Mannerist painters represented space in unpredictable and ambiguous ways, so that bodies sometimes seem to fall out of nowhere into the frame of the painting, as in Tintoretto's *The Miracle of the Slave* (**Fig. 19-26**). The drama of Tintoretto's painting is heightened by the descent of the vastly foreshortened St. Mark, who hurtles in from above to save the slave from his executioner. The rising spiral line created by the three central figures—the slave, the executioner holding up his shattered instruments of torture, and St. Mark—is characteristic of Mannerism, but the theatricality of the scene, heightened by its dramatic contrast of light and dark, anticipates the Baroque style that soon followed.

Birth of	Defeat of Spanish Armada by
William Shakespeare	English fleet
1564	**1588**

——1560——

1584
First English attempt to
colonize North America (Roanoke)

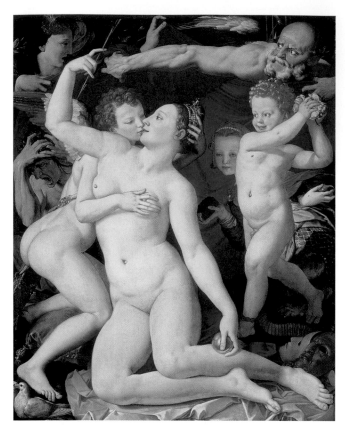

Fig. 19-27 Bronzino, *Venus, Cupid, Folly, and Time (The Exposure of Luxury)*, c. 1546.

Oil on wood, approximately 61 × 56¾ in. National Gallery, London.

© National Gallery London/Art Resource, NY.

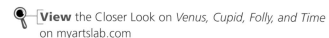

View the Closer Look on *Venus, Cupid, Folly, and Time* on myartslab.com

Often, the space of a Mannerist painting seems too shallow for what is depicted, a feeling emphasized by the frequent use of radical foreshortening, as in the Tintoretto. Or the figure itself may be distorted or elongated, as in Bronzino's *Venus, Cupid, Folly, and Time (The Exposure of Luxury)* (**Fig. 19-27**). The colors are often bright and clashing. At the upper right of Bronzino's painting, Time, and, at the upper left, Truth, part a curtain to reveal the shallow space in which Venus is fondled by her son, Cupid. Folly is about to shower the pair in rose petals. Envy tears her hair out at center left. The Mannerist distortion of space is especially evident in the distance separating Cupid's shoulders and head.

As in El Greco's *The Burial of Count Orgaz* (**Fig. 19-28**), Mannerist painting often utilizes more

than one focal point, and these often seem contradictory. Born in Crete and trained in Venice and Rome, where he studied the works of Titian, Tintoretto, and the Italian Mannerists, El Greco moved to Toledo, Spain, in 1576, and lived there for the rest of his life. In the painting we see here, the realism of the lower ensemble, which includes local Toledo nobility and clergy of El Greco's day (even though the painting represents a burial that took place more than 200 years earlier, in 1323), gives way in the upper half to a much more abstract and personal brand of representation. El Greco's elongated figures—consider St. Peter, in the saffron robe behind Mary on the upper left, with his long piercing fingers on a longer, almost drooping hand, to say nothing of the bizarrely extended arm of Christ himself—combine with oddly rolling clouds that rise toward an astonishingly small representation of Christ.

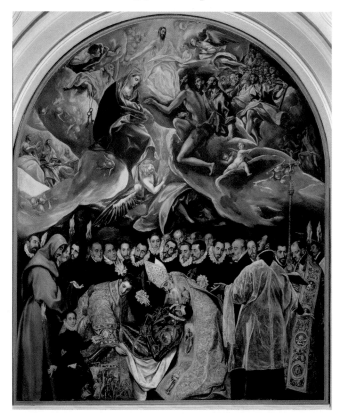

Fig. 19-28 El Greco, *The Burial of Count Orgaz*, 1586.

Oil on canvas, 16 ft. × 11 ft. 10 in. Church of Santo Tomé, Toledo, Spain.

Scala/Art Resource, NY.

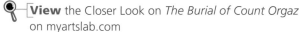

View the Closer Look on *The Burial of Count Orgaz* on myartslab.com

So highly eclectic and individual is this painter's style that it is difficult to label it even as Mannerist.

The Baroque

The **Baroque** style, which is noted particularly for its theatricality and drama, was, in many respects, a creation of the papacy in Rome. Around 1600, faced in the north with the challenge of Protestantism, which had steadily grown more powerful ever since Martin Luther's first protests in 1517, the Vatican took action. It called together as many talents as it could muster with the clear intention of turning Rome into the most magnificent city in the world, "for the greater glory of God and the Church." At the heart of this effort was an ambitious building program. In 1603, Carlo Maderno was assigned the task of adding an enormous nave to Michelangelo's central plan for St. Peter's, converting it back into a giant basilica (**Fig. 19-29**). Completed in 1615, the scale of the new basilica was even more dramatically emphasized when Gianlorenzo Bernini added a monumental oval piazza surrounded by colonnades to the front of the church. Bernini conceived of his colonnade as an architectural embrace, as if the church were reaching out its arms to gather in its flock. The wings that connect the facade to the semicircular colonnade tend to diminish the horizontality of the facade and emphasize the vertical thrust of Michelangelo's dome. The enormous scale of the space can be experienced in the architectural panorama shot from the center of the piazza in myartslab.

As vast as Bernini's artistic ambitions were, he was comparatively classical in his tastes. If we compare Bernini's colonnade at St. Peter's to Francesco Borromini's facade for San Carlo alle Quattro Fontane in Rome (**Fig. 19-30**), we notice immediately how symmetrical Bernini's design appears. Beside Borromini's facade, Bernini's colonnade seems positively conservative, despite its magnificent scale. But Borromini's extravagant design was immediately popular. The head of the religious order for whom San Carlo alle Quattro Fontane was built wrote with great pride, "Nothing similar can be found anywhere in the world. This is attested by the foreigners who . . . try to procure copies of the plan. We have been asked for them by Germans, Flemings, Frenchmen, Italians, Spaniards, and

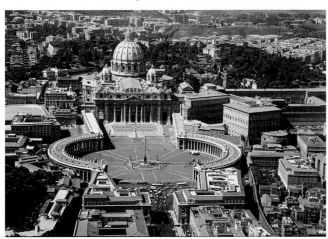

Fig. 19-29 Aerial view of St. Peter's, Rome. Nave and facade by Carlo Maderno, 1607–15, colonnade by Gianlorenzo Bernini, 1657.
Ikona.

⚹ Explore an architectural panorama of the piazza in front of St. Peter's on myartslab.com

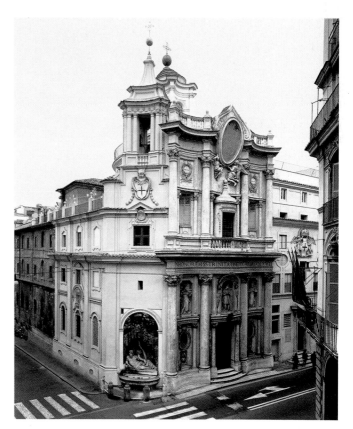

Fig. 19-30 **Francesco Borromini**, facade, San Carlo alle Quattro Fontane, Rome, 1665–67.
Electra/Ikona.

⚹ Explore an architectural panorama of San Carlo alle Quattro Fontane on myartslab.com

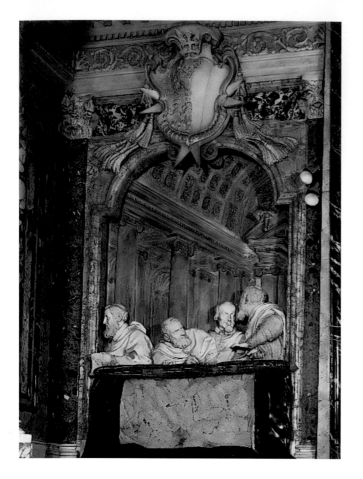

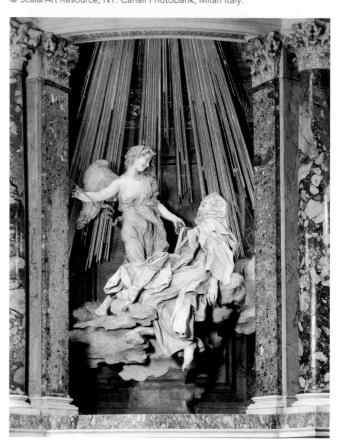

Figs. 19-31 and 19-32 Gianlorenzo Bernini, *The Cornaro Family in a Theater Box.* Marble, life-size; *The Ecstasy of St. Teresa.* Marble, life-size, 1645–52.
Cornaro Chapel, Santa Maria della Vittoria, Rome.
© Scala/Art Resource, NY. Canali Photobank, Milan Italy.

even Indians." We can detect, in these remarks, the Baroque tendency to define artistic genius increasingly in terms of originality, the creation of things never before seen. Bernini's colonnade makes clear that the virtues of the classical were continually upheld, but emerging for the first time, often in the work of the same artist, is a countertendency, a sensibility opposed to tradition and dedicated to invention.

One of the defining characteristics of the Baroque is its insistence on bringing together various media to achieve the most theatrical effects. Bernini's Cornaro Chapel in Santa Maria della Vittoria (**Figs. 19-31** and **19-32**) is perhaps the most highly developed of these dynamic and theatrical spaces. The altarpiece depicts the ecstasy of St. Teresa. St. Teresa, a nun whose conversion took place after the death of her father, experienced visions, heard voices, and felt a persistent and piercing pain in her side. This was caused, she believed, by the flaming arrow of Divine Love, shot into her by an angel: "The pain was so great I screamed

aloud," she wrote, "but at the same time I felt such infinite sweetness that I wished the pain to last forever. . . . It was the sweetest caressing of the soul by God." The paradoxical nature of St. Teresa's feelings is typical of the complexity of Baroque sentiment. Bernini fuses the angel's joy and St. Teresa's agony into an image that depicts what might be called St. Teresa's "anguished joy." Even more typical of the Baroque sensibility is Bernini's use of every device available to him to dramatize the scene. The sculpture of St. Teresa is illuminated by a hidden window above, so that the figures seem to glow in a magical white light. Gilded bronze rays of heavenly light descend upon the scene as if from the burst of light painted high on the frescoed ceiling of the vault. To the left and right of the chapel are theater boxes containing marble spectators,

Descartes publishes
his *Laws of Method*
1637
1640

1630s
Japan adopts a national
policy of isolation

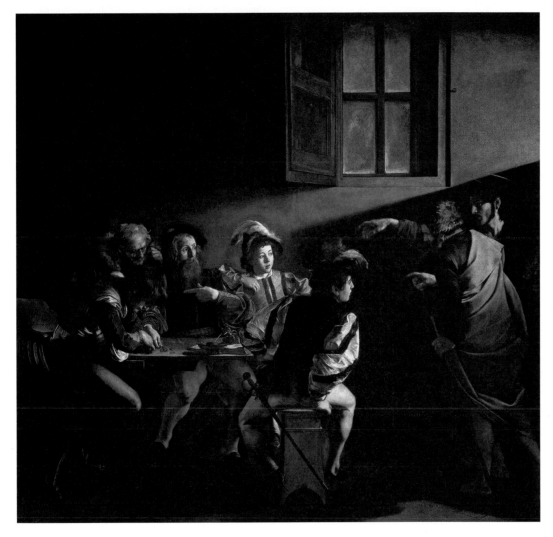

Fig. 19-33 Caravaggio,
*The Calling of St.
Matthew*, c. 1599–1600.
Oil on canvas, 11 ft.
1 in. × 11 ft. 5 in.
Contarelli Chapel, San
Luigi dei Francesi, Rome.
Canali Photobank, Milan, Italy.

like ourselves witnesses to this highly charged, operatic moment.

The Baroque style quickly spread beyond Rome and throughout Europe. Elaborate Baroque churches were constructed, especially in Germany and Austria. In the early years of the seventeenth century, furthermore, a number of artists from France, Holland, and Flanders were strongly influenced by the work of the Italian painter Caravaggio. Caravaggio openly disdained the great masters of the Renaissance, creating instead a highly individualistic brand of painting that sought its inspiration not in the proven styles of a former era but literally in the streets of contemporary Rome. When viewing his work, it is often difficult to tell that his subject is a religious one, so ordinary

are his people and so dingy and commonplace his settings. Yet despite Caravaggio's desire to secularize his religious subjects, their light imbues them with a spiritual reality. It was, in fact, the contrast in his paintings between light and dark, mirroring the contrast between the spiritual content of the painting and its representation in the trappings of the everyday, that so powerfully influenced painters across Europe.

Caravaggio's naturalism is nowhere so evident as in *The Calling of St. Matthew* (**Fig. 19-33**), which was painted, somewhat surprisingly, for a church. The scene is a tavern. St. Matthew, originally a tax collector, sits counting the day's take with a band of his agents, all of them apparently prosperous, if we are to judge from their attire. From the right, two barefoot

1640

1640
Russians reach
the Pacific Ocean

English Civil War and
Puritan Revolution
1642–49

and lowly figures, one of whom is Christ, enter the scene, calling St. Matthew to join them. He points at himself in some astonishment. Except for the undeniably spiritual quality of the light, which floods the room as if it were revelation itself, the only thing telling us that this is a religious painting is the faint indication of a halo above Christ's head.

Though not directly influenced by Caravaggio, Rembrandt, the greatest master of light and dark of the age, knew Caravaggio's art through Dutch artists who had studied it. Rembrandt extends the sense of dramatic opposition Caravaggio achieved by manipulating light across a full range of tones, changing its intensity

and modulating its brilliance, so that every beam and shadow conveys a different emotional content. In his *Resurrection of Christ* (**Fig. 19-34**), Rembrandt uses the emotional contrast between light and dark to underscore emotional difference. He contrasts the chaotic world of the Roman soldiers, sent reeling into a darkness symbolic of their own ignorance by the angel pulling open the lid of Christ's sepulchre, with the quiet calm of Christ himself as he rises in a light symbolic of true knowledge. Light becomes, in Rembrandt's hands, an index to the psychological meaning of his subjects, often hiding as much as it reveals, endowing them with a sense of mystery even as it reveals their souls.

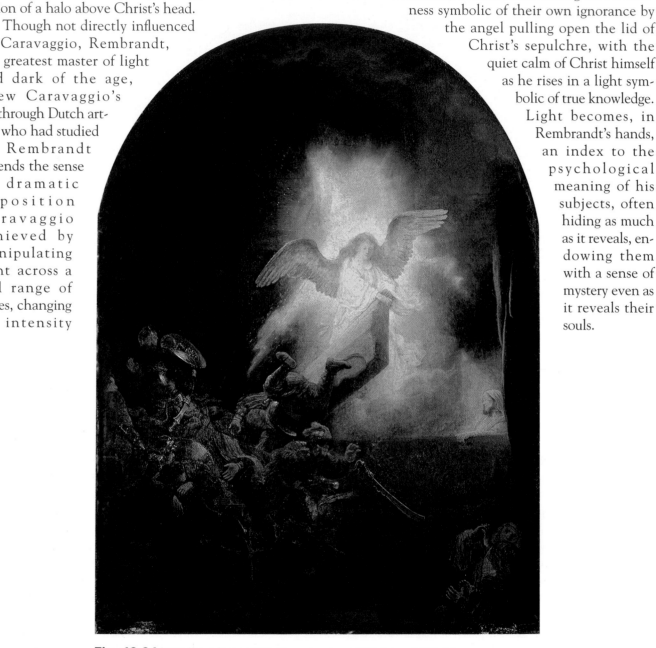

Fig. 19-34 Rembrandt van Rijn, *Resurrection of Christ,* c. 1635–39. Oil on canvas, 36¼ × 26⅜ in. Alte Pinakothek, Munich. Artothek.

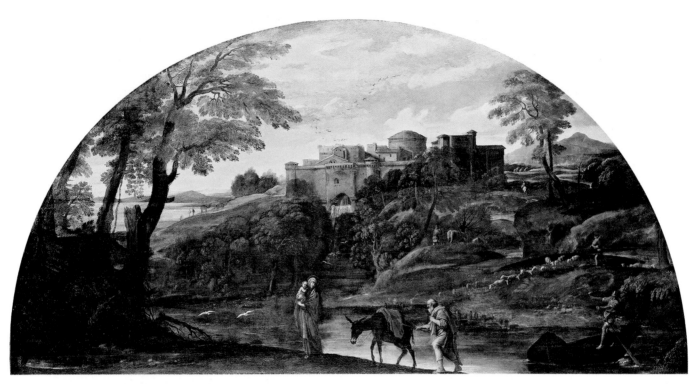

Fig. 19-35 Annibale Carracci, *Landscape with Flight into Egypt,* c. 1603.
Oil on canvas, 48¼ × 98½ in. Galleria Doria Pamphilj, Rome.
Canali Photobank, Milan, Italy.

In northern Europe, where strict Protestant theology had purged the churches of religious art and classical subjects were frowned upon as pagan, realism thrived. Works with secular, or nonreligious, subject matter became extremely popular: Still life painting was popular (see Jan de Heem's *Still Life with Lobster,* Fig. 11-16), as were representations of everyday people living out their lives (genre painting) and landscapes. In Spain, where the royal family had deep historical ties to the north, the visual realism of Velázquez came to dominate painting (see Fig. 8-17). Spurred on by the great wealth it had acquired in its conquest of the New World, Spain helped to create a thriving market structure in Europe. Dutch artists quickly introduced their own goods—that is, paintings—into this economy, with the Spanish court as one of its most prestigious buyers. No longer working for the Church, but instead for this new international market, artists painted the everyday things that they thought would appeal to the bourgeois tastes of the new consumer.

Of all the new secular subject matter that arose during the Baroque Age, the genre of landscape perhaps most decisively marks a shift in Western thinking. In Annibale Carracci's *Landscape with Flight into Egypt* (**Fig. 19-35**), the figure and the story have become incidental to the landscape. Joseph has dreamed that King Herod is searching for the infant Jesus to kill him, and he flees into Egypt with Mary and the child, to remain there until after Herod's death. But this landscape is hardly Egypt. Rather, Carracci has transferred the story to a highly civilized Italian setting. This is the pastoral world, a middle ground between civilization and wilderness where people can live free of both the corruption and decadence of city and court life and the uncontrollable forces of nature.

Plague kills
100,000 people in London
1665

Construction of Versailles Palace
begins outside Paris
1668

—**1660**—

1667
Publication of Milton's
Paradise Lost

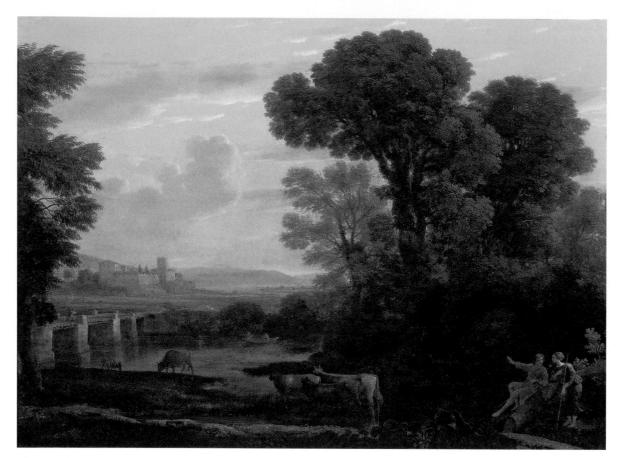

Fig. 19-36 Claude (Gelee) Lorrain (1600–1682), *A Pastoral Landscape*, c. 1648.
Oil on copper, 15½ × 21 in (39.4 × 53.3 cm) Leonard C. Hanna, Jr., B.A. 1913, Fund. 1959.47.
Yale University Art Gallery, New Haven, Connecticut, U.S.A.
Yale University Art Gallery/Art Resource, NY.

One of the most idyllic of all landscape painters goes even further. Claude (Gelee) Lorrain—Claude, as he is usually known—casts the world in an eternally poetic light. In his *Pastoral Landscape* (**Fig. 19-36**), he employs atmospheric perspective to soften all sense of tension and opposition and to bring us to a world of harmony and peace. In this painting, and many others like it, the best civilization has to offer has been melded with the best of a wholly benign and gentle nature.

Landscape painters felt that because God made the earth, one could sense the majesty of his soul in his handiwork, much as one could sense emotion in a painter's gesture upon canvas. The grandeur of God's vision was symbolically suggested in the panoramic sweep of the extended view. Giving up two-thirds of the picture to the infinite dimensions of the heavens,

Jacob van Ruisdael's *View of Haarlem from the Dunes at Overveen* (**Fig. 19-37**) is not so much about the land as it is about the sky—and the light that emanates from it, alternately casting the earth in light and shadow, knowledge and ignorance. It is significant that rising to meet the light is the largest building in the landscape, the church. The beam of light that in Caravaggio's painting suggests the spiritual presence of Christ becomes, in landscape, a beam of light from the "Sun/Son," a pun popular among English poets of the period, including John Donne. By the last half of the seventeenth century, it is as if the real space of the Dutch landscape had become so idealized that it is almost Edenic.

The example of landscape offers us an important lesson in the direction art took from the late seventeenth century down to our own day. The spiritual is no longer found exclusively in the church. It can

Native American population
reduced to around 70,000
1675

1669
Ottoman Turks seize the
island of Crete

1675

Fig. 19-37 Jacob van Ruisdael, *View of Haarlem from the Dunes at Overveen,* c. 1670.

Oil on canvas, 22 × 24⅜ in. Royal Cabinet of Painting Mauritshuis, The Hague.

Thinking Thematically: See Art, Science, and the Environment on myartslab.com

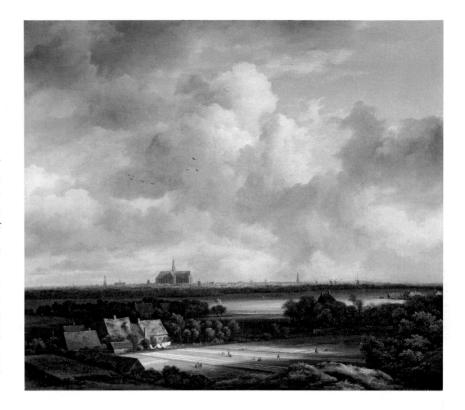

be found in nature, in light, in form—even, as we progress toward the modern era, in the artist's very self. And by the end of the seventeenth century, the church is no longer the major patron of art that it had been for centuries. From Spanish kings, to wealthy Dutch merchants, to an increasingly large group of middle-class bourgeoisie with disposable incomes and the desire to refine their tastes, the patrons of art changed until, by the middle of the twentieth century, art came to be bought and sold in an international "art market."

THINKING BACK

✓— Study and review on myartslab.com

Why does the Renaissance take its name from a word meaning "rebirth"?

The term "Renaissance" refers to a period of revived interest in the arts and sciences of classical antiquity. The Renaissance began at the turn of the fifteenth century, but was anticipated in the preceding Gothic period. How does Donatello draw upon classical traditions in *David*? What did the Neoplatonists believe?

How did African cultures regard the Portuguese?

The Benin peoples regarded the Portuguese as divine visitors because they could both "swim" (in their boats) and walk on land. How are the Portuguese represented in the mask of an *iyoba* (queen mother)? What is a *manilla*?

What distinguishes the style known as Mannerism?

Individualistic and artificial, the Mannerist style is dedicated to technical and imaginative virtuosity.

Mannerist artists use bright, clashing colors and represent space in ambiguous ways, departing from the balance of High Renaissance art. How does Bronzino's painting *Venus, Cupid, Folly, and Time (The Exposure of Luxury)* typify the Mannerist style? How does El Greco represent the human figure?

What are some defining characteristics of Baroque art and architecture?

The Baroque style is noted for its theatricality, drama, extravagance, emotionalism, and originality. The integration of various media in a single work is characteristic of the Baroque. In Baroque painting, naturalism and strong contrast are common. How does Francesco Borromini typify the Baroque in San Carlo alle Quattro Fontane? How does Rembrandt van Rijn demonstrate Caravaggio's influence in *Resurrection of Christ*?

20 | The Eighteenth and Nineteenth Centuries

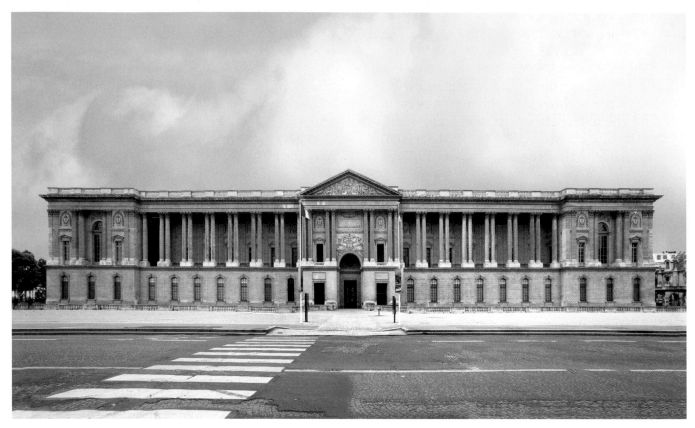

Fig. 20-1 Claude Perrault, with Louis Le Vau and Charles Lebrun, east facade of the Louvre, Paris, 1667–70.
© Achim Bednorz, Koln.

THINKING AHEAD

How did contact between China and Europe influence art?

How was Neoclassicism used to make political statements?

What unifies Romanticism as a movement?

How does Impressionism differ from earlier French art?

((•–Listen to the chapter audio on myartslab.com

The conflict of sensibility that became evident when, in the last chapter, we compared the architecture of Bernini to that of his contemporary Borromini—the one enormous in scale but classical in principle, the other extravagant in form and so inventive that it seems intentionally anticlassical—dominates the history of European art in the eighteenth century. In France, especially, anticlassical developments in Italian art were rejected. As early as 1665, Jean-Baptiste Colbert had invited Bernini to Paris to complete construction of the Louvre, the palace of King Louis XIV. But Louis considered Bernini's plans too elaborate, and the Louvre's new east facade finally was built in a highly classical style, based on the plan of a Roman temple (**Fig. 20-1**).

Newton publishes his
laws of motion
1687

John Locke publishes
Second Treatise of Government
1690

—1690—

La Salle takes possession of
Mississippi River for France
1682

1688–89
Glorious Revolution establishes
constitutional monarchy in Britain

The classicism of Bernini's colonnade for St. Peter's in Rome has been fully developed here. All vestiges of Baroque sensuality have been banished in favor of a strict and linear classical line. At the center of the facade is a Roman temple from which wings of paired columns extend outward, each culminating in a form reminiscent of the Roman triumphal arch.

One of the architects of this new Louvre was Charles Lebrun, a court painter who had studied in Rome with the classical painter Nicolas Poussin. Poussin believed that the aim of painting was to represent the noblest human actions with absolute clarity. To this end, distracting elements—particularly color, but anything that appeals primarily to the senses—had to be suppressed. In Poussin's *Landscape with St. John on Patmos* (**Fig. 20-2**), the small figure of St. John is depicted writing the *Revelations*. Not only do the architecture and the architectural ruins lend

a sense of classical geometry to the scene, but even nature has been submitted to Poussin's classicizing order. Notice, for instance, how the tree on the left bends just enough as it crosses the horizon to form a right angle with the slope of the distant mountain.

As head of the Royal Academy of Painting and Sculpture, Lebrun installed Poussin's views as an official, royal style. By Lebrun's standards, the greatest artists were the ancient Greeks and Romans, followed closely by Raphael and Poussin; the worst painters were the Flemish and Dutch, who not only "overemphasized" color and appealed to the senses, but also favored "lesser" genres, such as landscape and still life.

By the beginning of the eighteenth century, Lebrun's hold on the French Academy was questioned by a large number of painters who championed the work of the great Flemish Baroque painter Peter Paul Rubens over that of Poussin. Rubens, who had

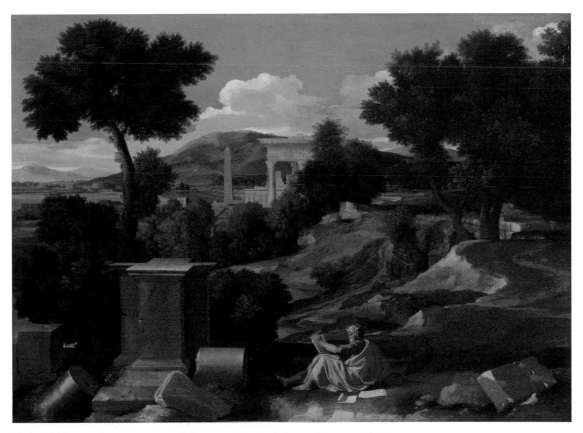

Fig. 20-2 Nicolas Poussin, *Landscape with St. John on Patmos*, 1640.
Oil on canvas, 40 × 53½ in. Art Institute of Chicago. A. A. Munger Collection, 1930.500.
Photography © The Art Institute of Chicago.

1690

Louis XV assumes
the French throne
1715

18th century
Literacy becomes
widespread

1726
Gulliver's Travels
published

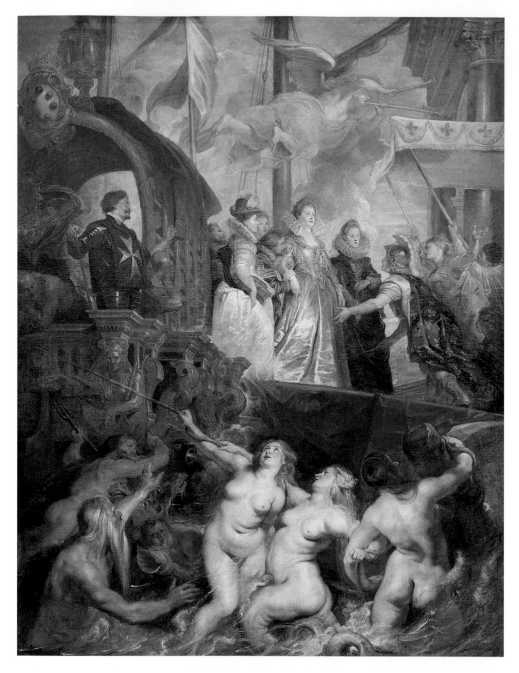

Fig. 20-3 Peter Paul Rubens,
*The Disembarkation of Marie
de' Medici at the Port of
Marseilles on November 3,
1600*, 1621-25.

Oil on canvas, 13 × 10 ft. Musée
du Louvre / RMN Reunion des
Musées Nationaux, France.
Erich Lessing/Art Resource, NY.

Thinking Thematically:
See **Art and Beauty** on
myartslab.com

painted a cycle of 21 paintings celebrating the life of Marie de' Medici, Louis XIV's grandmother, was a painter of extravagant Baroque tastes. Where the design of Poussin's *Landscape with St. John on Patmos* (see Fig. 20-2) is based on horizontal and vertical elements arranged parallel to the picture plane, Rubens's forms in *The Disembarkation of Marie de' Medici* (**Fig. 20-3**) are dispersed across a pair of receding diagonals. In this painting, which depicts Marie's arrival in France as the new wife of the French king, Henry IV, our point of view is not frontal and secure, as it is in the Poussin, but curiously low, perhaps even in the water. Poussin, in his design, focuses on his subject, St. John, who occupies the center of the painting, whereas Rubens creates a multiplicity of competing areas of interest. Most of all, Poussin's style is defined by its linear clarity.

Christianity banned
in China
1742

1732
Benjamin Franklin publishes
Poor Richard's Almanac

1750
mid-18th century
Beginning of
Industrial Revolution

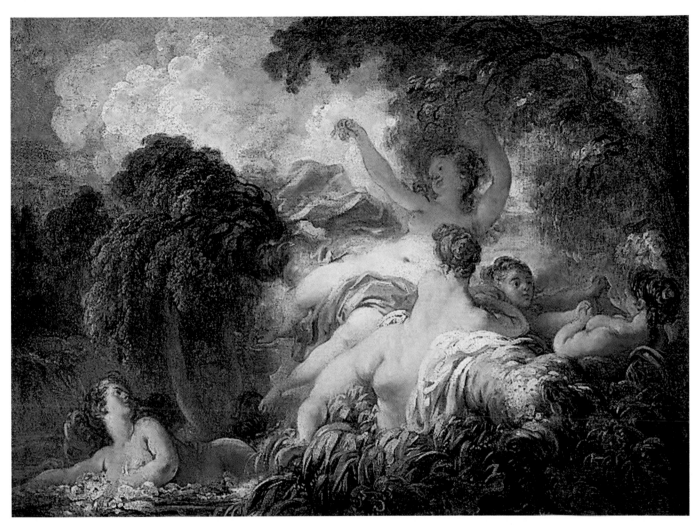

Fig. 20-4 Jean-Honoré Fragonard, *Bathers,* c. 1765.
Oil on canvas, 25¼ × 31½ in. Musée du Louvre, Paris.
Scala/Art Resource, NY.

Rubens's work is painterly, dominated by a play of color, dramatic contrasts of light and dark, and sensuous, rising forms. Poussin is restrained, Rubens exuberant.

The Rococo

With the death of Louis XIV in 1715, French life itself became exuberant. This was an age whose taste was formed by society women with real, if covert, political power, especially Louis XV's mistress, Madame de Pompadour. The *salons,* gatherings held by particular hostesses on particular days of the week, were the social events of the day. A famous musician might appear at one salon, while artists and art lovers would always gather at Mme. Geoffrin's on Mondays. A highly developed sense of wit, irony, and gossip was necessary to succeed in this society. So skilled was the repartee in the salons that the most biting insult could be made to sound like the highest compliment. Sexual intrigue was not merely commonplace but expected. The age was obsessed with sensuality, and one can easily trace the origins of Fragonard's *Bathers* **(Fig. 20-4)** back to the mermaids at the bottom of Rubens's painting. Fragonard was Madame de Pompadour's favorite painter, and the *Bathers* was designed to appeal to the tastes of the eighteenth-century French court.

| 1750 | James Watt invents the steam engine **1760** | American War of Independence **1775–83** | United States Constitution **1789** |

1774 Louis XVI assumes French throne **1776** Adam Smith publishes *Wealth of Nations*

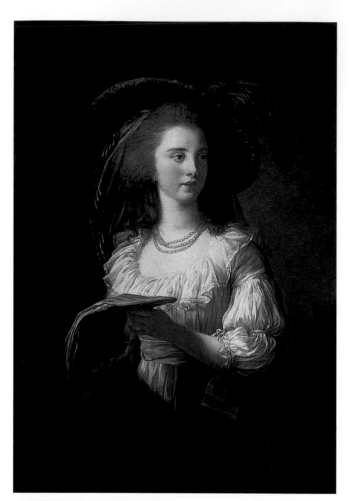

Fig. 20-5 Marie-Louise-Elisabeth Vigée-Lebrun, *The Duchess of Polignac*, 1783.

Oil on canvas, 38³/₄ × 28 in. © The National Trust, Waddesdon Manor, England.

Bridgeman-Giraudon/Art Resource, NY.

It is the age of the Rococo, a word derived from the French *rocaille*, referring to the small stones and shells that decorate the interiors of grottos, the artificial caves popular in landscape design at the time. The Rococo was deeply indebted to the Baroque sensibility of Rubens, as Fragonard's *Bathers* demonstrates. It was, in some sense, the Baroque eroticized, conceived to lend an erotic tone to its environment. Vigée-Lebrun's portrait of *The Duchess of Polignac* (**Fig. 20-5**) combines in exquisite fashion all of the tools of the Baroque sensibility, from Rembrandt's dramatic lighting to Rubens's sensual curves and, given the musical score in the Duchess's hand, even Bernini's sense of the theatrical moment.

China and Europe: Cross-Cultural Contact

Ever since the first Portuguese trading vessels had arrived in China in 1514, Chinese goods—porcelain, wallpapers, carved ivory fans, boxes, lacquerware, and patterned silks—flooded European markets. By 1715, every major European trading nation had an office in Canton, and Europeans themselves developed a taste for a style of art that became known as **chinoiserie** (meaning "things Chinese"). Blue-and-white porcelain ware—"china," as it came to be known in the West—was especially desirable, and before long ceramists at Meissen, near Dresden, Germany, had learned to make their own porcelain. This allowed for almost unbounded imitation and sale of Chinese designs on European-manufactured ceramic wares. Even a Rococo painter like François Boucher imitated the blue-on-white Chinese style in oil paint (**Fig. 20-6**). The scene depicts a Chinese man bending to kiss the hand of his lady, who sits with her parasol beneath a statue, not of Venus (as might be appropriate in a European setting), but of Buddha. A blue-on-white Chinese vase of the kind Boucher is imitating rests on a small platform behind the lady, and the whole scene is set in an elaborate Rococo frame.

Since 1644, China had been ruled by Qing ("clear" or "pure") Manchus, or Manchurians, who

View the Closer Look on chinoiserie on myartslab.com

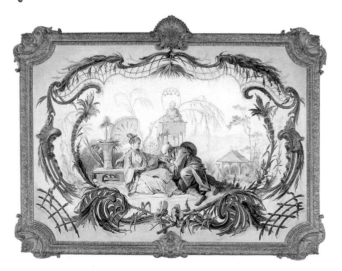

Fig. 20-6 François Boucher, *Le Chinois galant*, 1742.

Oil on canvas, 41 × 57 in. The David Collection, inv. B275.

Photo: Pernille Klemp.

| U.S. Bill of Rights 1791 | Eli Whitney invents the cotton gin 1793 | Napoleon becomes First Consul and absolute ruler of France 1799 | 1800 |

| 1789 Beginning of French Revolution | 1793 Louis XVI of France is beheaded | 1798 Wordsworth and Coleridge publish the *Lyrical Ballads* | |

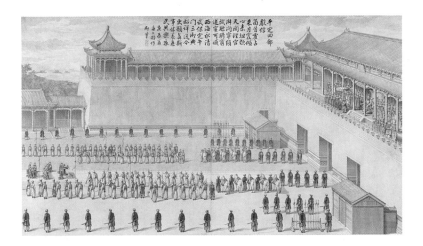

Fig. 20-7 Jean Denis Attiret, *The Presentation of Uigur Captives*, from *Battle Scenes of the Quelling of Rebellions in the Western Regions, with Imperial Poems*. c. 1765–74; poem dated 1760

Etching, mounted in album form, 16 leaves plus 2 additional leaves of inscriptions; 20 × 34¼ in. © The Cleveland Museum of Art, John L. Severance Fund. 1998.103.14.

had invaded China from the north and captured Beijing. By 1680, the Qing rulers had summoned many Chinese artists to the Beijing court, and the imperial collection of art grew to enormous size. (Today the collection is divided between the National Palace Museum in Taipei and the Palace Museum in Beijing.) While many court artists modeled their work on the earlier masterpieces collected by the Qing emperors, others turned to the study of Western techniques introduced by the Jesuits. The most famous of these Jesuits were Giuseppe Castiglione and Jean Denis Attiret, both of whom had been trained as painters of religious subjects before being sent to China in 1715. A series of prints made for the Qianlong emperor celebrated the suppression of rebellions in the Western provinces (present-day Xingjiang). The print illustrated here, *The Presentation of Uigur Captives*, from the series *Battle Scenes of the Quelling of Rebellions in the Western Regions, with Imperial Poems*, is a fine example of the representation of space through careful scientific perspective, a practice virtually unknown in Chinese painting before 1700 (**Fig. 20-7**). It is the kind of work that made Castiglione and Attiret extremely popular in the Qianlong court, for it combines an Eastern appreciation for the order of the political state with the Western use of perspective.

Neoclassicism

Despite the Rococo sensibility of the age, the seventeenth-century French taste for the classical style that Lebrun had championed did not disappear. When Herculaneum and Pompeii were rediscovered, in 1738

and 1748, respectively, interest in Greek and Roman antiquity revived as well. The discovery fueled an increasing tendency among the French to view the Rococo style as symptomatic of a widespread cultural decadence, epitomized by the luxurious lifestyle of the aristocracy. The discovery also caused people to identify instead with the public-minded values of Greek and Roman heroes, who placed moral virtue, patriotic self-sacrifice, and "right action" above all else. A new classicism—a **Neoclassicism**—soon supplanted the Rococo.

Virtue is, in fact, the subject of much Neoclassical art—a subject matter distinctly at odds with the early Rococo sensibility. Women are no longer seen cavorting like mermaids, or even luxuriously dressed like the Duchess of Polignac. In Angelica Kauffmann's *Cornelia, Pointing to Her Children as Her Treasures* (**Fig. 20-8**),

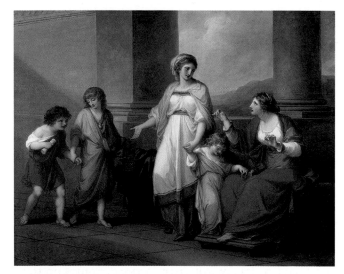

Fig. 20-8 Angelica Kauffmann (Swiss, 1741–1807), *Cornelia, Pointing to Her Children as Her Treasures*, ca. 1785.

Oil on canvas, 40 × 50 in (101.6 × 127.0 cm). Virginia Museum of Fine Arts, Richmond. The Adolph D. and Wilkins C. Williams Fund.

Photo: Katherine Wetzel. © Virginia Museum of Fine Arts.

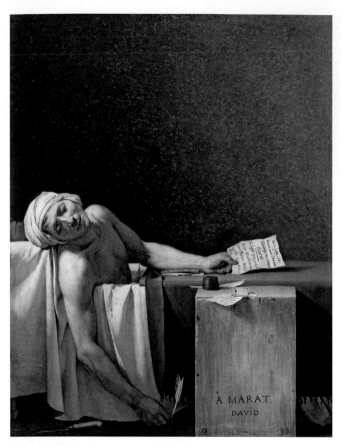

Fig. 20-9 Jacques-Louis David, *The Death of Marat*, 1793. Oil on canvas, 65 × 50½ in. Musées Royaux des Beaux-Arts de Belgique, Brussels.

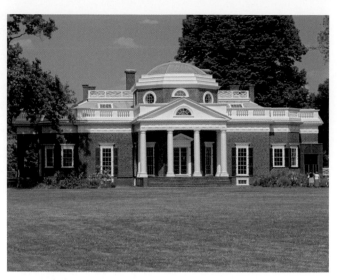

Fig. 20-10 Thomas Jefferson, Monticello, Charlottesville, Virginia, 1770–84; 1796–1806.
© idp eastern USA collection/Alamy.

Thinking Thematically: See **Art, Science, and the Environment** on myartslab.com

Cornelia demonstrates her Neoclassical virtue by declaring her absolute devotion to her family, and, by extension, to the state. Her virtue is reinforced by her clothing, particularly the simple lines of her bodice.

The most accomplished of the Neoclassical painters was Jacques-Louis David, whose *Death of Socrates* was discussed in Chapter 4 (see Figs. 4-25 and 4-26). David took an active role in the French Revolution in 1789, recognizing as an expression of true civic duty and virtue the desire to overthrow the irresponsible monarchy that had, for two centuries at least, squandered France's wealth. His *Death of Marat* (**Fig. 20-9**) celebrates a fallen hero of the Revolution. Slain in his bath by a Monarchist—a sympathizer with the overthrown king—Marat is posed by David as Christ is traditionally posed in the Deposition (compare, for instance, Rogier's *Deposition*, see Fig. 19-4), his arm draping over the edge of the tub. A dramatic

Caravaggesque light falls over the revolutionary hero, his virtue embodied in the Neoclassical simplicity of David's design.

The same sensibility informs the Neoclassical architecture of Thomas Jefferson. For Jefferson, the Greek orders embodied democratic ideals, possessing not only a sense of order and harmony but also a moral perfection deriving from measure and proportion. He utilized these themes in the facade of his own home at Monticello (**Fig. 20-10**). The colonnade thus came to be associated with the ideal state, and, in the United States, Jefferson's Neoclassical architecture became an almost-official Federal style.

Neoclassicism found official favor in France with the rise of Napoleon Bonaparte. In 1799, Napoleon brought the uncertain years that followed the French Revolution to an end when he was declared First Consul of the French Republic. As this title suggests, Napoleon's government was modeled on Roman precedents. He established a centralized government and instituted a uniform legal system. He invaded Italy and brought home with him many examples of classical sculpture, including the *Laocoön* (see Fig. 17-22) and the *Apollo Belvedere* (see Fig. 2-17). In Paris itself, he built triumphal Roman arches, including the famous Arc de Triomphe; a column modeled on Trajan's in

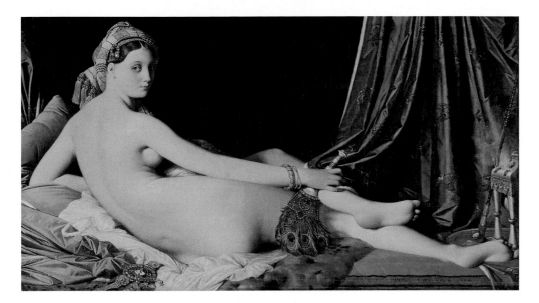

Fig. 20-11 Jean-Auguste-Dominique Ingres, *Grande Odalisque*, 1814.

Oil on canvas, 35¼ × 63¾ in. Musée du Louvre, Paris.

Herve Lewandowski/RMN Reunion des Musées Nationaux/Art Resource, NY.

Thinking Thematically: See **Art, Gender, and Identity** on myartslab.com

Rome; and a church, La Madeleine, modeled after the temples of the first Roman emperors. In 1804, Napoleon was himself crowned emperor of the largest European empire since Charlemagne's in the ninth century.

Neoclassical art was used to legitimate this empire. David saw Napoleon as the salvation of France (so chaotic had Revolutionary France been that David himself had been imprisoned, a sure sign, he thought, of the confusion of the day), and he received important commissions from the new emperor. But it was David's finest pupil, Jean-Auguste-Dominque Ingres, who became the champion of Neoclassical ideals in the nineteenth century. In 1806, he was awarded the Prix de Rome. He then departed for Italy, where he remained for 18 years, studying Raphael in particular and periodically sending new work back to France.

Ingres's Neoclassicism was "looser" than his master's. Looking at a painting such as the *Grande Odalisque* (**Fig. 20-11**), with its long, gently curving limbs, we are more clearly in the world of Mannerist painting than that of the Greek nude. Ingres's color is as rich as Bronzino's in *The Exposure of Luxury* (see Fig. 19-27), and, in fact, his theme is much the same. His odalisque—an "odalisque" is a harem slave—seems more decadent than not, deeply involved in a world of satins, peacock feathers, and, at the right, hashish. Certainly, it is not easy to detect much of the high moral tone of earlier Neoclassical art.

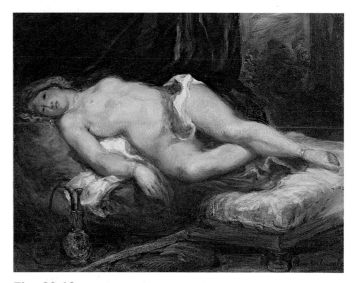

Fig. 20-12 Eugène Delacroix, *Odalisque*, 1845–50. Oil on canvas, 14⅞ × 18¼ in. © Fitzwilliam Museum, University of Cambridge, England.
The Bridgeman Art Library.

Beside Eugène Delacroix's own *Odalisque* (**Fig. 20-12**), Ingres's classicism becomes more readily apparent. To Ingres, Delacroix, who was a generation younger, represented a dangerous and barbaric Neo-Baroque sensibility in contrast to his own Neoclassicism.

Ingres and Delacroix became rivals. Each had his critical champions, each his students and followers. For Ingres, drawing was everything. Therefore, his

First British Reform Act
widens suffrage
1832

1830

1830s
First European
railroads

painting was, above all, linear in style. Delacroix, however, was fascinated by the texture of paint itself, and in his painterly attack upon the canvas, we begin to sense the artist's own passionate temperament. Viewed beside the Delacroix, the pose of the odalisque in Ingres's painting is positively conservative. In fact, Ingres felt he was upholding traditional values in the face of the onslaught represented by the uncontrolled individualism of his rival.

Romanticism

We have come to call the kind of art exemplified by Delacroix **Romanticism**. At the heart of this style is the belief that reality is a function of each individual's singular point of view, and that the artist's task is to reveal that point of view. Individualism reigned supreme in Romantic art. For this reason, Romanticism sometimes seems to have as many styles as it has artists. What unifies the movement is more a philosophical affirmation of the power of the individual mind than a set of formal principles.

One of the most individual of the Romantics was the Spanish painter Francisco de Goya y Lucientes. After a serious illness in 1792, Goya turned away from a late Rococo style and began to produce a series of paintings depicting inmates of a lunatic asylum and a hospital for wounded soldiers. When Napoleon invaded Spain in 1808, Goya recorded the atrocities both in paintings and in a series of etchings, *The Disasters of War*, which remained unpublished until long after his death. His last, so-called "Black Paintings" were brutal interpretations of mythological scenes that revealed a universe operating outside the bounds of reason, a world of imagination unchecked by a moral force of any kind. In one of these, *Saturn Devouring One of His Sons* (**Fig. 20-13**), which was painted originally on the wall of the dining room in Goya's home, Saturn is allegorically a figure for Time, which consumes us all. But it is the incestuous cannibalism of the scene, the terrible monstrosity of the vision itself, that tells us of Goya's own despair. The inevitable conclusion is that, for Goya, the world was a place full of terror, violence, and horror.

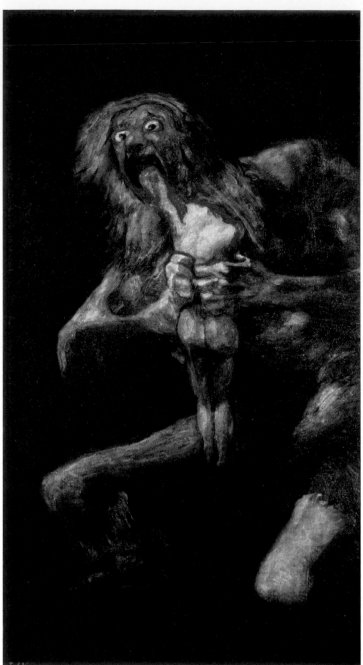

Fig. 20-13 Francisco Goya y Lucientes, *Saturn Devouring One of His Sons*, 1820–22.
Fresco, transferred to canvas, 57⅞ × 32⅝ in. Museo del Prado, Madrid.
Scala/Art Resource, NY.

Thinking Thematically: See Art and the Passage of Time on myartslab.com

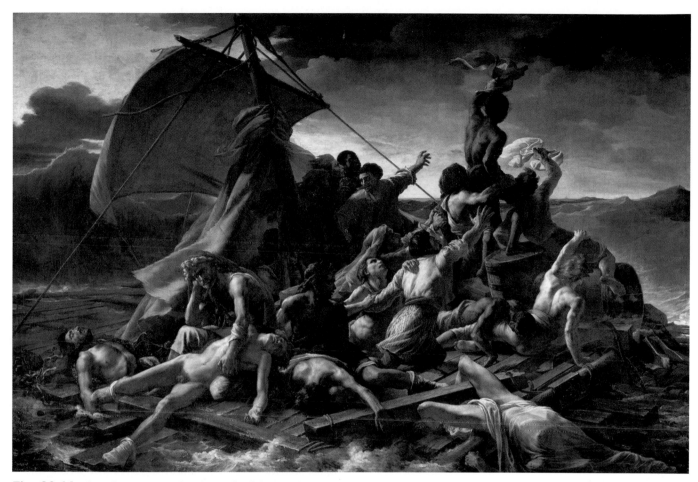

Fig. 20-14 Théodore Géricault, *The Raft of the Medusa*, 1819. Oil on canvas, 16 ft. 1¼ in. × 23 ft. 6 in. Musée du Louvre, Paris. Réunion des Musées Nationaux/Art Resource, NY.

View the Closer Look on *The Raft of the Medusa* on myartslab.com

This sense of the terrible is by no means unique to Goya. Compare, for instance, Théodore Géricault's *Raft of the Medusa* (**Fig. 20-14**). On July 2, 1816, the French frigate *Medusa* was wrecked on a reef off the African coast. The overloaded ship had been carrying soldiers and settlers to Senegal. The captain and other senior officers escaped in lifeboats, leaving 150 behind to fend for themselves on a makeshift wooden raft. After 12 harrowing days on the raft, only 15 survived. The incident infuriated Géricault. The captain's appointment had depended on his connections with the French monarchy, which had been restored after Napoleon's defeat at Waterloo. Here, therefore, was clear evidence of the nobility's decadence. To illustrate his beliefs and feelings, Géricault planned a giant canvas, showing the raft just at the moment that

the rescue ship, the *Argus*, was spotted on the horizon. He went to the Normandy coast to study the movement of water. He visited hospitals and morgues to study the effects of illness and death on the human body. He had a model of the raft constructed in his studio and arranged wax figures upon it. His student, Delacroix, posed face down for the central nude. The final painting positions the raft on a diagonal axis, creating two contradictory pyramidal points of tension. On the left, the mast not only suggests the crucifix but also reveals that the raft is sailing away from its rescuers, while on the right, the survivors climb desperately in their attempt to be seen. Géricault's horrifying picture, exhibited only a few months after it was conceived, fueled the Romantic movement with the passion of its feelings.

1835

Ralph Waldo Emerson
publishes *Nature*
1836

First regular Atlantic
steamship service
1840

1837
Victoria assumes
British throne

1844
First telegraphic
message

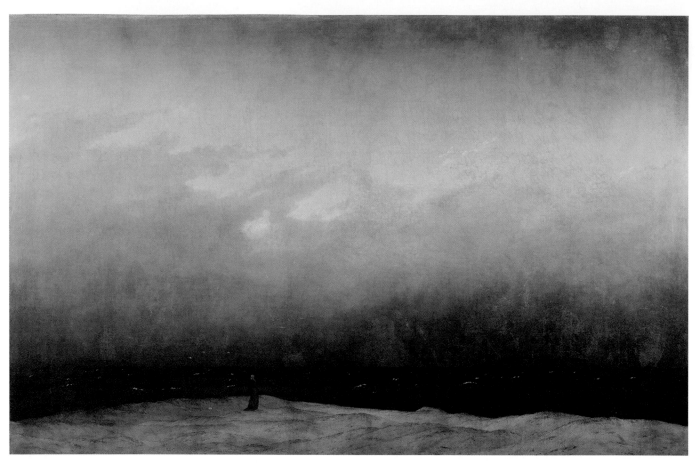

Fig. 20-15 Caspar David Friedrich, *Monk by the Sea*, 1809–10. Oil on canvas, 42¹/₂ × 67 in. Schloss Charlottenburg, Berlin.

Thinking Thematically: See Art and Spiritual Belief on myartslab.com

In his own journal, Delacroix wrote, "[The poet] Baudelaire . . . says that I bring back to painting . . . the feeling which delights in the terrible. He is right." It was in the face of the sublime that this enjoyment of the terrible was most often experienced. Theories of the **sublime** had first appeared in the seventeenth century, most notably in Edmund Burke's *Inquiry into the Origin of Our Ideas of the Sublime and the Beautiful* (1756). For Burke, the sublime was a feeling of awe experienced before things that escaped the ability of the human mind to comprehend them—mountains, chasms, storms, and catastrophes. The sublime exceeded reason; it presented viewers with something vaster than themselves, thereby making them realize their smallness, even their insignificance, in the face of the infinite. The sublime evokes the awe-inspiring forces of Nature, as opposed to the Beautiful, which is associated with Nature at her most harmonious and tranquil. A pastoral landscape may be beautiful; a vast mountain range, sublime.

No painting of the period more fully captures the terrifying prospect of the sublime than Caspar David Friedrich's *Monk by the Sea* (**Fig. 20-15**). It indicates just how thoroughly the experience of the infinite—that is, the experience of God—can be found in Nature. But the God faced by this solitary monk is by no means benign. The infinite becomes, in this painting, a vast, dark, and lonely space—so ominous that it must surely test the monk's faith. The real terror of this painting lies in its sense that the eternal space stretching before this man of faith may not be salvation but, instead, a meaningless void.

American landscape painters such as Albert Bierstadt (see Fig. 2-8), Thomas Moran (see Fig. 10-14), and Frederic Church continually sought to capture

Age of the realistic
novel begins
1840s

1847
Charlotte Brontë,
Jane Eyre

1848

the sublime in their paintings of the vast spaces of the American West. Church even traveled to South America to bring evidence of its exotic and remarkable landscapes to viewers in America and Europe. His painting *The Heart of the Andes* (**Fig. 20-16**) was first exhibited in 1859 in New York in a one-picture, paid-admission showing. The dramatic appeal of the piece was heightened by brightly lighting the picture and leaving the remainder of the room dark, and by framing it so that it seemed to be a window in a grand house looking out upon this very scene. Deemed by critics "a truly religious work of art," it was a stunning success. The insignificance of humanity can be felt in the minuteness of the two figures, barely visible in this reproduction, praying at the cross in the lower left, but the scene is by no means merely sublime. It is also beautiful and pastoral in feeling, and, in the careful rendering of plant life, it is almost scientific in its fidelity to nature.

The Romantic painter was, in fact, interested in much more than the sublime. A Romantic artist might render a beautiful scene as well as a sublime one, or one so pastoral in feeling that it recalls, often deliberately, Claude's soft Italian landscapes (see Fig. 19-36). It was the love of Nature itself that the artist sought to convey. In Nature, the American poet and essayist Ralph Waldo Emerson believed, one could read eternity. It was a literal "sign" for the divine spirit.

The painter, then, had to decide whether to depict the world with absolute fidelity or to reconstruct imaginatively a more perfect reality out of a series of accurate observations. As one writer put it at the time, "A distinction must be made . . . between the elements generated by . . . direct observation, and those which spring from the boundless depth of feeling and from the force of idealizing mental power." As we have seen in our discussion of painting in Chapter 11, the idealizing force of the imagination in painting distinguished it from mere copywork. Nevertheless, and though Church's *The Heart of the Andes* is an idealist compilation of diverse scenes, in many of its details—in, for instance, the accuracy with which the foliage has been rendered—it depends on direct observation.

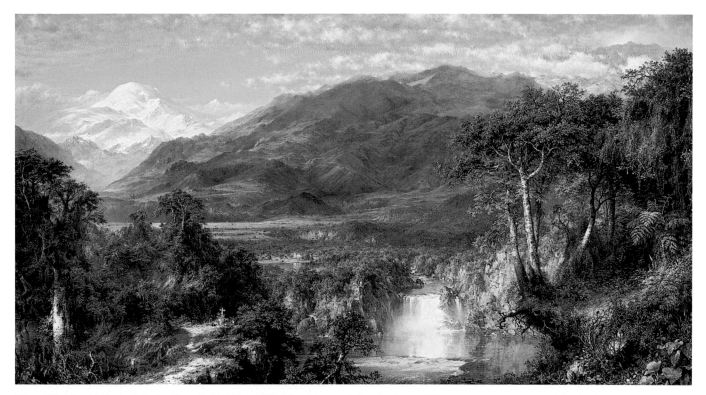

Fig. 20-16 Frederic Edwin Church (1826–1900), *The Heart of the Andes*, 1859.
Oil on canvas, 66^1/$_8$ × 119^1/$_4$ in. Signed and dated (on tree trunk, lower left): 1859/F.E. Church. The Metropolitan Museum of Art, New York, NY, U.S.A. Bequest of Margaret E. Dows, 1909 (09.95).
© The Metropolitan Museum of Art. Image source: Art Resource, NY.

Revolutions across Europe, in France, Vienna,
Rome, Venice, Berlin, Milan, and Prague
1848

— **1848** —

1848
The Communist Manifesto

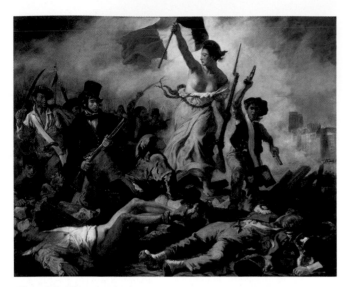

Fig. 20-17 Eugène Delacroix, *Liberty Leading the People*,
1830.
Oil on canvas, 8 ft. 6³⁄₈ in. × 10 ft. 8 in. Musée du Louvre, Paris.
Giraudon/Art Resource, NY.

**Thinking Thematically: See Art, Politics, and
Community** on myartslab.com

Realism

Church's accurate rendering of foliage reflects the im-
portance of scientific, empirical observation to the
nineteenth century as a whole, an urge for realism that
runs counter to, and exists alongside, the imaginative
and idealist tendencies of the Romantic sensibility. If
we compare two history paintings from the first half of
the nineteenth century, we can see how the idealizing
tendency of the Romantic sensibility gradually faded
away. Faced with the reality of war, idealism seemed
absurd. Eugène Delacroix's *Liberty Leading the People*
(**Fig. 20-17**) represents Liberty as an idealized allegori-
cal figure, but the battle itself, which took place during
the July Revolution of 1830, is depicted in a highly re-
alistic manner, with figures lying dead on the barricades
beneath Liberty's feet and Notre Dame Cathedral at the
distant right shrouded in smoke. In Ernest Meissonier's
Memory of Civil War (The Barricades) (**Fig. 20-18**), all the
nobility of war has been drained from the picture. The
blue, white, and red of the French flag have been reduced
to piles of tattered clothing and blood, or what one con-
temporary gruesomely described as an "omelette of men."

So thoroughly did the painter Gustave Courbet
come to believe in recording the actual facts of the

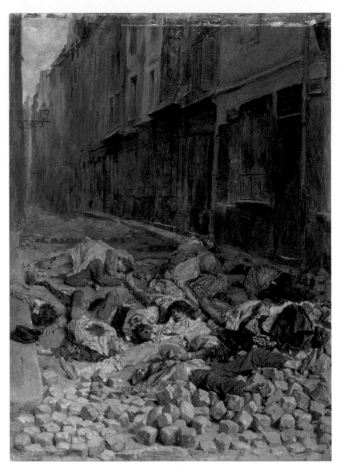

Fig. 20-18 Ernest Meissonier, *Memory of Civil War (The
Barricades)*, 1849.
Oil on canvas, 11¹⁄₂ × 8³⁄₄ in. Musée du Louvre, Paris.
Scala/Art Resource, NY.

world around him that he declared, in 1861, "Paint-
ing is an essentially concrete art and can only consist
of the presentation of real and existing things. It is a
completely physical language, the words of which con-
sist of all visible objects." Courbet and others ascribing
to realism believed artists should confine their repre-
sentation to accurate observation and notation of the
phenomena of daily life. No longer was there necessarily
any "greater" reality beyond or behind the facts that lay
before their eyes. Courbet's gigantic painting *Burial at
Ornans* (**Fig. 20-19**) seems, at first glance, to hold enor-
mous potential for symbolic and allegorical meaning,
but just the opposite is the case. In the foreground is
a hole in the ground, the only "eternal reward" Cour-
bet's scene appears to promise. No one, not even the
dog, seems to be focused on the event itself. Courbet

World population reaches
about 1.1 billion
1850

Admiral Perry's visit ends
Japanese isolation
1854

1854

1851
Herman Melville,
Moby Dick

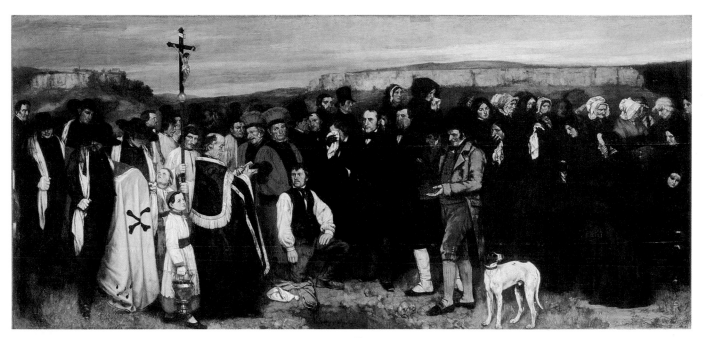

Fig. 20-19 Gustave Courbet, *Burial at Ornans*, 1849.
Oil on canvas, 10 ft. 3¹/₂ in. × 21 ft. 9 in. Musée d'Orsay, Paris.
Herve Lewandowski/Réunion des Musées Nationaux/Art Resource, NY.

View the Closer Look on *Burial at Ornans* on myartslab.com

offers us a panorama of distraction, of common people performing their everyday duties, in a landscape whose horizontality reads like an unwavering line of monotony. If the crucifix rises into the sky over the scene, it does so without deep spiritual significance. In fact, its curious position, as if it were set on the horizon line, lends it a certain comic dimension, a comedy that the bulbous faces of the red-cloaked officers of the parish also underscore. The painting was rejected by the jury of the Universal Exposition of 1855. To emphasize his disdain for the values of the establishment, Courbet opened a one-person exhibition outside the Exposition grounds, calling it the Pavilion of Realism. The cartoonist Honoré Daumier immediately responded with a cartoon depicting the *Fight between Schools, Idealism and Realism* (**Fig. 20-20**). The Courbet-like realist, with his square palette, house painter's brush, and wooden shoes, battles the aged, classically nude idealist, who wears the helmet of a Greek warrior.

It was, at least in part, the realist impulse that led to the invention of photography in the 1830s (see Figs. 12-5 and 12-6). And it was also in this spirit that Karl Marx, in *The Communist Manifesto*, declared: "All that was solid and established crumbles away, all

that was holy is profaned, and man is at last compelled to look with open eyes upon his conditions of life and true social relations." Marx's sentiments, written in response to the wave of revolutions that swept Europe in 1848, are part and parcel of the realist enterprise.

Fig. 20-20 Honoré Daumier, *Fight between Schools, Idealism and Realism*, 1855.
Embassy of the Federal Republic of Germany.

1859
Charles Darwin,
The Origin of Species

Fig. 20-21 Rosa Bonheur, *Plowing in the Nivernais*, 1849.

Oil on canvas,
5 ft. 9 in. × 8 ft. 8 in.
Musée d'Orsay, Paris.

Gerard Blot/Reunion des Musées Nationaux. Art Resource, NY.

Rosa Bonheur's *Plowing in the Nivernais* (**Fig. 20-21**) was commissioned in response to the French Revolution of 1848. It reveals her belief in the virtue of toil and the common life of the French peasant. But it is her realism, her extraordinary ability to depict animals, that made her the most famous female artist of her day. Suddenly, it was socially and aesthetically important, even imperative, to paint neither the sublime nor the beautiful nor the picturesque, but the everyday, the commonplace, the low, and the ugly. Painters, it was felt, must represent the reality of their time and place, whatever it might look like.

As Daumier's cartoon makes clear, the art of the past, exemplified by the classical model, was felt to be worn out, incapable of expressing the realities of contemporary life. As the poet Charles Baudelaire put it, *"Il faut être de son temps"*—"it is necessary to be of one's own time." He looked everywhere for a "painter of modern life." The modern world was marked by change, by the uniqueness of every moment, each instant, like a photograph, different from the last. Painting had to accommodate itself to this change. There were no longer any permanent, eternal truths.

Baudelaire's painter of modern life was Édouard Manet. As we have already seen in Chapter 3, Manet's *Luncheon on the Grass* (see Fig. 3-5), more commonly known by its French name *Déjeuner sur l'herbe*, caused an outcry when it was first exhibited in 1863. Two years later, at the Salon of 1865, Manet exhibited another picture that caused perhaps an even greater scandal. *Olympia* (**Fig. 20-22**) was a depiction of a common prostitute posed in the manner of the traditional odalisque. Though it was not widely recognized at the time, Manet had, in this painting, by no means abandoned tradition completely in favor of the depiction of everyday life in all its sordid detail. *Olympia* was directly indebted to Titian's *Venus of Urbino* (compare Fig. 19-11), just as the *Déjeuner sur l'herbe* had been based on a composition by Raphael (see Fig. 3-6). Manet's sources were classical. His treatment, however, was anything but. What most irritated both critics and public was the apparently "slipshod" nature of his painting technique. *Olympia*'s body is virtually flat. Manet painted with large strokes of thick paint. If the distorted perspective in *Le Déjeuner*—the bather in the background seems about to spill forward into the picnic—then he eliminated perspective altogether in the shallow space of the *Olympia*, where the bed appears to be no wider than a foot or two.

Manet's rejection of traditional painting techniques was intentional. He was drawing attention to his very modernity, to the fact that he was breaking with the past. His manipulation of his traditional sources supported the same intentions. In Marx's words, Manet is looking "with open eyes upon his conditions of life and true social relations." *Olympia*'s eyes directly confront us. The visitor, who is implicitly male, becomes a voyeur, as the female body is subjected to the male gaze.

Fig. 20-22 Edouard Manet, *Olympia*, 1863.
Oil on canvas, 51 × 74³/₄ in. Musée d'Orsay, Paris.

View the Closer Look on *Olympia* on myartslab.com

It is as if the visitor, who occupies our own position in front of the scene, has brought the flowers, and the cat, barely discernible at Olympia's feet, has arched its back to hiss at his approach. The Venus that once strode the heights of Mt. Olympus, home of the gods, is now the common prostitute. "Love" is now a commodity, something to be bought and sold.

In his brushwork, particularly, Manet pointed painting in a new direction. His friend, the novelist Emile Zola, who was the first to defend *Olympia*, described it this way: "He catches his figures vividly, is not afraid of the brusqueness of nature, and renders in all their vigor the different objects which stand out against each other. His whole being causes him to see things in splotches, in simple and forceful pieces." Manet was something of a professional observer—a famous *flâneur*, a Parisian of impeccable dress and perfect manners who strolled the city, observing its habits and commenting on it with the greatest subtlety, wit, and savoir-faire. The type can be seen strolling toward the viewer in Gustave Caillebotte's *Place de l'Europe on a Rainy Day* (see Fig. 5-15). Wrote Manet's friend Antonin Proust: "With Manet, the eye played such a big role that Paris has never known a *flâneur* like him nor a *flâneur* strolling more usefully."

Edgar Degas's *The Glass of Absinthe* (**Fig. 20-23**) was painted a decade after Manet's *Olympia*, but it was directly influenced by Manet's example. Degas's wandering eye has caught the underside of Parisian café society. Absinthe was an alcoholic drink that attacked the nerve centers, eventually causing severe cerebral damage. Especially popular among the working classes, it was finally banned in France in 1915. In the dazed, absent look of this young woman, Degas reveals the consequences of absinthe consumption with a shockingly direct realism worthy of Courbet.

Fig. 20-23 Edgar Degas, *The Glass of Absinthe*, 1876.
Oil on canvas, 36 × 27 in. Musée d'Orsay, Paris.
Scala/Art Resource, NY.

CHAPTER 20 **THE EIGHTEENTH AND NINETEENTH CENTURIES 505**

Fyodor Dostoyevsky,
Crime and Punishment
1866

Suez Canal links
Mediterranean and Red Seas
1869

1865

1869
The Subjugation of Women,
by John Stuart Mill

1869
Tolstoy completes
War and Peace

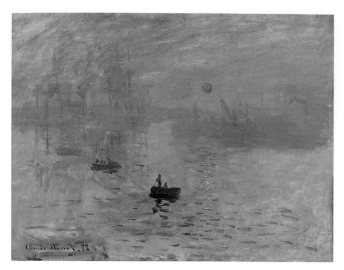

Fig. 20-24 Claude Monet, *Impression—Sunrise*, 1872. Oil on canvas, 19½ × 25½ in. Musée Marmottan, Paris. Giraudon/Bridgeman Art Library.

Impressionism

In the late 1860s, the young painter Claude Monet began to employ the same rich, thick brushstrokes Manet was already using, but with an even looser hand. Combining two or more pigments on a single wide brush, he allowed them to blend as they were brushed onto the canvas. He would paint "wet on wet"—with wet pigment over and through an already-painted surface that had not yet dried. Most of all, he painted with the intense hues made possible by the development of synthetic pigments.

Others followed his lead, and together, in April 1874, they held a group exhibition. They called themselves "Painters, Sculptors, Engravers, etc. Inc.," but before long they were known as the **Impressionists**. The painting that gave them their name was Monet's *Impression—Sunrise* (**Fig. 20-24**). Monet, the critic Théodore Duret wrote in 1878, "is the Impressionist painter par excellence. . . . [He] has succeeded in setting down the fleeting impression which his predecessors had neglected or considered impossible to render with the brush . . . the fleeting

appearances which the accidents of atmosphere present to him . . . a singularly lively and striking sensation of the observed scene. His canvases really do communicate impressions." The paintings, in fact, have the feel of sketches, as if they were executed spontaneously, even instantaneously, in the manner of photographic snapshots.

The Impressionists' subject matter sets them apart from their predecessors at least as much as their technique does. Unlike the Realist painters of a generation earlier, the Impressionists were less interested in social criticism than in depicting in their work the pleasures of life, including the pleasures of simply seeing. If Impressionism is characterized by a way of seeing—by the attempt to capture the fleeting effects of light by applying paint in small, quick strokes of color—it is also defined by an intense interest in images of leisure. The Realists would have rejected these images as unworthy of their high moral purposes. The Impressionists painted life in the Parisian theaters and cafés, the grand boulevards teeming with shoppers, country gardens bursting with flowers, the racetrack and seaside, the suburban pleasures of boating and swimming on the Seine. Pierre-Auguste Renoir's *La Moulin de la Galette* (**Fig. 20-25**) is typical. All of

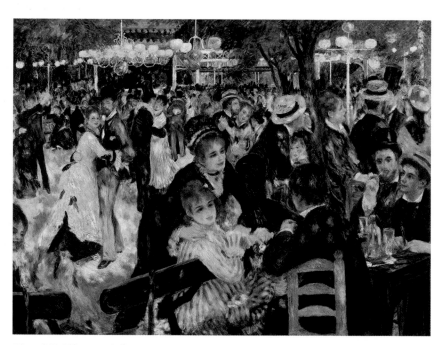

Fig. 20-25 Pierre-Auguste Renoir, *La Moulin de la Galette*, 1876. Oil on canvas, 51½ × 69 in. Musée d'Orsay, Paris. Bridgeman-Giraudon/Art Resource, NY.

European powers
carve up Africa
1870s and 1880s
1880

1870s
European birth and death rates
begin to decline

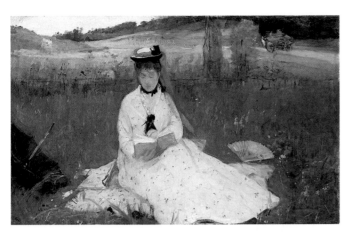

Fig. 20-26 Berthe Morisot (French, 1841–1895), *Reading*, 1873.
Oil on fabric, 17³/₄ × 28¹/₂ in (46.0 × 71.8 cm). The Cleveland Museum of Art. Gift of the Hanna Fund, 1950.89.

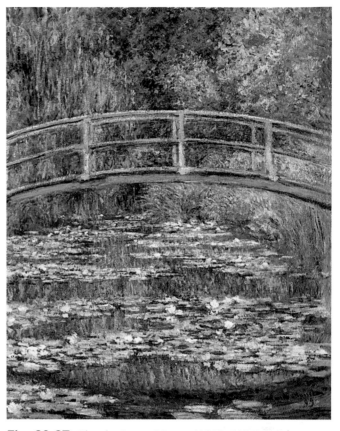

Fig. 20-27 Claude Oscar Monet (1840–1926), *Bridge over a Pool of Water Lilies*, 1899.
Oil on canvas, 36¹/₂ × 29 in. (92.7 × 73.7 cm) Signed and dated (lower right): Claude Monet 99. The Metropolitan Museum of Art, New York, NY, U.S.A. H. O. Havemeyer Collection. Bequest of Mrs. H. O. Havemeyer, 1929 (29.100.113).
© The Metropolitan Museum of Art. Image source: Art Resource, NY.

the figures in the painting are Renoir's friends. One of his closest, Georges Rivière, seated at the table at the far right, described the painting soon after it was shown at the third Impressionist exhibition in 1877: "It is a page of history, a precious monument to Parisian life, done with rigorous exactitude. No one before Renoir had thought of portraying an event in ordinary life on a canvas of such big dimensions."

The distance of Impressionist painting from its Realist predecessors is summed up in Berthe Morisot's *Reading* (**Fig. 20-26**), probably one of four paintings Morisot exhibited at the first Independents Exhibition in 1874. In the background, a farmer's cart heads down the road, the proper subject matter of the Realist. But Morisot's sister, depicted in the painting, has no interest in what passes behind her, and neither, really, does the painter herself. The cart is rendered in a few loose, rapid brushstrokes, as is the entire landscape. Leisure is Morisot's subject.

Increasingly, this urge to observe the world in its most minute particulars led to the investigation of optical reality in and for itself. As early as the 1870s, in his paintings of boats on the river at Argenteuil (see Fig. 8-35), or his series of studies of the Gare Saint-Lazare in Paris (see Fig. 1-9), Monet began to paint the same subject over and over again, studying the ways in which the changing light transformed his impressions.

This working method led to his later serial studies of the grainstacks (see Fig. 6-41), Rouen Cathedral, and his garden at Giverny (**Fig. 20-27**), where he moved in 1883. By the turn of the century, he had given up painting "modern life" altogether, concentrating instead on capturing the "presentness" of his garden, the panoramic views that would be installed in the Orangerie in Paris in 1927 (see Fig. 7-12).

For many artists, painting began to be an end in itself, a medium whose relation to the actual world was at best only incidental. In England, the American expatriate James McNeill Whistler equated his paintings to musical compositions by titling them "nocturnes" and "symphonies." He painted, he said, "as the musician gathers his notes, and forms his chords, until he

1875

Systematic slaughter of the buffalo
in American West
1870s

1877
Invention of phonograph and first public telephone
system installed in New Haven, Connecticut

1880
Invention of electric lights

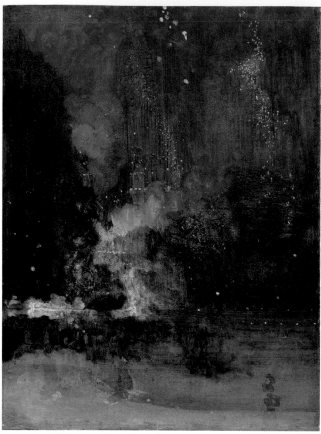

Fig. 20-28 James McNeill Whistler, *Nocturne in Black and Gold, the Falling Rocket*, c. 1875.
Oil on oak panel, 23³/₄ × 18³/₈ in. Detroit Institute of Arts.
Gift of Dexter M. Ferry, Jr., 46.309.
The Bridgeman Art Library Inc.

brings forth from chaos glorious harmony." Painting was, for Whistler, primarily an abstract arrangement of shapes and colors; only incidentally did it refer to the world. Believing that art should possess strong moral content, the English essayist John Ruskin was blind to Whistler's abstraction. After viewing *Nocturne in Black and Gold, the Falling Rocket* (**Fig. 20-28**), an image of fireworks falling over the Thames, Ruskin wrote that Whistler was "flinging a pot of paint in the public's face." Whistler, in turn, sued Ruskin for libel. A lengthy trial followed, and in 1878 Whistler finally won his case, but he was awarded damages of only a farthing, approximately half a U.S. cent. If artists were free to paint anything they wanted, they also had to accept whatever criticism came their way.

The Impact of Western Culture

In the last half of the nineteenth century, Western culture increasingly imposed itself upon other cultures whose values, particularly the sense of centeredness that had defined indigenous cultures for hundreds, even thousands of years, were often diametrically opposed to its values. Worldwide, non-Western cultures faced fundamental challenges to their cultural identities. In China, what had been the world's richest economy became increasingly dependent on manufacturing goods for export to the West. India's manufacturing economy had also been overwhelmed by British exploitation of its resources, coupled with an increased emphasis on low-cost exports that offered little profit. Soon, millions of people from both China and India accepted indentured servitude in foreign lands. Japan, which had been closed to trade with the West and to almost all international contact since the 1630s, was forced to open its ports in 1854 when the U.S. Navy threatened military action. Japan subsequently underwent a rapid process of industrialization, and, in Europe, Japanese prints found a ready market (see Chapter 5). In Africa, European countries vied with one another for control of the continent, motivated by both a sense of their own superiority to African peoples and competition for the region's vast natural resources.

By the 1870s, in the American West, the United States military was pursuing an unofficial but effective policy of Native American extermination, and it encouraged the slaughter of the buffalo as a shortcut to this end. By the late 1880s, almost all the buffalo were dead. By 1889, the crisis had come to a head. A Paiute holy man by the name of Wavoka declared that if the Indian peoples lived peaceably, and if they performed a new circle dance called the Ghost Dance, the world would be transformed into what it once had been, populated by great herds of buffalo and the ancestral dead. White people would disappear, and with them alcohol, disease, and hunger. Across the West, the message was adopted by various tribes, and the costumes associated with the dance were particularly beautiful. An Arapaho Ghost Dance dress (**Fig. 20-29**) is decorated with five-pointed stars, no doubt derived, in their design, from the American flag, but also a long-standing symbol in Native American culture of the cosmos. The yoke is decorated with a woman and two eagles, one

Germany introduces the
first social security laws
1883

1883
First skyscraper
built in Chicago

1884–85
International Conference in Berlin
to decide the future of Africa

1889

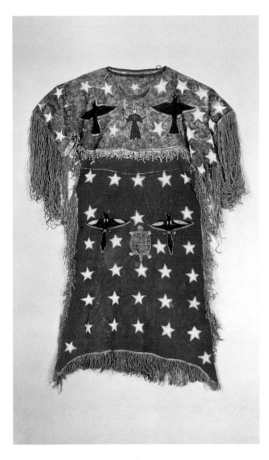

Fig. 20-29 **Arapaho artist,** Ghost Dance dress, 1890s.
Deerskin and pigments. Museum of the North American Indian, New York.
The Bridgeman Art Library International.

their dress, and, at least symbolically, Native American culture on the Great Plains came to an end.

Post-Impressionism

Although by the 1880s, many artists had come to see Impressionism's subject matter as trivial, they were still interested in investigating and extending its formal innovations and in reexamining the symbolic possibilities of painting. Monet's work at Giverny can be seen as an example of just such an ongoing formal exploration. A number of other painters—among them Vincent van Gogh, Paul Gauguin, Georges Seurat, and Paul Cézanne—embarked on a similar brand of **Post-Impressionism**, each dedicated to redirecting the Impressionist enterprise.

Paul Gauguin criticized the conditions of modern life, but he did so by leaving Europe and seeking out a new life in the South Seas. There, in paintings such as *The Day of the Gods (Mahana no Atua)* (**Fig. 20-30**), he tried to capture the mystery and magic of the

on each side of her. She holds a peace pipe in one hand and a branch in the other. The turtle in the lower section of the dress refers to a myth of origin, in which the turtle brings soil for the world's creation out of the primal waters. The birds on the skirt, magpies in this case, represent messengers to the spirit world. Many Plains Indians also believed that the Ghost Dance costumes had the power to protect them from harm, and thus left them immune to gunfire or other attack.

That belief would come to an end at Wounded Knee Creek, South Dakota, on December 29, 1890. The white population, paying little attention to the fact that the white population's presumed "disappearance" was predicted to be wholly nonviolent, soon reacted with fear and hostility. More than 200 participants in the Ghost Dance were massacred by the Seventh Cavalry of the U.S. Army at Wounded Knee that day, despite

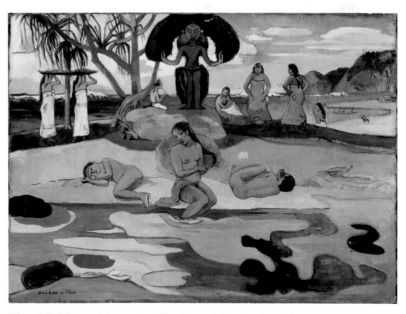

Fig. 20-30 **Paul Gauguin,** *The Day of the Gods (Mahana no Atua),* 1894. Oil on canvas, $26^{7}/_{8} \times 36^{1}/_{8}$ in. Art Institute of Chicago. Helen Birch Bartlett Memorial Collection, 1926.198.
© The Art Institute of Chicago.

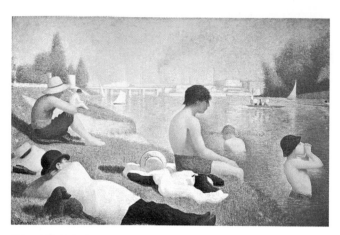

Fig. 20-31 Georges Seurat, *The Bathers*, 1883–84.
Oil on canvas, 79½ × 118½ in. The National Gallery,
London. Reproduced by courtesy of the Trustees.
Erich Lessing/Art Resource, NY.

"primitive" culture, a world of unity, peace, and naked
innocence far removed from the turmoil of civilized
life. The perfect balance of the painting's composition
and the brilliant color of the scene are structural realizations of paradise on earth.

In paintings such as *La Chahut* (*The Can-Can*) (see
Fig. 6-33), Georges Seurat sought to impose a formal

order upon the world, and in the process, he revealed its
rigidity, its lack of vitality. Though Seurat's subject matter in *The Bathers* (**Fig. 20-31**) is Impressionist, his composition is not. It is architectural, intentionally returning
to the seventeenth-century compositional principles of
Poussin (see Fig. 20-2). And it subtly critiques the image
of Impressionist leisure. These are not well-to-do middle-class Parisians, but workers (their costume gives them
away) swimming in the Seine just downriver from the
factory town of Asnières. Smokestacks belch soot in the
distance. The spot, as observant Parisians knew, was directly across from the outlet of the great collective sewer
from Paris. In the summer of 1884, according to the local
press, "more than 120,000 cubic feet of solids had accumulated at the sewer's mouth; several hundred square
meters of which are covered with a bizarre vegetation,
which gives off a disgusting smell." Suddenly, the green
material floating in the water is transformed.

Of all the Post-Impressionist painters, Paul Cézanne, working alone in the south of France, most
thoroughly emphasized the formal aspects of painting
at the expense of subject matter, and in this he looked
forward most to the direction of art in the twentieth
century. Cézanne pushed toward an idea of painting

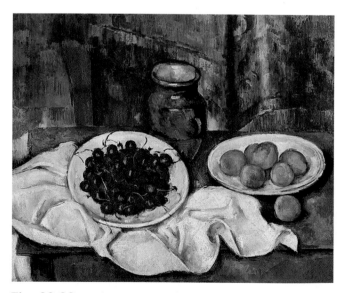

Fig. 20-32 Paul Cézanne, *Still Life with Cherries and
Peaches*, 1885–87.
Oil on canvas, 19¾ × 24 in. Los Angeles County Museum
of Art. Gift of Adele R. Levy Fund, Inc., and Mr. and Mrs.
Armand S. Deutsch, M.61.1.
Digital Image © 2012 Museum Associates/LACMA. Licensed by Art Resource, NY.

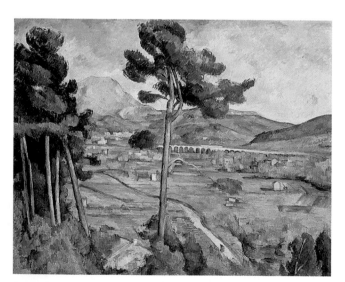

Fig. 20-33 Paul Cézanne (1839–1906), *Mont Sainte-Victoire
and the Viaduct of the Arc River Valley*, 1882–85.
Oil on canvas, 25¾ × 32⅛ in. (65.4 × 81.6 cm) The Metropolitan
Museum of Art, New York, NY, U.S.A. H. O. Havemeyer Collection. Bequest of Mrs. H. O. Havemeyer, 1929 (29.100.64).
© The Metropolitan Museum of Art. Image source: Art Resource, NY.

Discovery of radium
1898

1895
Invention of
motion picture camera

1900
Sigmund Freud,
The Interpretation of Dreams

1900

that established for the picture an independent existence, to be judged in terms of the purely formal interrelationships of line, color, and plane. In his *Still Life with Cherries and Peaches* (**Fig. 20-32**), he emphasizes the act of composition itself, the process of seeing. It is as if he has rendered two entirely different views of the same still life simultaneously. The peaches on the right are seen from a point several feet in front of the table, while the cherries on the left have been painted from directly above. As a consequence, the table itself seems to broaden out behind the cherries.

Similarly, *Mont Sainte-Victoire and the Viaduct of the Arc River Valley* (**Fig. 20-33**) collapses the space between foreground and background by making a series of formal correspondences between them, by the repetition of the shape of the lower right-hand branch of the tree, for instance, the road below it, and the shape of the mountain itself. Finally, in *The Large Bathers* (**Fig. 20-34**), the pyramidal structure of the composition draws attention to the geometry that dominates even the individual faceting of the wide brushstrokes, which he laid down as horizontals, verticals, and diagonals. The simplification of the human body evident here, as well as Cézanne's

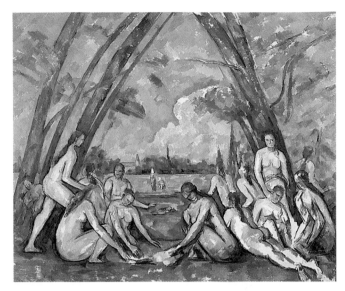

Fig. 20-34 Paul Cézanne, *The Large Bathers*, 1906. Oil on canvas, 82 × 99 in. Philadelphia Museum of Art. Purchased with the W. P. Wilstach Fund, W 1937-1-1.

overall emphasis on form, had a profound effect on painting in the twentieth century. It is in Cézanne that the art of the twentieth century dawns.

THINKING BACK

✓●—**Study** and review on myartslab.com

How did contact between China and Europe influence art?

Europeans developed a style of art called "chinoiserie," meaning "things Chinese." In turn, Chinese artists learned the art of perspective from trade with Europeans. How does François Boucher typify "chinoiserie" in his *Le Chinois gallant?* What was the Western reaction to Chinese porcelain?

How was Neoclassicism used to make political statements?

Jacques-Louis David used Neoclassicism to portray the virtue of a fallen revolutionary, Marat. Later, David and Jean-Auguste-Dominique Ingres used Neoclassicism to legitimize Napoleon's rule. In America, Thomas Jefferson used a Neoclassical style in his home at Monticello to embody democratic ideals. How does Jean-Auguste-Dominique Ingres's style differ from Eugène Delacroix's? Why is Neoclassicism regarded to be at odds with the Rococo style?

What unifies Romanticism as a movement?

Romanticism may seem to have as many styles as it has artists. The movement is unified by a philosophical affirmation of the power of the individual mind. At the heart of the movement is the belief that reality is a function of each individual's point of view. What does Francisco Goya express in his "Black Paintings"? What is the sublime?

How does Impressionism differ from earlier French art?

The Impressionists departed from their predecessors both in technique and subject. They painted spontaneously, recording fleeting appearances and the effects of light. They were less interested in social criticism than were the Realist painters of the previous generation, instead favoring the pleasures of life as subject matter. How did the name "Impressionism" originate? Why did Claude Monet paint the same subject repeatedly?

21 | From 1900 to the Present

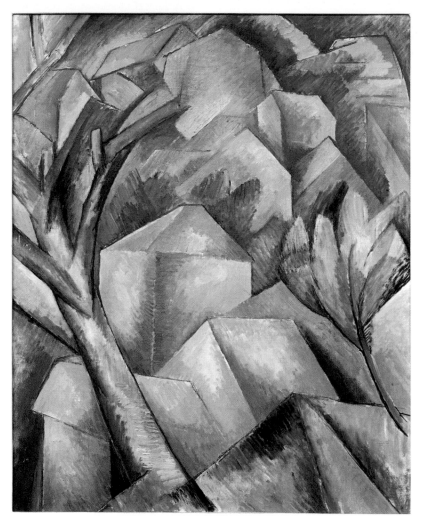

Fig. 21-1 Georges Braque, *Houses at l'Estaque*, 1908.
Oil on canvas, 28³/₄ × 23³/₄ in. Hermann and Margit Rupf Foundation.
© 2012 Artists Rights Society (ARS), New York/ADAGP, Paris.

THINKING AHEAD

What were the primary interests of the Cubists?

How did Dada differ from Futurism in its aims?

What characterizes Abstract Expressionism?

What defines Minimalist art?

((•─**Listen** to the chapter audio on myartslab.com

Sometime in the autumn of 1907, Pablo Picasso embarked on his monumental and groundbreaking painting *Les Demoiselles d'Avignon* (see Fig. 1-17). At the time, Paris was inundated with exhibitions of the work of Cézanne, which were to have a profound effect on the development of modern art. Soon after Cézanne died, in October 1906, a retrospective of 79 of his last watercolors was exhibited at the Bernheim-Jeune Gallery. At the Salon in the autumn of 1907, another retrospective of Cézanne's late paintings, mostly oils,

appeared. In his letters to the painter Emile Bernard, which were published posthumously in the Paris press, Cézanne advised painters to study nature in terms of "the cylinder, the sphere, the cone."

Cubism

Picasso was already under the influence of Cézanne when he painted *Les Demoiselles*, and when Georges Braque saw first Picasso's painting and then Cézanne's retrospective, he began to paint a series of landscapes based on their formal innovations. His *Houses at l'Estaque* (**Fig. 21-1**) takes Cézanne's manipulation of space even further than the master did. The tree that rises from the foreground seems to meld into the roofs of the distant houses near the top of the painting. At the right, a large, leafy branch projects out across the houses, but its leaves appear identical to the greenery that is growing between the houses behind it. It becomes impossible to tell what is foreground and what is not. The houses descending down the hill before us are themselves spatially confusing. Walls bleed almost seamlessly into other walls, walls bleed into roofs, roofs bleed into walls. Braque presents us with a design of triangles and cubes as much as he does a landscape.

Together, over the course of the next decade, Picasso and Braque created the movement known as **Cubism**, of which Braque's *Houses at l'Estaque* is an early example. The name derived from a comment made by the critic Louis Vauxcelles in a small review that appeared directly above a headline announcing the "conquest of the air" by the Wright brothers: "Braque . . . reduces everything, places and figures and houses, to geometric schemes, little cubes." It was, as the accidental juxtaposition of Cubism and the Wright brothers suggested, a new world.

Other artists soon followed the lead of Picasso and Braque, and the impact of their art could be felt everywhere. For the Cubist, art was primarily about form. Analyzing the object from all sides and acknowledging the flatness of the picture plane, the Cubist painting represented the three-dimensional world in increasingly two-dimensional terms. The curves of the violin in Braque's *Violin and Palette* (**Fig. 21-2**) are flattened and cubed, so much so that in places the instrument seems as flat as the sheets of music above it. The highly realistic, almost trompe-l'oeil nail at

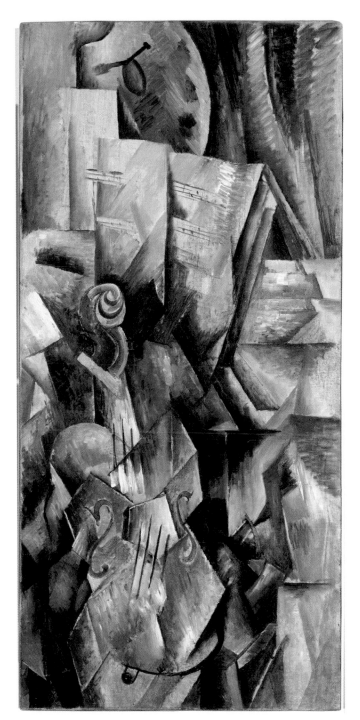

Fig. 21-2 Georges Braque, *Violin and Palette*, Autumn 1909.

Oil on canvas, 36$\frac{1}{8}$ × 16$\frac{7}{8}$ in. Solomon R. Guggenheim Museum, New York. 54.1412.

© 2012 Artists Rights Society (ARS), New York/ADAGP, Paris.

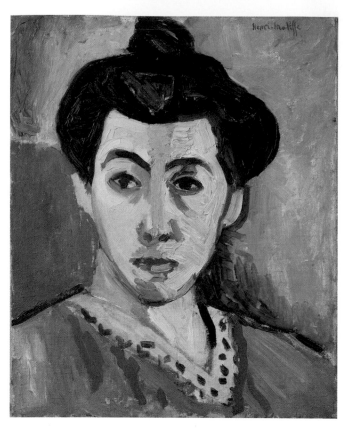

Fig. 21-3 Henri Matisse, *The Green Stripe (Madame Matisse)*, 1905.

Oil and tempera on canvas, 15⅞ × 12⅞ in. Statens Museum for Kunst, Copenhagen. J. Rump Collection.

© 2012 Succession Henry Matisse/Artists Rights Society (ARS), New York.

the painting's top introduces another characteristic of Cubist work. Casting its own shadow, it can be seen either as part of the painting, holding up the palette, or as real, holding the painting to the wall. Such play between the reality of painting and the reality of the world soon led both Picasso and Braque to experiment with collage, which we discussed in Chapter 11. Perhaps most important, Cubism freed painting of the necessity to represent the world. Henceforth, painting could be primarily about painting.

The Fauves

Though the Cubists tended to deemphasize color in order to emphasize form, Henri Matisse favored the expressive possibilities of color. Matisse, in a sense, synthesized the art of Cézanne and Seurat, taking the former's broad, flat zones of color and the latter's

interest in setting complementary hues beside one another. Under the influence of Van Gogh, whose work had not been seen as a whole until an exhibition at the Bernheim-Jeune Gallery in 1901, Matisse felt free to use color arbitrarily. A number of other young painters joined him, and in the fall of 1905 they exhibited together at the Salon, where they were promptly labeled **Fauves** ("Wild Beasts"). Not long after the exhibition, Matisse painted a portrait of his wife, known as *The Green Stripe* (**Fig. 21-3**) for the bright green stripe that runs down the middle of her face. The painting is a play between zones of complementary colors, and in its emphasis on blue-violet, red-orange, and green, it relies on the primary colors of light, not pigment. Although some critics ridiculed them, the Fauves were seen by others as promising a fully abstract art. The painter Maurice Denis wrote of them: "One feels completely in the realm of abstraction. Of course, as in the most extreme departures of van Gogh, something still remains of the original feeling of nature. But here one finds, above all in the work of Matisse, the sense of . . . painting in itself, the act of pure painting."

German Expressionism

It was in Germany that Denis's idea of "pure painting" fully took hold. In Dresden, a group of artists known as *Die Brücke* ("The Bridge"), among them Ernst Kirchner and Emil Nolde (see Fig. 10-5), advocated a raw and direct style, epitomized by the slashing gouges of the woodblock print. A group of artists known as *Der Blaue Reiter* ("The Blue Rider") formed in Munich around the Russian Wassily Kandinsky. They believed that through color and line alone works of art could express the feelings and emotions of the artist directly to the viewer—hence the name **Expressionism**.

In the 1890s, Kandinsky had seen an exhibition of Monet's *Grainstacks*. Noting how the grainstacks themselves seemed to disintegrate in the diffuse light, Kandinsky was convinced that "the importance of an 'object' as the necessary element in painting" was suspect. Nothing of the geometry of Cubism can be detected in Kandinsky's early paintings such as *Sketch I for "Composition VII"* (**Fig. 21-4**). Like Whistler before him, Kandinsky considered his painting to be equivalent to music, and his works are alive in nonfigurative movement and color. Each color and each line carried,

Titanic sinks
on its maiden voyage
1912

Panama Canal opens
1914

—1914—

1910
Stravinsky,
The Firebird

1914
10.5 million immigrants
enter the U.S.

Fig. 21-4 Wassily Kandinsky, *Sketch I for Composition VII*, 1913.
India ink, 30³/₄ × 39³/₈ in. Felix Klee Collection. Kunstmuseum, Bern.
© 2012 Artists Rights Society (ARS), New York/ADAGP, Paris.

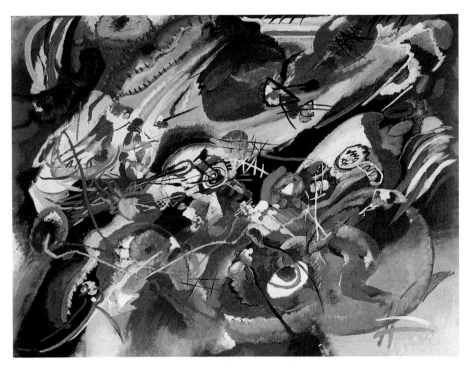

for Kandinsky, explicit expressive meaning (see Fig. 6-44). He believed that paintings like his had "the power to create [a] spiritual atmosphere" that would "lead us away from the outer to the inner basis."

The paintings of the Fauves convinced Kandinsky that through color he could eliminate the object altogether. "Color," Kandinsky wrote in his 1911 treatise *Concerning the Spiritual in Art,* "is able to attain what is most universal yet at the same time most elusive in nature: its inner force."

Kandinsky's ideas find remarkable expression in the work of another member of the Blue Rider group, Franz Marc, who adapted Kandinsky's color symbolism to the depiction of animals. "I try to heighten my feeling for the organic rhythm of all things," Marc wrote, "to feel myself pantheistically into the trembling and flow of the blood of nature." More than any other German painter, Marc understood the sensuality of Matisse's line and employed it in his work. His use of color, which

echoes, of course, the name of the movement to which he belonged, is liberated from the world of appearance, but it is highly emotional. He painted horses over and over again (**Fig. 21-5**). Sometimes they were blue—Marc associated blue with masculinity, strength, and purity—sometimes red, sometimes yellow, depending on his emotions as he was painting. Marc never fulfilled his promise as a painter. He was killed fighting in World War I in 1916.

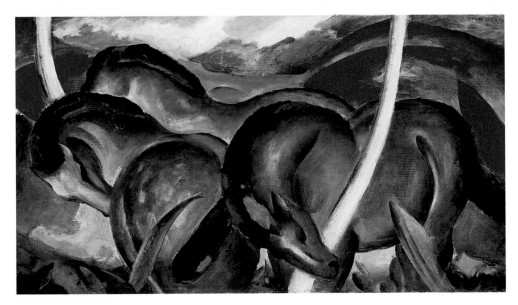

Fig. 21-5 Franz Marc, *Die grossen blauen Pferde* (*The Large Blue Horses*), 1911.
Oil on canvas, 41⁵/₁₆ × 71⁵/₁₆ in. Walker Art Center, Minneapolis. Gift of the T. B. Walker Foundation, Gilbert M. Walker Fund, 1942.

Thinking Thematically:
See **Art and Beauty** on myartslab.com

1914

D. W. Griffith,
Birth of a Nation
1915

Worldwide
influenza epidemic
1918–19

1914–18
World War I

1917
Bolsheviks seize
power in Russia

1920
Carl Jung publishes
Psychological Types

Futurism

If abstraction was the hallmark of the new century, certain thematic concerns defined it as well. The world had become, quite literally, a new place. In the summer of 1900, with the opening of the World's Fair, Paris found itself electrified, its nights almost transformed to day. The automobile, a rarity before the new century, dominated the city's streets by 1906. People were flying airplanes. Albert Einstein proposed a new theory of relativity and Niels Bohr a new model for the atom. Many people felt that there could be no tradition, at least not one worth imitating, in the face of so much change.

In February 1909, an Italian poet named Filippo Marinetti published in the French newspaper *Le Figaro* a manifesto announcing a new movement in modern art, **Futurism**. Marinetti called for an art that would

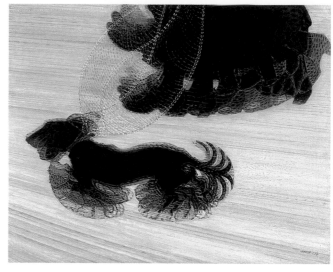

Fig. 21-6 Giacomo Balla, *Dynamism of a Dog on a Leash (Dinamismo di un cane al guinzoglio)*, 1912.
Oil on canvas, 35³/₈ × 43¹/₄ in. Albright-Knox Art Gallery, Buffalo, NY. Bequest of A. Conger Goodyear and Gift of George F. Goodyear, 1964.
Albright-Knox Art Gallery/Art Resource, NY. © 2012 Artists Rights Society (ARS), New York/SIAE, Rome.

champion "aggressive action, a feverish insomnia, the racer's stride . . . the punch and the slap." He had discovered, he wrote, "a new beauty; the beauty of speed. A racing car whose hood is adorned with great pipes, like serpents of explosive breath . . . is more beautiful than the *Victory of Samothrace*." He promised to "destroy the museums, libraries, academies" and "sing of the multicolored, polyphonic tides of revolution in the modern capitals." There were, at the time, no Futurist painters. Marinetti had to leave Paris, go back to Italy, and recruit them. But as they exhibited their show of Futurist painting around Europe from 1912 until the outbreak of World War I in 1914, outraging as many as they pleased, these painters—Umberto Boccioni, Carlo Carrà, Luigi Russolo, Giacomo Balla, and Gino Severini—embodied the spirit of the machine and of rapid change that seemed to define the century itself. Balla's *Dynamism of a Dog on a Leash* (**Fig. 21-6**)

Fig. 21-7 Umberto Boccioni, *Unique Forms of Continuity in Space*, 1913.
Bronze, 43⁷/₈ × 34⁷/₈ × 15³/₄ in. Museum of Modern Art, New York, NY, U.S.A. Acquired through the Lillie P. Bliss Bequest (231.1948).
Art Resource, NY.

captures the Futurist fascination with movement. It demonstrates, as well, its debt to new technological media—in particular, photography, as in Marey's and Muybridge's work (see Figs. 3-8 and 12-1), and the new art of film.

Umberto Boccioni's *Unique Forms of Continuity in Space* (**Fig. 21-7**) gives the sense of a figure striding forward, clothing flapping in the wind. But Boccioni probably means to represent a nude, its musculature stretched and swollen to reveal its movement through space and time. It could probably best be thought of as an organic response to Marcel Duchamp's mechanistic *Nude Descending a Staircase* (see Fig. 3-7).

World War I more than dampened this exuberance. The war was catastrophic (see the map of World War I below). As many as 10 million people were killed and 20 million wounded, most in grueling trench warfare on the Western Front, a battle line that remained virtually stationary for three years and ran from Oostende on the Dutch coast, past Reims and Verdun, to Lunéville in France. World War I represented to many the bankruptcy of Western thought, and it served notice that all that had come before needed to be swept away.

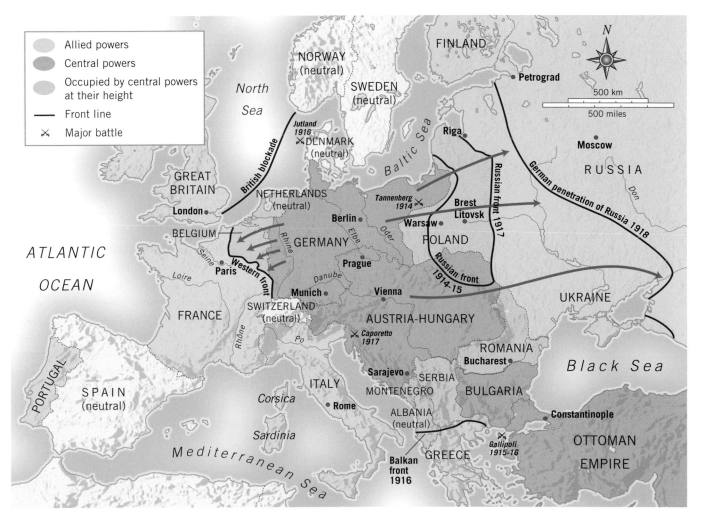

World War I, 1914–1918.

| Discovery of penicillin 1928 | First Soviet Five-Year Plan 1928 |

—1925—

| 1927 Charles Lindbergh flies nonstop from New York to Paris | 1928 First television broadcast | 1929 U.S. stock market crash; Great Depression begins |

Dada and Surrealism

Founded simultaneously in Zurich, Berlin, Paris, and New York during the war, **Dada** took up Futurism's call for the annihilation of tradition but, as a result of the war, without its sense of hope for the future. Its name referred, some said, to a child's first words; others claimed it was a reference to a child's hobbyhorse; and still others celebrated it as a simple nonsense sound. As a movement, it championed senselessness, noise, and illogic. Dada was, above all, against art, or at least art in the traditional sense of the word. Its chief strategy was insult and outrage. Perhaps Dada's chief exponent, Marcel Duchamp always challenged tradition in a spirit of fun. His *L.H.O.O.Q.* (**Fig. 21-8**) is an image of Leonardo's *Mona*

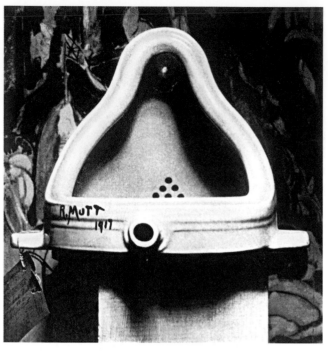

Fig. 21-9 Marcel Duchamp, *Fountain*, 1917.
Fountain by R. Mutt. Glazed sanitary china with black print. Photo by Alfred Stieglitz in *The Blind Man*, No. 2 (May 1917); original lost. © Philadelphia Museum of Art. The Louise and Walter Arensberg Collection, 1950. 1998-74-1.
The Philadelphia Museum of Art/Art Resource, NY. © 2012 Artists Rights Society (ARS), New York/ADAGP, Paris/Succession Marcel Duchamp.

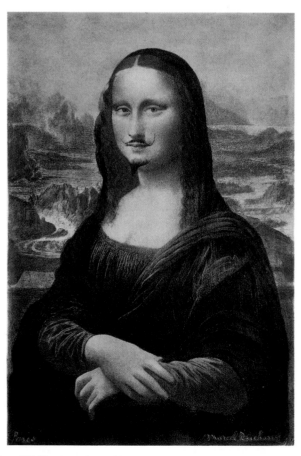

Fig. 21-8 Marcel Duchamp, *Mona Lisa (L.H.O.O.Q.)*, 1919. Rectified Readymade (reproduction of Leonardo da Vinci's *Mona Lisa* altered with pencil), 7³/₄ × 4¹/₈ in. The Louise and Walter Arensberg Collection. Lynn Rosenthal, 1998/ Philadelphia Museum of Art.

Lisa with a moustache drawn on her upper lip. Saying the letters of the title with French pronunciation reveals it to be a pun, *elle a chaud au cul*, roughly translated as "she's hot in the pants." Such is the irreverence of Dada.

In New York, Duchamp submitted a common urinal to the Independents Exhibition in 1917, titled it *Fountain*, signed it R. Mutt, and claimed for it the status of sculpture (**Fig. 21-9**). At first it was rejected, but when Duchamp let it be known that he and R. Mutt were one and the same, it was accepted. Thus, whether something was art depended on who made it—or found it, in this case. It also depended on where it was seen—in the museum it was one thing, in the plumbing store, quite another. Furthermore, on its pedestal, in the context of the museum, Duchamp's "fountain" looked to some as if it were indeed sculpture. Duchamp did not so much invalidate art as authorize the art world to consider all manner of things in aesthetic terms. His logic was not without precedent. Cubist collage had brought "real things" like newspaper clippings into the

Amelia Earhart first woman to fly
across the Atlantic alone
1932

Hitler comes to power
in Germany
1933

1933

1932
30 million unemployed
in U.S. and Europe

1932–33
Mass famine
in the U.S.S.R.

space of painting, and photography, especially, often revealed aesthetic beauty in common experience. But Duchamp's move, like Dada generally, was particularly challenging and provocative. "I was interested," he explained, "in ideas—not merely in visual products."

The art of **Surrealism** was born of Dada's preoccupation with the irrational and the illogical, as well as its interest in ideas. When the French writer André Breton issued the First Surrealist Manifesto in 1924, the nihilist spirit of Dada was clearly about to be replaced by something more positive. Breton explained the direction his movement would take: "I believe in the future resolution of these two states, dream and reality, which are seemingly so contradictory, into a kind of absolute reality, a surreality." To these ends, the new art would rely on chance operations, automatism (or random, thoughtless, and unmotivated notation of any kind), and dream images—the expressions of the unconscious mind. Two different sorts of imagery resulted. The first contained recognizable, if fantastic, subject matter. It was typified by the work of René Magritte (see Fig. 2-1), Giorgio de Chirico, who was acknowledged as an important precursor to the Surrealist movement by the Surrealists themselves, and Salvador Dalí. De Chirico claimed not to understand his own paintings. They were simply images that obsessed him, and they conveyed, Breton felt, the "irremediable anxiety" of the day. Thus, in *Melancholy and Mystery of a Street* (**Fig. 21-10**), the little girl rolls her hoop toward the ominous black shadow of a figure lurking behind the wall. Dalí called paintings such as *The Persistence of Memory* (**Fig. 21-11**) "hand-painted dream photographs." The limbless figure lying on the ground like a giant slug is actually a self-portrait of the artist, who seems to have moved into a landscape removed from time and mind.

🔍 **View** the Closer Look on *The Persistence of Memory* on myartslab.com

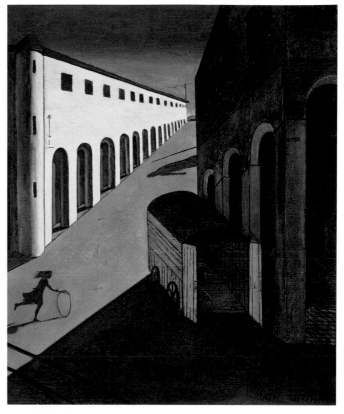

Fig. 21-10 Giorgio de Chirico, *Melancholy and Mystery of a Street*, 1914.

Oil on canvas, 24¼ × 28½ in. Private collection. Acquavella Galleries, Inc., New York.

© 2012 Artists Rights Society (ARS), New York/SIAE, Rome.

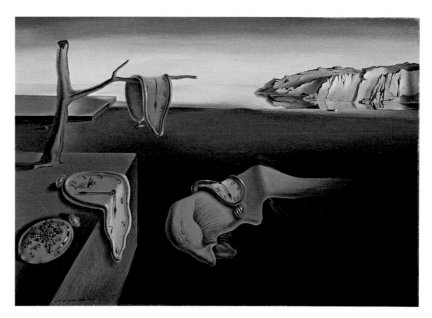

Fig. 21-11 Salvador Dalí, *The Persistence of Memory*, 1931.

Oil on canvas, 9½ × 13 in. (24.1 × 33 cm) Given anonymously. The Museum of Modern Art, New York, NY, U.S.A.

Peace restored in Mexico
after 24 years of revolution
1934

Social Security Act
passed in U.S.
1935

1934

1935
Mussolini invades
Ethiopia

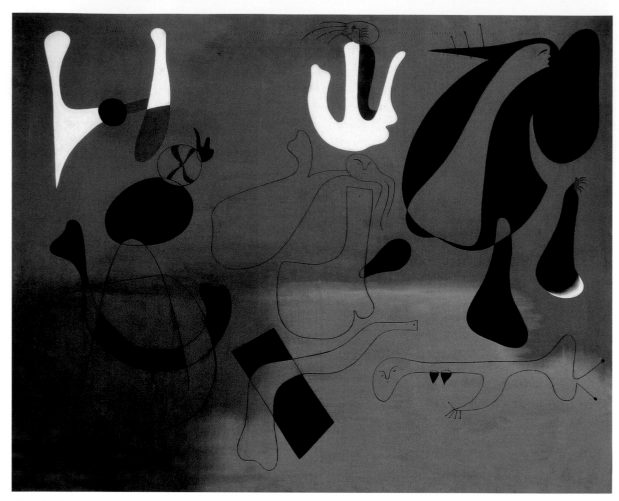

Fig. 21-12 Joan Miró, *Painting*, 1933.
Oil on canvas, 51³/₈ × 64¹/₈ in. Wadsworth Atheneum, Hartford. The Ella Gallup Sumner and Mary Catlin Sumner Collection Fund.
Wadsworth Atheneum Museum of Art/Art Resource, NY. © 2012 Successio Miro/Artists Rights Society (ARS), New York/ADAGP.

The other type of Surrealist painting was virtually abstract, presenting us with a world of indecipherable visual riddles. The painting of the Spanish artist Joan Miró and many of the early mobiles of Alexander Calder (see Fig. 7-1) fall into this category. In Miró's *Painting* (**Fig. 21-12**), biomorphic, amoeba-like forms float in a space that suggests a darkened landscape. If we look closely, however, faces, hair, and hands begin to appear. Everything in this composition appears fluid, susceptible to continuing and ongoing mutation, back and forth between representation and abstraction.

Politics and Painting

The era between World War I and World War II marks the period in Western history when, in Germany, Italy, Spain, and the Soviet Union, totalitarian and nationalistic regimes—fascist dictatorships—rose to power. It was also a time of political upheaval in Latin America, particularly in Mexico, where guerilla groups led by Emiliano Zapata and Pancho Villa demanded "land, liberty, and justice" for Mexico's peasant population. Their primary purpose was to give back to the people land that the government had deeded to foreign investors in the hope that they might modernize the country. In light of such events, politics impinged mightily on the arts.

Germany
occupies Austria
1938

James Joyce,
Finnegan's Wake
1939

—1939—

1936–39
Spanish Civil War

1939
Germany invades Poland;
World War II begins

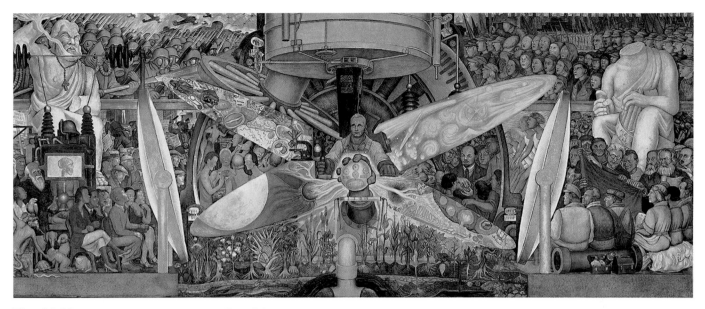

Fig. 21-13 Diego Rivera, *Man, Controller of the Universe*, 1934.
Fresco, main panel 15 ft. 11 in. × 37 ft. 6 in. Palacio de Bellas Artes, Mexico
City, D.F. Mexico.
Schalkwijk/Art Resource, NY. © 2012 Banco de Mexico Diego Rivera Frida Kahlo Museums Trust,
Mexico, D.F./Artists Rights Society (ARS), New York.

View the Closer Look on Diego Rivera's
Detroit Industry on myartslab.com

The Mexican Revolution fueled a wave of intense nationalism to which artists responded by creating art that from their point of view was true to the aspirations of the people of Mexico. When the government initiated a massive building campaign, a new school of muralists arose to decorate these buildings. It was led by Diego Rivera, David Siquieros, and Jose Clemente Orozco.

Rivera had lived in Europe from 1907 to 1921, mostly in Paris, where he had developed a Picasso-inspired Cubist technique. But responding to the revolution—and the need to address the Mexican people in clear and concise terms—he transformed his style by using a much more realist and accessible imagery focused on Mexican political and social life.

From 1930 to 1934, Rivera received a series of commissions in the United States. They included one from Edsel B. Ford and the Detroit Institute of Arts to create a series of frescoes for the museum's Garden Court on the subject of Detroit industry, a detailed description of which can be viewed on myartslab.com, and another from the Rockefellers to create a lobby fresco entitled *Man at the Crossroads Looking with Hope*

and High Vision to a New and Better Future for the RCA Building at Rockefeller Center in New York. When Rivera included a portrait of Communist leader Lenin in the lobby painting, Nelson A. Rockefeller insisted that he remove it. Rivera refused, and Rockefeller, after paying Rivera his fee, had the painting destroyed.

Rivera reproduced the fresco soon after in Mexico City and called it *Man, Controller of the Universe* (**Fig. 21-13**). At the center, Man stands below a telescope with a microscope in his hand. Two ellipses of light emanate from him, one depicting the cosmos, the other the microscopic world. Beneath him is the earth, with plants growing in abundance, the products of scientific advancements in agriculture. To the right, between healthy microbes and a starry cosmos, is Lenin, holding the hands of workers of different cultures. On the left, between microscopic renderings of syphilis and other diseases and a warring cosmos, is New York society, including Nelson Rockefeller enjoying a cocktail. At the top left, armed figures wearing gas masks and marching in military formation evoke World War I, while at the upper right, workers wearing Communist red scarves raise their voices in

—1939—

1940
Germans
invade France

U.S. enters
World War II
1941

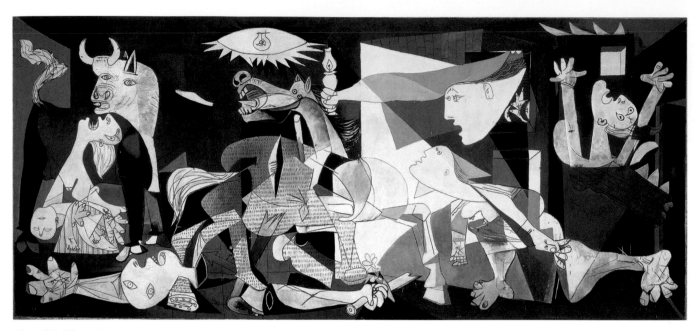

Fig. 21-14 Pablo Picasso, *Guernica*, 1937.
Oil on canvas, 11 ft. 5½ in. × 25 ft. 5¼ in. Museo Nacional Centro de Arte Reina Sofia, Madrid.

View the Closer Look on *Guernica* on myartslab.com

solidarity. Man must steer his course between the evils of capitalism and the virtues of communism, Rivera appears to be saying.

One of the greatest political paintings of the era is Pablo Picasso's *Guernica* (**Fig. 21-14**). It represents an event in the Spanish Civil War that occurred on April 26, 1937. That day, Republican Basque troops, who were fighting the Fascist forces of General Francisco Franco, were retreating toward Bilbao on the northern Spanish coast. A bridge over the Mandaca River, at the edge of a town of 7,000 people called Guernica, was the last escape route for vehicles in the area, and the German air force, which had come to the aid of Franco, was determined to destroy it. The attack was planned by Wolfram von Richthofen—the cousin of the almost-mythical German ace of World War I, Manfred von Richthofen, the Red Baron—a man eager to create his own legend. The strike force consisted of three squadrons—a total of 33 planes. Each was loaded with 3,000 pounds of bombs, as well as several hundred small incendiary cylinders. The attack, a type of sudden coordinated strike that soon became known as a blitzkrieg, commenced at 4:30 in the afternoon and lasted continuously for three-and-a-quarter hours. The first bombs were dropped near the railroad station—the bridge was ignored—and from that point on, the planes released their bombs indiscriminately into the smoke and dust raised by the first explosions. By the time the fires subsided three days later, the entire central part of the town—15 square blocks—was totally destroyed. Nearly 1,000 people had been killed.

Picasso, who was sympathetic to the Republican side and who considered himself exiled in Paris, was outraged at the events. Many elements of the painting refer to surrealist dream symbolism. The horse, at the center left, speared and dying in anguish, represents the fate of the dreamer's creativity. The entire scene is surveyed by a bull, which represents at once Spain itself, the simultaneous heroism and tragedy of the bullfight, and the Minotaur, the bull-man who for the Surrealists stood for the irrational forces of the human psyche. The significance of the electric light bulb, at the top center of the painting, and the oil lamp, held by the woman reaching out the window, has been much debated, but they represent, at least, old and new ways of seeing.

Enrico Fermi
splits the atom
1942

1945

1941–45
The Holocaust

1944
Allied invasion of Europe,
led by U.S. forces

American Modernism and Abstract Expressionism

With the outbreak of World War II, Picasso decided that *Guernica* should stay in the United States. He arranged for it to be kept at the Museum of Modern Art in New York, where it was to be held until the death of Franco and the reestablishment of public liberty in Spain. Franco, however, did not die until 1975, two years after Picasso himself. The painting was returned to Spain, finally, in 1981. It hangs today in a special annex of the Prado Museum in Madrid.

The painting profoundly affected American artists. "Picasso's *Guernica* floored me," Lee Krasner reported. "When I saw it first . . . I rushed out, walked about the block three times before coming back to look at it. And then I used to go to the Modern every day to see it." Krasner's own *Untitled* painting (**Fig. 21-15**),

Fig. 21-16 Piet Mondrian (1872–1944), *Composition II with Red, Blue, and Yellow*, 1930.
Oil on canvas, 28½ × 21¼ in.
© 2012 Mondrian/Holtzman Trust c/o HRC International Washington DC.

Fig. 21-15 Lee Krasner, *Untitled*, c. 1940.
Oil on canvas, 30 × 25 in.
© Estate of Lee Krasner. Courtesy Robert Miller Gallery, New York.
© 2010 Pollock-Krasner Foundation/Artists Rights Society (ARS), New York.

done soon after *Guernica*'s arrival in New York in 1939, reflects *Guernica*'s angular forms and turbulent energy. But it differs in important ways from *Guernica*. It is totally abstract, and where *Guernica* is a monochrome gray-brown, like burnt newsprint, Krasner's painting is vibrant with color. Probably more than any other artist of her day, Krasner understood how to integrate the competing aesthetic directions of European abstraction, fusing the geometric and expressionist tendencies of modern art in a single composition.

Like Krasner, and somewhat earlier, the Dutch painter Piet Mondrian, who had himself emigrated to New York in 1940, purged from his work all reference to the world. In paintings such as *Composition II with Red, Blue, and Yellow* (**Fig. 21-16**), he relied only upon horizontal and vertical lines, the three primary colors, and

─1945─

Atomic bombs dropped on Hiroshima and Nagasaki; World War II ends **1945**	First computer, ENIAC, built **1946**	Israel granted independence by U.N. **1948**
1945 United Nations chartered	**1947** Invention of the transistor	

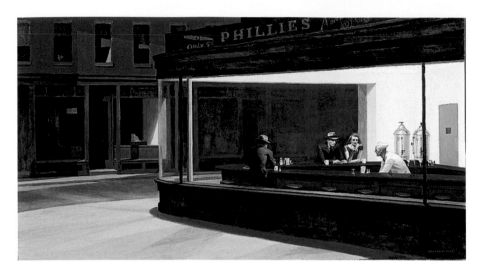

Fig. 21-17 Edward Hopper, *Nighthawks*, 1942.

Oil on canvas, 30 × 60 in. Art Institute of Chicago. Friends of American Art Collection, 1942.51.

Photography © The Art Institute of Chicago.

black and white, which were, he felt, "the expression of pure reality." Like the Russian Suprematists before him (see Fig. 2-15), who had sought to create a new art to match the spirit of the Russian Revolution, Mondrian's aims were, essentially, ethical—he wanted to purify art in order to purify the spirit. Krasner complicates, as it were, Mondrian's art, opening it to the color of the German Expressionists, and to the sometimes terrifying whirl of modern life that Picasso had captured in his art.

Until 1940, abstraction such as Krasner's was not very well accepted in the United States. To be sure, American **Modernism** had been responsive to trends in

European painting since the early years of the century, but instead of pushing toward abstraction, as had happened in Europe, American modernists tended to utilize European painting's formal innovations in more realist painting. Many artists preferred a realist approach, which was supported, on the one hand, by the growing popularity of photography, and, on the other, by an increasing conviction that art, in the face of the harsh realities of the Great Depression of the 1930s, should deal with the problems of daily life. Still, these artists were willing to learn from the formal discoveries of their more abstraction-oriented contemporaries, and we are often as attracted to the form of their work as to their subject matter. In a painting like *Nighthawks* (**Fig. 21-17**), Edward Hopper depicts the emotional isolation of the average American. But the composition is powerfully supported by the visual simplicity of his design, a geometry inspired by the example of Mondrian. It is as if his figures are isolated from one another in the vast horizontal expanse of the canvas. In her *Purple Hills Near Abiquiu* (**Fig. 21-18**), Georgia O'Keeffe utilizes the sensuous line of the German Expressionist painter Franz Marc (see Fig. 21-5) to create a landscape that almost seems to be alive, a body capable of moving and breathing like one of Marc's animals.

The Great Depression and the outbreak of World War II nevertheless provided the impetus for the development of abstract painting in the United States. President Roosevelt's WPA (Works Progress Administration) had initiated, in 1935, a Federal Art Project that supported artists financially and thus allowed them to work as they pleased. Furthermore, many leading European artists emigrated to the United States to escape ever-worsening conditions in Europe. Suddenly, in New York, American painters could not only see Picasso's *Guernica*, but also found themselves in the company of Fernand Léger, Piet Mondrian, Yves Tanguy, Marcel Duchamp, and André Breton. A style of painting referred to as **Abstract Expressionism** soon developed. It harkened back to Kandinsky's nonobjective work of 1910 to 1920, but it was not unified in its stylistic approach. Rather, the term grouped together a

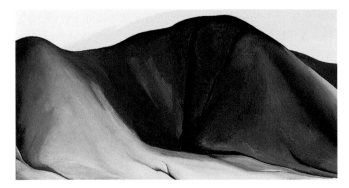

Fig. 21-18 Georgia O'Keeffe, *Purple Hills Near Abiquiu*, 1935.

Oil on canvas, 16 × 30 in. San Diego Museum of Art. Gift of Mr. and Mrs. Norton S. Walbridge, 1976:216.

George Orwell, *1984*
1949

Ray Kroc begins franchising
McDonald's restaurants
1954

1955

1950–53
Korean War

1954
Brown v. *Board of Education* ushers in
U.S. civil rights movement

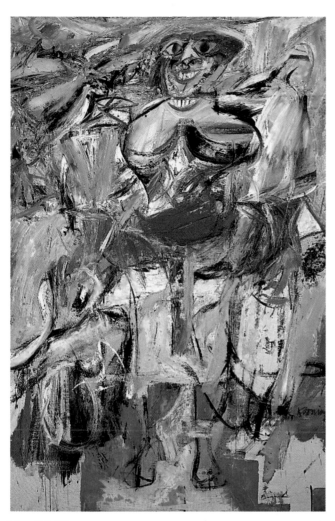

Fig. 21-19 Willem de Kooning (1904–1997), *Woman and Bicycle*, 1952–53.

Oil on canvas, overall (canvas) 76½ × 49 in. (194.3 × 124.5 cm) Whitney Museum of American Art, New York. Purchase 55.35.

© 2012 The Willem de Kooning Foundation/Artists Rights Society (ARS), New York/ADAGP.

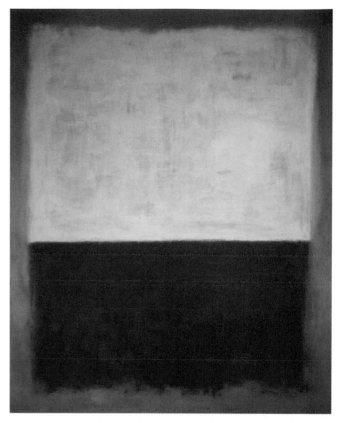

Fig. 21-20 Mark Rothko (1903–1970), *No. 12*. 1954. Oil on canvas, 115 × 91 in. (5137.54). Collection of Kate Rothko Prizel.

© 2012 Kate Rothko Prizel & Christopher Rothko/Artists Rights Society (ARS), New York.

number of painters dedicated to the expressive capacities of their own individual gestures and styles.

Jackson Pollock was deeply influenced by the Surrealist notion of automatism, the direct and unmediated expression of the self. Pouring and flinging paint onto canvas, usually on the floor, he created large "all-over"—completely covered, large-scale—surfaces with no place for the eye to rest (see Figs. 7-14 and 7-15). Because of the energy and movement of such paintings, the Abstract Expressionism of Pollock has been labeled "Action Painting." Willem de Kooning's work,

with its visible application of paint to the surface, is the definitive example of this approach. Though his paintings of women, including *Woman and Bicycle* (**Fig. 21-19**), are often seen as an attack upon women, de Kooning's hashed-out, scribbled-over, loosely gestural painting is equally a celebration of his own freedom from the conventions of figural representation. "I do not think . . . of art," he explained, "as a situation of comfort." What de Kooning liked most in Mondrian's work, for instance, was the instability, the vibration that occurs where black lines cross (see Fig. 21-16). This shimmer, he said, made him feel like he was about to fall out of the painting.

The monumental quietness of Mark Rothko's canvases (**Fig. 21-20**) conveys almost the opposite feeling. To call this "Action Painting" would be a misnomer.

Montgomery, Alabama
bus boycott
1956

Communist revolution
in Cuba
1959

—**1955**—

1956
First transatlantic
telephone service

1957
Soviets launch Sputnik,
first artificial satellite

Fig. 21-21 Robert Rauschenberg, *Odalisk*, 1955–58.
Oil, watercolor, pencil, fabric, paper, photographs, metal, glass, electric light fixtures, dried grass, steel wool, necktie, on wood structure with four wheels, plus pillow and stuffed rooster, Construction, 6'9" × 2'1" × 2'1" (205.7 × 63.5 × 63.5 cm). Museum Ludvig, Cologne. Rheinisches Bildarchiv, Museen Der Stadt Koln.

Art © Estate of Robert Rauschenberg/Licensed by VAGA, New York, NY.

The painting produces a meditative, not active, space. In place of action, we find a carefully modulated field of color that suggests the luminous space and light of Monet's *Grainstacks* (see Fig. 6-41), only without the realistic image. However, because Rothko emphasizes the horizontal band and the horizon line, his paintings often suggest the point where land meets sky. The bands of color bleed mysteriously into one another or into the background, at once insisting on the space they occupy by the richness of their color and dissolving at the edges like mist. "I am interested only in expressing the basic human emotions—tragedy, ecstasy, doom, and so on," Rothko explained, "and the fact that lots of people break down and cry when confronted with my pictures shows that I communicate with those basic human emotions. The people who weep before my pictures are having the same religious experience I had when I painted them."

Pop Art and Minimalism

By the middle of the 1950s, as Abstract Expressionism established itself as the most important style of the day, a number of young painters began to react against it. Robert Rauschenberg parodied the high seriousness of the Action Painters by using their gestures—supposed markers of the artists' sincerity—to paint over literal junk. Like the Cubists before him, he cut out materials from newspapers and magazines and silkscreened media images onto his prints (see Fig. 10-28). Rauschenberg went further, however, incorporating stuffed animals, tires (see Fig. 11-35), and all manner of things into the space of art. In *Odalisk* (**Fig. 21-21**), Rauschenberg parodies the nineteenth-century tradition of painting the nude (see Figs. 20-11 and 20-12). A stuffed rooster struts atop the construction, a pin-up nude decorates its side, and the whole rests, ironically, on a pillow—all a wry commentary on contemporary sexuality.

In the 1960s, inspired by Rauschenberg's example, a group of even younger artists, led by Andy Warhol, Claes Oldenburg, and Roy Lichtenstein, invented a new American realism, **Pop Art**. Pop represented life as America lived it, a world of Campbell's soup cans, Coca-Cola bottles, and comic strips. Based on an actual Sunday cartoon strip, Lichtenstein's giant painting *Whaam!* (**Fig. 21-22**) indicates, by its very size, the powerful role of popular culture in our emotional lives. This is an image of power, one that most American

| First manned space flight **1961** | Cuban Missile Crisis **1962** | The Beatles, *I Want to Hold Your Hand* **1963** | **1964** |

1961 Berlin Wall erected **1963** President John F. Kennedy assassinated

boys of the 1950s were raised to believe in wholly. One of the chief tactics of the Pop artists, in fact, was to transform the everyday into the monumental, as Oldenburg did by turning objects such as spoons and maraschino cherries into giant sculptural objects (see Fig. 8-20). Most important, perhaps, Pop Art left behind traditional artistic media like painting. Artists turned instead to slick renderings made by mechanical reproduction techniques, such as photolithography, that evoked commercial illustration more than fine art.

Another reaction against Action Painting led, in the same period, to a style of art known as **Minimalism**. In contrast to Pop works, Minimalist pieces were, in their way, elegant. They addressed notions of space—how objects take up space and how the viewer relates to them spatially—as well as questions of their dogmatic material presence. For Frank Stella, the shape of the painting determined its content, which might consist of a series of parallel lines that could have been drawn with a compass or protractor. "I always get into arguments with people who want to retain the old values in painting," Stella muses. "My painting is based

on the fact that only what can be seen is there. It is really an object. . . . All I want anyone to get out of my paintings, and all I ever get out of them, is the fact that you can see the whole idea without confusion. What you see is what you see." Thus, despite its title, *Empress of India* (**Fig. 21-23**) is contentless painting. It has no spiritual aspirations. It does not contain the emotions of the painter. It is simply there, four interlocked V's, before the viewer, a fact in and of itself. Stella has deliberately set out to make a work of art that has no narrative to it—that cannot, at least not very easily, be written about.

Postmodern Directions

From the time of Gauguin's retreat to the South Pacific and Picasso's fascination with African masks, Western artists have turned to non-Western cultures for inspiration, seeking "authentic" new ways to express their emotions in art. The African features of the two figures on the right in Picasso's *Les Demoiselles d'Avignon* (see Fig. 1-17) are a prime example of this. At the same time, other cultures have been dramatically affected by Western traditions. Although we normally think of the Western world's impact on these other cultures in negative terms—in the process of Westernization, ancient

Fig. 21-23 Frank Stella, *Empress of India*, 1965. Metallic powder in polymer emulsion on shaped canvas, 6 ft. 5 in. × 18 ft. 8 in. (1.96 × 5.69 m) Museum of Modern Art, New York. Gift of S. I. Newhouse. The Museum of Modern Art, New York, NY, U.S.A.
Digital Image © The Museum of Modern Art/Licensed by SCALA/Art Resource, NY. © 2012 Frank Stella/Artists Rights Society (ARS), New York.

————1964————

1964
Passage of
U.S. Civil Rights Act

Major increase in
U.S. commitment to Vietnam War
1965

Fig. 21-24 Jimmie Durham, *Headlights*, 1983.
Car parts, antler, shell, etc. Private collection.
Courtesy of the artist.

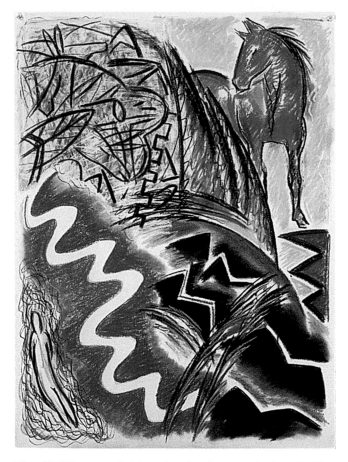

Fig. 21-25 Jaune Quick-to-See Smith, *Petroglyph Park*, 1986.
Pastel on paper, 22 × 30 in. Private collection.
© Jaune Quick-to-See Smith. Courtesy of the artist.

customs are lost, and cultural artifacts are looted and carried off for display in Western museums—many non-Western artists have incorporated the art of the West into their own art in positive ways. As Native American artist Jimmie Durham has put it, "We took glass beads, horses, wool blankets, wheat flour for frybread, etc., very early, and immediately made them identifiably 'Indian' things. We are able to do that because of our cultural integrity and because our societies are dynamic and able to take in new ideas." Similarly, the aboriginal paint-ers of Australia have adopted the use of acrylic paint, integrating the medium into their own cultural tradi-tions (see Fig. 2-14). Durham himself makes what he calls "fake Indian artifacts." Categorically non-Indian materials, such as the bright chrome automobile fender depicted here (**Fig. 21-24**), are transformed into some-thing that looks completely Indian. But the cultural forces at work are highly complex. As much as Indian culture has the ability to absorb Western materials and make them its own, anything an Indian makes, Durham knows, is always seen by the dominant Anglo-Ameri-can culture as an "artifact," a surviving fragment of a "lost" people that does not quite qualify as "art" proper. His "fake" artifacts expose this assumption.

Native American painter Jaune Quick-to-See Smith, who studied at the University of New Mexico, puts it this way: "With a university training, you're ex-posed to classic art and traditions from around the world. You wouldn't be true to yourself if you didn't incorpo-rate what you were familiar with." In her *Petroglyph Park*

(**Fig. 21-25**), Quick-to-See Smith makes direct allusion to the Blue Rider of Kandinsky and Marc, drawing an analogy between the fate of the wild horse and the fate of Native Americans. Everything in this painting refers to lost peoples—from the makers of the petroglyphs to Marc's early death in World War I—and the presence of those peoples in our memory. The simultaneous pres-ence of diverse traditions in a single work is indicative of what we have come to call **Postmodernism**.

The postmodern condition is imaged with partic-ular power in Native American artist David Bradley's *Indian Country Today* (**Fig. 21-26**). Bradley depicts a traditional Kachina dance taking place in the square of the pueblo. Performed by male dancers who imper-sonate Kachinas, the spirits who inhabit the clouds, rain, crops, animals, and even ideas such as growth and fertility, the dances are sacred, and although

Native Americans confront U.S.
armed forces at Wounded Knee
1973

1974

1969
Native Americans occupy Alcatraz Island,
reclaiming federal land as their own

tourists are allowed to view them, photography is strictly prohibited. The actual masks worn in ceremonies are not considered art objects by the Pueblo people. Rather, they are thought of as active agents in the transfer of power and knowledge between the gods and the men who wear them in dance. Kachina figurines are made for sale to tourists, but they are considered empty of any ritual power or significance. This commercialization of native tradition is further imaged by the train passing behind the pueblo—the Santa Fe Railroad's "Chief." Behind the train, at the right, is the Four Corners Power Plant in northwestern New Mexico, one of the largest coal-fired generating stations in the United States and one of the greatest polluters, spewing smoke into the air. Behind the power plant is an open-pit strip mine. The city of Santa Fe—a major tourist attraction—and an Indian-run casino, its parking lot full of buses, occupy the left side of the image. But overlooking all is a giant mesa, with Kachina-like eyes and mouth, suggesting that even in the contemporary world, where tradition and progress appear to be in a state of constant tension, the spirits still oversee and protect their peoples.

The return to tradition has, in fact, become a central theme of Native American art. This is especially true in the Pacific Northwest, where for generations cultural traditions were systematically suppressed by both the United States and Canadian governments. In 1884, for instance, the Canadian government banned the potlatch ceremonies long practiced by Northwest tribes. These ceremonies, hosted by a chief, revolved around major life events such as marriage, assumption of leadership, or death. The presentation and consumption of food was an important part of the ceremony, and so was the display of art—carved bowls and spoons for the food, masks, garments, and headdresses for performances—all designed to underscore

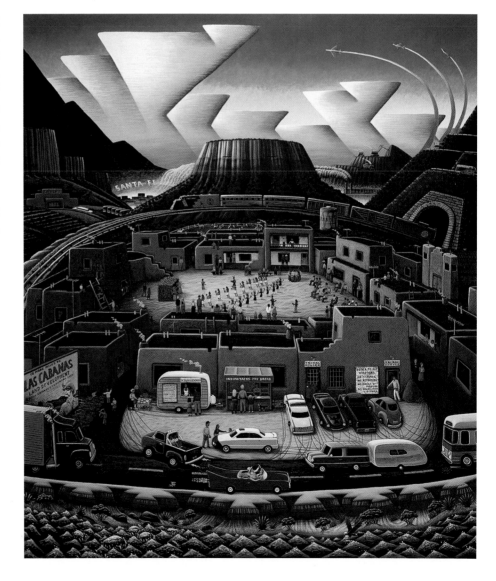

Fig. 21-26 David P. Bradley, White Earth Oijbwe and Mdewakaton Dakota, *Indian Country Today,* 1996–97.

Acrylic on canvas, 72 × 60 in. Peabody Essex Museum, Salem, Massachusetts. Museum Purchase through the Mr. and Mrs. James Krebs Fund. E300409.

Photograph courtesy of Peabody Essex Museum.

Thinking Thematically: See Art and Spiritual Belief on myartslab. com

1965 ──

First manned
moon landing
1969

Roe v. Wade
legalizes abortion in U.S.
1973

1965–69
Cultural Revolution
in China

early 1970s
Rise of the modern
feminist movement

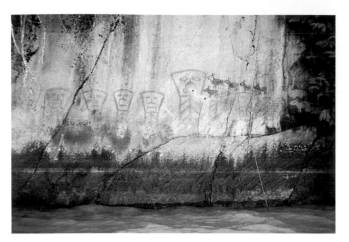

Fig. 21-27 Mollie Wilson, Kwakwaka'wakw, pictograph recording a 1927 potlatch showing coppers and cows, Kingcome Inlet, 1927.

Wall painting, 6 × 30 ft.

Photo credit: Marianne Nicolson. Courtesy of the artist.

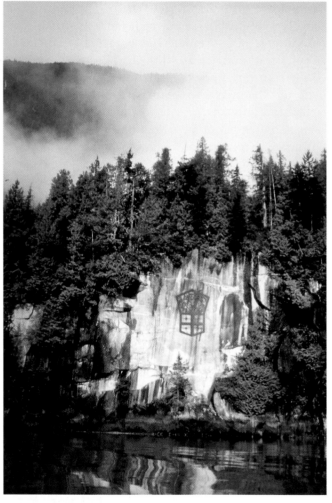

Fig. 21-28 Marianne Nicholson, Kwakwaka'wakw, pictograph of a copper on a cliff near Kingcome, 1998.

Red oxide paint, 28 × 38 ft.

Photo credit: Marianne Nicolson. Courtesy of the artist.

the chief's wealth, the principal symbol of which was the *copper*. A copper is a shield-shaped plaque made of beaten metal (originally from the Copper River, across the Gulf of Alaska from Anchorage, but after contact acquired through trade). A pictograph representation of a 1927 Kwakwaka'wakw potlatch, conducted in defiance of Canadian law in Kingcome Inlet, off Queen Charlotte Strait across from the north end of Vancouver Island, contains a series of coppers, as well as another symbol of wealth, cows purchased from white settlers, which were cooked at the feast (**Fig. 21-27**). In 1998, Kwakwaka'wakw artist Marianne Nicholson received permission from the Kingcome community to stencil a giant copper on the face of a cliff that falls into the inlet near her ancestral village of Gwayi (**Fig. 21-28**). The images on the copper include an image of Wolf with a treasure chest, based on a Kwakwaka'wakw story of the origin of the village of Gwayi itself in which two wolves, transformed into humans, journey up Wakeman and Kingcome Inlets where they build houses, make canoes, and receive treasures of supernatural power. The first pictograph painted in Kingcome Inlet for over 60 years, it celebrates the continuing tradition of the potlatch by directly referencing the small 1927 coppers nearby. As Aldona Jonaitis, director of the University of Alaska Museum of the North, has put it in her book, *Art of the Northwest Coast*, "This enormous

representation of an image imbued with such cultural meaning makes a clear statement: this land is ours."

As the world of art has become increasingly diverse and plural in character, new voices have continually entered into the arena, particularly African-American voices. Artists such as Jacob Lawrence (see Fig. 11-24) and Romare Bearden (see Fig. 11-29) have enjoyed major retrospective exhibitions. Martin Puryear (see Fig. 5-4) has established himself as one of America's leading sculptors. A younger generation of artists is following their lead. Kerry James Marshall's *Many Mansions* (**Fig. 21-29**), one of a series of paintings inspired by Marshall's observation that so many public housing

1975
South Vietnam falls
to Vietcong

━1975━

1973–74
Energy crisis in
Western countries

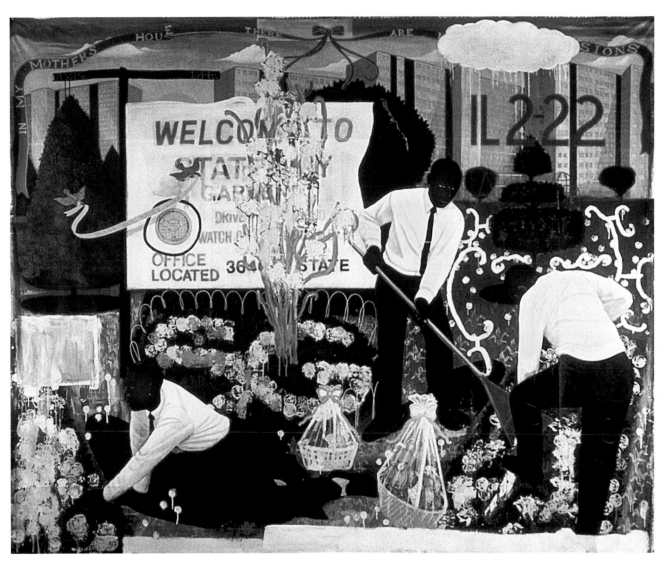

Fig. 21-29 Kerry James Marshall, *Many Mansions*, 1994.
Acrylic and collage on unstretched canvas, 114 × 135 in.
Jack Shainman Gallery, New York.

Thinking Thematically: See **Art, Politics, and Community** on myartslab.com

projects in the United States have "garden" in their names, is another meditation on African-American experience. This painting depicts Chicago's Stateway Gardens (officially known as IL2-22, as inscribed at the top right of Marshall's work), an immense complex of eight high-rise apartment buildings on Chicago's South Side. Three young men in white shirts and ties are working in the garden in what is at once an ironic commentary on the virtual impossibility of transforming the concrete urban environment into a garden and a sincere attempt on Marshall's part to contradict the false, negative image of the African-American male.

At the left, two bluebirds support a banner that reads "Bless Our Happy Home." Floating above the entire scene is a red ribbon that reads "In My Mother's House There Are Many Mansions." An adaptation of a Biblical passage from the Gospel of John that begins "In my father's house . . .", it is a reference to the matriarchal structure of urban African-American culture. Easter baskets embody the promise of hope and renewal even as they project a crass materialism. The painting is typically postmodern in its unwillingness to adopt a single point of view and the sense of irony it adapts in its embrace of contradiction.

CHAPTER 21 **FROM 1900 TO THE PRESENT** **531**

Elvis Presley found dead
1977

—1975—

1976
Death of Mao Zedong

1977
Star Wars movie

The ironies of modern political life are also the subject of Chéri Samba, whose narrative paintings of the despotic Mobutu regime in his native Zaire were treated earlier (see Fig. 4-10). In *Problème d'eau. Où trouver l'eau?* (*The Water Problem. Where to find water?*) (**Fig. 21-30**), a text block at the top of the painting reads, "Life is priceless. Concerned for his people suffering from dehydration, Chéri Samba goes looking for water on Planet Mars, as if there wasn't any water left on Earth. Yes . . . it is necessary to spend millions of dollars to better serve his people in 100 years." Samba's self-appointed superhero status, emphasized by the phallic missile that he straddles, is blatantly absurd in light of the thousands of refugees who died of dehydration on the Rwanda/Zaire border during the Rwanda civil war in the mid-1990s, and subsequent war between Ugandan and Rwandan forces in Zaire itself.

He assumes the attitude, that is, of the United States, spending millions upon millions of dollars for space exploration—to discover only trace particles of water on Mars—while millions die for lack of water in Africa.

One of the most important of the political voices to emerge in the last half of the twentieth century has been that of feminism. Since the early 1970s, when the feminist movement began to take hold in this country, women have played an increasingly vital role in defining the issues and directions of contemporary art. One important consequence is that women have retrieved for art history artists previously relegated to the sidelines or ignored altogether, among them Frida Kahlo. Kahlo was married to a successful painter, the Mexican muralist Diego Rivera (see Fig. 21-13), and her *Las Dos Fridas* (*The Two Fridas*) (**Fig. 21-31**) represents Rivera's rejection of her. According to Kahlo,

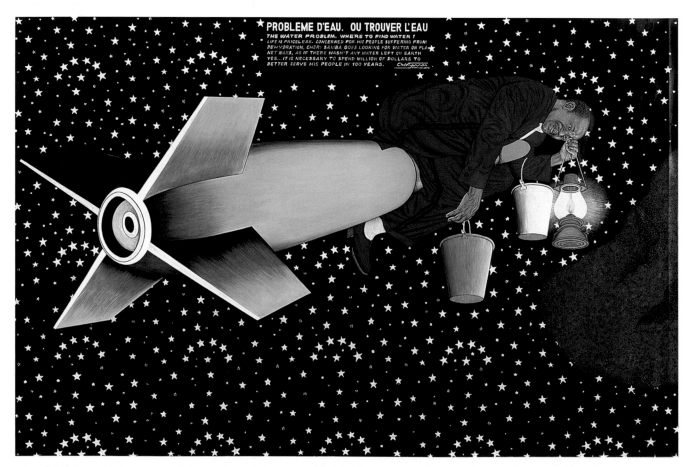

Fig. 21-30 Chéri Samba, *Problème d'eau. Où trouver l'eau?* (*The Water Problem. Where to find water?*), 2004. Acrylic on canvas, 53⅛ × 78¾ in. Contemporary African Art Collection (C.A.A.C.), The Pigozzi Collection, Geneva. Photo: Patrick Gries. © Chéri Samba. Courtesy CAAC/The Pigozzi Collection, Geneva.

The Islamic fundamentalist revolution in
Iran; U.S. hostages held
1979

1979
Egypt-Israeli
peace treaty

1980s
Beginning of AIDS
epidemic

—**1980**—

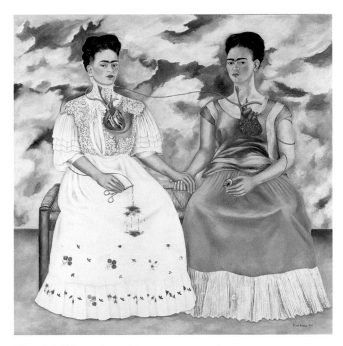

Fig. 21-31 Frida Kahlo, *Las Dos Fridas*, 1939.
Oil on canvas, 69¹/₅ × 69¹/₅ in. Museo de Arte Moderno, Mexico.
Bob Schalkwijk/Art Resource, NY. © 2012 Banco de Mexico Diego Rivera
Frida Kahlo Museums Trust, Mexico, D.F./Artists Rights Society (ARS), New
York.

the Frida on the right, in native Tehuana costume, is the Frida whom Rivera had loved. The Frida on the left is the rejected Frida. A vein runs between them both, originating in a small photo of Rivera as a child on the once-loved Frida's lap, through both hearts, and terminating in the unloved Frida's lap, cut off by a pair of surgical scissors. But the flow of blood cannot be stopped, and it continues to drip, joining the embroidered flowers on her dress.

An important aspect of feminist art has been its critique of traditional ways of seeing, ways of seeing prescribed and institutionalized by men. As our assumptions and expectations have become increasingly challenged, the art world has become increasingly unbound by any rules or by any ruling "isms." Artists can draw on personal experiences or stylistic trends and address their work to a wide audience or a relatively narrow one. But one overriding characteristic of contemporary art is its struggle with the question of identity. Cindy Sherman's untitled photographs, for instance, are self-portraits (**Fig. 21-32**), sometimes presented at the scale of a film still and other times at the scale of a large poster. They are actually performances that address the ways in which our culture "views" women. In this case, we are witness to a highly ironic, if empathetic, display of female passivity.

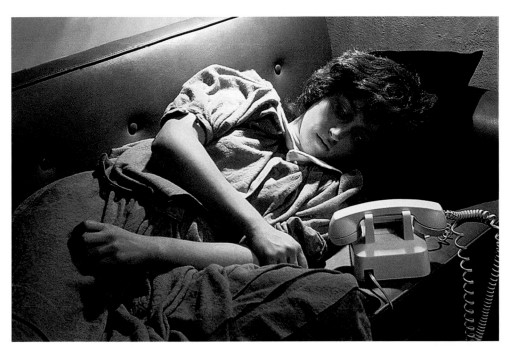

Fig. 21-32 Cindy Sherman,
Untitled #96, 1981.
Color photograph, 24 × 48 in.
Courtesy of the artist and Metro Pictures,
New York.

Thinking Thematically: See
Art, Gender, and Identity on
myartslab.com

CHAPTER 21 **FROM 1900 TO THE PRESENT** **533**

Pac-Man video game released
1980

First CDs marketed
1983

——1980——

1980
John Lennon assassinated

1982
Michael Jackson releases
Thriller

The implication is that Sherman's life, and by extension our own, is a series of performances; that, chameleon-like, we change identities as readily as we change our clothes, picking and choosing who we are from media images. The mass media—from television and video to electronic signboards and commercial photography—are increasingly not only the means of contemporary art but also its subject. Barbara Kruger's word-and-photograph pieces relate to billboard imagery, but they continue the feminist imperative of contemporary art, addressing issues of gender. In *Untitled (We won't play nature to your culture)* (**Fig. 21-33**), Kruger exposes the traditional nature/culture dichotomy for what it is—a strategy that authorizes the cultural and intellectual domination of the male over a passive and yielding female nature.

But there is nothing passive and yielding about the female character in the video installation *Ever Is Over All* (**Fig. 21-34**), made in 1997 by Swiss-born Pipilotti Rist. First screened at the Venice Biennale in 1997, one side of the double-projection video portrays a field of kniphofia, more commonly known as red-hot pokers. On the other side of the projection, a woman walks down a street, wearing a conservative blue dress and bright red shoes à la Dorothy in *The Wizard of Oz*. She is carrying a single stem of kniphofia. A soft, even soothing "la, la, la" of song accompanies her. With a broad smile on her face, she lifts the long-stemmed flower in her hand and smashes it into the passenger window of a parked car. Glass shatters. She moves on, smashing more car windows. Up from behind her comes a uniformed woman police officer, who passes by with a smiling salute. Her stroll down the boulevard plays in a continuous loop in the gallery. This is, apparently, the new

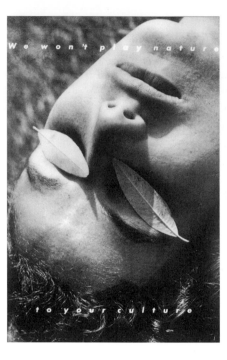

Fig. 21-33 Barbara Kruger, *Untitled (We won't play nature to your culture)*, 1983.

Photostat, red painted wood frame. 73 × 49 in.
Courtesy Mary Boone Gallery, New York.

Oz, the Emerald City that we discover "somewhere over the rainbow," where the tensions between nature and culture, violence and pleasure, the legal and the criminal, impotence and power, all seem to have dissolved.

One of the most important manifestations of the postmodern condition in art is the collapse of distinction

Fig. 21-34 Piplotti Rist, *Ever Is Over All*, 1997.

Video installation, National Museum of Foreign Art, Sofia, Bulgaria, 1999; sound with Anders Guggisbert; two overlapping video projections, audio system.

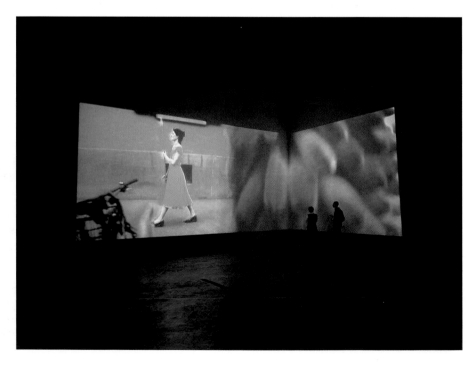

Mikhail Gorbachev introduces
glastnost in U.S.S.R.
1985

——**1985**——

1984
Apple Macintosh
computer first marketed

1985
Ozone hole above
Antarctica discovered

between high and low culture. Not only have artists mined popular culture for subject matter, generally to critique it, but popular culture has convincingly asserted its place in the art world on its own terms. Based in southern California, Raymond Pettibon began his career in the late 1970s publishing self-designed "zines," small-circulation magazines—at first offset printed and later on a photocopier—a form he has continued to practice. At about the same time he began to design album covers and 8½-by-11-inch concert flyers, at first for the punk band Black Flag, for which his brother, Greg Ginn, played lead guitar, and then for nearly every important punk band on the West Coast. Soon his repertoire included skateboards, surfboards, T-shirts, posters, and stickers, and he developed a vast following in the Los Angeles punk scene. In 1992, curator Paul Schimmel included him in the exhibition *Helter Skelter: L.A. Art in the 1990s* at the Los Angeles Museum of Contemporary Art, and his artworld career took off from there. His subjects are often deeply political, even dark, in their critique of current events, but surfing is a recurring theme, one in which he seems to find a modicum of peace. Below the giant breaking wave in this drawing (**Fig. 21-35**), dwarfing the surfer on his red board, he has written: "The bright flatness of the California landscape needs a dark vaulted interior." That interior space lies in the barrel or tube of the wave.

Enrique Chagoya's *Crossing I* (**Fig. 21-36**) draws on pop imagery to address the cultural, political, and psychological "borderland" that lies between Mexico and

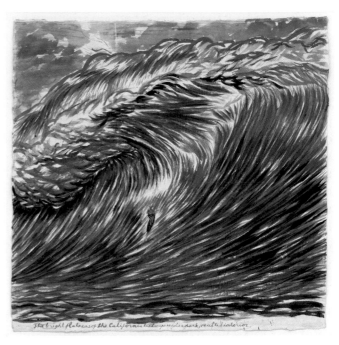

Fig. 21-35 Raymond Pettibon, *Untitled (The bright flatness)*, 2003.
Watercolor on paper, 39 × 38½ in. The Museum of Modern Art, New York. The Judith Rothschild Foundation Contemporary Drawings Collection Gift. 2736.2005.
Courtesy the artist and David Zwirner Gallery.

the United States. Born in Mexico in 1953, Chagoya immigrated to the United States when he was 24 years of age, and became a United States citizen in 2000. "I integrate diverse elements," Chagoya says, "from pre-Columbian mythology, Western religious iconography, ethnic stereotypes, ideological propaganda from various times and places, American popular culture, etc. The art becomes a product of [these] collisions." Here, the gods of two cultures confront each other—Superman, shedding his Puritan outerwear, and Tlaloc, the Aztec god of fertility and rain, lightning bolt in hand. An "alien" spacecraft, occupied by Quetzacóatl', the Aztec god

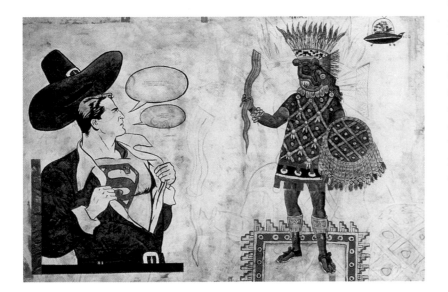

Fig. 21-36 Enrique Chagoya, *Crossing I*, 1994.
Acrylic and oil on paper; 48 × 72 in. Collection of Julia and Thomas Lanigan, Upper Montclair, New Jersey.
Photo: Rubén Guzmán; © Enrique Chagoya.

CHAPTER 21 **FROM 1900 TO THE PRESENT** **535**

U.S. space shuttle
Challenger explodes
1986

Pan Am flight 103
bombed over Lockerbie
1988

—1985—

1986
Chernobyl nuclear accident

1989
Communists defeated in free
elections in Soviet Union

whom, in 1519, Motecuhzoma believed the invading Hernán Cortés to be—a devasting case of mistaken identity—backs Tlaloc up. Pop art meets the indigenous Aztec style, itself largely destroyed by zealous missionaries intent on Christianizing the native population. While the outcome of this confrontation is hardly in doubt—the modern world will overcome the traditional one—Chagoya's design underscores the fact that it was the Puritans (and the Spanish) who were the first "alien" invaders of the Americas.

Perhaps no popular art style has more thoroughly entered the art world than graffiti. The example of Jean-Michel Basquiat (see Fig. 2-23) is a case in point. But the pseudonymous British graffiti artist Bansky has taken the form to a new level, stenciling his work on walls across Great Britain (**Fig. 21-37**). "Despite what they say," he writes in his 2006 book, *Bansky: Wall and Pieces*, "graffiti is not the lowest form of art . . . it's actually one of the more honest art forms available. There is no elitism of hype, it exhibits on the best walls a town has to offer and nobody is put off by the price of admission." The lowest form of art, he says, is corporate: "The people who truly deface our neighborhoods are the companies that scrawl giant slogans across buildings and buses trying to make us feel inadequate unless we buy their stuff." Banksy's exact identity remains a matter of speculation, but his work is widely revered. All London art museum bookstores stock Martin Bull's *Bansky Locations & Tours: A Collection of Graffiti Locations and Photographs in London, England*, first published in 2006, with new editions issued almost yearly since. A second volume, detailing locations from all around England, including a walking tour of Bansky's first works in Bristol, was published in 2011. In 2010, Banksy released the film *Exit Through the Gift Shop*, in which one Thierry Guetta, a Frenchman with a camera, is introduced into the world of graffiti artists and begins filming everything in sight, including Shepard Fairey (see Fig. 16-34), who in turn introduces Guetta to Bansky. Realizing that Guetta has no capability of actually making a film, but understanding that he possesses extraordinary documentary footage of both himself and Fairey, Banksy takes over the project as Guetta himself becomes a successful street artist, with the nom-de-plume Mr. Brainwash, culminating in Guetta's sensational one-person exhibition in Los Angeles in 2008.

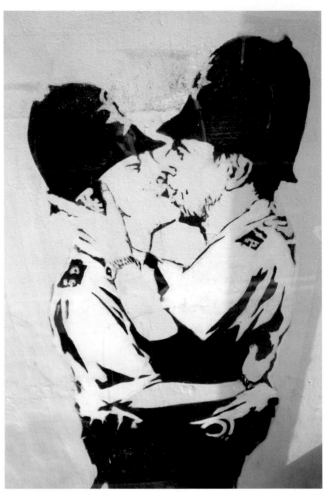

Fig. 21-37 Banksy, *Kissing Coppers*, c. 2005.
Spraypaint on wall, various sites, Brighton and London, UK.

The film was nominated for an Academy Award for Best Documentary in 2011.

In Japan, Takashi Murakami's career emerged out of the *manga* and *anime* comic and cartoon culture, and over the years he has transformed his work into an international "brand," including, during his retrospective exhibition at the Los Angeles Museum of Contemporary Art in 2008, a fully operational Louis Vuitton boutique showcasing the artist's collaboration with the designer brand. As an installation view of another gallery in that exhibition shows (**Fig. 21-38**), his work is extremely diverse. Here, the paintings on the left wall and the wallpaper throughout are of jellyfish eyes. The painting on the back wall and right are from his *Time Bokan* series of skull-shaped mushroom

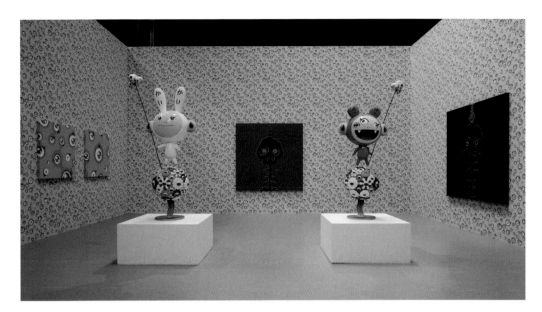

Fig. 21-38 Takashi Murakami, *Kaikai, Kiki, Jellyfish Eyes, Time Bokan—Black, and Time Bokan—Red*, 2007.

Installation view of exhibition Museum of Contemporary Art, Los Angeles.

© Takashi Murakami/Kaikai Kiki Co., Ltd.

Thinking Thematically: See Art, Science, and the Environment on myartslab.com

clouds, based on a 1975 Japanese anime series that concluded every episode with an apocalyptic explosion. The two sculptures are Kaikai and Kiki, the artist's spiritual guardians. Their names derive from the word *kaikaikiki*, used in the seventeenth century to describe the work of sixteenth-century painter Kano Eitoku and variously translated as "bizarre, yet refined" and "delicate, yet bold." Murakami describes his work as "superflat," at once evoking the flatness of *ukiyo-e* woodblock prints (see Figs. 10-6 through 10-12), and contemporary commercial graphics.

As Murakami's work suggests, the cultural specificity of artists' work is becoming, in the postmodern world, increasingly irrelevant. Today, artists tend to see themselves as "international" rather than Asian, Middle Eastern, European, or American. Again and again, their work is instilled with a distinct multicultural flavor. For instance, British artist Fiona Rae incorporates images of the kind of transfer decals popular especially among Japanese schoolgirls into her paintings—in the case of *I'm Learning to Fly!!* (**Fig. 21-39**), 11 multicolored Bambi-like deer and 18 black hearts. These pop culture images climb over and around an array of brushmarks in almost every idiom—Abstract Expressionist drips, Baroque ribbons, feathery gestures, heavily layered impasto, cartoonish outlines, a grid

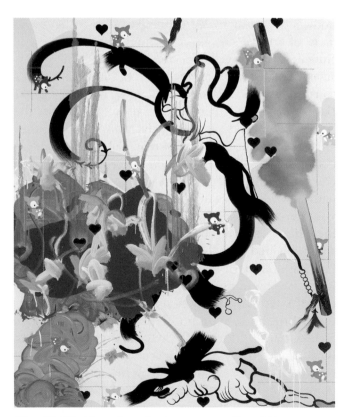

Fig. 21-39 Fiona Rae, *I'm Learning to Fly!!*, 2006.
Oil and acrylic on canvas, 84 × 69 in.
Courtesy the artist and the Pace Gallery, New York.

CHAPTER 21 **FROM 1900 TO THE PRESENT** **537**

1995 ——————————— | Alfred P. Murrah Federal Buidling in Oklahoma City bombed **1995** | Princess Diana dies in auto accident **1997**

1996
Almost 19,000 McDonald's restaurants in buisness worldwide

Fig. 21-40 Yasumasu Morimura, *Portrait (Furtago)*, 1988.
Color photograph, clear medium, 82 ¾ × 118 in. NW House, Tokyo.
Courtesy of the artist and Luhring Augustine, New York.

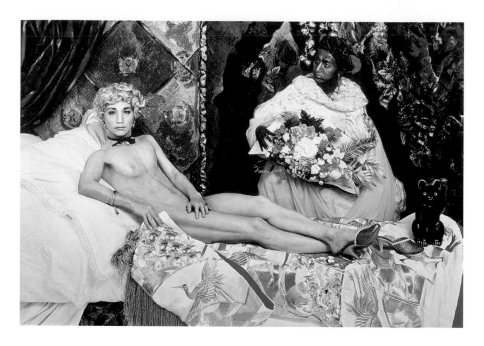

of narrow vertical and horizontal lines, and an area of apparent air-brushing. In the end, her painting reflects an all-inclusiveness and heterogeneity, admitting into the surface anything and everything.

In a similar way, the styles of the past—from the Renaissance to the Rococo, from Cubism, Abstract Expressionism, and Pop—have been raided and appropriated to the context of the present. Yasumasu Morimura's *Portrait (Twins)* (**Fig. 21-40**) is a case in point. Morimura has posed himself here as both Manet's *Olympia* (see Fig. 20-22) and her maid, manipulating the photograph with a computer in his studio. On the one hand, like Japanese culture as a whole, he is copying the icons of Western culture, but he undermines them even as he does so. For one thing, he draws attention to the fact that the courtesan and her maid share the same identity—they are "twins"—both essentially slaves to the dominant (male) forces of Western society. He places Japanese culture—and in particular the Japanese male—in the same position, prostitute and slave to the West.

Shahzia Sikander addresses the heterogeneity of her background in works such as *Pleasure Pillars* (**Fig. 21-41**), combining her training as a miniature artist in her native Pakistan with her graduate studies at the Rhode Island School of Design. In the center of the composition is a self-portrait with spiraling horns. Below it are two bodies, one a Western Venus, the other the Hindu goddess of fertility, rain, health, and nature, Devi, who is said to hold the entire universe in her womb (see Fig. 18-23). Between them two hearts pump blood—perhaps a reference to Frida Kahlo's *Dos Fridas* (see Fig. 21-31), her Western inspiration, just as the dancers surrounding her self-portrait are her Eastern inspiration. Western and Eastern images of power also inform the image—the fighter jet at the

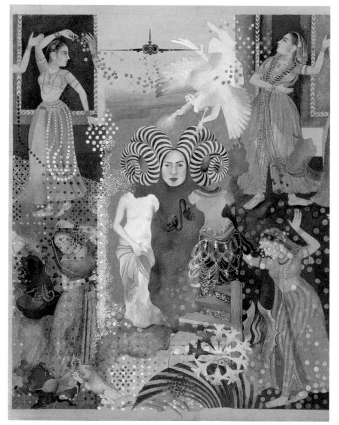

Fig. 21-41 Shahzia Sikander, *Pleasure Pillars*, 2001.
Watercolor, dry pigment, vegetable color, tea, and ink on wasli paper, 12 × 10 in. Collection of Amita and Purnendu Chatterjee.
Courtesy of Sikkema Jenkins & Co., New York.

Mapping of the human
genome
2000

2001

1999
The Euro established as the new
European currency

top of the image and the image of a lion killing a deer at the bottom left, copied from an Iranian miniature of the Safavid dynasty (1499–1736).

The fighter jet at the top of Sikander's painting suggests, of course, the almost constant state of conflict that has dominated Middle Eastern affairs since the creation of the state of Israel after World War II. The impact of this continuous conflict on our cultural consciousness is the theme of Martha Rosler's two series of photomontage images, *Bringing the War Home*, the first series dating from the Vietnam era and the second from the years of the war in Iraq (**Fig. 21-42**). In both, she combines news photographs of the war with advertisements from architecture, lifestyle, and design magazines. As surely as during the Vietnam era, when, for the first time, the day's battle could be seen on television in the comfort of our living rooms, the uncanny reality of her images suggests a comfort level with violence, as if what was, 45 years ago, a television image has now, in the new world of high-def digital 3-D animation, assumed a virtual presence. And yet her technique—the antiquated cut-and-paste routine of photomontage—belies the sense of reality achieved in the image, undermining it and forcing us to question any level of comfort we might feel. What real difference, as wars go on and on, she seems to ask, does technological advancement really make? At what cost comes a "house beautiful"?

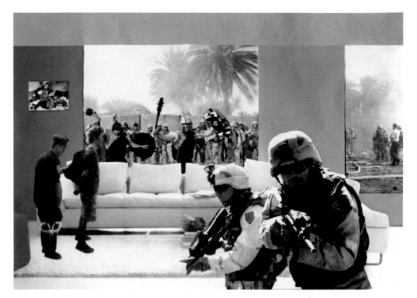

Fig. 21-42 Martha Rosler, *Gladiators*, from the series *Bringing the War Home: House Beautiful*, 2004.
Photomontage, dimensions variable.
Courtesy Martha Rosler and Mitchell-Innes & Nash, New York.

Rosler's work is an act of protest, and artists have increasingly felt the need to protest what they perceive as governmental malfeasance. In post-Mao China, Chinese artists have felt freer than ever before to state their opposition to the government, seeking change on a practical level. In his 1997 *To Raise the Water Level in a Fish Pond*, performance artist Zhang Huan invited immigrant workers in Beijing who had lost their jobs in the government's relentless modernization of Chinese industry to stand in a pond (**Fig. 21-43**). By raising the level of the water, they would assert their presence even as they ideally, but unrealistically, might raise the government's consciousness as well. As a political act, Zhang Huan acknowledged that raising the water in the pond 1 meter higher was "an action of no avail." But as an act of human poetry—the human mass serving as a metaphor for the Chinese masses—it verges on the profound.

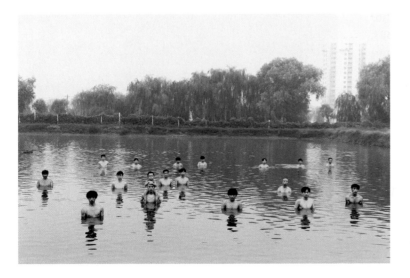

Fig. 21-43 Zhang Huan, *To Raise the Water Level in a Fish Pond*, August 15, 1997.
Performance documentation (middle-distance detail), Nanmofang Fishpond, Beijing, China. C-Print on Fuji archival paper, 60 × 90 in.
© Zhang Huan.

2001

World Trade Center attacked
September 11, 2001

Facebook begins operation
2004

October 7, 2001
War in Afghansitan begins

March 19, 2003
War in Iraq begins

August 2005
Hurrican Katrina wrecks havoc on
Gulf Coast

Fig. 21-44 Richard Misrach, *Untitled (New Orleans and the Gulf Coast)*, 2005.

Inkjet print, ed. #3/5, printed 2010. The Museum of Fine Arts, Houston, gift of the artist.

© Richard Misrach. Courtesy Fraenkel Gallery, San Francisco, Marc Selwyn Fine Art, Los Angeles and Pace/MacGill Gallery, New York.

was impractical on his trip through such a devastated landscape, and he chose to use instead a small, four-pixel pocket camera of the kind anyone can buy. "[The smaller camera] allowed me to do things I could not do with the bigger camera," he said, "and one of them was the sort of artless . . . raw communication that does parallel that actual writing on the walls." The pathos of the message in this photograph gave a title to the collection of the 68 other similar photographs of post-Katrina graffiti, but it is, in many ways, the reflection in the window of the twisted white picket fence that captures the real power of the tragedy.

Alan Montgomery's *Deepwater Horizon* (**Fig. 21-45**) is named for the oil spill in the Gulf of Mexico that flowed unabated from the Deepwater Horizon drilling rig operation for three months in 2010. By the time the flow was checked, an estimated 4.9 million barrels of crude oil had been released into the Gulf, killing scores of birds

The events of 9/11, which had such a profound impact, are represented in this book by the photography of Joel Meyerowitz (see Fig. 12-13), but, sadly, 9/11 was not the last tragedy to befall the United States in the opening decade of the twenty-first century. In late August 2005, Hurricane Katrina made landfall along the coast of the Gulf of Mexico form Florida to Texas, causing the deaths of 1,836 people either in the direct hurricane or in the flooding that followed it. Most severely damaged was the city of New Orleans, where the levee system designed by the U.S. Army Corps of Engineers disastrously failed. Nearly 80 percent of the city was under water, and the government's response, directed by the Federal Emergency Management Agency (FEMA), was anything but immediate.

Responding to the disaster, photographer Richard Misrach spent three months documenting the devastation on the Gulf Coast. When he reviewed his images on his return home, he was struck, particularly, by the graffiti messages left on the walls of the thousands of homes that had been abandoned in the wake of the disaster (**Fig. 21-44**). Normally, Misrach uses a large-format 8 × 10 camera to shoot his work, but that

Fig. 21-45 Alan Montgomery, *Deepwater Horizon*, 2011.
Oil on canvas and print media, 18 × 15 in.
Courtesy of the artist.

iPhone introduced
2007

Bank and insurance company failures trigger
financial crisis in the United States
2008

2006
U.S. population reaches
300 million

2008
Barack Obama elected President of
the United States

April 20, 2010
Deepwater Horizon oil platform
explodes in the Gulf of Mexico

─2010─

and fish, fouling wetlands and beaches, and destroying the economy of a region just barely recovering from the effects of Katrina. Montgomery's painting is part of a series entitled *Sweetcrude*, literally oil that has low levers of sulfur and hydrogen, and is thus much easier to refine, but, in Montgomery's view, a word that reverberates with double meanings. His painting reflects this duality, luscious and painterly on the one hand, but reflecting the tragedy of the disaster on the other. The palm at the lower right seems to disintegrate before our eyes. At the top center, a bird's head rises above the incoming waves. And at the bottom left, a fallen angel struggles to even stand. In the very center, the painting becomes almost totally abstract, black with traces of color, like oil consuming color, beyond Montgomery's ability to articulate it.

When the Puerto Rico-based team of Jennifer Allora and Guillermo Calzadilla were chosen to represent the United States at the 2011 Venice Biennale, they proposed what has been called a "neo-surrealistic" installation of six works under the overall title *Gloria*, referencing, according to the catalogue "military, religious, Olympic, economic, and cultural grandeur, as well as the numerous pop songs the word has inspired." They took a number of "everyday" objects—a tank, a sunbed, a copy of Thomas Crawford's 1855 *Statue of Freedom* that crowns the dome of the Capitol building in Washington, D.C., state-of-the-art business-class seats from Delta and American Airlines, an ATM, and a pipe organ—and transformed them into absurd and strange objects that force viewers to reconsider these markers of "cultural grandeur." *Algorithm* (**Fig. 21-46**) consists of a working ATM attached to the pipe organ so that every time a visitor uses the machine to get cash, make a deposit, check a balance, or transfer funds, a unique musical score is generated, based on an algorithmic procedure developed by composer Jonathan Bailey, and quoting, according to Bailey, "a wide variety of musical motifs from short individual notes to complex sequence of chords, melodies, as well as instructions to modify the tonality of the organ itself." Each transaction becomes a kind of surreal *Ode to Joy*, celebrating, to the generally perverse delight of the visitor, his or her participation in the global network of international commerce.

Fig. 21-46 Jennifer Allora and Guillermo Calzadilla, *Algorithm*, 2011.
ATM, pipe organ, and computer, 19 ft. 4³/₈ in. × 10 ft. ¹/₂ in. × 4 ft. 11¹/₈ in.
Photo: Andrew Bordwin. © Allora and Calzadilla, courtesy Glastone Gallery, New York and Brussels.

It is, finally, this sense of an increasingly global culture that defines the art world a decade into the twenty-first century, a fact underscored by English artist Phil Collins's video trilogy *The World Won't Listen*. Beginning in 2004, Collins created posters inviting people to perform karaoke renditions of all the songs from The Smiths' classic 1987 album *The World Won't Listen*, first in Bogotá, Colombia, then in Istanbul, Turkey, and finally in Jakarta and Bandung, Indonesia. From November 2007 through March 2008, the three 58-minute videos of the performances were screened simultaneously in three connected rooms at the Dallas Museum of Art.

2010

Earthquake and tsunami
devastate Japan
March 11, 2011

Official end of the
war in Iraq
December 2011

February 2011
Revolution sweeps Egypt

September 2011
Occupy Wall Street protests begin

"In all the locations," Collins told the Dallas Museum's curator of contemporary art, Suzanne Weaver, "some people had a very rudimentary grasp of English. But they knew the songs so devastatingly well through repetition, every breath and every ad lib, which, considering the importance of lyrics in the songs . . . is pretty amazing." The performers sing in front of travelogue leisure-world backdrops (**Fig. 21-47**) ranging from lakeside villas to tropical resorts to American national parks, each entering, as they sing, even if only for a moment, the glamorous world of pop idolatry. "Other people sometimes find karaoke embarrassing, or laughable, or delusional," Collins explains, "but I find it moving and incredibly courageous. . . . It's like a mild form of heroism." What Collins's trilogy suggests, finally, is a human community of far-flung "fans," but believers, too, in lyrics like those that conclude the song "Rubber Ring": "Don't forget the songs / That made you cry / And the songs that saved your life."

Fig. 21-47 **Phil Collins,** still from Part One of The Smiths karaoke trilogy, *The World Won't Listen,* 2004–2007.
Color video projection with sound, duration 58 min.
Courtesy Shady Lane Productions and Tanya Bonakdar Gallery, New York.

THINKING BACK

✓●─[**Study** and review on myartslab.com

What were the primary interests of the Cubists?

For the Cubist, art was primarily about form. Analyzing the object from all sides and acknowledging the flatness of the picture plane, the Cubist painting represented the three-dimensional world in increasingly two-dimensional terms. How did the Cubists respond to the work of Paul Cézanne? How did Cubism free painting?

How did Dada differ from Futurism in its aims?

In the words of its leader Filippo Marinetti, Futurism called for a new movement that would champion "a new beauty; the beauty of speed," which would replace traditional ideals of beauty. Dada took up Futurism's call for the annihilation of tradition, but, as a result of World War I, without its sense of hope for the future. How does Umberto Boccioni embody the ideals of Futurism in his sculpture *Unique Forms of Continuity in Space?* How did Marcel Duchamp's

Fountain comment on the status of sculpture, when it was first exhibited in 1917?

What characterizes Abstract Expressionism?

Abstract Expressionism groups together a number of painters dedicated to the expressive capacities of their individual gestures and styles. It is not stylistically unified in its approach. What is "Action Painting"? How did Mark Rothko approach painting?

What defines Minimalist art?

Minimalist artworks address notions of space—how objects take up space and how the viewer relates to them spatially. They also question the object's dogmatic material presence. Minimalist art directly reacts to the unmediated expression of Action Painting. How does Minimalist art contrast with Pop art? How did Frank Stella regard his practice of painting?

THE CRITICAL PROCESS

Thinking about Art Today

What is the role of art today? What does the museum offer us? Is it merely a repository of cultural artifacts? Or can it help us to understand not only our past, but also our present and our future? These are questions that museum professionals are asking themselves, and questions that students of art, coming to the end of a book such as this one, might well ask themselves as well.

Consider Olafur Eliasson's installation *The Weather Project* (**Fig. 21-48**). When it was installed in the mammoth Turbine Hall of the Tate Modern, London, in the winter of 2003, it was roundly criticized as "mere" entertainment, in no small part because it attracted over 2 million visitors. At the end of the 500-foot hall hung a giant yellow orb, 90 feet above the floor. The ceiling itself was covered with mirrors, thus doubling the size of the space. The "sun" was actually a semicircle of some 200 yellow sodium streetlights, which, when reflected in the ceiling mirrors, formed a circle. Artificial mist machines filled the hall with a dull, wintry fog. What was the attraction?

In no small part, it seemed to reside in the very artificiality of the environment. Visitors to the top floor of the gallery could easily see the trussing supporting the mirrored ceiling as well as the construction of the sun shape. The extraordinary visual effects of Eliasson's installation were, in the end, created by rather ordinary means. But this ordinariness, in turn, suggested profound and somewhat disturbing truths about our world and our environment. If Eliasson could create this almost post-apocalyptic environment—with its dead, heatless sun, perpetual fog, and cold stone ground—with such minimal means, what might we, as a world, create with the advanced technologies so readily at our disposal? In other words, as viewers lay on the floor of the museum and saw themselves reflected on the ceiling above, were they viewing themselves in the present, or seeing themselves in the future? What hath humanity wrought?

Fig. 21-48 Olafur Eliasson (b. 1967). © *The Weather Project*, installation view at the Tate Modern, London. 16 October 2003–21 March 2004.
Monofrequency lights, projection foil, haze machine, mirror oil, aluminum, and scaffolding.
Courtesy of the artist.

The Weather Project was, then, something of a chilling experience, both literally and figuratively. "I regard . . . museums," Eliasson has said, "as spaces where one steps even deeper into society, from where one can scrutinize society." It is perhaps relevant for you to consider this book as such a space. To conclude, what is it about your world that you have come to understand and appreciate more deeply and fully?

The Critical Process
Thinking Some More about the Chapter Questions

CHAPTER 1 Andy Warhol's *Race Riot*, 1963.

Warhol seems most interested in the second traditional role of the artist: to give visible or tangible form to ideas, philosophies, or feelings. He is clearly disturbed by the events in Birmingham. By depicting the attack on Martin Luther King, Jr., in the traditional red, white, and blue colors of the American flag, he suggests that these events are not just a local issue but also a national one. Thus, to a certain degree, he also reveals a hidden truth about the events: All Americans are implicated in Bull Connor's actions. Perhaps he also wants us to see the world in a new way, to imagine a world without racism. The second red panel underscores the violence and anger of the scene. As horrifying as the events are, it is possible to imagine a viewer offended not by the police actions but rather by Warhol's depiction of them, his willingness to treat such events as "art."

CHAPTER 2 Two Representations of *A Treaty Signing at Medicine Lodge Creek*.

Taylor's version of the events is the more representational by traditional Western standards, Howling Wolf's the more abstract. But Howling Wolf's version contains much more accurate information. Taylor's scene could be anywhere. In contrast, by portraying the confluence of Medicine Lodge Creek and the Arkansas River, Howling Wolf describes the exact location of the signing ceremony. Taylor focuses his attention on the U.S. government officials at the center of the picture, and relegates the Native Americans present to the periphery. From Taylor's ethnocentric perspective, the identities of the Native Americans present is of no interest. In contrast, Howling Wolf's aerial view shows all those present, including women, equally. Each person present is identified by the decoration of the dress and tipis. Women are valued and important members of the society. Their absence in Taylor's work suggests that women have no place at important events. In fact, it is possible to argue that Taylor's drawing is about hierarchy and power, while Howling Wolf's is about equality and cooperation.

CHAPTER 3 Suzanne Lacy's *Whisper, the Waves, the Wind*, 1993–94.

Lacy's work clearly gives tangible form to her feelings about the experiences of aging women in America. By isolating them on a beach, separated from those who need to hear them, she underscores their isolation. In doing so, she also represents the experience of aging in America, the experience of being caught between the culture's compassion for the aging and its willingness to ignore them. The image of these women, in white, in this setting, also helps us to understand the beauty of their aging, a fact that we might otherwise ignore, and thus Lacy helps us understand our world in a new way, eliciting not only our admiration but also a certain hope for our own endurance, the dignity of our own maturation. The stark contrast between the orderliness and "civilized" quality of the tables on the beach and the natural "wildness" of the shoreline suggests the power of the human imagination to transform our prejudices through art.

CHAPTER 4 *Zeus*, or *Poseidon*, c. 460 BCE, and Robert Mapplethorpe's *Lisa Lyon*, 1982.

In the Greek bronze, the submission of the male body to the discipline of a mathematical geometry is especially evident in the definition of the god's chest and stomach muscles, which have been sculpted with great attention to detail, and in the extraordinary horizontality of the outstretched left arm. Lyon presents herself to the viewer in the same terms. Rather than a passive object of display, Lyon is an active athlete. By presenting

herself in this way, Lyon asserts the power of the female and implicitly argues that the female body has been "conditioned" not so much by physical limitations as by culture.

CHAPTER 5 Doug Aitken's *the moment*, 2005.

Three different means of representing space coexist in Aitken's work: the viewer experiences his work in two, three, and four dimensions. If the invention of linear perspective in the fifteenth century provided artists with the means to represent three-dimensional space convincingly on a two-dimensional surface, then Aitken's multi-screen video projections, which are individually two-dimensional, suggests the possibility of representing four-dimensional space—that is, a space-time continuum—in the three-dimensional setting of the gallery. The viewer moves among these spaces in a kind of flow, as the figures in the videos migrate from one space to another, and as we migrate among them. Time is experienced as flux, change. The image lacks stability. In this way, Aitken might be said to capture the speed and instability of modern life itself.

CHAPTER 6 Don Gray's *Nine Stones*, 2009.

As diurnal and seasonal changes transform the local color of Gray's basalt stones optically, the sense of time passing in the present contrasts with the gradual transformation of the landscape of the Grand Ronde Valley over the course of millions of years. The sense of seeing the stones in the "present" moment is heightened by variations in color temperature as well as the simultaneous contrasts of colors, the latter of which causes the cells in the retina of the eye to respond to each color in rapid alternation. Both generate energy and movement in the viewer's eye. For Goethe, colors had moral and religious significance, existing halfway between the pure light of heaven and the pure blackness of hell. The play of light in Gray's paintings suggests, if not the promise of salvation, as for Goethe, but at least the "living" reality of the earth itself.

CHAPTER 7 Bill Viola's *Room for St. John of the Cross*, 1983.

The simple geometric architecture of the small cell contrasts dramatically with the wild natural beauty of the scene on the large screen. The former is closed and contained, classically calm; the latter open and chaotic, romantically wild. The former is still and quiet, the latter active and dynamic. The larger room, lit only by the screen image, seems dark and foreboding. The cell, lit by a soft yellow light, seems inviting. Time is a factor in terms of our experience of the work. If we approach the cell, our view of the screen is lost. When we stand back from the cell, the rapid movement on the screen disrupts our ability to pay attention to the scene in the cell. The meditative space of the cell stands in stark contrast to the turbulent world around it. And yet the cell represents captivity, the larger room freedom—both real freedom and the freedom of imaginative flight.

CHAPTER 8 Claude Monet's *The Railroad Bridge, Argenteuil*, 1874.

Monet uses one-point linear perspective to create the bridge. A grid-like geometry is established where the bridge's piers cross the horizon and the far riverbank. The wooden support structure under the bridge echoes the overall structure of grid and diagonals. In this picture is classical. But countering this geometry is the single expression of the sail, a curve echoed in the implied line that marks the edge of the bushes at the top right. A sense of opposition is created by the alternating rhythm of light and dark established by the bridge's piers and by the complementary color scheme of orange and blue in both the water and the smoke above.

The almost-perfect symmetrical balance of the painting's grid structure is countered by the asymmetrical balance of the composition as a whole (its weight seems to fall heavily to the right). There are two points of emphasis, the bridge and the boat. We seem to be witness to the conflicting forces of nature and civilization.

CHAPTER 9 Frank Auerbach's *Head of Catherine Lampert VI,* 1979–1980.

The energy of both sitter and artist is captured not only in the quick, almost furious movement of Auerbach's line but also in the almost three-dimensional sense of depth of the image resulting from repeated erasures and redrawing. As in Delacroix's drawing for *The Death of Sardanapalus,* this suggests the volatility of his sitter's personality, but just as, in his final painting, Delacroix presents Sardanapalus in quiet acceptance of the chaos surrounding him, Auerbach, especially in the white planes of Lampert's face and the apparently unerased certainty with which he has drawn her nose, presents her not just in repose, but as possessing a certain steadfastness, which might be said to mirror her willingness to return again and again to pose for the artist.

CHAPTER 10 Andy Warhol's *Marilyn Monroe,* 1967, and *San Francisco Silverspot,* 1983.

Marilyn Monroe died a suicide in 1963, as much an endangered species as the Silverspot butterfly: Monroe was a human being whose identity had been stripped, reducing her to an "image" whose real personality and humanity meant almost nothing to anyone. But Warhol understands that being transformed into a media image might have its positive effects as well, that where Monroe was destroyed by Hollywood image-making, the Silverspot might be saved. His color makes Monroe and the butterfly garish, but it draws attention to the plight of both. And both works are images that challenge their viewers to change, images that confront our collective indifference.

CHAPTER 11 Fred Tomaselli's *Airborne Event,* 2003.

Almost by definition, the medium of collage, which Tomaselli can be said to take to new heights, suggests the artificiality of our perceived environment, a world in which almost all visual experience is constructed and manipulated by others, a world in which our "highs" are no longer naturally, but instead artificially, induced. If in Fra Andrea Pozzo's *Glorification of St. Ignatius* (Fig. 11-7) St. Ignatius soars toward heaven in the contemporary world, Tomaselli suggests, such religious transcendence is increasingly only attainable by artificial (i.e., drug-induced) means.

CHAPTER 12 Jeff Wall's *A Sudden Gust of Wind,* 1993

The greatest transformation is that the pastoral world of the Hokusai print has been replaced by what appears to be an industrial wasteland. The businessmen, of course, have created this landscape. No mountain could be seen in Wall's work, even if there were one. The sky is thick with what appears to be pollution. There is nothing spiritual about this place. Wall's photograph is like a "still" from a motion picture. It implies that we are in the midst of a story. But what story? How can we ever know what is "really" happening here? Knowing that Wall has completely fabricated the scene, we recognize that, in fact, nothing is "really" happening here. Wall's is a world of complete illusion, in which meaning flies away as surely as the papers on a sudden gust of wind.

CHAPTER 13 Christo and Jeanne-Claude's *Over the River, Project for the Arkansas River, State of Colorado,* 2010.

Because viewers' experiences of *Over the River* will change depending on their point of view—above it, below it, at different points down the river—it is a kind of sculpture-in-the-round. As in Anish Kapoor's *Cloud Gate,* viewers can experience the piece from both outside and inside it, and it is designed, like *Cloud Gate,* to direct viewers' attention to the larger environment that surrounds it. But unlike Kapoor's, Christo and Jeanne-Claude's piece is temporary. For them, the debate surrounding its installation—especially the questions it forces the community to confront about the nature of art and aesthetic experience—are paramount. And the work will live on, perhaps more powerfully than if it were permanent, as a kind of legend— "Once upon a time... ."

CHAPTER 14 The Institute for Figuring, and companions, *Crochet Coral and Anemone Garden,* 2005-ongoing.

In Western culture, geometry and mathematics have been traditionally considered male domains (see the Greek treatment of the male body, Fig. 4-29). But, of course, it is males who have largely controlled political and economic power as the Great Barrier Reef has succumbed to their environmental policies—or, perhaps more accurately, their environmental indifference. Crochet is transformed here into an act of political commentary and community protest. The work is a visual record of its time and place, but one of ominous portent.

CHAPTER 15 Taos Pueblo, 1000–1450, and Moshe Safdie's *Habitat,* 1967.

The walls of Safdie's *Habitat* abut the walls of adjoining units, as in Native American pueblos, and Safdie also uses the roofs of units to provide outdoor living space for the units above. Safdie's *Habitat* is, however, decidedly modern in its look, creating a sense of visual variety absent in Native American pueblo design. This variety is made possible by technological advancements, specifically the use of reinforced concrete and steel cable construction techniques. Like Le Corbusier's Domino Housing Project, Safdie's design is modular and almost infinitely expandable, both sideways and upward. Any combination of windows and walls can be hung on the frame. Internal divisions can be freely designed in an endless variety of ways. It differs from Le Corbusier's project in the variety of elevations it presents to the viewer despite the uniformity of its parts, creating a sense of the individuality of each unit within the broader community.

CHAPTER 16 Andrea Zittel's *A-Z 1994 Living Unit,* 1994.

An artist needs to find one person who responds to his or her work—in fact, many artists frankly admit that they work "for themselves." Designers, or companies like IKEA, have to appeal to as many people as possible. Thus, the art market tends to value the unique object, while the marketplace values objects with broad, even mass appeal. It is Zittel's appeal to a relatively small and thoughtful audience, and her production of very "limited" editions of her work, that helps to define her as an artist, not a designer.

CHAPTER 21 Olafur Eliasson's *The Weather Project,* 2003.

The questions raised by Eliasson's work about the function of art today and the place of the museum will only be answered in the future, through your own experiences. But they invite you, as a viewer and participant in the world of art, to consider such questions every time you visit a museum or gallery. The idea is to end by asking questions, not answering them: Why am I here, in the museum? you should wonder. Why does it matter? What have I learned about who we are as humans? Why am I drawn to this space? to this work? to this line, or color, or form?

Glossary

Words appearing in italics in the definitions are also defined in the glossary.

absolute symmetry Term used when each half of a composition is exactly the same. (page 153)

abstract In art, the rendering of images and objects in a stylized or simplified way, so that though they remain recognizable, their formal or expressive aspects are emphasized. Compare both *representational* and *non objective art*. (page 26)

Abstract Expressionism A painting style of the late 1940s and early 1950s, predominantly American, characterized by its rendering of expressive content by *abstract* or *nonobjective* means. (page 524)

acropolis The elevated site above an ancient Greek city conceived as the center of civic life. (pages 362, 428)

acrylic A plastic resin that, when mixed with water and pigment, forms an inorganic and quick-drying paint *medium*. (page 247)

actual weight As opposed to *visual weight*, the physical weight of material in pounds. (page 152)

additive process (1) In color, the fact that when different *hues* of colored light are combined, the resulting mixture is higher in key than the original hues and brighter as well, and as more and more hues are added, the resulting mixture is closer and closer to white. (2) In sculpture, the process in which form is built up, shaped, and enlarged by the addition of materials, as distinguished from *subtractive* sculptural processes, such as carving. (pages 115, 295)

adobe A mixture of earth, water, and straw formed into sundried mud bricks. (page 391)

aerial perspective See *atmospheric perspective*. (page 101)

ambulatory A covered walkway, especially around the *apse* of a church. (page 439)

amphitheater A building type invented by the Romans (literally meaning a "double theater"), in which two semicircular theaters are brought face to face. (page 364)

analogous colors Pairs of colors, such as yellow and orange, that are adjacent to each other on the *color wheel*. (page 117)

animation In film, the process of sequencing still images in rapid succession to give the effect of live motion. (page 282)

animism The belief in the existence of souls and the conviction that nonhuman things can also be endowed with a soul. (page 11)

aperture The opening that determines the quantity of light admitted by a camera lens. (page 271)

apse A semicircular recess placed, in a Christian church, at the end of the *nave*. (page 366)

aquatint An *intaglio* printmaking process in which the acid bites around powdered particles of resin, resulting in a *print* with a granular appearance. The resulting *print* is also called an aquatint. (page 216)

arbitrary color Color that has no *realistic* or natural relation to the object that is depicted, as in a blue horse or a purple cow, but that may have emotional or expressive significance. (page 127)

architrave In architecture, the lintel, or horizontal, weight-bearing beam, that forms the base of the *entablature*. (page 362)

Art Deco A popular art and design style of the 1920s and 1930s associated with the 1925 Exposition Internationale des Arts Décoratifs et Industriels Modernes in Paris and characterized by its integration of organic and geometric forms. (page 399)

Art Nouveau The art and design style characterized by undulating, curvilinear, and organic forms that dominated popular culture at the turn of the century, and that achieved particular success at the 1900 International Exposition in Paris. (page 397)

assemblage An *additive* sculptural process in which various and diverse elements and objects are combined. (page 309)

asymmetrical balance Balance achieved in a composition when neither side reflects or mirrors the other. (page 154)

atmospheric perspective A technique, often employed in landscape painting, designed to suggest three-dimensional space in the two-dimensional space of the picture plane, and in which forms and objects distant from the viewer become less distinct, often bluer or cooler in color, and contrast among the various distant elements is greatly reduced. (page 101)

auteurs Film directors who are considered the "authors" of their work. (page 283)

axonometric projection A technique for depicting space, often employed by architects, in which all lines remain parallel rather than receding to a common *vanishing point* as in *linear perspective*. (page 89)

balance The even distribution of weight, either *actual weight* or *visual weight*, in a composition. (page 152)

balloon-frame Another name for *wood-frame* construction that came into usage because early skeptics believed that houses built in this manner would explode like balloons. (page 369)

Baroque A dominant style of art in Europe in the seventeenth century characterized by its theatrical, or dramatic, use of light and color, by its ornate forms, and by its disregard for classical principles of composition. (page 483)

barrel vault A masonry roof constructed on the principle of the *arch*, that is, in essence, a continuous series of arches, one behind the other. (page 364)

basilica In Roman architecture, a rectangular public building, entered through one of the long sides. In Christian architecture, a church loosely based on the Roman design, but entered through one of the short ends, with an *apse* at the other end. (page 440)

Bauhaus A German school of design, founded by Walter Gropius in 1919 and closed by Hitler in 1933. (page 403)

bilateral symmetry Term used when the overall effect of a composition is one of *absolute symmetry*, even though there are clear discrepancies side to side. (page 153)

binder In a *medium*, the substance that holds *pigments* together. (pages 180, 228)

buon fresco See *fresco*. (page 230)

burin A metal tool with a V-shaped point used in *engraving*. (page 211)

burning A photographic technique that increases the exposure to areas of the print that should be darker. Compare *dodging*. (page 271)

burr In *drypoint* printing, the ridge of metal that is pushed up by the *engraving* tool as it is pulled across the surface of the plate and that results, when inked, in the rich, velvety *texture* of the drypoint *print*. (page 216)

calotype The first photographic process to use a negative image. Discovered by William Henry Fox Talbot in 1841. (page 264)

canon (*of proportion*) The "rule" of perfect proportions for the human body as determined by the Greek sculptor Polyclitus in a now lost work,

known as the *Canon*, and based on the idea that each part of the body should be a common fraction of the figure's total height. (page 166)

cantilever An architectural form that projects horizontally from its support, employed especially after the development of reinforced concrete construction techniques. (page 373)

capital The crown, or top, of a *column*, upon which the *entablature* rests. (page 362)

Carolingian art European art from the mid-eighth to the early tenth century, given impetus and encouragement by Charlemagne's desire to restore the civilization of Rome. (page 448)

cartoon As distinct from common usage, where it refers to a drawing with humorous content, any full-size drawing, subsequently transferred to the working surface, from which a painting or *fresco* is made. (page 179)

cast iron A rigid, strong construction material made by adding carbon to iron. (page 368)

cast shadow In *chiaroscuro*, the shadow cast by a figure, darker than the shadowed surface itself. (page 104)

ceramics Objects formed out of clay and then hardened by *firing* in a very hot oven, or *kiln*. (pages 304, 330)

chiaroscuro In drawing and painting, the use of light and dark to create the effect of three-dimensional, *modeled* surfaces. (page 104)

chinoiserie Literally "all things Chinese," a style of art based on Chinese designs popular in Europe in the eighteenth century. (page 494)

cire-perdue See *lost-wax process*. (page 306)

closed palette See *palette*. (page 124)

close-up See *shot*. (page 280)

coiling A method of *ceramic* construction in which long, ropelike strands of clay are coiled on top of one another and then smoothed. (page 332)

collage A work made by pasting various scraps or pieces of material—cloth, paper, photographs—onto the surface of the *composition*. (page 250)

colonnade A row of *columns* set at regular intervals around the building and supporting the base of the roof. (page 362)

color wheel A circular arrangement of *hues* based on one of a number of various color theories. (page 114)

column A vertical architectural support, consisting of a *shaft* topped by a *capital*, and sometimes including a base. (page 362)

combine-painting Robert Rauschenberg's name for his works of high-relief collage. (page 256)

complementary colors Pairs of colors, such as red and green, that are directly opposite each other on the *color wheel*. (page 119)

composition The organization of the formal elements in a work of art. (page 31)

connotation The meaning associated with or implied by an image, as distinguished from its *denotation*. (page 233)

Constructivism A Russian art movement, fully established by 1921, that was dedicated to *nonobjective* means of communication. (page 401)

Conté crayon A soft drawing tool made by adding clay to graphite. (page 185)

content The meaning of an image, beyond its overt *subject matter*; as opposed to *form*. (page 21, 31)

contour line The perceived line that marks the border of an object in space. (page 61)

contrapposto The disposition of the human figure in which the hips and legs are turned in opposition to the shoulders and chest, creating a counter-positioning of the body. (page 301)

core of the shadow The darkest area on a form rendered by means of *modeling* or *chiaroscuro*. (page 104)

cornice The upper part of the *entablature*, frequently decorated. (page 362)

cross-cutting In film technique, when the editor moves back and forth between two separate events in increasingly shorter sequences in order to heighten drama. (page 280)

cross-hatching Two or more sets of roughly parallel and overlapping lines, set at an angle to one another, in order to create a sense of three-dimensional, *modeled* space. See also *hatching*. (page 106)

crossing In a church, where the *transepts* cross the *nave*. (page 366)

Cubism A style of art pioneered by Pablo Picasso and Georges Braque in the first decade of the twentieth century, noted for the geometry of its forms, its fragmentation of the object, and its increasing abstraction. (page 513)

Dada An art movement that originated during World War I in a number of world capitals, including New York, Paris, Berlin, and Zurich, which was so antagonistic to traditional styles and materials of art that it was considered by many to be "anti-art." (page 518)

daguerreotype One of the earliest forms of photography, invented by Louis Jacques Mandé Daguerre in 1839, made on a copper plate polished with silver. (page 262)

De Stijl A Dutch art movement of the early twentieth century that emphasized abstraction and simplicity, reducing form to the rectangle and color to the *primary colors*—red, blue, and yellow. (page 400)

delineation The descriptive representation of an object by means of *outline* or *contour* drawing. (page 184)

denotation The direct or literal meaning of an image, as distinguished from its *connotation*. (page 233)

diagonal recession In perspective, when the lines recede to a *vanishing point* to the right or left of the *vantage point*. (page 86)

didacticism An approach to making art emphasizing its ability to teach and, particularly, elevate the mind. (page 233)

dodging A photographic technique that decreases the exposure of selected areas of the print that the photographer wishes to be lighter. Compare *burning*. (page 271)

dome A roof generally in the shape of a hemisphere or half-globe. (page 365)

drums The several pieces of stone used to construct a *column*. (page 361)

drypoint An *intaglio* printmaking process in which the copper or zinc plate is incised by a needle pulled back across the surface, leaving a *burr*. The resulting *print* is also called a drypoint. (page 216)

earthenware A type of *ceramic* made of porous clay and fired at low temperatures that must be *glazed* if it is to hold liquid. (page 333)

earthwork An *environment* that is out-of-doors. (page 298)

editing In filmmaking, the process of arranging the sequences of the film after it has been shot in its entirety. (page 279)

edition In printmaking, the number of *impressions* authorized by the artist made from a single master image. (page 200)

elevation The side of a building, or a drawing of the side of a building. (page 362)

embossing In metalworking, the raised decoration on the surface of an object. The reverse of *repoussé*. (page 350)

embroidery A traditional fiber art in which the design is made by needlework. (page 340)

encaustic A method of painting with molten beeswax fused to the support after application by means of heat. (page 228)

engraving An *intaglio* printmaking process in which a sharp tool called a *burin* is used to incise the plate. The resulting *print* is also called an engraving. (page 211)

en plein air A French expression meaing "in the open air," used specifically to refer to the act of painting outdoors. (page 126)

entablature The part of a building above the *capitals* of the *columns* and below the roof. (page 362)

entasis The slight swelling in a *column* design to make the column appear straight to the eye. (page 361)

environment A sculptural space that is large enough for the viewer to move around in. (pages 298, 357)

etching An *intaglio* printmaking process in which a metal plate coated with wax is drawn upon with a sharp tool down to the plate and then placed in an acid bath. The acid eats into the plate where the lines have been drawn, the wax is removed, and then the plate is inked and printed. The resulting *print* is also called an etching. (page 211)

Expressionism An art that stresses the psychological and emotional content of the work, associated particularly with German art in the early twentieth century. See also *Abstract Expressionism*. (page 514)

extreme close-up See *shot*. (page 280)

Fauves The artists of the early twentieth century whose work was characterized by its use of bold *arbitrary color*. Their name derives from the French word meaning "wild beasts." (page 514)

firing The process of baking a *ceramic* object in a very hot oven, or *kiln*. (pages 304, 330)

flashback A narrative technique in film in which the editor cuts to episodes that are supposed to have taken place before the start of the film. (page 280)

fluting The shallow vertical grooves or channels on a *column*. (page 361)

flying buttress On a Gothic church, an exterior *arch* that opposes the lateral thrust of an arch or vault, as in a *barrel vault*, arching inward toward the exterior wall from the top of an exterior *column* or pier. (page 367)

focal point In a work of art, the center of visual attention, often different from the physical center of the work. (page 159)

foreshortening The modification of perspective to decrease distortion resulting from the apparent visual contraction of an object or figure as it extends backward from the picture plane at an angle approaching the perpendicular. (page 91)

form (1) The literal *shape* and *mass* of an object or figure. (2) More generally, the materials used to make a work of art, the ways in which these materials are used in terms of the formal elements (line, light, color, etc.), and the *composition* that results. (page 31)

fresco Painting on plaster, either dry (*fresco secco*) or wet (*buon*, or true *fresco*). In the former, the paint is an independent layer, separate from the plaster proper; in the latter, the paint is chemically bound to the plaster, and is integral to the wall or support. (page 230)

fresco secco See *fresco*. (page 230)

frieze The part of the *architrave* between the *entablature* and the *cornice*, often decorated. (pages 296, 362)

frontal An adjective used to describe any object meant to be seen from the front. (page 295)

frontal recession In perspective, when the lines recede to a *vanishing point* directly across from the *vantage point*. (page 86)

frottage The technique of putting a sheet of paper over textured surfaces and then rubbing a soft pencil across the paper. (page 136)

full shot See *shot*. (page 280)

functional objects Items intended for everyday use. (page 328)

Futurism An early twentieth-century art movement, characterized by its desire to celebrate the movement and speed of modern industrial life. (page 516)

gesso A plaster mixture used as a *ground* for painting. (page 233)

giornate Literally, "a day's work," the area a fresco painter is able to complete in a single sitting. (page 231)

glazing In *ceramics*, a material that is painted on a ceramic object that turns glassy when fired. (page 330)

Gothic A style of architecture and art dominant in Europe from the twelfth to the fifteenth century, characterized, in its architecture, by features such as *pointed arches*, *flying buttresses*, and a verticality symbolic of the ethereal and heavenly. (page 451)

gouache A painting *medium* similar to *watercolor*, but opaque instead of transparent. (page 247)

green architecture An architectural practice that strives to build more environmentally friendly and sustainable building. (page 382)

grid A pattern of horizontal and vertical lines that cross each other to make uniform squares or rectangles. (page 69)

groin vault A masonry roof constructed on the *arch* principle and consisting of two *barrel vaults* intersecting at right angles to each other. (page 364)

ground A coating applied to a canvas or printmaking plate to prepare it for painting or *etching*. (pages 211, 228)

Happenings Spontaneous, often multimedia, events conceived by artists and performed not only by the artists themselves but often by the public present at the event as well. (page 321)

hatching An area of closely spaced parallel lines, employed in drawing and *engraving*, to create the effect of shading or *modeling*. See also *cross-hatching*. (page 106)

Hellenism The culture of ancient Greece. (page 429)

high (*haut*) relief A sculpture in which the figures and objects remain attached to a background plane and project off of it by at least half their normal depth. (page 296)

highlights The spot or one of the spots of highest key or value in a picture. (page 104)

hue A color, as found on a *color wheel*. (page 115)

hypostyle space A large interior space characterized by many closely spaced columns supporting the roof. (page 445)

iconoclasts Literally "image breakers," those who, taking the Bible's commandment against the worship of "graven" images literally, wished to destroy images in religious settings. (pages 26, 442)

iconography The study or description of images and symbols. (page 34)

impasto Paint applied very thickly to canvas or support. (page 133)

implied line A line created by movement or direction, such as the line established by a pointing finger, the direction of a glance, or a body moving through space. (page 62)

impression In printmaking, a single example of an *edition*. (page 200)

Impressionists The painters of the Impressionist movement in nineteenth-century France whose work is characterized by the use of discontinuous strokes of color meant to reproduce the effects of light. (page 506)

infrastructure The systems that deliver services to people—water supply and waste removal, energy, transportation, and communications. (page 386)

installation An *environment* that is indoors. (page 298)

intaglio Any form of printmaking in which the line is incised into the surface of the printing plate, including *aquatint*, *drypoint*, *etching*, *engraving*, and *mezzotint*. (page 210)

intensity The relative purity of a color's *hue*, and a function of its relative brightness or dullness; also known as *saturation*. (page 115)

intermediate colors The range of colors on the *color wheel* between each *primary color* and its neighboring *secondary colors*; yellow-green, for example. (page 115)

International Style A twentieth-century style of architecture and design marked by its almost austere geometric simplicity. (page 377)

investment In *lost-wax casting*, a mixture of water, plaster, and powder made from ground-up pottery used to fill the space inside the wax lining of the mold. (page 307)

iris shot In film, a *shot* that is blurred and rounded at the edges in order to focus the attention of the viewer on the scene in the center. (page 280)

keystone The central and uppermost *voussoir* in an *arch*. (page 363)

kiln An oven used to bake *ceramics*. (pages 304, 330)

kinetic art Art that moves. (page 133)

kiva In Anasazi culture, the round, covered hole in the center of the communal plaza in which all ceremonial life took place. (page 359)

line A mark left by a moving point, actual or implied, and varying in direction, thickness, and density. (page 59)

linear perspective See *one-point linear perspective* and *two-point linear perspective*. (page 86)

linocut A form of *relief* printmaking, similar to a *woodcut*, in which a block of linoleum is carved so as to leave the image to be printed raised above the surface of the block. The resulting *print* is also known as a linocut. (page 209)

lithography A printmaking process in which a polished stone, often limestone, is drawn upon with a greasy material; the surface is moistened and then inked; the ink adheres only to the greasy lines of the drawing; and the design is transferred to dampened paper, usually in a printing press. (page 217)

load-bearing In architecture, construction where the walls bear the weight of the roof. (page 360)

local color As opposed to optical color and *perceptual color*, the actual *hue* of a thing, independent of the ways in which colors might be mixed or how different conditions of light and atmosphere might affect color. (page 126)

long shot In film, a *shot* that takes in a wide expanse and many characters at once. (page 280)

lost-wax process A bronze-casting method in which a figure is molded in wax and covered with clay; the whole is fired, melting away the wax and hardening the clay; and the resulting hardened mold is then filled with molten metal. (page 306)

low (bas) relief A sculpture in which the figures and objects remain attached to a background plane and project off of it by less than one-half their normal depth. (page 296)

Mannerism The style of art prevalent especially in Italy from about 1525 until the early years of the seventeenth century, characterized by its dramatic use of light, exaggerated perspective, distorted forms, and vivid colors. (page 481)

mass Any solid that occupies a three-dimensional volume. (page 79)

matrix In printmaking, the master image. (page 200)

medium (1) Any material used to create a work of art. Plural form, media. (2) In painting, a liquid added to paint that makes it easier to manipulate. (pages 115, 177, 228)

medium shot See *shot*. (page 280)

megaliths From the Greek *meaga* meaning "big," and *lithos*, meaning "stone." A huge stone used in prehistoric architecture. (page 418)

metalpoint A drawing technique, especially silverpoint, popular in the fifteenth and sixteenth centuries, in which a stylus with a point of gold, silver, or some other metal was applied to a sheet of paper treated with a mixture of powdered bones (or lead white) and gumwater. (page 181)

mezzotint An *intaglio* printmaking process in which the plate is ground all over with a *rocker*, leaving a *burr* raised on the surface that if inked would be rich black. The surface is subsequently lightened to a greater or lesser degree by scraping away the burr. The resulting *print* is also known as a mezzotint. (page 216)

mihrab A niche set in the wall of a mosque indicating the direction of Mecca. (page 445)

minbar A stepped pulpit for a preacher on the *qibla* wall of a *mosque*. (page 445)

Minimalism A style of art, predominantly American, that dates from the mid-twentieth century, characterized by its rejection of expressive content and its use of "minimal" formal means. (page 527)

mixed media The combination of two or more *media* in a single work. (page 250)

modeling In sculpture, the shaping of a form in some plastic material, such as clay or plaster; in drawing, painting, and printmaking, the rendering of a form, usually by means of *hatching* or *chiaroscuro*, to create the illusion of a three-dimensional *form*. (page 104)

Modernism Generally speaking, the various strategies and directions employed in twentieth-century art—Cubism, *Futurism*, *Expressionism*, etc.—to explore the particular formal properties of any given *medium*. (page 524)

monochromatic A color composition limited to a single hue. (page 124)

monotype A printmaking process in which only one *impression* results. (page 223)

montage In film, the sequencing of widely disparate images to create a fast-paced, multifaceted visual impression. (page 280)

mosaic An art form in which small pieces of tile, glass, or stone are fitted together and embedded in cement on surfaces such as walls and floors. (page 441)

mosque In Islam, the place of worship. (page 445)

naturalism A brand of representation in which the artist retains apparently realistic elements but presents the visual world from a distinctly personal or subjective point of view. (page 27)

nave The central part of a church, running from the entrance through the *crossing*. (page 366)

negative shape or space Empty space, surrounded and shaped so that it acquires a sense of form or volume. (page 80)

Neoclassicism A style of the late eighteenth and early nineteenth centuries that was influenced by the Greek Classical style and that often employed Classical themes for its subject matter. (page 495)

nonobjective art Art that makes no reference to the natural world and that explores the inherent expressive or aesthetic potential of the formal elements—line, shape, color—and the formal *compositional* principles of a given *medium*. (page 26)

nonrepresentational art See *nonobjective art*. (page 26)

oblique projection A system for projecting space, commonly found in Japanese art, in which the front of the object or building is parallel to the picture plane, and the sides, receding at an angle, remain parallel to each other, rather than converging as in *linear perspective*. (page 89)

oculus A round, central opening at the top of a *dome*. (page 365)

oil paint A medium using linseed oil as a *binder* that became particularly popular beginning in the fifteenth century. (page 237)

one-point linear perspective A version of *linear perspective* in which there is only one *vanishing point* in the *composition*. (page 86)

open palette See *palette*. (page 124)

optical painting (Op Art) An art style particularly popular in the 1960s in which line and color are manipulated in ways that stimulate the eye into believing it perceives movement. (page 142)

order In Classical architecture, a style characterized by the design of the *platform*, the *column*, and its *entablature*. (page 362)

original print A *print* created by the artist alone and that has been printed by the artist or under the artist's direct supervision. (page 200)

outline The edge of a shape or figure depicted by an actual line drawn or painted on the surface. (page 61)

palette Literally, a thin board, with a thumb hole at one end, upon which the artist lays out and mixes colors, but, by extension, the range of colors used by the artist. In this last sense, a *closed* or *restricted palette* is one employing only a few colors and an *open palette* is one using the full range of *hues*. (page 116)

pan In film, a *shot* in which the camera moves across the scene from one side to the other. (page 280)

pastel (1) A soft crayon made of chalk and pigment; also, any work done in this *medium*. (2) A pale, light color. (page 187)

patina In sculpture, a chemical compound applied to bronze by the artist; it then forms on the surface after exposure to the elements. (page 309)

pattern A repetitive motif or design. (page 132)

pencil A drawing tool made of graphite encased in a soft wood cylinder. (page 185)

pendentive A triangular section of a masonry hemisphere, four of which provide the transition from the vertical sides of a building to a covering *dome*. (page 442)

perceptual color Color as perceived by the eye. Compare *local color*. (page 126)

performance art A form of art, popular especially since the late 1960s, that includes not only physical space but also the human activity that goes on within it. (page 285)

photogenic drawing With the *daguerreotype*, one of the first two photographic processes, invented by William Henry Fox Talbot in 1839, in which a negative image is fixed to paper. (page 262)

photorealistic A drawing or painting so realistic in appearance that it appears to be a photograph. (page 26)

pigments The coloring agents of a *medium*. (page 180)

planographic printmaking process Any printmaking process in which the *print* is pulled from a flat, planar surface, chief among them *lithography*. (page 217)

platform The base upon which a *column* rests. (page 362)

pointed arch An *arch* that is not semicircular but rather rises more steeply to a point at its top. (page 367)

polychromatic A color composition consisting of a variety of *hues*. (page 124)

Pop Art A style arising in the early 1960s characterized by emphasis on the forms and imagery of mass culture. (page 526)

porcelain The type of *ceramic* fired at the highest temperature that becomes virtually translucent and extremely glossy in finish. (page 333)

post-and-lintel construction A system of building in which two posts support a crosspiece, or lintel, that spans the distance between them. (page 360)

Post-Impressionism A name that describes the painting of a number of artists, working in widely different styles, in France during the last decades of the nineteenth century. (page 509)

postmodernism A term used to describe the willfully plural and eclectic art forms of contemporary art. (pages 173, 410, 528)

primary colors The *hues* that in theory cannot be created from a mixture of other hues and from which all other hues are created—namely, in *pigment*, red, yellow, and blue, and in refracted light, red-orange, green, and blue-violet. (page 114)

print Any one of multiple *impressions* made from a master image. (page 200)

proof A trial *impression* of a *print*, made before the final *edition* is run, so that it may be examined and, if necessary, corrected. (page 200)

proportion In any composition, the relationship between the parts to each other and to the whole. (page 164)

qibla The wall of a mosque that, from the interior, is oriented in the direction of Mecca, and that contains the *mihrab*. (page 445)

radial balance A circular composition in which the elements project outward from a central core at regular intervals, like the spokes of a wheel. (page 158)

realism Generally, the tendency to render the facts of existence, but, specifically, in the nineteenth century, the desire to describe the world in a way unadulterated by the imaginative and idealist tendencies of the Romantic sensibility. (page 26)

rebars Steel reinforcement bars used in *reinforced concrete*. (page 376)

registration In printmaking, the precise alignment of *impressions* made by two or more blocks or plates on the same sheet of paper, used particularly when printing two or more colors. (page 209)

reinforced concrete Concrete in which steel reinforcement bars, or *rebars*, are placed to both strengthen and make concrete less brittle. (page 373)

relief (1) Any sculpture in which images and forms are attached to a background and project off it. See *low relief* and *high relief*. (2) In printmaking, any process in which any area of the plate not to be printed is carved away, leaving only the original surface to be printed. (pages 201, 295)

Renaissance The period in Europe from the fourteenth to the sixteenth century characterized by a revival of interest in the arts and sciences that had been lost since antiquity. (page 462)

repetition See *pattern* and *rhythm*. (page 170)

replacement process A term for casting, by, for instance, the *lost-wax process*, in which wax is replaced by bronze. (page 307)

repoussé In metalworking, a design realized by hammering the image from the reverse side. (page 350)

representational art Any work of art that seeks to resemble the world of natural appearance. (page 26)

restricted palette A selection of colors limited in its range of hues. (page 124)

rhythm An effect achieved when shapes, colors, or a regular *pattern* of any kind is repeated over and over again. (page 170)

rocker A sharp, curved tool used in the *mezzotint* printmaking process. (page 216)

Rococo A style of art popular in the first three-quarters of the eighteenth century, particularly in France, characterized by curvilinear forms, *pastel* colors, and light, often frivolous subject matter. (page 494)

Romanesque art The dominant style of art and architecture in Europe from the eighth to the twelfth century, characterized, in architecture, by Roman precedents, particularly the round *arch* and the *barrel vault*. (page 449)

Romanticism A dramatic, emotional, and subjective art arising in the early ninteenth century in opposition to the austere discipline of *Neoclassicism*. (page 498)

round arch A curved, often semicircular architectural form that spans an opening or space built of wedge-shaped blocks, called *voussoirs*, with a *keystone* centered at its top. (page 363)

sans serif A type of letter form that does not possess the small lines at the end of the letter's main stroke characteristic of *serif type*. (page 402)

saturation See *intensity*. (page 115)

scale The comparative size of an object in relation to other objects and settings. (page 164)

scarification Decorative effects made by scarring the body. (page 459)

sculpture-in-the-round As opposed to *relief*, sculpture that requires no wall support and that can be experienced from all sides. (page 298)

secondary colors *Hues* created by combining two *primary colors*; in *pigment*, the secondary colors are traditionally considered to be orange, green, and violet; in refracted light, yellow, magenta, and cyan. (page 114)

serif type Letter forms that have small lines at the end of the letter's main stroke. (page 402)

serigraphs Also known as silkscreen prints, in which the image is transferred to paper by forcing ink through a mesh; areas not meant to be printed are blocked out. (page 222)

shade A color or *hue* modified by the addition of another color, resulting in a *hue* of a darker *value*, in the way, for instance, that the addition of black to red results in maroon. (page 111)

shadow The unlighted surface of a form rendered by *modeling* or *chiaroscuro*. (page 104)

shaft A part of a *column*. (page 362)

shape A two-dimensional area, the boundaries of which are measured in terms of height and width. More broadly, the *form* of any object or figure. (page 79)

shell system In architecture, one of the two basic structural systems, in which one basic material both provides the structural support and the outside covering of a building. (page 360)

shot In film, a continuous sequence of film frames, including a *full shot*, which shows the actor from head to toe, a *medium shot*, which shows the actor from the waist up, a *close-up*, showing the head and shoulders, and an *extreme close-up*, showing a portion of the face. Other shots include the *long shot*, the *iris shot*, the *pan*, and the *traveling shot*. (page 280)

silkscreen Also known as a *serigraph*, a print made by the process of serigraphy. (page 222)

simultaneous contrast A property of *complementary colors* when placed side by side, resulting in the fact that both appear brighter and more intense than when seen in isolation. (page 119)

sinopie The *cartoon* or underpainting for a *fresco*. (page 184)

sizing An astringent crystalline substance called alum brushed onto the surface of paper so that ink will not run along its fibers. (page 205)

skeleton-and-skin system In architecture, one of the two basic structural systems, which consists of an interior frame, the skeleton, that supports the more fragile outer covering of the building, the skin. (page 360)

slab construction A method of *ceramic* construction in which clay is rolled out flat, like a pie crust, and then shaped by hand. (page 330)

slip Liquid clay used in decorating ceramic objects. (page 332)

solvent A thinner that enables paint to flow more readily and that also cleans brushes; also called *vehicle*. (page 228)

spectrum The colored bands of visible light created when sunlight passes through a prism. (page 114)

springing The lowest stone of an *arch*, resting on the supporting post. (page 365)

star In the popular cinema, an actor or actress whose celebrity alone can guarantee the success of a film. (page 281)

stippling In drawing and printmaking, a pattern of closely placed dots or small marks employed to create the effect of shading or *modeling*. (page 210)

stoneware A type of *ceramics* fired at high temperature and thus impermeable to water. (page 333)

stopping out In *etching*, the application of varnish or *ground* over the etched surface in order to prevent further etching as the remainder of the surface is submerged in the acid bath. (page 215)

storyboards Panels of rough sketches outlining the shot sequences of a film. (page 282)

stupa A large, mound-shaped Buddhist shrine. (page 436)

stylobate The base, or *platform*, upon which a *column* rests. (page 362)

subject matter The literal, visible image in a work of art, as distinguished from its *content*, which includes the *connotative*, symbolic, and suggestive aspects of the image. (page 21)

sublime That which impresses the mind with a sense of grandeur and power, inspiring a sense of awe. (page 27)

subtractive process (1) In color, the fact that, when different *hues* of colored *pigment* are combined, the resulting mixture is lower in key than the original hues and duller as well, and as more and more hues are added, the resulting mixture is closer and closer to black. (2) In sculpture, the process in which form is discovered by the removal of materials, by such means as carving, as distinguished from *additive* sculptural processes, such as *assemblage*. (pages 115, 295)

support The surface on which the artist works—a wall, a panel of wood, a canvas, or a sheet of paper. (page 228)

Surrealism A style of art of the early twentieth century that emphasized dream imagery, chance operations, and rapid, thoughtless forms of notation that expressed, it was felt, the unconscious mind. (page 519)

symbols Images that represent something more than their literal meaning. (page 34)

symmetrical When two halves of a *composition* correspond to one another in terms of size, shape, and placement of forms. (page 152)

tapestry A special kind of *weaving*, in which the *weft* yarns are of several colors that the weaver manipulates to make a design or image. (page 340)

technologies Technologies, literally, are "words" or "discourses" (from the Greek *logos*) about a "techne" (from the Greek word for art, which in turn comes from the Greek verb *tekein*, "to make, prepare, or fabricate"). In art, then, any medium is a techne, a means of making art. (page 177)

technology The materials and methods available to a given culture. (page 357)

tempera A painting *medium* made by combining water, pigment, and, usually, egg yolk. (page 233)

temperature The relative warmth or coolness of a given *hue*; hues in the yellow-orange-red range are considered to be warm, and hues in the green-blue-violet range are considered cool. (page 117)

tenebrism From the Italian *tenebroso*, meaning murky, a heightened form of *chiaroscuro*. (page 104)

tensile strength In architecture, the ability of a building material to span horizontal distances without support and without buckling in the middle. (page 360)

tesserae Small pieces of glass or stone used in making a *mosaic*. (page 442)

texture The surface quality of a work. (page 132)

time and **motion** The primary elements of temporal media, linear rather than spatial in character. (page 132)

tint A color or *hue* modified by the addition of another color resulting in a hue of a lighter value, in the way, for instance, that the addition of white to red results in pink. (page 111)

transept The crossarm of a church that intersects, at right angles, with the *nave*, creating the shape of a cross. (page 366)

traveling shot In film, a *shot* in which the camera moves back to front or front to back. (page 280)

trompe l'oeil A manner of two-dimensional representation in which the appearance of natural space and objects is re-created with the intention of fooling the eye of the viewer, who may be convinced that the subject actually exists in three-dimensional space. (page 28)

triumphal arches Roman arches designed for triumphant armies to march through, usually composed of a simple barrel vault enclosed within a rectangle, and enlivened with sculpture and decorative engaged columns. (page 433)

truss In architecture, a triangular framework that, because of its rigidity, can span much wider areas than a single wooden beam. (page 369)

tunnel vault See *barrel vault*. (page 364)

tusche A greasy material used for drawing on a *lithography* stone. (page 219)

two-point linear perspective A version of *linear perspective* in which there are two (or more) *vanishing points* in the *composition*. (page 88)

tympanum The semicircular *arch* above the lintel over a door, often decorated with sculpture. (page 450)

vanishing point In *linear perspective*, the point on the horizon line where parallel lines appear to converge. (page 86)

vantage point In *linear perspective*, the point where the viewer is positioned. (page 86)

visual weight As opposed to *actual weight*, the apparent "heaviness" or "lightness" of a shape or form. (page 152)

voussoir A wedge-shaped block used in the construction of an *arch*. (page 363)

warp In *weaving*, the vertical threads, held taut on a loom or frame. (page 340)

wash Large flat areas of ink or *watercolor* diluted with water and applied by brush. (page 191)

watercolor A painting *medium* consisting of *pigments* suspended in a solution of water and gum arabic. (page 244)

weaving A technique for constructing fabrics by means of interlacing horizontal and vertical threads. (page 340)

weft In *weaving*, the loosely woven horizontal threads, also called the *woof*. (page 340)

wet-plate collodion process A photographic process, developed around 1850, that allowed for short exposure times and quick development of the print. (page 265)

wood engraving Actually a *relief* printmaking technique, in which fine lines are carved into the block, resulting in a *print* consisting of white lines on a black ground. The resultant print is also called a wood engraving. (page 207)

woodcut A *relief* printmaking process, in which a wooden block is carved so that those parts not intended to print are cut away, leaving the design raised. The resultant *print* is also called a woodcut. (page 201)

wood-frame A true skeleton-and-skin building method, commonly used in domestic architecture to the present. (page 369)

woof See *weft*. (page 340)

Zone System A framework for understanding exposures in photography developed by Ansel Adams, where a zone represents the relation of the image's (or a portion of the image's) brightness to the value or tone that the photographer wishes it to appear in the final print. Thus each picture is broken up into zones ranging from black to white with nine shades of gray in between—a photographic gray scale. (page 270)

Photo Credits

Chapter 1

1-2 © Xiaoyang Liu/Corbis; **1-4** Digital Image © The Museum of Modern Art/Licensed by SCALA / Art Resource, NY; **1-8** Attributed to: Manohar, Indian, active about 1580 to 1620. Attributed to: Abul Hasan, Indian, active about 1600–1630. "Darbar of Jahangir." Indian, Mughal, Mughal period, about 1625. Object Place: Northern India. Opaque watercolor and gold on paper. 35 × 20 cm (13 3/4 × 7 7/8 in.). Museum of Fine Arts, Boston. Francis Bartlett Donation of 1912 and Picture Fund. 14.654; **1-9** Giraudon/Art Resource, NY; **1-10** Kane Kwei (Teshi tribe, Ghana, Africa), "Coffin Orange, in the Shape of a Cocoa Pod," ca. 1970. Polychrome wood, 34 in. × 15 1/2 in. × 29 in. (86.4 × 268 × 61 cm). Fine Arts Museums of San Francisco, Gift of Vivian Burns, Inc., 74.8; **1-12** Nr. RP2-8 Centre Tjibaou, New Caledonia. © Hans Schlupp/archenova. Architect/Designer: Renzo Piano Building Workshop; **1-13** Digital Image © The Museum of Modern Art/Licensed by SCALA / Art Resource, NY. © 2012 Estate of Pablo Picasso/Artists Rights Society (ARS), New York; **1-15** © 2012 Estate of Pablo Picasso/Artists Rights Society (ARS), New York; **1-16** Réunion des Musées Nationaux / Art Resource, NY. © 2012 Estate of Pablo Picasso/Artists Rights Society (ARS), New York; **1-17** Digital Image © The Museum of Modern Art/Licensed by SCALA / Art Resource, NY. © 2012 Estate of Pablo Picasso/ Artists Rights Society (ARS), New York; **1-19** Scala/Art Resource, NY; **1-20** Scala/Art Resource, NY; **1-23** Courtesy of Dread Scott; **1-24** © 2012 Andy Warhol Foundation for the Visual Arts, Inc./Artists Rights Society (ARS), New York.

Chapter 2

2-1 Banque d'Images, ADAGP / Art Resource, NY. © 2012 C. Herscovici, London//Artists Rights Society (ARS), NY; **2-2** Lorna Simpson, American, born in 1960. "She", 1992. Framed polaroids and plaque. 29 × 85 1/4 inches (73.6 × 216.5 cm). Museum of Fine Arts, Boston. Ellen Kelleran Gardner Fund. 1992.24a-e; **2-6** "Firdawsi's "Shahnama": illuminated text page". Persian, Safavid, 1562–83. Object Place: Shiraz, Iran. Opaque watercolor, ink, and gold on paper. W: 33 × L: 47.5 cm (13 × 18 11/16 in.). Museum of Fine Arts, Boston. Francis Bartlett Donation of 1912 and Picture Fund. 14.692; **2-7** © British Library Board IO Islamic 1129 (Ethe 982), f.29; **2-8** Image copyright © The Metropolitan Museum of Art. Image source: Art Resource, NY; **2-9** Photo by Aaron Johanson; **2-10** Photo by Aaron Johanson; **2-11** Photo by Aaron Johanson; **2-12** Photo by Aaron Johanson; **2-15** CNAC/MNAM/Dist. Réunion des Musées Nationaux / Art Resource, NY; **2-17** Alinari/Art Resource, N.Y; **2-19** Giraudon/Art Resource, NY; **2-21** © National Gallery, London / Art Resource, NY; **2-22** The Portrait of Giovanni (?) Arnolfini and his Wife Giovanna Cenami (?) (The Arnolfini Marriage) 1434 (oil on panel), Eyck, Jan van (c.1390–1441) / National Gallery, London, UK / The Bridgeman Art Library; **2-23** © 2012 The Estate of Jean-Michel Basquiat/ADAGP, Paris/ARS, New York.

Chapter 3

3-2 Installation view of the exhibition Giorgio Armani at the Solomon R. Guggenheim Museum, New York, October 20, 2000-January 17, 201. Photograph by Ellen Labenski © The Solomon R. Guggenheim Foundation, New York; **3-4** Photo: Diane Bondareff/ AP World Wide Photos; **3-5** Réunion des Musées Nationaux / Art Resource, NY; **3-6** Image copyright © The Metropolitan Museum of Art. Image source: Art Resource, NY; **3-7** The Philadelphia Museum of Art / Art Resource, NY. Art © 2012 Artists Rights Society (ARS), New York/ADAGP, Paris/Succession Marcel Duchamp; **3-9** Mark Wilson/Getty Images; **3-10** © 2012 Calder Foundation, New York/Artists Rights Society (ARS), New York; **3-11** © 2012 Richard Serra/Artists Rights Society (ARS), New York; **3-12** © Bill Ross / CORBIS.

Chapter 4

4-1 Paul Cezanne (French, 1839–196), "The Basket of Apples," c. 1895. Oil on Canvas, 65 × 80 cm. Helen Birch Bartlett Memorial Collection. 1926.252. The Art Institute of Chicago. Photography © The Art Institute of Chicago; **4-2** © Tate London 2012; **4-7** Digital Image © The Museum of Modern Art/ Licensed by SCALA / Art Resource, NY. © 2012 Succession Giacometti/ Artists Rights Society (ARS), New York/ADAGP, Paris; **4-8** Scala / Art Resource, NY; **4-9** Scala / Art Resource, NY; **4-12** © The Trustees of the British Museum / Art Resource, NY; **4-14** Digital Image © The Museum of Modern Art/Licensed by SCALA / Art Resource, NY; **4-15** Vincent van Gogh, "Letter to John Peter Russell," April, 1888. Reed pen and ink on wove paper, 20.3 × 26 cm (8 × 10 1/4 in.). Solomon R. Guggenheim Museum, New York. Thannhauser Collection, Gift, Justin K. Thannhauser, 1978. 78.2514.18 Photograph by Robert E. Mates. © The Solomon R. Guggenheim Foundation, New York; **4-18** Photograph © Board of Trustees, National Gallery of Art, Washington, D.C. Photo: Philip A. Charles; **4-19a** Photograph © Board of Trustees, National Gallery of Art, Washington, D.C; **4-19b** Photograph © Board of Trustees, National Gallery of Art, Washington, D.C; **4-20** Albright-Knox Art Gallery / Art Resource, NY; **4-25** Image copyright © The Metropolitan Museum of Art. Image source: Art Resource, NY; **4-26** Giraudon/Art Resource, NY; **4-27** Réunion des Musées Nationaux / Art Resource, NY; **4-28** Réunion des Musées Nationaux / Art Resource, NY; **4-29** Erich Lessing/Art Resource, NY.

Chapter 5

5-9 Steve DiBenedetto, Deliverance, 204. Colored pencil on paper, 30 1/8 × 22 1/2 in. (76 × 57 cm) Courtesy of David Nolan Gallery, New York, Private Collection, New York; **5-14** Canali Photobank, Milan, Italy; **5-15** Leonardo da Vinci (1452–1519), "The Last Supper". 1495–97/98. Mural (oil and tempera on plaster), 15' 1 1/8" × 28' 10 1/2". Refectory, Monastery of Santa Maria delle Grazie, Milan, Italy. IndexRicerca Iconografica. Photo: Ghigo Roli; **5-16** Leonardo da Vinci (1452–1519), "The Last Supper". 1495–97/98. Mural (oil and tempera on plaster), 15' 1 1/8" × 28' 10 1/2". Refectory, Monastery of Santa Maria delle Grazie, Milan, Italy. IndexRicerca Iconografica. Photo: Ghigo Roli; **5-18** Gustave Caillebotte, (French, 1848–1894), "Paris Street on a Rainy Day, Place de L'Europe un jour pluvieux". 1876/77. Oil on canvas, 83 1/2" × 18 3/4". (2012.2 × 276.2 cm). Charles H. and Mary F. S. Worcester Collection, 1964.336. The Art Institute of Chicago. Photography © The Art Institute of Chicago. **5-19** Gustave Caillebotte, (French, 1848–1894), "Paris Street on a Rainy Day, Place de L'Europe un jour pluvieux". 1876/77. Oil on canvas, 83 1/2" × 18 3/4". (2012.2 × 276.2 cm). Charles H. and Mary F. S. Worcester Collection, 1964.336. The Art Institute of Chicago. Photography © The Art Institute of Chicago; **5-21** Digital Image © The Museum of Modern Art/Licensed by SCALA / Art Resource, NY; **5-22** Courtesy of the Library of Congress; **5-23** Albrecht Dürer, German, 1471–1528. "Artist Drawing a Female Nude." Woodcut from the book, Underweysung der Messung (Teaching of Measurement), 1538. Book: 29.7 × 20.4 × 2 cm (11 11/16 × 8 1/16 × 13/16 in.). Museum of Fine Arts, Boston. Fund in memory of Horatio Greenough Curtis. 35.53; **5-24** DEA / G. CIGOLINI; **5-28** Réunion des Musées Nationaux / Art Resource, NY; **5-29** Photograph © The State Hermitage Museum. Photo by Vladimir Terebenin, Leonard Kheifets, Yuri Molodkovets. © 2012 Succession Henry Matisse/ Artists Rights Society (ARS), New York; **5-30** Paul Cézanne, French, 1839–196. "Madame Cézanne in a Red Armchair", about 1877. Oil on canvas. 72.4 × 55.9 cm (28 1/2 × 22 in.). Museum of Fine Arts, Boston. Bequest of Robert Treat Paine, 2nd. 44.776.

Chapter 6

6-2 © 2012 Stephen Flavin/Artists Rights Society (ARS), New York; **6-3** © National Gallery, London / Art Resource, NY; **6-4** Erich Lessing/Art Resource, NY; **6-5** © 2012 Artists Rights Society (ARS), New York/ADAGP, Paris; **6-7** Judith and Maidservant with the Head of Holofernes, c.1625 (oil on canvas), Gentileschi, Artemisia (1597–c.1651) / Detroit Institute of Arts, USA / Gift of Mr Leslie H. Green / The Bridgeman Art Library; **6-8** Mary Cassatt (American 1844–1926), "The Coiffure". c. 1891. Graphite with traces of Green and Brown Watercolor, (Breeskin 1970 815). Appx.148 × .112 cm (5 7/8" × 4 3/8"). Rosenwald Collection. Photograph © Board of Trustees, National Gallery of Art, Washington, D.C; **6-9** Giraudon/Art Resource, NY; **6-11** Mary Stevenson Cassatt, American, 1844–1926. Drawing for "In the Loge", 1878. Graphite. Sheet: 10.2 × 15.2 cm (4 × 6 in.) Museum of Fine Arts, Boston. Gift of Dr. Hans Schaeffer. 55.28; **6-12** Mary Stevenson Cassatt, American, 1844–1926, "In the Loge," 1878. Oil on canvas, 81.28 × 66.4 cm. (32 × 26 in.). Museum of Fine Arts, Boston. The Hayden Collection - Charles Henry Hayden Fund, 10.35; **6-13** © Hiroshi Sugimoto, courtesy The Pace Gallery; **6-14** © Hiroshi Sugimoto, courtesy The Pace Gallery; **6-27** AKG-Images; **6-28** Canali Photobank, Milan, Italy; **6-30** Giraudon/Art Resource, NY; **6-33** Erich Lessing/Art Resource, NY; **6-35** Detail Chuck Close, "Stanley" 1980–1981. Oil on canvas, 274.3 × 213.4 cm (18 × 84 in.) © The Solomon R. Guggenheim Foundation, New York. Purchased with funds contributed by Mr. and Mrs. Barrie M. Damson, 1981. 81.2839. Photograph by David Heald. (FN 2839). Courtesy The Pace Gallery; **6-36** Chuck Close, "Stanley" 1980-1981. Oil on canvas, 274.3 × 213.4 cm (18 × 84 in.) © The Solomon R. Guggenheim Foundation, New York. Purchased with funds contributed by Mr. and Mrs. Barrie M. Damson, 1981. 81.2839. Photograph by David Heald. (FN 2839). Courtesy The Pace Gallery; **6-38** Scala / Art Resource, NY; **6-40** © 2012 Brice Marden / Artists Rights Society (ARS), New York/; **6-41** Claude Monet, French, 1840–1926. "Grainstack (Sunset)", 1891. Oil on canvas. 73.3 × 92.7 cm (28 7/8 × 36 1/2 in.) Museum of Fine Arts, Boston. Juliana Cheney Edwards Collection. 25.112; **6-42** Image copyright © The Metropolitan Museum of Art. Image source: Art Resource, NY. © 2012 Artists

Rights Society (ARS), New York/ADAGP, Paris; **6-44** Wassily Kandinsky, "Black Lines (Schwarze Linien)," December 1913. Oil on canvas, 129.4 × 131.1 cm (51 × 51 5/8 in.) Solomon R. Guggenheim Museum, New York. Gift, Solomon R. Guggenheim, 1937. 37.241. Photograph by David Heald, © The Solomon R. Guggenheim Foundation, New York. © 2012 Artists Rights Society (ARS), New York/ADAGP, Paris.

Chapter 7

7-1 Alexander Calder, "Untitled". 1977. 9.13 × 23.155 in. (358.5 × 912 cm). Gift of the Collectors Committee. Image © 1976 Board of Trustees, National Gallery of Art, Washington, D.C. © 2012 Calder Foundation, New York/Artists Rights Society (ARS), New York; **7-2** Canali Photobank, Milan, Italy; **7-3** Photography by Bill Jacobson. Courtesy The Pace Gallery; **7-5** Collection Stedelijk Museum Amsterdam. © 2012 Artists Rights Society (ARS), New York/ADAGP, Paris; **7-6** Digital Image © The Museum of Modern Art/Licensed by SCALA / Art Resource, NY; **7-7** Cott Nero DIV f.2v Carpet page with cross introducing St. Jerome's letter to Pope Damasus, from the Lindisfarne Gospels, 710–721 (vellum), English School, (8th century) / British Library, London, UK / © British Library Board. All Rights Reserved / The Bridgeman Art Library; **7-8** Claudio Mari/©The Trustees of the British Museum; **7-9** Image copyright © The Metropolitan Museum of Art. Image source: Art Resource, NY; **7-10** Galleria Borghese, Rome/Canali PhotoBank, Milan/SuperStock; **7-12a** Giraudon/Art Resource, NY; **7-12b** Erich Lessing/Art Resource, NY; **7-13** Albright-Knox Art Gallery / Art Resource, NY; **7-14** © 2012 The Pollock-Krasner Foundation/Artists Rights Society (ARS), New York; **7-15** © 2012 The Pollock-Krasner Foundation/Artists Rights Society (ARS), New York; **7-18** LUX, London.

Chapter 8

8-1 Cameraphoto Arte, Venice / Art Resource, NY; **8-2** © Curva de Luz / Alamy; **8-3** Scala / Art Resource, NY; **8-4** Giraudon/Art Resource, NY; **8-6** Johannes Vermeer (Dutch 1632–1675), "Woman Holding a Balance". 1664. Oil on Canvas. .425 × .380 (16 3/4 × 15); framed .628 × .584 × .76 (24 2/4 × 23 × 3). Widener Collection. Photo: Richard Carafelli. Photograph © Board of Trustees, National Gallery of Art, Washington, D.C.; **8-7** Childe Hassam, American, 1859–1935. "Boston Common at Twilight", 1885–86. Oil on canvas 16.68 × 152.4 cm (42 × 60 in.) Museum of Fine Arts, Boston. Gift of Miss Maud E. Appleton. 31.952."; **8-9** Erich Lessing/Art Resource, NY; **8-11** Anne Vallayer-Coster (French, 1744–1818), Still Life with Lobster, 1781, oil on canvas, 27 3/4 × 35 1/4 in. (70.5 × 89.5 cm). Toledo Museum of Art (Toledo, Ohio), Purchased with funds from the Libbey Endowment, Gift of Edward Drummond Libbey, 1968.1A; **8-12** Gerard Blott/Réunion des Musées Nationaux / Art Resource, NY; **8-13** Tate, London / Art Resource, NY; **8-14** Albright-Knox Art Gallery / Art Resource, NY; **8-15** Erich Lessing/Art Resource, NY; **8-17** Scala / Art Resource, NY; **8-18** Erich Lessing/Art Resource, NY; **8-21** ©Historical Picture Archive/CORBIS; **8-22** Digital Image © The Museum of Modern Art/Licensed by SCALA / Art Resource, NY; **8-23** Alfredo Dagli Orti / The Art Archive at Art Resource, NY; **8-24** Studio Kontos Photostock; **8-27** Jacob Lawrence (American, 1917–2000), "Barber Shop," © 1946. Gouache on paper, 21 1/8 × 29 3/8 in. (53.6 × 74.6 cm). The Toledo Museum of Art, Toledo, Ohio. Purchased with funds from the Libbey Endowment, Gift of Edward Drummond Libbey.

1975.15. Photo Credit: Photography Incorporated, Toledo. © 2012 The Jacob and Gwendolyn Lawrence Foundation, Seattle/Artists Rights Society (ARS), New York; **8-33** Steve Vidler/SuperStock; **8-34** The Philadelphia Museum of Art / Art Resource, NY. Art © 2012 Artists Rights Society (ARS), New York/ADAGP, Paris/Succession Marcel Duchamp; **8-35** The Philadelphia Museum of Art / Art Resource, NY.

Chapter 9

9-1 Erich Lessing/Art Resource, NY; **9-2** E. Brandl/Courtesy of AIATSIS Pictorial Collection; **9-3** © The Trustees of the British Museum / Art Resource, NY; **9-4** © National Gallery, London / Art Resource, NY; **9-6** Alinari / Art Resource, NY; **9-7** Réunion des Musées Nationaux / Art Resource, NY; **9-8** Réunion des Musées Nationaux / Art Resource, NY; **9-9** Raphael (Umbrian, 1483–1520), "The Alba Madonna," c. 1510. Oil on panel transferred to canvas, diameter: .945 (37 1/4 in.); framed: 1.372 × 1.359 (54 × 53 1/2 in.). Andrew W. Mellon Collection, © 1999 Board of Trustees, National Gallery of Art, Washington, DC. Photo by: Jose A. Naranjo; **9-10** Digital Image © The Museum of Modern Art/Licensed by SCALA / Art Resource, NY. © 2012 Georgia O'Keefe Museum/Artists Rights Society (ARS), New York; **9-11** Kathe Kollwitz (German 1867–1945), "Self-Portrait, Drawing," 1933. Charcoal on brown laid Ingres paper, (Nagel 1972 1240), .477 × .635 (18 3/4 × 25 in.). Roselwald Collection, © 1999 Board of Trustees, National Gallery of Art, Washington, DC. 1943.3.5217. © 2012 Artists Rights Society (ARS), New York/VG Bild-Kunst, Bonn; **9-17** Christie's Images; **9-18** Digital Image © The Museum of Modern Art/Licensed by SCALA / Art Resource, NY. © 2012 Artists Rights Society (ARS), New York/ADAGP, Paris; **9-21** Henri Matisse, "Venus," 1952. Paper collage on canvas, 39 7/8 × 30 1/8 in. Ailsa Mellon Bruce Fund. Photo: © 210 Board of Trustees, National Gallery of Art, Washington, DC. © 2012 Succession Henry Matisse/Artists Rights Society (ARS), New York; **9-25** Digital Image © The Museum of Modern Art/Licensed by SCALA / Art Resource, NY.

Chapter 10

10-1 © British Library Board Or 8210/P2; **10-2** bpk, Berlin/Staatsbibliothek zu Berlin, Stiftung Preussischer Kulturbesitz, Berlin, Germany/Ruth Schacht/Art Resource, NY; **10-3** Image copyright © The Metropolitan Museum of Art. Image source: Art Resource, NY; **10-5** Emil Nolde (German, 1867–1956), "Prophet". (S/M 1966 (W) 110. only). 1912. Woodcut. Rosenwald Collection. Photograph © Board of Trustees, National Gallery of Art, Washington, D.C. 1943.3.6698; **10-6** Suzuki Harunobu (Japanese, 1725-1770), "Two Courtesans, Inside and Outside the Display Window". Japanese, Edo period, about 1768–69 (Meiwa 5-6) Woodblock print (nishiki-e); ink and color on paper Hashira-e; 67 × 12.8 cm (26 3/8 × 5 1/16 in.). Museum of Fine Arts, Boston. Denman Waldo Ross Collection, 6.1248; **10-7** Suzuki Harunobu, Japanese, 1725–1770. "Visiting (Kayoi), from the series Seven Komachi in Fashionable Disguise (Fūryū yatsushi nana Komachi)". Japanese, Edo period, about 1766–67 (Meiwa 3-4). Woodblock print (nishiki-e); ink and color on paper. Hosoban; 30.7 × 13.5 cm (12 1/16 × 5 5/16 in.) Museum of Fine Arts, Boston. William Sturgis Bigelow Collection. 11.16497; **10-8** The New York Public Library / Art Resource, NY; **10-9** Kitagawa Utamaro (Japanese, 1754–186), "How the Famous Brocade Prints of Edo are Produced," (Edo Meibutsu Nishiki-e Kosaku). Ink and color

on paper, 38.3 × 74.3 cm. Clarence Buckingham Collection, 1939.2141. The Art Institute of Chicago. Photography © The Art Institute of Chicago; **10-13** Mary Cassatt (American 1844–1926), "The Bath". c. 1891. Drypoint and soft-ground etching in yellow, blue, black and sanguine, (mathews and Shapiro 1989 5.xvi/xvii), Plate: .319 × .249 (12 9/16" × 9 13/16"); Sheet: .367 × .275 (14 7/16" × 10 13/16"). Rosenwald Collection. Photograph © Board of Trustees, National Gallery of Art, Washington, D.C. Photo: Dean Beasom; **10-15** The Tube Train, c.1934 (linocut), Power, Cyril Edward (1874–1951) / Private Collection / © Redfern Gallery, London / The Bridgeman Art Library; **10-18** ©The Trustees of the British Museum; **10-21** Image copyright © The Metropolitan Museum of Art. Image source:, NY; **10-24** Mary Cassatt (American, 1844–1926), "The Map (The Lesson)," 1890. Drypoint, 15.8 × 22.9 cm. Joseph Brooks Fair Collection, 1933.537. The Art Institute of Chicago. Photography © The Art Institute of Chicago; **10-25** Image copyright © The Metropolitan Museum of Art. Image source: Art Resource, NY; **10-27** Honore' Victorin Daumier, French (188–1879). "Rue Transnonain, on April 15, 1834, plate 24, April 15, 1834, Lithograph in black on white China paper laid down on ivory wove paper, 286 × 442 mm (image); 363 × 550 mm (sheet), The Charles Deering Collection, 1953.530. The Art Institute of Chicago. Photography © The Art Institute of Chicago; **10-31** Spencer Museum of Art, University of Kansas. Gift of the art, 205.072; **10-34** © 2012 Andy Warhol Foundation for the Visual Arts, Inc./Artists Rights Society (ARS), New York; **10-35** © 2012 Andy Warhol Foundation for the Visual Arts, Inc./Artists Rights Society (ARS), New York.

Chapter 11

11-1 Canali Photobank, Milan, Italy; **11-4** "Scala / Art Resource, NY" **11-5** Dinodia Photo LLP; **11-6** Canali Photobank, Milan, Italy; **11-7** Scala / Art Resource, NY; **11-8** Alinari/Art Resource; **11-9** Image copyright © The Metropolitan Museum of Art. Image source: Art Resource, NY; **11-10** A. Bracchetti/P. Zigrossi/IKONA; **11-11** Alfredo Dagli Orti / The Art Archive at Art Resource, NY; **11-15** Image copyright © The Metropolitan Museum of Art. Image source: Art Resource, NY; **11-16** Jan Davidsz de Heem (Dutch, 166-1684), "Still Life with Lobster," late 1640s. Oil on canvas, 25 1/8 × 33 1/4 in. (63.5 × 84.5 cm). The Toledo Museum of Art (Toledo, Ohio.) Purchased with funds from the Libbey Endowment, Gift of Edward Drummond Libbey, 1952.25; **11-17** © 2012 Artists Rights Society (ARS), New York / VEGAP, Madrid; **11-19a** Henry M. Sayre; **11-19b** Henry M. Sayre; **11-22** Image copyright © The Metropolitan Museum of Art. Image source: Art Resource, NY; **11-23** Smithsonian American Art Museum, Washington, DC / Art Resource, NY. © 2012 The Estate of John Marin / Artists Rights Society (ARS), New York; **11-24** © 2012 The Jacob and Gwendolyn Lawrence Foundation, Seattle/Artists Rights Society (ARS), New York; **11-25** The Bay, 1963 (acrylic on canvas), Frankenthaler, Helen (1928-211) / Detroit Institute of Arts, USA / Founders Society Purchase, Dr & Mrs Hilbert H. DeLawter Fund / The Bridgeman Art Library. © 2012 Estate of Helen Frankenthaler / Artists Rights Society (ARS), New York; **11-27** © Michel Setboun/Corbis; **11-28** The Philadelphia Museum of Art / Art Resource, NY; **11-29** Digital Image © The Museum of Modern Art/Licensed by SCALA / Art Resource, NY; **11-30** bpk, Berlin/Staatliche Museen zu Berlin, Preussischer Kulturbesitz

Nationalgalerie/Jorg R. Anders/Art Resource, NY. © 2012 Artists Rights Society (ARS), New York/VG Bild-Kunst, Bonn; **11-31** bpk, Berlin/Kulturbesitz, Nationalgalerie/Jorg R. Anders/Art Resource, NY. © 2012 Artists Rights Society (ARS), New York/VG Bild-Kunst, Bonn; **11-33** Kara Walker, "Insurrection! (Our Tools Were Rudimentary, Yet We Pressed On)". 2000. Cut paper silhouettes and light projections. Dimensions vary with installation. One of many views. Purchased with funds contributed by the International Director's Council and Executive Committee Members, 2000. Photo by Ellen Labenski © Solomon R. Guggenheim Museum, New York; **11-34** Kara Walker, "Insurrection! (Our Tools Were Rudimentary, Yet We Pressed On)". 2000. Cut paper silhouettes and light projections. Dimensions vary with installation. One of many views. Purchased with funds contributed by the International Director's Council and Executive Committee Members, 2000. Photo: Ellen Labenski © The Solomon R. Guggenheim Foundation, New York 2000.68; **11-37** © Erich Schlegel/Corbis.

Chapter 12
12-1 The Philadelphia Museum of Art / Art Resource, NY; **12-2** Mary Evans Picture Library/Everett Collection; **12-3** Courtesy of the Library of Congress; **12-5** Fox Talbot Collection, National Museum of Photography, Film & Television/Science & Society Picture Library; **12-8** Fox Talbot Collection, National Museum of Photography, Film & Television/Science & Society Picture Library; **12-9** Science & Society Picture Library; **12-10** Courtesy of the Library of Congress; **12-11** Digital Image © The Museum of Modern Art/Licensed by SCALA / Art Resource, NY. © 2012 Estate of Alfred Stieglitz/Artists Rights Society ARS, NY; **12-12** Charles Sheeler, American, 1883–1965. "Criss-Crossed Conveyors - Ford Plant", Negative date: 1927. Photograph, gelatin silver print. 25.4 × 20.3 cm (10 × 8 in.) © The Lane Collection Courtesy, Museum of Fine Arts, Boston; **12-15** Henri Cartier-Bresson/Magnum Photos, Inc; **12-16** Ansel Adams Publishing Rights Trust/CORBIS; **12-17** © Jerry Uelsmann; **12-18** © Jerry Uelsmann; **12-19** © Jerry Uelsmann; **12-20** © Jerry Uelsmann; **12-21** © Jerry Uelsmann; **12-23** Annie Leibovitz/Contact Press Images Inc; **12-28** Réunion des Musées Nationaux / Art Resource, NY; **12-29** © 2012 Artists Rights Society (ARS), New York/ADAGP, Paris; **12-30** D.W. Griffith, battle scene from "The Birth of a Nation," 1915. The Museum of Modern Art / Film Stills Archive. Courtesy of the Library of Congress; **12-31a** "Mary Evans/GOSKINO/Ronald Grant/Everett Collection."; **12-31c** "Mary Evans/GOSKINO/Ronald Grant/Everett Collection."; **12-31c** "Mary Evans/GOSKINO/Ronald Grant/Everett Collection."; **12-31d** "Mary Evans/GOSKINO/Ronald Grant/Everett Collection."; **12-33** Everett Collection; **12-34** Everett Collection; **12-35** MGM/Photofest; **12-36** MGM/Photofest; **12-44** Jacopo da Pontormo, "The Visitation," 1528. Oil on canvas. 79 1/2 × 61 3/8 in. Pieve di S. Michele, Carmignano, Italy. © Canali Photobank, Capriolo, Italy; **12-49** Tate, London / Art Resource, NY.

Chapter 13
13-1 Richard Serra The Matter of Time, 205. Installation of seven sculptures, weatherproof steel. Varying dimensions. Guggenheim Bilbao Museoa, GBM 1996-205. Photograph by Erika Barahona Ede © The Solomon R. Guggenheim Foundation, New York. Art © 2012 Richard Serra/Artists Rights Society (ARS), New York; **13-2** Scala / Art Resource, NY; **13-3** Organisers and ergastines (peplos-bearers), section of the Great Panathenaic procession from the east frieze of the Parthenon, c.442-438 BC (marble), Greek, (5th

century BC) / Louvre, Paris, France / Giraudon / The Bridgeman Art Library; **13-5** Scala / Art Resource, NY; **13-6** Canali Photobank, Milan, Italy; **13-7** Nimatallah/Art Resource, N.Y.; **13-9** "King Menkaura (Mycerinus) and queen". Egyptian, Old Kingdom, Dynasty 4, reign of Menkaura, 2490–2472 B.C Findspot: Egypt, Giza, Menkaura Valley Temple. Greywacke. Overall: 142.2 × 57.1 × 55.2 cm, 676.8 kg (56 × 22 1/2 × 21 3/4 in., 1492.1 lb.). Museum of Fine Arts, Boston. Harvard University—Boston Museum of Fine Arts Expedition. 11.1738; **13-10** Nimatallah/Art Resource, N.Y; **13-11** Studio Kontos Photostock; **13-12** © The Trustees of the British Museum / Art Resource, NY; **13-16** O. LOUIS MAZZATENTA/National Geographic Stock; **13-17** Image copyright © The Metropolitan Museum of Art. Image source: Art Resource, NY; **13-20** Nancy Graves, "Variability and Repetition of Similar Forms II". 1979. Bronze and Cor-ten steel Sculpture. 72" × 192" × 144". Collection of the Akron Art Museu, purchased with funds from the Mary S. and Louis S. Myers Foundation, the Firestone Foundation, National Endowment for the Arts and the Museum Acquisition Fund. Photo by Richman Haire; **13-21** © 2012 Estate of Luis A. Jimenez, Jr. / Artists Rights Society (ARS), New York; **13-22** Digital Image © The Museum of Modern Art/Licensed by SCALA / Art Resource, NY. © 2012 Artists Rights Society (ARS), NY; **13-23** © The Trustees of the British Museum; **13-24** © Jose Fuste Raga/agc fotostock; **13-25** The Philadelphia Museum of Art / Art Resource, NY; **13-29** © Arcaid Images / Alamy; **13-34** James Turrell (b. 1943), "A Frontal Passage". 1994. Fluorescent light. 12' 10" × 22' 6" × 34' (391.2 × 685.8 × 136.3 cm). Douglas S. Cramer, David Geffen, Robert and Meryl Meltzer, Michael and Judy Ovitz, and Mr. and Mrs. Gifford Phillips Funds. (185.1994) The Museum of Modern Art, New York, NY, U.S.A. The Museum of Modern Art/Licensed by Scala-Art Resource, NY. Digital Image © The Museum of Modern Art/Licensed by SCALA / Art Resource, NY; **13-37** Tony Linck / SuperStock; **13-43** © 2012 Marina Abramovic. Courtesy of Sean Kelly Gallery/(ARS), New York; **13-44** © 2012 Marina Abramovic. Courtesy of Sean Kelly Gallery/(ARS), New York; **13-45** Courtesy Goat Island; **13-46** Courtesy Goat Island; **13-47** Courtesy Goat Island; **13-48** Photo: Wolfgang Volz/laif/Redux; **13-49** Photo: Wolfgang Volz/laif/Redux.

Chapter 14
14-7 Courtesy of Laurence King Publishing Ltd; **14-8** Collection of the Arizona State University Art Museum. Gift of the Mulcahy Foundation, Tucson. 1988.25.000; **14-12** © 2012 Judy Chicago/Artists Rights Society (ARS), New York; **14-13** © 2012 Judy Chicago/Artists Rights Society (ARS), New York; **14-16** V&A Images, London / Art Resource, NY; **14-17** © Achim Bednorz, Koln; **14-18** Victoria & Albert Museum, London / Art Resource, NY; **14-20** Image copyright © The Metropolitan Museum of Art. Image source: Art Resource, NY; **14-25** © 2012 The Josef and Annie Albers Foundation/Artists Rights Society (ARS), New York; **14-29a** Courtesy of the artist; **14-29b** Courtesy of the artist; **14-33** Erich Lessing/Art Resource, NY; **14-34** Griffin bracelet from the Oxus Treasure, 500–400 bce. Gold and stones, diameter 5 in. British Museum, London, UK. The Bridgeman Art Library; **14-35** Kunsthistorisches Museum, Vienna, Austria; **14-39** Image copyright © The Metropolitan Museum of Art. Image source: Art Resource, NY.

Chapter 15
15-2 Courtesy of the Library of Congress; **15-4** ©Dallas and John Heaton/Free Agents Limited/CORBIS; **15-5** © Michael S. Yamashita/CORBIS;

15-7 John Deeks / Photo Researchers, Inc; **15-9** Studio Kontos Photostock; **15-10** Canali Photobank, Milan, Italy; **15-11** Courtesy of the Library of Congress; **15-13** Jon Arnold Images / DanitaDelimont.com; **15-15** "Scala / Art Resource, NY"; **15-16** Pubbli Aer Foto **15-17** Hemera Technolgies/Alamy; **15-18** Canali Photobank, Milan, Italy; **15-19** © Bildarchiv Monheim GmbH / Alamy; **15-21** © Achim Bednorz, Koln; **15-23** © Achim Bednorz, Koln; **15-25** Alain Evrard / Photo Researchers, Inc; **15-30** © Philip Gould / CORBIS; **15-31** Photo courtesy of The Bungalow Company; **15-32** © Angelo Hornak / CORBIS; **15-33** © Nathan Benn / CORBIS; **15-36** © The Frank Lloyd Wright Fdn, AZ / Art Resource, NY. © 2012 The Frank Lloyd Wright Foundation, Scottsdale, AZ/Artists Rights Society (ARS). NY; **15-37** Art Resource, NY; **15-38** © The Frank Lloyd Wright Fdn, AZ / Art Resource, NY. © 2012 The Frank Lloyd Wright Foundation, Scottsdale, AZ/ Artists Rights Society (ARS). NY; **15-39** Courtesy of the French Embassy; **15-40** Anthony Scibilia/Art Resource, N.Y. © 2012 Artists Rights Society (ARS), New York/ADAGP, Paris/FLC; **15-41** Hedrich Blessing; **5-44** © Angelo Hornak/Corbis; **15-45** © Keren Su / CORBIS; **15-47** Sketch by Frank Gehry, 1991. © Frank O. Gehry & Associates; **15-48** © Gehry Partners, LLP; **15-49** Guggenheim Museum Bilbao, 1997. Photograph by David Heald. © The Solomon R. Guggenheim Foundation, New York. Photo: David Heald; **15-50** Tim Griffith/Arcaid/Corbis; **15-51** © Skyscan/CORBIS; **15-53** © Ashley Cooper/Corbis; **15-54** Emilio Ambasz & Associates, Inc./Photographer Hiromi Watanabe; **15-56** © Ball Miwako / Alamy; **15-57** Courtesy of the National Park Service, Frederick Law Olmsted National Historic Site; **15-59** AP Photo/Port Authority of New York and New Jersey; **15-62** © Karl Weatherly / CORBIS; **15-63** © Michael Harding/Arcaid/Corbis.

Chapter 16
16-1 Aeronautic view of the Palace of Industry for all Nations, from Kensington Gardens, engraved by the artist, pub. 1851 (litho), Guildhall Library, Corporation of London, UK/The Bridgeman Art Library; **16-2** ©Historical Picture Archive/CORBIS; **16-5** Victoria and Albert Museum, London, Great Britain; **16-6** V&A Images, London / Art Resource, NY; **16-7** Gustav Stickley (American, 1857-1942), Settle, for the Craftsman Workshops, 199. Oak, back 38 × 71 1/16 × 22 in; seat 19 × 62 in. Gift of Mr. and Mrs. John J. Evans, Jr. 1971.748. The Art Institute of Chicago. Photography © The Art Institute of Chicago; **16-8** © 2012 Frank Lloyd Wright Foundation, Scottsdale, AZ / Artists Rights Society (ARS), NY; **16-9** Image copyright © The Metropolitan Museum of Art. Image source: Art Resource, NY; **16-10** Image copyright © The Metropolitan Museum of Art. Image source: Art Resource, NY; **16-11** Scala / Art Resource, NY; **16-12** Image copyright © The Metropolitan Museum of Art. Image source: Art Resource, NY; **16-15** © 2012 Artists Rights Society (ARS), New York/ADAGP, Paris// FLC; **16-16** Digital Image © The Museum of Modern Art/Licensed by SCALA / Art Resource, NY. © 2012 Artists Rights Society (ARS), New York/Pictoright, Amsterdam; **16-17** © 2012 Artists Rights Society (ARS), New York/Pictoright, Amsterdam; **16-18** © 2012 Artists Rights Society (ARS), New York/ VG Bild-Kunst, Bonn; **16-19** Scala / Art Resource, NY; **16-21** Digital Image © The Museum of Modern Art/Licensed by SCALA / Art Resource, NY; **16-22** © 2012 Artists Rights Society (ARS), New York/VG Bild-Kunst, Bonn; **16-23** © Bettmann/CORBIS **16-28** Digital Image © The Museum of Modern Art/Licensed

Index

All references are to page numbers. Italic numbers indicate an illustration.